The Greenwood Encyclopedia of
Homes through American History

The Greenwood Encyclopedia of Homes through American History

Volume 2
1821–1900

1821–1860, Nancy Blumenstalk Mingus

1861–1880, Thomas W. Paradis

1881–1900, Elizabeth B. Greene

Thomas W. Paradis, General Editor

GREENWOOD PRESS
Westport, Connecticut • London

Library of Congress Cataloging-in-Publication Data

The Greenwood encyclopedia of homes through American history.
 v. cm.
 Includes bibliographical references and index.
 Contents: v. 1. 1492–1820/Melissa Wells Duffes, William Burns, and Olivia Graf ;
1781–1820 / Melissa Wells Duffes ; Thomas W. Paradis, general editor—v. 2. 1821–
1900—v. 3. 1901–1945—v. 4. 1946–present.
 ISBN 978–0–313–33496–2 (set: alk. paper)—ISBN 978–0–313–33747–5 (v. 1: alk.
paper)—ISBN 978–0–313–33694–2 (v. 2: alk. paper)—ISBN 978–0–313–33748–2
(v. 3: alk. paper)—ISBN 978–0–313–33604–1 (v. 4: alk. paper)
1. Architecture, Domestic—United States—Encyclopedias. 2. Decorative arts—United
States—Encyclopedias. 3. Dwellings—United States—Encyclopedias. I. Greenwood
Press (Westport, Conn.) II. Title: Encyclopedia of homes through American history.
 NA7205.G745 2008
 728.0973'03—dc22 2008002946

British Library Cataloguing in Publication Data is available.

Library of Congress Catalog Card Number: 2008002946
ISBN-13: 978–0–313–33496–2 (set)
 978–0–313–33747–5 (vol. 1)
 978–0–313–33694–2 (vol. 2)
 978–0–313–33748–2 (vol. 3)
 978–0–313–33604–1 (vol. 4)

First published in 2008

Greenwood Press, 88 Post Road West, Westport, CT 06881
An imprint of Greenwood Publishing Group, Inc.
www.greenwood.com

Printed in the United States of America

The paper used in this book complies with the
Permanent Paper Standard issued by the National
Information Standards Organization (Z39.48–1984).

10 9 8 7 6 5 4 3 2 1

Contents

HOMES IN THE CIVIL WAR AND RECONSTRUCTION ERA, 1861–1880

Foreword

What if the walls of our homes could talk? Though perhaps a frightening thought for some, our walls would certainly relate countless happy memories and events throughout our lives and past generations. They might also tell us of their own origins—their own past, explaining their history of construction; materials; positioning within the home—their relationship to doors, windows, rooflines, and basements; and all the special ways in which they have been decorated or altered by their owners. In a sense, this unprecedented series of volumes on the history of the American home will allow our walls to talk to the extent possible through the written word. The physical structures of our homes today—whether condominium, townhouse, farmhouse, apartment house, freestanding house, mansion or log cabin—all have a story to tell, and the authors of this set have been determined to tell it.

It is easy to take our homes for granted; we do not often recognize the decades and centuries of historical development that have shaped and informed the construction of our own walls that shelter us. Our homes' room layouts, construction materials, interior furnishings, outdoor landscaping, and exterior styles are all contingent upon the past—a past comprising individual innovators, large and small companies, cultural influences from far-away places, political and economic decisions, inspirational writers, technological inventions, and generations of American families of diverse backgrounds who have all contributed to how our homes look and function. This set, titled *The Greenwood Encyclopedia of Homes through American History,* treats the American home as a symbolic portal to an historical account rarely viewed from this perspective.

This set focuses just as much on the interrelated past of American culture, politics, economy, geography, transportation, technology and demographics as on the home itself. By twisting the title a bit, we could easily justify renaming it to an *American History through the Home*. Given that most of us find history more meaningful if connected tangibly to our own lives, the American home perhaps serves as the ideal vehicle for relating the fascinating and engaging aspects of American history to students of any age and educational background. Our homes today are in large part a product of our past, and what better way than to use our own dwellings as veritable gateways to understanding American history—and for better understanding ourselves?

The volumes herein take us on an introductory though comprehensive tour through the dynamic developmental process of the American home from the earliest colonial cabins and Native-American precedents to present-day suburbs and downtown loft condominiums. Though treated as a historical account, this collection constitutes a multi-disciplinary approach that weaves together the influences of geography, urban and rural development, cultural studies, demographics, politics, and national and global economy. Each book in the set considers regional developments, relevant historical issues, and multicultural perspectives throughout the current-day contiguous 48 United States. Further, because most of us do not live in grand, *high-style* estates or mansions designed by professional architects, our authors devote more than the typical amount of space on common, or vernacular, architecture of the home. It is nonetheless vital to recognize the vast amount of past and contemporary research from which this set has borrowed and showcased. More than the latest write-up on architectural history, these volumes also provide an extensive overview of the more significant resources on this topic that will lead enthusiasts well beyond these specific pages. This set is perhaps best interpreted as a beginning on the journey of life-long learning.

Those interested in the American home—whether student, professional, layperson, or a combination—can approach *The Greenwood Encyclopedia of Homes through American History* in various ways. The set is divided into parts, or time periods, each written by a different scholar. Thus, each volume is divided into two or more chronological segments, and each can be read as a narrative, moving in the order presented by the sequence of chapters. Others will find an encyclopedic approach to be useful, allowing those searching for specific information to quickly access the volume and topic of choice through the volumes' contents pages and through the comprehensive index. Every chronological part of each volume includes a glossary and lengthy recommended list of resources to enhance the reader's search for clarity and to provide further sources of information. While impossible to scour the Internet for all relevant resources on the topic, this set has included a commendable listing of reliable and informative Web resources, all of which can potentially lead in new directions.

Like scaffolding that enables a building's construction, the sequence of chapters found in each chronological segment of the volumes progresses logically through major topics relevant to the home. With a few exceptions, each part takes us on a veritable tour, beginning first with a chapter devoted to relevant history and contextual background. From there, we tour the American home's exterior treatments, referred to as architectural styling, perhaps the

most visible and public feature of our dwellings. The tour then continues to the inner workings and construction of the home, highlighting the important building materials and manufacturing techniques available during that period of time. The home's interior serves as the next stop on the tour, with two successive chapters devoted to floor plans, room layouts and uses, topics on lighting, heating, and ventilation, and a full chapter devoted to furniture and interior design.

Completing most segment's tour is a final chapter taking us back outside to consider the approaches to landscaping around the home, its site on the lot, its situation in the local or regional environment, its relationship to the streets and neighborhood, and any outbuildings that may have contributed to the homestead.

Organized a bit differently from the rest, the final segment, from 1986 to the present, provides a sort of conclusion to the entire set, interpreting the most current trends in contemporary housing and society, with which we can all directly relate as we progress through the early part of the twenty-first century. As the series editor, I speak for all our authors by inviting you to explore the endless fascination provided by our cherished American home through history, and to discover for yourself how, indeed, our walls can talk to us.

Thomas W. Paradis
Series Editor

PART ONE

Homes in the Revival Era, 1821–1860

Nancy Blumenstalk Mingus

Introductory Note

The United States was expanding rapidly between 1820 and 1860, which is evident by the diversity of home styles in this period. Greek Revival (1825–1850); Gothic Revival (1835–1880); Italianate (1835–1885); Second Empire (1855–1885); a variety of exotic revivals, including Egyptian, Oriental, and Swiss Chalet (1835–1890); and specialty houses such as octagon houses, brought an eclectic mix to the existing housing stock. Used in conjunction with the other works in this series, this book provides both historians and the general public with detailed information on not only house design, but also on how homes were used in all regions of the country and by all levels of society. It is illustrated with descriptions of the housing styles, as well as by photographs and sketches showing landscaping, interior design, and building materials of the era.

As with the other books in the set, this section has six chapters that focus first on a general history of the period and then move on to specific house styles, building materials, room layout and use, furniture and decoration, and landscaping and outbuildings.

The first chapter, "Changes in American Life," sets the context for this first revival period in American housing, which saw great changes both in where people lived and in what types of homes they built. In 1820, the total U.S. population was 9,638,453, and the only city with more than 100,000 people was New York. By 1860, the total population had reached 31,443,321, nine cities had more than 100,000 residents, and New York had grown to more than 800,000 people. This chapter provides readers with an overview of the development in the country up to 1820 and then presents highlights of the revival period. Topics include presidents and their policies and how these influenced

transportation and settlement patterns; the general westward migration and its influence on housing; and the emerging importance of architects in common home design

From 1820 to 1860, the United States was evolving from an infant country into a world power. This was reflected in varying ways throughout the land. The second chapter, "Styles of Domestic Architecture around the Country," provides a general introduction to each of the major styles (Greek Revival, Gothic Revival, Italianate, Second Empire, octagon houses, and cobblestone houses), the regions in which most were found, how locale and wealth affected the trends, and the approximate timeframes in which each style was popular. The chapter highlights several specific buildings found in each of the five regions of the country: Northeast, South, Midwest, Southwest, and West Coast.

Part of the driving force behind the change of style in home design was the increased mechanization of the building process and a refinement of building material used. The third chapter, "Building Materials and Manufacturing," outlines these changes and how they applied to each of the popular styles as well as to vernacular homes still being built in rural areas. Specific topics include a change from hand-hewn to milled wood for beams, clapboards, and so on; the creation and use of balloon framing; the types of flooring materials (dirt, pine, oak) in use; methods for heating the house, including wood fireplaces, kerosene, and other fuels; options for lighting the house, ranging from candles to gas lanterns; and the availability of indoor plumbing. The chapter also discusses log homes still in use in the Midwest and West.

As the exterior style of homes changed, so did the layout and use of interiors. The fourth chapter, "Home Layout and Design," explores the general layout of a variety of homes, seen through the eyes of popular pattern books of the time, and discusses the specific evolution and use of the major rooms and features, including porches, kitchens, bathrooms, and basements. This chapter describes the types of tasks done in the home, the rooms in which they were done, and where those rooms were in the home. It answers questions of where people ate, bathed, and spent their free time.

Just as this period was marked by numerous revivals in architecture, period furniture and decoration was revivalist in nature. "Furniture and Decoration," the fifth chapter, describes the traditional furniture still popular during this time, as well as the various revival styles brought about by more effective manufacturing facilities. It discusses gilding, which began gaining popularity around 1850, and other painting techniques, as well as lighting revolutions, and the fabric and paper-related inventions that had affects on the manufacture and design of rugs, draperies, wallpaper, and other decorating items for the home.

As homes evolved, so did domestic landscaping and accompanying outbuildings. The sixth chapter, "Landscaping and Outbuildings," describes the evolution of landscaping, the types of gardens used during this period, and outdoor living areas such as patios and gazebos. This chapter also details the specialty buildings such as barns, outhouses, hop houses, and the like, commonly found in both rural and urban areas. It discusses regional differences in these constructs, especially in formal versus informal gardens and barn design, and highlights several striking examples of outbuildings.

This section on the period between 1821 and 1860 also contains material consistent with the other sections of the volume, including a timeline, a glossary, and a resource guide for doing further reading and research. Interspersed throughout the body of the work are sidebars highlighting important or interesting concepts.

ACKNOWLEDGEMENTS

One would think that a fourth book would be easier than the preceding three, but, alas, that was not the case. I would not have been able to complete this work without the patience of editor Anne Thompson, the research help of Michele Broczek, and the continued support and understanding of my husband, Mike, and my daughters Marissa and Paige. It was also great of all the Lakeside neighbors to ignore the three feet tall weeds in my own house's garden this year while I wrote rather than gardened.

Timeline

1820 The Missouri Compromise helps set the stage for national division on slavery.

James Monroe is re-elected for his second term as President of the United States.

The population in the United States is 9,638,453.

1821 The first James Fenimore Cooper novel is published.

Emma Willard founds Troy Female Academy, the first college for women.

1822 Denmark Vesey plans an unsuccessful slave revolt in South Carolina.

The first water-powered cotton mill opens in Massachusetts.

1823 James Monroe issues the Monroe Doctrine.

1824 John Quincy Adams is "elected" president after all candidates fail to carry the majority popular or electoral vote.

1825 The Erie Canal opens from Albany to Buffalo, New York opening up settlement in the Midwest.

The first steam locomotive in America is built.

Mexico allows Americans to settle in Texas.

The Greek Revival style becomes the popular "National" building style, remaining dominant until circa 1850.

1826	The questions around the disappearance of William Morgan prompt the formation of the Anti-Masonic party.
1827	The first Fourdrinier (continuous roll paper machine) arrives in the United States.
	Asher Benjamin publishes *The American Builder's Companion,* featuring Greek Revival designs.
1828	The "Tariff of Abominations" is passed by Congress further alienating the South.
	Andrew Jackson is elected president.
	The Baltimore & Ohio railroad is chartered as the first passenger railroad in the United States.
1829	Minard Lafever publishes *The Young Builder's Guide,* continuing the move toward Greek Revival residential architecture.
1830	The Mormon church is founded in upstate New York.
	The Indian Removal Act is passed by Congress, starting the devastating forced migration to Oklahoma.
	Mexico curtails Texas settlement.
	The first lawnmower is patented.
	The population of the United States in 12,866,020.
	The first issue of *Godey's Lady's Book* magazine is published. It would continue to be an influential magazine for the next 62 years.
1831	Nat Turner conducts the only major slave insurrection in America.
	The mechanical reaper is invented by Cyrus McCormick.
1832	The Tariff Act of 1832 repeals the "abominations" in the 1828 act to keep South Carolina from withdrawing from the Union.
	Philadelphia homes become the first to have running water from a public source and designated "bathrooms."
	George Washington Snow invents the "balloon frame" system of building construction, which revolutionizes the building industry.
	Eliphalet Nott patented a base-burning stove with a rotary grate, which was the first coal-burning stove.
1833	Oberlin College is founded as the first coeducational college in the United States.
	Great Britain abolishes slavery in all its colonies.
	The American Anti-Slavery Society is formed.
1834	Congress censures Andrew Jackson for his role in the demise of the Federal Bank.
1835	The Seminole War begins in Florida.
	A. W. Pugin publishes *Gothic Furniture in the Style of the Fifteen Century.*

1836	Martin Van Buren is elected president.
	The galvanization process for bonding zinc to iron was invented.
	Arkansas is admitted to the Union as the 25th state.
1837	The Panic of 1837 triggers an economic depression that lasts until 1843.
	Michigan is admitted to the Union as the 26th state.
	Alexander Jackson Davis publishes his book *Rural Residences.*
	Victoria becomes Queen of England, which prompts a great revival in Gothic architecture, furniture, and other decorations.
1838	The Cherokees are removed to Oklahoma.
	Public water is available in New York City.
	Robert Conner publishes *Cabinet Maker's Assistant.*
1839	Charles Goodyear first produces vulcanized rubber.
1840	William Henry Harrison is elected president.
	The population of the United States reaches 17,069,453.
	The National Road reached Vandalia, Illinois, stretching 800 miles inland from Maryland.
	Miss Eliza Leslie publishes her homemaking guide, *The House Book.*
1841	Harrison dies shortly after his inauguration, and John Tyler assumes the presidency after Harrison's death.
	The first wagon train of settlers arrive in California from Missouri.
	Andrew Jackson Downing publishes his first book, *Treatise On The Theory And Practice Of Landscape Gardening Adapted To North America.*
	Augustus Welby Northmore Pugin publishes *The True Principles of Pointed Architecture.*
1842	The Seminole War ends, forcing the remaining Seminoles to Oklahoma.
	Andrew Jackson Downing published *Cottage Residences.*
1843	The first caravans to Oregon depart from Missouri.
	The Convention of the Free People of Color is held in Buffalo, New York.
1844	James Polk is elected president.
	The first telegraph message is sent by Samuel Morse.
1845	Florida is admitted to the Union as the 27th state, and Texas is admitted as the 28th state.
	The Irish potato famine prompts the influx of Irish immigrants to America.
	Elizabeth Ellicott Lea publishes her book *Domestic Cookery.*

1846	Solon Robinson writes the first known article supporting balloon frame construction titled, "A Cheap Farm-House."
	The sewing machine is patented by Elias Howe.
	Iowa is admitted to the Union as the 29th state.
1847	Mormon settlers establish their home in Salt Lake.
	John Henry Belter patents his first steam machine designed to bend rosewood for furniture.
1848	Zachary Taylor is elected president.
	Wisconsin becomes the 30th state in the Union.
	The Mexican War ends, giving the United States the western states of Arizona, California, Colorado, Nevada, and New Mexico allowing the country to stretch from "sea to shining sea."
	Gold is discovered in California.
	The first Women's Rights Convention is held in Seneca Falls, New York.
	Orson Fowler publishes the first edition of *A Home for All*.
1849	John Ruskin publishes *The Seven Lamps of Architecture*.
1850	Millard Fillmore assumes presidency after Taylor's death.
	California is admitted to the Union as the 31st state.
	The United States population is 23,191,876.
	A. J. Downing publishes *The Architecture of Country Houses*.
1851	John Ruskin publishes the initial volume of *Stones of Venice*.
1852	Franklin Pierce is elected president.
	Richard Upjohn released *Rural Architecture*.
1853	Orson Fowler publishes the second edition of *A Home for All*, which includes not only plans, but his "gravel wall" construction technique.
	The Country Gentleman begins publication, which continues for 102 years.
1854	The Republican party is established.
	Railroads now reach from New York to the Mississippi.
1855	Gervase Wheeler publishes *Homes for the People in Suburb and Country*.
	The first railroad crosses the Mississippi River.
1856	James Buchanan is elected president.
	Fredrick Siemens invents the "regenerative" glass furnace, which leads the way for additional improvements to the glass production process.
1857	Another financial panic threatens the U.S. economy.

1858 William E. Bell publishes *Carpentry Made Easy*.

Olmsted and Vaux win Central Park commission.

Minnesota becomes the 32nd state.

1859 Edwin Drake drills the first oil well in the United States in Titusville, Pennsylvania.

Oregon becomes the 33rd state.

1860 Abraham Lincoln is elected president.

South Carolina secedes from the Union.

The population of the United States reaches 31,443,321, and the population of New York city is over 800,000.

George Woodward publishes an article in *The Country Gentleman*, which popularizes balloon framing nationwide. His later book *Woodward's Country Homes* (1865) also includes detailed material on balloon framing.

Changes in American Life

The span of years from 1821 to 1860 saw tremendous change in virtually all aspects of American life. Current residents moved west, while new immigrants poured in to the seaboard states and many also moved to the West. Technology in farming, manufacturing, and housing changed dramatically in these years, bringing with them ever-evolving tastes in ornamentation in architecture, furniture, and other worldly goods. While some of these tastes were for newly created cultures and symbols, many tastes returned to a focus on the ancient worlds. Because of the deep interest in reviving classics, this period can be appropriately referred to as the American Revival period.

This first revival period in American housing saw great changes not only in where people lived but also in what types of homes they built. In 1820, the total American population was 9,638,453, and the only city with more than 100,000 people was New York. By 1860, the total population had reached 31,443,321, nine cities had over 100,000 residents, and New York had grown to over 800,000. In fact, the 40 years between 1821 and 1860 represent the largest period of growth in the history of America, creating what we call today the middle class.

This chapter will provide readers with an overview of the development in the country up to 1820 and then will present highlights of the revival period. Topics include:

1. Settlement patterns, including the general westward migration;
2. Political and economic environment fueling migration;

3. Important changes in technologies, including canals, railroads, and building-specific improvements such as balloon framing; and

4. Emerging importance of architects in common home design.

EXPANSION AND SETTLEMENT

The tremendous growth that started with the Louisiana Purchase in 1803 doubled in the four decades from 1821 to 1860. In 1820, the United States was still less than 50 years old and was coming out of a deep depression caused by the influx of British imports after the end of the War of 1812. The population was still focused in the original 13 colonies, yet each had decreased in numbers as the original settlers moved west. The nearly 10 million residents of 1820 included 4.3 million in the New England and Middle Atlantic states and 2.9 million in the South, but the remaining 2.3 million were in the growing western regions. During the next four decades, westward development continued even more rapidly. The 23 states in existence at the beginning of these 40 years would grow to 33 by their end.

The states existing in 1820, listed in the order in which they were admitted as states, included: Delaware, Pennsylvania, New Jersey, Georgia, Connecticut, Massachusetts, Maryland, South Carolina, New Hampshire, Virginia,

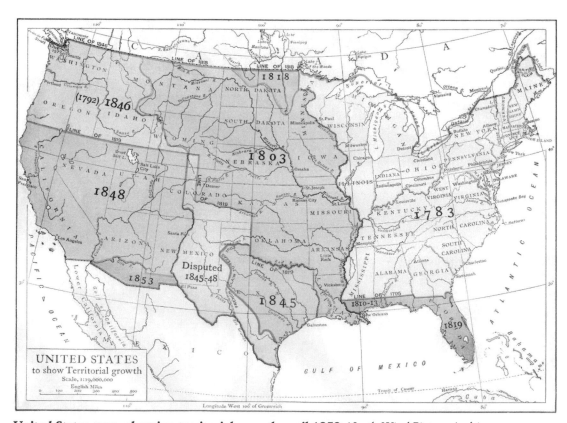

United States map, showing territorial growth until 1853. North Wind Picture Archives.

New York, North Carolina, Rhode Island, Vermont, Kentucky, Tennessee, Ohio, Louisiana, Indiana, Mississippi, Illinois, Alabama, and Maine. East of the Mississippi, the northern tip of Maine was claimed, but not yet incorporated in to the state, and Florida was only a territory. Michigan, Wisconsin, and the upper part of Minnesota were also territories, as was much of the Midwest, known then as the Missouri Territory. Today's southwestern states and California belonged to Spain. In fact, the only state west of the Mississippi was Louisiana.

Several of these states and territories were new U.S. acquisitions. Florida had just been annexed in early 1819 and would become a formal territory in 1822. The Arkansas Territory (sometimes referred to as the Arkansaw Territory) was also organized in 1819. Later that year, Alabama was admitted to the Union as the 22nd state, and Maine was added just three months after that. In the three years prior to its admission, the population in Missouri had doubled, and both it and Maine wanted to become states, but Congress did not want any more states that allowed slaves. As a condition of the Missouri Compromise, Maine was designated a free state, while Missouri, admitted in 1821, was admitted as a slave state. Another part of the compromise was that any states north of 36 30′ latitude would be free states.

By 1830, the U.S. population had increased another third to 12,866,020. Florida had become an organized territory, and the Arkansas territory had decreased to just the modern boundaries of the state of Arkansas. During the 1830s, two more states, Arkansas and Michigan, were added to the growing Union. Arkansas was admitted in 1836 as the 25th state and a slave state, and Michigan became a state in 1837.

Perhaps more importantly, three additional territories were created during the 1830s. The first was the Indian Territory, in present-day Oklahoma, formed in 1834 as an area to relocate Native Americans living in the eastern states. Two years later, in 1836, the Wisconsin Territory was added, followed in another two years by the Iowa Territory. The Wisconsin territory encompassed all of present-day Wisconsin as well as the northeastern portion of present-day Minnesota. The Iowa territory included Iowa, western Minnesota, and the eastern portions of North and South Dakota.

Westward and southern expansion continued in the 1840s. According to the 1840 census, the U.S. population had increased by another third to 17,069,453 and grew an additional third during this decade. The land area continued to grow, too. At the conclusion of the Mexican War, the United States annexed more than a million square miles of territory covering portions of today's states of Colorado, New Mexico, Kansas, Oklahoma, and Texas. Florida went from territory to slave state in early 1845, and later that same year, Texas went from independent republic to state.

The growth did not stop there. In the summer of 1846, New Mexico and Arizona were annexed, and in December, Iowa became the 29th state. Through the 1848 Treaty of Guadalupe Hidalgo, America added today's California, Nevada, Utah, and parts of Arizona, Colorado, New Mexico, and Wyoming. The remaining portion of Wyoming, as well as part of Montana, and all of present-day Washington, Idaho, and Oregon were annexed as the Oregon Territory. Also in 1848, Wisconsin became the 30th American state, and rounding out this explosive decade, the Minnesota Territory was created in early 1849.

The Oregon Territory had been claimed by four countries over a 200-year span, including Russia and Spain, before it became central in a debate between England and the United States. A compromise in the debate was "joint occupation" of the area, which continued until the 1848 annexation, with a negotiated northern border of the 49th parallel. Although President Polk and many northerners proposed the boundary at 54 40' with a catchy slogan of "Fifty-Four Forty or Fight!," the compromise at the 49th parallel gave the United States the northern boundary still in existence today.

The population of the United States had increased by one-third in each of the decades from 1820 to 1840. By 1840, the population center was west of the Appalachian mountains. By 1850, the population was 23,191,876, an increase of approximately 36 percent over the 1840 population. One-third of these people lived in portions of the country that were not even a part of the country in 1790, and 10 percent were born in foreign countries.

The 1860 population of 31,443,321 was another 36 percent increase from 1850. While the population numbers continued to increase as settlers moved west and south, the land area expansion of the United States stagnated in these two decades. Territory boundaries adjusted in both the 1850s and 1860s, but not in any significant ways, and only three new states joined the Union: California in 1850, Minnesota in 1858, and Oregon in 1859. By this time, settlers had cleared or improved 114 million acres.

Population patterns were not just changing from the east to the south and west, however, they were migrating from largely rural areas to urban ones as well. The largest urban areas at the turn of the century had less than 200,000 total inhabitants. This changed dramatically in the first two decades of this revival period. While overall population was increasing at about 33 percent per decade, the urban population was increasing by nearly 60 percent per decade.

The bulk of this urban migration was children moving off the family farms to work in the industrializing cities. These young adults were employed not just in the burgeoning factories, but in all the support services as well. Even those that continued to live on the farms began using the services available in the cities. Furniture, clothing and other necessities were cheaper in the cities, setting the stage for even more growth in factories and services.

Where were all these people coming from? In the first half of this 40-year period, the increase was largely due to the birth rate. In 1800, the average number of children per family was 7, and it was not uncommon for families to have 10 or more children. There were modest numbers of new citizens arriving from other countries, but that averaged around 5,000 per year through the 1820s. In the 1830s, migration from other countries increased to about 6,000 per year, but still the levels were manageable. That is, they were until 1845.

In the summer of that year, the great Irish potato famine hit that country, killing nearly a million people during its 10-year reign, and driving more than 2 million to other countries. It's estimated that in 1847 alone, some 200,000 Irish headed to the "New World." The modest 6,000 per year influx from the 1830s jumped to 170,000 per year in the 1840s, and accelerated again to 260,000 per year in the 1850s. The bulk of these 4 million immigrants came from Ireland.

Yet, the Irish were not the only immigrants during this time. Many came also from Germany and Scandinavia, and each group's culture would have a dramatic affect on the shaping of the United States. In New York City alone,

the immigrant population went from less than 10 percent to nearly half of all the residents by the 1850s.

Not all this urban growth was positive. Many of the people pouring in to the cities were poor and crammed in to substandard housing. Slums started to appear in New York City in the mid-1810s, but they were much worse by the 1840s. By that time, nearly 20,000 people occupied buildings stacked up to 20 per room. Unfortunately, these situations occurred in other major cities, too, well in to the later 1800s.

In addition to the over-population, cities in this time period were filthy. Because most of the transportation, especially in the 1820s and 1830s, was powered by horses, the city streets were covered with their biological wastes. Garbage collection and indoor plumbing were virtually nonexistent, adding human waste into the mix. This caused numerous epidemics, including four outbreaks of cholera. While cholera first hit Europe in 1817, it did not reach the United States until after its second insurgence in 1832. Especially hard hit in this wave were the port cities on the East Coast and all the small towns along the Erie Canal and other major travel ways. The disease returned in 1849 and would hit one more time just after these 40 years ended, in 1866.

At the turn of the nineteenth century, 94 percent of Americans lived in areas with populations of less than 2,500 people. When this revival period ended in 1860, the United States could boast of 43 cities of 20,000 or more people, and New York City had 800,000 residents. This made it the third largest city in western civilization, with only London and Paris larger.

POLITICAL AND ECONOMIC ENVIRONMENT

Much of the expansion in the land mass of the United States during this time was driven by the men in power. While prominent business men played a role, it was primarily the 11 Presidents in these 40 years who lead the country to its "Manifest Destiny."

The voting process changed greatly during these 40 years, especially from 1820 to 1840. The country went from two parties to one and back to two again. Prior to 1820, there were landowner restrictions on both voting and running for office. This limited the number of qualified candidates as well as those voting for them. During the next two decades, these limitations were removed, leading to a participation level in elections of some 80 percent of the white male population. Free African Americans were also allowed to vote in many of the northern states, while women, even those who owned property, would have to wait many more years.

The 1820s started with James Monroe being inaugurated for his second term. This allowed him to continue with the policies he had initiated during his first term, which included the displacement of Native Americans to make way for "civilized life" (Dudley 2003). In 1823, his other intentions for the country were codified into what has become known as the Monroe Doctrine. His three basic tenets were that: (1) North and South America were closed to new colonies, and any attempts to establish any would be seen as a threat to the United States; (2) European intervention in the governments of any American countries would also be considered a threat; and (3) the United States would stay out of European matters. Directed primarily at Russia, the Doctrine itself had little affect initially, but it set the stage for later actions (Findling and Thackeray 1997).

The mid-1820s saw a change in power as John Quincy Adams was elected to be the 6th President. Like his father before him, Adams was a strong supporter of Federal powers, especially in the areas of infrastructure and economic development. Although a brilliant negotiator, Adams was not charismatic, and he came to power just when his Republican party had divided. These latter two conditions worked against him during his tenure in office, making it impossible for him to further his vision of federally supported education, roads, canals, and territory expansion. To fund this vision, he supported a tax that became known as the Tariff of Abominations, especially in the South, where it was viewed as a pro-North move (Smith 1980).

After one of the dirtiest political campaigns to date, the 1820s closed with the reins of the young nation passing yet again, this time into the hands of Andrew Jackson. The personalities and history of the two candidates also spurred the largest voter turnout, with double the number of voters over the 1824 election. Some of this increase might have been due to backlash from Adams' being the only President elected without winning either the popular vote or the electoral vote (he was selected by the House because there had been no clear majority in the other two methods), but most was due to the formal campaigns run on both sides.

Jackson, largely remembered for his role in the War of 1812, helped change the Presidency in many ways. First, he strongly believed in sharing of the wealth. He fought hard for the nation's "created equal" founding principle. To help bring about this equalization of opportunity, and eventually wealth, Jackson staunchly opposed the national banking system. He also promoted a system of rotation of office, known as the "spoils system," to try to minimize government, which led to the dismissing of hundreds of appointees of the previous administration in favor of his own people.

Jackson was re-elected in 1832 and continued the policies he had started in his first term. In addition to managing to dismantle the national bank, he was also the only President to operate the country without a deficit. Unfortunately, he was responsible for the massive uprooting and transplanting of the Native Americans as well (Smith 1981; Dudley 2003).

In 1836, Martin van Buren, who had been Jackson's Vice President, became the 8th President of the United States. Shortly after his inauguration, however, conditions in the country took a rapid downturn. Although Jackson had been the only President to never operate with a deficit, his policies left the country unstable, leading to a depression in 1837 commonly called the Panic of 1837. Triggered by a sharp decline in cotton prices, the depression lasted well in to the 1840s (Smith 1981).

After surviving just a single term, van Buren was replaced in 1841 by William Harrison, a general who helped win the Battle of Tippecanoe. This political campaign, and Harrison himself, hold several national distinctions. For instance, this campaign was the first to use political jingles and icons to evoke positive images of the candidates. A popular symbol was that of a log cabin, associated both with western development as well as life in modest surroundings. The slogan "Tippecanoe and Tyler, too" also stems from this election and led to the popular use of political slogans in later years (Smith 1981).

On a personal level, Harrison had the distinction of being the last former British citizen to be elected President. He was also the first of the newly formed

Whig party to be elected to the country's highest office. He had run against van Buren in 1836, but lost. Still, he did well enough that when added to van Buren's implicit contribution to the Panic of 1837, Harrison carried the 1840 election with ease (Smith 1981).

Unfortunately for him and the Whigs, Harrison also holds the distinction of being the first president to die in office. While delivering his two-hour inaugural address in the cold and rain, Harrison contracted an illness and died exactly one month later. He was replaced by his Vice President, John Tyler. Although Tyler ran on the Whig party ticket with Harrison, he was a former Democrat, and when he took over the office, he returned to his former beliefs (Smith 1981).

Tyler ended up having some firsts of his own. Because he was the first President to assume office from the Vice Presidency, he was known, especially by his detractors, as "His Accidency." During his tenure, he vetoed all nine of the Whig bills trying to increase Federal spending and tariffs; a record number of vetoes, which led in 1843 to the first, though failed, attempt to have a president impeached.

There were some bright moments in Tyler's Presidency, however. He forged a treaty between the United States and Britain over the borders of Canada. He also was responsible, in 1844, for the annexation of Texas; but, it was not enough for his detractors. Tyler served out the remainder of Harrison's term but was not re-elected.

The 11th President of the United States, James Polk, was sworn in on March 4, 1845. Polk was only 49 years old when elected, making him one of the younger Presidents. He ran on a platform compatible with Jacksonian doctrine and was one of the most accessible Presidents of all time. He used the White House as a large community center and allowed the general public to visit twice a week. He was technologically progressive, yet aware of the importance of history. He both installed gas lights in the White House and established the Smithsonian Institution as the nation's museum.

Like Jackson, Polk believed in Manifest Destiny and had great plans for progress under his reign. In terms of economics, he wanted to fix the financial problems left over from the 1837 depression, while decreasing tariffs. On the land front, he hoped to finalize Oregon Territory issues as well as annex California. The catch phrase of the time was "54 40 or fight." Although the country settled for the 49th parallel as our border with Canada, Polk did accomplish most of his expansion objectives. The country ended just west of the Mississippi at the beginning of his term and extended all the way to the West Coast a mere four years later.

The two years from 1846 to 1848 during Polk's term were arguably the most important two years in the development of the United States. In just those two years, the United States acquired more than one million square miles of land, making the United States the "sea to shining sea" country it is today. How did Polk accomplish this? More than two-thirds of the growth was the result of the war with Mexico.

The Mexican War

Trouble had been brewing between the United States and Mexico since Mexico became independent from Spain. In 1821, Mexico allowed Americans to settle in Texas providing they would become citizens, speak in the national Spanish language, and convert to the national Roman Catholic religion. Agreeing

to those rules, hundreds of slave-owning families moved in to the area. As settlement increased, however, the later arrivals were no longer adhering to the agreement.

By 1830, Mexico had banned additional American relocation. More significantly, it banned slavery, which did not sit well with the existing settlers. In 1835, they had had enough, seceded from Mexico and formed the Republic of Texas. The revolt was a violent one, including the infamous loss at the Alamo in San Antonio. It ended at the battle of San Jacinto.

Texas remained independent for the next nine years, although it was never formally recognized as such by Mexico. Texas petitioned to join the United States in the summer of 1845 and was annexed as the 28th state in December that same year. In the spring of 1846, skirmishes erupted between Mexican and American troops along the Rio Grande. These skirmishes escalated to a formal declaration of war in May.

The war lasted for two years, with U.S. troops invading New Mexico and California and finally taking Mexico City. After that, the countries negotiated the 1848 Treaty of Guadalupe Hidalgo, which gave the territory to the United States for nearly $20 million of payments and forgiven debt. The treaty also gave any Mexican citizens living in the new American territories the rights to keep their property.

The Presidency

Zachary Taylor was elected the 12th President in 1848 and sworn in in 1849. He was the second and last Whig elected President. Taylor was also a war hero and oddly prided himself on the fact that he was not registered to vote and did not vote in his own election. He was a cousin of President Madison, father in law of future Confederate President Jefferson Davis and related to Robert E Lee, as well.

Unfortunately, the second Whig President did not fare much better than the first. While celebrating at the groundbreaking of the Washington Monument, Taylor contracted a form of cholera and died five days later. His Vice President, Millard Fillmore, took over the Presidency, completing his term through 1853. Fillmore was an affable man who supported slavery for economic reasons and did not understand the moral arguments against it. He fired Taylor's cabinet and signed the Compromise of 1850, helping set the stage for the Civil War.

Rounding out the Presidency in this 40-year period were Franklin Pierce, a Democrat who served from 1853 to 1857, and James Buchanan, 1857 to 1861. Buchanan never married, and the term "First Lady" was coined to represent the role his niece played when presiding over social functions at the White House. Buchanan's policies hastened the Civil War, which greatly shaped the next 40 years from 1861 to 1900.

Cultural Clashes

Although 1821 to 1860 was a time of great opportunity for Americans, it was also a time of pain as well. Americans in the outlaying areas of the country lived in constant fear of attacks by wild animals, raging storms, and, occasionally, other settlers. Americans in the inner cities, especially in the late 1840s through

the 1850s, lived on low wages, in squalor, in cramped quarters, and surrounded by thousands of others in the same situation.

Native Americans were also in a state of flux. Forced off their lands as settlers migrated westward, it was not just their way of life that was threatened, but their very existence. Hostilities over these worsening circumstances could not help but arise.

Conditions were not any better in the "genteel" south, especially for the plantation slaves. In fact, they were often much worse. Ripped from their families and sold as property, most slaves worked extremely long hours and were provided with little more than a life of subsistence. Their plight became increasingly intolerable to the northerners as the century continued, leading ultimately to the Civil War.

Native American Treatment

As soon as Europeans landed in the New World, a clash for land began. In the early years of the country, these clashes were settled with the Native Americans somewhat amicably. As the new Americans continued to grab space, however, these clashes became less peaceful and frequently violent. By the time that Andrew Jackson was elected in 1828, sentiments were strongly in favor of moving the Native Americans to the West: a task accomplished by Jackson.

When Jackson took office in 1829, there were approximately 125,000 Native Americans living in the eastern United States. By the time Harrison was elected in 1840, only a few pockets of Native Americans remained east of the Mississippi; most had been relocated to Oklahoma and Arkansas. While there was to have been an even trade of land in the East for the land in the West, and a ban on white settlement of the new western lands, this was never fully realized (Dudley 2003).

Some Georgian Cherokee were relocated to the West as early as 1830, but the majority did not move until 1837 and 1838. The Choctaw were moved in 1831, followed by the Creek in 1836. The Cherokee in Georgia refused to move at first, because a Supreme Court decision favored their right to stay in that state. Unfortunately, Georgia ignored the order, helping flame the feud between North and South over not just slavery, but human rights in general. All three tribes suffered great losses of members in the move. The Choctaw met with a cholera attack, the Creek and Cherokee with malnutrition, exposure, and abuse by their escorts. It is estimated that nearly 8,000 members of the 30,000 total in both tribes died en route (Dudley 2003).

Denouncing of Slavery

The clashes with the Native Americans were not the only clashes taking place. The northern United States continued to clash with the southern states over the issue of slavery. The northern states had abolished slavery at the close of the Revolutionary War, but the nature of the southern economy was such that southern states felt justified to continue the practice. In general, these years, especially in the North, were a period of social reform. Voting, prisons, hospitals/asylums, schools, labor conditions, women's rights, and general health were all targeted for reform, and, except for women's rights, the movements were largely successful. By 1824, states allowed men to vote without requiring

land ownership, which vastly increased the number of voters for elections. In the New England states, free blacks were also allowed to vote, although women were not. But these voting and other reforms did not accomplish freedom for slaves (Dudley 2003).

During the 1830s, a formal movement against slavery was put in motion by people generally referred to as abolitionists. Seen by many in both the North and South as dangerous, there was a great swell of opposition to the group. Internal strife was also a problem, and the abolitionists had split into two groups by 1840. Still, while their antislavery views were gaining support in the North, the economy in the South was depending on slaves more than ever. Even with fewer total residents, smaller cities, less transportation infrastructure, and only a minor share of immigrant influx, improvements in cotton processing by 1840 allowed southern cotton production to account for half of the U.S. exports. This meant a heavy reliance on slaves. By 1850, there were three million slaves in America, all in the southern states (Dudley 2003).

Despite the shear numbers of slaves, the United States did not have many major slave rebellions. Nat Turner's 1831 Virginia insurrection was a wake-up call that went largely unheard. During this revival period from 1821 to 1860, thousands of slaves ran away from their southern owners, on to a free life in the North and in Canada via the Underground Railroad, yet their brethren continued to suffer abuse and indifference. By the end of this period, the northerners would take a stand against slavery that would shape the entire country during and in the aftermath of the Civil War.

TECHNOLOGY AND TRANSPORTATION INNOVATIONS

Intertwined with the changing political and social environments were the major technological innovations taking place. Several transportation initiatives were encouraging this expansion. While early long-distance travel was done primarily on natural waterways, the process was slow and arduous. The budding country needed a better way of moving people and supplies to the burgeoning areas. This was accomplished first with roads, next with canals, and most dramatically, with the coming of railroads.

The National Road

Started in 1811 in Cumberland, Maryland, the Cumberland Road (National Road, US 40) was still being constructed during much of this revival period from 1821 to 1860. Designed to open the country through to St. Louis, by 1818, it was to Wheeling, Virginia. By 1833, the road had been completed to Columbus, Ohio. It reached Springfield, Ohio in 1838. Costing a total of $7 million, road construction was stopped in 1840 with the terminus in Vandalia, Illinois. In all, the road traversed six states and covered more than 800 miles.

Originally proposed by George Washington, Jefferson approved the plan for the National Road in 1806. Because much of the travel in the country in these early years was still by water, the road was designed to connect the East Coast and the Potomac River to the Ohio River, passing through each state's capital along the way. While initially federally funded through state land sales, in 1834 the states it traveled through became the owners of their portions of the road. This meant that in some places, it was never really finished.

The builders of the National Road started with a survey of the proposed route, then acquired the right of ways, and finally clearing could begin. A 66-foot-wide swath was cut through what was virgin wilderness in many places. Trees had to be cut, their stumps removed, uneven land filled and leveled. The road bed was 20-feet wide and made with stone or gravel in most places, although only dirt in some. Numerous bridges of stone, wood, and sometimes iron, connected the road surfaces over streams and rivers (Brigham 1905).

Travelers headed west along the road in a variety of ways. Horse-drawn coaches and Conestoga wagons were most common, but singles on horseback, wagons, walkers, and even animals used the road. The road shortened travel time from weeks to four or five days. Not all travel was westward, though. The National Road also gave farmers and others a reliable way to get their products to the East. This was especially important in the early years of the road to encourage western Americans to trade with their eastern brethren and not with the British or Spanish still occupying much of the continent west of the Mississippi.

Inns, taverns and other businesses grew rapidly along the route, and many small villages owe their existence to the road, but by 1879 other means of transportation would replace the road. Another "National Road" project, stretching from Buffalo to New Orleans, through Washington, D.C., was approved by Congress in 1830, but vetoed by Jackson and never came to fruition (Baker 2002).

The Erie Canal

Another major contribution to the transportation system between 1821 and 1860 was the Erie Canal through New York state. Proposed in the late 1700s, it took decades to come to fruition. A commission was created in 1809 to study the potential route, and Dewitt Clinton was appointed to serve on it. Once the commission determined a canal was possible, Clinton then turned to Congress to support the project.

Although Thomas Jefferson enthusiastically supported the National Road, he was dead set against a canal. His successor, James Madison, also did not favor the canal. So, while the National Road was funded largely by the federal government, the Erie Canal was largely funded by New York state. As it had with the National Road, Congress passed a bill to fund the canal, but it was vetoed by President Madison. This led, in 1816, to New York state agreeing to front the funds for the canal, with tolls charged to repay the state once the canal was in use.

DeWitt Clinton, still a strong canal advocate, was elected Governor of New York in 1817, and the canal era was on its way. Groundbreaking for the canal was on Independence Day, 1817, and the canal was opened in 1825. It ran 363 miles from near Albany to Buffalo and rose in elevation over 550 feet through a series of 83 stone locks. The canal bed was 40 feet wide, and 4 feet deep, and used a network of stone aqueducts to cross streams and rivers.

The success of the canal owes a great deal to the decision to build stone locks rather than wooden ones, as the stone locks were much easier and less costly to maintain. This was possible due to a chance discovery of the stone sediment used to create the hydraulic cement necessary to hold the stones together.

Quick completion of the canal was possible by dividing the route into three main sections, each with its own engineer, primary contractor, and legions of subcontractors. The 69 1/2-mile "Long Level" section between Syracuse and Herkimer was completed in less than a year, helping convince canal deriders that completion would be a reality. By 1821, when Clinton faced strong competition for re-election as governor, two-thirds of the canal had already been finished.

Clinton carried the contest and remained in power to celebrate the canal's grand opening on October 26, 1825. He and a large entourage in Buffalo boarded a barge known as the "Seneca Chief" and headed to New York City. Thirty-thousand delighted onlookers shouted and waved as the group arrived on November 4.

The opening of the Erie Canal greatly reduced produce and travel costs and time. Prior to the canal, it cost approximately $100 per ton to ship goods between New York City and Buffalo. Using the canal, the cost decreased to one-tenth the original cost, and shipping times went down to about six days. The canal also increased migration, reducing travel time from several weeks to approximately four days.

The canal went through a series of widenings in this 40-year period and continued to be a popular travel and shipping route well in to the late 1800s. As one of the greatest engineering marvels in the world, it tied Americans together in not only increased travel opportunities, but in a developing national pride in accomplishments.

With the success of the Erie Canal came dozens of other canals. Some fed in to the Erie Canal, while others connected a variety of other waterways and cities. By 1840, there were more than 3,000 miles of canals in the United States (Dudley 2003). None of these other canals were as successful as the Erie had been, yet most also continued to operate until near the century's end.

Railroads

While most people think of railroads as a late 1800s phenomenon, the framework for the nationwide network of railroads that would develop in the latter part of the century was established during the 40 years from 1821 to 1860. From modest beginnings of track lain for horse drawn carriages, by the end of this revival period, the nation would have more than 20,000 miles of track running in the North, South, and developing West and Midwest.

Although the transcontinental railroad would not be approved by President Lincoln until 1862, and not completed until 1869, passenger trains started running in 1807 in England and by 1827, the idea had blossomed in the United States. This was when the Baltimore and Ohio (B&O) Railroad was chartered as were the South Carolina and Georgia Railroad and the Switch Back Gravity Railroad, the latter of which was used primarily for hauling coal. The following year saw the first Delaware and Hudson railroad, with cars run by horses, and the beginning of laying of track for the B&O. In 1829, steam locomotives were first put in to commercial use. By 1830, there were 20 miles of track in the United States, and by 1832, the B&O had had 140,000 passengers on its lines between Baltimore and Washington; a trip that took two and a quarter hours by 1835.

The depression of 1837 slowed down progress on railroads, but it did not stop their development. By 1840, there were 2,500 miles of track. Just six years later, the number had more than doubled to over 5,700 miles. A third of this was in the Northeast, with plans for another 4,000 miles in the works. By 1850, the number had grown to over 9,000 miles, and by the end of this revival period, this had once again doubled, with Chicago alone running approximately 120 trains daily to the East, South, and West (Dudley 2003; Smith 1981). Settlers, and the supplies they needed to forge their new lives, were moving easily around the country by 1860.

Building Technology

Westward settlement and urbanization were fueled not just by the availability of land and the transportation system capable of getting people to that land, but also by vast improvements in the building technology used. The demand for millions of new houses and outbuildings in the western regions, and new apartment buildings, town houses, and factories in urban areas, spurred creative builders to develop more effective and efficient technologies for erecting structures.

Some of the improvements in building technology during this revival period from 1821 to 1860 include the widespread use of circular saws, band saws, and planers in lumber milling. By 1840, at least in the Northeast, there were many saw mills producing sawn lath, shingles, flooring, and clapboards. Cut nails were also being mass-produced by the middle of this revival period.

Exact dates on some of these inventions cannot be given due to the sparsity of primary documents from that period. Specialists in this area of technology history agree, however, that although claims exist that there were circular saws in Holland in the sixteenth or seventeenth century, the circular saw had certainly come in to existence sometime in the late eighteenth century, perhaps in the 1770s (Ball 1975; Curtis 1973).

The major change in building technology during this period, however, was the 1832 invention of a new construction method now known as "balloon framing." Prior to balloon framing, houses were built in what is normally called a timber frame manner, where large, heavy boards are connected to even heavier beams to create the structure for a home. Timber frame buildings took great skill to construct, as well as a large team to lift and place completed units.

By 1832, because of the great strides made in the milling of lumber, standard-sized boards were becoming available. These standard boards were much lighter and allowed frames to be constructed in situ instead of being constructed on the ground and hoisted. This meant that one building could be constructed by only a few men at a time, with much less skill needed.

The first balloon frame building was constructed in Chicago, and the method spread both west and east from there throughout the remainder of this revival period. More detail on this construction method and other materials is provided in the chapter on materials and methods.

PROFESSIONAL ARCHITECTS AND STYLE BOOKS

Also fueled by the country's explosive growth was the development of a new profession known as architect. While architects had existed for centuries, during

this revival period from 1821 to 1860, the country first saw a differentiation in the roles of architect and builder. It started in 1795 with Benjamin Henry Latrobe, a British architect who came to the United States to practice his craft. As a trained engineer as well as architect, Latrobe became a role model for others wanting to break in to the building trade. His first commission was in 1797 for the Richmond Penitentiary, and he went on to great renown for designing the Bank of Pennsylvania and other prominent Philadelphia buildings (Williamson 1991). He and those who followed differentiated themselves as competent professionals by developing impressive client lists and working on a contract basis separate from a construction contract (Woods 1999).

Latrobe practiced into this revival period and was influential not just in building design, but in furniture design as well. Other prominent architects during these 40 years, many trained by Latrobe, included Ithiel Town, Richard Upjohn, Alexander Jackson Davis, Andrew Jackson Downing, and Fredrick Law Olmsted. Lesser, but still important players included Calvert Vaux, Samuel Sloan, and Henry Austin (Williamson 1991; Woods 1999). Together, these and other architects led the country through the various style periods discussed in detail in the following chapter.

These professional architects and other building craftsmen published hundreds of building guides and also contributed to the popular magazines of the era. The first known guide book in the United States was the 1797 *Country Builder's Assistant* by Asher Benjamin. In 1830, he released another popular book titled *The Practical House Carpenter.* From the time of Benjamin's first book until this revival period ended in 1860, 188 different architecture-based books were published. The number of volumes of these books increased exponentially over these years. Ninety-three of them, or nearly half, were released from 1850 to 1860 (Upton 1984).

Most of the books written before 1830 were guides for builders/carpenters and only rarely contained building plans. During the 1830s, the architectural books began to be targeted more toward building owners and included plans and elevations for different types of buildings. They also held guidance on interior design, including suggestions for furniture, wallpaper, curtains, and other decorations. These books introduced new styles as well as perpetuated styles already popular.

In addition to Asher's books noted previously, some of the more influential guides from this period include Alexander Jackson Davis' 1837 book *Rural Residences* and three Andrew Jackson Downing books: *Treatise on the Theory and Practice of Landscape Gardening* (1841), *Cottage Residences* (1842), and *The Architecture of Country Houses* (1850). Richard Upjohn released *Rural Architecture* in 1852, and a particular oddity was Orson Fowler's *A Home for All* (1848).

Magazines of the time were also important in refining the tastes of the new nation. These ranged from magazines targeted specifically to women and the domestic scene to those targeted to farmers, as well as those specifically for people in the building trades. Those that most shaped opinion in this revival period from 1821 to 1860 were largely agriculture magazines including *American Farmer* (founded in 1819), *Plough,* and *The Country Gentleman* (1853–1955; Lemmer 1957). Last, there was *Godey's Lady's Book and Lady's Magazine,* a monthly published from 1846 to 1892, which, in those 46 years, published approximately 450 original house plans (Hersey 1959).

Reference List

Baker, Pamela L. 2002. "The Washington National Road Bill and the Struggle to Adopt a Federal System of Internal Improvement." *Journal of the Early Republic* 22(3): 437–464.

Ball, Norman. 1975. "Circular Saws and the History of Technology." *Bulletin of the Association for Preservation Technology* 7(3): 79–89.

Brigham, Albert Perry. 1905. "The Great Roads across the Appalachians." *Bulletin of the American Geographical Society* 37(6): 321–339.

Curtis, John O. 1973. "The Introduction of the Circular Saw in the Early 19th Century." *Bulletin of the Association for Preservation Technology* 5(2): 162–189.

Dudley, William, ed. 2003. *Antebellum America: 1784–1850,* vol. 4. New York: Greenhaven Press.

Findling, John E., and Frank W. Thackeray. 1997. *Events that Changed America in the Nineteenth Century.* Westport, CT: Greenwood Press.

Hersey, George L. 1959. "Godey's Choice." *The Journal of the Society of Architectural Historians* 18(3): 104–111.

Lemmer, George F. 1957. "Early Agricultural Editors and Their Farm Philosophies (in The Agricultural Press)." *Agricultural History* 31(4): 3–22.

Smith, Page. 1980. *The Shaping of America.* New York: McGraw-Hill.

Smith, Page. 1981. *The Nation Comes of Age.* New York: McGraw-Hill.

Upton, Dell. 1984. "Pattern Books and Professionalism: Aspects of the Transformation of Domestic Architecture in America, 1800–1860." *Winterthur Portfolio* 19(2/3): 107–150.

Williamson, Roxanne Kuter. 1991. *American Architects and the Mechanics of Fame.* Austin: University of Texas Press.

Woods, Mary N. 1999. *From Craft to Profession: The Practice of Architecture in Nineteenth-Century America.* Berkeley: University of California Press.

Styles of Domestic Architecture around the Country

From 1821 to 1860, the United States was evolving from an infant country into a world power. This was reflected in varying ways throughout the land. This chapter provides a general introduction to each of the major architectural styles popular in this time period, the regions in which most were found, how locale and wealth affected the trends, and the approximate time frames in which each style was popular. It will also detail the building types found in each of the five regions—Northeast, South, Midwest, Southwest, and West Coast—and give examples of some of the more interesting representative buildings.

The 40-year span from 1821 to 1860 introduced more variety in domestic architecture than in any other 40 years in U.S. history. The first major new style was the Greek Revival, built from approximately 1825 to 1850, primarily in the eastern states. As the population grew and prospered, the new romantic styles began to appear. These included the Gothic Revival (1835–1880), Italianate (1840–1885), and Second Empire (1855–1885). Several exotic revivals, including Egyptian, Oriental, and Swiss Chalet (1835–1890), also appeared during this time, as did specialty houses such as Octagon and Cobblestone houses. This chapter reviews the genesis and development of these eclectic styles.

GREEK REVIVAL (1825–1850)

The Greek Revival style is considered by many to be the first truly American architectural style. Because it was easy to design buildings in one-story, two-story and larger forms, it appeared in homes, churches, schools, and public buildings throughout the country. Known as the National style during its heyday (Massey and Maxwell 1996), not only was the style flexible for a variety

of sizes, but also in levels of decoration, ranging from modest rural houses to highly ornate state capital buildings.

Origins and Influences

Much of early American culture was focused on the traditions of the Greeks and Romans. Thomas Jefferson was a great proponent of a return to classic forms, especially those demonstrated by the Romans; and during the early 1800s, this national love for classical forms turned from the Roman to the Greek.

There were several reasons for this. First, the education system in the United States at that time focused on the classical world, including its architecture. These educational policies became more widespread as the population grew and migrated. Second, architects of the time were taught in the classical elements, and, surprising perhaps, many found it easy to show their creativity within the confines of the style. One such example of this is the New York firm of Town and Davis. Often considered the first fully functioning architectural firm in the United States, Ithiel Town and his partner, a young Alexander Jackson Davis, were very dedicated to the Greek form. Town had a massive architectural library and allowed others to refer to the works in it on a regular basis (Pierson 1970). This helped spread the trend.

The third impetus for the Greek Revival was the emerging builders' guides published by many architects and builders. Those written by Asher Benjamin and Minard Lafever were undoubtedly the most influential. Their books, published in 1827 and 1829, introduced Greek elements and continued to feature

Ansley Wilcox House, 641 Delaware Avenue, Buffalo, New York. Courtesy of the Library of Congress.

them well in to the 1850s. Latrobe and Mills were also major proponents of the style, especially at the public/government building level.

So both the general population and the budding architectural profession began favoring a return to the simplicity of the Greek era. What many found pleasing in the Greek form was its familiarity and the powerful way in which the form evoked the feeling of a Greek Temple. Of particular interest were the vertical elements in the style, which center on the three classic Greek orders: Doric, Ionic, and Corinthian. Doric order columns are the simplest of the three, have no bases, and are made up of a short, stocky, shaft topped by a round capital. In the strictest interpretations, the column is tapered and fluted. Ionic order columns, on the other hand, are taller and more slender. Most distinctive, however, is the large volute capitals and round base. Corinthian columns are even more ornate, with acanthus leaves adorning the capital.

Yet, as graceful as this form is, there was a practical side to the Greek form as well. It was easily adaptable to multiple materials. Although wood was by far the most common material, especially in homes, Greek Revival buildings can be found made from brick, marble, cut block stone (primarily limestone and sandstone, although granite as well, where present), and even cobblestone. So, regardless of the building material available in a given region of the country, the Greek Revival house could be made from the least expensive material in that region.

The Greek proportions also made the buildings easy to construct. There were no odd angles to be measured and cut and no odd joinery to perform, just simple construction methods known to builders in any locale. All of this combined to make this house style extremely popular with everyone throughout the nation.

Defining Features

Whether a simple home, or majestic state building, Greek Revival structures have three primary defining features. The first is a low gable, commonly facing the front on public buildings, but generally parallel to the street in homes. While Federal style buildings also featured side-facing gables, the pitch on a Greek Revival is much more shallow and, especially in the Northeast, only high enough for a half-story.

The second major characteristic of Greek Revival is the pilasters on all four corners of the main building. On frame buildings, the pilasters are generally plain wooden boards from the foundation to the cornice returns on both faces of each corner. With stone renditions, pilasters may be of wood, a complimentary colored stone, or may also be quoins.

Greek order columns on the front porch are a third feature of Greek Revival homes. In northeastern homes, the porches are commonly one story, while in the southern states, full height porches were much more common. There is some looseness in interpretation of the orders in porches, however. As McAlester notes, approximately 40 percent of the columns and pilasters on Greek Revival front porches are square, not round, technically making them not Greek at all. Of the remaining columns that are traditional Greek, 40 percent are Doric, 15 percent Ionic, and 5 percent Corinthian (McAlester and McAlester 1996).

While there are no defining windows for the Greek Revival style, there are several window features to look for that are not often found in other styles. One

is the series of small windows in the frieze band. Grilles made of cast iron were popular accents in these windows, especially in the Northeast. Also common are sidelights and transoms surrounding the front door.

Tying in to the purity aspect of the traditional temple from, publications from the day recommended that Greek Revival homes be painted white and, if they used shutters, that the shutters be a deep green. While many Greek Revival homes today paint the frieze boards and pilasters contrasting colors, these accents would have also been originally white.

Regional Focus

While the Greek Revival style was used throughout the country, it was especially strong in the developing Northeast, primarily along the westward passage routes. Pockets also occur in other areas settled before 1860, such as the coastal areas of California and Oregon and in eastern Texas (McAlester and McAlester 1996). Recognizing that even log cabins should have style, Alexander Jackson Davis, in his 1837 book *Rural Residences,* features a log cabin version of Greek Revival. Dubbed the "American House," Davis notes that this house "might be easily constructed in a woodland region" (see http://www.vintagedesigns. com/architecture/ms/rr/americanhouse.htm).

Northeast

With the exception of the northwestern tip of Maine, which was not settled until later in the century, Greek Revival homes were very common in the Northeast, especially in New York, which increased in population by more than 2 million while this style was popular. The two most common substyles in this area were the side-gabled homes with entry porches less than full height and the front-gabled homes (McAlester and McAlester 1996).

Some excellent examples of this style include the circa 1840 Ansley Wilcox House in Buffalo, New York; the 1835 Harmon House in Stafford, New York; the Captain Charles Wordin House in Belfast, Maine; and the 1845 Isreal Munson House in Wallingford, Vermont, designed by Asher Benjamin.

The Wilcox House, now known as the Theodore Roosevelt Inaugural National Historic Site, was built circa 1840 as what is presumed to have been the officers' quarters of the Poinsett Barracks, designed to protect western New York from another burning such as it had suffered in 1813. The building was enlarged and converted to a home circa 1847. The house is now a five bay, gabled-fronted building with a full facade portico supported by six Doric columns. This portico was most likely added in the 1850s. The gable above the portico is pedimented and houses a Palladian window (see http://www.nps.gov/thri/propertyhistory.htm).

A much more modest yet very representative example of Greek Revival in the Northeast is the one and one-half storied, side gabled Harmon House in Stafford, New York. Built in 1835, this small, three-bay home has fireplaces and chimneys at each gable end and the typical cast-ironed grilled windows in the frieze. Thin pilasters are located on the buildings' four corners, and a simple porchless entrance with sidelights and transom is slightly recessed in from the main facade plane (McAlester and McAlester 1996).

Unlike the Harmon House and most of the rural Greek Revival buildings in the Northeast, the Wordin House in Belfast, Maine is a full two stories with

full-size windows on the second floor as well as in the attic gable ends. It is three bays wide and two bays deep with a simple two-columned, one-story entrance porch in the center bay. Rather than simple cornice returns implying a pediment, the wide frieze is accentuated by a complete pediment on each gable end. Pilasters on all four corners support the frieze, giving it a substantial temple look.

The Benjamin-designed Munson House—now known as the White Rocks Inn—was once the family farmhouse for Israel Munson of Wallingford, Vermont. Circa 1845, Munson contracted with Asher Benjamin, whose books had helped popularize the Greek Revival style in the United States, to design a new home around the existing family home. Constructed in the traditional post and beam construction method of the time, the main section of the house is a full two stories, five bays wide, and four bays deep, with a centered single-story entrance porch supported by four Ionic columns. The gable ends are side facing and pedimented, with Ionic pilasters on the corners (see White Rocks Inn, http://www.whiterocksinn.com).

South

Greek Revivals in the southern United States have a significantly different look than do those in the Northeast, primarily due to their two-story, one-bay entry porches, either with or without a balcony on the second story. Most of these southern two-story, single-bay porches are pedimented and are supported by traditional Doric or Ionic columns. Porches in the South may also cover the full-front building facade. Columns on both types of porches were often square rather than rounded. The most common substyles in the South are those with full-height entry porches and full-facade porches, although in the Atlantic Coast southern states, Greek Revivals with the single-story front porches were also relatively prevalent.

Quintessential southern Greek Revivals include Oak Alley in Vacherie, Louisiana and Sturdivant Hall in Selma, Alabama. More modest examples include the South Brick House in Wake Forest, North Carolina. Midway between the lavish plantation mansions and modest homes is the former governor's mansion in Milledgeville, Georgia.

Perhaps the most recognized plantation home in the United States, Oak Alley is an outstanding example of the Greek Revival form in the South. Designated a National Historic Landmark, the plantation was constructed from 1837 to 1839 and was originally known as Bon Sejour. The original owner, Jacques Telesphore Roman, was the brother of Andre Roman, who served two terms as Louisiana governor. The architect for the building is not known, but it may have been Roman's architect father-in-law. Other than the live oak trees guarding the driveway to the building, the most impressive aspect of Oak Alley is its colonnade. Unlike colonnades that run simply across the front facade, the colonnade at Oak Alley is a peripteral, surrounding the home on all four sides, and made up of 28 massive Doric columns.

The columns in the colonnade have a circumference of eight feet and are constructed of brick. The bricks were made on site in special molds that produced pie-like wedges to make it easier to shape the cylindrical columns. Just as the brick columns were produced on site, so were the materials for everything

else in Oak Alley, with the exception of the imported slate and marble used on the roof, fireplaces, and floors (Amort 2007).

Unlike more traditional temple-form buildings, Oak Alley is square, not rectangular. The floor plan does use the traditional southern arrangement of central halls on each floor, though, which were designed, in combination with the colonnade, to keep the interior of the building cool in the midst of the hot, humid, Louisiana summers. Doors at both ends of each hall open to allow the breeze to pass through. All four doorways are flanked by colonnettes and decorated with fanlights and sidelights (see http://www.nps.gov/history/nr/travel/louisiana/oak.htm).

Selma's Sturdivant Hall was designed in 1852 by Robert E. Lee's cousin, Thomas Helm Lee. Completed in 1853, the house cost an estimated $69,000 when other homes in the nation were built for less than $1,000. Sturdivant Hall exhibits all the Greek Revival features found in southern homes. Six large Corinthian columns support the massive entablature, which covers the two-tiered porch that runs across the entire five-bay front. A shallow hipped roof, hidden from view at ground level, is topped by a square cupola. As was customary in the South, the rear of the building is nearly as ornate, with a two-story, three-bay porch supported by two Corinthian columns. The kitchen is in an outbuilding, which was also common during this antebellum era (see http://www.sturdivanthall.com).

In Wake Forest, North Carolina is a much more modest and more typical example of Greek Revival. South Brick House is the only remaining of three brick structures built between 1835 and 1838 to be the campus buildings of the then newly established Wake Forest Institute. Two faculty homes and one classroom building were designed by John Berry, an architect practicing in Hillsborough. The side-gabled house with cornice returns on each end and wooden frieze boards, is two and one-half-stories, three bays wide, and three bays deep. A pedimented one-story entrance porch is supported by four columns, and the door is flanked by matching pilasters. As was common during this revival period, the South Brick House also has extant outbuildings. These include an external kitchen as well as a servants' house, smokehouse, and barn (Whitfield 2006).

In Milledgeville, Georgia, the former governor's mansion is another interesting example of Greek Revival. More in line with other southern homes of this era, this three-story stuccoed brick building was designed circa 1838 by architect Charles B. Clusky. It has a pedimented full-height entrance portico, supported by four massive Ionic columns. The mansion is seven bays wide and five bays deep and at one time was topped by a square cupola (New Georgia Encyclopedia 2002).

Midwest

As northeasterners and southerners poured into the Midwest, they brought their love of the Greek Revival style with them. Homes in Michigan, Illinois, Iowa, Minnesota, and throughout the Midwest region were constructed in the developing National style. Representative of the style in the Midwest are the circa 1837 Elijah Iles House in Springfield, Illinois; the 1847 John E. and Martin Mower House in Stillwater, Minnesota; the Plum Grove in Iowa City, Iowa; and the 1840 Munro House in Jonesville, Michigan.

In Illinois, one of the earliest Greek Revival homes is the Elijah Iles House in Springfield. Built circa 1837, the Iles House is the oldest building in Springfield. Purported to be designed by the architect of the original nineteenth-century capital building in Springfield, the timber-frame Iles House is a rare, raised, one-story cottage. Although moved twice since its original construction, the house retains much of its original character and still exhibits many of the Greek Revival features. Its very shallow-pitched pedimented gable extends in the front over the full-facade porch, supported with six square pillars topped by Doric-like capitals. Also somewhat rare are the pair of gable-end windows, as most Greek Revivals have a single gable-end window or none at all. The main door is located in the center of the five bays and is flanked by pilasters, sidelights, and a transom. Pilasters also adorn the four corners of the building (see http://www.springfield.il.us/Commissions/HistSites/ElijahIlesHouse.asp).

The John E. and Martin Mower House in Stillwater, Minnesota was built in 1847. The Mower brothers started a lumber milling village they named Arcola Mills in the early 1840s, and by 1847, they had constructed a large timber-frame Greek Revival home on the site. The building, considered the largest timber-frame home in the state, is five bays wide and four bays deep with a frieze along the front. The frieze is not present on the sides, and there are only simple cornice returns rather than a pediment. There are pilasters on the building corners and a full facade, one-story porch. The porch may or may not be original to the home (see http://www.arcolamills.org/history.shtml).

A small brick example of Greek Revival is Plum Grove in Iowa City, Iowa. Three bays wide by four bays deep, Plum Grove is a two-story brick building that has a front-gable with shallow cornice returns. It has eight over eight sash windows, sidelights and a transom surrounding the entrance, and an oculus window beneath the gable. However, it also has several attributes that are less commonly associated with Greek Revival. The entrance is not in the central bay, but in the left bay, and it has no porch. The door is accented only by a stone lintel. It is also lacking frieze boards and corner pilasters.

The interior plan of the home is simple as well. It has a total of seven rooms: four on the first floor and three on the second. As does North Carolina's South Brick House, Plum Grove has a separate kitchen wing, although Plum Grove's kitchen is attached to the main building (see http://www.iowahistory.org/sites/plum_grove/plum_grove_history.html).

The Munro House, in Jonesville, Michigan, presents a variation of the front gable and wing subtype of Greek Revival homes. Instead of a single wing, its three-bay, two-storied main section is flanked by a pair of one-story wings; a rare occurrence in buildings not in the northeastern states (McAlester and McAlester 1996). The main section is brick and was built in 1840 as an addition to an existing Federal style home. It features a pedimented gable with fanlight window and a one-story, right-hand main entrance porch, which is also pedimented and supported by a pair of Doric columns. The porches on the wings run the entire length of each and are also supported by Doric columns.

Southwest

In general, Greek Revival homes are scarce in the Southwest, primarily due to the settlement pattern during the Greek Revival era. Still, isolated examples

can be found in the eastern portions of Texas, which were settled during this revival period, as well as in scattered places in New Mexico. Most of the New Mexico examples are either a mix of Greek Revival adornments on traditional pueblo homes, dubbed Territorial style, or are much later homes, built after the railroads arrived in the late 1800s. Four of the more outstanding examples include the Cartwright/Campbell House in San Augustine, Texas; the Lambart House in San Felipe, Texas; the Pearce Mansion (Woodlawn) in Austin, Texas; and the Thomas House in Central City, Colorado.

The Cartwright/Campbell House is a very early example of Greek Revival in the Southwest. Designed and constructed in 1839 by noted architect/builder Augustus Phelps, the house is a side-gabled, five-bay wide, and two-bay deep version of the temple form. It is two stories high, with a central entrance and one-story porch. The gable ends are pedimented, and the frieze band boards on all sides are accented with moldings. Originally owned by Isaac Campbell and purchased in 1847 by Mathew Cartwright, the property includes several of the original outbuildings also designed in Greek Revival style (see http://visit. sanaugustinetx.com/homes/mcic.html).

In San Felipe, Texas, the circa 1838 Lambart House is a much more modest example of Greek Revival. A rare one-story home, the Lambart House is five bays wide with a one-story porch in the center bay. A frieze is present under the eaves, and both the porch and house are topped with shallow hip roofs. Narrow columns support the porch and matching narrow pilasters appear on either side of the entry and at the corners of the house. The double-entry doors have the typical transom across the top and sidelights on each side (McAlester and McAlester 1996).

Woodlawn, also known as the Pearse House, is in stark contrast to the Lambart House. Located in Austin, Texas, Woodlawn was designed in 1853 by Abner Cook for James B. Shaw, then comptroller for the state of Texas. Cook also designed the Governor's mansion in Texas, and when Elias Pease left the governors office in 1857, he purchased Woodlawn. His family remained there for the next century (see http://www.ci.austin.tx.us/library/ahc/green/private1. htm).

In true temple form, Woodlawn's five-bay front facade is accented by a deep, full-height portico, supported by six massive Ionic columns, complete with the traditional flutes. Three similar Doric columns support a side portico, and both porticos have second-story balconies trimmed with cast iron balustrades. The front doors on both stories are flanked by sidelights and topped by a transom.

By the time Colorado was settled, much of the Greek Revival era was over. Still, residents moving in from other states, especially those on the East Coast, brought with them their love of the simple style and constructed new homes in keeping with the older style. One such home is the Thomas House in Central City. Although not constructed until 1874 (due to an 1873 fire, which destroyed most of the wood frame buildings in Central City), the Thomas House displays all the features found in period Greek Revivals. The one-story, full facade porch, the side frieze boards, the corner pilasters, and even the cornice returns are all classic Greek Revival. The house, built around the entrance to a mine, is three-bays wide with a side wing, which also has a typical Greek Revival porch (see http://www.gilpinhistory.org/thomas_house.html). In fact, the building looks remarkably like the farmhouse in Oliver P. Smith's 1854

plan book, which he showed with Italianate style, but which he noted could be executed with Greek Revival features instead (Mitchell 2007).

West Coast

On the West Coast, there were also pockets of Greek Revival buildings. Because many of the coastal and mining areas of California, Washington, and Oregon were settled during this revival period, a fair representation of each of the Greek Revival subforms can be found. The most common of the subforms are the front-gabled roof and entry porch less than full height or absent, while rare occurrences of the full-height entry porch and full-facade entry porch also existed (McAlester and McAlester 1996).

Examples include the 1857 Whaley House, in San Diego, California; the 1856 Blackburn House in Santa Cruz, California; the Captain Ainsworth House, Oregon City, Oregon; and the Joseph Borst House in Centralia, Washington.

San Diego's two-story, three-bay front-facing (not gabled) brick Whaley House was the first two-story brick building in San Diego. Designed and built in 1857 by its owner, Thomas Whaley, the building has seen many changes over the years. Still, its Greek Revival characteristics show through. These include the one-story, full-facade front porch (although not original), window and door alignments, and transom over the central entrance door. As was also typical of its day, the interior of the Whaley House featured faux-painted woodwork and walls. The walls were painted to resemble marble blocks, while the woodwork was painted in a grained pattern. There was also an exterior 12- by 8-foot kitchen attached to the home (see http://sohosandiego.org/).

The 1856 Judge Blackburn house in Santa Cruz, California is a much more intact example of California's early Greek Revival homes. It is a two-storied, three-bay, front-gabled house with a right side wing. Common for winged Greek Revival homes, the main entrance is not in the center bay, but on the right side near the wing. It is decorated by a transom and sidelights. A one-storied, full facade porch is supported by four square rather than round columns, and matching pilasters adorn the building's corners. The gable is not pedimented, but features cornice returns (see http://www.blackburnhousemotel.com).

In 1851, John C. Ainsworth, a shipping entrepreneur, built the large Greek Revival house now known as the Ainsworth House, located in Oregon City, Oregon, near Portland. The Ainsworth House is a rare example of West Coast Greek Revival architecture because, although it is two stories and has a front-facing gable, it has the full-height entry portico and massing more common in southern plantations. The home is three bays wide, with the main entrance on the right. The entry door is topped by a transom and flanked by sidelights. The portico is pedimented and includes a second-story balcony, which also runs along the full front facade (see http://nwda-db.wsulibs.wsu.edu/findaid/ark:/80444/xv61910).

The 1857 Joseph Borst House is a more typical West Coast Greek Revival, both in its substyle as well as its more modest size. Built near the confluence of the Chehalis and Skookumchuck rivers, the Borst house is two and a half stories in height, five bays wide, and three bays deep. The gable end has cornice returns, and each building corner has pilasters. A frieze band runs on only the five-bay facades. It has a one-story entrance porch, although it

is atypical in that it spans only three of the five bays, rather than either all bays or only the central bay. Also atypical are the drip moldings over the door and windows. These moldings were much more common on Gothic Revival buildings than they were on Greek Revival. The main entrance is in the center bay and has a very narrow transom over the door, with equally narrow sidelights (see http://www.nr.nps.gov).

GOTHIC REVIVAL (1835–1880)

The Gothic Revival style arrived in the United States circa 1832. It was very popular in church designs and other public buildings, but Gothic Revival homes are among the most rare in the country for two reasons. First, the Gothic Revival did not last long. While it spanned roughly from 1835 into the 1880s, it had peaked by 1860, making it popular for a mere 20 years. Second, it was considered a rural, even vacation, style. Although short-lived, this style period gave the United States some of its most intriguing homes.

The Wide-Reaching Impact of an Architect

Arguably the most influential architect during this revival period from 1821 to 1860 was Alexander Jackson Davis. Born in 1803, Davis worked for Ithiel Town from circa 1827 to 1829 when he was promoted to partner. With Town, he drove the move to Greek Revival architecture, and then later spearheaded the Gothic Revival and cottage movements. From 1853 to 1857, he designed the layout for Llewellyn Park in New Jersey, often considered to be the first planned suburban development in the country. He also designed some of the homes in Llewellyn Park (Fleming 1998; Williamson 1991).

Among Davis' more famous residences are the castle-style Gothic Revival Lyndhurst in Tarrytown, New York (1838) and the William Rotch House in Massachusetts. A close associate with Andrew Jackson Downing, the style books produced by the two changed the shape of housing in the United States for nearly 50 years.

Davis is also credited as the first American architect to understand that the client may have his own sense of a building and that the architect needed to heed that (Upton 1984). While not all architects, even today, understand that aspect of working with a client, Davis appears to have not only understood the concept, but acted on it, thus designing homes that satisfied his vision as well as that of his client.

Origins and Influences

The popularity of this first style to return to the romance of architecture is often credited to Victoria's accession to the throne of England, yet the beginnings of the style had been brewing for at least two decades before Victoria took over the reins of Great Britain. Still, Victoria's influence cannot be discounted. She became queen in 1837 and spurred interest in the move to a Gothic Revival when she redecorated Windsor and Balmoral castles with Gothic-inspired furniture (Massey and Maxwell 1994).

Rural Gothic Revival homes were loosely derived from English cottages, while the grander executions of the style were based on medieval churches and castles. Both derivations were encouraged by the popular architects of the time. One of these early Gothic proponents was Augustus Welby Northmore Pugin. Two of his books, *Contrasts,* released in 1836, and *The True Principles of Pointed Architecture,* released five years later, preached a return not just to the architecture of the Middle Ages, but to the materials and methods of that period as well.

Pugin was greatly influenced by the earlier work of his father, Auguste Charles Pugin, who published three books on Gothic architecture, Gothic furniture, and Gothic ornamentation from 1821 through 1831 (Osband 2000). Traveling with his father while he collected material for his books, the younger Pugin was able to see some of the world's best medieval architecture firsthand

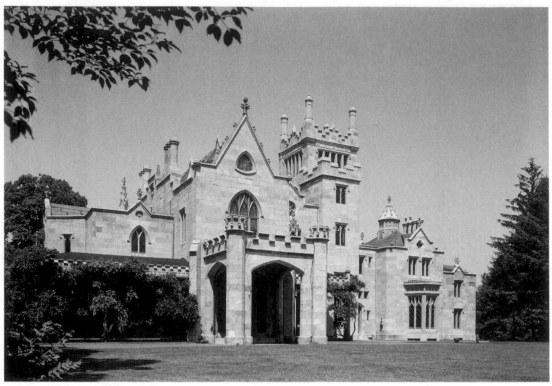

Lyndhurst, Main House, 635 South Broadway, Tarrytown, New York. Courtesy of the Library of Congress.

and sought to meld his fascination with the old with a desire to shape the current design trend.

In his three-volume anthology, *The Stones of Venice,* John Ruskin expressed similar ideals. Released over a series of three years (1851–1853), one of his most moving pieces in the collection is his "Characteristics of Gothic Architecture," in which Ruskin encourages a return to artistry in medieval Gothic architecture. One aspect evocative of Ruskin's beliefs is the elaborate and labor-intensive ornamentation of the Gothic style. Ruskin was a strong supporter of individual art and craftsmanship and felt that the buildings should reflect not just the architect's skill in design, but the tradesmen's skills in execution.

In France, Viollet-le-Duc lead the Gothic Revival charge. Active as a public works architect, Viollet-le-Duc was in charge of major restorations of France's original Gothic buildings. This heightened his appreciation of the style. He went on to design original Gothic buildings as well as work on additional restorations.

While the early nineteenth-century incarnation of Gothic in Europe harkened back to the austerity of the style, American architects focused on the romantic aspects of the style, especially in the rural cottages. Early U.S. supporters, especially in church design, were Alexander Jackson Davis and Richard Upjohn. In the 1840s, Gothic was interpreted again by Renwick, although primarily in church design.

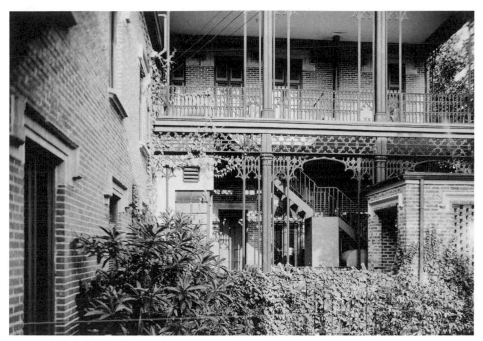

Veranda at Green-Meldrim House, 327 Bull Street, Savannah, Georgia. Courtesy of the Library of Congress.

The first known use of Gothic Revival for a home in the United States is the 1832 Glen Ellen castle in Baltimore County, Maryland. Designed by Alexander Jackson Davis, the house was based on similar castles the owner, Robert Gilmor, had seen on a trip to England and Scotland. After his experience with Glen Ellen, Davis promoted the Gothic style throughout the United States with his popular house plan book *Rural Residences*. Released in 1837, this is often considered the first plan book published in America (versus the more builder-related books that preceded it). Davis also designed one of the most recognizable Gothic houses in the country: the large, stately 1838 home for William Paulding known today as Lyndhurst.

A friend and colleague of Davis', Andrew Jackson Downing, also favored the return to the medieval-inspired architecture. In 1842, Downing published *Cottage Residences,* which turned out to be so popular it went through 13 editions in the next 45 years. An 1850 companion volume, *The Architecture of Country Houses,* also included Gothic Revival homes.

Although generally known for his magnificent Gothic churches, Richard Upjohn designed Gothic Revival homes as well. One of his earliest was the 1835 stone castle in Maine called Oaklands. Much closer to today's image of Gothic Revival, however, is his later work, the 1839–1841 Kingscote, located in Newport, Rhode Island. In 1852, Upjohn released his own plan book, simply titled *Rural Architecture.* Complete with plans for builders, the book was designed to show Americans how English villas could be replicated in the materials commonly found in the United States (Osband 2000).

In addition to the advances in the architectural profession, the highly decorative aspects of the Gothic Revival style were made possible by the invention

of the steam-powered scroll saw and the abundance of wood as a building material. These will be discussed in more depth in the following chapter.

Defining Features

In his 1850 book, *The Architecture of Country Houses,* Downing tried to match a house's style with the personality of its owner. Downing called the owners of the style that became known as Gothic Revival "men of imagination" because they wanted in their houses "high roofs, steep gables, unsymmetrical and capricious forms—any and every feature that indicates originality, boldness, energy and variety of character" (Downing 1850).

Not surprisingly, then, the most distinctive feature of Gothic Revival homes is their steeply pitched gabled roofs. While some Gothic Revivals have only one set of gables, most also include cross gables or gable dormers. These gables contrast sharply with very low pitch on Greek Revival buildings and greatly accent the verticality of the style.

Pointed arches in large masonry and wooden buildings are extremely strong structural devices, yet, in the majority of the residences built in this style, the pointed arch is simply decorative. Some pointed arches are used in doors and some in trim on porches, but the primary use of the arch is in the lancet windows. Nearly all Gothic Revival homes have at least one lancet window, often placed in the main gable over the entrance. In simple dwellings, the lancet windows are plain glass, while in more affluent homes, they often contain at least one center pane of stained glass. In the castle-like stone versions of this style, full-stained glass windows such as those used in churches are not uncommon.

One-story porches decorated with carved wood trim emulating ecclesiastical tracery are also found in the Gothic Revival home. In fact, this is the first domestic style to feature porches as an integral and functional area for resting and socializing (Massey and Maxwell, 1994), so much so, that the majority of Gothic Revival homes have more than one porch.

Another common feature in Gothic Revival homes, especially those constructed later in the period, is decorative bargeboard (or vergeboard) commonly called "Gingerbread." On later homes, or in rural versions, simple cross bars in the gable or scalloped trim along the gable end eaves were all that were present. In the wealthier homes, however, intricately carved, lace-like scroll work adorned the gable ends. Lathed drops often hung like icicles from the eaves and cross bars and were balanced by majestic finials perched on gable peaks.

Early and rural Gothic Revival homes tended to be symmetrical in design, with the main gable ends running parallel to the street, and a cross gable, generally smaller in scale, was centered in the front. Double gables were also built, but they were relatively rare. In the later years of the Gothic Revival, buildings were primarily asymmetrical. In these versions, a large cross gable was either on the left or right over the entrance door, with one or more smaller gable dormers on the opposite side.

Masonry allowed a stricter adherence to Middle Ages style, so stone and brick Gothic Revival buildings often have castle-like qualities. The most pervasive of these features were the towers. On some homes, a central tower replaced

the center cross gable over the entrance. In others, it was asymmetrically placed and may or may not house the entrance. Battlements might also be found both on the towers as well as along the roof line.

Both masonry and wooden buildings might have trefoil or quatrefoil windows (three or four intersecting circular lobes), usually on the gable ends, above, or in place of a lancet window. These were designed to emulate the tracery found in medieval churches. Bay windows and oriel windows were also common in both materials. Bay windows are actually a series of windows (typically three, four, or, sometimes five) projecting out from the floor, usually in dining rooms or parlors. They increase both the floor space as well as the interior light in any given room. Oriel windows perform a similar function on floors other than the first floor. They are generally smaller, with three windows (one on each face), and are supported by brackets or corbels. In southern Gothic Revivals, bay and oriel windows were sometimes made of cast iron, especially on masonry buildings.

The siding on wood frame Gothic Revival homes could be made of traditional clapboards, but was often board and batten as well. In board and batten, 10- to 12-inch wide boards were run vertically, and the gaps where the boards met were covered with smaller 1- or 2-inch wide boards. Not only did board and batten siding accentuate the verticality of a Gothic Revival building, it added more dimension and interest to the exterior surface.

Proponents of the Gothic Revival style sought to break not only from the massing of the Greek Revival form, but from its boring color scheme as well. It is in this style that the first use of what we now think of as Victorian colors emerged. Downing was especially annoyed by the traditional white, stating in his 1842 book, *Cottage Residences* that:

> There is one color . . . frequently employed by house-painters, which we feel bound to protest against most heartily, as entirely unsuitable and in bad taste. This is white, which is so universally applied to our wooden houses of every size and description. The glaring nature of the colour, when seen in contrast with the soft green of foliage, renders it extremely unpleasant to an eye attuned to harmony of coloring, and nothing but its very great prevalence in the United States could render even men of some taste so heedless of its bad effect (p. 14).

Because of this, Downing recommended earth tones for his cottages, especially green (olive), beige (sand), red (brick), and grays. The interesting thing about Downing's color schemes today is that they appear rather boring themselves when compared to the bold colors of the later Victorian Era.

Regional Focus

The greatest number of Gothic Revival homes still standing are in the Northeast, and they are least present in the South (McAlester and McAlester 1996). While this style was nowhere near as popular as the Greek Revival that preceded it or the Italianate that followed, most areas have at least one representative home. There were no apparent differences in the style based on region. Both the masonry castle-like versions and the more modest wooden Carpenter Gothic were found scattered in all the regions.

Northeast

Both the traditional masonry castle-like Gothic Revival homes and the wood Carpenter Gothic interpretations are found throughout the Northeast. Some of the more notable, as well as typical, include the 1838 Lyndhurst in New York, the 1845 Rotch House in Massachusetts, Roseland in Connecticut, and the author's own Hall House, also in New York.

Lyndhurst was designed in 1838 by Alexander Jackson Davis for William Paulding, a former mayor of New York City. It is often considered one of the most remarkable Gothic Revival homes in the country. Sitting on a bluff in Tarrytown, New York, the building commands a spectacular view of the Hudson River Valley. Constructed of marble, the home, completed in 1841, was originally called "Knoll." Asymmetrical in plan, the main entrance was accentuated by a parapeted gable, flanked by buttresses, with a finial on the gable and pinnacles on both buttresses. A large arched window with tracery was situated above the door, and above that, in the gable peak, a trefoil window. A step parapet gable to the left and a traditional gable to the right balance out the massing (for more information see http://www.lyndhurst.org/history.html).

In 1865, Knoll was purchased by George Merritt, who commissioned Davis to build an addition to the building, doubling its size. To the left of the step parapet gable, Davis added a large tower, now the primary focus of the building. On the second story of the tower, an oriel window seemingly hangs in the air. To the left of the tower, a two-story bay window is topped with battlements, completing the castle look (Donnell 1936).

Contrasting with Lyndhurst is a house Davis designed for William Rotch in New Bedford, Massachusetts. Designed in 1845, the Rotch House is halfway between Lyndhurst and the modest Gothic cottage found in many areas. This is the best documented of all Davis' houses, with two complete boxes of his papers dedicated to the design and construction of this home (see http://findingaid.winterthur.org/html/col114.html). The Rotch House is a symmetrical, front gabled, two and one-half story Gothic, with the main entranced recessed under a porch formed by the main gable. Two verandas extend from the front porch out past the house corners in each direction. Unlike most Gothic Revival homes, the roof is hipped, and two small gables top the left and right bay windows. Two monolithic double chimneys jut from the roof on either side of the gable.

The gingerbread trim under the eaves of the main gable is wide and intricately detailed. Three large fleur-de-lis points accent each side, with pairs of smaller fleur-de-lis points between the larger ones. On each end of the sets of fleur-de-lis are quatrefoils. Dividing the trim in the center of the gable is a large drop and massive finial combination. Above the slightly arched entrance porch is an oriel window, and above that, just under the peak, is a lancet window and balcony. Although not in the original design, two small gables, one over each veranda, allow space on the second story for one lancet window each.

Inside the Rotch House, the room arrangements are typical of the era. Off the central hall, the drawing room is placed in the front left, and the dining room in the front right. To the rear of the dining room is the kitchen, and across the hall from it, behind the drawing room, is the library. Fireplaces were located in the drawing room, library, and dining room. (Sketch and floorplan

available at http://www.uvm.edu/~rmccullo/ahp200website/class12/1208.html; photos at http://users.rcn.com/scndempr/dave/bedbreak/east/Mass02.jpg.)

Roseland, in Woodstock, Connecticut, is considered by many to be the quintessential wooden Gothic Revival house. Built in 1846 as New York City businessman Henry Bowen's summer retreat, the front facade of Roseland looks suspiciously like the Rotch House. It, too, has a large, projecting central gable flanked by two smaller ones and verandas on each side of the gable projection. Two large, symmetrically placed double chimneys add to the castle-like feel, just as they do at the Rotch House, and in the second story of the main gable is an oriel window. The gingerbread here, too, is intricate and accented by a large drop and finial, but this is where the similarities end (see http://www. historicnewengland.org/visit/homes/roseland.htm).

Perhaps the most striking differences in the two buildings are Roseland's board and batten siding and the addition of finials and drops on all of its gables. This gives the building a verticality that appears much steeper than that of the Rotch House. The coral-pink color that it is painted matches the original color scheme and, contrasted with the dark trim, adds to the sense of height.

Other differences include the lack of an entrance door in the center gable. Rather than a door, there is a large, pointed arch window. Also, there are no lancet windows under the small gables. Here, double diamond-paned windows appear instead. Last, above the oriel window in the center gable there is a simple trefoil window (see http://users.rcn.com/scndempr/dave/bedbreak/east/Conn04.jpg).

Another highly decorative wooden Gothic Revival is the author's own Erasmus Hall House in Knowlesville, New York. While not built until 1907, the Hall House exhibits all the common elements of typical Gothic Revival homes in the original era of construction. Five steep gables dominate the facades, and the four public-facing gables are virtually dripping with gingerbread trim. Somewhat more ornate than original period gingerbread, it features octagonal cross braces and a central drop supporting four intricately carved lace-like panels, the top two panels with quatrefoils resembling eyes. Matching octagonal finials used to extend approximately two to three feet above each gable. Drops matching the gable drops extend down from each of the corner eaves. On the second story, centered in the large left gable is a lancet window with a purple stained glass inset. Above that, and in each large gable-end, is a trefoil window.

South

With its love of romance, it is no surprise that the South embraced the switch from Greek Revival to the much more romantic Gothic Revival style. Although Gothic Revivals were popular in the South, unlike the wooden Carpenter Gothic houses in the North, southern Gothic houses were much more commonly made of masonry. The elaborate Gothic trim elements, such as porch railings and columns, fences, and window trim, were often executed in cast iron rather than wood. Four representative Gothic Revivals in the South include two Davis-designed homes in Lexington, Kentucky; the Barkman House in Arkansas; and the Green-Meldrim House in Georgia.

Another example of the castle-like Gothic Revival motif is the 1850 Loudoun House. Designed by Alexander Jackson Davis, the house has several

towers, turrets, irregularly placed fenestration, massive chimneys, crenelation, and parapet gables typical of the style. A four-story octagonal tower forms the visual center, just to the right of a large, parapeted gable and pavilion over the main door. The building is built of brick, coated with a mixture designed to resemble the stone of castles (see http://www.nps.gov/history/nr/travel/lexing ton/lou.htm). Although the main house is faux stone, the foundation (as well as the decorative drip mold over the windows and doors), the sills, and other ornate details are made of limestone (Lancaster 1947).

The interior of the home is fashioned around a long hall reaching from front to back. In the hall, a large stairway leads to the upper levels. A beam in the hall is supported by grotesques. A first-floor drawing room runs the entire depth of the long, narrow house. Across the stair hall from the drawing room was the parlor, and down a much narrower hall was the library and then the kitchen. The first-floor rooms have 14-foot ceilings, and those on the second floor are 12-feet high. So as not to detract from the castle-like exterior, the windows have walnut interior louvered shutters. Very early for its time, each floor had its own water closet, and there was a formal bathroom, complete with copper tub (Lancaster 1947).

Not far from the Loudoun House is another Gothic Revival of a completely different style. Yet, Aylesford (also known as Elley Villa) might also have been designed by A. J. Davis. Although some historians believe that the house is based on Andrew Jackson Downing's design number XXV in his 1850 book, *The Architecture of Country Houses* (Lancaster 1947) the similarities to the Rotch House are also striking. It is possible that Downing used Davis' 1845 Rotch House as inspiration for his design, and hence, the commonalities between the Rotch House and Aylesford. Both have the jutting central gable covering the entrance porch, which is flanked by verandas and contains a second-story oriel window. Both have the small second-story gables over the verandas as well as the dominating pairs of chimneys.

The interior plan for the two homes varies, however. Here, Aylesford parallels the published Downing drawings. Straight back from the entrance is the library, with dining room, drawing room, and parlor off the hall on either side. Rather than a grand center stair, the stair is placed in a small stair hall off the main hall and kitchen (Lancaster 1947).

The circa 1860 Barkman House in Arkadelphia, Arkansas, is a completely different Gothic Revival home. In fact, much like Kennebunkport's Wedding Cake House is a Federal House with added Gothic Revival features, the Barkman House is a Greek Revival home with Gothic Revival elements. The frieze band, pilasters, windows, and doors are clearly Greek Revival, but the two-story, full facade front porches have intricately carved Gothic Revival features (see http://www.arkansaspreservation.org/).

Another atypical Gothic Revival house is the circa 1860 Green-Meldrim House in Savannah, Georgia. Featuring neither towers, nor gables, the Green-Meldrim House is still clearly Gothic Revival. The five-bay by four-bay main house is made of stuccoed brick, two-stories tall and topped by a crenulated parapet around the entire perimeter. A large, crenulated bay window is centered on the second story above the dramatic cast iron entrance porch. A matching two-story bay window appears on the rear (north) elevation. Four smaller oriel windows are evenly spaced along the right (east) second floor (HABS 1962).

The bays and oriels are made of cast iron. Flanking the cast iron entrance porch are two, one-story cast iron verandas. Another cast iron veranda spans the first floor of the east facade.

The roof on the verandas is metal, as is the main building's shallow hipped roof. Four massive triple chimneys dominate the roof line near each of the main building's corners. To the west of the main building, a matching wing housed servants and the kitchen (HABS 1962).

Not only architecturally significant, the Green-Meldrim is also historically significant. It was spared destruction during the Civil War because it was used as Sherman's headquarters when he occupied Savannah. The building is a National Historic Landmark (see http://tps.cr.nps.gov/nhl/detail.cfm?ResourceId= 1429&ResourceType=Building).

Midwest

Much of the Midwest was just being settled during the original Gothic Revival period from 1835 to 1860. Still, Gothic Revival homes were built there, most of which were in the wooden, Carpenter Gothic mode. An exception to this is the 1853 Abner Baker House (Mabin house) in Marshall, Michigan (see http://www.marshallmich.com/hometour04/pages/mabin_jpg.htm). This brick house is an asymmetric, two and one-half story house, similar to the Hall House. The front facade features a large gable on the left and a two-bay ell with a small second-story gable dormer on the right. Unlike the Hall House, however, the front gable on the Baker House is two bays wide, with the entrance in the right bay. A one-story porch spans the front of the ell and continues across the front door. The windows are topped with drip molding, and the gables feature a delicate, frosting-like vergeboard decoration (HABS 1965).

The Baker House has a matching Gothic Revival carriage house, which was at one time connected to the main house. Unlike many homes where the decoration was only on the front of building, the Baker House also has decorative vergeboards and drip molding trim in the rear (HABS 1965).

Another example of Midwest Gothic Revival is Oak Hill Cottage in Mansfield, Ohio. Built in 1847, the brick cottage is five bays wide and three bays deep. It is symmetrical, with a large center gable flanked by two smaller gables. Each gable has decorative vergeboards, accented by finials and drops. A total of seven gables adorn the building, and, combined with the five double chimneys, give the building a romantic feel.

A full facade, one-story porch is supported by four columns and decorated with an intricate trim featuring fleur-de-lis drops and carved quatrefoils. The trim has five bays, even though one on each side is not supported by a corresponding column. A large lancet window is centered in the large gable on the second floor. Perhaps the most striking features of the home, however, are the diagonal muttons dividing the panes in all the front windows (see http://www.oakhillcottage.org/).

Southwest

Gothic Revivals in the Southwest arrived much later than they did in the eastern states. Several excellent late examples exist in Colorado (especially in Aspen, 1879–1892). One example is the John Adams Church House in Georgetown,

Colorado. This 1877 simple wooden home is primarily a cross-gable plan, with small gable dormers added. Unlike many Gothic Revival homes of this period, the Church House does not have decorative gingerbread in the gable ends. Instead, simple finials and drops accent the home's verticality. Only the small gabled canopies over the main and side entrance doors have vergeboards (see http://photoswest.org:8080/cgi-bin/cw_cgi?fullRecord+11690+594+738900+2 6+0).

A completely different looking southwestern Gothic Revival is the circa 1875 Adams House in Brownwood, Texas. Made of sandstone blocks, this three-bay wide house features a larger, central gable dormer flanked by two smaller gable dormers. A one-story front porch with a balcony covers the front door. Most interestingly, the front windows all have rounded tops much more typical of Italianate buildings. The rectangular drip moldings, however, are very common in Gothic Revival buildings (McAlester and McAlester 1996).

West Coast

As with the southwestern United States, Gothic Revival homes are relatively scarce in the West. One fine example is the two and one-half story 1879 Lee Laughlin House, in Yamhill, Oregon. (Some sources cite 1858, although the style of the gingerbread and other documentation implies the 1879 date is the correct one.) With large, steep cross-gables, and smaller gable dormers, the Laughlin House evokes the romance of the Gothic era. The gingerbread in the main gables is supported by cross braces, and the finials and drops on all the gables punctuate the roof line. Two porches are accented with trim emulating flatten arches, which is a pattern repeated in the trim surrounding the double lancet windows in two of the main gables (see http://www.pricecatcher.com/galleries/gallery1/gallery/yamhill/Lee_Laughlin_House and http://photos.salemhistory.org/cdm4/item_viewer.php?CISOROOT=/max& CISOPTR=407&REC=1).

Another later example of the Gothic Revival on the West Coast is the 1875 Andrew J. Landrum House in Santa Clara, California. Designed and constructed by its owner, the house is constructed in a T layout, with the top of the T facing the street. A central gable dormer bisects the front roof line, and each of the gable ends have plain cross bars, with drops and finials. A small, simple, one-story porch protects the entrance door, and over it is a lancet window. Lancet windows also appear in the side gables. The windows on the first floor, however, are one over one double-hung windows topped with a pediment (see http://www.nps.gov/history/nr/travel/santaclara/lan.htm).

ITALIANATE (1835–1885)

Also one of the styles typically considered "Victorian," Italianate buildings harken back to the romance of the rural Italian houses of the 1600s. The most ornate of the styles discussed thus far, Italianate homes virtually drip with decoration, especially those after the 1860s. Still, even those from the 1840s to the 1860s evoke the wealth that was developing throughout the nation.

Both Gothic Revival and Italianate styles are considered part of the Picturesque movement in architecture; a move from the traditional Roman and Greek building styles to those that are more romantic in nature. The Italianate

style was also encouraged by Andrew Jackson Downing. As he had with the Gothic Revival, Downing included Italianate homes in his popular home design books, which helped make the style well known across the country.

Origins and Influences

While the Gothic Revival harkened back to historic England, the Italianate style was driven by the desire to recreate the Italian rural landscape. Many of the buildings were based on simple farmhouses, while others where based on Italian mansions. Although this movement toward Italianism, as many called it, was most popular in the mid-nineteenth century, portions of it were introduced in the United States by Thomas Jefferson as early as 1784 in designs Jefferson created for a proposed Governor's mansion in Virginia. Based on an Italian building known as Villa Rotundo, Jefferson's designs for this and at least two other buildings were clearly influenced by Italian architects, and especially Andrea Palladio and his characteristic Palladian windows (Lancaster 1952).

Pattern books published at the beginning of the nineteenth century included Italian-based designs as early as 1805, when British author Robert Lugar titled a work "Italian Villa" in his book *Architectural Sketches for Cottages.* In a followup 1807 book, *The Country Gentlemen's Architect,* Lugar included a design for a farmhouse, complete with a three-storied, asymmetrically placed tower. The Italianate style became more visible to American architects and homeowners when John Havilland, in his set of plans titled *The Builders Assistant (1818–1821),* included a design for a building he constructed outside of Philadelphia. While this building was symmetrical and included a squat tower, not

Variations in Gothic Revival Gingerbread

While Gothic Revival buildings are easily recognizable by their steep gables, most people associate the style with dramatic, romantic gingerbread vergeboards. Surprisingly, though, much of the gingerbread was quite simple, especially during these years from 1820 to 1860. One of the most basic patterns was a scalloped board on each side of the gable running from the gable peak down to the bottom of the eaves. This board may have had openings cut into the curves to make them more like tracery, or they may have been plain. They may also have had drops on each side.

Another type of vergeboard was designed to look like icicles hanging from the eaves. In this style, boards were cut so that 10 to 15 narrow, usually pointed, portions dropped down on each side of the gable. A variant on the icicle theme used carved drops individually mounted along the eaves. All of the icicle-style decorations appear to have been painted white to further the analogy.

Rather than curve down like scallops, some gingerbread was multifoiled; that is, the curves were at the eaves, and the points between the curves hung down. The points on each foil were often accented with fleur-de-lis drops, also pointing down. Each foil was three-dimensional, too, rather than cut from a flat board. These styles were preferred by Davis on his buildings, and, because of the shape and dimensionality, were the ones that most resembled church tracery.

As seen on this Gothic Revival home, decorative vergeboard, also called "Gingerbread" could be quite intricate. Nancy Mingus.

the more stylistic taller, narrower tower, it was clearly influenced by Italian villas (Lancaster 1952).

While these early homes, and several public buildings (especially U.S. Customs Houses built nationwide), set the stage for the Italianate style, it was Andrew Jackson Downing who is generally credited with the great popularity of the style. In his 1841 *Treatise on the Theory and Practice of Landscape Gardening,* Downing pictures the Bishop Duane (or Doane, sources disagree on the name) House in Burlington, New Jersey. Designed in 1837 by John Notman, the Duane House is considered to be the first Italianate house built in the United States, although Alexander Jackson Davis and his partner, Ithiel Town, exhibited designs for a villa in 1835 (Lancaster 1952; Meeks 1948). Downing's *Cottage Residences,* published the year after *Treatise . . . ,* also includes an Italianate building, as does his 1850, *The Architecture of Country Houses.* Downing divided his Italian-influenced designs in to "Villas," and "suburban cottages" saw villas as a "country-house" belonging to "a person of competence or wealth sufficient to build and maintain it with some taste and elegance." (Downing 1850 as quoted in Lancaster 1952) To Downing, the more modest houses with Italian features were based on farm houses and were "Suburban Cottages," as opposed to villas (Lancaster 1952).

In addition to Davis, Downing, and Notman, other popular architects practicing the Italianate style included Richard Upjohn, known primarily for his marvelous Gothic church designs, and Henry Austin. Both designed

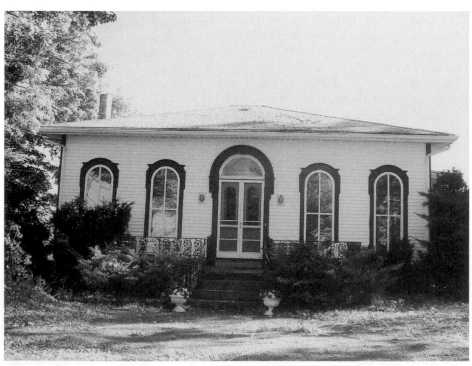

This rare one-story Italianate near Albion, New York, still manages to reflect the ornate decoration of the style. Nancy Mingus.

landmark-quality Italianate villas for wealthy clients. The homes so popular with the growing American middle class, on the other hand, were rarely architect designed. Local builders either added Italianate features to a simple house design, or they may have copied homes directly from the pattern books (Lancaster 1952; Massey and Maxwell 1996).

Because there were two disparate sources for revived designs, some historians divide the Italian revival styles into more than one category, usually referred to as Italian Villas and Italianate (Massey and Maxwell 1996). Others simply refer to the differences as subtypes of the overall Italianate style (McAlester and McAlester 1996). Because the defining features of both buildings are virtually the same, differences will be addressed in the following text also as subtypes.

Defining Features

Designed to emulate the Italian hillside villas, the Americanized Italianate buildings have two dominate features; their roof and window decorations. Like Greek Revival buildings, Italianate buildings can have shallow gabled roofs, but more commonly, they have flat or low hipped roofs. They are usually two stories, although rare one-story versions also exist. Regardless of the shape of the roof or number of stories, however, wide eaves extend out from the building and are supported by large, elaborately carved brackets. The brackets are most often single, although on more elaborate homes, they were paired for an even more substantial effect.

Accentuating the lavish look of the cornice brackets, the fenestration was also highly ornate. Doors and windows were tall and narrow and commonly curved on top; windows almost always so, especially on the upper stories, while doors less commonly. Whether curved on top or not, both windows and doors were accented with intricately detailed moldings. The moldings consisted of "hoods" outlining the top third to top half of the window or bracketed pediments on just the tops. The hoods were more common on round-topped windows, while the latter were more common on rectangular windows. Some of the pedimented tops featured dental moldings, which gave the buildings a somewhat Greek Revival look. On some Italianate buildings, the windows were completely framed with moldings. When this was the case, the top and bottom of the frame were generally wider than the center, giving a flared appearance.

Most of the Italianate homes have one or more one-story porches. The porch roofs are most commonly slightly hipped or shed and have eaves in scale with the main house roof. These eaves usually have cornice brackets matching those of the main house, although they may be smaller in scale on smaller porches. Support columns vary greatly from traditional Doric and Ionic columns, done in stone or wood and found primarily on the masonry villa examples, to more delicately carved, square or round, wooden columns.

Less ubiquitous, but also common, were cupolas and towers. A tower, or *campanile,* when present, could be centered or asymmetrically placed. Italianate towers were square or rectangular, unlike the curved towers that would be present in the later Queen Anne and Romanesque houses. Also, towers were usually one to two stories taller than the main house, making the entire building seem larger and more substantial. These towered versions are often referred to as the Italian Villa style.

Rather than towers, many Italianate houses had cupolas. These cupolas were normally square, although some were rectangular, octagonal, or even round. As with the main house, the roof of the cupola was most often a shallow hip, with wide, overhanging eaves decorated with the same cornice brackets used on the main roof eaves. The windows in the cupola were generally smaller versions of the windows in the second story, which means they were often rounded on top. Both cupolas and towers were often topped by finials. On the less ostentatious buildings, a simple, single-pointed finial was used, made either of wood or sometimes copper. In the more ornate homes, though, finials were often accompanied by elaborate, heavily carved, bracket-like decorations several feet high. Unfortunately, many of these finials were removed when roofs were repaired and were not returned or replaced.

Regional Focus

While Italianate houses can be found across the country, they are most prevalent in the areas of the country that were rapidly growing during this period, especially in the Midwest. Cleveland, Chicago, St. Paul, St. Louis, and other midwestern cities have a large stock of Italianate homes. New expansion in the Northeast was also constructed in Italianate style, especially in western Northeast areas near Buffalo and Pittsburgh. As a booming city throughout the Italianate era, the majority of the homes in San Francisco are also in this style. Due to the slow building rate caused by the Civil War, there are limited numbers of Italianate buildings in the southern states (McAlester and McAlester 1996).

Northeast

Although much of the Northeast was settled by the 1840s, the growing cities and villages still had a tremendous need for new houses, which led to a large number of Italianate homes built around the Northeast. Most of the remaining Italianate homes in this region date to the later years of the style from 1860 to 1880, but they are representative of what would also have been built from 1840 to 1860.

An early, yet elegant, northeastern Italianate home is the Edward King House in Newport, Rhode Island. Designed by Richard Upjohn in 1845 for Edward King, a wealthy landowner in the city, the large brick home reflects the developing trend to the romance associated with Italian villas (Lancaster 1952). With two, three-story towers flanking the two-story main building, the King House has many of the other Italianate features, as well, including small rounded arched windows in the second and third stories, a large one on the main level, and an arched entrance door, all heavily decorated with wooden trim, balconies, and brackets under all the eaves. The house is a National Historic Landmark.

One of the most striking Italianates in the Northeast is the E. B. Hall House in Wellsville, New York. Known affectionately by the locals as "The Pink House," the Hall House was built in 1868 and is typical of a central towered, though asymmetrical, Italianate. It is constructed of brick, with dripping wood gingerbread decoration around the windows and on the porches and tower. And, as the local name implies, the house is painted a medium pink, which contrasts starkly with the all-white trim.

But it was not just rural areas and small towns that embraced the Italianate style. Major northeastern cities put their own twist on the style by creating rows of townhouses. In New York City, for example, the style was becoming dominate by 1853, when *Putnam's Monthly* noted, "The Grecian taste . . . has within the last few years been succeeded and almost entirely superseded, both here and in England, by the revival of the Italian style" (Lockwood 1972).

Generally credited as the first Italianate residence in New York City is the 1846–1848 Thorne Mansion. During its construction in 1847, it was heralded as the "finest private dwelling in the country" by *The United States Magazine, and Democratic Review,* yet compared to Gothic Revival mansions and other Italianate homes, it was quite restrained. It was three stories tall, with no tower; just a slightly jutting center bay. The windows on the front of the first story were arched, while those on the second floor were rectangular and accented by pediments. The third-story windows were very small and looked suspiciously like Greek Revival frieze band windows. The main entrance was fronted by a one-story porch, with rounded arch decorations (Lockwood 1972).

South

There are relatively few Italianate buildings in the southern United States, especially in the Deep South. Most of those that do exist were built prior to the break out of the Civil War in 1861. This is because very little building took place during the War. In fact, much of the building that had started prior to the outbreak, stopped, never to resume. Still, several remarkable Italianates were built during this revival period of 1821 to 1860. These include the 1858 Kenworthy Hall, in Marion, Alabama, and the Haxall House in Richmond, Virginia (also 1858).

Perhaps the most important Italianate in the South is Kenworthy Hall in Marion, Alabama, designed in 1858 by Richard Upjohn. Built with brick and brownstone trim, this Italianate is asymmetrical with a four-story tower. What is most significant about this building, and differentiates it from Upjohn's work on the Edward King House, however, is the manner in which he modified the Italianate form he used in northern buildings to blend in with Kenworthy Hall's southern location. Upjohn modified the interior design to reflect both the southern need for cooling ventilation as well as the use of servants. The house is a National Historic Landmark (Mellown and Gamble 2003).

Another fine example of Italianate during this revival period is the 1858 Bolling Haxall House in Richmond, Virginia. Built by the owner of a local flour mill, this brick house is striking for a number of reasons. While it falls into the subcategory of centered gable, this gable is in fact an arch. An arched attic window appears in the center of the gable, and single and paired rounded-top windows are symmetrically placed on the front facade. As did many wealthy southerners, Haxall lost his fortune in the Civil War, and the house has been owned by the Richmond Woman's Club since 1900 (http://www.twcrichmond.org/).

Midwest

The Midwest was going through a tremendous growth spurt during these revival decades, therefore, much of the housing stock in the Midwest is Italianate. A simple yet stately-looking Italianate in Franklin, Indiana is the circa

1872 August Zeppenfeld House. A two-story brick home, three bays wide, the most intriguing feature of this building is the fenestration. The windows on both floors as well as the entrance door located in the left hand bay have rounded arched windows and matching rounded arched shutters. The hipped roof has the customary wide eaves decorated by paired cornice brackets (see http://www.preserveindiana.com/pixpages/franklin.htm).

Another prime Midwest example is the 1878 Mulvey House in Stillwater, Minnesota. This two-story wood frame building also has a hipped roof and is three bays wide, with the main entrance in the left bay. Like the Zeppenfeld House, all the front windows are round-topped with matching shutters, but they are also framed in wood trim. The porch is one story, but it spans the entire width of the facade. Both the porch eaves and the main house eaves are decorated with an unconventional grouping of brackets. Large brackets appear on each corner and in the center, where much smaller brackets are spaced between the large brackets (see http://www.jamesmulveyinn.com/).

Southwest and West Coast

For more information on post-Civil War homes see Part II of this volume, *Homes in the Civil War and the Reconstruction Era, 1861–1880.*

SECOND EMPIRE (1855–1885)

Another romantic house style is the Second Empire style. Named after the French Second Empire Era, which encompassed the years 1852 to 1870, this building style started as early as 1855, but was much more popular after the Civil War.

Origins and Influences

While the Gothic style harkened back to the medieval period, Second Empire drew its inspiration from the *modern* development taking place in Europe and specifically in France. Additions to the Louvre museum in Paris from 1852–1857 were designed for the French king Louis Napoleon (also known as Napoleon III) to be compatible with the original Baroque architecture.

Some Second Empire houses in Baltimore, Boston, and New York, designed by European-trained American architects, were built prior to 1860 and predate the Louvre work. McAlester shows the 1847 four-story Pratt House in Baltimore, Maryland, repleat with mansard roof, yet it is difficult to tell if this is truly the first Second Empire home in America (McAlester and McAlester 1996). According to Roth, another likely candidate for the first Second Empire home in the United States is the Hart M. Shiff House in New York City, designed in 1850 by architect Detlef Lienau (Roth 1979). The owners of the Felt Manor, in Galena, Illinois, claim it was built in 1848, but the National Register lists it as 1850, tying it with the Shiff House.

Defining Features

The dominant features of the Second Empire style are mansard roofs and decorative roof dormers. In fact, many architectural historians suggest a better

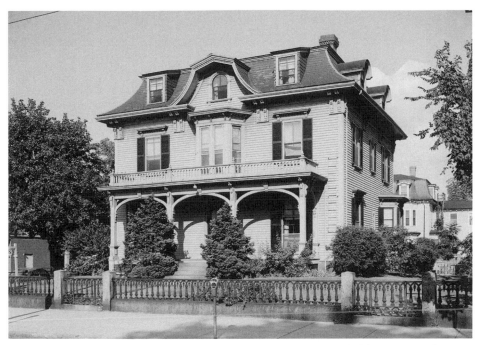

Charles Saunders House, 1627 Massachusetts Avenue, Cambridge, Massachusetts (blend of Italianate and Second Empire). Courtesy of the Library of Congress.

name for the style would be mansard style, because the roof is the single uniting feature of the style. Mansard roofs are so named for the French architect Francois Mansart, who first used this roof style in the 1600s. It was reintroduced to the general public with the 1852 to 1865 restoration of tens of thousands of Paris buildings during Napoleon's reign (Foster 2004).

What is intriguing about these mansard roofs is the variety with which they were built. The simplest ones were sloped at about a 60-degree angle straight back from the eaves. Two other common shapes were straight, but flared at the eaves, as well as full concave curve. Less common were convex curves and ogee (S-shaped) curves. The more complex roof lines were found on the more expensive buildings, because building those roof shapes and then shingling them involved significantly more work.

Regardless of the shape of the mansard, the roofing material was generally slate or fancy butt wood shingles. On simpler buildings, the covering was homogenous, but in the more expensive ones, it was often multicolored and arranged in intricate patterns.

Towers were also popular in Second Empire buildings. These were placed in the center, or asymmetrically, just as they were in the Italianate villa substyle. As with the Italianate towers, Second Empire towers were also one or two stories higher than the main building. Wrought iron cresting long the roof line of the main roof and the tops of the tower or cupola was present in many of the Second Empire houses, although this attractive adornment is often missing today as it was difficult to maintain.

An interesting aspect with Second Empire houses is their symmetry. Unlike Federal and Greek Revival homes, which were always symmetrical, Second Empire buildings, like the Italianates before them, can be symmetrical or asymmetrical. The distinctive aspect of most asymmetrical ones are the towers.

As with Greek Revival homes, Second Empire homes run the gamut from small, plain farm houses to mansions dripping in gilt. They can be single-story to four-story and single family detached or row houses. The style was especially fitted for row houses because the shape of the mansard roof added living space to the home without adding an official, taxable story.

Regional Focus

Second Empire homes, both detached as well as urban row houses, appeared throughout the settled areas of the country, but primarily after the Civil War. For more information on specific Second Empire homes in the post–Civil War years, see Part II of this volume, "Homes in the Civil War and Reconstruction Era, 1861–1880."

OCTAGON HOUSES (1850–1870)

Unlike the styles mentioned so far, Octagon houses were not known for their gables, or their roof lines, or their decorative features. Octagon houses, as the name implies, were octagonal in shape. In decoration, they span other ornamentation styles, including Greek Revival, Gothic Revival, Italianate, and Moorish. They are also made of each of the major building materials, although the majority are wooden. Found primarily in New York, Massachusetts, and the Midwest, it is estimated that only a few thousand were ever built.

Origins and Influences

Although often thought of as an American invention because of the popularity in the United States, octagonal-shaped buildings had been around for centuries prior to their introduction as a house style. A stone octagonal baptistery in Ravenna, Italy is estimated to date to the fourth or fifth century. In the 1600s, the Dutch settlers in America built an octagonal trading post and several octagonal churches. At Mount Vernon, George Washington had both a barn and a garden house that were octagonal, and Thomas Jefferson had an octagon-shaped country retreat. The 1807 pattern book *The Country Gentlemen's Architect* included the design for an octagonal beer house. Yet, none of these influenced the residential home market as much as one slender book.

In 1848, Orson Fowler, phrenologist and amateur architect, self-published his first version of a pattern book designed to introduce all societal levels to the benefits of living in an octagon-shaped house. Calling his book *A Home for All,* Fowler's unorthodox choice for home design mirrored his beliefs in other cultural matters. A proponent of equal rights for women and children, he also encouraged better health for all. He believed living in an octagon house was one way to a healthier life.

Born in Cohocton, New York, Fowler attended Amherst College in Massachusetts, majoring in theology. While studying there, he was introduced to phrenology, which became the family profession, practiced by Fowler, his

brother and sister, and eventually by his daughter. While many favored octagon buildings because the "devil couldn't catch you" in a corner, Fowler's love of the shape was much more practical. According to Fowler, octagon houses were healthier because they had more windows, hence more light, and better air circulation. They also had more interior living space than did both their rectangular and square counterparts. And the space was used more efficiently, with a minimal amount of hallways. Finally, they were cheaper to build and cost less to heat in the winter once they were built (Fowler 1853).

Although these were the benefits Fowler preached, it is likely these benefits were not realized by the owners, leading to the very small number of homes actually built. Still, the book was popular enough to be reprinted nine times from its original date to 1859. In the 1853 edition, Fowler had discovered a wall-building method he called "gravel wall method," and he spent much of the revised book describing how he had constructed his house in this manner and how other homeowners should as well (Fowler 1853).

The onset of the Civil War ended much of the building boom in this revival period and also sounded the death knell for the octagon house. It is estimated that less than 5,000 were built, primarily in the 1850s and 1860s. Because they were so notable, though, a large majority still remain (McAlester and McAlester 1996).

Defining Features

There is only one defining feature of an octagon house; it is octagonal. Other than its shape, an octagon house varied greatly depending not as much on the area in which it was built as it did on the eccentricities and wealth of the owner. Octagon houses were found in one, two, and even three stories, although the majority were two stories. Many octagon houses had cupolas that were usually also octagonal, although occasionally round.

Octagon houses were decorated in a variety of styles, though primarily in Greek and Gothic Revival style, and, later, in Italianate. They were also made with all types of materials. Most were wooden, but many were brick; a few were cobblestone or cut stone, and those that were built by owners following Fowler's 1853 instructions for building their own homes were made of concrete.

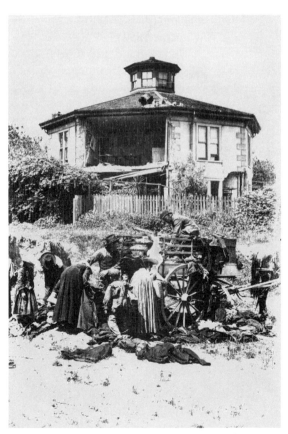

A survivor of the 1906 earthquake, the 1861 McElroy House in San Francisco is made on concrete with redwood quoins. Courtesy of the Library of Congress.

Regional Focus

Octagon houses are found primarily in the Northeast, with smaller concentrations in the South and Midwest. Rare examples are found in the West and Southwest. Some details on the houses in the various regions are discussed here.

Northeast

To Fowler, the perfect octagon house was his own masterpiece in Fishkill, New York. Known as "Fowler's Folly" to the locals, his house was situated on more than 100 acres in New York's Hudson Valley. With walls made of the special concrete he advocated, the three-storied house had more than 100 rooms, when counting traditional rooms as well as closets and other enclosed spaces. It also had a full, above-ground basement and a central spiral staircase used to reach each floor, as well as the glass-domed octagonal cupola sitting 75 feet above the first floor (Fowler 1853).

The main floor had four large octagonal rooms and several smaller spaces, all of which could be converted to one large room by the use of folding partitions. In its subdivided state, the four rooms included the traditional parlor and dining room as well as a sitting room and an amusement room. When the four rooms were opened up, there was 900 square feet of floor space available (Fowler 1853).

The second and third floors each held 20 rooms, 12 of which were bedrooms complete with attached dressing rooms. There were also several recreation-oriented rooms and guest rooms and many closets. Wide porches encircled the first and second floors, with a narrower porch encircling the third. These helped insulate the home from the weather, especially rain, allowing windows to remain open in poor weather, which Fowler believed to be healthier (Fowler 1853).

Fowler also practiced what he preached in terms of hygiene and time-saving technologies. His Fishkill house had built in many modern conveniences such as dumbwaiters; central heating; indoor plumbing, complete with toilets; and "speaking tubes" for contacting those in other rooms. Unfortunately for Fowler, his house did turn into a folly. He lost much of his money in the Panic of 1857, and by 1859, he had sold his beloved building. Due to poor maintenance as well as poor design, the concrete walls deteriorated, eventually making the building uninhabitable. It was demolished in 1893 (Creese 1946).

Other Northeast Octagon houses were much more modest than Fowler's. Two very interesting ones are the Williams and Stancliff Octagon Houses in Portland, Connecticut. Located side by side, and apparently constructed of Fowler's recommended cement, these octagons were built for two brothers circa 1854–1855 (Clementsen 2007). They are both two-story with octagonal cupolas. They also have a wide eave decorated with large, ornate Italianate-looking cornice brackets.

Another intriguing octagon is the Captain Haskell octagon house in New Bedford, Massachusetts. Constructed for one of the city's prominent whalers and completed in 1848, this three-story octagon went through some major alterations in the 1860s when three-story bays were added to the octagonal sides to the left and right of the main entrance door. This yielded a pleasing change to the roof line, which is still topped by an octagonal cupola (see http://www.theoctagonhouse.com/).

South

One of the best known octagon houses in the country is the Haller Nutt House, known as Longwood, located in Natchez, Mississippi. Designed in 1860 by Samuel Sloan from Philadelphia, the four-story, 32-room brick mansion is the world's largest octagon home. What makes it even more architecturally distinctive is the Moorish Revival onion dome perched on its sixteen-sided cupola.

But the size and architecture of this particular octagon house is not its most unique attribute because, in fact, only 9 of the 30 rooms were ever completed. Northern craftsman completed the exterior of the building in less than a year, but when the Civil War broke out in 1861, they fled home, leaving Nutt's slaves to finish the interior work. Laboring throughout the War, they did complete those nine rooms, but the rest of the house is still naked walls and temporary staircases.

As was common during these revival years when owners overbuilt their homes, many people considered Nutt crazy for attempting to build this house, and it is frequently purported that the connotation of "Nuts" as a synonym for crazy derives from this house's owner.

A more modest two-story octagon house located in Clayton, Alabama has an interesting arrangement of chimneys; four of them alternate with windows on every other side along the octagonal cupola. Built from 1859–1861, it is claimed that the house is the only remaining octagon in the state. Older photographs of the building show a two-story porch supported by pairs of columns in the center bays and triple columns on the corners, making the home seem much larger than it is. Recently renovated, the home now has a one-story porch, giving a much more Italianate feeling to the building (see http://www.americanheritage.com/articles/magazine/ah/1983/1/1983_1_109_print.shtml).

Midwest

Second only to the Northeast in the number of octagon houses, the Midwest boasts many fine examples. One striking example is the Gothic Revival Lane-Hooven octagon in Hamilton, Ohio. Built in 1863 for one of Hamilton's wealthiest residents, Clark Lane, the house has many Gothic Revival features, including the steeply pitched gables and decorative vergeboards. A pointed arch forms the entrance to the inset front porch. Jutting over this area is a balcony with cast iron fencing. Another cast iron fence, complete with fleur-de-lis post finials, protects the property. An octagonal cupola allows sunlight into the main hall, highlighting the three-story circular staircase (see http://www.ohiochannel.org/your_state/remarkable_ohio/marker_details.cfm?marker_id=358).

Also in the Midwest is the 1856 Isaac Brown octagon house in Fond du Lac, Wisconsin. This simple one and one-half story octagon is constructed in Fowler's grout method and is rather Greek Revival in appearance, with a wooden molding below the eaves encircling the building and emulating a frieze-board. Four of the eight hip sections of the roof have dormers, and the single-story front porch is enclosed on both sides of the main entry bay (see http://www.marlenesheirlooms.com/octagon.html).

In Red Wing, Minnesota sits the 1857 Lawther House. This two-story brick house is done in an Italianate style and was built for a former mayor of Red Wing. The building has the wide Italianate eaves along the porch and main roof, both supported with paired cornice brackets. The home is topped with a matching octagonal cupola, complete with its own paired brackets, and topped by a cast iron railing (see http://www.octagon-house.com/history.html).

West Coast

Perhaps the most famous West Coast octagon house is the circa 1861 William C. McElroy House in San Francisco, California. This two-story concrete building is decorated in a Greek Revival motif, complete with quoins. The odd thing about the quoins, and the rest of the masonry-like siding, however, is that it is redwood placed over the concrete, then rusticated to look like stone. Paired, single-paned, double-hung windows are placed in the center of each side. The single-story entrance porch protects the main entrance, which includes the door, flanked by sidelights and topped by a transom. The house has an octagonal cupola, and the roof eaves on both the main portion of the building and on the cupola have a single bracket in each corner, adding a slight Italianate cast to the primarily Greek Revival features (HABS 1965).

COBBLESTONE (1825–1860)

Just as Octagon houses were defined by their shape and crossed the styles of the era, Cobblestones, though all built from the same material, were built in a variety of styles. This section looks more closely at the origin and spread of Cobblestone houses.

Origins and Influences

Buildings have been made from stone for thousands of years, but primarily cut stone. Small pockets of cobblestone buildings were built in the countrysides of European countries, and for a brief time in the 1800s, the art was revived, generating a burst of cobblestone buildings in the United States. By definition, a cobblestone is a smooth, rounded stone, larger than a pebble and smaller than a boulder. To geologists, a "cobble" falls between 2.5" and 10", but in cobblestone building construction, most cobblestones are 3" to 5". Cobblestones were created during the glacial ages and are the "garbage" left behind on the land as the glaciers receded. This is key, because the conditions for leaving cobblestones limited where cobblestone buildings were erected.

Two conditions were actually required for good house cobblestones: an old lake bed to lay the foundation sediment, and then the glacial action to leave them in the fields. Both of these requirements were met along the southern shores of today's Great Lakes, which is where the bulk of the Cobblestone houses were built.

Defining Features

Cobblestone buildings are similar to other masonry buildings in that they can be found in any architectural style. The majority of them, not surprisingly

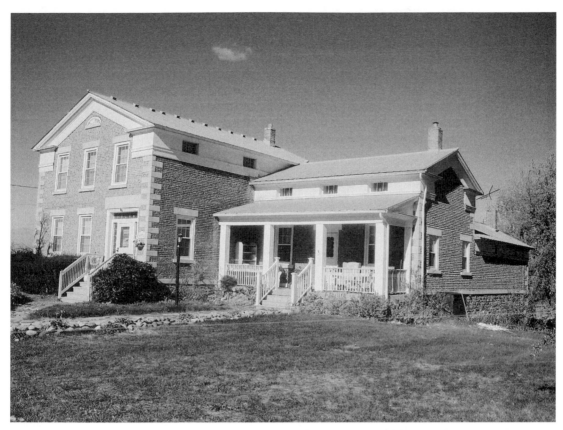

This cobblestone house on NYS Route 104 is one of the larger cobblestone houses in the country. It is only one of the many cobblestone buildings on this road, which is noted as having the highest per capita cobblestones in the country. Nancy Mingus.

based on the time period in which they were constructed, are Greek Revival. A few are Federal, even fewer, Italianate. There are numerous Gothic Revival, some vernacular, and even several Octagonal and other oddly-shaped buildings. Most of the buildings were farm houses, but a fair number were commercial buildings, especially taverns, stores, and warehouses.

The key defining feature is that at least the veneer is built with cobblestones. The walls in some buildings are completely made from cobblestone, but in others, there is a hidden stone supporting wall covered with the decorative cobbles. On rare occasions, wooden walls were erected, and the cobbles were adhered to wooden interior walls. The walls of a cobblestone building range from 10 to 24 inches in thickness, giving a distinctive inset look to the doors and windows, regardless of style.

There are several different styles of cobblestone exteriors, and they tend to follow periods based on the refinements of masonry methods. In the first period, the cobblestones are used throughout the structure, as both interior and exterior walls. The stones used during the second period included primarily facing stones interfaced with longer cobbles reaching into a "rubble" interior wall. These longer cobbles served to strengthen the rubble wall, and both the

interior and exterior walls were built simultaneously. The third method, while the most decorative, was the least stable. In this last method, a rubble wall was built and then a thin veneer of quite small cobbles was attached to the rubble wall. This tended to allow water between the rubble wall and veneer, destroying the veneer (Shelgren et al. 1978).

Stone block quoins are also a later addition to the look. This is most likely because masons found traditional corners difficult to build with cobblestones, and the joints started to fail. Other decorative features, primarily on the Gothic and Italianate versions, included accent rows of cobblestones following the outlines of the pointed, pointed arched, or rounded windows. Some used long, thin cobblestones placed vertically, as decorative lintels; others used more traditional cut stone blocks as lintels.

Regional Focus

While there are Cobblestone buildings scattered across the country, they are predominately found in New York. The styles of the various buildings give an approximate time line and directionality to their construction, implying that the trend started in upstate New York around Rochester and then spread east and west from there. Cobblestone buildings are found along a fairly straight swath running from Wisconsin and Michigan through Buffalo, Rochester, and Syracuse, New York and on into Vermont.

MISCELLANEOUS STYLES

Scattered exotic styles started appearing in the United States during this revival era. One of the most intriguing of these revivals is the Egyptian Revival, which was first used in the United States circa 1835. Other exotic revival styles included Oriental or Moorish, as well as Scandinavian motifs.

In the early nineteenth century, the United States was still deeply influenced by European style. It is suspected that the American interest in Egypt during this time stems from the French discovery of the Rosetta Stone in 1799, which led to heightened awareness of Egyptian culture throughout Europe and the United States. In addition to the influence from France, several architecture books also highlighted the style. One of the first books to do so was the 1848 *History of Architecture, From The Earliest Times,* by L. C. Tuthill. The 1854 book *The Domestic Architect,* by Oliver Smith, also showed images of Egyptian design. While many public buildings were designed in Egyptian Revival, very few homes were.

CONCLUSION

While this period from 1821 to 1860 has one of the most diverse collections of home styles in U.S. history, it is important to note that for every high-styled house built in this era, there was an equal or larger number of vernacular buildings constructed. This is especially true of the farmhouses in the Northeast and Midwest after the 1840s. This revival period in our history brought us not only our first national style, but our most eclectic collection of styles, too. The next chapter will take a look at the building materials and manufacturing methods that made this all possible.

Reference List

Amort, Joanne. 2007. "The Genesis of Oak Alley." Oak Alley Plantation. Available at http://www.oakalleyplantation.com/about/history/.

Creese, Walter. 1946. "Fowler and the Domestic Octagon." *The Art Bulletin* 28(2): 89–102.

Donnell, Edna. 1936. "A. J. Davis and the Gothic Revival." *Metropolitan Museum Studies* 5(2): 183–233.

Downing, Andrew Jackson. 1842. *Cottage Residences.* Repr. Watkins Glen, NY: Century House, 1967.

Downing, Andrew Jackson. 1850. *The Architecture of Country Houses.* Repr. New York: Dover Publications, 1969.

Fleming, John, Hugh Honour, and Nikolaus Pevsner. 1998. *The Penguin Dictionary of Architecture and Landscape Architecture.* New York: Penguin Books.

Foster, Gerald. 2004. *American Houses: A Field Guide to the Architecture of the Home.* Boston: Houghton Mifflin.

Fowler, Orson. 1853. *The Octagon House; a Home for All.* Repr. New York: Dover Publications, 1973.

HABS No. GA-222. 1962. Available at http://memory.loc.gov/.

HABS No. MI-236. 1965. Available at http://memory.loc.gov/.

Lancaster, Clay. 1947. "Three Gothic Revival Houses at Lexington." *The Journal of the Society of Architectural Historians* 6(1/2): 13–21.

Lancaster, Clay. 1952. "Italianism in American Architecture Before 1860." *American Quarterly* 4(2): 127–148.

Lockwood, Charles. 1972. "The Italianate Dwelling House in New York City." *The Journal of the Society of Architectural Historians* 31(2): 145–151.

Massey, James C., and Shirley Maxwell. 1994. *Gothic Revival.* New York: Abbeville Press.

Massey, James C., and Shirley Maxwell. 1996. *House Styles in America: The Old-House Journal Guide to the Architecture of American Homes.* New York: Penguin Studio.

McAlester, Virginia, and A. Lee McAlester. 1996. *A Field Guide to American Houses.* New York: Knopf.

Meeks, C.L.V. 1948. "Henry Austin and the Italian Villa." *The Art Bulletin* 30(2): 145–149.

Mellown, Robert, and Robert Gamble. 2003. "Kenworthy Hall National Historic Landmark Nomination Form." Available at http://www.nps.gov/nhl/designations/samples/al/KenworthyHall.pdf.

Mitchell, Sarah. 2007. "One House, Two Faces; or, Would You Like It With Brackets or Greek Revival Entablature?" Available at http://www.vintagedesigns.com/architecture/misc/brgrk/index.htm.

New Georgia Encyclopedia. 2002. *Old Governor's Mansion.* Available at http://www.georgiaencyclopedia.org/nge/Article.jsp?id=h-620.

Osband, Linda. 2000. *Victorian Gothic House Style.* Newton Abbot, Devon, UK: David and Charles.

Pierson, William Harvey. 1970. *American Buildings and Their Architects: The Colonial and Neoclassical Styles.* Garden City, NY: Doubleday.

Roth, Leland. 1979. *A Concise History of American Architecture.* New York: Harper and Row.

Shelgren, Olaf William, Cary Lattin, and Robert W. Frasch. 1978. *Cobblestone Landmarks of New York State.* Syracuse, NY: Syracuse University Press.

Upton, Dell. 1984. "Pattern Books and Professionalism: Aspects of the Transformation of Domestic Architecture in America, 1800–1860." *Winterthur Portfolio* 19(2/3): 107–150.

Whitfield, Johnny. 2006. "New Use for South House." *The Wake Weekly*. October 26. Available at http://www.wakeweekly.com/2006/Oct26-2.html.

Williamson, Roxanne. 1991. *American Architects and the Mechanics of Fame*. Austin: University of Texas Press.

Building Materials and Manufacturing

Part of the driving force behind the change of style in home design was the increased mechanization of the building process and a refinement of building material use. This chapter outlines these changes and how they applied to each of the popular styles as well as to vernacular homes still being built in rural areas. Specific topics considered include a change from hand-hewn to milled wood for beams, clapboards, and so forth; heating with wood fireplaces versus kerosene and other fuels; lighting from candles to gas lanterns; and availability of indoor plumbing. This chapter also discusses log homes still in use in the Midwest and West.

READYING THE LAND

It is important to remember that during this revival period there was no such thing as the cleared, shovel-ready building lots that are available today. Before a settler could build the family house and barn, the land needed to be prepared. Even in city areas where lots did exist, someone had to have originally cleared that land. The technology for doing this was primitive, and the techniques varied based on the region.

Controlled burns were the first method of clearing used in the forested areas in both the North and South. What varied, though, was when and how the trees were burned. In what is known as the Yankee method, trees were cut down with axes and left for months or even years to dry out. Once dry, the piles were burned and remaining wood was chopped, replaced in piles, then burned again. The southern version, based on a technique learned from the Native Americans, employed girdling. In this method, large swaths of bark encircling

the tree were removed, leaving it no way to feed. When the trees were dead, they were usually blown over by the wind, and once down, they were gathered and burned (Primack 1962).

Whatever method was used to bring down the trees, it was only the beginning of the work. Next, stumps had to be removed. They were usually chopped and pulled out by oxen in a very long process said to take 13 man-days per acre. An early version of a stump-pulling machine was invented in 1850, but it was not in general use by the end of this revival period (Primack 1962).

Settlers in the Midwest had different problems with clearing land. Rather than removing trees, prairie grass and shrubs needed to be removed. By the 1840s, though, there were suitable plows available to turn the prairie sod, allowing a three-person team to clear an acre in four days (Primack 1962).

STRUCTURAL METHODS AND MATERIALS

As noted in the chapter "Changes in American Life, 1821–1860," one of the greatest changes in both residential and commercial construction occurred during this revival period from 1821 to 1860. This shift was precipitated by the invention of the balloon frame for the skeletons of buildings. This type of framing made more effective use of scarce wood, especially in urban areas, and also made a building easier to construct. It was a major contributor to the growth of cities in areas west of Chicago, which were virtually treeless by the time of their settlement (Sprague 1981).

Yet, even as balloon framing took root in the building trades, other structural systems were still actively used throughout the revival period from 1821 to 1860. This section reviews balloon framing, but discusses these other methods as well.

Balloon Framing

Before the introduction of balloon framing, houses and other wood buildings were timber framed, meaning that each section of the frame was held in place by mortise and tenon joints and joined with diagonal braces. Each timber was hand-hewn and heavy. Because of this, each wall in a timber frame building had to be constructed on the ground and raised into position. This required a large labor force.

Various sources credit different individuals with the invention of the balloon frame process. According to Condit (1968), a Hartford, Connecticut carpenter named Augustine D. Taylor first used the technique in Chicago in 1833. Taylor was hired by Father St. Oyr of St. Mary's Church to build their new church. Taylor both designed and constructed the church, located on Chicago's Lake Street a little to the west of State Street (see http://www.encyclopedia.chicagohistory.org/pages/1058.html).

Other sources credit George Washington Snow with the creation of balloon framing. According to these sources, Snow developed his process a year earlier, in 1832 (Elliott 1992; Sprague 1981). The population of Chicago had nearly tripled from 60 to 150 in the previous year, which led to a building boom and an insufficient supply of both lumber and skilled construction laborers. Due to the scarcity of lumber and talent that fall, Snow was motivated to develop a way to both conserve wood yet erect a structurally sound building. As nails at that

time were in abundance, Snow devised a way to use scantling wood and nails to erect a warehouse for his business (Sprague 1981). While sources disagree on the actual first use of the technique, Sprague's work appears to have settled the matter in Snow's favor (1981). Yet, regardless of the inventor of the process, there is no doubt that balloon framing revolutionized the building industry.

It is ironic that the term *balloon framing* has survived for nearly two centuries. Originally a derisive term, alluding to the supposition by traditional timber framers that these buildings would blow away in a heavy wind, the naysayers were proven wrong and both the buildings and the term remained in place.

What gave timber framers these notions was the size of the lumber used in balloon framing as well as its dependence on nails. While the balloon frame was based on the traditional timber frame, it did not require large wood pieces, including girts and posts. These were replaced with a network of joists and studs (Condit 1968). Heavy timbers were still used, however, in sills (Sprague 1981).

Traditional timber frame mortise and tenon joints were still used in areas requiring these large timbers. These included the corner joints where sills met as well as the joints where joists and studs met the sills (Sprague 1981). Foundations were made of stone, or sometimes brick or even logs, and then the sill logs were placed on top of the foundation (Condit 1968).

Once sills were in place, studs were then attached to the sills either with mortise and tenon joints, or, more commonly via nails. As is done today, the studs were placed 16 inches on center (Condit 1968), meaning that from the center of one stud to the center of the next was exactly 16 inches. This allowed the industry to standardize the sizes of many other building supplies, too, especially those designed to be nailed directly to the studs.

The studs in a balloon frame were 2- by 4-foot milled boards, commonly equivalent in length to one to two stories in height. Lighter and easier to handle than their hand hewn cousins, these precut framing members allowed the structure to be quickly assembled. Where there was concern about wind effects from the outside, studs were occasionally doubled or even tripled. They were also doubled at window and door openings to reinforce the structure. Running horizontally along floor lines for floor supports were larger boards known as joists. Joists were commonly 2 by 8 or 2 by 10 to support heavy loads over greater distances. They were also spaced on 16-inch centers (Peterson 1992).

Fastened with nails to the top of each stud was a plate that supported the purlins, roof rafters, and sheathing. Roof rafters were then angled to give the roof the appropriate slope. Rafters were connected with ceiling joists or collar beams depending on whether or not the ceiling ended in a gable. Rafters were generally placed 24 inches on center, although they were also placed on 16-inch centers to align with the studs. After the rafters were in place, boards 1-inch thick were nailed to the rafters. Finally, wood shingles were layered on the roof boards and nailed down to form a water-tight surface (Peterson 1992).

In two-story buildings, the plate (ribbon) supported another set of joists rather than roof rafters. On both the first floor and second floor, floor boards were laid directly on and perpendicular to the joists, then nailed to them (Condit 1968).

For weather-proofing the exterior walls of a balloon frame building, wood sheathing was nailed to the outside of the studs. Once this was in place, clapboard siding, shingles, or other protective material were nailed over the

sheathing then painted or stained just as were timber frame buildings. This made the exterior walls as protective as possible (Condit 1968; Sprague 1981).

There were many advantages to balloon framing. It used less lumber than traditional framing, and its standard-sized boards could be milled and transported to virtually any site in the country. The lumber was light and easy to use, which allowed a home to be constructed by a single carpenter, or two at the most.

Another major advantage of this style of construction was the ease of designing and building multifaceted shapes, both in the original building as well as additions. Rather than building a plain rectangular box, or common L-shaped designs, balloon frame buildings could be built in virtually any shape. Shortly before the Civil War, a common shape was cruciform; a central core with four radiating wings (Condit 1968).

The lightness of balloon frames also gave rise to a whole new prefabricated building industry. Wall frames and roofs could be built in a factory setting, bundled, and shipped nationwide on the developing network of railroad and boat transportation. Before this period ended in 1860, major manufacturers in New York, Boston, and Chicago were selling prefabricated houses, barns, and other structures (Condit 1968).

There were, however, severe drawbacks to the balloon framing method. The greatest drawback was that, because the studs went directly from the sills to the roof, a fire in any of the wall surfaces spread rapidly both up and down the walls. In later years, fire blocks were used to minimize this problem, but in these revival years, fire was still a major concern. Another drawback was in the length of studs needed to span two-story buildings. In the early years of the technique, this was not as much an issue, because the height of the old growth trees was sufficient to mill extremely long boards. As the availability of old trees decreased, however, this became a greater issue.

Balloon construction techniques spread from Chicago both westward and eastward in the same manner as other architectural and design trends; through design books and articles. In 1846, Solon Robinson, writer for *The Plough* and a variety of other agricultural periodicals, published plans for "A Cheap Farm House" in *The Cultivator*. His farm house was designed to be built with balloon frame construction, which he argued was cheaper and easier for the farmers to construct (Peterson 1982).

George Woodward, in a variety of articles and in his later book *Woodward's Country Homes* also advocated for the new nonmortise and tenon process (Sprague 1981). According to Woodward, balloon framing was superior to timber framing for several reasons, not the least of which that it cost 40 percent less than other framing methods (Peterson 1992). These promotions in popular literature, combined with the advantages inherent in balloon framing, made it the most common type of building construction by the 1900s. Balloon framing continued to be the dominate construction method until the adoption of today's platform or Western framing in the 1940s (Elliott 1992).

Other Wall Structural Systems

Despite the rapid acceptance of balloon framing, it was more a steady transformation to the new technique, not an overnight, universally adopted transition. Many builders continued to use a mix of traditional timber framing techniques

while migrating to the newer balloon framing approach. One of the intermediary construction methods used planks for walls. In fact, it used planks for the entire frame, not just the walls. Rather than use any of the traditional studs, posts, braces, or exterior sheathing, boards about 18 inches wide, 3 inches thick, and up to 16 feet in length were run vertically and connected directly into the sills and plates. This left a solid board surface that formed the house. Vertical plank framing was used in the Northeast, especially Vermont and New York, well into the 1850s (Lewandoski 1995).

In the southern Midwest region, because wood was not available locally and was expensive to import, a unique structural system was developed using the naturally occurring, densely rooted sod. To build a sod house, the sod was first turned with a plow, then blocks of sod were cut and stacked similar to bricks and stones. The blocks, 12 to 18 inches wide, were laid out in a square or rectangular perimeter of approximately 14 by 14 or 14 by 20 and connected to one another by pounding the sod. The stacking then continued until the walls were about eight feet tall. Across the top, a frame of tree branches or milled wood was covered with tar paper, and then a final layer of sod was placed on the roof (Peterson 1992).

A construction and framing method unique to Wisconsin and Northern Michigan (as well as scattered parts of Minnesota and Iowa) is known as stove-wood and was also used during this time. With this method, short lengths of wood (14 to 20 inches), usually pine or cedar, were placed in a bed of mortar and then stacked just like a stack of firewood, hence the name. A distinct advantage of this method is that it uses what would otherwise be considered scrap as its primary material. It also does not require much skill and can be built by a single person. Last, the depth of the walls created this way provide excellent natural insulation (Larkin 1995; Tishler 1982).

Some variants on the method incorporate timber frames or balloon frames for additional structural support. When this is the case, the logs function as insulating filling and siding, rather than as a structural element. Because they no longer needed to provide structure, logs in these variants tended to be short. Where only logs were used, squared logs placed like quoins were often employed for more strength, just as cross logs are used on the corners and ends of a wood pile (Larkin 1995; Tishler 1982).

The last structural-related material and method introduced in this period is cast iron. While cast iron had been used in Europe since the early 1700s, it was not widely used in America until the mid-nineteenth century. Cast iron was used in support columns of large American commercial buildings as early as the 1820s and 1830s and was quite common for these uses in the 1840s. The best known cast iron building is the Crystal Palace, built in London in 1851 (Jandl 1983). Cast iron was not really used in residential buildings, however, especially in the United States, although, like the Crystal Palace, it may have been used for private greenhouses or conservatories on the estates of the wealthy. (It is known to have been used in Gothic pinnacles and drip-molds designed by A. J. Davis; Lancaster 1947.)

Foundations

Regardless of the type of wall structural systems used, each house needed to be built on some type of foundation. These varied greatly from region to region

based on climate conditions. They also varied based on the type of wall they needed to support. Because of the need for a cellar to help keep the home warmer in the winter, most northern houses were built on some type of stone foundation. The stone may have been cut blocks, but in rural areas it was typically field stone. The field stone may have been held together with some type of mortar, or it may just have been held by the weight of the building. Cut stone usually was mortared. Both wood frame houses and masonry houses used stone foundations.

In the South, or other areas where winters were not as severe, or with modest homes, the foundation may have been either wooden posts or brick or stone piers. These posts or piers were placed at each corner of the building, as well as at even intervals between the corner supports. The house sill then rested on the tops of all the piers or posts.

Nail Materials

Driving the move to balloon framing was another revolutionary change: the manufacturing of nails. Prior to the late 1700s, nails were hand-wrought with iron one at a time. It was a long, tedious process. Then, circa 1790, Jacob Perkins, a New England inventor with a deep interest in steam power, began working on an automated nail-cutting machine. By 1794, Perkins had developed a working prototype and applied for a patent on the process. His patent was granted in 1795 (Phillips 1996).

Nathan Read, another inventor who had applied for patents for a steam powered boat and a steam powered car in 1790, also set his sights on the nail-cutting business. In 1797, Read created a machine that would cut the nails and also create the nail head. His patent for this machine was awarded in 1798. While Read's machine was used in his own operations, it was never a commercial success (Phillips 1996).

Still, everyone knew that the key to winning the cut nail production war was a machine such as Read's, which could create a nail in a single operation, so many continued experimenting with adjustments to perfect the machine. One of those men was Jesse Reed, who had worked with Perkins. Perkins two-step nail production process was refined by Reed, who, in 1807, received his own patent for a one-step nail-cutting machine. Although Reed's patent was later voided in a patent battle, it was his machine on which the future of nail manufacturing improvements were based (Phillips 1996).

By 1830, much of the American nail business had been converted from hand-wrought nails to machine-cut nails. Most of these nails continued to be produced in the Northeast, primarily New England, in large mills using Perkin's steam-powered concepts (Condit 1968).

These new nail plants had a profound effect on the price of nails. In 1795, a box of nails cost 25 cents. By 1828, the price had dropped to 8 cents per box, and by 1842, had plummeted yet again to 3 cents (Elliott 1992). This rapid increase in nail availability and their rock-bottom costs combined with the scarcity of lumber and the high demand for buildings fueled the switch to balloon frame construction.

ROOFING MATERIALS

Roofing materials themselves did not see a great change in the period from 1821 to 1860, however, how the materials were produced, shipped, used, and

attached did change. Improvements in milling kept the wood shingle market strong, and the new, cheaper nails helped both wooden and slate roofing. The more common roofing materials are discussed in this section.

Thatch

Many of the early settlers in the United States came from sections of Europe that used thatch for the roofs on their buildings, and it is not surprising that they continued to use thatch when they arrived in America. This is especially true of the earliest homes in New York and New England. Thatch was a good material for roofing because it was made from locally grown material, and therefore, it was readily available, which in turn made it inexpensive. It also helped to insulate the building and was relatively long lasting. The ease of applying thatch to the roof also made it popular ("Early Roofing Materials" 1970).

Thatch is an umbrella term used to describe roofs made of some type of grass-like vegetation, usually straw, reed, or, in tropical locales, palm leaves. The vegetation is gathered together in bundles and each bundle is then attached to a grid system spanning the roof, often made for small limbs. Successive bundles are overlapped on the tops and sides until the whole roof is covered.

By the early 1700s, however, most Americans had switched to wooden shingles for their homes, because they were also readily available, lasted longer in the severe winter conditions in most of the colonies, and were easier to extinguish once burning. In fact, some building and fire codes prohibited the use of thatch in the late seventeenth century. Outlying areas of the country continued to use thatch on their roofs well in to this revival period, though. Some of this was because there were no fire codes prohibiting its use in these areas. The other reason was that pattern books and builders' guides were still recommending thatch roofs well past 1860. John Bullock, in his 1873 book *The American Cottage Residence,* promoted its use on "humble" cottage dwellings ("Early Roofing Materials" 1970).

Boards

One of the alternatives to thatching in the early 1800s was the application of boards to the rafters. Starting at the eaves, boards of four to six feet in length were placed horizontally and nailed directly to the rafters. To make the roof weather tight, subsequent boards overlapped the first row and this was repeated on up to the roof ridge. Because these longer boards tended to warp and cup as they aged, however, they often lost their ability to keep out the elements. As was thatch, they were replaced with wood shingles.

Wood Shingles

Wooden shingles have been used on the roofs of buildings since the Middle Ages, but by the 1500s, their use had become negligible, especially in England, where there was a short supply of trees, making wood shingles more expensive than slate and clay shingles. Wood was plentiful in the United States, allowing colonists to return to wood shingling. Original shingles used in the colonies were hung on strips of lath and were up to three feet in length. This application

method meant that the shingles also had to be nailed in the "butt" ends to prevent moving in the elements. Unfortunately, because these nails were not covered by additional shingles, butt-end nail holes often leaked ("Early Roofing Materials" 1970).

Later in the seventeenth century, roofing shingles got progressively shorter until they were stable enough to no longer require butt-end nails. Exposures of 15 inches were common during this time. As with clapboards and wall shingles, roof shingles were up to 5/8-inch thick at the butt end and tapered to very thin tops. They were hand made from cedar, cypress, and pine ("Early Roofing Materials" 1970).

With the onset of the nineteenth century and the continued building boom, the lumber industry began looking for faster, more cost-effective ways of producing wood shingles. An 1803 patent for a machine to make shingles was followed by three others before 1820. From 1820 to 1850, seven other patents were granted. By mid-century, machine-sawn shingles were readily available, yet the boom in the technology came shortly after mid-century. Between 1850 and 1860, 65 more patents for shingle machines or related saws and feeders were issued. While they were not all converted to manufactured devices, the sheer volume points to the demand for shingles in this decade (see http://www.datamp.org/).

The most common type of shingle used during this revival era was a flat- (or square-) butt shingle. When produced by hand, these were significantly easier to make. Even so, there are several early examples of rounded-butt and other "fancy-butt" shingles used on roofs. This is especially true as Americans switched to the Gothic Revival and Second Empire building styles, whose proponents often lauded the benefits of rounded, octagonal, hexagonal, and diamond-shaped butts. As Andrew Jackson Downing noted in his 1842 *Cottage Residences,* rounding shingle butts would give a roof "character" (Downing 1842; Peterson 1976).

Wood shingles did not last as long as other types of roofing materials, so by the mid-nineteenth century there were several products available to attempt to make the shingles last longer. These included the ancient method of tarring, as well as oil-based paints, or special sealers. Most of these methods did not function as well as manufacturers claimed, yet, despite its durability issues, wood shingling was still the most common type of roofing material well into the twentieth century (Peterson 1976).

Slate

Slate has been a popular roofing material for centuries, and it was especially common in this revival period from 1821 to 1860. The variety of colors in which it can be found, the relative ease of shaping it, and its durability fit well with the types of houses built during these years, and the improvements in transportation allowed it to be shipped virtually anywhere.

Slate works so well on a roof because it is a metamorphic rock, hardened by extreme compression, making it impervious to the elements, especially fire. Not all slate can be used on roofs, however, as some of it was not completely hardened. Other slates are too hardened to be of use. The ideal type of slate for roofing is usually called mica slate, whose crystalline structure allows it to be

broken in sheets from the rock bed, but also allows it to be evenly cut on the sides and ends to appropriately shape the shingle ("Early Roofing Materials" 1970).

The early building codes in Boston and New York specified that fireproof materials, such as clay tile or slate, should be used on new buildings, and by 1830, it is speculated that half of the buildings in New York City had slate roofs. Prime roofing slate used in the United States up until the 1830s was imported Welsh slate. While slate was plentiul in the United States, it was difficult to mine in the northeastern states: it produced large amounts of waste (up to 85%) and was too heavy to ship, making the cost of American slate shingles about the same as the better shingles from Wales. But as demand for slate increased, better mining methods were used, and more deposits were found, production in the states increased and finally outpaced imports (Peterson 1976).

Even when there were no building code requirements, slate became popular because it was readily available in the growing areas of the country. Not only were there deposits in all the major Northeast states (Maine, Maryland, Massachusetts, New Hampshire, New Jersey, New York, Pennsylvania, and Vermont), but slate was locally available in the South in Virginia and Georgia, in the Southwest in Texas, in the Midwest in South Dakota, and in the West in California. Combined with better shipping methods on canals and railroads, these diverse, scattered deposits also helped increased demand ("Early Roofing Materials" 1970; Pierpont 1987).

While slate might have been used on any type of building, it was an excellent material for the early Victorian styles of Gothic Revival and Second Empire, which had dominant roof lines. Slate in the United States is found in eight different colors ranging from black to grey, blue to green, and purple to red (Pierpont 1987). This variety of coloring was also a perfect fit for the highly decorative Gothic Revival and Second Empire styles, all of which led to slate roofs being installed with not only the same type butt-end patterns as shingles, but with patterned colors as well. This greatly enhanced the picturesque quality of the buildings (Peterson 1976).

Pattern books during the 1840s and 1850s helped to spread the use of slate. Both Andrew Jackson Downing and Calvert Vaux in their 1850s books describe how slate roofs should be installed on their cottages and villas. Downing even describes nailing methods, and Vaux gives price comparisons to wooden shingles, showing that slate could be cost effective as well as beautiful. Other later-century books would continue to describe and encourage slate roofing, especially on Second Empire mansard roofs and turrets on the late nineteenth century Queen Annes (Pierpont 1987).

The reason that many architects, builders, and owners preferred slate roofing is that, if properly installed, it was truly maintenance free for nearly 100 years. Ranging in thickness from 3/16-inch to 3/4-inch, each piece of slate was attached with nails or wired to roof boards or "sleepers" through two to four punched holes. Flashing, usually copper, was used around chimneys and other things breaking the roof (Pierpont 1987).

The only real drawback to slate roofing was its weight. This was a factor in its cost for shipping, but it was also a factor in the structural soundness of a building. Wooden shingles weigh only 200 pounds per square (material to cover 100 square feet), while even the thinnest 3/16-inch slate weighed 750 pounds per square.

Full-thickness slates of 3/4-inch weighed a whopping 3,000 pounds per square. The roof rafters on some homes could not handle the extra burden, and some moved up to three inches due to the weight (Pierpont 1987). Still, properly installed on sufficient support, slate remained a viable alternative for homes of this revival period.

Terra-Cotta/Clay Tile

Terra cotta is a special type of clay tile produced in pantile (s-shaped) form in the United States from the late 1700s until about 1830. Shaped by an augur, the clay was then pressed and left to dry. Once it was dried, it was fired, turning its characteristic orange color once baked. Tiles were also used in Pennsylvania as flat tiles on outbuildings from circa 1740 to the mid-nineteenth century, but either in flat or pantile shapes, it was rarely used on other domestic buildings until it went through a revival in the late 1800s. Molded terra cotta was also used for decorative accents, although this was also primarily in the late 1800s (Jandl 1983; Peterson 1976).

Metal Roofing

There were three primary types of metal roofs found on the homes from 1821 to 1860. The first is tin, commonly referred to as tinplate. The second, much less common type, was zinc. The third, which was the most common, was galvanized iron. Copper sheets were occasionally used, although they were very expensive. In the later years of the century, metal shingles were also used on roofs.

Tinplate was a relatively thin layer of iron coated with tin to keep it from rusting. It was then cut into sheets, and the sheets were nailed to the roof. It was a popular roofing material because not only was it very durable (Thomas Jefferson boasted it would last at least 100 years), but it was relatively inexpensive. It was also lighter than other materials, especially slate. It did have drawbacks, however. It needed to be painted on the bottoms before it was applied, and then on the tops every 3–4 years. A mixture of linseed oil and iron oxide was the most common type of paint applied, which gave the tin a brown or red tint (Peterson 1976).

From its introduction in the early 1800s to the 1830s, it was sold in 10 by 13 3/4 inch sheets. In the late 1830s to the 1870s, it was produced in 10 or 20 by 14 inch sheets. Most tinplating used in the United States during this time period was imported from England, and it was by far the most popular metal roofing material of the era (Peterson 1976).

Zinc roofing and galvanized iron roofing are both based on zinc. Pure zinc roofing was made by heating the zinc and then rolling it into sheets. The rolling process was patented in Belgium in 1805, and sheet zinc was used as a roofing material instead of copper shortly thereafter. It was first imported into the United States as early as the 1820s, and by 1837, nearly 100 buildings in New York City had zinc roofs (Downs 1976; Peterson 1976).

In 1836, the first galvanized iron was invented by subjecting iron and zinc to a special bonding process that kept the iron from rusting. It was also sold in sheets and was being used in New York City circa 1839 and produced there by 1854 (Downs 1976; Peterson 1976).

SIDING MATERIALS AND TECHNOLOGY

Siding is the name given to any covering applied to the exterior walls of a building to keep it weather resistant. In the simplest early structures, the exterior walls did not require siding. Logs, once properly daubed (and kept daubed), were weatherproof, as were masonry walls of brick or stone. If a home was built with any of the wood-based structural systems, however, it needed to have some type of siding applied to make the building weatherproof.

As construction techniques and milling technology improved, so did the types of siding available for homes. The more common varieties are described in this section.

Clapboards

The most popular siding in the United States during 1821 to 1860 was clapboard siding. Clapboards are thin boards that run horizontally on the structure. Originally hand split from logs, they had a natural taper from top to bottom. They varied in width from about five inches to eight inches, depending on the size of the log used, and were generally less than six feet in length. They were made primarily from evergreens; usually pine, although cedar was also used.

One of the first applications of the new sawing technology earlier in this century was to make clapboards. As more mills switched to newer methods of producing siding, the length, width, and depths at the top and bottom of the taper started to standardize, as had the sizes for studs.

Whether hand made, or produced in a mill, clapboards were attached directly to framing posts, or, more commonly, especially after the switch to balloon framing, they were attached to wood sheathing that was covering the framing studs. The boards were overlapped, and, in some cases, rabbeted to create a tighter fit. This latter version of clapboards is often referred to as shiplap siding.

Wood Shingles

While wooden shingles have been used in roofing for centuries, their use as siding in the United States is not common, especially during this time frame. This is likely due to the fact that wood was in large supply, and of excellent quality, so it was much less labor-intensive to produce and use clapboard siding than it was to cut and individually nail shingles. Where shingles were used as siding, they were produced and applied in the same way they were for roofing.

Board and Batten

Board and batten siding is a wood siding technique where the boards run vertically rather than horizontally as they do with clapboards. When used on houses, the boards are a standard width of about 6 to 10 inches. When used on outbuildings, however, the board widths tended to vary greatly. The boards were nailed to wooden sheathing, and then their joints were covered with smaller boards, called battens, typically one to two inches wide.

Introduced to the masses in the works of Richard Upjohn and pattern books of Davis and Downing, board and batten is simply a more decorative version of

plank framing. In this incarnation, rather than slightly overlapping the planks, the narrow boards cover the gaps. Also, in most board and batten installations, the wood is strictly cladding and does not provide building support as it does in plank framing. The reason that the Gothic architects favored this technique on homes is that the narrow battens greatly increased the verticality of the buildings.

Stucco

Stucco is a coating material that can cover both wood-based structural systems as well as masonry systems. It is a mixture of cement, lime, sand, and water that dries to a hard finish. It is applied to the building in a number of different ways, which gives stucco a wide variety of textures. Some stucco is nearly completely smooth, while others can have regular or random patterns. Stucco can be tinted before it is applied, and it is also commonly painted.

Applying stucco to masonry buildings was not as common as it was to apply it to wood frame buildings, although it did occur. When used on masonry, it was often on a rubble stone wall. In this way, the less decorative wall was hidden beneath the stucco. On wooden buildings, stucco might have been etched or patterned to emulate stone block or marble construction.

EXTERIOR PAINT

Paint in this revival period from 1821 to 1860 was in a state of flux. It was being used on both interior and exterior surfaces, as both decoration and protection. It was used on virtually all interior and exterior surfaces, although the paint chemistry varied somewhat from exterior to interior. As is also the case today, when applying paints to different surfaces, different techniques, and sometimes completely different paints were required. For these reasons, exterior paint is discussed here, while interior paints are discussed in the chapter on furniture and decoration.

Lead

The most common exterior paint used during this revival period was a lead-based paint. Recipes for the paint mixture varied greatly from publication to publication and painter to painter, but, in general, it was some combination of lead carbonate, known as white lead, mixed with powdered, colored pigments and some type of oil or other liquid. The most common liquid used was linseed oil, but fish oil was also used, as was milk (Jandl 1983).

Zinc

In the 1850s, another type of base for paint became available. Made from zinc oxide, commonly referred to as zinc white, it was advertised in 1852 as available in white, black, blue, and light and dark brown. The other marketed benefit was that zinc paint would not cause "Painter's Colic" as did lead paint (Downs 1974; Jandl 1983). It is interesting to note that as early as 1852, the painting industry acknowledged the harmful and often deadly effects of lead paint, yet, it was not outlawed in the United States until 1978.

Standard Application Techniques

Well into the early twentieth century, painting was considered a specialized skill. Professional painters advertised in local directories, but they were not often used by the less affluent because it was considerably cheaper for homeowners to paint their own houses. To that end, books and magazines describing how to do so abounded. One of the earliest was *The Family Receipt Book* published in 1819. Farm-oriented magazines such as the *New England Farmer* often included articles on painting barns and houses, as did the *Journal of the Franklin Institute*.

Much of the emphasis in these books and articles was on how to properly mix the paint medium, as premixed paint was not available in this revival period. They commonly included their own recipes for homeowners to try. To make paint, the homeowner needed to buy the pigment powders, turpentine, and oils from a druggist who had imported them from England, or, in later years, from an American manufacturer. Then the homeowner would grind the pigments on a special device known as a slab and muller, which consisted of a half-egg-shaped metal piece and a marble grinding surface. Once that was done, he was ready to mix the pigments with the liquids (Jandl 1983).

However, once the paint was ready, the application process also required special knowledge. As is the case today, surfaces had to be prepared for painting, then they had to be primed. Once primed, two to three coats of paint were applied. While the process was not difficult on the main building surfaces, it was quite tedious work to paint the detailed trimwork, windows, and sash. Paint was applied with a round or oval pound brush that was used first to prepare surfaces, and once it had loosened up, it could be used with the paint. Smaller brushes were used for window sash, muntins, and other trim pieces (Jandl 1983).

Unfortunately, the work still wasn't finished once the paint was on. Buildings also needed to be repainted on a regular basis. Lead- or zinc-based applications needed repainting within 5–10 years, while whitewashing really needed to be recoated every year (Jandl 1983).

Faux Techniques

A variety of faux painting techniques were used on both interior and exterior surfaces during this period. One exterior technique was the addition of sand to already applied, drying paint. Once the wood was primed, the sand particles were blown into two or more layers of final coat paint. This gave the entire surface the appearance of brownstone or other types of sandstone depending on the color of the underlying paint. Such a technique was used on the 1858–1860 Henry Austin-designed Italian villa mansion known as the Victoria Mansion in Portland, Maine (see http://www.victoriamansion.org/; Phillips and Weiss 1975).

INTERIOR WALL AND CEILING MATERIALS

Even with the great strides in building technology between 1821 and 1860, very little changed in the home in terms of wall and ceiling materials or methods. The following section outlines those materials that continued to be used in revival era homes.

Before standardized wall studs were common, walls were often made of planks, as seen in this 1830s Greek Revival home in Cuba, New York. Karen Reynolds.

Throwing Open the Doors

During this revival period, rooms had to serve multiple purposes, so it was common to have a way to combine smaller rooms into a larger space. This was accomplished in three primary ways. The first was to have a large open archway between the two areas. When used as two rooms, furniture was arranged in groupings in each room, but could be moved to use the total space. Another way to have more separation for the individual rooms was to have doors between them that could be thrown open when needed. Both pocket doors and French doors were used in these doorways, as were early versions of folding doors.

French doors were also popular on exterior walls as entrances to gardens and patios, especially during the Picturesque movement. With these doors closed, the glass allowed the homeowners to enjoy the views and feel more like part of the outdoors. With the doors opened, the adjoining areas became secondary living and gathering places.

Plaster and Lath

Plaster and Lath was the dominate wall material throughout these 40 years. Thin, narrow pieces of wood, known as lath, was nailed to planks or studs, or, sometimes to wood sheathing. It was usually laid horizontally with a space of 1/4 to 1/2 inch between each board, although it was also laid diagonally with the same amounts of spacing. In the early 1800s, lath was made by hand, but by the mid-1820s it was milled.

Once the lath was in place, plaster was applied. The plaster oozed into the openings in the lath and behind the boards, and when it hardened, it anchored the rest of the plaster to the wall. Finish or top coats of plaster were then applied to smooth the surface. Most plaster in this era was made from lime and may or may not have had horse or other hair fibers added to it for strength.

Logs

The inside of an exterior wall in a log structure is also logs. In most log cabins, these walls were left in their natural condition and not covered with any other wall materials. The open rafters were also left as they were; there were no decorative ceilings.

Plank

In pre-1840s homes, interior walls were often made of planks, not studs. These planks were 8 to 10 inches wide and were spaced 8 to 10 inches apart. Plaster and lath was then attached to the planks.

Paneling

In Gothic Revival homes, the walls were often heavily paneled, floor to ceiling, with mahogany, oak, or other decorative wood. This was especially true in

the parlor, dining room, and library. Greek Revival homes also had paneling, although it usually only went approximately three-quarters of the way up the walls. It was also used for parlors and dining rooms.

Metal/Tin

Although Gothic Revival, Italianate, and Second Empire houses are considered early Victorian styles, and metal ceilings are generally associated with the Victorian Era, metal was not used as a ceiling material in the United States until 1868. It was most popular in the late Victorian years from the 1880s to the early 1900s (Dierickx 1975).

Wallpaper

Commonly applied to plaster and lath walls, wallpaper not only decorated the room, but it helped cover minor imperfections in the plaster work. Detailed information on wallpaper is located in the chapter on furnishings and decoration.

WINDOW AND DOOR MATERIALS

Windows and doors are extremely important elements in any building, but especially in a home. Windows allow warm sun and light in, while keeping out the cold wind as well as insects, rain, and snow. When wanted, though, they can let in fresh air and cooling breezes. They also give people a view to the outside world, making them feel a part of their surroundings and less isolated.

Yet, early windows were very hard to create and maintain. Some of the original materials include thin slices of mica, thickly oiled paper, and animal hides, stretched and treated to an opaque appearance. While these early materials functioned well in the "keeping out" aspects of windows, most did not work well in their "letting in" role, as most were permanently installed. This began to change in the seventeenth century with the invention of casement windows, a window that is surrounded by a wooden, hinged frame, thus allowing the window to open and close. The bulk of the windows in the United States as well as in Europe were casement windows until the mid-eighteenth century.

After the mid-1700s, windows started to switch to the vertically oriented double-hung sash window. In this window, there were two sashes, one on top and one underneath, that could raise and lower to let in air, or let out smoke. In the early years, these had tiny panes of glass, but by this time period, changes in the glass industry made much larger panes possible.

Doors, especially the front door, are also important home features. They give visitors entry into the homeowners' lives, not just their houses. As did windows, doors evolved from stretched animal hides on cross-braced frames, hinged with strips of hide, to rustic logs mounted on hewn boards, to the machine sawn, often delicately carved doors of the mid-nineteenth century.

While door and window openings were changing during this revival period from 1820 to 1860, the primary change was in window material and style. Prior to 1800, glass was a rare commodity in the United States, so window openings were modest, filled with small pieces of window glass. As window glass became less expensive and easier to produce in larger pieces, window openings included a smaller number of panes, and both the panes and the windows became larger.

By the mid-Victorian Era, six-foot-tall, double-hung windows with only four panes (a two-pane sash over a two-pane sash) were common.

At the beginning of the nineteenth century, though, there were less than a dozen glass houses in America. Theses glass houses were producing primarily window glass, yet not in sufficient quantities to meet new construction demands. The bulk of the glass used in homes and other buildings had to be imported. As with most imported products, this meant that glass was relatively expensive (Scoville 1944).

By 1820, there were 22 factories making window glass, which consisted of 70 percent of all glass being produced in the United States at that time. Still, well into the 1840s, these glass shops remained small and the production of glass insufficient. The primary reason for this was the amount of labor involved in creating the glass and the lack of appropriately skilled workers (Scoville 1944).

Throughout the 1850s and well until the end of the century, the price of glass varied greatly. It was based on two factors: the prevailing price of imported British glass, and the location of American glass factories or distributors. Imported window glass generally cost a third less than comparable domestic glass because of the lack of nearby glassworks to most American households. Both domestic and imported glass increased in price based on distance from either shipping ports for imported glass, or glassworks facilities for domestic glass. Because of steep shipping fees, domestic glass near Philadelphia, Boston, or other cities with their own glassworks was cheaper than glass in outlaying areas. Similarly, imported glass purchased near a major seaport cost significantly less than glass purchased inland (Elliott 1992).

Window glass during this time was made with two different processes. The first process required three types of differently skilled workers. The first worker, known as the gatherer, would collect molten glass on a blowpipe then roll (marver) it on a piece of marble or wet wooden block into a pear or similar shape. Next, the blower would inflate the glass into a globe shape. Then a third worker would attach a second rod and spin the glass into a thin plate. When this rod was broken off the glass, it left a thicker bull's eye-like spot in the center of the plate (Scoville 1944; Elliott 1992).

The plate that was created in this manner had a fairly uniform thickness and might be as large as six feet in diameter. Once the plate was cooled, it was cut into pane-sized pieces. This type of glass was known as crown glass, and it was noted for its distinctive brilliance (Elliott 1992).

The second process created cylinder glass. It was gathered and rolled in the same manner, but rather then blowing a globe, the blower created a round-ended cylinder. It was cooled with water then reheated. After reheating, the top and bottom were sliced off and trimmed to produce a tube. The tube was then heated and flattened with a charred block of wood. Because the wood was used before the glass hardened, it removed the natural brilliance in the glass. Even so, it had the advantage of being able to yield larger pieces of glass with less waste because the bull's eye did not get in the way. The flattening process also created a more even thickness, meaning that incoming light was not as distorted (Elliott 1992; Scoville 1944). Laborers in the glass factories were scarce and highly skilled, which meant that the workers earned much higher than the prevailing wages of their times (Elliott 1992). In 1850, 43 percent of the total

cost of glass was for labor, with individual laborers earning close to $100 per month by 1878 (Scoville 1944).

The first known crown window glass house in America operated in Boston from 1787 to 1792. Still, by 1830, it and its six competitors had gone out of business or switched to manufacturing other glass. From 1831 to 1832, the only company making crown glass in the United States was the New England Crown Glass Company in East Cambridge. While other crown glass manufacturers came and went, by 1850 no crown glass was being made in the country. From then on, the only American-made window glass was cylinder glass (Scoville 1944).

During the reign of the Boston-based company, though, its glass was highly treasured. Called "Boston glass," this glass was considered by some to be better than the glass available from Europe. In addition to the Boston glasshouse, glass was produced near Pittsburgh, Pennsylvania and in Utica, New York (Elliott 1992).

The fires used to melt the glass were fueled largely by wood well into the middle of the nineteenth century. The Pittsburgh glass house started using coal in the late 1700s, but others did not immediately follow suit. In addition to the fact that coal did not burn as hot as pine and oak, using coal was smelly and smokey and required a reworking of the furnaces. Still, as easily available and cheap wood supplies ran out, by 1860, the remaining glass houses had converted to coal.

A major boom to the glass industry was a cost-saving unit referred to as a regenerative furnace. Patented by Fredrick Siemens in 1856, this furnace recycled hot air rather than introducing cold air. Tank furnaces for continuous operation soon followed (Elliott 1992).

After the 1861 invention of gas furnaces, glass houses switched technology again. By the end of the century, the majority of the glass houses were using gas furnaces (Scoville 1944).

Hinges, Latches, and Locks

Well into the early nineteenth century, wrought iron was the material of choice for connecting doors to their frames. The most common style of wrought iron hinge during the late 1700s and early 1800s was the H hinge, so named because it was indeed shaped like an H. One leg of the H was nailed to the door and the other flush to the frame.

Another popular wrought iron hinge was the dovetail hinge. In this style hinge, each half was trapezoidal, like a dovetail used for wood joints. When the sides were combined, the hinge resembled a bow tie. It was attached to doors and frames in a similar manner, but it was much wider than an H hinge, giving it more strength (Streeter 1973).

Just before the Revolutionary War (1775) a new type of hinge was introduced made of cast iron. Known as cast iron butt hinges, these hinges were the predecessors of the most common hinges still in use today. The impact of these hinges was significant because doors no longer had to be flush-mounted to trim. They could also be hung more easily (Streeter 1973).

Cast iron butt hinges were used in American building starting shortly after the Revolutionary War and were used in conjunction with wrought iron hardware for many decades. They came in a variety of sizes and two standard configurations called three or five part, referring to the total number of connection

points. The pin was an integral part of the hinge and not a separate removable piece as it is today. The male half was cast, the pin inserted, and then overcast when the female half was cast onto the male half (Streeter 1973).

MASONRY MATERIALS

Unlike wood, which was light and relatively easy to transport, masonry materials such as stone and brick were extremely heavy, and therefore costly to transport. This meant that in the early part of this revival period, masonry materials were quarried, gathered, or made locally.

Brick

As a material made from the earth, bricks were often made on site by homeowners or a local brick maker. With a sharp increase in demand during the 1820s and 1830s, brick companies were formed. An early brick manufacturer was the 1846 Hudson Bay Company in Vancouver, British Columbia. Here, clay was placed in brick molds and placed in the sun to dry for up to two weeks. Once dry, the bricks were fired in a kiln, 20,000 to 50,000 at a time to harden them (Elliott 1992).

By mid-century, a shorter way to make bricks was developed. Called dry press, this process took a finely ground clay or shale mixture and pressed it into brick molds. Once molded, the bricks would be fired, eliminating the two week drying time (Elliott 1992).

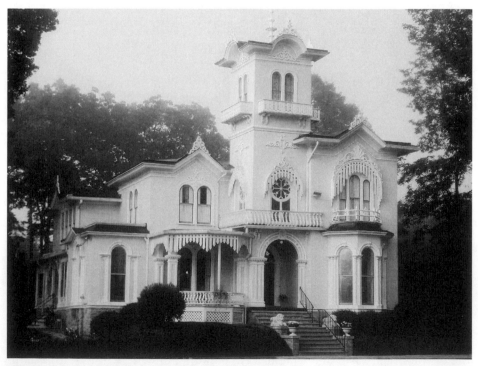

The pink E. B. Hall House in Wellsville, New York, is a brick example of the Italian Villa form of Italianate buildings. Nancy Mingus.

Bricks were used in a variety of ways between 1821 and 1860. When used in walls, they could be laid in many strikingly beautiful patterns. The most common patterns, however, were the stretcher/running, English and Flemish bonds. In a running bond, each brick was laid running lengthwise, offset every other row so that the left edges of one block were aligned in the centers of the bricks above and below it. In English bond, the first row of bricks are laid lengthwise, but the next is laid with the headers (short ends) facing out. This pattern of stretcher row then header row is repeated up the wall. Flemish bond also uses headers and stretchers, but alternating so that a brick is laid header out, the next, stretcher out, the third header out, and so forth across the row. Then the next row starts with a stretcher brick, and alternates stretcher, header, as well. The third row starts again with a header, and the alternating bricks and rows continue to the top of the wall.

When available locally, or in areas where they could be made on site, bricks might have been used as a flooring material, especially in a kitchen. This made the kitchen floor much easier to clean. It also helped keep the house warmer, as the bricks absorbed and then dispersed the heat from the kitchen fireplace.

On wealthier estates, bricks were used as garden paths. They may have been laid in a traditional running bond format, but serpentine and other patterns were also popular.

Cut Stone

Sandstone, limestone, and granite, where locally available, were popular building materials during this time. This was especially true in the Northeast after 1825, when an abundance of stone masons who had built New York's Erie Canal were unemployed and ready to turn their skills to home building.

Even where stone could be found, quarrying it was a tedious process. The primary method used during this period was known as the jumper quarrying method. It started with a 5- to 6-foot long iron rod that was then pounded into the stone surface to split it from the rest of the formation. The problem was that it required more than 100 strikes on the rod to form an opening a little over 2 1/4 inches deep. The hole would then be packed with explosives. After the site was cleared of workers, the hole would be blasted and pieces of stone later collected. Blasting would often occur at the end of a shift, and another shift would collect the stone. It was not until after this revival period that steam-powered drills were available to speed the quarrying process. Once the large stones were separated from the rock wall, they needed to be cut into appropriate sized blocks. This was also a manual process until 1863, when the steam channeler that quarried the rock also cut it into appropriate lengths (Elliott 1992; Peterson 1976).

Cobblestone

In the 1820s to 1850s, cobblestones were also a popular building material, primarily in the mid-Atlantic and Midwest. Cobblestones are small rocks, about 3 to 5 inches in diameter, laid in decorative courses. Thousands of houses were constructed completely of cobblestone, and tens of thousands of foundations of houses and barns were also made of cobblestone.

Fire Hazards in Revival Era Homes

Changing technology in heating, lighting, and construction greatly improved the standard of living in the United States from 1821 to 1860. There were down sides to many of these improvements, however, especially in the increased chances for fire. This is especially true with the switch to lamps for lighting and balloon framing for home construction.

While the risk of fire when heating with wood and lighting with candles was always present, the advent of the whale oil lamp, and later petroleum-based products, made lighting even more dangerous. Accidentally tipping over a lamp could spread the oil, and hence the fire, along wooden floors to the frame. Some of the more volatile fuels did not need to be tipped over to combust. Jostling or too much heat or sun could cause them to explode. Although there are no exact numbers on how many fires were caused by lamps, literature from the era suggests it was a frequent occurrence.

Balloon framing construction techniques made the situation even worse. All wood frame buildings are susceptible to fire, but the unblocked open areas between studs in balloon frame buildings allowed faster combustion. Fires could spread from the floor to the frame, and straight up the open space in two-story studs, to the equally open space along the floor joists, fully engulfing the building at warp speeds. Even more insidious was that these fires were often thought to be out, only to spring up fully involved in other sections of the structure. With the high density in urban areas, fires also spread quickly between buildings. This caused several cities to enact legislation limiting the construction of wooden buildings.

HOME HEATING

Keeping warm, especially in the northern states, has always been a concern for Americans. Heating systems were influenced by architecture design as well as building techniques; changes in both necessitated a rethinking of traditional heating methods. In the revival period from 1821 to 1860, home heating saw advances similar to those in other areas of technology, going from simple wall fireplaces, to stoves, to central heating.

When this period started, there were several ways to heat a home, but by far the most common was with fireplaces located on the walls, often in every room. These multiple fireplaces tended to be small and not overly effective at heating, primarily due to deficiencies in drawing air from the room, which often created smoky conditions (Elliott 1992).

Also still in use in some homes at the beginning of the revival age were jamb stoves. A jamb stove was made of five cast iron plates tucked into a wall in a parlor or other common room. It was often connected to a fireplace on the adjoining wall, usually in the kitchen (Barber 1912). Coals or wood from the fireplace were pushed into the jamb stove, which warmed the cast iron plates, providing heat to the room. Ashes were drawn from the jamb stove back into the fireplace and then removed (Elliott 1992).

The third type of stove in use was a cast iron firebox designed in 1740 by Benjamin Franklin. This firebox opened in the front and provided a larger heated area and a slower burning fire than earlier models, making the heating more efficient. It was fed fresh air through the floor. The cycle continued with the now heated air passing through a rear air box and up the chimney (Elliott 1992).

These three types of stoves continued to be the primary types of heat until the 1830s, when two inventions aided home heating. In 1832, Eliphalet Nott, a Presbyterian minister and president of Union College in Schenectady, New York, patented a base-burning stove with a rotary grate. The iron stove stood six feet tall and is credited as being the first to use coal for fuel. The coal was dropped in to a container at the top of the stove and was gravity-fed into the fire pit below. The fire burned on the rotary grate, which spun to dump the

ashes into an ash drawer below the fire box. This allowed air to continue to circulate and kept the coal burning, which made it superior to other previous stoves. Known as a Nott stove, this stove was found in houses nationwide and overseas within a few short years after its invention (Elliott 1992; Wise 1990).

In 1827, avid water and steam power advocate Jacob Perkins partnered with his son Angier March Perkins to loose the power of water on the heating industry. By the 1830s, the Perkins' had developed functional hot water heating systems, which were being installed throughout England. As did many inventions, hot water heat came to the United States shortly thereafter.

Not only did hot water heating require special furnaces, but it also required large quantities of heat-resistant piping. Although American factories began producing hot water pipes and fittings as early as 1830, by mid-century, the majority of hot water pipes used in home heating were still made in England (Elliott 1992).

While the technology for hot water heat was available in America in the early to mid-1800s, between 1821 and 1860, most heat in homes was still produced by stoves and fireplaces. Although hot water heat, and its cousin steam heat (first produced in the 1870s from centralized steam plants that distributed steam to homes), were being planned, it would be the late 1800s and early 1900s before these heating methods became commonplace fixtures in U.S. homes. It was also the late 1800s before the familiar cast iron furnaces started to dominate American basements (Elliott 1992).

INDOOR PLUMBING

During this revival period, although the technology existed, very few homes had running water or indoor bathroom facilities. Prior to the late nineteenth century, the inclusion or lack of indoor plumbing in a home was largely a sign of the wealth of the owner. This is especially true in the first part of this revival period from 1821 to 1840. Indoor plumbing became more prevalent from 1840 to 1860, especially in urban areas such as Philadelphia and Boston, but it still would not be considered common until the 1880s.

Water Closets

The first advance related to indoor plumbing was the 1775 invention of the valve water closet. In this early incarnation of a toilet, a valve was placed at the bottom of a bowl and covered with a leather seal. To flush this water closet, water from a tank mounted high on the wall above the bowl came in through a hole on the side of the bowl. The leather-covered valve opened and the water and waste exited the bowl via an s-shaped pipe. To help reduce odors in later years, rubber seals were added (Elliott 1992). Other rudimentary types of water closets were also developed around this time, including pan water closets, which used a basin that led to a pan that required cleaning following use; and earth closets, in which dry earth was used to cover waste temporarily before it was removed.

Water closet technology continued to evolve in the nineteenth century. By mid-century, less expensive hopper water closets became available. In this new style, wastes were eliminated by water circulating around the bowl. Unfortunately, this

method was not always effective, and as a result hopper water closets were used mostly by the poor (Elliott 1992).

Two additional types of water closets were the plunger water closet and the washdown water closet. Today's modern toilet evolved from the washdown water closet. In this type of water closet, water was used to seal an s-shaped drain pipe. The pipe remained filled with water between uses to seal the bowl from the sewer below, thus keeping unpleasant odors from entering the room.

Although this technology was found in wealthier homes, it would not be until the end of the century that a toilet more similar to today's emerged. The remaining households continued to use chamber pots and outhouses, some well into the twentieth century. (For more information on chamber pots, see the chapter "Home Layout and Design, 1821–1860," and for more information on outhouses, see the chapter "Landscaping and Outbuildings, 1821–1860.")

Sinks and Tubs

Running water to sinks and permanently plumbed bath tubs were also present in the home during these 40 years, but as with toilets, they were not common. The first installed bath tub was purported to have been in a Cincinnati home in 1842, but most homes in this revival period continued to use portable tubs and wash basins in either their bedrooms or the kitchen (Brumbaugh 1942).

CONCLUSION

The materials used during this revival period from 1821 to 1860 changed very little from materials that had been in use for centuries. The technology available to process these materials, however, gave Americans in this era the ability to continue to spread across the growing nation. It also changed interior layouts and functions of homes, as discussed in the next chapter.

Reference List

Barber, Edwin A. 1912. "American Iron Work of the Eighteenth Century." *Bulletin of the Pennsylvania Museum* 10 (40): 59–62.

Brumbaugh, Richard Irvin. 1942. "The American House in the Victorian Period." *The Journal of the American Society of Architectural Historians* 2 (1): 27–30.

Condit, Carl W. 1968. *American Building: Materials and Techniques from the First Colonial Settlements to the Present.* Chicago: University of Chicago Press.

Dierickx, Mary. 1975. "Metal Ceilings in the U.S." *Bulletin of the Association for Preservation Technology* 7 (2): 83–98.

Downing, Andrew Jackson. 1842. *Cottage Residences.* New York: Wiley and Putnam.

Downs, Arthur Channing, Jr. 1974. "The Introduction of American Zinc Paints, ca. 1850." *Bulletin of the Association for Preservation Technology* 6 (2): 36–37.

Downs, Arthur Channing, Jr. 1976. "Zinc for Paint and Architectural Use in the 19th Century." *Bulletin of the Association for Preservation Technology* 8 (4): 80–99.

"Early Roofing Materials." 1970. *Bulletin of the Association for Preservation Technology* 2 (1/2): 18–55, 57–88.

Elliott, Cecil D. 1992. *Technics and Architecture: The Development of Materials and Systems for Buildings.* Cambridge, Mass.: MIT Press.

Jandl, H. Ward. 1983. *The Technology of Historic American Buildings.* Washington, D.C.: Association for Preservation Technology.

Lancaster, Clay. 1947. "Three Gothic Revival Houses at Lexington." *The Journal of the Society of Architectural Historians* 6 (1/2): 13–21.

Larkin, David. 1995. *Farm: The Vernacular Tradition of Working Buildings.* New York: The Monacelli Press.

Lewandoski, Jan Leo. 1995. "Transitional Timber Framing in Vermont, 1780–1850." *APT Bulletin* 26 (2/3): 42–50.

Peterson, Fred W. 1982. "Vernacular Building and Victorian Architecture: Midwestern American Farm Homes." *Journal of Interdisciplinary History* 12 (3): 409–427.

Peterson, Fred W. 1992. *Homes in the Heartland: Balloon Frame Farmhouses of the Upper Midwest, 1850–1920.* Lawrence: Kansas University Press.

Phillips, Maureen K. 1996. "Mechanic Geniuses and Duckies Redux: Nail Makers and Their Machines." *APT Bulletin: A Tribute to Lee H. Nelson* 27 (1/2): 47–56.

Phillips, Morgan W., and Norman R. Weiss. 1975. "Some Notes on Paint Research and Reproduction." *Bulletin of the Association for Preservation Technology* 7 (4): 14–19.

Pierpont, Robert N. 1987. "Slate Roofing." *APT Bulletin* 19 (2): 10–23.

Primack, Martin L. 1962. "Land Clearing Under Nineteenth-Century Techniques: Some Preliminary Calculations." *The Journal of Economic History* 22 (4): 484–497.

Scoville, Warren C. 1944. "Growth of the American Glass Industry to 1880." *The Journal of Political Economy* 52 (3): 193–216.

Sprague, Paul E. 1981. "The Origin of Balloon Framing." *The Journal of the Society of Architectural Historians* 40 (4): 311–319.

Streeter, Donald. 1973. "Early American Wrought Iron Hardware: H and HL Hinges, Together with Mention of Dovetails and Cast Iron Butt Hinges." *Bulletin of the Association for Preservation Technology* 5 (1): 22–49.

Tishler, William H. 1982. "Stovewood Construction in the Upper Midwest and Canada: A Regional Vernacular Architectural Tradition." *Perspectives in Vernacular Architecture* 1: 125–133, 135–136.

Wise, George. 1990. "Reckless Pioneer." *American Heritage of Invention and Technology Magazine* 6 (Spring/Summer): 26–31.

Home Layout and Design

Most of the home styles in this period featured symmetrical exteriors, and this symmetry was generally carried into the interior design and room layout as well. This chapter will review the popular room layouts and functions from this era, discuss the activities taking place in the various rooms, and highlight any special-purpose rooms in use at the time. Some of these include the library and summer kitchen as well as multipurpose areas including cellars, attics, and porches. It will also introduce multifamily dwellings and their unique requirements.

INTERIOR DESIGN OF HOMES

In the earliest years of the United States, homes were simple, temporary, one-story, one-room buildings. By the seventeenth century, however, more permanent structures were being built. The interior layouts of these homes depended on the region in which they were built. Homes in New England, especially in Massachusetts, were two stories, with the second story jutting out past the first. There was a small entry area and hall with a large room both to the left and right of the hall. The entry hall also contained a narrow stairwell to the upstairs. Behind the stairs, and between the two main rooms, were two large masonry fireplaces, back to back. One of the fireplaces was set up to also be used as the cooking area. Up on the second floor there were bedrooms (Roth 1979).

Homes in the South were also two stories, with two rooms sometimes off of a small entrance hall, or, most often, directly adjacent. The main entrance to the home in the latter case would then open into the main living area. Unlike

the New England houses, the fireplaces for each room were located on the exterior walls. The stairwells were commonly in the rear of the building, usually issuing from whichever room was used as the kitchen (Upton 1998).

As the United States passed through the seventeenth and eighteenth centuries and into the early nineteenth century, the layouts of exterior shapes and interior spaces in the home evolved to reflect the changing nature of domestic life. During these 40 years, homes began to change shape as they grew larger. From the single-room cabins, houses first doubled to two, and then three or more rooms. Originally these rooms were arranged linearly, because the new rooms we generally additions, and it was much easier to simply add another room to the end of the existing building. Some of these linear homes were one room wide and multiple rooms deep, while others ran horizontally instead.

The next evolution was to massed plans, where buildings became multiple rooms deep as well as multiple rooms wide. By the 1850s, despite the exterior style, many of the interiors were what is sometimes referred to as the Georgian-plan, with two rooms deep on each side of a central hall. Downing used this layout for the interior of the Gothic Revival Rotch House described in the chapter on styles around the country. This arrangement was popular because it helped separate public spaces from private ones.

Other arrangements, especially in vernacular homes, were L-plans, facing either to the front or the rear. The rear-facing pattern was more common, as a new building was often added to an existing one, which had been parallel to the road, so the addition had its gable end to the front. Multiple T patterns, U patterns and even H and cross plans could be found.

The Greek Revival homes of this period were commonly rectangular, with the long side facing the street. A smaller number of Greek Revivals had the gable end facing the street. Many Greek Revival homes, especially in rural areas, often had a side ell, while two-story town homes may have been flanked with one-story wings. When the plan was of the four-room five-bay type, a very common massing, entry to the home was through a central stair hall regardless of how the house was oriented on the lot. Rear wings sometimes created L, T, and other irregularly shaped plans. Regardless of the footprint pattern of the building, the interiors continued to evolve into more rooms and a more obvious division between public and private space.

Homeowners desired not only increased privacy within their homes, yielding more bedrooms and less public space, but they were also encouraged to be more private on the outside of their homes as well. Wide porches, porticos, and verandas over the main and secondary entrances helped to shield occupants from the prying eyes of passers-by (Upton 1998).

So it was during these years that porches became popular. Prior to the development of the Greek Revival homes, building entries were rarely covered. If they were, it was generally with a small roofed overhang over the entrance door, not supported by posts but by simple brackets attached to the wall. The Greek Revival style, and to a certain extent, the Classical Revival before it, virtually required porches, often in the form of full-height porticos. The majority of those that did not have porticos had one-story porches supported by columns.

Porches were also defining features of Gothic Revival and Italianate style homes. Each style often had highly ornate porches, both covering the main entrance as well as side entrances. Steeply gabled roofs on many Gothic Revival

porches added to the picturesque character of the building, as did cast iron balusters and other decorative elements. The roofs on Italianate porches were slightly sloped rather than gabled, but equally elaborate in decoration. Both styles often had intricately carved support columns and pilasters.

Types of Period Room Layouts

Before reviewing the specific uses for the rooms during this period, it is important to set the stage for the vast variety of layouts available to homeowners and recommended by style book writers. To that end, this section describes the room layouts for urban and rural Greek Revival homes, as well as cottages and villas, as published in John Hall's *A Series of Select and Original Modern Designs for Dwelling Houses for the Use of Carpenters and Builders Adapted to the Style of Building in the United States: With Twenty-Four Plates,* which was originally released in Baltimore in 1840.

Plate III: A Dwelling House of Six Rooms

The entry on this small house leads to a hall and staircase. Off this hall is the kitchen, with a washhouse and a [root] cellar adjoining it. The plans note that if it is preferred to have the cellar sunken, there can be another room added over it for a pantry. The staircase leads up to the second story, where there are three private bedrooms, and a hall closet, which has a window facing the hall for light. The use of a closet in this home is interesting, as they were not common in this era.

Plate IV: A House Two Stories High with an Attic

Notable features in this home are the multiple parlors and sliding doors to divide or open the parlors into larger rooms. More intriguing is that "there is a wash-house adjoining the kitchen, where water is heated and conveyed to the bath-room above. There is a piazza on the second story, enclosed with venetian shutters" (Hall 1840, p. 7) for ventilation for the watercloset. Homes in this era rarely had bathrooms and water-closets, even though style books such as this were starting to promote them. Note, too, that these are specified as separate areas. The concept of combining the watercloset and bath into a "bathroom" was a much later one.

Plate V: A Cottage Containing Seven Rooms on the Principle Story

As noted by Hall, "In the arrangement of this cottage . . . the rooms differ in their dimensions, to suit a variety of uses . . ." (Hall 1840, p. 8) The washhouse and kitchen are located in the basement. Placing the kitchen in the basement was common in the northern areas of the country.

Plate VI: A Three-Story House with a Back Building

As with the house in plate IV, this home has a front and back parlor with pocket doors so that they do not obstruct the placement of the furniture when they are open (Hall 1840). This house is also designed to include inside shutters, if desired, as noted, "the front and back walls are of sufficient thickness to

admit of inside shutters." The second floor in this home has a front bedroom with a dressing room directly adjoining. The third story has two bed "chambers," one in front and one in back, both, again with closets. There are also two "garret rooms which are lighted with dormars. [sic]" (Hall 1840, p. 9).

Hall describes the rest of this large home as follows: "The back entry . . . is as small as it could be, to admit of a side light door." (Hall 1840, p. 9) A built in china closet is located across from this door. The back stairs are between the kitchen and the breakfast room (so that unpleasant odors from the kitchen do not enter the breakfast room) and are located near the servant's quarters. Next to the kitchen is the washhouse and a storeroom is located above. An "office" is located in a separate building in the back so that it gets fresh air. "A door in the back chamber opens on the terrace that leads to the water closet. . . . A bath room [is located] directly over the breakfast room which can be supplied with hot water." (Hall 1840, p. 9) This would have obviously been a home for a wealthy family, especially with the inclusion of indoor plumbing.

Plate VII: One Story Cottage

Because this is a one-storied building, the kitchen, along with a washhouse and pantry, is located in the basement. This home also features a "dairy" in the basement. Access to the basement is below the rear steps. On the first floor there are six rooms, as well as a bath and a watercloset. The plan is arranged so that the latter could be hidden behind shutters, making it more private. Unlike some homes of this time where access to rear bedrooms is through front bedrooms, the bedrooms in this home come directly off the hall, also making them more private. This proposed house gives a look at materials as well as layout, stating that the walls are framed in wood and chimneys are brick.

Plate XIII: Three Story House in the Grecian Style, Adapted for a Large Family

As with many of Hall's other houses, this one has a kitchen in the basement, under the dining room. A dumbwaiter connects the two rooms so that food can be transported directly between them. Upstairs on the first floor, the entrance hall has a door to an antiroom and another to the main stair. Also off the hall are doors to three entertaining rooms: the "saloon room," the drawing room, and the living room. In the drawing room, French doors flank the fireplace and allow people to go out to the portico. There are bay windows in both the drawing and dining rooms.

Through the antiroom there is access to the greenhouse and the gardener's room. Past the main staircase is the butler's pantry as well as a servant's room. The second story has a summer sitting room, which is also the principle entry to the other rooms. The arrangement and dimensions of rooms on the second and third floor correspond with those on the main floor.

Plate XVI: Three Story House with Back Building

Reflecting both the love of porticos and octagons in this eras, the front portico on this house opens into an octagonal vestibule. "The parlor and breakfast rooms have a door that leads into the private passage. In the drawing room there

are two Corinthian columns one on each side of the sliding doors, supporting a projecting entablature" (Hall 1840, p. 20). This home also has a washhouse, and over the washhouse is a bath room. Hall notes again that it is preferable to have the water closet separate from the bath room.

Plate XXI: A Villa Two Stories High, with a Basement

This home introduces some other special purpose rooms such as the library, scullery, wine cellar, and cistern. In this dwelling, the basement "contain[s] a kitchen, under the library. The wing under the library is used as a scullery and wash house, and the wing under the drawing room is a man's bedroom; that part of the basement under the drawing room is subdivided into a butler's pantry, larder, &c." (Hall 1840, p. 26), whereas the basement under the dining room may be divided up as a wine cellar, pantry, or other type of storage area. The first floor has as an entry porch with doors to a main hallway that leads to a drawing room, and a library. "The entrance to the dining room is from the hall under the stairs" (Hall 1840, p. 27). From the dining room, there are doors that allow guests to enter the garden. On the second floor are three bedrooms and there is a dressing room over the dining room, with a bath in it that may have both hot and cold water. A cistern located under the roof carries water through a lead pipe. Water is heated in the pipes behind the kitchen fire and ascends back up to the bath room.

With this background on the types of rooms and their relationships in the home, it will be easier to understand the next section, which describes how these rooms normally functioned.

ROOMS AND FUNCTIONS

In this revival age from 1821 to 1860, there were great changes in the way Americans viewed their homes. This was reflected not only in the exterior design and ornamentation, but in the interior arrangements and uses for rooms during this time. Rooms, in general, became more private. They also went from multi-functional to single purpose. Regardless of rooms' purposes, they had a variety of ceiling heights. Typical revival style homes had 10-foot ceilings on the main floor and 8-foot ceilings on the second, although in larger homes, 12-foot ceilings were also common on the first floor, with 9-foot ceilings on the second. Ceilings in rural, vernacular homes tended to be much lower, often 7 feet high.

Most rooms also had a fireplace, even in a bedroom. Fireplaces were made of brick and fronted with tile and had a variety of mantels. Some were intricately carved marble or other stone, while many were simple wooden boards. Carved oak and mahogany were also popular. In homes of the less affluent, mantles were commonly painted to look like richer wood, or like marble.

The rest of this chapter reviews the general purposes of the various room types as well as the influence wealth and location (rural versus urban) had on these rooms.

Entry Hall

The most public room in any house was the entry hall. For some visitors, this was the only room they would see, and even for those who would be allowed

into the parlor or other rooms, the entry hall set the expectations of guests for the rest of the house. Because of this, the entry hall often had the finest floors, as well as the best lighting and furniture. In two or more storied homes, the staircase to the upper stories was generally located here as well. In southern homes, especially plantations, there were often two entry halls: one for the front door, which faced the river, and another for the back door facing the road or lane (Busch 1999).

In Gothic Revival and Italianate villas, the entry halls soared a full two stories high and were sometimes separated from the main entrance by a small vestibule. The halls in castle-style Gothic Revival houses commonly had vaulted ceilings, rich, dark wood paneling and other Medieval symbols, even the occasional suit of armor. Castle-style Gothics were also known to have heavy timbered ceilings (Osband 2000).

Some entrance halls, especially those in the two by two Georgian plan, extended the depth of the house. These long halls started to reappear in American architecture as early as the 1820s. Reminiscent of the great halls of English manors, these halls were often considered the "heart of the home," as everyone had to pass through the hall on the way to any other room, just as blood flows through the heart to reach all the other parts of the body. In very large homes, the entry hall served as a replacement of the European ballroom, or banquet hall (Osband 2000).

Entrance halls in smaller homes also functioned as reception space, but in a different context. These small halls usually contained a chair or a bench on which visitors could sit and wait to be shown into the parlor. Other furniture that commonly adorned the entrance hall included hall trees; small, often marble-topped, tables; and large, ornate mirrors.

Parlor/Drawing Room

The next most public room in a house during this period was the parlor. It was usually the first room off of the entry hall to ease in access without invasion into the private areas of the home. This was generally a very formal room, containing the most expensive (and uncomfortable) furniture, generally of a matched set. This was the room for entertaining, so personal collections of art, knick-knacks, and the like were also on public display. In the later years of this revival period, it was often jamb packed with material goods (Grier 1988). If the homeowners had a piano, it was commonly placed in the parlor.

Furniture in the parlor was arranged in seating groups encouraging conversation, yet it was also moveable to allow flexibility in room use. Chairs, sofas, and tables were often on casters so they could be moved more easily, with less risk of damaging the legs of the expensive pieces. The parlor table was used for many different purposes, and because of this, it was commonly protected with some type of tablecloth. This cloth, often homemade, minimized the damage caused by scratches, wax drips, and ink spills (Garrett 1990).

Expensive carpets, such as Brussels, Wilton, or Axminister, were on display on the floors in many parlors of the wealthy. In less affluent homes, ingrain carpets were used instead. Regardless of the type of carpet, its color scheme would have been bright and bold to contrast with the somber colors of the furniture. Loud carpet patterns also contrasted well with the plain, stark walls in many

homes. Common colors were red and green or blue and cream, executed in floral or geometric motifs (Garrett 1990).

The various home guide books published during these 40 years differed greatly in their advice for maintaining the best parlor carpet. Some suggested that cedar branches be placed beneath the carpet to help keep the smell of the rug fresh as well as to discourage moths. Others suggested that it should be cracked black pepper or tobacco leaves under the carpet. One 1844 book recommended that straw be used, as it would both cushion the carpet as well as allow dirt to fall through to later be cleaned. By 1855, however, guides admonished that straw posed too high a fire risk, and that large sheets of coarse paper would suffice (Garrett 1990).

Sitting Room/Living Room/Dining Room

The rear parlor, also known as the sitting room, living room, or dining room, was the more private gathering room in the house. These rooms were more feminine in design because they were where the women of the household spent their time in domestic and creative pursuits such as sewing and needlework. Children and adults often gathered in this room to read the popular books of the time. Sitting rooms as well as parlors usually had fireplaces. In some arrangements, they were back to back on the common wall between the two rooms. As it became more popular to be able to throw open the parlor doors for larger gatherings, these fireplaces migrated to exterior walls and were replaced by sliding pocket doors that were stored within the walls when open. Sitting rooms, as well as parlors, may have been paneled and were occasionally octagonal or oval in shape rather than rectangular.

Library

One of the more common special purpose rooms in a home was the library. It is theorized that this room most likely evolved into its own room in the 1700s as men of wealth needed a place to display their riches and wisdom in the form of expensive books. Their use during this revival era was similar. They were commonly darkly paneled, usually in mahogany or oak, and furnished with leather upholstered heavy wooden chairs and sofas. The book shelves were also large, heavy units that often ran from floor to ceiling. In addition to housing the family's books, the library also stored and displayed travel or hunting souvenirs (Busch 1999). In terms of shape, they were normally rectangular, but could also be round, oval, or octagonal.

Bedrooms (Bed Chambers)

In the early years of the United States, there were no separate rooms designated bedrooms. The heads of the household often slept in the parlor. By the middle of the eighteenth century, wealthy and middle-class families had incorporated the concept of the bedroom into their homes, although those living in log cabins and other small homes in the country's heartland continued to use lofts or other undivided rooms for sleeping.

The bedrooms in this revival period from 1821 to 1860, especially the master bedroom, were often located on the first floor and were directly accessible

from the main hallway in case they needed to be enlisted for use as entertainment space. First floor bedrooms were also used for temporary or long-term rooms for the ill or infirmed family members. This minimized the need for their caretakers to climb stairs to care for them (Cromley 1991; Osband 2003).

Bedrooms on the second floor were to be used by the other family members. When there were multiple children, it was common for the girls to share one room and the boys to share another. In larger, wealthier households that could afford the space, however, each child had a private room. Servants in these larger homes often resided in the rear of the second floor, or in the third floor attic area. Some bedrooms, especially those on the main floor, had fireplaces both for heating in the winter as well as a source of fresh air in the warmer months (Cromley 1991; Osband 2003).

Some of the more popular pattern books of this era show this trend in room layout. One such book was Gervase Wheeler's *Homes for the People,* released in 1855. This book was

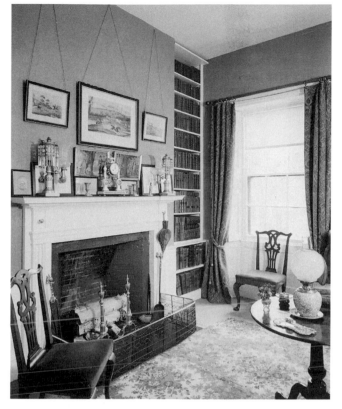

As the wealth of the nation continued to grow, the library became a popular room in all home styles. This 1824 one in the John Black House, Ellsworth, Maine, is typical of Greek Revival homes. Courtesy of the Library of Congress.

somewhat different from other books of this era because it included designs for a range of wealth as well as a range in settings. In all these designs, the master bedroom was still on the first floor.

Coinciding with the trends to better health and a desire for privacy, bedrooms in the latter years of this revival period were designed to be light, simple, and restful places to which occupants could retreat. They often contrasted greatly with the dark, more severe, more public spaces of the home. Continuing with the desire for personal privacy, husbands and wives often slept in adjoining bedrooms that had doors to the hall as well as a door on the common wall between them. This was especially true in larger, wealthier homes (Osband 2003).

Bedrooms in this era may or may not have been carpeted. Again, due to health concerns, there was controversy over the difficulty of keeping a carpet clean and germ free, versus the problems of continually washing a wooden floor, thus making the room damp. If a large carpet was used in the bedroom, it was frequently covered with a smaller throw rug at the bedsides to protect it from the frequent wear (Garrett 1990).

Well into this period, sanitary appliances such as chamber pots and, less often, water pitchers and wash bowls were still used in bedrooms. Even though books such as A. J. Downing's *Architecture of Country Houses* started promoting the use of a separate "bathroom" in the 1850s, indoor plumbing and bathrooms were very rare until the 1870s, even in major cities such as New York and Boston.

In houses with indoor plumbing, a chamber pot might still be used, as it alleviated the need to stumble through a cold, dark house to the bathroom. These pots were commonly stored under the bed, or in a cabinet. Wash basins, where used, minimized the demand for what was often the only bathroom in a home. The stand for the basin might have had storage space beneath it, and if so, the chamber pot may have been hidden there instead of under the bed (Garrett 1990; Osband 2003).

Dressing Room

Adjacent to the bedrooms there might also be special rooms generally referred to as dressing rooms. Also known as a boudoir or sitting room, especially when used by the female of the house, these small rooms became popular starting in the 1770s. Dressing rooms generally contained dressers, often built in, as well as closets or armoires (wardrobes) for hanging clothes. These pieces pointed to the primary function of this room; a place to get dressed away from those who might be sharing the bedroom. In homes without interior plumbing, the dressing room often held the washstand, too (Busch 1999; Garrett 1990; Osband 2000).

A dressing room might also have a small desk, chaise, bookcase, or other furniture allowing it to function as an area for reading or relaxing. In these cases, the room served both as a dressing area as well as a small office space or sitting room. Concerns for health in the dressing room were similar to those in the bedroom, so these rooms may or may not have been carpeted or wallpapered (Busch 1999; Garrett 1990; Osband 2000).

In wealthier homes, each resident might have their own dressing room. This was the case in Fowler's octagon home, which, as noted earlier, had 12 bedrooms, each with its own dressing room. These more affluent households commonly had servants quarters connected to a rear door in the dressing room so that the servants could enter and help the occupant get dressed.

Kitchen

Regardless of the size of a house, the wealth of its owner, or the region in which it was built, all homes in the United States, even from its earliest beginnings, had to have some type of place to cook and serve food. For more than 200 years,

In Search of Storage

Simple homes in the early settlement years did not have closets. The settlers had very few possessions that required storage. Most had limited clothing and shoes, and all the bed linens were on the beds. As the country grew, a new middle class developed, and one of the changes this brought was in possessions. Special purpose furniture, such as knick-knack shelves, evolved to store these new possessions, but in addition to furniture for storage, homeowners began to allocate precious square feet in their homes to storage. Pantries were used to store food and other domestic goods, and closets became critical for personal storage. Wealthy homes had closets well before the middle-class homes, but by the end of this revival period, even the eclectic octagon houses were being designed with closets.

the technology of the American kitchen virtually stood still. Food was cooked over open hearth fires in cast iron kettles and served to household members seated on benches at the sturdy, chunky kitchen table. In the late 1700s, this began to change.

Always the center of the kitchen, the cook hearth went through a dramatic change in this revival period between 1821 and 1860. This upheaval was created by the invention of the cast iron cook stove. The kitchen might be located in the cellar; in a separate, but attached building; in a completely detached building; or, most commonly, within the main house on the first floor. The location of the kitchen relative to the house was determined by both the wealth of the household as well as the region in which it was built. How it was used also depended on the affluence of the owners. In the Northeast, the kitchen was usually in the house or basement, with a summer kitchen on the grounds for use in the summer. In the South, the kitchen was usually in a separate building (Garrett 1990).

When kitchens were included in the main house, they were commonly on the ground floor, though removed from the main public areas. This was done to separate the kitchen smells from the rest of the house, but also to keep the hustle and bustle of food preparation in its own isolated area. Interior kitchens were usually connected to the dining room directly with a door on a common wall, or, often, through a pantry or other small hall.

The focal point of the kitchen was the cooking area. When cooking over an open hearth, cast iron or copper pots were hung on cast or wrought iron hooks or cranes and swung into the fire. When the cast iron stove was invented, cooking migrated from the open hearth to the plates on the coal stove. (See the chapter "Building Materials and Manufacturing, 1821–1860" for more information on the evolution of kitchen technology.)

The function of the kitchen varied based on urban or rural location as well as on affluence of the owners. In the wealthier city homes, servants were commonly employed to do the cooking and other food preparation. When this was the case, the female head of the household functioned exclusively as the kitchen manager, directing the work of the servants (Osband 2000). In these kitchens, generally only the wife and servants entered. In less affluent homes, however, the wife had to do the kitchen chores. The latter kitchens were much more social places, with children and guests often either helping the wife, or at least keeping her company.

No matter who had the primary kitchen duties, the kitchen was clearly a place for work, not relaxing. It was not decorated, per se, although the pots, pans, and utensils did add a measure of ornament. Pots made of copper were most often highly polished and neatly arranged on open shelves or hung above the stove on a pot rack. Utensils often hung from the same rack, or on another rack over the table (Busch 1999; Osband 2000). Though disturbing to us today, also found throughout the kitchen in this era were traps to catch rodent intruders (Garrett 1990).

The kitchen was also painted simply. Most kitchens were whitewashed, although, in 1845, Elizabeth Ellicott Lea, in her book *Domestic Cookery,* recommended that they be a sunnier yellow color. This yellow wash was made of yellow ocher, whiting, and glue. It was applied to the walls as well as the floors (Garrett 1990).

The final kitchen-related innovation in this era involves the storage and use of ice. In the 1840s, the predecessor of today's refrigerator known as an icebox decreased enough in cost to be practical to install in even middle-class homes. Designed to store ice to preserve food or chill a drink, the ice for this appliance came from an ice house, or, in urban areas was most often purchased from an ice vendor (Gordon 1989).

Bathrooms

As noted earlier, today's concept of bathrooms did not exist in this revival area. The bathrooms referred to in the building plans of the era were simply that: a room in which to take a bath. Houses did not have separate bathrooms that combined all the sanitary functions until the 1870s. In most homes prior to that time, bathing was accomplished by having servants carry hot water to one of the four types of portable bathtubs available during the early 1800s. These tubs were normally situated in dressing rooms or bedrooms to give the bather privacy. The most common tubs used were small, shallow cast iron ones simply for washing off, or deeper, hip-baths in which one could submerge (Osband 2000).

In urban areas, however, more modern bathing was possible. Philadelphia opened a public water works in 1830, and in 1832, Philadelphia home builders constructed the first U.S. dwellings with running water and designated bathrooms. New York's public water system opened 10 years later, in 1842. By the time this period ended in 1860, both the middle-class and wealthier areas of each major city in the United States had access to piped water (Gordon 1989). Even though these early bathrooms had water, the watercloset, if one was installed, was still generally in a different area.

Main Stairways

Main stairways in a building of this era were not simply a way to get from one floor to the next, they were designed to make a statement about the success of the homeowner. Therefore, in wealthy estates, the main stairway tended to rise directly from the main hall, in full view of everyone. Even though often elaborately carved in mahogany or other exotic wood, most stairways provided a straight path to the second floor. Others, however, especially in southern manor houses, rose to a mezzanine, then split in two, with one branch going to the left side of the second story and the other branch going to the right. In more modest homes, staircases were generally simple affairs. They may even have been located behind a door to hide their plainness.

Servants Quarters

When this revival period started in 1821, few but the wealthiest had homes big enough to need or board servants. By the 1850s, however, the affluent upper middle class had emerged, and it was common for them to employee live-in servants, especially in homes in cities large enough to have people willing to work in a servant capacity. These homes typically had three servants; the butler, the cook, and the maid. Wealthy estates may have had six or more servants, requiring a maid for each floor, plus a chauffeur and governess. Each servant was usually

paid a weekly salary and was given room and board (Gordon 1989).

This meant that these servants also needed their own rooms. In the wealthy homes that had three or more stories, the servants rooms were generally on the top floor. In two-story homes, the servants quarters were in a separate wing in the rear of the second floor. Their rooms were much smaller than the family's bedrooms and did not have fireplaces to keep them warm. They may or may not have shared a small stove for heat. The servants apartments also did not have bathrooms and waterclosets, even when the rest of the house did. This meant that servants had to continue to use wash stands and chamber pots; some well into the twentieth century.

A narrow rear servants' stair lead from their rooms down to the kitchen so that the servants did not need to use the main stair to come and go from their rooms. In fact, in many houses, there was no connection between the servants quarters and the rest of the bedrooms, so the rear stair was their only access. In homes that had multiple servants, each room was off a narrow central hall.

This curved stair in the McElroy House in San Francisco leads to the cupola. Courtesy of the Library of Congress.

Cellar (Basement)

The cellar or basement of a home is the open area under the main floor of the building, within the foundation walls. Not all houses had basements, but those that did housed many things in this revival era. In homes built in the late 1700s up to the mid-1800s, the basement was often where the kitchen was located. Root cellars for wintering carrots, potatoes, and other foods were also located in the basement, as were cisterns and wine cellars.

Attic

An attic is the portion of a building above the ceiling of the highest story and below the roof rafters. The use, and even the availability, of an attic depended greatly on the architectural style of a home. One and a half-storied Greek Revival buildings had no attics, nor did many of the vernacular houses

Southern houses often had external servant's quarters, but in the northeast and Midwest, servants lived in small rooms in the rear of the house. This photo from an 1850s Italian Villa style home shows how small the rooms were. Courtesy of the Library of Congress.

built during this era. Second Empire and other houses with mansard roofs, on the other hand, had full walk-up attics. In these homes, the attic often held the servants' quarters. Many Gothic Revival homes also had walk-up attics, especially those with cross gables. Unless used as servants' quarters, however, most attic space in this era was used strictly for storage.

Special Purpose Rooms

Homes of the wealthy during these 40 years may also have had special purpose rooms such as pantries, billiards rooms, smoking rooms, laundry rooms, and wine cellars. Pantries were used to store food and often dishes and other kitchen items and commonly had built-in shelving. If the pantry was visible to the public, this shelving was often a fine grade of oak.

Billiards rooms were used for family entertainment, primarily, as the name implies, billiards. These rooms were furnished in a manner similar to libraries, as were smoking rooms. Laundry rooms were often in the basement, or rear of the house off the kitchen, and accessible by the servants' stair. Wine cellars were also commonly in the basement, although they may also have been separate stone or brick structures.

CONCLUSION

Many advances in these 40 years influenced the way Americans designed as well as used the space in their homes. Regardless of the external style of a home, common themes occurred in the shape of the building as well as the interior arrangement and function of rooms. This, in turn, led to a change in furniture and decoration, as discussed in chapter five.

Reference List

Busch, Akiko. 1999. *Geography of Home*. Princeton, NJ: Princeton Architectural Press.

Cromley, Elizabeth Collins. 1991. "A History of American Beds and Bedrooms (in Buildings and Popular Culture)." *Perspectives in Vernacular Architecture* 4: 177–186.

Garrett, Elisabeth Donaghy. 1990. *At Home: The American Family 1750–1870*. New York: Harry N. Abrams, Inc.

Gordon, John Steele. 1989. "When Our Ancestors Became Us." *American Heritage Magazine* 40(8). Available at http://www.americanheritage.com/articles/magazine/ah/1989\8/1989_8_106.shtml.

Grier, Katherine C. 1988. *Culture and Comfort: People, Parlors, and Upholstery, 1850–1930*. Rochester: Strong Museum.

Hall, John. 1840. *A Series of Select and Original Modern Designs*. Reprinted in *John Hall and The Grecian Style in America*. New York: Acanthus Press, 1996.

Osband, Linda. 2000. *Victorian Gothic House Style*. Newton Abbott, Devon, UK: David and Charles.

Roth, Leland. 1979. *A Concise History of American Architecture*. New York: Harper & Row.

Trollope, Frances. 1832. *Domestic Manners of the Americans*. Repr. New York: Vintage Books, 1960.

Upton, Dell. 1998. *Architecture in the United States*. Oxford: Oxford University Press.

Getting the Lay of the Land

While millions of settlers traveled across the United States during this revival period from 1821 to 1860, thousands of travelers went not in search of new riches and a better life, but merely a curious need to see what all the fuss was about. One of the most notorious travelers to the United States during this time was Frances Trollope. Trollope arrived in 1827 with her family planning to settle in Cincinnati. While they did complete the journey to Ohio, they did not stay there, deciding instead to travel the country. In 1832, a book of her travels, *Domestic Manners of the Americans*, was released.

Trollope had several scathing things to say about the people, places, buildings, and decorations she saw. About the windows in her room in an inn, she complained:

[It] was darkened by blinds of paper, such as rooms are hung with, which required to be rolled up, and then fastened with strings very awkwardly attached to the window-frames, whenever light or air were wished for. I afterwards met with these same uncomfortable blinds in every part of America.

Although Trollope did not care for most of America, she did like Baltimore. She greatly praised its buildings, especially the material from which they were constructed:

Baltimore is in many respects a beautiful city; it has several handsome buildings, and even the private dwelling-houses have a look of magnificence, from the abundance of white marble with which many of them are adorned. The ample flights of steps, and the lofty door frames, are in most of the best houses formed of this beautiful material.

Trollope also greatly admired the Capital in Washington, D.C., and the city as a whole, but she did not care for Cincinnati, Philadelphia, or most of the other places she visited. Still, her focus on both the people and the structures during her travels give us a vivid picture of the era. (Trollope 1832, pp. 37, 205)

Furniture and Decoration

This chapter reviews the various revival styles of furniture popular between 1821 and 1860 and explores how these styles were encouraged by more effective manufacturing techniques and facilities. The advancement of technology in other interior finishes, such as lighting and upholstery, will also be covered. This chapter also introduces the concept of gilding, which gained popularity circa 1850, and discusses home-related inventions from the period, including the sewing machine, which affected the way homes were decorated.

Just as this period was marked by numerous revivals in architectural style, period furniture and decoration was revivalist in nature. While many styles in interior design and decoration were popular—and almost mainstream—in American homes as a result of style and pattern books of the time, individuality was reflected in the homeowners' adoption of a selected style. In wealthier homes, it was common for one style to completely replace another. New sets of furniture and other decorative articles, such as drapes, carpets, and wallpaper, would be purchased to replace the "outdated" items in the home.

Less affluent homes, on the other hand, did not have the luxury of wholesale replacement of household goods whenever the styles changed. They would make do with a purchase of one or two items of the new style. They were also content with purchasing outdated but perfectly functional items from estates and other venues. This mixture of pieces gave middle-class homes an eclectic yet individual feel. The advent of the sewing machine helped to further encourage this individuality, as women had the opportunity to create their own curtains, pillows, and other items.

Despite the outcome of the War of 1812 against Great Britain, the young United States had yet to find its own way in terms of a national style, preferring to continue to rely on the traditional tastes brought over by the English settlers. These tastes were perpetuated in not only the architectural styles prevalent following the war, but in the interior design and decoration of the public buildings and homes throughout the country.

However, there was a movement starting in the early 1800s toward a revival of Greek and Roman styles in American architecture and interior design. Moldings and other interior architectural elements of this era, such as mantles and cornices, were very masculine—bigger and bolder than in previous decades. Windows were also taller, stretching from just a foot or so off the floor to within a foot of the ceiling. Carpeting, window treatments, and upholstery were also bolder, featuring contrasting arrangements of green, red, yellow, and blue (Von Rosenstiel and Winkler 1988). This movement spread across the United States in the same way architectural styles did: by the introduction of books on furniture and decoration.

An early player in the interior style book arena was British designer Thomas Hope who wrote *Household Furniture and Interior Decoration* in 1807. An avid antique collector who traveled extensively in the "Old World," Hope was also friends with French designers Charles Percier and Pierre Fontaine. Working for Napoleon Bonaparte, Percier and Fontaine had the opportunity to travel and document the Roman and Egyptian furniture they saw. They used these drawings to create their French Empire style. As did Hope, Percier and Fontaine published their designs in an illustrated volume titled *Recueil des decorations interieures* in 1801 and 1812 (Fairbanks and Bates 1981).

These books by Hope and Percier and Fontaine were followed by another important publication highlighting classically based style: *A Collection of Designs for Household Furniture and Interior Decoration,* written by George Smith and published in London in 1808 (Fairbanks and Bates 1981).

FURNITURE

Because of how it dominated the home, the major expression of a family's wealth and taste was in its furniture. During this revival period, Americans continued to purchase their furniture from overseas, especially England and France. However, as the population increased, and local demand grew, the number of American furniture manufacturers also grew. These budding furniture makers got their design ideas in three main ways. First, the individual craftsman had worked in a furniture company in the Old World and remembered the styles and simply recreated them. A great number of early American furniture pieces were created this way. Furniture makers could also look to pattern books, both those from Europe, as well as a new crop of American pattern books. Last, the designer could base designs on actual pieces of furniture. This was the least used method (Fennimore 1981).

Regardless of where the designs of American furniture originated, they tended to follow the major European trends in furniture. Only the Shaker furniture could be considered a truly American design. The rest of this section discusses the most popular furniture designs found in American homes in this revival era. To better align this discussion with the architectural periods from

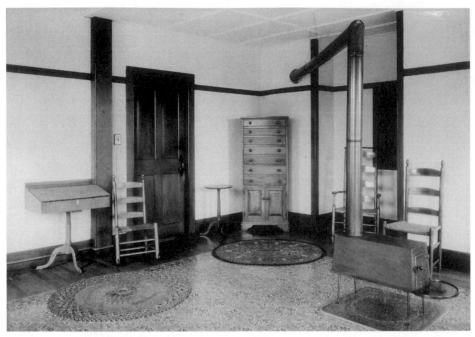

Interior showing typical Shaker furniture and heating stove. Shaker Church Family Main Dwelling House, Hancock, Massachusetts. Courtesy of the Library of Congress.

1821 to 1860, the material is grouped by the various revival eras, not by the individual furniture styles.

Greco-Roman Revival (Classical) Style (1805–1850)

Just before this revival period, American furniture was becoming more of a status symbol to its owners. This encouraged furniture manufacturers to design and build more substantial pieces that would last long enough to become treasured family heirlooms. The Classical style had invaded all areas of American art and style, including the dominate Greek Revival form of architecture, but also in painting and sculpture as well as fashion. Even American women's high-wasted dress styles harkened back to the classic chiton dresses worn by the Ancient Greeks (Fairbanks and Bates 1981).

Not surprisingly, these classical influences affected furniture design. The light, sleek, and highly polished veneered style of the late 1700s was starting to be replaced by acanthus leaves and other classic ornamentation, combined with the deeply carved wood influences of the French Regency furniture. While furniture in this period continued to be designed by the craftsmen who built it, this era was the first where architects began to regularly design furniture to match their building designs.

One of the first U.S. architects to champion the reinvention of the classic styles was Benjamin Henry LaTrobe (1764–1820). In addition to the churches and other public buildings designed by LaTrobe, he was called upon by First Lady Dolly Madison in 1809 to design the "Oval Drawing Room," today known as the Blue Room. For the Madisons, LaTrobe created 36 chairs, as well

as 4 window seats and 2 couches. Combining both Greek and Roman elements, the gilded chairs were fashioned after a Greek *klismos,* while the couches and window seats were based on the Roman *triclinium* (see http://www.whitehouse.gov/history/whtour/blue-suite.html).

Although LaTrobe's designs and the styles presented in various publications were influential, their intricacies and ornateness were more than the general American public could afford to purchase or build. So Americans simplified the style, making the forms heavier and less detailed than the Classical styles on which they were based (Fairbanks and Bates 1981).

But it was not just the ornamentation and wood tones that changed. The shapes of the major furniture pieces evolved, as well. Just as LaTrobe had based his White House chairs on Greek *klismos* chairs, so, too, did other furniture designers take cues from classical influences. Chair and table legs were simplified to emulate sabers, and chair backs morphed to an uncomplicated curve. Tables, plant stands, and chairs also sported Greco-Roman pillars topped by brass capitals and supported by brass-jacketed feet. This period also saw furniture feet shaped as simple animal paws, often made from brass, as well as water-leaf carving with reeding (Fairbanks and Bates 1981).

One of the most prominent makers of this style of furniture, often called English Regency, was Duncan Phyfe, a New York City–based furniture maker who opened shop in 1792 and continued to produce cabinets, tables, chairs, and other furniture until 1847. Although part of the traditional Classical furniture line, some furniture historians considered Phyfe's furniture to be a distinct substyle that originally ran from 1801 to 1825, but that still persists today in its many revivals. Phyfe's furniture was noted for the high quality of both the mahogany

Greek and Roman Furniture Antecedents

LaTrobe and others based many of their furniture designs on Greek and Roman antecedents. The couches and window seats Latrobe designed for the White House were based on a Roman *triclinium,* a U-spaced dining area formed by three couches with inclined seat backs so that diners would be reclining while eating.

This era's version of *Klismos* chairs (pronounced KLIHZ-mos) had wide top rails, about twice as high as the back supports. The top rails curved to the front, the back supports curved from the top rail forward to the seat, and all four legs tapered to the ground while curving away from the seat. They were decorated with a variety of Greek-inspired features including anthemia (clusters of honeysuckle or palm leaves), arabesques (intricate patterns of animals, leaves, etc.), and special carved or molding details such as rosettes, palmettes, and astragal (resembling a string of beads) molding. Chair backs were often made of caning.

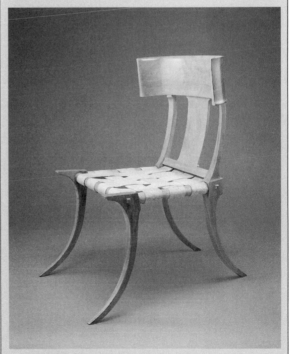

This Klismos chair at the Met is very similar in design to those of Latrobe. Metropolitan Museum of Art/Art Resource, NY.

he used as well as his craftsmanship in executing the designs. Although many of Phyfe's pieces were based on early European design books, such as *London Chair-Maker's* and *Carver's Book of Prices for Workmanship* (1802 and 1808 editions), his firm grew to be one of the largest in the United States, having as many as 40 employees when his peers had shops of 3 to 12 employees (Naeve 1998).

Early Victorian Period (1830–1850)

By the 1830s, American furniture designers were thought to be national figures, especially in Philadelphia, Boston, and New York, and they were helping lead American and European furniture styles on another evolution. Unlike the preceding style, whose large, heavy features were clearly masculine, this new evolving style, known today as Early Victorian, was decidedly feminine. It was smaller in scale, and often was very delicate, both in structure and decoration. Surfaces were no longer hard, but predominantly soft (Fairbanks and Bates 1981).

Still, this late Classical Revival and early Victorian style continued to share some Classical features, and, as did early Victorian architecture, some early Victorian furniture also included Gothic details. One substyle during this time is now called the French Restauration style. From the classics, its chairs were also based on the Greek *klismos,* but had curved crests, splats resembling urns, and more complexly shaped front legs. Tables had heavy scrolled feet and single pedestal supports, and tops were hinged to fold. Hall tables often had white marble tops, and all types of furniture might have incorporated small Egyptian touches such as lotus, circles, and ormolu (a gilding technique). Duncan Phyfe was also one of the most prominent makers of furniture in this style (Naeve 1998; Payne 1989).

Another substyle of this Early Victorian furniture period is the Gothic Revival. Perhaps even more popular than the French Restauration style, Gothic Revival furniture incorporated all of the attributes found in Gothic Revival houses: rosettes emulating tracery, trefoils and quatrefoils under lancet, and roman and ogee arches accented by finials and drops. Dining tables, chairs, couches, dressers, etageres, beds, bookcases, and other pieces were all created in Gothic Revival form. Early pieces (circa 1830) were often delicate, with slender legs, arms, and back supports, and decorated with intricate carved patterns. Later pieces (circa 1850), especially in bookcases and other large items, where much heavier and often inlayed.

Alexander Jackson Davis deigned Gothic Revival furniture for his Gothic Revival creation Lyndhurst. Other popular promoters of the style include A. W. Pugin and Robert Conner, who both published books on the topic. Two examples of these were Pugin's 1835 *Gothic Furniture in the Style of the Fifteen Century* and Conner's 1842 *Cabinet Maker's Assistant* (Naeve 1998).

Mid-Victorian Period (1850–1870)

The Gothic Revival substyle continued through the mid-Victorian period, ending circa 1860. Midway into the nineteenth century, another style, known as the Rococo Revival style, began to dominate American furniture. With simple

lines and decorations featuring nature designs such as leaves, vines, fruits and birds, this style was popular with the middle as well as the upper classes, both of which were becoming keenly involved in the trend toward naturalism (Fairbanks and Bates 1981).

The most noted designer of this mid-Victorian Rococo Revival furniture was John Henry Belter (1804–1861), who, from 1847 to1860, patented four techniques to saw, steam bend and laminate rosewood in 1847 and 1861. Belter's processes allowed more intricate carvings because the laminated wood was considerably stronger. Unfortunately for Belter, despite the fact that he held patents for his processes, they were copied by a variety of manufacturers (Fairbanks and Bates 1981; Payne 1989).

Known during its time as Modern French, Rococo furniture popularized furniture items such as "tete-a-tetes," chairs with upholstered "balloon" backs, and love seats. It is best identified by its extensive use of wood curved or carved (or iron cast) into "S" and "C" scrolls and nature motifs including flowers, animals, and fruits. Rococo pieces also commonly had cabriole legs (Payne 1989).

Although not as popular in the United States as it was in England, another substyle during this mid-Victorian period was the Elizabethan style. Starting circa 1830 in England and 1850 in the United States, Elizabethan pieces were recognizable by their turned legs, braces, and other components. Most of the turned pieces were done in a variety of spiral patterns, but bead-like "bobbin and ball" and other patterned turnings were also used. The latter were found on the less expensive versions of the style advocated by Andrew Jackson Downing as compatible with his middle-class cottages. Both types of Elizabethan furniture were popular for needlepoint designs on the chairs, which could be handmade (Naeve 1998; Payne 1989).

Second Empire Furniture (1860–1880)

As this revival era was ending in 1860, another furniture style was beginning. The French Empire era, which inspired magnificent, ornate architecture, also inspired its own furniture style. From the simplified, Greek-based furniture, designers and manufacturers moved on to the design of much more grandiose furniture. The small, almost subdued animal-based furniture was replaced by domineering animal paws and even legs; as well as swans, wreaths, and other plant-based shapes; and even human figures. Much of this was also done in brass or gilt on the more expensive pieces.

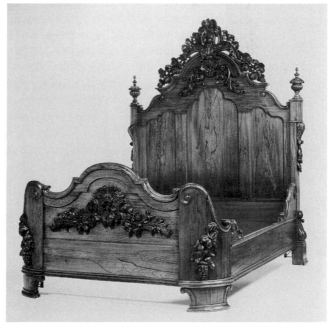

American carved rosewood double bedstead. Peter Harholdt/Corbis.

And it wasn't only furniture legs and feet that became ornately decorated. To avoid any jarring features, every component of a piece of furniture was designed and manufactured without any sharp geometric shapes. Much of the furniture was also painted or gilded in an attempt to evoke a more refined, austere presence. Plain or painted wood surfaces were also adorned with quilled ink images or painted or gilded stencils. To preserve the largely hand-crafted artwork, a clear coat or more of varnish was applied to the furniture (Fairbanks and Bates 1981).

Another very common painting practice involved faux painting. Because many of the evolving middle class could not afford to purchase furniture and other decorations made of exotic materials, furniture, mantles, and doors were frequently painted to look like ebony, mahogany, or rosewood as well as stone or metal materials such as antique bronze and marble (Fairbanks and Bates 1981).

Ongoing Furniture Styles

Throughout 1821 to 1860, the less wealthy Americans were not able to purchase full sets of the new, in vogue furniture designs. Instead, they were making due with vernacular furniture as well as eighteenth century furniture and designs that remained popular through the revival years. The three most enduring of these styles were Queen Anne, Chippendale, and Windsor. Various ethnic and religious groups, such as the Shakers, also continued to produce their own traditional designs.

LIGHTING

Another major influence on homes in this period was interior lighting. Prior to the invention of the various incarnations of lamps, the only lighting available at night was from candles, either in individual candlesticks, or in wall-hanging sconces, in tabletop candelabras, or suspended on chandeliers. This limited the amount of after-dark activity that could take place in a home. During this period, lamps were being refined and began slowly replacing candles. This was especially true in the homes of wealthier Americans, where it was quite common to find Asigle astral lamps on tables and Argand mantel lamps by the end of the 1850s (Moss 1988).

Grease Lamps

In addition to candles, throughout the first half of the nineteenth century, grease lamps were very common. They were open bowls, usually with some type of spout in which to lay the wick and a handle to carry the lamp while it was burning. The bowlshad three primary shapes: oblong, saucer, and chalice cup, and may or may not have had spouts or wick holders. On rare examples, there were holes for three wicks. The wick used in lamps without wick holders was usually just a piece of rag soaked in oil. Often the handle was looped, and on an oblong bowl with a spout, this handle gave the lamp an Aladdin's Lamp appearance (Cooke 1984).

Designed to burn common household waste grease or other animal fats, most were made of wrought iron, although pockets of locally made redware

and stoneware versions were produced in the German areas of Pennsylvania, Ohio, North Carolina, and Tennessee. Pottery lamps were made in glazed and unglazed variations. In both the iron and pottery versions, the lamp might also be affixed to a three- to six-inch stand, or simply placed on a wooden or iron stand (Cooke 1984).

Later versions of the grease lamp mode included the Betty lamp, which functioned in a similar manner, but had an integral wick holder that forced any dripping grease back into the well. Legend has it that the name "Betty" comes from the fact that this new style lamp was originally referred to as the "Better" lamp. Betty lamps were also produced in pottery and iron versions (Cooke 1984).

Neither type of grease lamp was alluring, however. They were designed merely to be functional. Unfortunately, they weren't all that functional, either. The light produced by grease lamps was minimal, and neither the smell of the burning grease nor the smoke it created was attractive. This set the stage for immediate acceptance of a truly better lamp.

Whale Oil Argand Burner Lamps (1800–1840)

The first major breakaway from candle, torch, and grease lamp lighting occurred circa 1783 (cited dates range from 1780 to 1784, but two give 1783) when Swiss inventor Francois-Pierre Ami Argand created what is known as the Argand lamp. This was the first device to allow adjustments to the amount of light given off, and Argand's lamp design rapidly spread in Europe and then later in the United States (Cooke 1984; Moss 1988).

Although based on the same type of oil as simpler oil lamps of the day (it could burn "colza" vegetable oil or whale oil), Argand's oil-burning lamp burned brighter and could be dimmed or brightened based on the user's needs. This was accomplished by the addition of a glass chimney, a modified wick, and burner adjuster. The glass chimney drew air up and away from the flame, creating a better draft as well as protecting the flame from errant cross breezes. The burner adjuster allowed the wick to be raised and lowered, adjusting the flame. More importantly, the wick Argand used was hollow, which brought more air to the flame, and hence burned brighter; the equivalent of 10 candles (Cooke 1984; Moss 1988).

The lamp was not only more functional, it was cleaner to use. It did not produce dripping wax messes that often marred the beauty of a home's furnishings, nor did it smoke or smell as much as grease lamps. All of these advantages led to its unprecedented adoption by affluent homeowners in their main living areas before the beginning of the nineteenth century, including such prestigious homes as Washington's Mt. Vernon (Cooke 1984; Moss 1988).

As is often the case with technological leaps, the new Argand lamps needed a higher quality whale oil to burn correctly. This need for increased quality coupled with the rising demand for whale oil, caused the cost of the oil to skyrocket. In 1827, sperm oil sold in New York City for 66 cents per gallon. In Boston in 1835 it was up to 84 cents, and by 1850 it cost $1.20. By 1852, in just 25 years, it had more than doubled to $1.50 per gallon. This led to a relatively low popularity and use of the better lamp in less affluent homes (Cooke 1984; Moss 1988).

Where adopted, however, Argand lamps became an integral part of everyday life. The family congregated around a single lamp placed on the parlor table, where they could play games, sew, read, or simply talk after dark. Rather than using candles to augment the central light, smaller Argand lamps were set on brass or cast iron wall brackets (Moss 1988).

Although they were the center of attention in a home, early whale oil lamps still were not overly attractive. They were made from a variety of materials, including glass (both pressed and blown), as well as an array of metals including brass, pewter or tin. The base of the lamp held a font for the oil and a burner set on top of it. Inside the burner was one, or sometimes two or more, wick tubes. The earliest lamps had rather short wick tubes so that the flame could keep the oil in the font liquid enough to continue to draw into the wick (Moss 1988). While not beautiful, these lamps were functional.

Solar Oil and Lard-Burning Argand Lamps (1840–1850)

In the early years of the nineteenth century, inventors continued to enhance the design and functioning of the Argand oil lamp. By the 1840s, these industrious developers had refined the placement of the oil fonts to reduce shadows and had created a mixture of lard and oils that provided superior lighting for a much lower cost. This new type of lamp is commonly referred to as an Astral Solar lamp.

The first change on the way to the new lamps was in the design of the fonts. In original Argand lamps, the font was to the side of the light, thus producing shadows. In the Astral lamp, the burner is set on the reservoir, which is often rounded to minimize shadowing. Patented in France in 1809, Astral lamps derive their name from the French word for starry, so named because the light was above the lamp, as star light is above the earth (Moss 1988).

The progression from Astral to Solar came in the 1840s when Astral lamps were modified to burn with a much less expensive blend of lard, lard oil, and fish oil. Because this new fuel tended to thicken and harden, to properly burn this new mixture the shape of the lamp and much of its internal working needed to change. A variety of approaches were used to keep the oil flowing. Some lamps used small pistons to force the fuel into the burner. Others used mechanical springs to accomplish the same thing. Still others contained an innovative system of wires that transported the burner's heat byproduct to the oil reservoir to keep the oil in a more fluid state. In another effort to keep fuel flowing smoothly, the reservoir was often shaped like an inverted pear (Cooke 1984; Moss 1988).

The solar lamps generally had a flat wick to draw fuel as well as distribute and stabilize the flame. As compared to other lamps of the time, and in keeping with its name, the solar lamp provided a sun-like brilliance. The light was so bright that it was common for users to put paper over the glass shades to diffuse the light. This was one of the first uses of paper shades on lamps (Moss 1988).

Once this cheaper fuel was invented, American demand for lamps skyrocketed. Throughout the 1840s, lamp manufacturers grew in both size and number. Two of the most dominant companies were located in Philadelphia. The first was Cornelius and Company, founded in 1783 by Christian Cornelius, a silversmith. By the mid-1820s, Cornelius had begun making lamps and

chandeliers. His son Robert joined the company in 1831, and the corporate name was changed to Cornelius and Son. Circa 1840, the name changed again to Cornelius and Company. Cornelius patented a solar lamp design in 1843, and by that time was the largest lamp manufacturer in the United States (Cooke 1984; Sherman 2000).

The second Philadelphia-based producer of solar lamps was Archer & Warner, founded by Ellis Archer and Redwood F. Warner (Moss 1988). In later years, this firm became known as Archer, Warner, Miskey, and Company and continued to be a dominate lamp vendor well into the twentieth century. It spun off into several competing lamp manufacturers, as its enterprising employees left to start their own companies (Moss 1988).

A later arrival was Menden Britannia Co. in West Menden, Connecticut. Founded in 1852, they produced lamps as well as candlesticks (Cooke 1984).

One of the developments spawning this rise in the manufacture and use of solar lamps was the ability of factories to mass-produce the lamps' brass castings by the 1840s and 1850s. This led the way for producing lamps in an urban location and selling them to home owners all across the country (Moss 1988).

Starting circa 1850, more volatile fuel sources were introduced for lighting. Commonly called burning fluid, this new fuel combined turpentine with alcohol, both of which could be produced inexpensively and locally throughout the country. This new fuel burned clean, with a bright white flame, but its volatile nature was a severe drawback. Unlike the blended lard-based oil, burning fuel sometimes led to fires or explosions. To limit some of this potential danger, burning fluid lamps were designed and manufactured with much longer wick tubes to separate the burner from the fuel reservoir. Still, many Americans were hurt and even killed simply by dropping or overturning the lamp. Despite this drawback, by the late 1850s, Philadelphia was producing more than a million gallons of burning fluid per year (Moss 1988).

Kerosene

While many were switching to burning fluid for interior lighting, another evolution in lighting fuel was beginning. Discovered contemporaneously by Abraham Gesner and James Young, kerosene would take the nation by storm. Around 1846, Gesner, a Canadian geologist, began experimenting with a coal distillation process that produced an oily substance he dubbed "kerosene," from the Greek words *keros* meaning wax and *elaion* meaning oil. Convinced that this new oil would make a fine lamp oil, he later patented his process and went on to found a New York City–based production company call the North American Kerosene Gas Light Company (Moss 1988).

Young's process, dating to about 1850, used standing oil as its raw material, but also produced kerosene. Both processes increased demand for lighting fuel and prompted entrepreneurs to search for more reliable oil sources. In 1859, Edwin Drake drilled the first producing oil well in the country in Titusville, Pennsylvania, which led to an enormous increase of oil rigs and refineries across that section of the state (Tarbell 1904). The newly discovered and refined oil was easily distributed nationwide on the growing web of railroads.

By the end of 1859, refineries were churning out nearly 25,000 gallons of kerosene per day. Once kerosene became readily available, the traditional lamps

were transformed into new kerosene-burning ones. All that was required was the replacement of the old burner. These modified burners used flat wicks and had a small wheel to allow users to regulate the height of the wick and flame. As with the earlier lamps, kerosene lamps were placed on the centers of tables and in iron or brass wall sconces. They were also hung from the ceilings in kitchens and dining rooms, and some of these hanging lamps became very ornate as the country moved into the Victorian Era (Moss 1988).

Gas Lighting

While gas lighting would become much more popular after the Civil War, it got its start in American homes during this revival period. Natural gas produced from coal had been available in parts of Europe in the late 1700s, but the harnessing of manufactured natural gas in the United States did not start until the 1800s. The first patent for the process of manufacturing gas was issued in 1810 (Rushlight), and in 1816, Baltimore founded a gas lighting company and became the first U.S. city to be lighted by manufactured gas (Moss 1988).

After the successful lighting of Baltimore, cities around the country, especially on the East Coast, scrambled to create their own gas plants to light their streets. Once the streets were lighted, the citizens clamored to move the lights indoors. By the 1840s, after the lamp manufacturers were able to minimize the smoky and smelly byproducts of gas burning, home owners readily adopted this new fuel (Moss 1988).

Gas was used primarily to light chandeliers and other hanging lamps in entryways and parlors/dining rooms, but it also was used in wall sconces in hallways or gathering rooms, and, in grander homes, in ornate brass or iron lights mounted on stairway newel posts. Chandeliers, also known as gaseliers after the 1840s, often contained a series of weights and pulleys that allowed them to be stored near the ceiling, then lowered over a table or other piece of furniture as needed. An additional feature on some gaseliers was a hose designed to connect to a special gas table lamp, allowing the gas to power the table lamp when it wasn't powering the chandelier. This was not common, though, and nongas table lamps continued to be used for portable lighting (Moss 1988).

Early gas lights were utilitarian in design, but as they evolved, they became much more ornate. This was especially the case with newel post lights, which, true to the era, were often representations of Greek and Roman gods, especially Venus, as well as other mythical creatures. Lights also depicted Christopher Columbus and other renowned people associated with American history.

Most lights were made of brass or bronze. They also were designed to match the furniture trends of the period. While some had plain arms, columns, and bobeches, others were decorated with hundreds of prisms hanging off of the arms and bobeches and strings of prisms extending from the canopy to each arm. The prisms helped to enhance the light by reflecting it off the burners. Rococo-styled chandeliers had arms covered with the intricately cast leaves, fruits, and vines consistent with this style and matching leave-shaped bobeches, finials, and feathers. Their circular etched glass globes were also patterned with vines. Gothic gaseliers had arms notched with quatrefoils, diamond-shaped cut crystal pendants with quatrefoils, fleur-de-lis finials, feathers shaped like pinnacles, and ogee-arched canopies.

Bringing the gas to these lights caused problems, though. Gas was brought from the central plant through subterranean gas mains, then along smaller pipes into the home. Pipes then had to be run through the walls and ceilings in the home to the lighting fixtures. In existing homes, this often meant that walls needed to be removed and then rebuilt. The lights also needed a valve on the pipe to regulate the gas flow.

While the light provided by the new gas lamps was superior to that of the older fuels, there was a drawback to gas lights. Older lamps were portable and could be moved to wherever the resident needed light, but gas lighting required permanent fixtures. This affected not only lighting use, but furniture and room functions as well.

Prior to the installation of gas, furniture was multifunctional. It would be placed near walls when not in use, then, when needed, moved close to the windows for light. Furniture that was constantly in motion had to be relatively small and light weight so that a single person could move a piece as needed. Fixed lights eliminated much of this

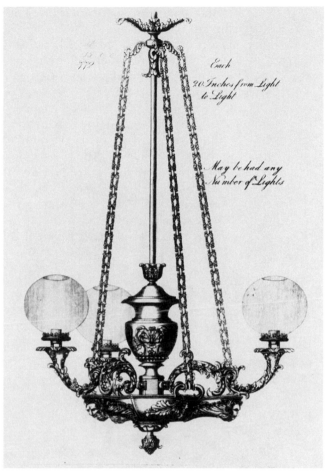

Chandelier for gas lamp, highly ornamented, ca. 1830–1850. Courtesy of the Library of Congress.

need for moving furniture and allowed it to become larger, heavier, and more stationary. Gas lighting also changed where and how furniture was arranged. This was especially true of tables, which moved to the center of the room under the chandelier. To minimize fire threats, chairs and other upholstered furniture were often moved away from gas fixtures (Moss 1988).

FABRICS IN THE HOME

Fabrics were used to decorate American homes in a variety of ways during the revival period from 1821 to 1860. Primary uses included wall hangings, drapes, and furniture upholstery. Their use increased dramatically from 1821 to 1860, largely because of improvements in manufacturing technology, but also due to the improved transportation infrastructure.

Another influence on fabrics in the home came from the increasing number of design books available in America. As did the popular architectural books of the time, these interior design books included directions and detailed

illustrations of suggested interiors. The first American style guides were published in the 1820s and 1830s. These included *Domestic Duties or Instructions to Young Married Ladies,* published originally in London and released in the United States in 1829. Another influential book in all areas of the home was J. C. Loudon's 1833 *Encyclopaedia of Cottage, Farm and Villa Architecture and Furniture.* In addition to furniture suggestions, Loudon offered fabric design suggestions for a wide range of incomes (Nylander 1990). These books paved the way for acceptance of the changing production and use of fabrics.

The first, and perhaps most dramatic, change in fabrics was in the weaving process, guided by two major inventions. In 1785, a British clergyman Edmund Cartwright, patented a water-powered loom. He later refined the loom to run on steam. While his specific looms did not work as effectively as hoped, many others improved on his work and perfected automated looms by the 1820s.

Also important to the weaving process was a new approach to weaving patterns. In 1801, Joseph Marie Jacquard, a French silk weaver, invented a punched card mechanism that would automatically weave a highly complex pattern. This allowed the weaver to concentrate on the weaving process without worrying about creating the design. This also gave weavers the ability to make exactly the same pattern every time, because the pattern was stored in the cards. Not only did this revolutionize the textile industry, but it would influence music (player pianos) and, at the end of the nineteenth century, led to the punch cards used in the first computers.

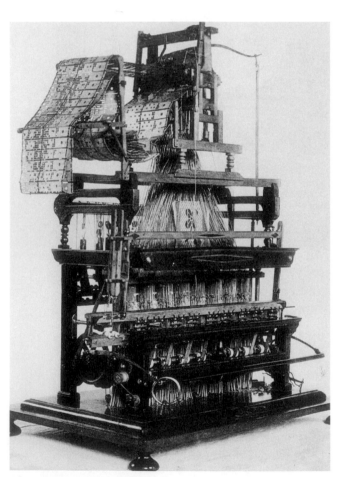

The Jacquard Loom revolutionized the fabric industry, and, with the punched cards shown in this photo, later paved the way for modern computers. Courtesy of the Library of Congress.

While Cartwright was developing his power loom, Joseph Bell was developing an engraved copper rolling device to print one- to six-color patterns on fabric. Bell had originally patented a copper plate printing mechanism in 1770, and in 1785, he created a print roller. Bell's original device did not print multicolors as expected, but after later refinements, printing could be done in multiple colors by engraving each cylinder only where each color was to appear. Printing cylinders increased production to 10,000 yards per day.

Fabric Decoration (1820–1850)

All of these changes led to a significant increase in the use of

fabrics in the home starting in the 1820s. Complicated silk-, wool-, and cotton-based designs brightened the rather drab décor of earlier eras. Wallpapers also brightened and embellished rooms, with the most popular patterns depicting natural elements, such as birds, flowers, coral, seashells, and ivy. Shell and floral designs were commonly striped, and ivy was often drawn covering pillars or other architectural elements (Nylander 1990).

Bell's cylinder printing invention also allowed manufacturers to easily produce fabrics with monochromatic landscape designs. These were often scenes of important historical events, and might have been accented with small dot clusters. Faces of Presidents and other famous people were also common. Although the United States was developing its own cultural influences, European cities such as London and Paris were still major trendsetters for interior styles, especially as they related to fabrics during this period. Wealthier Americans commonly asked European acquaintances to ship them the latest raw fabrics as well as premade curtains and furniture covers (Nylander 1990).

In keeping with the classical influence on the exteriors of homes, Greek, Roman, and Egyptian designs also found their way to the design of curtains and drapes used during this revival period. Chinese and other oriental designs were occasionally found as well. One popular classically inspired window treatment was known as "Roman drapery" and consisted of deep swags intermingled with a series of deep, vertical, conical, or cylindrical pleats.

Classical designs such as this were used starting in the early 1800s, and by the 1820s, more modern European styles were becoming popular. These window treatment styles included Louis XIV and Louis XV, as well as Gothic and Elizabethan, and generally featured sheers at the windows, covered on the sides by solid-colored, heavier fabrics such as velvet layered over the sheers (Nylander 1990).

Valances of a variety of shapes often topped the drapes. Stiff, flat valances became stylish in 1838, although French-influenced swag valances remained popular as well. Rings made of brass or wood were used to hang the drapes off of wooden, or sometimes brass or iron, poles. Much as is done today, the rings were attached to the backs with hooks and then fed over the rods (Nylander 1990).

Straight hanging panels with straight or shaped valances layered over the panels were popular in houses of middle-class America. In 1849, this style was depicted in the fashionable *Godey's Lady's Book* and in *Peterson's Ladies National Magazine* in 1860. While the wealthier Americans, and many of the middle class in urban areas, followed the window treatment trends in these and other books, many of the middle-class Americans living in rural areas chose not to have window treatments at all. Some, on the other hand, selected much simpler designs, often just a piece of white cotton fabric swagged to either the left or right side to allow the natural light to enter during the day (Nylander 1990). In the evenings, if desired, they could let down the swag for privacy.

Another approach for privacy was the use of roller shades. Available to the general public around 1825, the shades were often referred to as Holland shades as they were often made from an unbleached linen known as Holland. They were also available in undecorated white cotton, or sometimes painted. If painted, the design was commonly a landscape scene.

Just as draperies provided privacy and a barrier to cold emanating through windows, closed bed curtains were often used in bedrooms to shield sleepers

and keep them warmer. Although some were concerned with the negative health effects of bed curtains throughout the 1830s and 1840s, interior designers were still recommending their use. In northern areas of the country, bed curtains were made of heavy fabrics, while in the South, they were more often light, made of gauze or bobbinet (Nylander 1990). Bed curtains, drapes, and chair covers were often done in matching fabric to express the homeowner's taste and status (Cromley 1991).

As noted previously, in addition to fabrics on beds, fabrics were being employed on other furniture pieces. Chairs and couches were increasingly upholstered or covered with fabric. The most common upholstery fabric was horsehair because it was durable. However, it was also scratchy and hot, especially in the summer or year round in the South.

For these reasons, furniture upholstered with horsehair or wool was often slipcovered with plain white cotton. This served three purposes: covered furniture was cooler, it was more comfortable, and, equally important, it was protected from common household accidents that could otherwise ruin the expensive furniture. By the mid-1830s, slipcovers made of white cotton striped with green, blue, or red were also being used (Nylander 1990).

Tables, too, were being decorated with fabrics. It was quite common to find the center parlor table covered with a plain woven cloth, or, on occasion, a printed woven cloth. Many times, these pieces were not manufactured, but had been sewn by the females in the household (Nylander 1990).

Fabric Decoration (1850–1860)

As the early Victorian Era began, the sumptuous nature of the times was reflected in the home decoration fabrics. Silks continued to be well-liked, but satin, velvet, damask, and chintze also became popular. The demand for attractive interior designs grew even larger in the mid-1800s, which led to new service businesses specializing in interior design. The number of furniture warehouses also rose, as both designers and homeowners developed an interest in furniture shopping (Nylander 1990).

Much of this increased fascination with interior design can be traced to the advice columns and books of the time, which were advocating for women to become more involved in decorating. For middle-class women who could not afford interior designers, articles in popular magazines explained how to make homemade window and bed curtains as well as other items for the interior (Nylander 1990).

Some of these guides included *The House Book* (1840) by Miss Eliza Leslie and *Godey's Lady's Book,* a monthly magazine edited originally by Sarah Josepha Hale and published for 62 years starting in 1830. *The House Book* gave instructions on a variety of domestic activities, including the proper way to make a bed. Mary Todd Lincoln is said to have diligently followed the advice in this guide. In *Godey's Lady's Book,* Hale provided similar advice, as well as specifics on color schemes and other interior design tips.

Women in the 1850s who followed the instructions in these books on how to make draperies by hand found it to still be labor-intensive. The amount of labor involved in hand sewing would begin to change as more people purchased sewing machines. Although invented in 1846 by Elias Howe, sewing

machines did not reach the American home in masses until well after the Civil War.

The styles for these homemade window treatments, as well as for manufactured ones, had not changed from the earlier decades: heavy, layered side curtains over curtain sheers, often all topped with valances. Valances continued to be found in a variety of styles, including Greek and Gothic as well as Moorish or Jacobean. The centers of Gothic and Moorish valances were sometimes attached above the window casings to create an arched affect (Osband 2000).

The materials used for the drapes were also largely unchanged. Damasks of wool, velvets, and silks were found adorning windows in public rooms of the home such as parlors or drawing rooms. These heavy fabrics were also used in dining rooms and libraries, as were rep and moreen fabrics. Rep fabrics were tightly woven, with obvious ribs running crosswise. Moreen fabrics were made of heavy wool and cotton, commonly embossed with intricate designs formed by pressing fabric over a hot, engraved brass roller.

Evolving Leisure Time

As the middle-class professions evolved in the early to mid-1800s, both men and women were finding they had free time to devote to hobbies and other leisure activities. One of the most popular hobbies for women was *Fancywork*. The term applied to embroidery and needlepoint done with a variety of materials including traditional cotton thread and wool yarn, but also with decorative glass beads, shells, and seeds, as well as more esoteric materials such as feathers and human hair.

Fancywork was a common pastime of the wealthy in the eighteenth century, but by 1840, it had become the rage among middle-class American women. Fueling this interest were the same home-oriented magazines that are credited with spurring the general interest in home decoration. The most prominent were *Godey's Lady's Book* and *Peterson's Magazine*, both of which printed fancywork patterns as well as illustrations of completed projects. Fancywork creations decorated revival era homes, giving them the personal touch of the ladies of the house. Common uses for finished pieces included two-dimensional objects such as wall hangings and chair cushion covers and pillows, but three-dimensional wreaths, wall pockets, and the like were also created (Bercaw 1991).

Regardless of fabric type, these drapes were hung in layers of two or more contrasting colors, just as they were in earlier decades (Nylander 1990).

In 1846, a special loom was created that could produce curtain-sized lace quickly and inexpensively. This led to a transition from the use of sheer undercurtains to lace ones in the 1850s and 1860s. Lace known as dotted Swiss was another popular covering, especially on the windows in exterior doors and on side lights (Nylander 1990).

It was also during the 1850s that homeowners first used curtains on kitchen windows. These curtains were primarily simple muslin panels with narrow top casings. Sometimes the fabric was Swiss dotted, and occasionally checked Gingham (Nylander 1990).

In bedrooms during this decade, fabrics became more popular. Chintzes in a variety of bright colors covered the windows of the bedrooms in many homes, although some homeowners continued to use heavy wools and silks and matching bed curtains. Jacquard-patterned coverlets graced many beds and continued to gain popularity as production moved to America, in states such as New York, Ohio, Illinois, Indiana, and Pennsylvania (Nylander 1990).

Upholstering of chairs, sofas, and stools was also growing in popularity in the mid-nineteenth century. Horsehair continued to be the most common covering, and it was available plain or patterned. Silk, wool damask, and moreen was used as well, but to a much lesser extent. A new trend was the inclusion of

needlepoint upholstery, especially on chair seats. Magazine articles of the time published a variety of designs and complete instructions on how to create the handmade covers (Nylander 1990).

FLOOR COVERINGS

Just as late eighteenth- and early nineteenth-century inventions revolutionized fabrics, there were also inventions that revolutionized floor coverings, especially in the area of carpeting. Advances in wool spinning prior to 1830 allowed for the growth of the American carpet industry. Erastus Bigelow opened a mill in 1825 in Clinton, Massachusetts, and by 1839, invented the power loom that revolutionized the carpet-making industry. By the mid-nineteenth century, an increasing number of middle-class Americans could afford factory-made floor coverings (Von Rosenstiel and Winkler 1988).

As in earlier years, wood floors made from soft woods such as pine were still the primary flooring medium, but the planks had decreased from sometimes more than one-foot wide down to four to six inches in width. It was becoming more popular to have hard wood floors, however, as well as a sturdier yellow pine (Von Rosenstiel and Winkler 1988).

To help protect the soft floors, the wood was often painted. In more affluent homes, plain canvas floor cloths covered wooden floors, and in some homes, the floor clothes were painted. The price of the floor cloths varied, based on the quality of the canvas itself as well as on how many colors of paint were used and how many layers were applied. The most expensive floor cloths were painted in patterns, stenciled, or printed (Von Rosenstiel and Winkler 1988).

Another type of floor covering in use, especially in less wealthy homes, was cotton matting. Placed near exterior doors, strong, somewhat rough, mats trapped dirt and other debris to minimize the amount of foreign material entering the house. More delicate mats were scattered around the house. In addition to cotton, these interior mats were made from braided wool, or occasionally sheepskin (Von Rosenstiel and Winkler 1988).

Only the wealthiest homeowners during this time could afford tiled floors. When used, the tiles were marble, or, in later years, ceramic, and placed in the entry hall, often laid in a checkerboard pattern (Von Rosenstiel and Winkler 1988).

Flooring 1820–1850

Starting as early as the 1820s, upper- and middle-class homeowners began to install carpets rather than floor cloths. The most common types of these early carpets were known as Brussels, Wilton, and ingrain carpets. Wilton carpets were a spinoff of Brussels carpets, and both were piled worsted carpets available in muted colors such as olive or sage green, cream, and mauve. The major difference between the two was that the pile on Wilton carpets was cut, while Brussels was looped. These carpets were quite expensive, as they were made by expert weavers at the modest daily pace of seven yards (Von Rosenstiel and Winkler 1988).

More affordable carpets, such as List carpets or Rag carpets, were popular in middle-class homes. In fact, Rag rugs were often woven by the homeowners out of discarded clothing and other fabrics. Another less expensive carpet

from this period was the Venetian carpet. Often striped in contrasting colors, it, too, was flat woven without a pile, which made it reversible (Von Rosenstiel and Winkler 1988).

The most common carpet during the 1800s, however, was known in the United States as ingrain carpet. Called ingrain because the materials were died before the carpet was woven, this carpet was also reversible, with the negative image on the other side. This helped the rug wear more evenly, extending its life. Ingrain carpets were also popular because of the intricate designs possible in the weaving process. Bright, detailed, geometric patterns made these carpets an attractive feature in the home. Most were bordered in complimenting patterns, while others kept the same pattern throughout. To protect the soft wood floors, wall to wall carpets were common, even in rooms with fireplaces. Because ingrain rugs were woven on 54-inch or smaller looms, ingrain carpets were pieced together to make larger rugs.

Although ingrain carpets were first developed in Great Britain, by the 1840s, U.S. mills were weaving more ingrain carpets than the country was importing. Mills were located primarily in New England, and many of the looms were powered by water. Venetian carpet was also available in America. Produced in widths of 18–36 inches, this reversible striped wool and cotton carpet was used on stairs, halls, or in servants rooms. This style of carpet was not as popular as ingrain carpets for main public rooms, though, because they could not provide the complicated patterns or colors of the ingrain carpets (Von Rosenstiel and Winkler 1988).

Very wealthy homes may have also had oriental or Suzani rugs. Oriental rugs were woven and hand-knotted, generally made with wool or silk. Suzani rugs were hand embroidered in silk over a linen background. Both were available in a variety of patterns including a central medallion pattern. They also usually had borders, although some of each rug type simply had a repeating pattern across the entire rug. If lower-income homes did have oriental or Suzani rugs, they were often used as wall hangings or as table cloths to preserve them.

Flooring 1850–1860

As the country moved in to the second half of the nineteenth century, little changed in terms of flooring types. What did change, though, was where the various carpet types were used. For instance, floor cloths (also known as oil cloths) continued to be used in homes in the 1850s, but were found less and less frequently in parlors and other rooms open to the public. Matting, too, was still in use, but was relegated to private rooms only (Von Rosenstiel and Winkler 1988).

Tiles were also in use and gained popularity in this decade. Ceramic tiles were available in a large number of colors such as blue, red, buff, and brown and had various shapes, allowing them to be laid in intriguing mosaic-like patterns. Because tiles were still very expensive they were used in very public spaces, primarily entrance ways, although in homes of the wealthy, they were also used in conservatories, libraries, and other retreat rooms (Von Rosenstiel and Winkler 1988).

Carpeting remained one of the most important interior design elements, and the majority of this carpeting was ingrain style. It is estimated that during

this decade, 80 to 90 percent of all carpeting being produced in U.S. mills was ingrain carpeting. Brussels and Wilton styled carpets were still in use, too, but primarily in the homes of the well to do. New styles known as Tapestry carpets were introduced circa 1840 and were created in a manner that allowed the use of virtually unending colors in the floral and leaf motifs common in this Rocco era. By century's end, tapestry carpets would replace ingrain carpets in popularity (Von Rosenstiel and Winkler 1988).

WALL AND CEILING ORNAMENTATION

The final type of decoration used in houses in the revival period from 1821 to 1860 was on the walls and ceilings of the rooms. The walls themselves were still made of plaster, and openings and other joining places were trimmed with wood or plaster to hide the joints. In the early 1800s, plasterwork decoration was often quite elaborate, yet by the 1830s and 1840s, it was replaced by much simpler designs. Medallions were still used in the center of various rooms, especially those that were more public in function, but they were less ornate. Uncomplicated plaster or wood cornices were also common (Winkler and Moss 1986).

Each room tended to be decorated differently, as it was thought that the room's function should be reflected in the color scheme. Although common today, white was very uncommon during this time, whereas papered and painted walls and ceilings were ubiquitous.

Walls and ceilings of public gathering rooms such as drawing rooms and parlors were painted or papered in pale shades of "happy" colors such as apple green, pearl gray, or grayish pink. Dining room colors varied from household to household, but tended to be either restrained or the opposite; deep and bold. To meld the color scheme from one room to the next, hallways, stairways, and entryways were generally quiet and cool in their color.

Bedrooms, as nonpublic spaces, were generally decorated more to reflect the personalities of the occupants and were usually bright to maximize the limited natural and artificial light. If homeowners were wealthy enough to have the extra space for a library, it would have been painted a peaceful, restful color such as fawn.

Regardless of the function of a room, its ceilings were generally a lighter color than the walls, giving the room a larger, higher appearance. Wooden trim in all rooms was normally painted in darker contrasting, yet complimentary, colors, although occasionally it was left natural, or painted in a lighter color. It was very infrequent to find white paint on any wooden surfaces; this was particularly true of baseboards, which were often painted a very dark shade to hide accumulation of dirt and grime. If the room had cornices, they were often painted in subtle shades, different than those of the other trim. As with furniture, it was quite common to find doors and other woodwork, especially mantles, faux painted to resemble marble or exotic wood grains.

Paint

The multicolored, ready to apply paints we know today were not produced until the 1870s. In fact, paint options were rather limited prior to 1850. The colors that were available were based on natural colors including indigo and

orchid. After 1850, however, the coal tar produced from creating gas for lighting fuel found a reuse in a product known as aniline dyes. The first color produced in this method was mauve.

Paints based on tempera were also popular. They were less expensive to buy and could be applied to a variety of surfaces, including sand or lime walls as well as plastered ceilings and walls. These paints went by several different names, including kalsomine, distemper, and calcimine, but all were made in the same way. The color was produced from tempera, and then whiting and sizing was added to create an opaque paint.

Another common paint of the time was white wash. Similar to kalsomine, the namesake white color came from chalk powder mixed in water along with salt and lime. Unfortunately, because of its makeup, white wash was not very durable.

Wallpapers

The most common decoration in homes of this revival period was wallpaper. Although often viewed as a much later phenomenon, wallpaper began to be popular with interior designers in the 1840s. It had existed prior to this, but it was too expensive for everyday citizens to afford, as each piece was hand made with a very labor-intensive process. As with other papers, wall paper consisted of a ground pulp material, usually cotton, linen, or occasionally wool, that was suspended in a water solution to make a pasty-like substance. This paste was removed with screens, spread to a consistent thickness, then pressed. The flattened sheets were removed from the screen and allowed to dry.

To color the paper, plant, mineral, or other extracts were added to the pulp mixture prior to pressing. Very few colors were available except for shades of the rainbow, copper, brown, and black. The limited availability and expense of wallpaper started to change in 1799 when Nicolas Louis Robert developed a machine to make paper in a continuous roll. Dubbed a "Fourdrinier" after the Company Sealy ad Henry Fourdrinier who commissioned the design, the machine revolutionized paper making. The first Fourdrinier arrived in the United States in 1827.

Early wallpapers were used in much the same way as the faux painting of the time. Homeowners who could not afford the natural materials used wallpaper to emulate a variety of decorative architectural features such as columns and friezes, as well as simpler trims such as cornices, panels, and moldings. There were also wallpapers that simulated ashlar stone walls or other stone gray-colored patterns as well as those that looked like fabrics, including damasks and jacquards.

In keeping with the medieval practice of hanging tapestries on walls, another popular subject for wallpapers was nature scenes and landscapes. How natural the scenes appeared varied depending on the number of colors used. This, of course, also determined how expensive the paper was. It was not uncommon to see scenic prints in simple monochrome shades of gray, brown, or green.

In the United States, scenic wallpaper was especially popular in the South. It debuted in New Orleans in 1808, and appeared in Lexington, Kentucky in 1816. In 1857, when its use was advocated by *Godey's Lady's Book,* it spread rapidly nationwide.

Scenic wallpapers were 8- to 10-feet long and depicted both ground and sky. The scene was designed to start at the room's chair rail and then extend up to the ceiling. A portion of the sky could be cut off as needed to accommodate various ceiling heights. To create some variety in a room, these scenic wallpapers were sometimes sold in sets of 20, with each roll having a different scene.

Although scenic wallpapers were common, especially in the more public areas of a home, they were not the only designs available and in use. Striped wallpapers were also popular decorations for bedrooms and parlors. These stripes might have been simple vertical lines, or, more commonly, ribbons and geometric designs, as well as flowers and fruits. Rainbow papers, which combined light and dark shades of the same color to create a shadowy patterned effect, were also popular.

Just as wood trim was introduced in homes to hide wall and floor joints, giving homes a more finished, and hence, rich, look, wallpaper borders were often used to hide wallpapering mistakes. While adding to the cost of a room, using a border was cheaper than having to remove and discard improperly installed wallpaper. Borders, by the 1840, had thinned to approximately three inches wide.

CONCLUSION

As technology continued to improve from 1821 to 1860, the variety of furnishings and decorations increased. Amenities such as carpet and wallpaper, once limited to wealthy homeowners, began being used in homes throughout the United States. All of the amenities helped to develop a sense of "home."

Reference List

Bercaw, Nancy Dunlap. 1991. "Solid Objects/Mutable Meanings: Fancywork and the Construction of Bourgeois Culture, 1840–1880." *Winterthur Portfolio* 26(4): 231–247.

Cooke, Lawrence S. 1984. *Lighting in America: From Colonial Rushlights to Victorian Chandeliers.* Pittstown, NJ: Main Street Press.

Cromley, Elizabeth Collins. 1991. "A History of American Beds and Bedrooms." *Perspectives in Vernacular Architecture* 4: 177–186.

Fairbanks, Jonathan L., and Elizabeth Bidwell Bates. 1981. *American Furniture, 1620 to the Present.* New York: R. Marek.

Fennimore, Donald L. 1981. "American Neoclassical Furniture and Its European Antecedents." *American Art Journal* 13(4): 49–65.

Mattausch, Daniel W. 1998. "David Melville and the First American Gas Light Patents." *The Rushlight.* The Rushlight Club. Accessed online at http://www.rushlight.org/

Moss, Roger W. 1988. *Lighting for Historic Buildings: A Guide to Selecting Reproductions.* Washington, D.C.: Preservation Press.

Naeve, Milo M. 1998. *Identifying American Furniture.* New York: W.W. Norton and Company.

Nylander, Jane C. 1990. *Fabrics for Historic Buildings: A Guide to Selecting Reproduction Fabrics.* Washington, D.C.: Preservation Press.

Osband, Linda. 2000. *Victorian Gothic House Style.* Newton Abbott, Devon, UK: David and Charles.

Payne, Christopher, ed. 1989. *Sotheby's Concise Dictionary of Furniture.* New York: Harper and Row.

Sherman, Mimi. 2000. "A Look at Nineteenth-Century Lighting: Lighting Devices from the Merchant's House Museum." *APT Bulletin,* 31 (1): 37–43.

Tarbell, Ida M. 1904. *The History of the Standard Oil Company.* New York: McClure, Phillips and Co.

Von Rosenstiel, Helene, and Gail Caskey Winkler. 1988. *Floor Coverings for Historic Buildings: A Guide to Selecting Reproductions.* Washington, D.C.: Preservation Press.

Winkler, Gail Caskey, and Roger W. Moss. 1986. *Victorian Interior Decoration: American Interiors, 1830–1900.* New York: Henry Holt.

Landscaping and Outbuildings

As homes evolved, so did domestic landscaping and accompanying outbuildings. This chapter describes the types of gardens used during this period, any outdoor living areas such as patios and gazebos, as well as specialty buildings such as barns, outhouses, hop houses, and the like, commonly found in both rural and urban areas. It will also discuss regional differences in these constructs, especially in formal versus informal gardens and barn design.

LANDSCAPING AND DECORATIVE FEATURES

Before taking a look at specific attributes of the landscapes and decorative features associated with homes in the revival era from 1821 to 1860, it is important to review the general development of the relationship between Americans and their land. Unlike Native Americans who lived off the land and believed they were a part of it, most Americans saw their land as a tool to be used much as is a hammer.

Americans bought, sold, and claimed the land in a way that was totally foreign to the Native Americans. As noted in the chapter "Building Materials and Manufacturing," the first thing that most settlers in America did, whether it was the first settlers to the East Coast, or those moving to the West and Midwest during this revival period, was clear the land. With seemingly reckless abandon, they scarred the land by chopping down and burning trees, plowing fields, moving rocks, and, sometimes, even moving rivers and streams. And on this now cleared land, Americans then built their homes.

As the nation grew and cities developed, the gap between how people lived in rural areas and how they lived in the cities continued to widen. The relationships

with the land also began to change. In this age of reform movements, especially in the area of both physical and mental health, many began to understand that green, open spaces with plants and other wildlife promoted healthier people. By the time this revival period ended in 1860, a new profession had evolved focusing specifically on the art and science of landscape design.

This new profession was called landscape architecture, and the most famous landscape architect in the United States was Fredrick Law Olmsted (1822–1903), who started his practice in the late 1850s shortly before this revival period ended. His most famous commission, with his partner, Calvert Vaux, is New York City's Central Park, which they won in 1858. The pair went on to design more than 50 parks and several elaborate parkway systems, such as those in Buffalo and Boston.

Although Olmsted gets the bulk of the credit for this nationwide swing to greener cities and well-designed landscapes, he was greatly influenced by the work of Andrew Jackson Downing (1815–1852). Downing's father was a nurseryman, which likely sparked his interest in plants and landscapes. As noted in the previous chapter on styles of architecture, Downing was one of the dominant design book authors, yet his books emphasized not just the building itself, but its compatibility with the land, as well. The title of Downing's first book, *Treatise on the Theory and Practice of Landscape Gardening Adapted to North America*, published in 1841, portrays that interest in the land. He was a partner with Calvert Vaux from 1850 until his tragic death in the 1852 explosion of the steamboat *Henry Clay*. One of his last commissions was for the grounds at the White House.

Downing, Olmsted, Vaux, and the other new landscape architects shaped the developing country as much as the professional building architects had in the early 1800s, and together both types of architects gave the country a legacy still seen today.

GARDENS AND OTHER PLANTINGS

Although the wealthy had kept gardens for centuries, it was not until this revival period from the 1820s to the 1860s that the growing American middle class was both encouraged and had the time to engage in recreational gardening. Prior to this time, gardens were chiefly for sustenance and medicinal purposes. Vegetables such as corn, carrots, and so forth were grown in large enough quantities to feed the family throughout the year (by storing them in a root cellar or other storage area). Flowers and herbs were grown to be used in poultices, potions, or lotions for combating a variety of ailments ranging from high fevers to childbirth (Leighton 1987).

There were three main impetuses in the early nineteenth century toward recreational gardening. One was the discovery of and publications about the vast and varied collection of trees, shrubs, and plants native to America. From 1810 to 1813, a three-volume collection of books on America's rich botanical assets, authored by Francois André Michaux, was published in France. Titled *Histoire des arbres forestiers de l'Amérique septentrionale* in its French edition, it was released shortly after this in an English version called *North American Sylva*.

The next major survey took place when John Charles Fremont was hired by Andrew Jackson to survey the West for a variety of defensive locations. Fremont

performed five surveys from 1842 to 1854, adding to the body of knowledge about native botany. Fremont's reports, along with other important publications including Thomas Nuttall's 1818 *Genera of North American Plants,* Constantine Rafinesque's *New Flora of North America* (1836), and Joseph Breck's *The Young Florist* (1833) and *The Flower Garden; or Breck's Book of Flowers* (1851) helped give Americans an appreciation of their native plants and botany in general. Breck also influenced gardening by editing *The New England Farmer,* helping found the Massachusetts Historical Society, and launching the Breck's horticultural company in 1818. Breck's company is still one of the leading suppliers of bulbs and other plants (Leighton 1987).

The first true gardening book tailored for American gardeners was Bernard M'Mahon's 1806 *The American Gardener's Calendar.* In it, M'Mahon encouraged all Americans to do their part in beautifying the country by beautifying their own homes. Throughout the revival period from 1821 to 1840, other gardening books would follow. This new love of gardening led to the development of nurseries that sold trees and plants as well as those that simply sold seeds. Not surprisingly, the first nurseries were on the East Coast, but as the population spread west, the nurserymen followed (Leighton 1987).

The last driving force behind the rising interest in landscapes and gardening was the architectural and gardening design books published by Downing and others, as well as the women's books such as *The House Book* (1840) by Miss Eliza Leslie and periodicals including *Godey's Lady's Book,* both discussed in more depth in the previous chapter. Once Americans had caught the landscaping bug, they set to work in an almost rabid fashion using one or more of three typical garden styles as well as a variety of plant features.

Formal gardens of this revival era from 1821 to 1860 were very structured places. Most of them had geometric shapes for the beds and garden paths, and both the beds and paths were commonly outlined in boxwood. Popular layouts included circles, Greek and Maltese crosses, octagons, and ovals. Many of the more complicated gardens involved a combination of various shapes so that circles were surrounded by quarter circles, or the crosses were placed inside circles, or octagons contained triangles, or trefoils, and the like. The combinations were limitless. Regardless of the shape of the gardens, often there were fountains, bird baths, sundials, or large, flower-filled urns as focal points in the center.

Where space allowed, there were multiple areas of the garden, each with a different layout and different types of plants. Paths wound between these different areas and connected the garden to the rest of the yard. These paths in the garden were made from several different types of materials. They may have been grass, brick, slate, or cobblestone, but most frequently they were gravel. Paths in formal gardens were a part of the pattern, and hence were very geometric.

Formal gardens generally contained stone, cast iron, or wooden benches for resting and observing an especially attractive garden view. Arbors, trellises, and gates were also commonplace. They, too, were made of a variety of materials including wood, stone, and cast or wrought iron. These structures were intricately detailed, especially in Gothic Revival gardens, but also in other styles.

During this pre–air conditioning revival era, summerhouses were popular retreats. They may have been located at the end of a garden path, or they may

have not been in the garden, but in one of the yards. Summer houses were a favorite of Andrew Jackson Downing, and he recommended a rustic structure made from tree limbs and covered with vines. His book contained detailed instructions for building a summer house, and in one of his drawings, he shows a tree growing through the center of the structure.

There are many outstanding examples of formal nineteenth-century gardens open to the public today. The premiere garden in the Northeast is the splendid garden at the Gothic Revival Roseland in Woodstock, Connecticut. Based on designs created by Andrew Jackson Downing, this garden contains all the elements Downing recommended for the landscape (see http://www.historicnewengland.org/visit/homes/roseland.htm).

Rather than create formal gardens, some gardeners chose a more natural, picturesque approach to their plots. In these more informal spaces, the paths were typically curvilinear, as were the shapes of the beds. Informal gardens did not employ boxwood hedges, but rather let the differences in the plant life mark the beds. Southern gardens may have included palm trees for added visual interest.

Throughout these years, kitchen and medicinal gardens remained popular. Kitchen gardens provided the fresh herbs and small vegetables for the cook and were generally placed right outside the kitchen door. This eased the daily harvesting process. Medicinal plants were also grown in the kitchen garden, or, if ornamental, may have been included in the formal or informal gardens.

> ### Revival Era Gardenesque
>
> Many of the plants found in today's gardens were also common in the revival era gardens. Gardeners who cultivate these plants purely because of their historical merits are true to the spirit of John Loudon's Gardenesque movement. Loudon introduced the idea of Gardenesque in 1832 as his parallel to the Picturesque movement. According to Loudon, gardens should display their owner's horticultural knowledge as well as their gardening skills. He saw gardens as a work of art, geometrically designed and spotlighting specimen plants. The principles he espoused could be applied to gardens of any size, from tiny urban yards to majestic rural estates and on salaries of the lower class through the aristocracy. His own quarter-acre garden exemplified his beliefs.
>
> Loudon published several books during the revival years from 1821 to 1860. These included his oft-cited *Encyclopedia of Gardening*, released in 1822. Perhaps even better known is his 1838, *The Suburban Gardener and Villa Companion*. Loudon also wrote and published *The Gardener's Magazine*, which he published from 1823 until his death. When the family ran into financial difficulties, Loudon's wife, Jane, began to publish her own gardening books aimed at middle-class women. Her most popular book, *Ladies Companion to the Flower Garden*, released initially in 1841, came to the United States in 1843, published by Andrew Jackson Downing. She also was editor of a companion magazine to her husband's called *The Ladies' Magazine of Gardening*. After her husband's death, Jane published a more generic women's self-help book titled *The Lady's Country Companion; or How to Enjoy a Country Life Rationally* (1845) (Conan 2002).

In rural areas, vegetables and fruits were typically grown on site. They might have also been grown in urban areas if lots were large enough. Rural residences also had orchards. Peaches and apples were the most popular fruit trees, but in the South, citrus trees were also common.

The last horticultural topic that needs to be mentioned in discussing the landscape of the homes in this period is the concept of the yard. During this time, as today, there were three yards commonly found at a home. In rough terms, the front yard consisted of the land between the road, the porch, and the driveway of a home. The side yard lay between the side door, driveway, and carriage house or barn, and the backyard behind the house. But none of

these were the lush, green, manicured areas known today as a yard. The idea of planting grass and keeping it mowed was foreign at this time.

Although a simple push mower had been patented in 1830 as a replacement for the scythe, grass was only planted and mown in public parks, botanical gardens, and other public spaces throughout this era. It was the early 1860s before manufacturers started selling lawn mowers and near the end of the century before personal lawns became in vogue.

OUTBUILDINGS

In 1820, 90 percent of Americans lived and worked on farms. By 1860, that number had dropped to 60 percent. Though a significant decrease in four decades, it was also still the majority of the American population. Because of this, understanding the outbuildings used on farms is an integral part of understanding homes and living patterns in this revival period. The barns, cribs, stables, and other outbuildings constructed and used during these 40 years helped form the fabric of the nation that at that time had just recently stretched "from sea to shining sea."

The arrangement of houses and outbuildings to the sun, roads, and other geographic formations, while it looked haphazard, was often carefully planned. Houses were normally placed closest to the road, and faced it, but were also slanted, when possible, such that the longest side of the building faced south. This allowed the home to get heat from the sun, as well as protect itself from north winds. In fact, for this reason, it was common for houses to have many more windows on the south side of the house than the north side. Barns and other outbuildings would then be arranged behind the house, usually in such a way as to created protected southern yards. Occasionally, when a road divided a property, barns were on the opposite side of the road from the house.

What is intriguing about the evolution of American outbuildings is that the original barns built in this country were adapted from European single-use structures to be larger and multipurposed. This saved settlers from having to construct and maintain a series of individual buildings. Yet, as America moved into the nineteenth century and the barn became largely a home to hay and livestock, special-use buildings began a comeback. They became associated with the overall affluence of a farm; the more outbuildings, the better and more diverse the products grown and made there. The more products, the wealthier the farmer.

Note that while the implication in this chapter is that these outbuildings only occurred on farms and in rural areas, many of these outbuildings were also found in cities, or in suburban properties that were not farms. This is especially true of ice houses and carriage houses, but also of smoke houses, summer kitchens, and stables. Also note that one of the most picturesque of the farmstead features, the silo, was not yet in use during these 40 years, except as internal features in round barns. The free-standing silo known today was not invented until 1873 and was not in common use until the 1890s.

Barns

As important as outdoor spaces were to the Americans living during this revival period, it was the outbuildings upon which their lives revolved. The

primary outbuilding in U.S. history, the barn, is indicative of the large dependence on agriculture during the vast expansion period from 1821 to 1860. Nearly every rural homestead built during this time included at least one barn, to store grains and farm animals. Most early barns were simple log structures designed to protect a homeowner's produce and livestock from the elements. In fact, on many new homesteads, building the barn was a priority over building a house (Fitchen 1968). It is ironic that American barns today symbolize cows and their hay, because the original derivation of the word *barn* from the Saxon *bere* for barley and *aern* for place clearly shows that originally barns were intended only to store grains (Vlach 2003).

In the early days of the country, farmers farmed to feed their families. As populations grew and farming technology improved, farmers were able to feed not just their own families, but two. As progress continued to march, one farm could feed 20, then 30 people. This allowed people to leave the farm and find work in other areas, knowing that they would still be able to eat (Weller 1982). While this change was taking place, the chief farm outbuilding evolved.

This barn evolution was also fueled by the change in lumber milling. Just as houses evolved from timber frame to balloon construction in the mid-1800s, so did barns. Balloon framing made the majestic gambrel barns much easier to build. The majority of new barns constructed after the Civil War were balloon framed.

Log Barns

As with early homes, early barns were made of logs. In fact, even in some of the original colonies such as Virginia, log barns continued to be constructed well into the early twentieth century. Most of these were traditional log construction, but some in the northern Midwest were made of stovewood. Traditional log barns tended to be relatively small, and so multiple ones would have been built to meet all the farmer's storage needs (Larkin 1995; Tishler 1982).

Dutch Barns

Most of the remaining early U.S. barns are found in the Mohawk, Schoharie, and Hudson valleys in New York state. Built by the Dutch settlers in the region in the late seventeenth through the late eighteenth century, these barns are commonly known as Dutch barns. While only isolated examples were erected during this revival period from 1821 to 1860, they were still very much in use and set the stage for adjustments to the barn form in later eras.

Dutch barns were constructed in the North only, primarily in New York and New Jersey, with some found in New Hampshire as well. To store livestock and enough food for a family through Northeast winters, Dutch barns needed to be large. And that they were. While nearly square, although generally wider than they were deep, they ranged in size from approximately 40 feet wide to up to 54 feet wide. They were constructed entirely from wood, generally cleared from the farm site. The primary species used were oak, yellow pine, and white pine. No metal was used in framing, because joints were made with notches, wooden pegs, and other wood parts. They had no foundation to speak of. Sills were lain directly on regularly placed stone blocks (Fitchen 1968).

Dutch Barns were gabled, with a roof peak nearly 90 degrees, and had no projecting eaves. The roof rafters supported a layer of wide planks, to which roofing shingles were nailed. On some occasions, the wide boards were left as the only roofing surface, or, in the very early years, they were covered with thatch (Fitchen 1968).

They are a single story, and the primary entrance doors for farm wagons were placed in the gable ends with doors swinging inward to more easily allow wagons to enter. Even the hinges on these doors were commonly made with wood. Smaller doors near the edges of the gable end were sometimes cut to allow homeowners to enter and exit the barn without opening the main doors. Other openings in the barns included ventilation holes, cut near the peak of the gables. Sometimes referred to as "Martin holes" because they allowed martins, owls, and other birds in to nest in the barn, these holes were intricately shaped and often cut in pairs or threes (Fitchen 1968).

The walls in a Dutch Barn ranged in height from 9 feet high to 16 feet high, but most were between 13 and 16 feet. Regardless of the actual wall height, the full height of the barn from floor to peak was always more than double the wall height. This was what gave the roof its sharp pitch. The barn walls, as well as the gable ends, were sided with horizontal boards, which were not painted. The boards were usually made of pine, were about 10 to 12 inches wide, and were nailed in place with hand-wrought nails (Fitchen 1968).

Although the exterior characteristics of a Dutch Barn are distinct, it is the interior arrangement and method of construction that confirm the barn's style. Each Dutch Barn has three aisles: a large one down the center where the wagons would drive, and two smaller ones on each side of the central aisle. Livestock were stored in Dutch barns, and they were brought down the central aisle and placed in stalls facing the central aisle to facilitate feeding. Pigs were housed closest to the door, with other livestock such as cows, sheep, and horses occupying stalls further inside (Leffingwell 1997). The central aisle was approximately twice as wide as the side aisles, and it had a thick plank floor that supported the wagons and animals, as well as allowed grain to be threshed on it. Each barn was also divided into bays that ran perpendicular to the aisles. Three- and four-bay barns were the most common, although some five- and six-bay barns also existed (Fitchen 1968).

Even more distinctive, however, than the aisle and bay arrangement was the Dutch Barn's anchor beams, which spanned the central aisle, parallel to the gable ends, creating the bays. These beams were often 12 inches wide by 24 inches high and, in the larger barns, could be as much as 30 feet long. Four or five of these massive beams (four for three bay barns, five for four, etc.) were used to support the rest of the barn structure (Fitchen 1968). The size of the tree necessary to produce such beams is staggering.

As settlement increased, and the nationality, and hence customs, of the arriving settlers changed, the building of Dutch Barns largely ceased. Some Dutch Barns had their roofs raised and rotated in the 1830s to better emulate newer barns (Vlach 2003), and some new ones were constructed by immigrants as late as 1834 (Leffingwell 1997), but these were scattered occurrences. The original barns were still maintained throughout the revival period from 1821 to 1860 (and dozens, now over 200 years, old still survive today), but their construction gave way to the more modern barns of the early nineteenth century.

English Threshing Barns

The next oldest barn type in America, and one of the most common, especially in the Northeast and Midwest, is the English threshing barn. Presumed to have originated with the early British settlers, this unassuming barn was the workshop of rural homesteads throughout these revival decades. Settlers used these barns for food production and storage although not generally for livestock. They were generally oriented on the land so that they were perpendicular to the prevailing winds in the area.

Traditional English threshing barns have a very distinctive look, but it does take time to recognize them, as they do not dominate the landscape as much as do the later red-painted gambrel roof barns. Their relatively small size and unpainted siding tend to make them blend into their surroundings. These barns were simple rectangles, approximately 30 feet wide and 40 feet long, with somewhat shallow gable ends. Unlike Dutch barns, the English barns were sided with vertical boards and have no openings other than the doors, which were in the long sides, not the gable ends.

The foundations of English barns were of common fieldstone placed on a leveled piece of land. On occasion, the stone was mortared, but most often not, as the weight of the building itself was enough to anchor it to the foundation, and hence the foundation to the ground. Sills were used between the foundation and the bents of the barn. As with Dutch barns, the posts and beams were mammoth. While posts were a modest 10 inches square, the beams (called summer beams in this type of barn) were 12 to 18 inches wide and up to 24 inches deep. In extended versions of the standard 30 by 40 size, it was not uncommon for some of these beams to be 60 feet or more in length (Leffingwell 1997).

On the inside of the English barn, there were usually three bays. In fact, this barn style is often referred to as simply the "three bay barn." The center bay was accessed directly from the side doors. These doors swung open outward on leather or iron hinges, or, in later years, they slid to either side on metal rails.

The floor of the central bay was used as a driveway for wagons loaded with hay or other goods. For better air circulation, and easier

As is common in rural areas, this English threshing barn in Fort Plain, New York, has been converted to a garage. Nancy Mingus.

egress, this central bay generally had a rear door as well. A farmer would fill the wagon and drive into the barn. If carrying hay, the wagon would be unloaded into one of the side bays, known as mows, and then driven out the other side ready to get another load.

When wheat or oats were in season, the barn would be used for a different purpose. Grain would be lain on the floor of the center aisle where it would be threshed, meaning that the grain seeds would be removed from the stalks on which it grew. Threshing was done manually, using special sticks called flails, or, in larger barns, it may have been tread on by horses. Once the grain was threshed it was winnowed; that is, the chaff was removed from the grain. This was often done by opening both barn doors, throwing the grain in the air, letting the chaff be blown out by the wind, and catching the grain in a basket (Fink 1987).

Other Barn Styles

English threshing barns were built in the United States from the late 1700s and throughout this revival period. As was the norm of this style, they had no basement and were built on a level grade. By 1850, bank barns were also found dotting the landscape. A bank barn is a two-storied structure, and, as the name suggests, a bank barn was generally built into a natural or man-made hill. The first floor and main entrance to the barn was on the bank side of the hill. On the other side of the barn, there was access to the ground level.

Most bank barns were made of wood and were considerably larger than the English barns were, and are found throughout the Northeast and Midwest. Some bank barns, especially those in the German areas of Pennsylvania, had first floor cantilevers projecting two to five feet out above the lower level. These projections are known as forebays. This style of bank barn was also made of wood, but many large stone versions were built as well. The stone ones often date back to the late 1700s and early 1800s, while the wood ones tend to be from the 1820s to 1850s. Scattered versions of the cantilevered bank barn also exist in the Midwest, New England, and New York.

Also by the 1850s, especially on prosperous farms, the original 30 by 40 foot size of an English barn had increased to about 40 feet wide and 70 feet long. In some areas of the country, especially in New England, English barns took another twist, literally. Farmers found that if they rotated the gable and entrance door on an English barn, they were then able to have enough room in the barn for cow stalls on one side and hay on the other side of the new main entrance. The other advantage to this approach is that they could more easily extend the barn lengthwise.

Although the barns in the Northeast followed the cycle of the majority of barns in the growing United States, one feature of northeastern and, especially, New England barns, was the concept of a connected farmstead. Based loosely on the idea of European Long Houses, where one end of a building was for livestock and produce and the other was residential, New England connected farms combined all the farm building functions in a contiguous space. This sequence of space is often referred to as "big house, little house, back house, barn." In this arrangement, the main house is at the front of the property; the barn is toward the rear; and in between is the little house, which commonly

held the kitchen, pantry, and other home storage areas; and the back house. The contents of the back house varied greatly from farm to farm and may have included a woodshed, wagon shed, crib, milk house, summer kitchen, outhouse, laundry, and the like. It was often used as the preparation center for a variety of produce that was stored for use during the winter (Hubka 1984).

Other shapes for barns during this period included round barns, octagon barns, and other polygonal barns. Most round barns were designed with the silo in the middle, which was an interesting way to integrate the two farm functions. The most famous round barn in the United States is the stone Shaker barn in Hancock, Massachusetts. Built in 1826, this barn is 270 feet in circumference and has walls 21 feet high. As with other round barns, it has a central silo. It could hold stalls for 52 cows. Another massive Shaker barn built during this revival period is the North Family Barn in New Lebanon, New York. This barn, also made of stone, is 196 feet long and 5 stories tall (Sloane 2001).

Hop Houses

In the early 1800s, a specialized barn evolved primarily in central New York. Known as hop houses, hop kilns, or hop barns, these outbuildings were created to dry the hops used in making beer. Hops were originally dried in more traditional barns, but as the industry accelerated, it became obvious that a structure tailored specifically to the unique aspects of hop drying was needed.

The American hop-growing industry started in Massachusetts in the 1790s, with German and French demand for the beer brewing ingredient increasing. As settlers moved into New York, they brought with them both the knowledge of hop production and the desire to sell hops to the European and burgeoning

An Eclectic Array of Barns

Although the most common barns in the revival era were English threshing barns or close derivations thereof, many unique barns were also constructed during these 40 years. Some of the most interesting include two very different stone barns built by the religious group now known as Shakers. The first barn, located in Hancock, Massachusetts, is a round stone barn built in 1826. With a circumference of 270 feet, the walls of the round barn are 21 feet high, and 2 1/2 to 3 1/2 feet thick. By the 1960s, this barn was in great disrepair, but it was restored in 1968.

Diametrically opposed in design is the equally impressive, even more massive, 196-foot long, 50-foot wide, 5-story high, stone Shaker barn in New Lebanon, New York. Built in 1859, this large rectangular barn is purportedly the largest dairy barn in the United States. A devastating 1972 fire gutted the building and took the roof, but today the barn is slowly being restored (Shaker Museum 2007).

Not as large, nor as iconic, as the two Shaker barns, the 40 by 60 circa 1850 Coe barn in South Livonia, New York, is a quintessential Gothic Revival barn. Strikingly like the Gothic carriage house illustrated in the 1842 A. J. Downing book, *Country Residences*, the Coe barn is an L-shaped building nearly four stories tall, with an ornate fancy-butt slate shingle roof, topped with a square cupola. Emulating lancet windows, each window is louvered and decorated with a triangular hood. Intricately carved bargeboards decorate the main gables, the dormer gables, the cupola, and the double entrance doors.

This round stone Shaker barn in Hancock, Massachusetts, is one of the most recognizable barns in the country. Courtesy of the Library of Congress.

American markets. By 1819, the hop production in central New York was so high, and competition so fierce, growers in Madison County were able to get state legislation passed requiring hops crops to be inspected prior to sale (Tomlan 1992, 2000).

Rather than limiting hop sales, however, the industry continued to grow. Madison County lost its first place in hop production to neighboring Otsego County in 1835, and the surrounding counties of Oneida, Ontario, Schoharie, Herkimer, and Franklin had all joined in the game. This established a hop-growing swath across the central portion of the state nearly 30 miles wide by 120 miles in length. To support the unique production requirements for hops, thousands of specialized outbuildings dotted this seven-county area (Tomlan 1992, 2000).

These 1830s hop kilns were based on a design from New England where the kilns were constructed of wood and stone and banked into a hillside. Starting in the 1840s, hop houses began to incorporate fire drying technology. At this time, the kilns were then built as free-standing structures. They were made primarily of wood and were round or square with a conical or pyramidal roof. These roof designs created a chimney effect in the barns and pulled the heat from the fires through a grid on which the hops were laid. The walls of these newer hop houses were made of plaster and lath just as homes were. This helped keep the warm air in and the cold air out (Tomlan 1992, 2000).

In terms of function, these newer kilns were designed with both storage rooms and pressing rooms in addition to the drying kiln area. As the hop business continued to grow, second kilns were often added to an existing kiln. Double kilns with the storage area between them were most common because they functioned most efficiently in terms of air flow in and around the buildings. When balloon framing techniques were adopted for home construction, the practice spread to the construction of hop houses, too, allowing a farmer to build one much more quickly and cheaply (Tomlan 1992). A few of the hop houses were made from cobblestone. One of the most interesting is a circular one in Oneida County, New York (Shelgren 1978).

Hops continued to be grown in Massachusetts, and for a time in the 1840s, New Hampshire produced more hops than any other state. As hop production had spread from New England to New York, it continued to spread along the Erie Canal and other western routes. Wisconsin started growing hops in 1837 (Tomlan 2000). By 1850, hops were being grown in both California and Oregon, and by the end of the century, were no longer grown in New York state (Moir 2000).

Tobacco Barns

The tobacco barn is another specialized drying barn that was found primarily in the southern states. Although tobacco barns were used to dry tobacco, they did not look anything like hop houses. This is because tobacco barns used the hot southern air to dry out the tobacco, not fires. Most tobacco barns were made from wood and, at first sight, looked very much like a threshing barn. But on closer inspection, there are some obvious differences, which varied depending on the region.

Northeastern tobacco barns were found primarily in Connecticut and Massachusetts along the Connecticut River Valley, although they were also used in New York. These barns were larger than threshing barns and were long and nar-

Constructed ca. 1840–1850, the Warington tobacco barn is the best surviving example of a mid-nineteenth century tobacco barn in Prince George's County, Maryland. Courtesy of the Library of Congress.

row to promote stronger cross breezes for drying. They generally ranged in size from 25 to 35 feet wide and 65 to 100 feet long. Some versions had hinges on the tops of alternating boards, and these boards were then propped open on the bottom for air circulation. Others had hinges on the sides of every other board, allowing the boards to be opened like window shutters (Sloane 2001; Sommer 1997; Vlach 2003).

Southern tobacco barns also came in a variety of shapes and sizes depending on how far into the South the barns were. Those in Kentucky and Virginia were often painted black to increase the sun's heating properties. Tobacco barns in Maryland are generally smaller than their New England counterparts; closer in size and internal arrangement to the English barns. For ventilation, they had large portions of the siding on hinges, which may have opened out or up. Some Maryland tobacco barns had one-story sheds on all four sides, making them much easier to identify on the landscape. The "top hat" tobacco barn, with roof points used as rain hoods projecting from each end, were also distinctly shaped (Sloane 2001; Sommer 1997; Vlach 2003).

CARRIAGE HOUSES, SUMMER KITCHENS, OUTHOUSES, AND OTHER STRUCTURES

Carriage Houses

While carriage houses were found on farms, they were more common in urban areas. As the name implies, carriage houses were the forerunners of

today's garages, but in the years from 1821 to 1860, they held the homeowner's horses and carriage. Carriage houses were almost always designed to be compatible with the main house, so that Greek Revival houses had matching Greek Revival carriage houses, often with full Greek Revival detailing. Gothic Revival houses had among the most dramatic carriage houses with steep roofs, decorative bargeboards, and even lancet windows. Carriage houses were primarily constructed of wood, but were also built in brick, cut stone, and cobblestone.

Stables

During the early years of the nineteenth century, most of the heavy farm work was done by teams of oxen. By the 1830s, however, it was increasingly common to also have work horses on the farm. When there were just one or two, the horses generally lived in the barn with the cows, but as farms grew and more horses were required, homesteads began to need separate storage barns for horses.

Summer Kitchens

As noted earlier, it was common for homes of this era to have two kitchens, one used in the fall, winter, and spring and another used in the summer. While not all summer kitchens were external buildings, those that were became another outbuilding on the homestead.

Outhouses

Well into the twentieth century, outhouses were used as toilets in homes that did not yet have plumbing. In the revival period from 1821 through 1860, virtually all homes had outhouses. As a home's style and size reflected the wealth and stature of its owner, so did the outhouse. Also known as privies, these outbuildings not only ranged in size from small one-holers to large five-hole versions but varied greatly in ornamentation.

Outhouses in urban areas or on the estates of the wealthy were often very ornate. Greek Revival homes would have matching Greek Revival outhouses, complete with pilasters, friezes, and perhaps even porticos. Gothic Revival houses may have had outhouses with steeply pitched roofs, and even board and batten siding and gingerbread. They might also have been made of brick, with ceramic or slate tile roofs. The outhouse on Thomas Jefferson's estate was octagonal and made of brick.

Most outhouses, though, were small, plain, shed-like buildings that covered a hole in the ground. In most versions, a wooden bench was affixed to the back and side walls and a round or oval hole carved in the center of the board, forming the toilet seat. The majority of outhouses were only large enough for one person and had only one hole in the seat, hence the nickname of a one-holer or one-seater. Larger households would have had two-seaters, and it was not unheard of to have outhouses with three or more seats. Households with small children occasionally had special versions of a two-seater, where one of the benches was lower and had a smaller hole it its center so that children would not be at risk of getting stuck in the larger adult seat.

Because of the smell of an outhouse, most were located well away from the main house and were not heated. This meant that on snowy winter days in the northern states, many householders resorted to their chamber pots. The pits under an outhouse would eventually get filled, and there were two ways to handle the waste. One was to have some type of pan in the hole that would be periodically emptied and the contents buried elsewhere. The second was to dig a new hole, move the outhouse over the new hole, and fill in the old one. The latter was a very common technique in rural areas. In some urban areas, there were sanitary codes regulating how the contents might be disposed.

While considered quaint today, and worthy of photographing, in the revival years from 1821 to 1860, outhouses were purely functional and hardly quaint for those tasked with using them on a regular basis. It would be many decades before homes in rural areas abandoned their outhouses, and well into the late 1800s before most urban homes were able to move this sanitary function indoors.

Smoke Houses

One of the ways to prepare meat in this revival period from 1821 to 1860 was to smoke it. Smoke houses were small square or nearly square buildings usually about two- to three feet wide and specially designed for a low heat fire that would smoke turkey, ham, or sometimes beef. The fires burned hickory as well as maple, and sometimes corn cobs for up to three weeks to smoke meats suspended from the ceiling. Because they did have fires in them, they were built from stone or brick (Visser 1997).

Cribs

Another common outbuilding, especially in the Northeast and Midwest is the crib. Cribs generally dry and store corn while still on its cob, although they can be used for other products as well. Most cribs had slanted side walls with two storage areas, one on each side of a central aisle used for threshing. The roof eaves extended past the walls on the sides as well as the gable ends, helping to keep the interior of the cribs dry (Visser 1997).

The cribs were usually suspended above the ground on posts covered by metal pie pans used to deter vermin from entering up the posts. Instead of inverted metal pans, plates of glass might have been used to line the post, keeping rodents from gaining purchase on the posts (Sloane 2001). The walls of these cribs were generally vertical slats. On one of the gable ends of the aisle was the crib door. In addition to being used for threshing, the center aisles might also have been used to store baskets, bags, or other supplies that should also be kept dry (Visser 1997).

Corn cribs were used in the United States as early as 1701 and had been converted to their perched on posts slanted wall structure by the late 1700s. Larger versions of the crib, which had an open center aisle for wagons rather than an enclosed space, were being built in the middle Atlantic in the 1830s. The corn crib came into popularity on New England farms circa 1850 when it became fashionable to grow and dry Indian corn. These cribs could hold up to 100 bushels of corn while it dried. If farmers raised more than that, rather

than enlarge the crib, they often built a second crib, as corn dried better in the smaller cribs (Sloane 2001; Visser 1997).

Ice Houses

In the age before electricity, storing perishable food was a difficult proposition, so having a way to store ice, and hence the food, was critical. The solution to this was the ice house. Nearly all farms, especially in the northern areas where ice would have been abundant in the winter but scare in the summer, had a special outbuilding used for keeping ice frozen during the warm seasons.

Ice houses were generally made of wood with hollow walls that were then filled with some type of insulating material, generally either straw or sawdust. There were two doors; an inner door and an outer door. The inner door was usually just stacked planks, and the space between the inner and outer doors would also be lined with sawdust, straw, or some other material. The house was built over a pit dug into well draining earth (gravel or sand) that had been lined with stone or cement. A small ventilator in the roof could be opened to allow excess water vapor out as needed (Larkin 1995).

Large ice blocks were then loaded into the house and the pit and thoroughly covered with sawdust on all sides. These large blocks were cut from the farms'

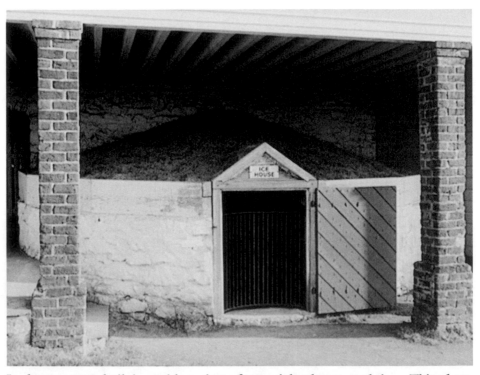

Ice houses were built in a wide variety of materials, shapes, and sizes. This photo shows the ice house at Monticello. Courtesy of the Library of Congress.

own ponds, or, in urban areas, supplied by ice vendors. By the 1850s, these suppliers, based largely in New England, shipped ice worldwide and employed about 10,000 people. The approximately 150,000 tons they shipped made the ice industry second only to cotton in terms of tonnage at that time (Gordon 1989).

When the blocks were needed, they were removed for use by gradually taking planks away from the inner door. Once the ice block was out, the planks would be replaced. By following this process, well constructed ice houses could hold ice for an entire year. The amount of ice that could be stored depended on the overall size of the ice house, but it ranged from just a few blocks to hundreds of tons of blocks (Larkin 1995). Rather than removing ice blocks for use, some ice house owners used the ice house itself as a large refrigerator, storing the carcasses of wild game directly inside (Humphris 1974).

While wood was the most common material for ice houses, and rectangular the most common shape, they could be built in virtually any shape with a variety of materials. The grander ice houses were made of stone or brick. These masonry buildings tended to be round, hexagonal, or octagonal with shingled roofs of cedar, slate, or even terra cotta. On less affluent homesteads, they were not even buildings, per se, but large, deep, round or rectangular holes in the ground or in a side hill. The sides of these holes would be lined with up to two feet of sawdust, straw, or some other insulating material, the ice placed in the hole with more straw or sawdust, and then covered with another three to four feet of insulation. With holes in the ground, as opposed to those in a hill, the final foot of the hole might have been covered with sod and planted so that the hole was not even visible (Humphris 1974). While this helped keep the ice for up to a year, it was more difficult to retrieve it when needed.

Dovecote

These rare outbuildings were designed to house pigeons. Generally two stories tall, they were made of wood, stone, or brick. Thomas Jefferson had planned one for Monticello, but it was apparently never built. On castle-form Gothic buildings, they were often incorporated into a tower or turret, such as Richardson did at the Glessner House later in the nineteenth century.

Well Houses

While not truly decorative, well pumps and well houses were certainly obvious features in the landscape of farms and other rural homes. Surrounding the well to keep people and rodents from falling into the deep well hole, they were round or square and made of wood, stone, or brick. The roof was usually a low sloping gable set on posts to cover the opening.

Other Outbuildings

Other outbuildings that may have appeared on the farmsteads were wagon sheds, open-bay buildings used to store farm wagons; chicken coups; granaries; blacksmith or carpentry shops; piggeries; cabbage barns; slaughterhouses; sheep houses; milk houses; cider houses; laundry/wash houses; windmills, used after 1850 to pump water; maple sugar houses for boiling down maple syrup

starting circa 1850; greenhouses; potato houses; and cranberry, blueberry, and apple houses (Fink 1987; Sloane 2001; Visser 1997).

The 40 years from 1821 to 1860 saw great changes in the United States. From colonies located along the East Coast, the nation grew to spread "from sea to shining sea." Population increased, and people migrated into the newly opened western areas of the country. The types of houses they lived in changed from simple log cabins and sod houses to spectacular castle-like homes and any size and shape in between. Barns and outbuildings went through similar evolution. The country went through four major housing style revivals, which, coupled with the similar changes in furniture and decoration styles, revealed the growth of the American middle class.

Much of this was driven by the technological advances during these 40 years. Balloon frame construction; better, cheaper nails; and great strides in transportation systems and in the printing and weaving processes all played significant roles in the path the country followed. The developing professions of architect and landscape architect, because of their numerous publications, were also great influences.

Yet, while all these positive events were taking place, controversy and conflict were developing over relationships with Native Americans as well as over the South's continued reliance on slaves. Just after this revival period ends, these conflicts would erupt into the Civil War, which would have a devastating affect on Americans' lives and their homes from the 1860s to the 1880s, the period covered in Part II of this volume.

Reference List

Conan, Michel, ed. 2002. *Bourgeois and Aristocratic Cultural Encounters in Garden Art, 1550–1850*. Washington, D.C.: Dumbarton Oaks Research Library and Collection.

Fink, Daniel. 1987. *Barns of the Genesee Country, 1790–1915*. Geneseo, NY: James Brunner.

Fitchen, John. 1968. *The New World Dutch Barn*. Syracuse, NY: Syracuse University Press.

Gordon, John Steele. 1989. "When Our Ancestors Became Us." *American Heritage Magazine* 40(8): 106–121.

Hubka, Thomas C. 1984. *Big House, Little House, Back House, Barn*. Hanover, NH: University Press of New England.

Humphris, Ted. 1974. "The Ice House." *Garden History* 2(2): 81–82.

Larkin, David. 1995. *Farm: The Vernacular Tradition of Working Buildings*. New York: The Monacelli Press.

Leffingwell, Randy. 1997. *The American Barn*. Osceola, WI: Motorbooks International.

Leighton, Ann. 1987. *American Gardens of the Nineteenth Century*. Amherst, MA: The University of Massachusetts Press.

Moir, Michael. 2000. "Hops—A Millennium Review." *Journal of the American Society of Brewing Chemists* 58(4): 131–146.

Shaker Museum and Library at Mount Lebanon Shaker Village. 2007. Available at: http://mountlebanonshakervillage.org/.

Shelgren, Olaf William, Cary Lattin, Robert W. Frasch, Gerda Peterich. 1978. *Cobblestone Landmarks of New York State*. Syracuse, NY: Syracuse University Press.

Sloane, Eric. 2001. *Eric Sloane's An Age of Barns*. Stillwater, MN: Voyageur Press.

Sommer, Robin Langley. 1997. *The Old Barn Book*. New York: Barnes and Noble.

Tishler, William H. 1982. "Stovewood Construction in the Upper Midwest and Canada: A Regional Vernacular Architectural Tradition." *Perspectives in Vernacular Architecture* 1: 125–133, 135–136.

Tomlan, Michael. 1992. *Tinged with Gold: Hop Culture in the United States*. Athens: University of Georgia Press.

Tomlan, Michael. 2000. "The Roots of the American Hop Industry," *USA Hops,* 8–13, 24–26.

Visser, Thomas Durant. 1997. *Field Guide to New England Barns and Farm Buildings*. Hanover, CT: University Press of New England.

Vlach, John Michael. 2003. *Barns*. New York: W. W. Norton and Co.

Weller, John. 1982. *History of the Farmstead*. London: Faber and Faber.

Glossary

Balloon frame: A construction method developed in the 1830s in Chicago that made use of standard 2′ × 4′ milled lumber to build structures more quickly and with fewer people. By 1860, it was used throughout the country and eventually replaced the traditional European timber frame.

Bargeboard: A board hanging from the eaves of a gable, usually ornately carved or cut to emulate Gothic church tracery.

Board and batten siding: A type of exterior siding that uses vertical boards abutted to one another. The joints between the boards are typically covered with vertical "battens," narrow strips of wood one to two inches wide. This siding is common on Gothic Revival homes and is also found on barns and outbuildings.

Clapboard siding: A type of exterior siding that uses overlapping horizontal boards to protect the structure. The boards are commonly four to six inches wide and are often tapered at the top for easier overlapping.

Cobblestone: Small (generally 2.5 to 5 inch), round or oblong stones used for walls or as decorative exterior siding on early nineteenth-century buildings.

Cupola: Originally used to refer to a dome over a structure projecting from a roof, the term is now used to describe any small structure projecting from a roof, commonly containing windows. Cupolas were popular on Italianate buildings and octagons.

Dutch Barn: A large, virtually square, steeply gabled barn constructed by the Dutch settlers in the eastern United States. Entry doors in the gable end,

horizontal siding, and vent holes near the gable peaks are also hallmarks of this style.

English Barn: A 30 by 40, three-bay barn built by English settlers in the eastern and Midwest states. The entry doors were on the long sides, and siding was vertical planks.

Gingerbread: An umbrella term for any of the ornate wooden decoration on Victorian buildings. In these decades, it was found on Gothic and Italianate buildings.

Gothic Revival style: A romantic style popular from 1835 to 1880, it features steeply gabled roofs, lancet windows, cross gables, and gingerbread on the wooden forms. Masonry forms are more like castles, including crenulated towers and parapets, and also lancet windows, usually in stained glass. Finials (tall, thin, generally tapered wooden or iron decoration common on roof peaks) and drops (carved wooden pieces similar to finials but descend rather than rise) were also common.

Gravel siding: Cement coating promoted by Orson Fowler for use on his octagon houses.

Greek Revival style: Considered the first American national style, it was popular from approximately 1825 to 1850 and featured low-pitched gable roofs, pilasters on building corners, and Greek order columns on porches and colonnades. Frieze bands and pediments were also common.

Italianate style: Another Victorian romantic style popular from 1835 to 1885, featuring wide eaves supported by large, elaborately carved brackets and round-topped windows and, sometimes, doors.

Italian Villa style: Generally considered a substyle of Italianate; featured large towers commonly a story or two taller than the main building.

Jacquard loom: A revolutionary loom design that stored weave patterns on a series of punched cards, the forerunners of the cards used on the first electronic computers.

Lancet arch: Pointed arch common in Gothic Revival windows and doors.

Octagon house: An eight-sided house, usually of equal sides, popularized in the late 1840s and early 1850s by Orson Fowler.

Outhouse: An outbuilding housing at least one "hole" used as a toilet. Also known as a privy.

Picturesque movement: A movement away from Classical forms toward a more romantic style in structures, landscapes, and decoration. Generally considered to have started with Andrew Jackson Downing, the movement coincides with the Victorian styles, starting with Gothic Revival and Italianate and running through the Queen Anne and Stick styles of the early twentieth century.

Rococo: An ornate style focusing on nature motifs (especially leaves and birds) and curves.

Scullery: A room near the kitchen similar to a pantry, but is used to wash and store dishes, pots, pans, and the like.

Second Empire style: A mid-Victorian style featuring Mansard roofs, towers, and other French influences.

Timber Frame: The traditional European style of building using heavy timbers, generally hand-hewn, held firmly together with mortise and tenon joints.

Vergeboard: *See Bargeboard.*

Victorian Era: The romantic period roughly coinciding with the beginning of the reign of England's Queen Victoria from 1837 through the early 1900s.

Water closet: The name given the first indoor toilets.

Resource Guide

PRINTED SOURCES

Baker, Pamela L. 2002. "The Washington National Road Bill and the Struggle to Adopt a Federal System of Internal Improvement." *Journal of the Early Republic* 22(3): 437–464.

Ball, Norman. 1975. "Circular Saws and the History of Technology." *Bulletin of the Association for Preservation Technology* 7(3): 79–89.

Barber, Edwin A. 1912. "American Iron Work of the Eighteenth Century." *Bulletin of the Pennsylvania Museum* 10(40): 59–62.

Bercaw, Nancy Dunlap. 1991. "Solid Objects/Mutable Meanings: Fancywork and the Construction of Bourgeois Culture, 1840–1880." *Winterthur Portfolio*, 26(4): 231–247.

Boardman, Fon W., Jr. 1975. *America and the Jacksonian Era 1825–1850*. New York: Henry Z. Walck, Inc.

Brigham, Albert Perry. 1905. "The Great Roads across the Appalachians." *Bulletin of the American Geographical Society* 37(6): 321–339.

Brumbaugh, Richard Irvin. 1942. "The American House in the Victorian Period." *The Journal of the American Society of Architectural Historians* 2(1): 27–30.

Busch, Akiko. 1999. *Geography of Home*. Princeton, NJ: Princeton Architectural Press.

Carley, Rachel. 1994. *The Visual Dictionary of American Domestic Architecture*. New York: Henry Holt & Co., LLC.

Cole, Arthur H. 1970. "The Mystery of Fuel Wood Marketing in the United States." *The Business History Review* 44(3): 339–359.

This is the resource guide for Part I of the volume (1821–1860). For the resource guide to Part II (1861–1880), please see page 317. For the resource guide to Part III (1881–1900), please see page 489.

Condit, Carl W. 1968. *American Building: Materials and Techniques from the First Colonial Settlements to the Present.* Chicago: University of Chicago Press.

Cooke, Lawrence S. 1984. *Lighting in America: from Colonial Rushlights to Victorian Chandeliers.* Pittstown, NJ: Main Street Press.

Cromley, Elizabeth Collins. 1991. "A History of American Beds and Bedrooms (in Buildings and Popular Culture)." *Perspectives in Vernacular Architecture* 4: 177–186.

Curtis, John O. 1973. "The Introduction of the Circular Saw in the Early 19th Century." *Bulletin of the Association for Preservation Technology* 5(2): 162–189.

Davis, David Brion. 1997. *Antebellum American Culture.* University Park: Pennsylvania State University Press.

Dierickx, Mary. 1975. "Metal Ceilings in the U.S." *Bulletin of the Association for Preservation Technology* 7(2): 83–98.

Donnell, Edna. 1936. "A. J. Davis and the Gothic Revival." *Metropolitan Museum Studies* 5(2): 183–233.

Downing, Andrew Jackson. 1850. *The Architecture of Country Houses.* Repr. New York: Dover Publications, 1969.

Downs, Arthur Channing, Jr. 1974. "The Introduction of American Zinc Paints, ca. 1850." *Bulletin of the Association for Preservation Technology* 6(2): 36–37.

Downs, Arthur Channing, Jr. 1976. "Zinc for Paint and Architectural Use in the 19th Century." *Bulletin of the Association for Preservation Technology* 8(4): 80–99.

Dudley, William, ed. 2003. *Antebellum America: 1784–1850,* vol. 4. New York: Greenhaven Press.

"Early Roofing Materials." 1970. *Bulletin of the Association for Preservation Technology* 2(1/2): 18–55, 57–88.

Elliott, Cecil D. 1992. *Technics and Architecture: The Development of Materials and Systems for Buildings.* Cambridge, MA: MIT Press.

Fairbanks, Jonathan L., and Elizabeth Bidwell Bates. 1981. *American Furniture, 1620 to the Present.* New York: R. Marek.

Fennimore, Donald L. 1981. "American Neoclassical Furniture and Its European Antecedents." *American Art Journal* 13(4): 49–65.

Findling, John E., and Frank W. Thackeray. 1997. *Events that Changed America in the Nineteenth Century.* Westport, CT: Greenwood Press.

Fink, Daniel. 1987. *Barns of the Genesee Country, 1790–1915.* Geneseo, NY: James Brunner.

Fitchen, John. 1968. *The New World Dutch Barn.* Syracuse, NY: Syracuse University Press.

Fleming, John, Hugh Honour, and Nikolaus Pevsner, 1998. *Penguin Dictionary of Architecture and Landscape Architecture.* New York: Penguin Books.

Fleming, John, Hugh Honour, and Nikolaus Pevsner. 1999. *Penguin Dictionary of Architecture and Landscape Architecture,* 5th ed. New York: Penguin Books.

Fleming, Robin. 1995. "Picturesque History and the Medieval in Nineteenth-Century America." *The American Historical Review* 100(4): 1061–1094.

Foster, Gerald. 2004. *American Houses: A Field Guide to the Architecture of the Home.* Boston: Houghton Mifflin.

Fowler, Orson. 1853. *The Octagon House; a Home for All.* Repr. New York: Dover Publications, 1973.

Garrett, Elisabeth Donaghy. 1990. *At Home: The American Family 1750–1870.* New York: Harry N. Abrams, Inc.

Giedion, Sigfried. 1948. *Mechanization Takes Command.* New York: W. W. Norton & Company.

Gordon, John Steele. 1989. "When Our Ancestors Became Us." *American Heritage Magazine* 40(8).

Grier, Katherine C. 1991. *Culture and Comfort: People, Parlors, and Upholstery, 1850–1930.* Rochester: Strong Museum.

HABS No. GA-222. 1962. Available at http://memory.loc.gov/.

HABS No. MI-236. 1965. Available at http://memory.loc.gov/.

Hersey, George L. 1959. "Godey's Choice." *The Journal of the Society of Architectural Historians* 18(3): 104–111.

Hubka, Thomas C. 1984. *Big House, Little House, Back House, Barn.* Hanover, NH: University Press of New England.

Humphris, Ted. 1974. "The Ice House." *Garden History* 2(2): 81–82.

Jandl, H. Ward. 1983. *The Technology of Historic American Buildings.* Washington, D.C.: Association for Preservation Technology.

Kniffen, Fred, and Henry Glassie. 1966. "Building in Wood in the Eastern United States: A Time-Place Perspective." *Geographical Review* 56(1): 40–66.

Kramer, Ellen Weill. 2006. *The Domestic Architecture of Detlef Lienau, a Conservative Victorian.* West Conshohocken, PA: Infinity Publishing.com.

Lancaster, Clay. 1947. "Three Gothic Revival Houses at Lexington." *The Journal of the Society of Architectural Historians* 6(1/2): 13–21.

Lancaster, Clay. 1952. "Italianism in American Architecture Before 1860." *American Quarterly* 4(2): 127–148.

Larkin, David, Farm. 1995. *The Vernacular Tradition of Working Buildings.* New York: The Monacelli Press.

Leffingwell, Randy. 1997. *The American Barn.* Osceola, WI: Motorbooks International.

Leighton, Ann. 1987. *American Gardens of the Nineteenth Century.* Amherst: The University of Massachusetts Press.

Lemmer, George F. 1957. "Early Agricultural Editors and Their Farm Philosophies (in The Agricultural Press)." *Agricultural History* 31(4): 3–22.

Lewandoski, Jan Leo. 1995. "Transitional Timber Framing in Vermont, 1780–1850." *APT Bulletin* 26(2/3): 42–50.

Lockwood, Charles. 1972. "The Italianate Dwelling House in New York City." *The Journal of the Society of Architectural Historians* 31(2): 145–151.

Massey, James C., and Shirley Maxwell. 1994. *Gothic Revival.* New York: Abbeville Press.

Massey, James C., and Shirley Maxwell. 1996. *House Styles in America: The Old-house Journal Guide to the Architecture of American Homes.* New York: Penguin Studio.

Mattausch, Daniel W. 1998. "David Melville and the First American Gas Light Patents." *The Rushlight.* The Rushlight Club.

McAlester, Virginia, and A. Lee McAlester. 1996. *A Field Guide to American Houses.* New York: Knopf.

McMurry, Sally. 1985. "City Parlor, Country Sitting Room: Rural Vernacular Design and the American Parlor, 1840–1900." *Winterthur Portfolio* 20(4): 261–280.

McMurry, Sally. 1988. *Families and Farmhouses in 19th Century America.* New York: Oxford University Press.

McMurry, Sally. 1995. *Transforming Rural Life: Dairying Families and Agricultural Change, 1820–1885.* Baltimore: Johns Hopkins University Press.

Meeks, C.L.V. 1948. "Henry Austin and the Italian Villa." *The Art Bulletin* 30(2): 145–149.

Mellown, Robert, and Robert Gamble. 2003. "Kenworthy Hall National Historic Landmark Nomination Form." Available at http://www.nps.gov/nhl/designations/samples/al/KenworthHall.pdf.

Moffatt, Maurice P., and Stephen G. Rich. 1955. "Buildings as Mirrors of Change." *Journal of Educational Sociology* 28(8): 329–342.

Moir, Michael. 2000. "Hops—A Millennium Review." *Journal of American Society of Brewing Chemists* 58(4): 131–146.

Moss, Roger W. 1988. *Lighting for Historic Buildings: A Guide to Selecting Reproductions.* Washington, D.C.: Preservation Press.

Muldoon, Peter L. 1995. "Monument to Truth and Beauty." *Smithsonian Preservation Quarterly* (Winter) as available at http://www.si.edu/oahp/spq/spq95w5.htm.

Murphy, David. 1989. "Building in Clay on the Central Plains." *Perspectives in Vernacular Architecture* 3: 74–85.

Naeve, Milo M. 1998. *Identifying American Furniture.* New York: W. W. Norton and Company.

Nylander, Jane C. 1990. *Fabrics for Historic Buildings: A Guide to Selecting Reproduction Fabrics.* Washington, D.C.: Preservation Press.

Osband, Linda. 2000. *Victorian Gothic House Style.* Newton Abbot, Devon, UK: David & Charles.

Payne, Christopher, ed. 1989. *Sotheby's Concise Dictionary of Furniture.* New York: Harper & Row.

Peterson, Fred W. 1982. "Vernacular Building and Victorian Architecture: Midwestern American Farm Homes." *Journal of Interdisciplinary History* 12(3): 409–427.

Peterson, Fred W. 1992. *Homes in the Heartland : Balloon Frame Farmhouses of the Upper Midwest, 1850–1920.* Lawrence: University Press of Kansas.

Phillips, Maureen K. 1996. "Mechanic Geniuses and Duckies Redux: Nail Makers and Their Machines." *APT Bulletin: A Tribute to Lee H. Nelson* 27(1/2): 47–56.

Phillips, Morgan W., and Norman R. Weiss. 1975. "Some Notes on Paint Research and Reproduction." *Bulletin of the Association for Preservation Technology* 7(4): 14–19.

Pierpont, Robert N. 1987. "Slate Roofing." *APT Bulletin* 19(2): 10–23.

Pierson, William Harvey. 1970. *American Buildings and Their Architects: The Colonial and Neoclassical Styles.* Garden City, NY: Doubleday.

Primack, Martin L. 1962. "Land Clearing Under Nineteenth-Century Techniques: Some Preliminary Calculations." *The Journal of Economic History* 22(4): 484–497.

Rickert, John E. 1967. "House Facades of the Northeastern United States; A Tool of Geographic Analysis." *Annals of the Association of American Geographers* 57(2): 211–238.

Roth, Leland. 1979. *A Concise History of American Architecture.* New York: Harper & Row.

Schultz, LeRoy. 1986. *Barns, Stables, and Outbuildings: A World Bibliography in English 1700–1983.* Jefferson, NC: McFarland.

Scoville, Warren C. 1944. "Growth of the American Glass Industry to 1880." *The Journal of Political Economy* 52(3): 193–216.

Shelgren, Olaf William, Cary Lattin, Robert W. Frasch, Gerda Peterich 1978. *Cobblestone Landmarks of New York State.* Syracuse, NY: Syracuse University Press.

Sherman, Mimi. 2000. "A Look at Nineteenth-Century Lighting: Lighting Devices from the Merchant's House Museum." *APT Bulletin* 31(1): 37–43.

Sloane, Eric. 2001. *Eric Sloane's An Age of Barns.* Stillwater, MN: Voyageur Press.

Smith, Page. 1980. *The Shaping of America.* New York: McGraw-Hill Book Company.

Smith, Page. 1981. *The Nation Comes of Age*. New York: McGraw-Hill Book Company.

Sommer, Robin Langley. 1997. *The Old Barn Book*. New York: Barnes & Noble.

Sprague, Paul E. 1981. "The Origin of Balloon Framing." *The Journal of the Society of Architectural Historians* 40(4): 311–319.

Stilgoe, John. 1988. *Borderland: Origins of the American Suburb, 1820–1939*. New Haven, CT: Yale University Press.

Streeter, Donald. 1973. "Early American Wrought Iron Hardware: H and HL Hinges, Together with Mention of Dovetails and Cast Iron Butt Hinges." *Bulletin of the Association for Preservation Technology* 5(1): 22–49.

Tarbell, Ida M. 1904. *The History of the Standard Oil Company*. New York: McClure, Phillips and Co.

Tishler, William H. 1982. "Stovewood Construction in the Upper Midwest and Canada: A Regional Vernacular Architectural Tradition." *Perspectives in Vernacular Architecture* 1: 125–133, 135–136.

Tomlan, Michael. 1992. *Tinged with Gold: Hop Culture in the United States*. Athens: University of Georgia Press.

Tomlan, Michael. 2000. "The Roots of the American Hop Industry." *USA Hops*: 8–13; 24–26.

Trewartha, Glenn T. 1948. "Some Regional Characteristics of American Farmsteads." *Annals of the Association of American Geographers* 38(3): 169–225.

Upton, Dell. 1984. "Pattern Books and Professionalism: Aspects of the Transformation of Domestic Architecture in America, 1800–1860." *Winterthur Portfolio* 19(2/3): 107–150.

Upton, Dell. 1998. *Architecture in the United States*. Oxford: Oxford University Press.

Upton, Dell. 2002. "Architecture in Everyday Life." *New Literary History* 33(4): 707–723.

Visser, Thomas Durant. 1997. *Field Guide to New England Barns and Farm Buildings*. Hanover, NH: University Press of New England.

Vlach, John Michael. 2003. *Barns*. New York: W. W. Norton & Co.

Von Rosenstiel, Helene, and Gail Caskey Winkler. 1988. *Floor Coverings for Historic Buildings: A Guide to Selecting Reproductions*. Washington, D.C.: Preservation Press.

Weller, John. 1982. *History of the Farmstead*. London: Faber and Faber.

Williamson, Roxanne Kuter. 1991. *American Architects and the Mechanics of Fame*. Austin: University of Texas Press.

Winkler, Gail Caskey, and Roger W. Moss. 1986. *Victorian Interior Decoration: American Interiors, 1830–1900*. New York: Henry Holt.

Wise, George. 1990. "Reckless Pioneer." *Invention and Technology Magazine* 6(1): 26–31.

Woods, Mary N. 1999. *From Craft to Profession: The Practice of Architecture in Nineteenth-Century America*. Berkeley: University of California Press.

WEB SITES

"American House." VintageDesigns. Available at: http://www.vintagedesigns.com/architecture/ms/rr/americanhouse.htm

Amort, Joanne. "The Genesis of Oak Alley." Oak Alley Plantation. Available at: http://www.oakalleyplantation.com/about/history/

"Andrew J. Landrum House." Santa Clara County. Available at: http://www.nps.gov/history/nr/travel/santaclara/lan.htm

Arkansas Historic Preservation Program. Available at: http://www.arkansaspreservation. org/

"Captain Haskell's Octagon House." TheOctagonHouse.com. Available at: http://www. theoctagonhouse.com/

Cartwright, Mathew, and Isaac Home. "Historic Homes And Buildings." Visit San Augustine. Available at: http://visit.sanaugustinetx.com/homes/mcic.html

"Eight More Octagons." December 1983. AmericanHeritage.com. Available at: http:// www.americanheritage.com/articles/magazine/ah/1983/1/1983_1_109_print. shtml

"Elijah Iles House." Historic Sites Commission of Springfield, Illinois. Available at: http://www.springfield.il.us/Commissions/HistSites/ElijahIlesHouse.asp

"Finding Aid to Alexander Jackson Davis Papers." Winterthur. Available at: http:// findingaid.winterthur.org/html/col114.html

"Green-Meldrim House." National Historic Landmarks Program. Available at: http:// tps.cr.nps.gov/nhl/detail.cfm?ResourceId=1429&ResourceType=Building

"The Historic 1856 Octagon House." MarlenesHeirlooms.com. Available at: http://www. marlenesheirlooms.com/octagon.html

"Historic Homes." GalvestonIslandTX.com. Available at: http://www.galvestonislandtx. com/tourism/homes.htm

"Historic Structures of Franklin, Indiana: Commercial Structures." Indiana Historic Architecture. Available at: http://www.preserveindiana.com/pixpages/franklin.htm

"The History of Arcola Mills." Arcola Mills. Available at: http://www.arcolamills.org/ history.shtml

"The House at 641 Delaware." National Park Service U.S. Department of the Interior. Available at: http://www.nps.gov/thri/propertyhistory.htm

"Loudoun House." National Park Service. Available at: http://www.nps.gov/history/nr/ travel/lexington/lou.htm

"Marker #7–9: Lane-Hooven House." The Ohio Channel. Available at: http://www. ohiochannel.org/your_state/remarkable_ohio/marker_details.cfm?marker_id=358

"Marshal Michigan." Historic Home Tour. Available at: http://www.marshallmich.com/ hometour04/pages/mabin_jpg.htm

Mitchell, Sarah. "One House, Two Faces; or, Would You Like It With Brackets or Greek Revival Entablature?" Available at: http://www.vintagedesigns.com/architecture/misc/ brgrk/index.htm

National Register Information System. Available at: http://www.nr.nps.gov/

"Oak Alley Plantation." Explore the History and Culture of Southeastern Louisiana. Available at: http://www.nps.gov/history/nr/travel/louisiana/oak.htm

"Oak Hill Cottage." Oak Hill Cottage. Available at: http://www.oakhillcottage.org/

"Old Governor's Mansion." The New Georgian Encyclopedia. Available at: http://www. georgiaencyclopedia.org/nge/Article.jsp?id=h-620

The Original Classical—Revival Furniture Drawings for the Blue Room. Available at: http://www.whitehouse.gov/history/whtour/blue-suite.html

"Plum Grove." State Historical Society of Iowa. Available at: http://www.iowahistory. org/sites/plum_grove/plum_grove_history.html

"Private Homes." Austin City Connection. Available at: http://www.ci.austin.tx.us/ library/ahc/green/private1.htm

"Roseland Cottage." Historic New England. Available at: http://www.historicneweng land.org/visit/homes/roseland.htm

Save our Heritage Organisation. Available at: http://sohosandiego.org/

"A Short History of Lyndhurst." Lyndhurst: A National Trust Historic Site. Available at: http://www.lyndhurst.org/history.html

Smith, Rose. "Guide to the John C. Ainsworth Papers." NWDA. 2004. Available at: http://nwda-db.wsulibs.wsu.edu/findaid/ark:/80444/xv61910

"Thomas House." Gilpin Historical Society. Available at: http://www.gilpinhistory.org/thomas_house.html

"A Vermont Bed and Breakfast." White Rocks Inn. Available at: http://www.whiterocksin.com/

Victoria Mansion, A National Historic Landmark. Available at: http://www.victoriamansion.org/

Welcome to the James Mulvey Inn. Available at: http://www.jamesmulveyinn.com/

Whitfield, Johnny. "New Use for South House." The Wake Weekly. Available at: http://www.wakeweekly.com/2006/Oct26-2.html

PART TWO

Homes in the Civil War and Reconstruction Era, 1861–1880

Thomas W. Paradis

Introductory Note

The built environment is collectively a product of our past. Successive cultural and historical developments of generations before ours have continuously reshaped our *human landscapes*—that is, everything our society has built over time to alter natural conditions for our own purposes. America's residential scene illustrates this fact particularly well, which is the primary topic of this volume and the entire series. The focus here is on two specific decades of American residential development, namely the 1860s and 1870s. For contemporary readers, this historical period may seem far too distant in the past to be relevant or instructive for our own time. I contend, however, that this could not be further from the truth, and the contents of this book should serve as testament to the relevance of this distant period for helping us to better understand ourselves as Americans, and why we live as we do.

Upon graduating from college with a bachelor's degree in geography, I realized that I had additionally learned just as much history, as the two disciplines are necessarily interrelated. This realization was powerful enough to convince me to attempt graduate school with the goal of eventually teaching at the college level. It is difficult to make historical connections with our past without recognizing that events must transpire across geographic space. History does not happen on the head of a pin. What occurs in one place will affect people and places elsewhere to varying extents and in either negative or positive ways—or quite often, both. Conversely, the contemporary geographical patterns that comprise our cities, homes, street networks, population distributions, and public infrastructures have come to us through cultural values, economic developments, and political decisions rendered through prior generations and

their own contexts and situations. History and geography are thus intimately intertwined, and for this reason I have employed the academic perspective of historical geography to shape the story of the American home as it played out during and after the Civil War.

This set of volumes provides important lessons on the progression of the American home, especially to assist us in forging a more meaningful connection with our collective past. It was in college when I discovered the multitude of ways the nineteenth century was relevant to how we now live. Occasional field trips, for instance, allowed students to experience a wide variety of housing styles, urban neighborhoods, business districts, farmsteads, and other urban or rural landscapes that enabled a more solid comprehension of the nineteenth-century role in shaping our American scene. Technically, our entire built environment is inherited from our past and is more or less being continuously transformed and reshaped. To learn that colonial New England village patterns were showing up in southern Wisconsin, or that the Chicago World's Fair in 1893 had spawned an architectural style used for classroom buildings in Pennsylvania and train stations in Kansas, were the type of lessons that got me hooked on studying history as well as geography. I hope to share some of this enthusiasm for students of all ages who may be curious about the origins of American lifestyles focused on the home.

It is important to recognize this section of the volume's emphasis on only two short decades of American residential development—decades that are in themselves no more or less important than earlier or later ones. Other volumes in this series focus admirably on these other periods of the full American story. Still, it was during the 1860s and 1870s, as the Civil War and its aftermath played out, when the conveniences we take for granted today either rapidly developed into familiar forms, or made their initial appearances—indoor plumbing and the bathroom, central air, public rail transit systems, steam railroad networks, horse cars, "park ways," public water works, and sewer systems, to name a few.

The suburban residential landscape itself came into its own during this time, characterized by picturesque, free-standing homes on separate lots, adorned with flower gardens and obligatory green lawns. This was also when the centuries-old, medieval construction method of heavy-timber framing made its last gasp, as Americans finally adopted the lighter and innovative "balloon-frame" for housing after decades of skepticism. With the balloon frame came two-by-four dimension lumber and steel nails that we know well today.

This is also when a distinctive middle-class population emerged, generated largely through the urban industrial revolution that enabled more families to purchase modest homes in the countryside. Men commuted to work as women stayed at home to tend fashionable, middle-class homes and gardens. On one end of the socioeconomic spectrum was an increasingly wealthy class of new millionaires made fat from their industrial pursuits, while the other end consisted of the impoverished working poor, often living in the squalor of overcrowded tenements or neighborhoods in the larger cities. The story of Civil War–era housing—from mansion to tenement—is therefore also the story of the ever-widening income gap between the rich and poor as the industrial revolution continued unabated after the Civil War. In short, our focus on housing will further provide a broader picture of American history and geographic development during these decades.

In "Political, Social, Geographic, Cultural, and Technological Issues in 1861–1880," I provide some historical and geographical context pertaining to American society and westward expansion. A fundamental though brief overview of the Civil War is provided here, along with the significance of the centennial celebrations of 1876. In addition to the Civil War itself, this chapter provides overviews of Victorian cultural traits, the transition from an agrarian to an industrialized and urban population, the expansion of Anglo-Americans into the vast midwestern and western realms, the influx of European immigrants into America's cities and farming regions, and the booming steam railroad network that allowed products, people, and ideas to move around the country much faster than ever before. This historical and geographical overview, therefore, sets the contextual stage for discussions on the American residential scene. All chapters that follow will tie back into the lessons of this chapter in some way.

The following four chapters provide more specialized and focused topics on American housing. One of the most visible and recognizable aspects of housing can be found in its exterior styling, of which numerous choices were available during this Victorian-era time period. "Styles of Domestic Architecture around the Country," provides an overview of dominant cultural trends and origins that led to the popularity of certain architectural styles commonly applied to homes both of the wealthy and those of more modest means. Specific styles popular during these decades included earlier Gothic Revival and Italianate designs in addition to newer fashions of the French Second Empire, Stick, Romanesque, Eastlake, and Colonial Revival styles. The common characteristics and identifying features of these Victorian styles are discussed and illustrated.

In "Building Materials and Manufacturing," we learn how to construct a brick or wood-frame home that might have been built around 1870, focusing on a discussion of construction and manufacturing techniques common to the time. The revolutionary method of "balloon frame" construction is described in detail.

"Home Layout and Design," addresses the status of innovative conveniences such as lighting, heating, and water supplies. The wealthiest homes already demonstrated all the standard, modern conveniences that we now take for granted, revealing the technological abilities of the time. Still, most of these innovations had not yet become accessible for the bulk of the American population and were still reserved for the most economically well-off.

Our attention to style returns once again in "Furniture and Decoration," though focused now on interior design. Like the succession of Victorian exterior styles, the fashions of interior designs came and went with time, overlapping with one another to provide an eclectic array of design choices for those who could afford them. Entire rooms might be decorated in the Gothic, Rococo, or Renaissance Revival styles, though most families of modest means usually settled for one or two pieces of furniture or carpeting that represented the latest fashions.

This section of the volume concludes with "Landscaping and Outbuildings," a rather lengthy chapter providing a sweeping overview of trends in outdoor landscaping and gardening, the origins of natural and geometric landscaping styles, innovative American land survey systems in which our housing was

placed, and a special focus on American lawns and gardens. The chapter—and book—concludes appropriately with a look at Riverside, Illinois, which is considered the first planned, suburban community designed with now-familiar curvilinear streets, open spaces, and single-family homes on separate, private lots. With Olmsted's 1869 plan for Riverside, the necessary technologies, urban planning, design strategies, house styles, and real estate marketing all came together into what had become the new American dream—free-standing, suburban homes, surrounded by their own carpets of lawns and gardens and served by an integrated network of water, sewer, and gas lines. The now-standard American subdivision was born.

This section also includes a number of helpful features for readers, as do all in this set: a timeline to put prominent event dates of this period into context; a glossary, for terms that may be unfamiliar; and a resource guide, which provides recommended information for readers from a wide variety of resources, including books, journals, and Web sites.

I have written with two approaches to reading in mind. Those interested in specific topics may skip to individual chapters, which stand reasonably well on their own. Or, one may start in the beginning and move methodically through the text to Riverside, as one might with a narrative work. Either way, the reader might do well to keep in mind the extensive glossary of terms and list of additional resources available for further study on any given topic sampled herein. The vast majority of resources at the end of this section of the volume were utilized for this compilation. Much of the information here should therefore be duly credited to the impressive work and research of others who together represent a variety of disciplines including architectural and engineering history, geography, sociology, landscape architecture, urban studies, and related fields.

I have enhanced this compilation with some primary materials dating back to the Civil War era, especially the dominant prescriptive literature, which influenced countless Americans and their own tastes for home and lifestyle. Particularly, the works of Andrew Jackson Downing, Catharine Beecher, Frederick Law Olmsted, and their notable contemporaries provided direct sources for analysis here. Added to that is my own analysis of three years' worth of the monthly publication *Manufacturer and Builder,* 1869–1871, which provided a rich additional source of specific examples to illustrate larger trends and patterns in domestic housing and technology.

Given the design of *The Greenwood Encyclopedia of American Homes through History* as a compilation work, I therefore suggest viewing it as a beginning point for initial exploration rather than a conclusion on all that you need to know. The topics addressed throughout the book may variously encourage new students of architecture, landscape studies, history, or geography to seek out further information on whatever topics appeal the most. As you explore this volume, perhaps as a starting place, I invite you to begin your own journey of learning, to which there should never be a true conclusion.

Timeline

1860	November: Abraham Lincoln elected President of the United States.
	December: South Carolina secedes from the Union, soon followed by other southern states.
1861	April 12: The South begins bombardment of Fort Sumter, beginning the American Civil War.
1862	The *Homestead Act* is passed, allowing settlers to claim public lands in the Midwest and West.
	The *Morrill Land-Grant Act* is passed, enabling the sale of public lands for the construction of schools of agriculture and mechanical arts, eventually in all 50 states.
1863	Frederick Walton invents linoleum, which becomes a popular floor covering by the 1870s and an alternative to floorcloths, tiles, and matting.
	First official use of the term *landscape architects* in government documents referring to Olmsted and Vaux. Considered the birth of the discipline of landscape architecture.
1864	The Massachusetts Institute of Technology (MIT) becomes the first institution in America to create an architecture department, though instruction did not begin until 1868.
1865	The Thirteenth Amendment to the U.S. Constitution is passed by Congress, abolishing slavery.

President Abraham Lincoln is assassinated at Ford's Theater by John Wilkes Booth.

April 9: Confederate General Robert E. Lee surrenders to the North at Appomattox, Virginia, officially ending the Civil War.

1866 The Fourteenth Amendment to the U.S. Constitution is passed by Congress, allowing citizenship for African Americans.

1867 The landmark *Tenement House Act of 1867* legally defines the tenement and mandates certain requirements, including fire escapes and a maximum of 20 people per water closet.

George M. Pullman forms the Pullman Palace Car Company, providing employment for freed slaves and their descendants.

1868 Emery Childs meets with Olmsted and Bogart during the summer to formalize plans for a contract with Olmsted, Vaux, and Company to design Riverside, Illinois, which is considered the first fully applied rendering of the American suburban ideal in a planned community.

1869 America's first transcontinental railroad is completed at Promontory Summit, Utah.

Catharine Beecher and her sister Harriet Beecher Stowe publish *The American Woman's Home,* urging women to take charge of the suburban house and family.

Frederick Law Olmsted and his partner, Calvert Vaux, are officially asked to design the suburb of Riverside, Illinois, on 1,600 acres of prairie land, nine miles from Chicago's center.

The Fifteenth Amendment to the U.S. Constitution is passed by Congress, allowing African Americans to vote.

1871 The catastrophic Chicago Fire of 1871 destroys much of the city, prompting new construction methods for rebuilding.

Henry H. Richardson wins a competition for the design of Trinity Episcopal Church in Boston, considered the prototype for the Romanesque Revival style that quickly gained popularity.

Olmsted and Vaux report to the Central Park Board of Commissioners that the primary construction of Central Park is now complete.

1872 Charles Eastlake, an English interior designer and writer, publishes his American edition of *Hints on Household Taste,* first published in London in 1868.

1873 Over-extension of railroad construction leads to the economic depression of 1873.

New York's Central Park, designed by Frederick Law Olmsted, is officially completed after more than a decade of construction.

The Gilded Age, by Mark Twain and Charles Dudley Warner, is published.

Origin of the term *Gilded Age,* emphasizes the apparently endless greed and corruption of the time.

First tall building in the United States is planned to incorporate an Otis elevator, ushering in the age of the skyscraper.

1874 Frances Willard founds the Women's Christian Temperance Union (WCTU), which would become the nation's most powerful women's organization.

1876 Alexander Graham Bell obtains patent for the telephone.

Philadelphia *Centennial Exhibition,* America's first World's Fair, marks the nation's first 100 years of history.

The Progressivist movement begins, eventually leading to the development of America's public school system.

1877 Invention of the phonograph, by Thomas Alva Edison.

1878 Edison Electric Light Company is founded.

A competition is announced by the *Plumber and Sanitary Engineer* to improve the tenement by overcoming the geographical constraints of New York's city lots. The winner is James E. Ware for his so-called dumbbell apartment.

Louis G. Tiffany (1848–1923) founds his interior decorating firm to provide advice on interior design to wealthy clients. Tiffany would eventually become most famous for his iridescent Favrile glass and its use in lamps, vases, and windows.

1879 The dumbbell plan is built into the *Tenement House Law of 1879,* mandating construction of tenements that covered only 65 percent of their lots while adopting plans similar to Ware's dumbbell.

1880 Construction begins on the innovative company town of Pullman, Illinois, providing homes and community services for employees of the Pullman Palace Car Co.

Political, Social, Geographic, Cultural, and Technological Issues in 1861–1880

American home life is best understood as a reflection of larger society. How and where we live is influenced heavily by political, socioeconomic, geographic, cultural, and technological trends. For many Americans, the 20 years that encompassed 1861 through 1880 were dominated by the American Civil War and its challenging aftermath in the South known as Reconstruction. Only 11 years following the surrender of the Confederacy, however, many Americans celebrated a newfound optimism through the centennial celebrations of 1876. Although the War and centennial are considered watershed events in American history, they sandwiched numerous important societal trends that perhaps more thoroughly defined the 1860s and 1870s, including railroad expansion, westward migration, the idea of the Gilded Age, urbanization and housing, suburban development, Victorian culture, and advances in education, science, and technology. During this time Americans still faced daunting challenges, especially a proportionally large population of urban poor living in substandard housing, former slaves and their families attempting to improve their lives, American Indian tribes still fighting desperately for native lands and human rights, and ever-growing immigrant groups seeking opportunities in the New World. These historical contexts are vitally important for providing a wider window into the American home during and after the Civil War.

THE AMERICAN CIVIL WAR

More than an isolated incident of American history, the roots of the American Civil War are traceable to the nation's founding. For instance, the decision to locate Washington, D.C. near Georgetown in 1800 was a compromise between

northern and southern interests. During his first term as President, George Washington expressed concern that "there would be ere long, a separation of the union" (Meinig 1993, 461). In 1798, Thomas Jefferson called for patience among disgruntled southerners, arguing that splitting from the union would be foolish. When Jefferson, from Virginia, became President, it was the New Englanders who then spoke of separation. Following the so-called Nullification Crisis of the 1830s, which threatened to plunge America into conflict, pivotal issues fundamentally dividing the North and South were purposely not addressed for two decades. An informal "gag rule" reduced debate over slavery in Congress, and the issue of states' rights shifted to the concerns of westward expansion and the war with Mexico (Karabell 2001).

The dominant political parties tenuously holding the nation together had lost their public appeal by the 1850s, especially following the Compromise of 1850, which admitted California into the Union as a free state and, as a concession to the South, created the Fugitive Slave Law. Under this new law, federal officials who failed to arrest suspected runaway slaves would be fined $1,000. Law enforcement officials throughout the United States, therefore, were obligated to arrest anyone even suspected of being a runaway slave. This concession understandably caused passionate objections throughout slave-free states. Meanwhile, the emerging political vacuum was filled by a new Republican Party gaining ground in the North and West. The Republicans publicly denounced slavery and rejected the philosophy that state powers superseded those of the Union.

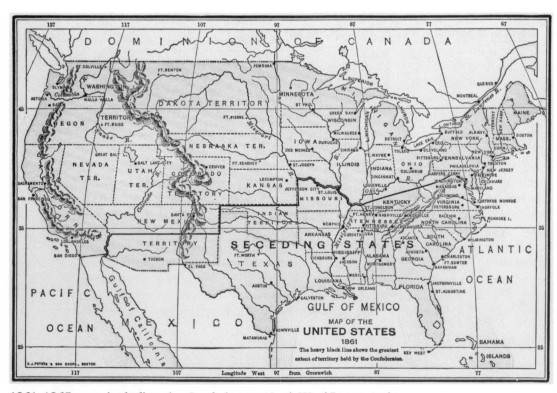

1861–1865 map, including the Confederacy. North Wind Picture Archives.

Still, many believed the institution of slavery would eventually disintegrate on its own. Nevertheless, the rising Republicans concerned the southerners, as did a strong Republican showing in the 1856 presidential election that produced Democratic President James Buchanan.

Abraham Lincoln was little known until his famed debates with Stephen Douglas in 1858. A Republican, Lincoln viewed the United States as hypocritical in allowing slavery within a nation priding itself as the "land of the free." He did not think it was possible to preserve the current setup of slave states and free states, arguing there was no such thing as a nation partly free. His idealist vision led him to run for President as the Republican nominee in 1860, fully aware that his election might signal the end of the Union. Lincoln won only the northern states in the election and received barely 40 percent of the popular vote nationally. Still, he gained a majority in the electoral college, which ultimately decided the election. He was not even on the ballot in 10 states (Meinig 1993).

Southern reaction was swift. South Carolina seceded from the Union first, on December 20, 1860, six weeks after the election. The rest of the Deep South and Texas followed thereafter. On February 8, 1861, representatives convened in Montgomery, Alabama to form the Confederate States of America, and two days later elected Jefferson Davis as President. Donald Meinig (1993) notes, however, that it was a peaceful secession. This new South was the result of legislative processes undertaken by each of the seven states, without direct provocation by threat of war with northern forces. Rather, their separate actions had been initiated in response to a democratic, national election. These first seven acts of secession occurred before Lincoln took office.

Lincoln's vision ultimately led to war. He informed the first seven secessionists that their actions would be met by force if necessary. Prior to Lincoln's inauguration, the seceding states had taken peaceful control of customhouses, arsenals, the Pensacola navy yard, and forts at Savannah, Mobile, and the mouth of the Mississippi River. Three important points remained under federal control, however: Fort Taylor at Key West, Fort Pickens at Pensacola, and Fort Sumter at Charleston. Due to a federal attempt to send supplies to Fort Sumter, the South was prompted on April 12, 1861 to begin bombardment of the fort. The event galvanized the North despite suffering no casualties. Lincoln's subsequent military response to suppress the insurrection in turn united the Upper South. On April 17, Virginia seceded from the Union, followed later by Arkansas, Tennessee, and North Carolina. The Confederate states now numbered 11, increasing the Confederacy's population by over 4 million. On May 20, its capital was moved from Montgomery to Richmond, Virginia. The War Between the States, as many have called it, had begun.

It is worth noting here that more Americans died in this four-year conflict than in all of America's twentieth-century wars combined. Less than a week after the South's surrender in April, 1865, President Lincoln was assassinated by John Wilkes Booth while watching a play at Ford's Theater. Despite the tragedy, Lincoln's vision emerged victorious, though complicated in its aftermath. The issue of states' rights would never again present a formidable challenge to the federal government. Still, complicated postwar challenges abounded. Life for most had not become easier, and injustices to American Indians and other entire segments of society had not yet been vanquished. The so-called

Indian Wars in the West would only worsen now that northern and southern armies were no longer fighting each other. It was still a nation of inequality in many ways, and the pressures of an industrializing economy would leave no American untouched.

The Role of Home

America's interest in home life, a strong Victorian cultural trait, continued unabated throughout the War. The home was frequently discussed in conjunction with the extensive loss of human life and mounting battlefield injuries. Americans both at home and in the soldier camps came to depend on their personal home images of "security and repose" (Handlin 1979, 484). Further, few military recruits had been far from home prior to being called for duty. A deep concern existed with the War's potential effect on soldiers' character, not the least being evil temptations at camp. Absent from a nurturing home life, it was feared that soldiers might succumb to gambling, drinking, prostitution, or other vices. Out of this concern came new organizations to assist soldiers during the War. Many recognized, however, that their most effective services were those that linked aspects of home life with camp. Nurses wrote of the positive effects of human compassion related to the sense of home that soldiers missed so much (Handlin 1979). Directly following the War, a committee of doctors wrote that nostalgia had been a frequent issue among soldiers, considered as an ailment difficult to define. Soldiers were sometimes found paralyzed in their beds by homesickness. The virtues of home were widely disseminated in numerous publications, including Louisa May Alcott's *Little Women,* which describes home life during the War.

The notion of home ownership was already favored by Americans. For decades the advocates of free land had pressed the government to allow farm homesteads on western public reserves, culminating in the Homestead Act of 1862. Southerners had opposed the idea prior to the War, however, fearing the eventual creation of more nonslave states. For their part, some northerners feared a resulting drain on the labor force by encouraging migration westward. While the immediate focus was on free land, the consistent arguments promoting the Homestead Act focused on the simple farmer's home, which connoted self-sufficiency. A parallel idea emerged that urban working families should own their own homes as well. As America's cities grew during the nineteenth century, rural self-sufficiency was translated into a call for urban independence through home ownership.

Reconstruction

Postwar politics and decision making were chaotic and without precedent. With the War's conclusion in the spring of 1865, there suddenly existed a new American empire of continental scope. Secession had been subdued, but the Union would not be completely restored until 1870 when the last Confederate state, Georgia, was readmitted to the Union. Until readmittance, Confederate states were under direct military occupation and governance. The southern region was divided into four military divisions, each ruled by army officers and federal officials. From a southern perspective, this was no less than an imperialistic occupation. Each military governor relied basically on martial

law but tried not to disturb local customs. What next? The War had ended without a policy on future directions. To use a popular cliché, the North had won the War but showed little vision about how to "win the peace" (Meinig 1993, 517).

Challenging questions remained. Especially, what was the status of the Confederacy that had been prevented by force from seceding from the Union? The slavery issue had been settled with the Thirteenth Amendment to the Constitution in 1865. However, countless freed slaves and their families still lived in proximity to their former owners with very few options. The Confederate states had been seriously damaged physically and economically. President Lincoln and his successor, Andrew Johnson, both favored a policy of conciliation that would allow southern states to regain their full Union status. During the Johnson Administration, control went to the radical Republicans who aimed to punish the leaders of the Rebellion. Many also envisioned the spread of Republican control throughout the South by winning the favor of freed slaves. Southern whites played into their hands by refusing to grant African Americans the civil rights of free men. Radical Republicans retaliated with two more amendments to the Constitution. The Fourteenth Amendment of 1868 established African American citizenship, while the Fifteenth Amendment assured their voting rights.

A peculiar vacuum of power materialized in the southern state governments. Former confederates were by and large prevented by Republicans from political participation. Responding to this vacuum largely for personal gain were carpetbaggers from the North, so-called because of their travel luggage known as carpetbags. Gaining seats in state legislatures, carpetbaggers joined forces with the scalawags—southerners willing to cooperate with the Republicans and the northerners, also for personal gain. Together, these infiltrating politicians presented themselves as defenders and patrons of the African Americans and thereby manipulated their votes. Corruption and crime eventually led to the return of southern white Democrats in state governments. Meanwhile, the intimidating tactics of the Ku Klux Klan, a secret vigilante organization of Confederate veterans, attempted to restore prewar social conditions in the South. By 1876, only three southern states were still under Republican control—Florida, Louisiana, and South Carolina (Boardman 1972). Southern African Americans were legally free but still lacked opportunities and respect.

The final abolition of slavery required eight additional months following the South's surrender. In December 1865, the last state ratified the Thirteenth Amendment to the U.S. Constitution. Suddenly, 4 million African Americans found themselves technically out of bondage; on paper, they were allowed to live, work, and travel where they pleased. Slavery was criminalized, marriages were legally recognized, and former slaves could organize their own churches. Nonetheless, a harsh reality was obvious soon enough. Fewer than 10 percent of freed slaves could write their names, and even fewer still had been educated enough to understand labor contracts. They found little individual power to realize their dreams, as most had no money to buy land, no skills beyond farming, and no experience overseeing their own lives.

Further, powerful southern whites were determined to restore the previous social hierarchy. Many were upset with their wartime defeat and loss of racial dominance. They equally despised the high taxes imposed on them to fund Reconstruction. The Fourteenth Amendment came to be undermined in

the South by a series of codes that enabled the hiring of unemployed African American adults as forced labor and allowed white employers to take custody of unattended children. Evolving throughout the South was a segregation system known as Jim Crow, named after the crippled slave in an 1830s minstrel show (Tye 2004).

The result was that most of the 4 million African Americans remained in the South and stayed bound to wealthy landowners as part of the oppressive system of sharecropping and tenancy, still working the cotton fields as they had done before. In 1896, the U.S. Supreme Court officially allowed southern states to create separate accommodations for blacks and whites, so long as they were roughly equal. Feeling more like serfs, many African Americans headed to the urbanizing North, only to find equally grueling work in iron and textile mills. They occasionally met unexpected hostility from unionized white coworkers who resented African American competition and their frequent role as strike breakers.

Pullman Porters

One of the few promising opportunities for freed slaves involved railroad work. Railroad companies eyed African Americans as inexpensive labor. Compared to sharecropping, the relatively lucrative railroad jobs enticed numerous freed slaves. Opportunities abounded with the postwar railroad construction boom and as southern railways rebuilt their track. They often worked on track gangs but also found jobs as locomotive firemen and brakemen on the trains. Others helped load baggage and freight. African Americans generally earned 10–20 percent less than whites in the South, and they were also used as strike-breakers when needed. Railroad management was determined to suppress trade unions.

George M. Pullman, one of the richest men in the country by 1876, noticed this hiring trend and capitalized on it. Trained initially as a cabinet maker, Pullman began to convert old passenger railway cars into sleeping cars, determined to improve the comforts of overnight train travel. With his earlier experimental sleeping cars receiving rave reviews, he formed the Pullman Palace Car Company in 1867 and made himself its president and general manager. Pullman competed successfully with some three dozen rivals and struck lucrative deals with railroad companies to lease his innovative cars and crews. He became a quintessential industrial capitalist as he pursued his dream of revolutionizing overnight train travel (Randel 1969). The railway train had become the only sensible way to traverse the country after the War, and with dozens of his cars in service, the Pullman name came to stand for luxury (Tye 2004).

With the potential labor pool of 4 million freed slaves, George Pullman learned to recruit dark-skinned African Americans from the South—not as a philanthropist but because it was a good business decision. As Larry Tye (2004) explained in his book about Pullman porters, *Rising from the Rails,* African Americans were a bargain, and Pullman aimed to pay as little as possible. Further, African Americans would deliver obedient service to meet Pullman's strict Victorian standards on his luxurious sleeping cars. Most of all, Pullman needed his elite Victorian travelers to feel safe, ideally with African American servants who provided necessary services but were rarely noticed otherwise. There was

also no danger of an African American employee ever being mistaken for a passenger. Referring to them as his Pullman "porters," Pullman had his first porter on board by 1867, and they became fixtures on his cars by 1870.

Early porters were paid poorly, worked excruciating hours, and depended on tips from passengers. Despite holding the worst jobs on the train, freed slaves and their descendants often jumped at the chance to work for Pullman. It was on these cross-country trains that they gained their first taste of upper-class life, access to education through books and magazines, and the opportunity to travel beyond their homeland. To become a porter was a mark of distinction in succeeding decades, and it was not uncommon to find three or more generations of porters from the same family. Those who wisely managed their money owned homes and cars by the 1920s, partly due to additional income from extra jobs. Porters generally believed in higher education and came to embrace the American Dream. More significant, their long-fought negotiations with the Pullman Company to secure improved working conditions became an inspiration for the Civil Rights movement through the initial successes of its own union, the Brotherhood of Sleeping Car Porters (BSCP).

At its peak, Pullman had 10,000 railroad cars in service at any one time, with over 12,000 porters (Tye 2004). Porters made their mark with each child they sent to college and graduate school. They watched their children and grandchildren become engineers, academics, doctors, business and city leaders, and teachers. It was accepted wisdom that the porters turned out more African American college graduates than any other occupational group. The Pullman porters of this postwar Victorian era helped give birth to the African American professional classes that succeed today.

THE RAILROAD BOOM

Aside from its employment of freed slaves, the railroad became the pivotal integrator of the new industrial economy. Although railroads moved an impressive amount of freight prior to and during the Civil War, the total 30,626 miles of track in 1860 did not constitute an integrated network. Today's typical standard-gauge track (4 feet 8 1/2 inches between the rails) only existed on about half the nation's railways, and the tracks linking New York, Philadelphia, and Baltimore were incompatible. Southern railway gauges were also different from their northern counterparts, and few lines had connected the North with the South. Federal pressure to unify the railways intensified during the Civil War, when the difficulties of transporting troops and supplies became apparent. Congress ultimately legislated that the standard gauge be used on transcontinental routes. By 1880, nearly 81 percent of railroad mileage was standard gauge, a big change from 53 percent in 1861 (Meyer 1990).

A construction boom ensued after the War, mirroring the nation's industrial growth. Between 1866 and 1875, the rail network doubled from 36,801 to 74,096 miles of track, doubling yet again to 149,214 miles by 1887. The most dramatic development after the Civil War was the completion of the first transcontinental railroad in 1869, with the historic meeting and celebration at Promontory Summit, Utah. Half of all new track was laid in the West between 1868 and 1873, encouraging the rapid appearance of new farm towns and the development of farmland on the Great Plains. Between 1860 and 1870, the

number of farms in North and South Dakota, Nebraska, and Kansas increased from 13,000 to 52,000, and by 1880 there were 220,000 farms on the Plains (Meyer 1990).

Conceptualized decades earlier, the nation's first transcontinental railroad was completed in 1869. When the tracks of the Central Pacific and Union Pacific Railroads were joined in Utah, America's opposite shores suddenly became only a week apart. Prior to that, a full month of travel had been necessary from New York to San Francisco through various rail and stagecoach connections, up to five months by wagon train from Missouri, or six months by ship. A full-page advertisement announcing direct, cross-country rail service in 1870 revealed the nearly instant reduction of the East–West friction of distance: The daily "Through Express" was scheduled to leave Oakland, California at 8:30 A.M. on day 1, arriving in Chicago on day 5 at 4:00 P.M. and New York on day 7 at 6:40 A.M. Another train was scheduled for twice a week in 1870, the "Atlantic Hotel Express," which already featured the "celebrated Pullman Sleeping Hotel and Commissary Cars" (Bowen 1970). Between 1870 and 1900, 60 percent of all steel manufactured in the United States was used for rails themselves, feeding the massive railroad construction boom of the late nineteenth century. The United States could boast by 1898 of owning nearly half the railway mileage of the world. Like the computer chip and the Internet of the twentieth century, the rail network constituted a similar agent of globalization in the nineteenth century, effectively linking Pacific Rim economies with the eastern United States. Asian household goods and clothes soon became readily available in East Coast cities.

The extent of the railroad's economic importance became painfully apparent during the depression (or panic) of 1873. Railroad construction happened too fast as companies overextended themselves. Many collapsed financially, leading to the depression. Only one-third of the nation's 350 railroad companies could pay stock holders any dividends by 1872 (Cashman 1993). A half-million men were out of work two years later. Breadlines were necessary in the cities, and numerous industries dependent on the railroad also suffered—iron, steel, lumber, glass, and upholstery, to name a few. Hopes revived only by the close of the 1870s.

INTEGRATING THE WEST

As the population of the eastern United States steadily increased after the War, so too did that of the American West. Migration west of the Great Plains provided only a few primary opportunities: farming in the Willamette Valley of Oregon, communal Mormonism in the Great Salt Lake Basin, or mining in the gold fields of California. Still, the population of the West exploded, focused on four rather isolated settlement cores. With more than 13,000 inhabitants by 1850, the Willamette Valley was most like the eastern frontier, with many transplanted newcomers from Missouri, Indiana, Illinois, and Kentucky. The Great Salt Lake Basin was populated by determined Mormons, already thriving there after experiencing religious persecution in the East. More accurately described as members of the Church of Jesus Christ of Latter Day Saints, these settlers had been driven from Kirkland, Ohio, to Independence, Missouri, to Nauvoo, Illinois. From Nauvoo, the first 1,500 Mormon migrants entered the Salt Lake

Basin in 1847. The number increased to nearly 12,000 by 1850, and after the War the number of distinct Mormon settlements increased by 100, from Idaho south to the Colorado River. Its urban core of Salt Lake City expanded and controlled commerce and trade with its own hinterland, maintaining its distinctiveness from San Francisco. Though losing some of their cherished isolation with the transcontinental railroad, the Mormons took early economic advantage to secure trading connections with the East and West.

In central California, the economy transformed rapidly from subsistence farming to industry and mining by the 1860s. By 1865, mining had been integrated into a highly capital-intensive industry controlled by large companies. Miners now became wage laborers rather than the individual treasure hunters of the previous decades. San Francisco—not Los Angeles—dominated California and the entire West Coast as the primary gateway to the interior mining districts and agricultural Great Valley. With its population of 234,000 and counting, by 1880, San Francisco dwarfed its urban rivals and established economic and political control over the entire West (Hornbeck 1990). According to David Hornbeck, San Francisco resembled a sort of city-state, commanding lumber and agricultural products from the Pacific Northwest, gold and silver from the interior mountains, and cattle from southern California. It was no accident that, with its booming economy and deep, natural harbor, San Francisco became the terminus of the first transcontinental railroad in 1869.

A few population figures illustrate the entire West's impressive growth in the postbellum decades. In the 20 years between 1860 and 1880, San Francisco grew from 57,000 to 234,000, while Salt Lake City grew from 8,000 to 21,000. All of California increased its population from 380,000 to 865,000, mirroring the growth in the entire Far West from 585,000 to 1.5 million over this two-decade period. It is worth noting that in 1880, Phoenix was not yet on the map, and Los Angeles claimed less than 12,000 residents, given its insufficient water supply and poor natural harbor.

By 1880, the national economy morphed into a continental set of integrated regions. This represented yet another early and rapid phase of a process known today as globalization. Improvements in transportation and communication, along with the emerging regional economies in the American West, allowed formerly isolated regions to specialize in certain resources in which they were particularly well endowed. In turn, this growing regional specialization encouraged further improvements in transportation and communication. This circular and cumulative relationship between specialization and integration became the principal engine for the national economy between 1860 and 1920 (Meyer 1990).

Actual manufacturing activities—transforming raw materials into consumer goods and industrial machines—concentrated after 1860 into the American Manufacturing Belt. This was a sizeable industrial region that dominated the economy through much of the twentieth century. Households now demanded a diverse set of manufactured products, including clothes, furniture, stoves, houses (lumber, doors, windows), and food (flour, sugar, spices, meat). The growth of cities during this period stimulated demand for construction materials including bricks, lumber, pipes, glass, nails, and hinges. By 1880, the entire nation was integrated into what geographers refer to as a *core–periphery* relationship. A largely urban *core* in the Northeast and Midwest created finished

products sold to the nation's rural *periphery* in the South and West. In turn, the periphery supplied raw materials to the core region, forging an interdependent relationship between them. Well developed by the 1880s, this core–periphery organization of the national economy persisted until after World War Two. It is this initial period of economic integration that, for better or worse, became known as the Gilded Age.

THE GILDED AGE

A long period of peace followed the Civil War, allowing the nation to focus inward. Depending on one's perspective, this enabled either an embarrassing period of political corruption, monetary greed, and appalling national morals, or it was the nation's greatest innovative period ever, building a solid foundation for education, science, etiquette, transportation, housing, and communications. It was realistically a combination of both, an era of extremes in wealth and poverty, political progress and scandals, glorified self-interest and social reform. The description of this postwar period as a Gilded Age came from a novel of the same name published in 1873, co-authored by Mark Twain (Samuel Clemens) and Charles Dudley Warner. *The Gilded Age* especially emphasized the endless greed, low moral capacity, and rampant corruption within American political and business life. Though definitions vary, the Gilded Age is often assigned to the years between 1875 and 1900 (Boardman 1972). The gap between rich and poor widened during this time as a predictable result of industrialization and migration to the cities. It was also a time of great optimism for those with access to the potential benefits of capitalism. Even speculators who had lost several fortunes remained optimistic.

Industrial growth and scientific innovations occurred simultaneously, one fueling the other. The Gilded Age up through 1890 saw 440,000 patents issued for new inventions. Among them were the steam boilers of Babcock and Wilcox, the electric lamp of Thomas Alva Edison, the telephone of Alexander Graham Bell, the telegraph stock ticker of E. A. Callahan, the elevator of Elisha G. Otis, machine tools of Pratt and Whitney, the elixirs of John Wyeth, and the typewriter of Christopher Sholes. These inventions depended upon improved technology, encouraging even more inventions of still greater refinement.

Both Edison and Bell recognized the industrial need to transmit light and sound. To that end, their combined accomplishments included the incandescent light bulb, telephone, motion picture, and phonograph. Despite popular notions, their inventions resulted more from years of perseverance and hard work than from accidental discoveries. Improvements on the telegraph, already proven instrumental in winning the Civil War, were in high demand by numerous industries. Growing businesses desired to improve communications to improve their own efficiency and, in turn, their profits. There was consequently a strong economic rationale for encouraging new and improved innovations. Thomas Edison invented the phonograph in 1877 during his search for a way to record messages for commercial purposes. In so doing he initiated a new mode of entertainment. He then focused on lighting. The Edison Electric Light Company was founded in November, 1878, and subsidized by a combination of New York financiers and the prominent banker, John Pierpont Morgan. The first viable incandescent lamp burned for 16 hours on November 17, 1879. The early 1880s

saw its demonstration in New York, Paris, and London. By 1883, Edison had 246 plants making electricity for 61,000 lamps (Cashman 1993). Edison's work epitomized the growth of this nineteenth-century "innovation economy" at the height of the Gilded Age.

A fellow contemporary, Alexander Graham Bell regarded his true profession as teaching the deaf. In his attempt to make an instrument for transmitting sound vibrations, he ultimately obtained a patent for his telephone in 1876. He demonstrated the imperfect device at the Massachusetts Institute of Technology (MIT) on June 23, and two days later to judges at Philadelphia's Centennial Exhibition. The first commercial telephone switchboard was installed in New Haven, Connecticut in 1878, and two years later there were 138 exchanges with some 30,000 subscribers. The American Bell Telephone Company was formed in 1880, reorganized as the now-familiar American Telephone and Telegraph Company (AT&T) in 1885. Still, this progress should be viewed in perspective: Only one telephone existed for every 66 people by 1900.

Other corporations likewise survived their Gilded Age beginnings to become household names. Many were organized after the Civil War and became successes by 1900, including John D. Rockefeller's Standard Oil Company, James B. Duke's American Tobacco Company, Andrew Carnegie's steel company, and the House of Morgan. Others remained small enterprises until around 1900 but found their beginnings during the Gilded Age: Coca-Cola, Levi Strauss, Kellogg, Eastman Kodak, Sears Roebuck, and R. J. Reynolds, to name a few (Cashman 1993).

Steel-frame construction was invented in Chicago and ultimately led to the modern skyscraper. After the catastrophic Chicago fire of 1871, architects and engineers from across America participated in its reconstruction. Chicago's need to rebuild quickly encouraged the trend toward steel-frame buildings. The invention of the Bessemer steel-making process in the 1870s and the presence of the steel industry in Chicago further allowed that city to lead in the development of tall office towers. Another necessity for building tall, the elevator, also underwent technical improvements during this time. Elisha Graves Otis had installed his first passenger elevator in a five-story building in New York City in 1856. It was not until 1873 that the first tall building was planned with the elevator in mind—the 10-story Western Union Building in New York, equipped with four Otis elevators. By 1904, the first electric gearless traction elevators finally made buildings over 500 feet tall feasible (Ford 1994). The initial innovations that led to the modern-day skyscraper and to America's familiar skylines were therefore products of the Gilded Age.

URBANIZATION AND HOUSING

The process of urbanization—the shift from rural, agrarian communities to an urban industrial society—occurred steadily after 1820. In that year there existed only 56 towns with between 2,500 and 25,000 residents, and 5 large cities. By 1870, these numbers exploded to 612 towns, 45 cities, and 6 metropolises with over 250,000 inhabitants. As foreign immigrants and rural transplants fueled urban growth after the Civil War, challenging social and economic issues weighed heavily on Americans trying to understand these profound changes. Foreign immigrants were arriving en masse from Europe, many having been

actively recruited by railroad companies and midwestern states that desired to populate their fertile farm land quickly. Those not settling as yeoman farmers settled mostly in crowded urban cities, contributing to congestion and urban growth—as well as to industrial production. During the 1860s and 1870s, the bulk of European newcomers arrived from northwestern Europe, their primary sources being the British Isles, the German states, Scandinavia, and Switzerland. These European source areas expanded after 1880 to include immigrants from southern and eastern Europe. The vast majority of all immigrants avoided the American South, given the dominant plantation agricultural system that provided little industrial incentive for newcomers (Ward 1990).

The Civil War did little to alter this migration pattern. With increased industrialization came a more rapid shift to urban areas, so that by 1880, America's urban population had become 28 percent of the total, compared with 11 percent in 1840. For those seeking opportunities in cities and towns, this was a promising era (Conzen 1990). Hundreds of villages and towns were settled during this time, providing for America's collective image of the typical main street business district, most often along a railroad line and focused on the town depot. Visitors to Walt Disney's theme parks today experience Disney's own idealized version of the American main street landscape. Disney was influenced by his own boyhood town of Marceline, Missouri, and those who knew him claim he never forgot his early years there (Francaviglia 1996). More important, the Disney version of Main Street reflects America's own fascination with this characteristic urban settlement pattern that spread nationally during the Gilded Age.

As linear business blocks appeared along small town main streets, larger urban downtowns were undergoing immense changes of their own. *Downtown* refers to the center city in general, including the mixed land uses of industry, retail, hotels, warehouses, office space, theaters, and tenements. The term *downtown* originated in New York, due to the location of the financial district at the southern tip of Manhattan. As the American frontier moved west, newer cities were laid out with specialized business districts in mind. The modern central business district, or CBD, appeared in larger cities during these postwar decades and encouraged specialized land-use zones. The CBD became the office core of downtown, often including high-end retail options and entertainment venues. Office activities require intensive interaction and a very small amount of space. They can therefore outbid all other land uses for central locations with higher property values. While many activities are found within the CBD, it is shaped and organized primarily by office space (Ford 1994).

The bidding process for urban space encouraged industrial activities to separate from the office core of the city, corresponding with a similar "filtering out" of social and ethnic populations and classes. During these decades, residential districts became more socially, ethnically, and occupationally similar and less diverse. Prior to the 1860s, most large cities had contained a great mixture of wholesale and retail traders, financiers, professionals, craftsmen, government workers, and a wide variety of residences and social classes all mixed together. By the 1880s, larger cities witnessed a new pattern of concentric land-use rings. Progressing outward from the CBD was the industrial zone, working-class neighborhoods, wealthier suburbs, and finally the agricultural hinterland. This urban pattern still generally characterizes today's larger American metropolises.

The Urban Residential Scene

Prior to the Civil War, people of greatly differing income and social status often lived side by side in residential districts. Immigrants continued to arrive during the last half of the nineteenth century, with no choice but to occupy cramped, run-down housing near the traditional city center. A vast residential filtering process ensued, as the wealthiest residents moved to newer suburban neighborhoods to escape the central city's overcrowding. As the wealthy moved out, increasing numbers of middle-class families took over the vacated homes of the wealthy, and the working class moved into the housing evacuated by the middle class. This filtering process still did not fully satisfy the intense demand for urban housing, however, which led to other residential patterns and challenges (Conzen 1990). Newfound industrial wealth enabled the upper and middle classes to escape the congested city of "teeming masses," leading to a growing demand for suburban housing. The poorer classes, full of immigrants, remained in the central city to rent in slum or near-slum conditions. When substantial numbers of African Americans migrated to northern industrial cities, they competed with immigrants at the bottom of the social hierarchy.

Tenement apartments often lacked heating, windows, running water, indoor plumbing, and proper sewers. Approximately one in five urban families took in boarders during the nineteenth century, despite crowding. Even worse, the homeless were left to find sleep in doorways or alleys. Tuberculosis, cholera, diphtheria, and influenza claimed as many lives as did industrial hazards. There were no public housing developments or medical services during this time—only a few charitable associations to cope with needs of millions (Hayden 2002).

Philanthropists founded numerous experiments with subsidized housing for the poor, though such efforts were generally short-lived due in part to mismanagement. Overcrowding and poor sanitation led to epidemic outbreaks of disease, eventually leading to reforms in public water supplies and health services. The severity of urban problems expanded continuously after the War and encouraged gallant efforts to reform everything from housing to health and crime, pollution, politics, and private morals. These collective efforts led to some much needed improvements by 1900, such as reducing infant mortality, vocational training for ghetto youths, the advent of kindergartens to ease working mothers' daily problems, and increased attention to slum conditions. Their failure to eradicate urban poverty in a time of unprecedented wealth, however, led to the conclusion that the root causes of poverty were not to be found in the quality of the physical environment alone (Conzen 1990).

Suburban Development

The idea of suburban living—on the city's edges—is not recent. Suburbs are likely as old as civilization, conceived initially as scattered dwellings and businesses outside medieval city walls. However, the systematic promotion of suburban neighborhoods with private land and freestanding homes occurred first in the United States and Great Britain. Between 1815 and 1860, the cities of New York, Philadelphia, Boston, and Chicago exhibited the most extensive suburban growth yet witnessed in the world (Jackson 1988). The urban poor and African Americans led the way to the periphery during the early nineteenth

century. By the 1850s, however, the country borderlands beyond the city were increasingly discovered by middle- and upper-class families.

The American suburban ideal was entrenched prior to the Civil War. Around Chicago, for instance, a variety of country homes and "villa-residences" had already materialized. An 1858 *Atlantic Monthly* essayist wrote, "To drive among them is like turning over a book of architectural drawings—so great is their variety, and so marked the taste which prevails" (Stilgoe 1988, 140). Middle- and upper-class women were already remaining at home in the borderlands prior to the Civil War, and women found it troubling on Chicago's difficult roads to make frequent shopping or social trips into the city. Only after 1865 did the horse railways of Chicago—combined with existing steam railroads—fuel an even more rapid transition of families to that city's periphery.

A series of innovative transportation improvements allowed ever-more American families to realize the new suburban dream. Two inventions had already provided access to the borderlands by the 1840s. Steamboat service, particularly in New York, up the Hudson River, and around Long Island, enabled many families to live in outlying small towns. Brooklyn began to prosper with middle-class commuter families. It was railroad travel that precipitated a revolution in suburban living, however. It made possible the success of places like Llewellyn Park (see "Styles of Domestic Architecture around the Country") and additional square miles of borderland country cut into one- to three-acre lots (Stilgoe 1988).

By the 1870s, political alliances—known today as urban "growth machines"—had organized for mutual self-interest. These were coalitions of growth proponents that viewed suburban development on massive scales as economically beneficial. Real estate developers, land owners, and city boosters learned to promote urban peripheries systematically, often in partnership with transit owners, utilities, and local governments (Hayden 2003). Together these progrowth advocates promoted the new American Dream for middle- and upper-class families desiring to escape the perceived ills of the inner city.

Following the Civil War, America's largest cities underwent dramatic spatial change. A combination of steam ferry, omnibus, commuter railroad, horse car, elevated railroad, and cable car enabled cities to virtually turn themselves "inside out." A periphery of new-found affluence contrasted greatly with central-city despair. According to Kenneth Jackson, this was the "most fundamental realignment of urban structure in the 4,500-year past of cities on this planet" (1988, 20). This new distribution of population was governed primarily by growth coalitions enhancing their investments by attracting the wealthy and excluding the poor. The number of commuters between suburb and city center increased as businessmen opted for the benefits of country living, within an easy and cheap commute of downtown.

So-called ferry suburbs, such as Brooklyn, were not common, given the geographical requirements of a short river or coastal trip. It was the omnibus, horse car, and, by the 1880s, the electric streetcar that opened up the suburban fringe to a wider population. The worsening urban congestion of the nineteenth century could be partially relieved by providing inexpensive access to more territory. First invented in France in 1826, the horse-drawn *omnibus* was introduced to North America in 1829 with its first route along Broadway in New York. Other eastern cities soon caught on. By the 1850s, the taxi-like omnibuses

were omnipresent, constituted big business, and added to traffic congestion themselves. New York City counted 683 licensed omnibuses in 1863, with 22 competing firms (Jackson 1988).

Building on the success of omnibus traffic was the *horse car*. In 1832, John Mason created the first horse-drawn streetcar railroad in New York City. The horse car blended the virtues of the steam train and omnibus, but it did not gain wide popularity until the 1850s when rails could be set flush with the street. By 1855, horse-car railways were competing effectively with omnibus routes in New York, and by the 1860s in Baltimore, Philadelphia, Pittsburgh, Chicago, Cincinnati, Montreal, and Boston. The horse car offered a smoother ride at twice the speed (6–8 miles per hour) of an omnibus. One horse could pull a 30- to 40-passenger vehicle. Tracks were usually laid in a radial pattern and expanded from the city center like spokes on a wheel. Routes followed major roads and allowed for development of wealthy neighborhoods on the periphery. By the mid-1880s, there were 415 street railway companies across the nation with some 6,000 miles of track (Jackson 1988). Horse-car lines significantly increased the "riding habit" among urban Americans—a habit that would only increase with the dawn of the automobile.

Of course, millions of workers and their families, concentrated in vast urban slums, could only dream about suburban life. By the end of the nineteenth century, an estimated two of every three American urban residents were still tenants, most of them living in crowded tenement buildings (Hayden 2002). For those who could afford it, however, the race to the suburbs was on. Victorian middle- and upper-class families took full advantage and used their bucolic suburban settings to nurture their own cultural principles.

Alternatives to the Suburban Model

Not everyone dreamed of life in the suburbs. Numerous writers, activists, and designers hoped to induce urban change with alternatives to suburban, single-family homes. Activists of the abolitionist movement and women's movement gathered strength between the 1840s and 1870s to make demands for political and spatial rights that inspired generations of reformers. For his part, Walt Whitman—editor, printer, building contractor, and poet—declared that a great city is not "the place of the tallest and costliest buildings or shops selling goods from the rest of the earth" (Hayden 2002, 41). Instead, great cities were marked by equal political participation without regard to gender, race, class, or sexual preference. All adults should be provided with equal access to public spaces and to public office. Whitman's urban place was the antithesis to the "sentimental, gender-stereotyped private domestic spaces that Jefferson and Beecher promoted" (Hayden 2002, 41).

Whitman was not alone in his vision. Frederick Law Olmsted, the founder of the profession of landscape architecture, gave a lecture in Boston in 1870 that called for the replanning of American cities. He desired to see cities encourage diversity of their populations and equitable access to public places. Like Whitman, Olmsted valued the traditional family while acknowledging specific needs of women and children. Perhaps ahead of his time, he abhorred suburban sprawl. The public landscape should serve as an expression of human social evolution, he believed, tied to housing and social service programs. In brief,

some of these programs included the cooperative residential neighborhoods advocated by Melusina Fay Peirce beginning in 1869, the municipal house-keeping campaigns of 1870s, and the Socialist Settlement houses developed by Jane Addams in the late 1880s (Hayden 2002).

Peirce and her supporters, known as *material feminists,* envisioned nothing less than new homes with socialized house work and shared child care. They raised fundamental questions about the so-called women's sphere and wom-en's work promoted by the likes of Beecher. The material feminists challenged two characteristics of industrial capitalism that suburban lifestyles promoted: the physical separation of household and public space, and the economic sepa-ration of the domestic (home) economy from the industrial (work) economy. Though gaining little mainstream acceptance, these reformers experimented with new forms of neighborhood organizations, such as housewives' coopera-tives and new building types, including the kitchen-less house, the day-care center, the public kitchen, and the community dining club (Hayden 2002).

Frances Willard founded the Women's Christian Temperance Union (WCTU) in 1874, which would become the nation's most powerful women's organization, dedicated to temperance, women's suffrage, and urban reform. Her slogan, "municipal housekeeping," reflected her view that good govern-ment was only good housekeeping on a larger scale. She fought against po-litical corruption along with the physical and social ills of the American city, which many capitalists justified as the "survival of the fittest" by Social Dar-winists. Women of the WCTU promoted the regulation of industry, elimina-tion of political corruption, and the improvement of urban housing, education, and health. They further assisted with organizing trade unions for increasing numbers of working women. The dominant Victorian culture of the Gilded Age may have tolerated or justified suburban living, the "survival of the fittest," and an entrenched urban poor. In contrast to the majority, these reformers and activists highlighted numerous challenges requiring society's attention in the midst of an otherwise prospering economy.

THE VICTORIANS

Victorianism became a transatlantic culture, initially derived from England. On August 17, 1858, Queen Victoria and President Buchanan exchanged a message in Morse code via a new transatlantic cable: "Europe and America are united by telegraph. Glory to God in the highest. On earth peace and good-will toward men" (Howe 1976, 3). The message reflected the unified Victorian culture shared by both nations. Victoria reigned in Britain from 1837 to 1901, providing a convenient period of time to define the so-called Victorian Era. Throughout these decades, American Victorianism became the dominant national culture, especially through the printed words of etiquette manuals and social guide-books. Of course, the Victorians co-existed with a multitude of other cultural belief systems and subcultures within a diverse American population, especially those of Native Americans, African Americans, people of Hispanic origin, and a wide variety of immigrants from Europe, Asia, and Africa. These cultures over-lapped and intermingled, and many people were influenced by several cultural systems. Regardless, the culture that dominated American life for the majority of white, middle- and upper-class families was that of American Victorianism

(Howe 1976). A few paragraphs cannot adequately encapsulate the complexity of Victorian cultural values. Those highlighted here are most useful for understanding the Victorian obsession with family and home.

Emerging values of domesticity, privacy, and isolation reached their fullest development during the Victorian Era. This gradual shift from public to private life was influenced in part by America's expanding wealth, which enabled more families to own separate homes and land. Countless sermons and articles only strengthened the trend toward private nuclear families, whereby ministers commonly glorified the family as a safeguard against moral ills, sinfulness, and greed. The parallel growth of manufacturing further led to an increased isolation between men and women during the day, as men went off to work and women largely remained at home. The family became increasingly isolated and feminized, and this "woman's sphere" came to be regarded as superior to other nondomestic institutions. The writings and speeches of Catharine Beecher epitomized this trend. The song "Home, Sweet Home," written by John Howard Payne in 1823, became the most widely sung lyrics of the day (Jackson 1988).

The home became the most important focus of the Victorian cultural system. This was an orderly and secure place for the proper indoctrination of children, preparing them with the values necessary to navigate a rapidly changing world. As the home became less a center of economic production through traditional farming and handicrafts, it became an increasingly pivotal and necessary setting for the socialization of the children. The successful introduction of the Christmas tree and Santa Claus into this Protestant Victorian culture was made possible by this new perspective on the home life (Howe 1976).

The Victorians held a growing faith in science and technology. For instance, health problems could be overcome by sensible behaviors and scientific remedies. Practical lessons would result from poor behaviors in contrast to their ancestors who feared God's wrath. Children were treated as naturally pure and innocent, though their initial innocence required protection allowing them to develop a capacity for self-control. Parents and teachers instructed children how to control impulses and to avoid improper behavior. A core Victorian quality was the mastering of self-governance, to reduce personal urges for wayward temptations.

Academic goals became important in schooling, though the development of good character, proper etiquette, and manners all trumped academics. The famous McGuffey texts, for instance, emphasized moral lessons, obedience to parents, and integrity. A related Victorian focus was on good character and discipline. A proper Victorian punishment involved sending children to their room to think about the consequences of their actions and to suffer separation from the loving family (Stearns 1999). Victorians naturally became a target audience for manuals that outlined appropriate child-rearing standards and adult manners. Such behavioral rules were important in allowing individuals to better handle strangers and class divisions that appeared with the onset of industrialization, and to explain why certain groups of people were undeserving of social support.

Sex became a cornerstone of Victorian self-control, partly in response to the advertised necessity of reducing birthrates (Stearns 1999). Sexual misconduct was linked to potential health consequences—specifically to mental illness,

sterility, and shortened lives. Doctors regularly spoke of moral issues pertaining to premarital sex or sexual frequency as their own status increased within society. It was vital to urge self-control among children as they matured. Likewise, decent women were instructed to show little interest in sex and were responsible for their own restraint, though men were obligated to comply.

POPULAR LITERATURE ON HOME DESIGN

Mid-nineteenth-century illustrators and writers encouraged what Dolores Hayden (2003) refers to as the "triple dream": (1) free-standing suburban house, (2) ample private land, and (3) community interaction and social opportunity. The new suburban way of life was promoted in manuals of advice for Victorian home owners and prospective buyers. Two inspirational leaders produced best-selling publications about suburban planning: Andrew Jackson Downing and Catharine Esther Beecher. Downing produced landscape designs for middle-class suburban properties while Beecher focused on the interiors of the home, promoting various house plans and technologies to support middle-class women. Beecher's writings prompted innovations for heating, ventilating, cooking, bathing, and instructions on spiritual guardianship of family life. Together, Downing and Beecher enjoyed broad influence in creating the romantic ideal of remote yards and homes favored by middle-class, suburban families (Hayden 2003).

Publications devoted to suburban lifestyles and housing existed in relatively vast quantities by the mid-1800s. Etiquette manuals appeared in unprecedented numbers in both Britain and America. These were most abundant in the United States and coincided with rapid industrial growth and an expanding Victorian culture. The number of manuals and guidebooks on etiquette and manners, conduct, character-building, beauty, and household management grew steadily after the Civil War (Kasson 1990). Direct-mail sales became a vital component of the book trade, and publishers advertised them heavily in various periodicals of the time. The subscription book trade likewise played an increasing role in sales of guidebooks. Former soldiers became virtual armies of sales agents sweeping through cities, towns, and countryside in their pursuit of book sales. In addition to their own staffs, publishers further took advantage of distribution firms that employed thousands of salesmen.

Prospering Americans, unsure about how to handle themselves with company or in other new situations, provided ready buyers. They consequently lived by rigid rules of etiquette. A typical Victorian woman might own a half-dozen books on social rules, instructing women how to behave at picnics, how to give a proper birthday party, or how and when to contact a friend. In her 1878 volume, *Sensible Etiquette of the Best Society,* Mrs. H. O. Ward counseled readers that "lunch is served at one o'clock, and dinner at six or seven o'clock," and therefore "the calling hours are from two to five" (Bowen 1970, 199). Readers further learned when and how to deploy napkins and when not to use finger bowls (at breakfast). Postbellum Victorians simply became obsessed with doing the "right" thing.

The steady stream of new prescriptive literature was augmented by increased advertising for new and innovative household products and ornament. Roughly prior to 1850, demand for manufactured goods regularly outpaced

the supply, and overland transportation of merchandise was still slow. With such conditions, little advertising was necessary to promote a company's products. Total income from advertising in all American magazines was about 25 cents per person at the time of the Civil War. The two decades following the War saw a three-fold increase in advertising, which directly impacted options for interior design of the middle-class home (Winkler and Moss 1986). The methodical sequence of singularly dominant interior and exterior styles prior to the War shifted to a barrage of multiple and detailed stylistic choices by the 1870s—confusing homeowners to the point where they started to hire interior decorators to help them navigate all the new choices. Thus, a new profession was born in the form of interior design.

Prior to the 1820s, books had been regarded as rare and precious objects. Most readily available were books of psalms and hymns, *The New England Primer,* and the Bible. In contrast, advances in printing and publishing technologies throughout the nineteenth century essentially democratized reading by making publications available to a wider public. The previous domination of devotional literature focused on the Bible gave way to a wider variety of more secular works. Reading increasingly became a diversion for entertainment and knowledge no longer restricted to the elite. One of the most prolific writers and publishers up to the Civil War was Samuel G. Goodrich, who embodied this secular goal. His cheerful stories of progress and perseverance mirrored the capitalistic spirit of the Industrial Revolution, including the timeless phrases "Make the Best of It" and "Try, Try Again":

'Tis a wisdom you should heed—
Try, try again,
If at first you don't succeed,
Try, try again. . . . (Kasson 1990, 40)

For centuries, families both rich and poor had lived together in city centers or rural areas, and the man was the head of house in all matters. Many middle-class families also had domestic servants. With the guiding literature of Downing, Beecher, and their Victorian contemporaries, these traditional family patterns and lifestyles were turned on their heads. A new gender division of labor emerged, first promoted by Downing and Beecher themselves—man nurturing yard, woman nurturing the house and family. This Victorian ideal remained prominent throughout the 1970s and, though weakened, still remains a powerful idea in American culture today. Likewise, their collective views of proper ways to build and decorate the home remain influential. Dolores Hayden refers to this nineteenth-century period as the "era of manual mania" (Hayden 2003, 42).

Of course, with all cultural changes come new adversities and challenges. Women living in early suburbs complained of "lonelyville" for decades, revealing a new issue of social isolation. Early suburbs may have provided the "home and land" of the triple dream, but they often failed on the count of community interaction. Commuting patterns established by the 1870s would become an American ritual and entitlement throughout the following century. The suburban ideal of the Victorians remains dominant today, and only by the 1990s did a small but increasing number of middle-class Americans signal a willingness

to venture back to the city center. The prescriptive literature and increased advertising of and for the nineteenth-century Victorians ultimately shaped American culture and lifestyle preferences throughout the twentieth.

THE BIRTH OF PUBLIC EDUCATION

The proliferation of manuals, guidebooks, and reading for pleasure was one indicator of a parallel interest in education. Especially notable was the Progressivist movement begun the centennial year of 1876 and the Morrill Land-Grant Act of 1862, which was already showing an impact. On July 2, 1862, President Abraham Lincoln signed into law what is generally referred to as the Land Grant Act. The new legislation was introduced by U.S. Representative Justin Smith Morrill of Vermont, granting 30,000 acres of public land for each U.S. state. Proceeds from the sale of these lands would be placed in a perpetual endowment fund designed to support new schools of agriculture and mechanical arts in each of the states. Although a provision of the Act denied its benefits to Confederate states during the War, the Act was eventually extended to the former Confederate states as well, along with every additional state and territory created after 1862. One or more institutions of higher education in all 50 states were made possible by this Act, and many of them today are among the nation's top universities. With a few exceptions, nearly all land-grant institutions are public.

Concurrent with the Land Grant Act, all disciplines of learning were being aggregated into single institutions, noted by University of Minnesota president Folwell, "from hog cholera to Plato" (Randel 1969, 395). Graduate study received a significant boost as well, with the opening of Johns Hopkins University in Baltimore in 1876. At this time, the fundamental purpose of education was under scrutiny, as more Americans increasingly questioned the educational emphasis on producing gentlemen through traditional lessons in Latin, theology, and logic. As business and industry developed, capitalist entrepreneurs replaced gentlemen in the control of the economy, and it was increasingly perceived that few college graduates were prepared for changing economic conditions. Becoming impatient with the pace of change at established institutions, some wealthy philanthropists founded new schools devoted to an educational curriculum they believed to be more practical. Such was the beginning of Rensselaer Polytechnic Institute as early as 1824, followed by Cooper Union in 1859, Stevens Institute in 1870, Rose Polytechnic in 1883, Pratt Institute in 1887, and Drexel Institute in 1891 (Randel 1969). These reforms were slow in coming, however, as traditional education still dominated numerous institutions into the twentieth century.

More important for influencing the entire curriculum was the Progressivist movement, which formally existed from 1876 to 1955. It was the logical outcome of notions first promoted by Horace Mann before the Civil War that all children should be required to attend school to a fixed age and that the schooling should be financed by taxation. Following strong opposition by the elite, state after state eventually adopted compulsory attendance laws. Educating all children required an extensive change to the typical grade-school curriculum. The curriculum needed to be flexible to allow for individual differences related to socioeconomic background and employment probabilities. Progressivists

also shared Mann's idealistic conviction that democratized schools would banish poverty, crime, vice, and illness and would lead to something of a Great Society.

Mann and his Progressive followers consequently pioneered America's public education system as we know it today. Although the idea of public education was not wildly radical by 1876, public education for all children remained for the most part a vision before 1880. Only two-thirds of America's children between 5 and 17 years of age were enrolled in school by 1876. The average school year was only 79 days, about 16 weeks, and few of the pupils went to college—slightly more than two percent of the college-age population (Randel 1969).

THE PHILADELPHIA CENTENNIAL

No account of the 1870s would be complete without acknowledging America's first centennial. As 1875 turned into 1876, the nation reflected on its achievements, self-pride, confidence, and optimism. America's independence had survived a full century. Not content to wait for the Centennial Exhibition at Philadelphia, local celebrations began promptly on New Year's Eve. Cincinnati's fireworks display and Cleveland's mammoth bonfire topped with 20 barrels of crude petroleum epitomized the local celebration scene. Newspaper reports wrote of bells ringing with fervor across the country, factory whistles blowing louder and longer, and public squares becoming packed with revelers. Numerous parades and speeches occurred on New Year's Day, along with sumptuous feasting and yet more parties. Sermons and newspaper editorials on Sunday focused on a new dawn of hope and the meanings of the centennial. A New York *Herald* editorial provided a rosy view of the past: "The last hundred years have been the most fruitful and the most glorious period of equal length in the history of the human race," as evidenced by the political progress of America's cities, numerous scientific advances, the abolition of slavery, and the growth of newspaper influence (Randel 1969, 3). Historian William Randel noted that the hundredth anniversary of the signing of the Declaration of Independence was perhaps the *only* event that could successfully unite America's extremely diverse population, with the Civil War only recently behind them.

Taking the form of America's first World's Fair, the Philadelphia Centennial Exhibition became the official national celebration between May and November, 1876. During these months some 10 million people paid the 50-cent entrance fee into the Centennial Exhibition and its 450 acres, located meaningfully in the city where the Declaration of Independence was signed. Included in its total of 180 buildings, every state of the Union had a building of its own, and 25–50 foreign nations sent exhibits, depending on the source. Other buildings were devoted specifically to advances in machinery and agriculture. Apparently the Exhibition's most popular feature was Machinery Hall, which showcased inventions and gadgets ushering in a new age of technology (Boardman 1972). Other exhibits showed off jewelry from India, a new contraption called a bicycle from England, porcelain from Germany, textiles from France, and 6,000 live Chinese silkworms spinning silk. In Machinery Hall, it was the 1,500 horsepower Corliss steam engine that gained people's attention, the most powerful machine yet devised in the world. Nearby was a typewriter,

on which its attendant would write a letter home for any visitor willing to pay 50 cents. At the Main Building, housewives first learned of linoleum, a waterproof, washable floor covering promised to last a decade. The telephone on display was one of only 3,000 in the country at the time. The Otis elevator, which would allow skyscrapers to be practical, was still frightening in the minds of many visitors.

Congress allocated $1.5 million to underwrite the Exhibition, matching the $1.5 million already raised by Philadelphia and the State of Pennsylvania. A front-page story in the Philadelphia *Inquirer* declared that "the occasion will be grand and imposing, as the magnificence of the event itself demands it shall be." Attempting to put the War in the past, the article continued: "The dazzling pageantry is not to be of war" (Bowen 1970, 26). The *New York Times* noted the diversity of attendees, stating "The crowd was nothing if not American," in that there were "fair ladies gorgeously attired, plain workwomen from workshops and factories, cooks and servant-maids, dandies in broadcloth, Western farmers in homespun, workmen fresh from their benches—rich men and poor men were all mingled together" (Bowen 1970, 26). The Exhibition, aside from the foreign exhibits, was intended to proudly display the positive achievements of the Americans during their first century since independence from Britain. Although many critics have condemned the event severely, the Exhibition is best viewed here as a window into this period of history, essentially revealing some important American characteristics during the early years of the Gilded Age.

It is important to note that Americans were not so much celebrating the institution of the federal government, but the nation's independence from a foreign power (Randel 1969). It is further a generalization to suggest that all Americans shared the same enthusiasm for national progress. Poor whites, African American families, Chinese railroad workers, Mexicans in Texas, and American Indians still fighting for their lands and families in the West could be forgiven if more solemn attitudes prevailed. In one respect, 1876 could be interpreted as just another year, during which Americans at once expressed awe and wonder at society's advances and growth while attempting to find solutions to the nagging problems of poverty, corruption, diseases, the integration of the South, and a host of other challenges associated with rapid industrialization. Following the pomp and celebrations, there remained much to be done.

Reference List

Boardman, Fon W., Jr. 1972. *America and the Gilded Age 1876–1900*. New York: Henry Z. Walck, Inc.

Bowen, Ezra, ed. 1970. *This Fabulous Century: 1870–1900*. New York: Time-Life Books.

Cashman, Sean. 1993. *America in the Gilded Age: From the Death of Lincoln to the Rise of Theodore Roosevelt*. New York: New York University Press.

Conzen, Michael. 1990. "The Progress of American Urbanism, 1860–1930." In *North America: The Historical Geography of a Changing Continent,* ed. Robert Mitchell and Paul Groves, 347–370. Savage, MD: Rowman and Littlefield Publishers, Inc.

Ford, Larry. 1994. *Cities and Buildings: Skyscrapers, Skid Rows, and Suburbs.* Baltimore: The Johns Hopkins University Press.

Francaviglia, Richard. 1996. *Main Street Revisited.* Iowa City: University of Iowa Press.

Handlin, David. 1979. *The American Home: Architecture and Society, 1815–1915.* Boston: Little, Brown.

Hayden, Dolores. 2002. *Redesigning the American Dream: Gender, Housing and Family Life.* New York: W. W. Norton & Co.

Hayden, Dolores. 2003. *Building Suburbia: Green Fields and Urban Growth, 1820–2000.* New York: Vintage Books.

Hornbeck, David. 1990. "The Far West, 1840–1920." In *North America: The Historical Geography of a Changing Continent,* ed. Robert Mitchell and Paul Groves, 279–298. Savage, MD: Rowman and Littlefield Publishers, Inc.

Howe, Daniel. 1976. "Victorian Culture in America." In *Victorian America,* ed. Daniel Howe, 3–28. Philadelphia: University of Pennsylvania Press, Inc.

Jackson, Kenneth. 1988. *Crabgrass Frontier: The Suburbanization of the United States.* New York: Oxford University Press.

Karabell, Zachary. 2001. *A Visionary Nation: Four Centuries of American Dreams and What Lies Ahead.* New York: HarperCollins Publishers, Inc.

Kasson, John. 1990. *Rudeness and Civility: Manners in Nineteenth-Century Urban America.* New York: Hill and Wang.

Meinig, Donald. 1993. *The Shaping of America: A Geographical Perspective on 500 Years of History.* Vol. 2 of *Continental America: 1800–1867.* New Haven: Yale University Press.

Meyer, David. 1990. "The National Integration of Regional Economies, 1860–1920." In *North America: The Historical Geography of a Changing Continent,* ed. Robert Mitchell and Paul Groves, 321–346. Savage, MD: Rowman and Littlefield Publishers, Inc.

Randel, William. 1969. *Centennial: American Life in 1876.* Philadelphia: Chilton Book Co.

Stearns, Peter. 1999. *Battleground of Desire: The Struggle for Self-Control in Modern America.* New York: New York University Press.

Stilgoe, John. 1988. *Borderland: Origins of the American Suburb, 1820–1939.* New Haven and London: Yale University Press.

Tye, Larry. 2004. *Rising from the Rails: Pullman Porters and the Making of the Black Middle Class.* New York: Henry Holt & Company.

Ward, David. 1990. "Population Growth, Migration, and Urbanization, 1860–1920." In *North America: The Historical Geography of a Changing Continent,* ed. Robert Mitchell and Paul Groves. 299–320. Savage, MD: Rowman and Littlefield Publishers, Inc.

Winkler, Gail, and Roger Moss. 1986. *Victorian Interior Decoration: American Interiors, 1830–1900.* New York: Henry Holt and Company.

Styles of Domestic Architecture around the Country

The progressing Industrial Revolution after the Civil War set the pace for housing construction and a growing diversity of architectural styles. Just as the income gap between the richest and poorest Americans expanded greatly during this period, so, too, did the diversity of housing and architecture. Architectural innovations and fashions that followed the Civil War diffused, or spread, down the urban hierarchy from urban cultural centers to smaller cities and rural areas, often with a lag time of many years. Nearly everyone had access to post–Civil War architectural ideas sooner or later, given the advent of standardized, interchangeable parts, better rail transportation, and readily available catalogs and published house plans. Styles became less distinct throughout this period and were not always easy to identify, given an increasingly eclectic variety of designs and choices of floor plans and decorative ornament. As individual styles became less distinctive, the long-standing practice of linking specific styles to floor plans likewise eroded (Foster 2004).

Many urban working-class and immigrant families found fewer housing choices, often remaining tied to crowded tenements with few amenities. This situation only worsened over time, with little relief into the early twentieth century. Many Americans with the means to afford a small home often lived in vernacular, or folk, dwellings—those common and rather basic houses not specifically designed by architects but often with familiar architectural forms and minimal stylistic treatments. The so-called shotgun house in the South and the I House in the Northeast and Midwest provide two excellent examples of regional folk housing of the post–Civil War period.

At the other end of the spectrum were the fortunate industrial entrepreneurs in control of much of the nation's increasing wealth. Their collective riches from these decades led to the construction of immense vacation homes (referred to as cottages) and mansions by the 1880s and 1890s. More than 100 Americans had become millionaires by 1889, having accrued much of their wealth during the 1870s and 1880s (Bowen 1970). In between these extremes was a growing middle-class population that learned to escape unhealthy urban congestion in favor of newer, stylish country houses and suburbs now made accessible with advances in mass transit. In concert with new suburban housing was the emergence of a new division of labor between men and women—promoted in large part through the writings of Catherine Beecher and her contemporaries. Americans became accustomed to distinguishing men's work from women's, and separating the workplace from home and commuting between the two.

The now-familiar American Dream became a reality for more families, and trendy architectural styles came with it. Even modest suburban homes and urban townhouses sported new architectural fashions, due to cheaper construction costs, better railroad transportation, and mass production of exterior ornamental treatments, windows, and doors. It was the upper-class elite who could afford the most extravagance, however. Many apparently were not used to the extra income and could not decide how to spend it all. E. L. Godkin noted in *The Nation* this predicament at the time by asking, "Who knows how to be rich in America? Plenty of people know how to get money; but not very many know what best to do with it" (Bowen 1970, 180). They learned to emulate the lifestyles of wealthy Europeans and their earlier generations by accumulating foreign

Vernacular Housing: The Shotgun and the I House

Though many authors and researchers focus their attention on elaborate, high-style architecture, most Americans have always lived in more vernacular, or folk, dwellings that were not specifically designed by architects. Such housing is typically more modest in size and ornament, though may adapt particular regional characteristics or simpler versions of stylistic trends. One example of such a housing form is perhaps disturbingly known as the Shotgun house, which became a distinctly regional marker of folk residential architecture in the American South between roughly 1840 and 1920. Typically only one room wide, several rooms deep, and one story tall with the gable end perpendicular to the street, the Shotgun's interior doors were typically aligned on one side of the house to provide better ventilation and to eliminate the need for a separate hall. It was said that, with all doors open, one could fire a shotgun through the long axis of the house without hitting anything—hence the name. The simple, modest floor plan was efficient to build and adapted well to narrow, urban lots. It also became a common house in more rural areas and proliferated widely throughout the South during the last half of the nineteenth century. With its apparent origins traced all the way to West Africa, the Shotgun form served as common slave quarters in Haiti, from which it diffused into New Orleans before the Civil War. By the 1860s, the Shotgun house had already spread throughout other southern cities, as far north as Louisville, Kentucky.

Typical shotgun house in the South, 1812 West Muhammad Ali Blvd., Louisville, Kentucky, constructed in 1869. Courtesy of the Library of Congress.

(continued)

Another common folk house that remained popular throughout the nineteenth century in the Northeast and Midwest was the so-called I House. Adopted from a similar house form in England during the 1700s, the house in its earliest guise showed up in the mid-Atlantic colonies and diffused north to New England and south to tidewater Virginia and North Carolina. Unlike the Shotgun's one-room-wide floor plan, the I House is typically only one room deep, two stories tall, and two or more rooms wide with a central entry and hallway. Like its larger Georgian-style counterpart, the facade is typically symmetrical with the gable ends parallel to the street (or river). Scholars still debate the origin of the term I House, though it either represents its characteristic I-shaped floor plan, or its proliferation as a common rural folk house throughout Indiana, Illinois, and Iowa during the mid-nineteenth century.

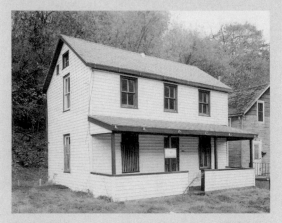

Typical I house in the Midwest. Jeremiah Mahoney House, 263 Southern Avenue, Dubuque, Iowa, constructed in 1880. Courtesy of the Library of Congress.

antiquities and adorning their mansions with elaborate ornamentation. A veritable "free-for-all" ensued by the 1880s with an increasing diversity of architectural styles that only become more confused by the early 1900s. The two decades following the Civil War set the stage for the displays of architectural opulence that would come later. The so-called Victorian Era of American architecture was already well underway when the South seceded from the Union. Still, as suburban architecture became more adventurous, life in the urban tenements changed little. Driven by the Industrial Revolution, the Victorian Era became an age of extremes, with respect to architecture, economic status, and social health.

Little building activity occurred in the United States between 1856 and 1866 due to a short economic depression followed by the War. In some ways, things continued for the next 20 years as they had prior to the slowdown. According to Gelernter, "No fundamentally new problems or ideas appeared in this period that were not presaged before the Civil War" (1999, 166). Postwar architects generally continued to reinterpret historical styles as they had prior to the hiatus in construction. Moreover, Americans fervently continued to look to Europe for guidance on architectural and artistic tastes and culture.

Still, fundamental shifts had occurred during that 10-year construction slowdown. Prevailing public cultural tastes and values had changed, in part due to significant culture shifts in Europe. Architectural theory and building technologies had advanced measurably, combined with a revived American optimism in the postwar industrial economy. These changes found expression especially in architectural styles employed for housing. The period 1865–1885 could be described as the "Age of Energy," according to historian Howard Mumford Jones—referring to the energy of humans rather than fossil fuels. Postwar architecture in turn became more energetic and modernized in its visible expression. The exterior facades of houses became increasingly ornamental and complex, making full use of new construction technologies

and methods such as the balloon frame, standardized lumber, wire nails, and elaborate woodwork (Roth 2001).

By the 1870s, home owners could adopt a variety of distinctive architectural styles, though no truly homogenous style existed. Mixtures of historical patterns and motifs were the rule rather than the exception, much of it conceived of and interpreted by local builders. Many industrial entrepreneurs were quite business-savvy but rarely educated in the humanities, arts, or architecture. This is to say that the newly rich were not necessarily sophisticated with respect to these topics. What they did know is that they loved excessive ornament, and new machines provided a generous supply of mass-produced elements, such as wooden spindles and balls, wooden grilles, stylish porch columns, finials, patterned shingles, and bargeboard. The ultimate result, according to Hammett, was that "the craftsmen of preceding eras who had schooled themselves to build were now replaced in large part by machines that could do wonderful things but without taste" (1976, 78). In time, these mid-era Victorian styles were given names in an attempt to make sense of the eclecticism, including Italianate, Italian Villa, Stick style (termed by Vincent Scully, Jr.), Eastlake (for Charles Eastlake, who later popularized the style), Second Empire (also referred to facetiously as the "General Grant" style), Queen Anne, Romanesque Revival, High Victorian Gothic, and several others of lesser popularity. All of these had in common their overt celebration of machine-made, mass-produced construction materials of the Industrial Revolution (Hammett 1976). Americans who could afford to dabble in architectural styles had become industrial romantics, ready to apply any amount and degree of rich exterior ornamentation known collectively as *gingerbread*.

Historians of nineteenth-century domestic architecture have categorized postwar styles into two dominant modes: one classical, consciously modern, orderly, and Renaissance-oriented; the other romantically picturesque, with its characteristic asymmetry and unpredictable floor plans. The latter mode was reminiscent of medieval Europe and its Gothic cathedrals, already promoted by Downing, Davis, and others in the United States by the 1830s. In contrast, the Classical mode reflected then-modern thinking, primarily manifested in America as the Second Empire Baroque style. Rather than romanticizing the Middle Ages, the Baroque favored more contemporary trends—in this case focused on advances in Paris, France during the Second Empire of Napoleon III. Hammett (1976) went so far as to describe this confused period of architecture as a battle of historical styles.

The classically derived Second Empire style became popular for both domestic and public buildings, adding to the existing diversity of picturesque styles still remaining more or less fashionable. Only by the early 1880s did predominant American tastes shift to a preference for the Romanesque Revival style of Henry Hobson Richardson. Parallel to Richardson's Romanesque was the Shingle style, a wooden adaptation of the masonry-dominated Romanesque Revival. Concurrent with this entire later Victorian period was a free interpretation of the medieval-inspired Gothic Revival, referred to as High Victorian Gothic. To summarize, the 1860s and 1870s belonged to a continuing variety of picturesque, romantic styles, augmented by the classicism inspired by the French Second Empire.

THE BUDDING ARCHITECTURE PROFESSION

Formal education expanded rapidly following the Civil War. Encouraged by the Morrill Land Grant Act of 1862 and persistent calls for more practical curricula, the growth of colleges and universities was unprecedented. New degree programs concentrated on the sciences, particularly related to agriculture and engineering (Roth 2001). The architectural profession likewise gained status during these years. In 1864, the Massachusetts Institute of Technology (MIT) became the first institution in America to create an architecture department, though instruction did not begin until 1868 (Gelernter 1999). The new department was led by William Robert Ware, who naturally looked to Europe for guidance. Trained in the Beaux-Arts (Fine Arts) in Richard Morris Hunt's atelier, Ware implemented a similar system for his own department at MIT. Soon, other American institutions looked to MIT for their inspiration when organizing similar departments or architecture offerings within engineering programs. Those that followed MIT's lead included the University of Illinois (1867), Cornell (1871), Syracuse University (1873), University of Pennsylvania (1874), University of Michigan (1876), and Columbia University (1880). All adopted the Beaux-Arts teaching agenda, and many of their instructors had studied or taught at the École des Beaux-Arts in France (Gelernter 1999).

The rise of architectural instruction in America paralleled an increasing professionalism in the field. The American Institute of Architects was founded in 1857 by Richard Morris Hunt, in part to defend the common interests of its members. By the 1860s, architects had won their right to receive fees based on a percentage of building construction costs, as well as for preliminary designs of projects not making it past the conceptual phase.

The expanding architecture profession was accompanied by a renewed flood of national publications, the demand for which continued to expand. After the War, residential construction boomed in suburban communities outside all major cities (Roth 2001). Beyond the growth of academic journals, the American public enjoyed a wealth of residential pattern and plan books written for both architects and builders. Leland Roth (2001) highlighted a few of the more influential publications, including Wheeler's *Homes for the People in Suburb and Country* (New York), 6 editions of which were distributed between 1855 and 1868. Wheeler's *Rural Homes* (New York) came out even earlier in 1851 and went through 9 editions by 1868. Likewise, Calvert Vaux's *Villas and Cottages* (New York) was published in 1857 and enjoyed no less than 5 editions by 1874. Of George E. Woodward's 9 separate works, his 2 most popular were *Woodward's Country Homes* (New York, 1865) and *Woodward's National Architect* (New York, 1868), both with follow-up editions. Palliser and Palliser were likewise prolific, with 12 titles from 1876–1883, including *Palliser's American Cottage Homes* (Bridgeport, Conn., 1877). It is important to note that such publications were written or compiled by entrepreneurs rather than architects. Most were in the business of selling house plans, answering the unquenchable demand for new ideas in architecture and housing. Regardless of their source, however, it is through these and many other publications that enabled architectural ideas to diffuse throughout the United States with relative ease.

Even more widely read than Downing and Davis were the guiding principles of Catharine Beecher (Hayden 2003). Perhaps most significant were two

of her publications, *A Treatise on Domestic Economy for Use of Young Ladies at Home and at School* (1841) and *The American Woman's Home* (1869), which she coauthored with her sister, Harriet Beecher Stowe. The first American writer to produce an all-encompassing manual of domestic life, Catharine Beecher wrote on a diverse array of related topics that included architectural styles, outdoor landscaping, interior design, cooking, cleaning, and child-raising. Her primary audience consisted of white, middle-class women of all ages. Desiring to influence all socioeconomic classes, she clearly held most influence over those women fortunate enough to afford suburban living with their husbands and families (Jandl 1991). Her impact was felt much less on the urban poor, especially women who worked 12–15 hour days and lived in crowded tenements.

Nonetheless, Beecher instructed her female audience to serve as the spiritual nurturers of large families and to stay home and master efficient suburban house design, housekeeping, and gardening—concepts of a gender division of labor that have survived more or less to the present. Her writings on architecture favored the trendy domestic styles of the 1840s related to the Greek and Gothic Revival modes. Beecher believed passionately that the private suburban house was where women derived their power, through the training of their children and by providing shelter for their husbands away from the industrial world of urban work. Dolores Hayden (1981) views Beecher as the ultimate domestic feminist who demanded women's control over the entire range of domestic life. With her far-reaching domestic principles and her widely accepted ideas for interior and exterior designs, her books of 1841 and 1869 impacted virtually every suburban, twentieth-century home (Jandl 1991).

LEGACY OF THE GEORGIAN ROW HOUSE

Outside of the major cities there appeared a variety of rural folk housing types, variously constructed throughout the early-to-middle nineteenth century. These included the Upright and Wing in the Northeast, the I House in the mid-Atlantic and Midwest, and the narrow, Haitian-derived Shotgun house in the South. Elite plantation families and successful industrialists enjoyed freestanding mansions decorated in the fashionable Federal or GreekRevival styles right up through the Civil War. The housing type dominating urban America, however, was the Georgian-style, red-brick row house (Ford 1994). Variations on this theme could be found in New Orleans and San Francisco, with stucco or wooden exteriors rather than the standard brick. Another variation was the folk style known as Pennsylvania Georgian, consisting of wooden, working-class row houses found in eastern and central Pennsylvania communities. Regional differences aside, most antebellum cities and towns displayed some form of the Georgian row house as the residential standard. By 1800, most cities along the eastern seaboard, from New England to Virginia, demonstrated a more or less uniform appearance with their predictable grids of streets lined with brick or wood-framed Georgian row houses. In the decades after the Civil War, much of this late colonial and early federal era housing remained in these cities and naturally continued to house sizeable proportions of America's urban population.

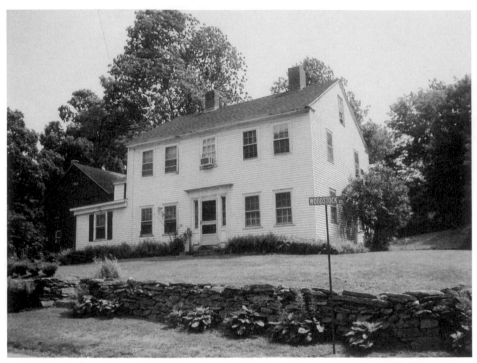

North Woodstock, Connecticut. Free-standing, four-over-four Georgian plan, with Greek Revival entryway. Thomas Paradis.

The row house concept originated in seventeenth-century England. The British were increasingly attracted to parks and greenery by 1700, and new suburbs were already under construction to enable an escape from the filthy, industrial English city. The brick row house became the predominant choice within these newer and greener suburbs, many of them decorated with the latest Georgian-style ornament named for the era of King George III. Combined with new building codes and urban design regulations resulting from the Great London Fire of 1665–1666, the Renaissance-inspired row house became a distinctly English phenomenon. Predictably, as the English colonies in America grew in population and influence, so too did the Georgian row house, which likewise became the standard building tradition in the American colonies during the 1700s.

Widespread dissatisfaction with the row house appeared during the 1820s as the Renaissance Georgian mode gave way to the more nationalistic Greek Revival style and its ideological trappings. The simplest way to comply with the newer Greek Revival was to rotate a row house 90 degrees with the gable end facing the street, thereby creating an instant temple-front facade. In growing western cities (in today's Midwest), the standard row house landscapes emerged as one might expect, but instead with their gable ends facing the street. Many were free-standing without shared walls, honoring the new Greek Revival protocol. By the time Chicago boomed in the 1850s, nearly all of that city's houses were built gable-to-street (Ford 1994).

New Englanders, for their part, began to experiment with free-standing, wood houses as early as the American Revolution. Only a short distance inland

from the coast, New Englanders abandoned the traditional urban row house, instead preferring free-standing houses on spacious lots. Pennsylvania towns still appeared distinctly European right up until the Civil War, but the New England village had begun to assume an open and countrified appearance (Lewis 1990). New Englanders further adopted the Greek Revival with much fervor, building entire interior villages and towns with classical temples and free-standing, clapboard houses. They went so far as to name new interior settlements with Greek names such as Ithaca, Brutus, Syracuse, Athens, Sparta, and Cincinnatus, to name a few. Interestingly, Americans everywhere west of the Appalachians took up the New England model in the pre–Civil War decades, given plenty of wood and land. House construction has followed this model ever since, widely promoted for early Civil War–era suburbs by advocates including Andrew Jackson Downing and Catherine Beecher. Still, as the Fort Sumter incident opened the Civil War, the bulk of American housing still consisted of urban row houses (Ford 1994).

During the 1860s and 1870s, several converging factors enabled the expansion of housing styles and forms. The commuter railroad, omnibus, and horse car expanded the range of urban residential neighborhoods at the periphery, and increased the amount of free time gained from shorter working hours. Leisure and recreation became possible, or at least within reach, along with the tending of private gardens. Americans were learning to spread out in their determined effort to escape inner-city congestion and perceived urban ills. Coupled with the existence of the lawn mower after the 1840s was a multitude of guide books promoting suburban and country life styles, especially from the likes of Beecher and Downing. These postbellum decades represented no less than a revolution of housing and urban spatial change in America, and the long-standing tradition of the row house essentially saw its final days with the close of the Civil War. The American dream of a free-standing house on a country lot within commuting distance of the urban center became a reality for more Americans, and the Victorians that promoted this new dream looked back with only disdain to the antiquated era of the row house.

THE TENEMENT CHALLENGE

As white, middle- and upper-class families bolted from the city for the suburbs after the Civil War, the bulk of overcrowded, urban poor and immigrant populations remained to occupy older row houses and newer tenement buildings. The most common type of accommodation for lower-income residents after the Civil War became the tenementized house, or tenement. At the same time, older Georgian row houses initially built for wealthy families were filtered down and converted internally into low-income residences. The density of the lower-class urban population continued to increase as row houses were subdivided further. Serious health issues emerged as even the alleys filled with new tenements. Families were fortunate if they had one or two rooms to themselves, though sometimes new connecting stairways invaded what little private space they had. Cellars designed for cooking or canning remained dark and damp, and these spaces soon became the incubators for tuberculosis and high infant mortality.

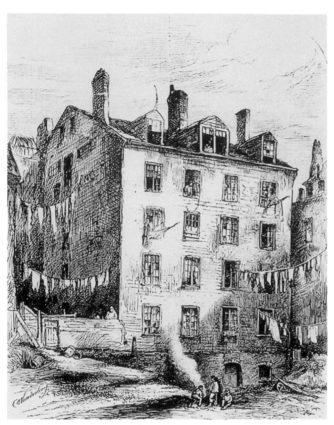

A tenement house on Mulberry Street, 1873. Courtesy of the Library of Congress.

The problem of urban overcrowding—particularly in New York—was recognized as early as the 1830s. Very little was done to relieve the problems that overcrowding exacerbated. However, it is important to understand that overcrowding was itself a byproduct of larger economic and social forces. Economic growth fueled by industrialization meant that very large houses could be built on a wide scale, leading to a rather formulaic development of tenement buildings throughout the middle and late nineteenth century. Tenements were built in increasing numbers after the 1840s in an attempt to satisfy the growing demand of urban newcomers, especially those shifting from country to city in search of factory work and newly arrived immigrants seeking quick and inexpensive accommodations (Jayne 2005).

New York City provides a typical story of inner-city transition. Prior to the introduction of tenements during the 1850s, urban housing had been designed for affluent capitalists and their families who lived close to their places of work. Gradually, these elite populations shifted to the booming suburb of Brooklyn, allowing their older housing to filter down to the working class, converted into multitenant housing. Thus, as Larry Ford (1994) points out, many of the innovations in multiunit and multifamily housing, including high-density residential construction, occurred in New York prior to the Civil War. Ford (1994) described the first purpose-built tenement buildings as little more than speculative boxes loaded with people, the structures sometimes covering 90 percent of the lot, with perhaps 18 rooms per floor. Only the front and back rooms of these so-called railroad tenements might enjoy some access to outside air and light. These buildings earned the term *railroad tenements* because their standardized, narrow corridors with strings of rooms resembled the interior space of a passenger railway car (Ford 1994). Even small, interior air shafts added occasionally by the 1860s were considered a significant improvement. Interior water closets and piping became common in new construction by the 1850s, though the wash basins and toilets were typically placed in the cellars for communal use.

By 1865, New York alone hosted more than 15,000 tenement buildings (Ford 1994). Journalist and author Walt Whitman, for one, expressed outrage at the overcrowded tenement conditions in New York City. He thus became a

fierce advocate for home ownership and believed that every American family should be able to enjoy a separate home. He wrote, "A man is not a whole and complete man unless he owns a house and the ground it stands on" (Handlin 1979, 69). Whitman promoted the idea of constructing "model lodging houses" that would provide more space, adequate lighting and ventilation, and sanitary facilities—in all, providing sufficient accommodation for families on modest budgets. Both middle-class families and the working population would benefit from such improvements, he imagined. The idea of designing improved housing was still novel in 1860, however, and effective change would require decades rather than years. Still, the call grew louder from spokesmen such as Whitman for increased home ownership.

The notion of home ownership had gained popularity by 1860 in part because Americans were unimpressed with the alternatives. Science had never established convincing conclusions about direct relationships between crowded tenements and various social and health problems, but housing reformers made it increasingly clear to the public that overcrowded tenements would only serve as breeding grounds for disease, crime, and prostitution. Reformers consequently promoted new legislation that would force landlords to take better care of their tenement buildings and to encourage healthier construction designs (Handlin 1979). In 1876, Frederick Law Olmsted identified New York's urban geographical characteristics that, he claimed, limited the opportunities for better multiunit housing. The rectilinear grid system of city blocks, for instance, limited the placement of all buildings to only one orientation. Further, access to back yards was inadequate, and a 100-foot deep lot was too large for just one inexpensive home. These lots had therefore been typically arranged with a large building covering most of the lot with one or more smaller houses behind it. Such close proximity of buildings on the same lot discouraged the use of windows or alleys with sufficient lighting.

Though slow in coming, political pressure increased to improve urban housing. The landmark Tenement House Act of 1867 legally defined the tenement as a residence with three or more unrelated families living independently of each other. More important, the law mandated certain requirements, including fire escapes and a maximum of 20 people per water closet. Still, such regulations were difficult to enforce. Alfred T. White, for one, attempted to answer the call for improved housing by forming the Improved Dwellings Company in 1876. White envisioned the construction of model tenements with enhanced lighting and sanitary conditions. The company's Home Building on Hicks Street, Brooklyn, became the prototype, built in 1877. The Tower Apartments on nearby Baltic Street soon followed in 1884, with additional projects completed during the successive 15 years. Leland Roth (2001) described these projects collectively as one of the earliest efforts to create decent public housing in the United States. Though inspired by social concerns, White's housing projects were still designed to turn a modest profit for their investors. Delivering as promised, the projects generated 5–7 percent returns on their investments, teaching other builders that decent tenement housing did not necessarily have to be constructed at an economic loss.

Concurrent with White's projects was an innovative competition announced by the *Plumber and Sanitary Engineer* publication in 1878. Its aim was to improve the tenement by overcoming the geographical constraints of New York's

city lots. Contenders were required to meet some basic conditions, including a design that fit on a 25- by 100-foot lot that could produce a modest profit while housing at least 20 rent-paying families. The magazine received 206 entries from the United States and Europe. The winning entry was submitted by James E. Ware for his so-called dumbbell apartment, due to its resemblance to a weightlifter's dumbbell when viewed from above (Roth 2001). The design had the building extending far back onto the lot with 14 rooms per floor, 7 on each side of a central dividing wall. Each of the five or six floors could accommodate four families (Handlin 1979). Both sides of the building were indented inward (creating the dumbbell shape) allowing for a narrow shaft of air and light to reach 10 of the 14 rooms on each floor. This rather innovative floor plan came none too soon, given the continued influx of ever-more European immigrants into crowded eastern cities. The boom years of the 1880s encouraged the construction of thousands of dumbbell tenement buildings. By 1900, New York City had more than 80,000 total tenements housing some 2.3 million people, comprising three-fourths of the city's entire population (Ford 1994).

The dumbbell plan was built into the Tenement House Law of 1879, mandating construction of tenements that covered only 65 percent of their lots while adopting floor plans similar to Ware's (Roth 2001). Though a welcome improvement to the tenement housing scene, the dumbbell's total impact was minimal. The new style represented only a fraction of existing tenements, as much urban housing remained overcrowded with insufficient light, ventilation, and sanitation. Further, the air shafts easily conducted noise and smells—and fire—to different floors (Handlin 1979).

Whatever its design, the tenement building remained the predominant form of urban housing in America, roughly between 1860 and the 1920s. It had become difficult to differentiate between tenements and apartment buildings by the 1920s, however, as the latter term came to represent any form of rental housing. The tenement building as both concept and building form therefore belonged to the nineteenth century, though much of this housing survived well into the twentieth and continues to house urban dwellers into the present day, often through renovation projects leading to gentrification of older neighborhoods.

COMPANY HOUSING

Despite moral teachings of the Victorian Era, the economic growth of this period was justified through a philosophy of Social Darwinism, or the "survival of the fittest." This was the new age of "Robber Barons" most interested in maximizing profit and securing individual wealth. Industrial companies and the entrepreneurs who operated them generally showed little concern for the effects of their own actions on others, or for the rapidly increasing income gap. Some industrialists realized, however, that it was in the best interest of their enterprises to provide a minimum set of amenities for their employees, even if the primary aim consisted of preventing labor strikes or forestalling unionization altogether (Roth 2001). Companies moved beyond designing their own employee housing to create entire towns and communities by the 1870s. New England, for instance, saw a number of initiatives toward company housing and industrial towns. In Hopedale, Massachusetts, the Draper

Company established a loom manufacturing business by 1856, followed with worker row houses during the 1870s and duplexes the following decade. Other company towns followed suit, including the S. D. Warren Company at Cumberland Mills, Maine, and the Willimantic Linen Company with its Oakgrove housing group at Willimantic, Connecticut. This trend toward company-built towns and housing marked a shift away from urban tenements, eventually to the construction of individual homes. The strategy was to generate rental income for the company while hopefully reducing the transience of employees through the improvement of living conditions.

A discussion of company housing would not be complete without considering Pullman, Illinois. Located 12 miles south of Chicago on Lake Calumet, George M. Pullman built an entire community for his employees and their families, including houses, parks, recreational space, retail, churches, library, and a music hall (Roth 2001). Completion of the community required five years, from 1880–1884. In 1885, Richard T. Ely published a study of the new town in *Harper's Monthly* titled "Pullman: A Social Study." Ely was clearly enthused about the architectural standards, street layout, landscape aesthetics, and community services housed in stylish structures—quality design and housing features expected more from middle-class suburbs than from company towns, but he was "less complimentary of the town's social conditions and its operating rationale," reminding his readers that all investments in housing and aesthetics were designed deliberately to maximize economic returns for George M. Pullman. Noting that a large part of the town was owned by the Pullman Palace Car Company, the working families were denied the ability to own their own land and homes. While praising George Pullman for raising the standard of worker housing in company towns, Ely ended with a scathing assessment of the Pullman town as "un-American." The place represented an "absolute power" of capital and the "repression of all freedom." The characteristics of Pullman noted by Ely were emphasized eight years later when workers' wages were reduced in 1893 but rents remained high. The ensuing workers' strike and riot necessitated the involvement of federal troops and, according to Leland Roth, discredited the idea of company towns across America (Roth 1983). The prevailing concern for generating corporate wealth ultimately won out over the needs of employees, leading to an increasing public distaste for corporate-controlled communities.

ARCHITECTURE OF THE VICTORIAN ERA

Technically, the Victorian Era in America and Europe coincided with the lengthy reign of Queen Victoria in England, from 1837 to 1901. As many as a dozen distinct architectural styles appeared that could be described as Victorian during this era, many of which became fashionable for new suburban homes. Nearly all of these Victorian styles had in common their roots in the eighteenth-century Picturesque movement in England, inspired in part by various French landscape painters such as Claude Lorraine and Nicolas Poussin (Foster 2004). English landscapers promoted the picturesque ideals of situating residences within their natural environments, taking advantage of topographical and physical diversity in the landscape. This orientation to the unpredictability of natural surroundings led to asymmetrical, irregular floor plans that deviated

markedly from the previous symmetry of Classical Renaissance traditions. The Gothic Revival style of the 1830s, for instance, encouraged expressive detailing that could compliment the natural setting, in contrast to Renaissance-inspired classical designs associated with formal, geometric gardens. By the 1840s, picturesque styles and landscaping had gained popularity and competed successfully with the classical designs of Thomas Jefferson's Greek Revival. Americans looked primarily to Victorian England for cultural and architectural inspiration throughout the remainder of the nineteenth century.

The Victorian Era was further a time of great romanticism. Whereas the Renaissance Classicism of the former century had stressed intellect, reason, and formality, romanticism was appealing for its attention to imagination that evoked mystery, passion, and nostalgia. This shift toward romantic and picturesque sentiments led to the rediscovery of medieval European architecture that became a favorite for Victorian proponents on both sides of the Atlantic. Early Victorian styles, especially Gothic Revival and Italianate, represented direct reflections of the picturesque, a romantic perspective that celebrated the variety, texture, and unpredictability found in nature (Carley 1994, 134). Though each style was unique and favored one or two design elements over others, they tended to include one or more medieval combinations of multicolored or textured walls, asymmetrical facades, steeply pitched roofs, multiple gables and dormers, bay windows, and cantilevered overhangs. This was an era of increasing architectural experimentation and extravagance that continued unabated into the early twentieth century (McAlester and McAlester 1997).

Numerous factors enabled the predominance of the picturesque suburban ideal in America. Balloon frame construction techniques, with light, 2-inch boards and wire nails, allowed for more economical and efficient construction than did the bulky timber frame, in turn enabling more creative floor plans suitable to the Picturesque. Houses were freer to include numerous corners, wall extensions, overhangs, and irregular floor plans. Americans were no longer constrained to boxy, rectangular-shaped houses. Interior innovations and technologies contributed to the new diversity of floor plans, such as cast-iron stoves, which replaced inefficient fire places. Larger rooms could be built, farther from the heat source. Promoting this new variety of Victorian styles and plans was an emerging coalition of land development interests that hastened the sale of peripheral, suburban land and distributed fashionable house plans through a large selection of printed literature. Allowing for the consumption of such property was the emergence of new capitalist and associated middle-class populations who increasingly desired to escape the crowded confines of the city.

Innovative tools such as the scroll saw allowed for the proliferation of complex house components—doors, windows, siding, roofing, detailing—that could be produced cheaply and shipped virtually anywhere over America's expanding rail network. As the same published design books and mass-produced building parts spread from coast to coast, previous regional distinctions became more subtle. By the 1890s, prefabricated construction materials for new Queen Anne-styled houses were being transported efficiently by rail across the nation (Jayne 2005). Reflecting the ever-widening income gap between rich and poor, the Victorian Era showcased this uneven distribution of wealth as elite country suburbs with picturesque homes contrasted sharply with tenements that housed the urban working class.

Decorative extravagances reached new heights with the progression of the Victorian Era. Houses built with multiple gables, dormers, parapets, turrets, pinnacles, oriel windows, and patterned siding became visual expressions of the excess wealth generated through the process of industrialization. Homes were adorned to the fullest extent possible with wooden gingerbread, cast-iron detailing, decorative quoins and colored glass, and wood trim painted in any variety of bright, contrasting colors (Williams and Williams 1962).

The American Victorian Era included numerous secondary styles and movements, all of which are now incorporated under the broad heading of Victorian. Much like clothing fads that come and go with changing tastes and cultural values, the Victorian styles overlapped in date and rarely had specific beginnings or ends. Many buildings exhibited a combination of two or more stylistic themes, further complicating the analysis of nineteenth-century architecture. All disclaimers aside, however, some broad generalizations of the chronological sequence of Victorian Era styles can help make sense of how architecture progressed during this period.

The romantic styles of the Gothic Revival and Italianate appeared in force by the 1840s, promoted heavily by Downing and his contemporaries. The Stick style and even more popular Second Empire style became dominant through the 1860s and 1870s, while the late nineteenth century produced the Queen Anne, Eastlake, Romanesque Revival, Shingle, and Colonial Revival styles. At same time, more exotic Egyptian and Asian elements were sometimes added, and imitations of Swiss chalets and octagonal building plans only enhanced the eclecticism of the time (Jayne 2005). The remainder of this chapter focuses on the predominant architectural trends that influenced American housing, especially between 1861 and 1880.

DOMESTIC VICTORIAN STYLES

Gothic Revival (1840–1880)

Often considered the earliest of the Victorian styles, the Gothic Revival was inspired by the innovative Gothic cathedrals constructed in England and France between the twelfth and sixteenth centuries. This was the first style in America to successfully challenge the entrenched Greek Revival Classicism. The term *Gothic* was actually invented at the end of the original Gothic period as a derogatory reference to an outdated style that its detractors believed was as primitive as the Goths (Foster 2004). With the Picturesque movement underway by the late 1700s, the Gothic was rediscovered with a newfound appreciation for its asymmetrical designs suitable for informal, romanticized landscaping. The Gothic Revival can be dated to England in 1749 with the remodeling of a country house in the medieval style by Sir Horace Walpole, including the Gothic features of battlements and multiple pointed-arch (lancet) windows. Picturesque Gothic houses then became common in England during the next century (McAlester and McAlester 1997). Prominent Americans eventually learned of the English revivalist trend, including landscape gardener Andrew Jackson Downing who was much impressed with the Gothic style.

Prominent identifying features of the Gothic style in America included vaulted ceilings, battlements (or "castellated parapets"), and lancet-arched windows—all of which suggested a romanticized interpretation of the distant medieval past.

The style became suitable by the 1840s for brownstone, urban row houses but became most commonly applied to large country villas and small cottages. This was also the first house type in America designed specifically for the middle class. Innovative tools such as the scroll saw, or jigsaw, allowed for exuberant wood trim that further encouraged the style's creativity (Carley 1994).

The first documented and fully developed example of the Gothic Revival in America was designed by Alexander Jackson Davis in 1832. Davis was the first American architect to promote the use of Gothic styling for suburban country homes. In fact, his 1837 book, *Rural Residences,* was dominated with Gothic examples. This was the first house plan book published in America, and the first to include three-dimensional views with floor plans. Davis' friend Andrew Jackson Downing picked up on his ideas and expanded them for successive pattern books in 1842 (*Cottage Residences*) and 1850 (*The Architecture of Country Houses*). It was Downing who therefore promoted the Gothic style most effectively (McAlester and McAlester 1997). As Downing learned more about the style, he discouraged architects from limiting themselves to the boxy forms of Greek temples, arguing for freer, more picturesque expressions of design.

Contributing to the rise of the Gothic Revival in America were the novels of Scottish poet and writer Sir Walter Scott (1771–1832). Scott's romantic novels provided a nostalgic perspective on the Middle Ages, specifically through the imaginations of a highly idealized medieval Britain. During a time of early and rapid industrial change and technological innovations in America, the romantic stability of the Middle Ages became quite appealing to those yearning for the past (Loth and Sadler 1975). The Gothic Revival therefore increasingly became the style of choice. One regional exception to this trend was in the Deep South, where examples of Gothic Revival plantation houses were rare. Instead, planters preferred the popular Greek Revival homes up through the Civil War, apparently most suitable for hot and humid climates with their airy porticos.

The earlier phase of Gothic Revival evolved into a uniquely American variety. Unlike the academic "correctness" expected of the Classical styles, the more practical and picturesque Gothic lent itself to vernacular experimentation. The Gothic style was quickly adapted for light, wood-frame construction, often with vertical board and batten siding. This uniquely American wooden variety became known as Carpenter Gothic. Wood construction allowed for the use of patterned bargeboard, decorative trusses, and ornamental porches. Downing and Davis encouraged more modest, smaller houses known as "picturesque cottages" that lacked even the extravagant detail of the Carpenter Gothic. Whatever the variation, the Gothic Revival spread nationally, though less commonly in the South, and usually for rural or suburban homes. Although it lost favor after the Civil War, it re-emerged as High Victorian Gothic later in the century (Foster 2004). This later phase of the Gothic Revival gained prominence between 1865 and 1880, featuring decorative polychrome patterns produced by bands of contrasting color or texture in brick or stonework. This High Victorian Gothic variation was most commonly used for churches and public buildings. After 1865, bargeboards were less popular, often replaced by decorative trusses at the apex of gables.

Although the Gothic style became less popular for domestic architecture following the Civil War, the style held its own for public institutions, such as

colleges and state houses, which adopted the later phase of High Victorian Gothic. Architects favoring the new Stick style in the 1870s frequently used Gothic elements, and American churches continued to use Gothic styling right up until World War II.

Italianate and Italian Villa (1830–1880)

Americans imported another style from England, referred to generally as Italianate, sometimes distinguished from its predecessor, Italian Villa. Both were inspired initially by Renaissance Era villas and manors found in northern Italy, and they became popular not long after Americans began their love affair with the romanticized Gothic Revival. While the Gothic remained popular up to the Civil War period, Italianate became the dominant style for American houses and townhouses between 1850 and 1880 (Calloway 2005; McAlester and McAlester 1997). Americans created highly romanticized versions of villas of Tuscany, Umbria, and Lombardy. Italianate was especially common in the expanding midwestern states and in older northeastern cities, and the romantic style became widely popular in San Francisco,

> ### *Ruskin's Seven Lamps and Venetian Gothic*
>
> High Victorian Gothic was essentially a reinterpretation of the earlier Gothic Revival from the 1840s. One of the more influential prototype structures representing this later Gothic interpretation was the All Saints' Church in London (1849–1859). Holding true to its picturesque origins, the Church exhibited an unorthodox, irregular plan decorated with an extreme polychromy on its brickwork and interior. The theoretical basis for High Victorian Gothic has its origins in the books of John Ruskin, namely *The Seven Lamps of Architecture* (1st ed. 1849), and *The Stones of Venice* (1st ed. 1851–1853). Ruskin stipulated seven conditions, or lamps, essential to great architecture. To paraphrase these conditions in brief, they included: "Sacrifice," through the creation of extensive and didactic ornament; "Truth," through an honest expression of materials; "Power," through the massing of structural forms; "Beauty," through observations of natural laws; "Life," through an expression of complex human activity; "Memory" through building for posterity; and "Obedience," through adherence to various Gothic styles, which incorporated all of the previous six conditions. All of these lamps were studied by American architects and taken quite seriously. According to Ruskin, the examples of Venetian Gothic found in Venice, Italy, would be most instructive for nineteenth-century architecture. Combined with the All Saints' Church prototype, Ruskin's theoretical underpinnings helped establish the Victorian Gothic style as a strong counterpart to the Second Empire Baroque during the 1860s and 1870s (Roth 1979).

where many examples survived the 1906 earthquake and fires. Similar to the Gothic Revival, however, Italianate homes were found least often in the South, due to the continued popularity of the Greek Revival and the construction slowdown associated with the Civil War and 1873 depression.

Like the Gothic, Italianate emerged in England as part of the growing Picturesque movement, reacting to the formal Classical ideals in art and architecture that preceded it. Early Italianate-styled houses were built in America during the 1830s and popularized by Downing's influential pattern books into the 1850s and 1860s. By the Civil War, Italianate had surpassed the earlier popularity of Gothic Revival and became the American style of choice until 1873. By the time housing construction resumed on a large scale in the 1880s, later Victorian styles, such as the Queen Anne, overshadowed the earlier popularity of Gothic and Italianate.

Italianate styling and floor plans were open to experimentation and flexibility, with accurate reproductions of Italian prototypes being less of a concern. Although considered a revival style, builders and designers rarely attempted

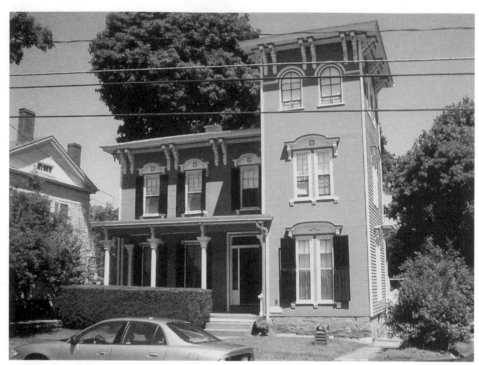

Windham, Connecticut, ca. 1850. Italian Villa style. Features include tall, narrow windows, massive paired brackets under the eaves, and protruding tower or campanile. Thomas Paradis.

accurate, or authentic, reproductions of Italian villas and farm houses. The Picturesque movement recognized the appeal of rambling, informal Italianate farm houses, sometimes with square towers or *campaniles,* as models for Italian-style villa architecture. In America, however, the Old-World prototypes were usually modified or embellished into an indigenous American Italianate style. For instance, pure and accurate Italianate townhouses were far less common than rural folk houses that resembled simple square and boxy plans with minimal Italianate detailing.

The Italian Villa style is usually grouped with Italianate, though the Villa was typically suited to more rural applications with its picturesque massing. In contrast, Italianate tends to be more formal and symmetrical, making it more suitable for urban and suburban building lots (Foster 2004). Overall, the Italianate style was designed to emulate the housing of the wealthiest families, but in America it was adopted at all levels of American society. Italianate detailing was also enthusiastically adopted for existing row houses, apartments, and older residences. The style reached its zenith, perhaps, in the brownstone row houses of New York City and elsewhere (Carley 1994).

The principal identifying features for the Italian Villa style (1830–1880) and the later Italianate style (1845–1880) are essentially similar, though the former typically exhibited more irregular, asymmetrical (i.e., picturesque) massing than did the latter. On both, the roof tends to be flat or low-pitched with wide, overhanging eaves. Large scrolled brackets, either single or paired, are found

under the eaves, often associated with an elaborate cornice. Doors and windows typically have tall and narrow proportions and are often arched or curved above. Windows can be grouped together and mounted within a decorative cornice. Square cupolas or towers were also common, though the tower (*campanile*) is associated more with the Italian Villa. Italianate detailing was typically applied to boxy-shaped buildings as an ornamental form, while the Italian Villa was a distinct, irregular form designed specifically for that style. Some consider the Italian Villa style to be the transition between Gothic Revival and Italianate (Calloway 2005; Foster 2004; McAlester and McAlester 1997).

Second Empire (1855–1880)

Though still considered Victorian and picturesque, the Second Empire style actually represented a modern expression of Classical symmetry and order. The style did not focus on historical revivals as with the Gothic and Italianate, but rather found its inspiration in contemporary architecture and planning of mid-nineteenth-century Paris. The mansard roof became the identifying feature of the style, named for France's Second Empire during the reign of Napoleon III (1848–1871). The roof style had been introduced on seventeenth-century buildings designed by French architect Francois Mansart, once again making a comeback with Napoleon's ambitious revitalization of some 60,000 buildings in Paris between 1852 and 1865 (Foster 2004). Most notable were the additions to the Louvre in Paris between 1852 and 1857, whose architects created a new, modern style that broke away from a mere historical interpretation of the earlier French Baroque. Consequently, architectural historians refer to this nineteenth-century version as Second Empire Baroque to distinguish it as a more modern style not simply considered a revival (Roth 1979). The Louvre served the French government through its numerous functions, including palace, art gallery, government house, and museum. More than any other, it was the renovation of the Louvre, coupled with the Paris exhibitions of 1855 and 1867, that invited international attention on the city of Paris and inspired the Second Empire style in America.

Aside from England's ubiquitous influence on American architecture, it was Paris that enjoyed its status as the artistic capital of the western world prior to and during the time of Napoleon's Second Empire. Baron Haussmann had redeveloped the streets of Paris with his now-famous system of boulevards and public areas. France further led the West with its prominent and systematic educational system for aspiring architects, providing an innovative and specialized curriculum in architecture since the early nineteenth century (Bunting 1967). The French student, for example, was required to complete one year in a government drawing school and an additional one or two years in a private "atelier"—specifically to prepare for the demanding entrance exams of the École des Beaux-Arts (School of Fine Arts).

During the 1860s, Boston was considered the artistic and intellectual capital of the United States, gaining many of its innovative architectural ideas from Paris and the École (Hammett 1976). Henry Hobson Richardson, known for his innovative Romanesque Revival style in America, was perhaps the best known of Boston's students to attend the prestigious École. It is no surprise that Boston's architectural practices and trends became closely tied

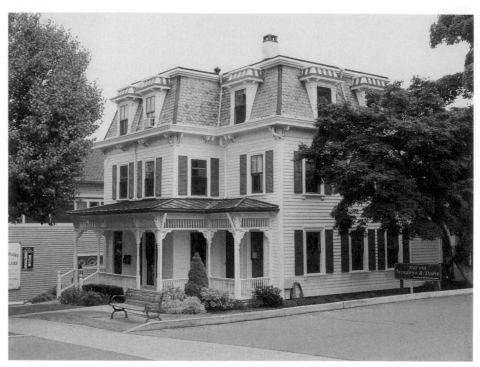

Branford, Connecticut. Second empire-style home with Italianate massing and the requisite Mansard roof. Thomas Paradis.

to those of France during this time. Boston's Back Bay area, for one, played host to a prominent early set of Second Empire houses. Further, Boston's Hotel Pelham closely resembled the modern French style with its formal, Classical features and especially its necessary mansard roof. Boston's first mansard structure was actually completed in 1848, the Deacon mansion, later demolished. At the time, the mansion exhibited what became the dominant characteristic features of the Second Empire style in the United States, given its projecting pavilions, mansard roof, and formal facade and gardens. As Bainbridge Bunting described the mansion, "whole rooms were brought from France to be reinstalled there and furniture and fabrics were imported 'by the boatloads'" (1967, 80).

By the 1860s, Boston had become well acquainted with the stylistic trends of the French Second Empire and consequently made prolific use of them. The mansard roof itself became a prominent symbol of modernity and was likewise heavily used in Boston's growing Back Bay neighborhoods. Stylistic trends of the Second Empire were so compelling by the 1860s that numerous town houses in the Back Bay were actually paired together allowing for the appropriate symmetry in their facades. One analysis of the Back Bay indicated that a full four-fifths of the houses there built between 1857 and 1869 were grouped in some manner, while 24 percent of them were specifically grouped in pairs (Bunting 1967). Paris' modern Baroque style of the Second Empire had clearly made an impact in America's urban cultural center.

The style in Paris featured Classical symmetry, an emphasis on horizontal layering, and a division into dominant *pavilions*—sections of the main facade

projected outward. The most characteristic feature, however, was the mansard roof. In America, this signature roof style provided good use of attic space by providing a full additional floor behind the sloping roof line. Second Empire thus essentially became a roof style more than anything else, as new or previously constructed Italianate buildings could simply be "topped off" with a mansard roof (Foster 2004). The style's real impact in America occurred after the Civil War, especially given the prototype influences of Alfred B. Mullett (1834–1890), supervising architect for the federal government. Mullett used the fashionable style for numerous government buildings across the nation, with one of the first being the State, War, and Navy Building (now the Executive Office Building) just west of the White House, built 1871–1875 (Roth 1979). More than any other, this building was given credit by Hitchcock, in his book *Architecture, Nineteenth and Twentieth Centuries,* for single-handedly setting off a national program of constructing public buildings with the style (Hammett 1976). Given its ensuing popularity, the Second Empire essentially became the "official" style for government buildings and railroad stations in America.

The first domestic examples of the style were built in the 1850s, though it wasn't until the 1870s when Second Empire became dominant for American middle- and upper-class housing. Demonstrating the lag time required for a style to become popular, Americans had made Second Empire their preeminent style for housing and public buildings well after Napoleon's actual Second Empire had been destroyed in the Franco-Prussian War of 1870–1871 (Walker 1981). Due to its popularity during President U.S. Grant's administration following the War, the style is sometimes facetiously referred to as the General Grant style (McAlester and McAlester 1997). By 1880, the style had faded in popularity, replaced by Queen Anne and other later Victorian styles to close out the nineteenth century (Carley 1994).

Some American designers retained the symmetrical planning of the Louvre, applying mansard roofs and projecting pavilions to otherwise simple, boxy buildings. Others applied its basic features to picturesque Italianate houses constructed in prior decades. Examples of the latter could essentially pass for versions of the Italianate style, including a combination of picturesque romanticism with asymmetrical massing and dramatic towers, still exhibiting various Classical detailing. The Second Empire version is mainly dependent on the additional mansard roof, which could appear in numerous shapes including convex, concave, straight, and S-curved slopes (Gelernter 1999). At the top and bottom of more elaborate mansards were massive cornices or "French curbs." The lower ones rested on a series of brackets while the upper ones were sometimes capped with cast iron cresting (Walker 1981). Regardless of the variations on the mansard theme, this prominent French feature ultimately made a significant impact on American architecture, both public and domestic, in the decades during and after the Civil War. Because the Second Empire Baroque was often a theme applied to otherwise Victorian, picturesque buildings, the style has come to be classified as Victorian.

Stick Style (1855–1875)

As the Second Empire asserted its influence in America, so, too, did the lesser-known Stick style, providing discriminating Americans with yet another

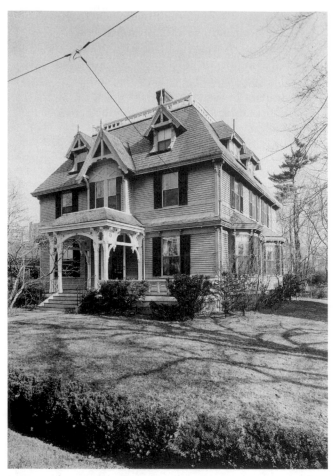

Frances M. MacKay House, 10 Follen Street, Cambridge, Massachusetts. This building is a fine example of a symmetrical Stick Style suburban house of 1870s. Courtesy of the Library of Congress.

Victorian option. Though relatively uncommon, this picturesque style is sometimes viewed as the transition between the antebellum Gothic Revival and the postbellum Queen Anne of the 1880s. Still other authorities consider it to be the wooden equivalent of colorful High Victorian Gothic. Regardless of its architectural relatives, the *sticks* of the Stick style consist of undecorated, milled boards applied to a building's facade, designed to resemble medieval half-timbering. It was Vincent Scully, a prominent twentieth-century art historian, who gave Stick style its name (Foster 2004). In his book *Modern Architecture,* Scully associates the style with "Romantic Naturalism—a movement which started about 1840, and went through several phases down to the present time" (quoted in Hammett 1976, 91). It is thus a product of the same Picturesque movement that inspired Davis and Downing to promote the Gothic and Italianate styles of the early Victorian Era.

The style is defined primarily through its exterior decorative detailing, including the prominent half-timbering stick work, but also multicolored or textured wall surfaces, roof trusses, and creative patterns of wood shingles and siding. Most of the better Stick style examples survive in the Northeast, constructed during the 1860s and 1870s. Townhouses exhibiting the style are still concentrated in San Francisco, reflecting the abundant supply of lumber that was favored for Victorian Era houses there (McAlester and McAlester 1997). The style grew initially from the Picturesque ideals of A. J. Downing and were included within house pattern books of the 1860s and 1870s. Downing had argued against the use of wood to imitate other building materials, claiming that it should instead be used for features designed specifically for wood itself: bargeboards, roof trusses, and half-timbering elements. The authors of pattern books adopted Downing's ideas, to the point where the style lost nearly all association with its medieval, historical inspirations, except for a vague resemblance to Tudor half-timbering (Loth and Sadler 1975). Downing's insistence on truthfulness in wooden materials, combined with the innovation of balloon-frame construction, led many architects and builders to expose important balloon frame elements for exterior visual effect. These

included asymmetrical, massive brackets under large roof projections, and, of course, the characteristic diagonal stick work made to resemble either half-timber construction or the exposed balloon frame (Walker 1981).

The style was apparently favored for resorts, exemplified on the prominent houses designed by Richard Morris Hunt (1827–1895) in Newport, Rhode Island. Hunt was one of numerous American architects influenced by the budding fascination for late medieval country architecture, including the elaborately decorated chalets of the Alps and half-timbered cottages of Normandy and Tudor England. Variations on the so-called Stick style had appeared across the nation by the 1860s, remaining relatively popular for domestic architecture in resorts, suburbs, and small towns well into the 1870s (Carley 1994). The Michigan pavilion at the Philadelphia Centennial perhaps reflected the height of the Stick style's popularity in 1876. The elaborate wood structure was designed specifically to draw attention to and celebrate Michigan's lumber industry. True to its inspiration, the pavilion was constructed entirely with Michigan lumber and exhibited an excellent example of the style. It was then promptly sold and dismantled after the fair (Hammett 1976). Another notable example was found in Hunt's J.N.A. Griswold house, built in Newport, Rhode Island in 1862. This elaborate structure combined the influences of numerous inspirations and places, including medieval English half-timbering, Gothic Revival, Carpenter Gothic, and Swiss Cottage modes of design and construction (Walker 1981).

The Griswold house and its Newport neighbors reflected the growing trend for industrialist millionaires of New York and Boston to retreat to summer cottages. New summer social capitals were growing in number and status, first in Long Branch and Elberon, New Jersey during the early 1870s, followed by Newport, Rhode Island by the end of the decade. Architectural historian Leland Roth attributes the emergence of the Stick style in such summer resort towns as a product of the ability for wealthy clients to experiment with unconventional building designs. Millionaire clients referred to their summer mansions as cottages, pretending humility and simplicity. Their generous budgets allowed architects to experiment with new methods of floor plan configurations, interior and exterior designs, and spatial configurations that were later adopted by other architects (Roth 2001). The results were highly irregular, asymmetrical plans and forms, combined with exterior surfaces exhibiting a variety of surfaces and varied textures. Roofs were likewise varied and complex, often with steep pitches and interrupted with a variety of dormers.

Through these Stick style mansions, therefore, came an even greater application and exaggeration of picturesque, countrified ideals that had emerged and spread nationally several decades earlier. Houses only became more complex in form and design and more picturesque than those imagined initially by the likes of Downing and Davis. The conspicuous consumption of the Gilded Age was now in full swing, a product of the ever-widening income gap provided by the Industrial Revolution. The romanticized, Picturesque movement that had rejected change and industrialism had inspired styles that reflected a simpler past, including those of the Gothic, Italianate, and Stick. In no small amount of irony, however, it was ultimately the wealth generated through industrial growth itself that enabled the full expression and flowering of the otherwise romantic Stick style.

Romanesque Revival (1870–1900)

The final wave of Victorian Era styles gained full prominence by the 1880s and 1890s. Still, certain styles emerged through earlier inspirations during the 1870s. One case is found in the beginnings of the Romanesque Revival style. This style is also commonly referred to as Richardsonian Romanesque, so named for the unparalleled influence of its founding Boston architect and promoter, Henry Hobson Richardson (1838–1886). Born in Louisiana, Richardson attended Harvard but was drawn to France to study architecture at the École. He studied for two years in the atelier of Jules-Louis Andre, before his family cut off his financial support due to the Civil War. He then found work for four years in the office of Theodore Labrouste. This combination of academic and practical training provided him with the best of the French architectural discipline. He then returned to the United States in 1865 and established a practice in New York, which led to a collaboration with Fredrick Law Olmsted (Roth 1979). Two of his architectural projects especially propelled his career, namely his Trinity Church in Boston (1872–1877) and a summer house for William Watts Sherman (1874–75) in Newport, Rhode Island. Richardson used contemporary English work to guide his design of the Sherman house, including that of Richard Norman Shaw. Richardson's plan was more spacious, however, providing a large central hall surrounded by a cluster of rooms (Roth 2001). This is considered by historians to be the beginning of the Shingle style, more heavily influenced later by McKim, Mead, and White.

The style named for Richardson himself, however, is owed to his winning an 1871 competition for the design of Trinity Episcopal Church in Boston. Out of this prototype sprung a Romanesque Revival style that quickly gained popularity and was soon used for the designs of churches, public buildings, and elite residences. Richardson's indigenous version of the Romanesque supplanted the popular Second Empire style nearly overnight (Hammett 1976). Unfortunately, Richardson died prematurely at the height of his and his style's popularity in 1886. Though he designed numerous buildings prior to his death, Trinity Church is considered to be his masterpiece, having become a model for numerous public buildings nationwide. Many architects adopted the heavy masonry style for civic buildings, churches, railroad stations, and residences up until about 1900 as the sun set on the lengthy Victorian Era in America.

The original Romanesque architecture from which Richardson took his cues had been the dominant form and style of Catholic Europe prior to A.D. 1200. With its thick, masonry, round-arched construction, the style varied regionally. It was the variation found in southern France that most attracted American architects due to the decisive Roman influence. A few American churches and institutional buildings—including the original Smithsonian Institution in Washington, D.C.—had adopted a revival of the Romanesque style prior to the Civil War. It was Richardson, however, who created his own interpretation of the style that gained wide popularity. His uniquely American version of Romanesque relied on heavy, massive construction with brick or stone—or both—and was most suitable for grand public buildings and churches. The style in its full expression was typically too expensive for average home owners

and builders, leaving the style reserved more for the mansions and townhouses of the upper gentry class (Foster 2004).

Richardson's style relied on massive, masonry construction, punctuated with wide, low arches, thick walls, and cavernous entryways. The rounded arch was ubiquitous, used around grand entryways or smaller upper-story windows and parapetted dormers. The massive, load-bearing walls were often measured in feet instead of inches. There were frequently two or more colors or textures within the stone or brickwork. A wide, round arch was the key identifying feature. An imposing, round tower was occasionally added to one or more corners of the structure. Windows and doors were typically recessed deeply and surrounded by round arches.

Richardson borrowed from numerous sources in addition to Romanesque prototypes. For instance, his arches are frequently not Romanesque but Syrian, reflecting an early Christian form of archway rooted to the ground level rather than from supporting pedestals (McAlester and McAlester 1997). Regardless of his inspiration, Richardson created the first truly indigenous American architectural style that was actually taken seriously in Europe.

Additional Victorian Styles and Revivals

A more distinctive style than Romanesque Revival gained attention especially for domestic buildings during the 1870s and 1880s, known simply as Eastlake, credited to Charles Locke Eastlake. Well known in his home country of England, Eastlake was an interior designer, writer, and so-called taste-maker, having become best known for his book *Hints on Household Taste,* first published in London in 1868. An American edition that became even more popular was published in 1872. Eastlake abhorred heavy and oversized mid-nineteenth-century furniture and consequently provided numerous lighter designs making use of straight, wooden elements adorned with scroll-sawn decorations and delicate wooden ornament. Eastlake also promoted a focus on the natural colors and textures of materials. With his own designs finding their way into various house plan books, Eastlake's style proved especially popular in California, not the least being San Francisco, though he actually described houses on the West Coast bearing his own designs to be "extravagant and bizarre" (Roth 2001, 239).

A number of exotic architectural revivals also appeared during the mid-Victorian Era, often incorporated into Picturesque, romantic houses. Decorative ornament was occasionally applied to otherwise Victorian homes, hinting at Egyptian, Oriental, or Swiss Chalet designs. These three styles in themselves were relatively rare and were thus treated as subunits of a single Exotic Revival movement. Once again, Americans followed Europe's lead, with Egyptian and Oriental versions modeled after similar designs in Europe. The Swiss Chalet style was a romanticized adaptation of contemporary Swiss domestic building practice. As for the Egyptian revival, it was a rather uncomplicated task to insert Egyptian columns on otherwise Victorian Era houses. Oriental styling was most frequently found attached to Italianate style, boxy structures with ogee arches, oriental trim, and occasionally a Turkish (onion) dome. A Chalet-style house, by contrast, would typically exhibit low-pitched, front-gable roofs, broad overhanging eaves, and a second-story porch balcony with a wooden balustrade. Such Swiss-inspired

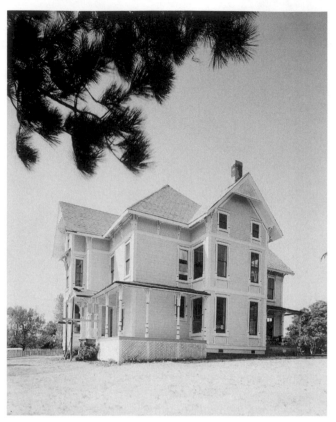

Eastlake-influenced house. Crooks House, 285 West G Street, Benicia, California. Courtesy of the Library of Congress.

designs were actually introduced to America once again by Downing's 1850 pattern book, *The Architecture of Country Houses*. In this book Downing provided Swiss models he felt most appropriate for "bold and mountainous" sites (McAlester and McAlester 1997, 231).

Perhaps even more innovative was the idea of creating eight-sided houses and barns known as octagons. In 1848, Orson Fowler (1809–1887) published *A Home for All*, in which he promoted numerous claimed benefits of constructing buildings in the shape of an octagon. Fowler argued that octagons enclosed more floor space per linear foot of wall than the usual square or rectangular shapes used for rooms. Such homes would therefore prove to be less expensive. The octagon shape further allowed for improved sunlight and ventilation while eliminating, as he said, "dark and useless corners" (McAlester and McAlester 1997, 235). He also advocated indoor plumbing and central heating. Although he claimed to be the originator of the octagon idea, eight-sided buildings had already been variously used in numerous countries for thousands of years (Walker 1981). Still, his were among the first houses to offer hot and cold running water, filtered drinking water, dumbwaiters, speaking tubes, and even indoor flush toilets (Carley 1994).

Practicing what he preached, Fowler built his own octagon house in Fishkill, New York in the 1850s with all of these modern conveniences. Though considered relatively rare and on the fringe of national domestic architectural trends, thousands of octagon houses and barns were built nationwide, most around the 1860 timeframe. Most of them were two-story structures with low-pitched, hipped roofs and widely overhanging eaves. An estimated half of octagon homes also included a central cupola above the roof, and most had porches. Octagon houses were most prevalent in New York, Massachusetts, and in the Midwest. Nearly any popular Victorian Era stylistic treatments could be attached to their exteriors.

The Colonial Revival

The centennial of 1876 was a turning point for how Americans viewed their colonial and early American heritage. Prior to that, colonial building styles such

as the Renaissance-inspired Georgian and Federal were viewed as antiquated and obsolete, offering little to the modernizing society of the middle nineteenth century. A steady process of destruction ensued during these decades, with hundreds of colonial buildings razed to make way for more modern structures (Roth 1983). In the years between the War and the centennial, however, some prominent Americans gained a newfound appreciation for the apparently useless architecture of the previous two centuries. One pioneering architect who recognized the virtues of the past was the young Charles Follen McKim, who became a leading voice in what would become known as America's Colonial Revival. He was among the first of his profession to call for the preservation of rapidly disappearing examples of colonial architecture. Serving as the editor of the new *New York Sketch Book of Architecture* produced by Henry Hobson Richardson in 1874, McKim used its premier issue to invite colleagues to submit drawings or sketches of the "beautiful, quaint, and picturesque features which belong to so many buildings, now almost disregarded, or [of] our Colonial and Revolutionary period" (McKim 1874a, in Roth 1983, 232). In a following issue in December, 1874, McKim acknowledged the common reference to colonial architecture as "ugly," and promoted instead a new appreciation. He recognized that Americans favored more modern styles of the Victorian Era, oriented to design trends in Europe. Refuting the "ugly" characterization, McKim focused on the picturesque surroundings and instructive architectural features of colonial buildings—not the least being their solid construction allowing them to survive for one or two centuries. One could find a greater charm in such colonial architecture, he claimed, than in "most of the ambitious dwellings of the present day" (McKim 1874b, 45).

The colonial landscapes of New England became the favored locale for field studies, conducted by contingents of architects newly awakened to the positive traits of colonial buildings. McKim and a few colleagues took part in one such sketching tour of coastal New England, as did Boston architect Robert Swain Peabody on a separate expedition. Peabody's work resulted in a two-part article published in the *American Architect and Building News* in 1877–1878, in which he suggested that Americans should recognize the positive merits of their own colonial past as well as that of Europe. Following his article, titled *The Georgian Houses of New England,* the *American Architect* began to publish viewpoints and short entries on eighteenth-century structures (Roth 1983).

In his article, Peabody claimed that the English Queen Anne movement, which reacted disdainfully to earlier revivals, was actually yet another revival itself. He explained that the advocates of the fashionable Queen Anne style had shown disinterest in earlier revivals of Palladian art, Grecian architecture, and the more recent Gothic style, as they tended to characterize these earlier traditions as "lifeless imitations of the antique" (Peabody 1877, in Roth 1983, 236). Amusingly, Peabody pointed out that leading Queen Anne advocates—including Richard Norman Shaw—"admired and studied and sketched all the quaint old work they could find" (Peabody 1877, in Roth 1983, 238). Americans should therefore not be discouraged from looking at our own American past, asserted Peabody, to inform contemporary architectural design. He asked, "With our Centennial year have we not discovered that we too have a past worthy of study? . . . Our colonial work is our only native source of antiquarian study and inspiration" (Peabody 1877, in Roth 1983, 238).

This budding appreciation of colonial traditions gained more credibility with the centennial celebrations. In one respect, the centennial encouraged nostalgic feelings among contemporary Americans for their founding fathers and the presumed values upon which the new nation was built. Numerous patriotic societies were formed shortly thereafter, including the *Sons and Daughters of the American Revolution,* the *Colonial Dames of America,* and the *Society of Mayflower Descendants.* A newfound interest in genealogy arose, in part due to the centennial, but also as a social reaction to increasing numbers of non-British immigrants flooding into American cities at the time. Rybczynski (1986), therefore, views the Colonial Revival as an invented tradition, in that Americans created a romanticized, nostalgic image of the Pilgrims and the so-called founding fathers, which in turn became materialized as Colonial Revival architecture. The intensity of interest in America's early national heritage continued to grow through the nineteenth century and into the twentieth. Domestic (i.e., residential) architecture represented the first dominant manifestation of revived Georgian, Federal, and Classical styles, with the Colonial Revival gaining full force by 1885 (Roth 2001).

Boston's Back Bay as Architectural Record

In 1967, Bainbridge Bunting published a remarkably thorough analysis of the sequence of architectural history in Boston's Back Bay residential district. Titled *Houses of Boston's Back Bay: An Architectural History, 1840–1917,* the book details the architectural evolution of housing that ultimately shaped the Back Bay landscape. Geographically, the Back Bay comprises all of the filled land along the Boston side of the Charles River estuary, containing some 450 acres. Bunting's analysis provided an instructive window into a remarkably complete example of nineteenth-century American architecture. As Bunting describes, "With a precision almost unique in American history, the buildings of the Back Bay chart the course of architectural development for more than half a century" (Bunting 1967, 2).

Bunting analyzed nearly 1,500 case studies of individual structures, constituting nearly the entire building stock of the Back Bay area. This record is more important given Boston's leading role as the educational and publication center for American architecture during much of the period when Back Bay developed. The fashions established in the Back Bay reflected nearly immediate applications of European stylistic trends arriving into the United States for the first time. Many of the styles found in Back Bay were, sooner or later, passed along to other American cities and regions. The history of the Back Bay's development began officially in 1857 with the filling in of polluted tidal flats, followed soon thereafter by new residential construction of elegant town houses. The nearly consistent period of development ended around World War One when construction of large town houses ceased. During this 60-year period, Back Bay essentially became the test case for more than six decades worth of architectural styles and fashions, much of it designed by some of the nation's leading architects.

The architectural story of Back Bay presents a useful conclusion to this section devoted to architectural styles. Not only does Bunting's analysis provide an instructive summary of architectural fads that came and went during

the late nineteenth century, but it also documents the important correlation between building booms and national economic and political crises (see Bunting 1967, 5, graph). The panics of 1857, 1873, and 1893 are clearly indicated by corresponding sharp declines in construction, including a minor recession near the end of the Civil War. In between these crises were longer waves of more prosperous times, namely 1853–1856, 1859–1863, 1866–1872, 1876–1887, and 1899–1902. Especially of note is the boom associated with the end of the Civil War. Back Bay as a case for successive architectural styles is seen beginning with the Greek Revival prior to 1850 and transitioning through French Academic (Second Empire) influences during the 1860s, with successive mixtures of later Victorian styles by the later part of the nineteenth century (see Bunting, 1967, 173, graph).

THE WEST IN TRANSITION

In a period of only three years during the Mexican–American War, 1845–1848, the United States expanded its boundaries to largely include today's lower 48 states. By

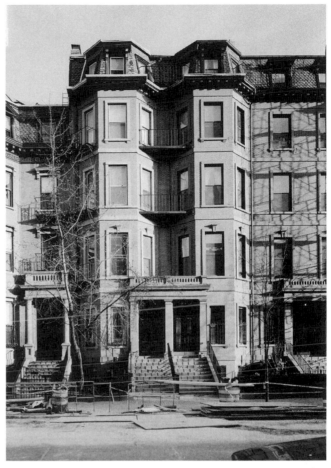

A group (72–80 Marlborough Street) considered "valuable to the district" in the Back Bay Historic District. Courtesy of the Library of Congress.

1860, the American West consisted of three new states—Oregon (1859), California (1850), and Texas (1845)—with all other western lands comprising a series of territories. This carving up of western lands into new states and territories looks impressive on a map (see McAlester 1998, xviii), though the reality was that the dominant Anglo-American population in 1860 was concentrated in a few isolated cities separated by vast unpopulated open spaces. Much of the rural West was still home to remnants of desperate Native American tribes struggling to hold onto their lands. When speaking of the vast West, between 1860 and 1880, therefore, it is wise to place the Euro-American population in perspective, generally inhabiting a few growing cities: Portland and its hinterland, San Francisco and Sacramento, Albuquerque and Santa Fe, Salt Lake City, and San Antonio. To the nearly ultimate demise of Native America, the West was consolidated both economically and culturally in the 20 short years following the Civil War.

Between 1869 and 1884, no less than five transcontinental railroads were built to connect the West with the East. It was during these years, combined

with rapid urban population growth and a developing western rail network, that eastern Victorian Era styles and mass-produced construction materials made their first prominent impact in the American West. Successive styles had required numerous decades to develop in the eastern United States, an evolution necessarily collapsed into a few short decades in much of the West. Numerous earlier eastern styles consequently appeared simultaneously on the western scene (Stoehr 1975). A trend toward Victorian standardization was superimposed onto existing regional distinctiveness, such as that of Mormon-based pioneer dwellings in Utah and Arizona, and Spanish–American, adobe pueblo vernacular housing in New Mexico, southern California, Tucson, and Texas. In Oregon, settlers from New England and New York brought their northeastern building traditions with them, going so far to create near-replicas of northeastern buildings from their more familiar homelands (Dole 1997). Regardless of location or degree of isolation in the transitional West, eastern Victorian and Classical architectural practices ultimately influenced the entire region in the years surrounding the Civil War.

As Victorian culture moved in, railroad expansion and the American military presence only accelerated the persecution and forced removal of Native Americans from their homelands. As such, the optimistic expansion of American progress justified through the ideology of Manifest Destiny was bittersweet, at best, during these decades. The final, brutal phase of Indian–Anglo conflict was coming to a conclusion (McAlester and McAlester 1998, xxvii). Even as the Civil War ended in 1865, Native Americans still controlled a large portion of the rural West. Troops no longer busy with the Civil War were redeployed, ultimately leading to open warfare during the ensuing two decades and hastening the end of Native American subsistence lifestyles.

In early western cities, stylish homes were understandably rare due to poor transportation options and primitive roads. Still, many westerners found ways to incorporate Greek, Gothic, and Italianate styling that roughly mirrored the Picturesque movement of the Romantic Era. Such styling was most common in San Francisco, the region's largest city and principal seaport. Still, various romantic and Victorian styles were delayed by one or more decades due to the *friction of distance*, or the difficulty of moving people and ideas across the vast West. Popular styles in the West were therefore simplified and lagged behind their heights of popularity in the East. New Italianate and Gothic Revival houses were still appearing in the West through the 1880s as more contemporary styles prevailed in the East. The Meeker Mansion, for instance, displaying the Italianate style near Tacoma, Washington, was built as late as 1890, and Greek Revival homes were constructed into the 1850s and 1860s. By that time, eastern Americans had grown tired of the Greek Revival. The West adopted it for its own, however, creating a frontier-era variation known now as Territorial style. Today, surviving Territorial style structures demonstrate the characteristics of a simplified Greek Revival, enhancing a collective sense of place for the West as a distinct region.

The Victorian Era in the West, therefore, paralleled its eastern counterpart only vaguely, often lagging behind and necessarily compressed into the shorter timeframe between 1860 and 1900. Six principal architectural types emerged during these decades: Second Empire (primarily 1870s), Stick (1880s), Shingle (1880s–1890s), Queen Anne (1880s–1890s), Folk Victorian (1870–1900), and

Romanesque (1890s; McAlester and McAlester 1998). Gothic-style churches and Italianate style commercial buildings continuously added to the Victorian landscapes of the West throughout all four decades.

Colorado Mining Towns

The collapsing of numerous architectural styles into a few short decades was particularly evident in Colorado frontier towns. Many of them evolved into substantial mining communities and tended to transition through three phases of town development: settlement phase, camp phase, and town phase (Stoehr 1975). The communities that remained most in tact through the twentieth century were those that grew to become permanent towns. These offer perhaps the best preserved examples of the architectural diversity that accompanied their first decades of settlement during the Victorian Era. Though rarely as pure as their eastern counterparts, Greek Revival homes were plentiful during the early years when initial wood-frame buildings dominated the town scene. Also referred to now as the Territorial style, this simplified western version of the Greek Revival typically included symmetrical, gable-front or hall-and-parlor forms with Greek pediments over windows and doorways. Occasional Greek Revival entryways were found on more fashionable homes, including rectangular transom and side lights. On the heels of the western Greek Revival came Gothic styling, typically revealed in the wooden versions of stone buildings in the East—that is, the Carpenter Gothic, with its characteristic lancet-shaped (pointed-arch) windows, steeply-pitched gables, and vertical board and batten siding. Fancier houses might include bargeboards under the eaves and elaborate wood lace around the porch. Gothic style windows and dormers were occasionally mixed with otherwise Greek Revival floor plans and facades. New homes in the Gothic style continued to be constructed throughout the 1860s and 1870s, though other styles had already become popular in eastern cities.

As Gothic Revival remained relatively popular, other eastern styles made their mark simultaneously throughout the 1870s and 80s, especially Italianate, Italian Villa, and Second Empire. By the 1880s, mass-produced housing components, literature, and cultural tastes and values were spreading nearly immediately across the country, allowing Queen Anne and Eastlake styles to simultaneously appear in the East and West. In a few short decades, Colorado's mining towns reflected a similar trend for the entire region—the collapsing of successive eastern-originated architectural styles into a few decades of rapid boomtown development. Much of this nineteenth-century eclecticism still defines the historic Main Street and residential landscapes of these western towns and cities.

The Spanish–Colonial Southwest

The culturally rich city of Santa Fe, New Mexico, provides one excellent case of eastern American architecture gradually supplanting more regional Hispanic and Pueblo building traditions. Santa Fe and other southwestern cities still resembled foreign countries to early American newcomers. Political control of a territory may change overnight on a map, but local culture and lifestyles can be slow to change. As described by Christopher Wilson (1997a), American

newcomers to Santa Fe found it difficult to describe and come to terms with the place's widely different appearances and traditions. One traveler likened Santa Fe to "a dilapidated brick kiln or a prairie-dog town" (Wilson 1997a, 52). Americans soon equated flat-roofed, adobe buildings that appeared to be in a "perpetual state of decay" with "loose women, gambling, cowardice, a lack of proper hygiene, and immoral clergy—all symptoms, in their minds, of the decline of Christian civilization in New Mexico" (Wilson 1997a, 53). With presumptions such as these, it was clear that the Anglo-American Victorian culture aimed to influence and update New Mexico as soon as humanly possible.

Between 1860 and 1880, architectural transformations in Santa Fe began to reflect the incoming dominant culture from the East. At first, decorative Anglo-American—that is, Victorian—elements were applied to pre-railroad Santa Fe buildings. Americans replaced the rough-hewn beams of Mexican *portales* (porches) with whitewashed, milled posts and trim. By the early 1860s, only two Spanish colonial-style porches remained around the Santa Fe plaza (Wilson 1997a). American windows, doors, and other mass-produced architectural treatments were shipped in greater quantities over the Santa Fe Trail from Missouri, and traditional adobe houses and businesses increasingly applied American windows and doors to the older structures.

At first, the simplified, western version of the Greek Revival, known regionally as Territorial style, dominated architectural additions in Santa Fe. The style included brick cornices on the roof of buildings to resemble Greek style dentil courses, with raw lumber fashioned into door and window frames simulating Greek columns, entablatures, and pediments. In the West, this Greek Revival influence symbolized not only the earlier democratic ideals of Jeffersonian times, but also came to represent American imperialism in this previously Spanish-controlled region (Wilson 1997a).

The Territorial style was long lived in Santa Fe and other rural western areas, appearing well into the 1860s. At this time, Gothic and Romanesque styles were being applied to Santa Fe churches, though change was gradual until the railroad arrived in 1880. Consequently, the 1860s and 1870s were years of slow transition, though with visible architectural changes and trends. In pre-railroad Santa Fe, Spanish adobe buildings and houses still remained dominant, if increasingly exhibiting new American details and hints of eastern architectural styles. Generally, the Mexicans and Americans worked collaboratively throughout these changes. With the railroad came a more pronounced transformation of Santa Fe architecture with incoming eastern styles and materials, while Mexican–American collaboration deteriorated. Earlier Greek, Romanesque, and Gothic Revivals were rapidly augmented by Italianate, Queen Anne, and Second Empire styles. By the 1880s, Italianate had emerged as the sole commercial style around the plaza (Wilson 1997a).

A study of nearby Las Vegas, New Mexico, also by Christopher Wilson (1997b), provides deeper insight into the transitions of Spanish-era folk housing in the Southwest. Wilson found that a Spanish–Mexican style of building and the focus of household activities in a single, multipurpose room provided the basis for local folk architecture. After the Civil War, Americans introduced new construction practices and house plans that separated public and private spaces. These new ideas were incorporated into the existing Hispanic tradition up through 1910. The ideal Hispanic house in New Mexico consisted of a fully

realized dwelling called a *placita,* termed by New Mexican Spanish for a house with a courtyard surrounded on all sides by rooms. Only the wealthiest families could afford a full *placita* with rooms on all four sides of the courtyard. Most variants were smaller U-shaped, L-shaped, and single-file buildings owned by common families. If family wealth increased, the *placita* may have been correspondingly enlarged. *Placitas* typically lacked exterior windows and had only one large door or a pair of doors leading directly to the courtyard. Roofs were flat with adobe or stone.

The origin of this building tradition can be traced to the Mediterranean and Middle East. Early colonists brought the tradition from Spain to central Mexico where a similar indigenous type already existed. The *placita* was consequently introduced into current-day New Mexico by both Spanish explorers and their Native American assistants around 1600. Wilson comments that, "The persistence of the type in New Mexico is remarkable; one example remaining in Las Vegas, the Manuel Romero House, was not completed until about 1900" (Wilson 1997b, 115). In 1882, this house still consisted of a flat-roofed, L-shaped building with only three rooms. Additions came in stages, finally enclosing the full courtyard by 1902.

Anglo-American influences on architecture in New Mexico after 1848 did not occur by accident, but through an intentional modernization campaign by merchants, military, and local officials. Local saw mills produced the territory's first milled lumber, doors, and windows. Although new construction continued to use adobe, Anglo-American windows, doors, and porches were added to reorient Mexican houses to the street and away from internal courtyards. The picturesque cottage-type likewise influenced the locale after the railroad's arrival in 1879. True to eastern precedents, these cottages exhibited asymmetrical facades, often with a front-facing gable to one side balanced by a porch across the remainder of the facade. In contrast to the *placita,* these Anglo housing plans were oriented entirely to the street with their full porches. By this time the American dream had impacted the United States greatly, given the trend for building free-standing houses on private lots and set back from the street. Their specialized rooms and interior hallways essentially internalized the social distancing previously provided by the Hispanic courtyard. Wilson (1997b) refers to this period of 1870–1910 as the "period of experimentation," characterized by a mixing of cultural traditions until a uniquely New Mexican culture emerged exhibiting influences of Native, Spanish, and Anglo traditions.

San Francisco

American influence was felt more immediately in this booming port city than in rural New Mexico. San Francisco had likewise begun as a remote Spanish settlement, including after 1776 a modest presidio (fort) facing the Bay entrance and a mission three miles to the south. Only 100 villagers resided there when the United States occupied the area in 1847. Taking on the role of a Gold Rush boom town, the population rose to 35,000 only three years later, and California was admitted to the Union as a new state. During the 1860s and 1870s, the Italianate style became the dominant choice for middle-class housing in San Francisco, with new residential neighborhoods rapidly conquering

the city's steep hills due to an innovative transit project. The world's first cable car transit system was implemented in 1873, invented by Scots-born designer Andrew Hallidie. His innovation was referred to as "Hallidie's folly" by local skeptics, but the system soon proved itself reliable and consequently spawned a local transportation and real estate revolution. Other cities took San Francisco's lead, adopting their own cable car systems in places including Los Angeles, New York, Chicago, Denver, and Oakland. At their peak before the 1906 earthquake, more than 600 cable cars traveled on 110 miles of track in San Francisco. Hallidie had designed a pulley system based on the thick wire rope patented by his father in England and widely used in eastern California gold and silver mines.

High sections of San Francisco's Nob Hill suddenly became accessible, and businesses and homes were constructed along cable car routes, allowing the spread of middle-class housing westward from the central city (Bosley 2000). As cable car routes expanded, new residential suburbs quickly spread beyond Nob Hill to vacant lands beyond Van Ness Avenue. The city's sequence of architectural styles closely mirrored that of eastern cities between roughly 1860 and 1920, despite its relatively isolated West Coast location. All of the styles that appeared during these decades consisted of variations of architectural trends occurring elsewhere in the country (McAlester and McAlester 1998). This is less surprising given the rapid influx of eastern immigrants into San Francisco during those years and the continuing integration of that city by ship and rail with the eastern industrial economy.

The Salt Lake Basin

In Utah, houses from the period 1849–1890 are typically described as Mormon or Pioneer structures and identified with the folk (or vernacular) phase of architectural development (Carter 1997). Like their East and West Coast counterparts, even the settlers of the isolated Salt Lake Basin enjoyed access to a wide variety of house plan books, magazines, and newspapers informing them of national ideas. Mormon folk-housing features, therefore, revealed the continuing western influences of the Greek Revival (i.e., neoclassicism), with its overriding emphasis on bilateral symmetry. Folk houses of this period were often constructed with logs that were sawed or hewn square, though often disguised by the more orderly appearance provided by smooth lumber siding or plaster. Stone buildings were likewise given a regular finish uncharacteristic of typical pioneers, as Mormons were determined to create an orderly and controlled environment. The organic irregularities of stone blocks were chiseled smooth, and the Mormons carefully quarried the stone, shaped it into blocks, and added mortar on evenly coursed lines.

The most common building material for Mormons, however, was adobe brick. Clay was mixed with sand and molded into bricks, their walls often sheathed with plaster to protect the adobe and to present a smooth exterior finish. Such careful efforts with construction, Carter (1997) explains, served as an important indicator that determined Mormon communities were designed to be permanent. By the 1850s and 1860s, Mormon houses increasingly displayed their own concern for eastern comforts and fashions. Brigham Young's admonition to "build beautiful houses" was apparently taken seriously by his

loyal followers. Architectural historian Peter Goss identified five major styles surfacing in Utah during the 1847–1890 period: Federal, Greek Revival, Gothic Revival, Second Empire, and eclectic Victorian—ideas found in house pattern books and disseminated throughout the countryside. Therefore, "Folk architecture does not exist in a cultural vacuum," explains Carter (1997, 51). People in early Utah were likewise exposed to progressive urban and cultural ideas in spite of their self-chosen geographical isolation.

Mormon structures between 1860 and 1880 tended to demonstrate Classical or Picturesque plans and designs, again following the prevailing dominant eastern modes. Still, it was eighteenth-century American classicism that dominated Mormon building traditions at this time. The diffusion of classical principles into the isolated Salt Lake Basin was initially the result of Renaissance-inspired ideas that had influenced America by the time of the Revolution, after which they emerged as a new national style manifested in the Greek Revival. The style's symmetrical composition, rectangular facades, and classical ornamentation subsequently moved westward with an expanding United States prior to the Civil War. The Mormons were no exception. The classicism brought in by the Mormon settlers from the Midwest dominated the architecture throughout Utah, from adobe cabins to Greek Revival mansions, well into the 1880s (Carter and Goss 1988). The Mormons utilized features from all the early Classical styles, including Georgian, Federal, and Greek Revival. It wasn't until after the Civil War when the Picturesque influence of Gothic Revival and Italianate styles provided the first serious challenge to classicism in Utah. The romantic features of asymmetrical massing, emphasis on verticality, rich colors, and decorative wooden ornament provided for an increasingly eclectic landscape of residential architecture that moved beyond classicism.

The Gothic Revival in Utah enjoyed its highest popularity during the 1870s, well after initial Picturesque designs had appeared in early style books of the 1840s and 50s (Carter and Goss, 1988). Gothic houses built of stone appeared first during the 1860s, their builders commonly using simple I-, T-, or H-plans in story-and-a-half configurations, common to those found throughout the eastern United States. Later dwellings were more elaborate and decorative than earlier versions, eventually characterized with the familiar steep-pitched roofs, cross-gables, dormers, and Gothic style windows in flat, round, or pointed arches, and bargeboard and scrollwork along the eaves and porches (Hamilton 1995). Consequently, even the Mormon culture region embraced national architectural trends as the new American West became increasingly integrated with the rest of the country.

Reference List

Bosley, Deborah. 2000. *The Rough Guide to San Francisco*. London: Rough Guides Ltd.

Bowen, Ezra, ed. 1970. *This Fabulous Century: 1870–1900*. New York: Time-Life Books.

Bunting, Bainbridge. 1967. *Houses of Boston's Back Bay: An Architectural History, 1840–1917*. Cambridge: The Belknap Press of Harvard University Press.

Calloway, Stephen. 2005. *The Elements of Style: An Encyclopedia of Domestic Architectural Detail*. Buffalo, NY: Firefly Books, Inc.

Carley, Rachel. 1994. *The Visual Dictionary of American Domestic Architecture*. New York: Henry Holt & Co., LLC.

Carter, Thomas. 1997. "Folk Design in Utah Architecture, 1849–1890." In *Images of an American Land: Vernacular Architecture in the Western United States,* ed. Thomas Carter, 41–60. Albuquerque: University of New Mexico Press.

Carter, Thomas, and Peter Goss. 1988. *Utah's Historic Architecture, 1847–1940*. Salt Lake City: University of Utah Press.

Dole, Philip. 1997. "The Calef's Farm in Oregon: A Vermont Vernacular Comes West." In *Images of an American Land: Vernacular Architecture in the Western United States,* ed. Thomas Carter, 69–89. Albuquerque: University of New Mexico Press.

Ely, Richard. 1885. "Pullman: A Social Study." *Harper's Monthly* 70(February): 452–466.

Ford, Larry. 1994. *Cities and Buildings: Skyscrapers, Skid Rows, and Suburbs.* Baltimore: The Johns Hopkins University Press.

Foster, Gerald. 2004. *American Houses: A Field Guide to the Architecture of the Home*. Boston: Houghton Mifflin Co.

Gelernter, Mark. 1999. *A History of American Architecture: Buildings in Their Cultural and Technological Context*. Hanover: University Press of New England.

Hamilton, C. Mark. 1995. *Nineteenth-Century Mormon Architecture and City Planning*. New York: Oxford University Press.

Hammett, Ralph. 1976. *Architecture in the United States: A Survey of Architectural Styles Since 1776*. New York: John Wiley & Sons, Inc.

Handlin, David. 1979. *The American Home: Architecture and Society, 1815–1915*. Boston: Little, Brown.

Hayden, Dolores. 1981. *The Grand Domestic Revolution: A History of Feminist Designs for American Homes, Neighborhoods, and Cities*. Cambridge, MA: The MIT Press.

Hayden, Dolores. 2003. *Building Suburbia: Green Fields and Urban Growth, 1820–2000*. New York: Vintage Books.

Jandl, H. Ward. 1991. *Yesterday's Houses of Tomorrow. Innovative American Homes, 1850–1950*. Washington, D.C.: The Preservation Press.

Jayne, Thomas. 2005. "American Victorian, 1840–1910." In *The Elements of Style,* ed. Stephen Calloway, 272–305. Buffalo, NY: Firefly Books, Ltd.

Lewis, Peirce. 1990. "The Northeast and the Making of American Geographical Habits." In *The Making of the American Landscape,* ed. Michael Conzen, 80–103. London: HarperCollins.

Loth, Calder, and Julius Sadler, Jr. 1975. *The Only Proper Style: Gothic Architecture in America*. Boston: New York Graphic Society.

McAlester, Virginia, and Lee McAlester. 1997. *A Field Guide to American Houses*. New York: Alfred A. Knopf.

McAlester, Virginia, and Lee McAlester. 1998. *A Field Guide to America's Historic Neighborhoods and Museum Houses: The Western States*. New York: Alfred A. Knopf.

McKim, Charles. 1874a. *New-York Sketch Book of Architecture* 1(January): v.

McKim, Charles. 1874b. *New-York Sketch Book of Architecture* 1(December): 45.

Peabody, Robert. 1877. "The Georgian Houses of New England." *American Architect and Building News* 2(October): 338–339.

Roth, Leland. 1979. *A Concise History of American Architecture*. New York: Harper & Row.

Roth, Leland. 1983. *America Builds: Source Documents in American Architecture and Planning*. New York: Harper & Row.

Roth, Leland. 2001. *American Architecture*. Cambridge, MA: Westview Press.

Rybczynski, Witold. 1986. *Home: A Short History of an Idea*. New York: Penguin Books.

Stoehr, C. Eric. 1975. *Bonanza Victorian: Architecture and Society in Colorado Mining Towns*. Albuquerque: University of New Mexico Press.

Walker, Lester. 1981. *American Shelter: An Illustrated Encyclopedia of the American Home*. Woodstock, NY: The Overlook Press.

Williams, Henry, and Ottalie Williams. 1962. *A Guide to Old American Houses, 1700–1900*. New York: A.S. Barnes and Company, Inc.

Wilson, Chris. 1997a. *The Myth of Santa Fe: Creating a Modern Regional Tradition*. Albuquerque: University of New Mexico Press.

Wilson, Chris. 1997b. "When a Room is the Hall: The Houses of West Las Vegas, New Mexico." In *Images of an American Land: Vernacular Architecture in the Western United States,* ed. Thomas Carter, 113–128. Albuquerque: University of New Mexico Press.

Building Materials and Manufacturing

To learn about the construction of 1870s middle-class housing is to learn something about our own. Though machines and techniques were still being perfected, building methods and materials by the 1870s had become fundamentally similar to what Americans now recognize as commonplace. Most significant was the so-called balloon frame technique that revolutionized and enabled the construction of suburban housing on a massive scale for some 150 years to follow. Likewise, the terminology and materials familiar to a builder of the 1870s have survived through to the present: studs, sills, joists, mortar, nails, shingles, doorknobs, hinges, face bricks, gutters, clapboards, rafters, and scroll saws, to name just a few.

The drive for experimentation and progress was based on an emerging scientific method well accepted by the 1860s and 1870s. In this way, the burgeoning housing industry became evermore intertwined with the Industrial Revolution and the mass production of products that it spawned. More than ever before, the newest theories, products, and gadgetry of science were increasingly influencing the American home. Popular magazines and scientific journals reported ceaselessly on every new invention or improvement that might aid the builder—from new wood preservation techniques and more durable mortar, to efficient scroll saws and brick manufacturing methods. This flowering of experiments, innovations, and new patents occurred simultaneous to the unprecedented growth of the American population and the consequential suburban housing boom.

The process of industrialization led especially to standardization of construction materials and the tools that made them. Particularly, standardized

processes for the manufacture of common bricks and dimension lumber—perhaps the two most vital materials enabling the housing boom—were well established following the Civil War. Between 1860 and 1880, a wealth of new machines allowed for great changes in the manufacture and finishing of brick, stone, and wood. More materials were prefabricated at various factories, shipped to the construction site, and pieced together. In previous decades, it had been more common to craft nearly everything from scratch right on site. After the Civil War, it became standard practice to order and ship prefinished flooring, bricks, steel nails, window units, wall panels, doors, and lumber to practically any construction site in advance.

The standardization of construction materials marked the beginning of the Age of Steel and Steam, which Hammett (1976) labeled the decades from 1860 to 1930. The author of an article in *Manufacturer and Builder* in 1869 seemed in awe of the vast move toward business specialization taking place at the time, exclaiming: "Today we find that the most successful houses [businesses] confine themselves to special departments, and devote all their energies to one or two articles. At one establishment nothing but chairs are turned out; another house confines its attention solely to office furniture; a third selects school and lecture-room furniture as a special branch of business; and the consequence is, that this concentration of capital, energy, and intellect not only materially lowers the price and improves the general quality, it also tends largely to the introduction of those special devices which add so much to the efficiency of the articles produced" ("Improved Reversible Seats" 1869, 301).

Specialization of production in turn led to cheaper construction costs and allowed more individuals to build their own homes faster and with fewer skills in construction. No longer would the free-standing house be restricted to the wealthiest elite. Nearly every monthly issue of *Manufacturer and Builder,* for instance, featured a variety of "how-to" articles on topics ranging from polishing wood and building retaining walls to the construction of entire two-story wood or brick homes. Entire kits of one- or two-story homes could be ordered in New England by the late 1860s. Contractors and dealers included a variety of house designs, sizes, varieties of buildings, and prices within their advertising pamphlets. A house's entire bill of materials, including doors, windows, frames, clapboard siding, and roof shingles, could be ordered, transported by rail and carriage, and assembled on site. Anyone who could understand the basic concepts of the balloon frame and pay for the prefabricated materials could now construct their own dwelling with minimal professional assistance.

BUILDING A WOOD-FRAME HOUSE AROUND 1870

Most houses constructed through the 1850s were still built with techniques similar to those of medieval Europe. Known as heavy-timber framing, or post and girt, fresh logs were transported to each site of construction where carpenters and joiners fashioned bulky timbers into place. The building's structural weight rested on thick horizontal beams held up by bulky vertical timbers. The traditional frame house was typically constructed of oak, known for its excellent strength and durability since colonial New England times. The construction of a heavy-timber frame house required extensive manual labor and specialized knowledge, discouraging most prospective homeowners from building one themselves. Timbers were ei-

William H. Ward House, Georgetown vicinity, Delaware. Constructed in 1880, contains both traditional based timber framing and balloon framing. Courtesy of the Library of Congress.

ther hand-hewn or power-sawed from fresh logs to create each individual framing member, usually consisting of 8- by 8-inch beams. Either straight butt joints or—later—mortise and tenon joints were used to connect the massive beams to one another. Oak dowels or hand-wrought nails of iron were further used to join the timbers, prior to the manufacture of standardized steel nails. Homes built in this manner were impressively rugged and long lasting, but this specialized and laborious medieval-era construction technique kept such houses out of the reach of most Americans (Hammett 1976; Jackson 1985).

The Balloon Frame

Though its inventor remains unclear to historians, an innovative method for the construction of wood buildings was introduced as early as 1833 in Chicago. This was a midwestern innovation that spread along the Ohio River Valley and into the densely populated Northeast, where it became known initially as "Chicago construction" (Jackson 1985). Early skeptics mocked the new method and awarded it the derogatory label, balloon frame—though the term eventually stuck and became its common name. Following a generation of builders slow to adopt it due to concerns of durability and strength, the balloon-framing method had proven itself by the 1870s and was recognized as the preferred substitute for the medieval timber frame. Kenneth Jackson (1985) ranked the balloon frame as equal to the expansion of mass transit in its significance in

enabling the growth of suburban neighborhoods. American houses of every type, whether built of wood, stone, brick, or stucco, eventually made use of the revolutionary framing method. Further, the balloon frame allowed for the rapid reconstruction of Chicago after its great fire of 1871, further showcasing its appeal. After some time, however, it became clear that the balloon frame presented a significant fire hazard in itself, given the ability for fire to rise quickly up the frame's vertical boards to upper floors. This led to a growing demand for brick by the 1870s and 1880s associated with municipal ordinances that often prevented wood construction in densely packed downtown districts.

The main ingredient for the balloon-frame method of construction was—and still remains—the mass-produced 2- by 4-inch board. The advent of the circular saw and gang saw meant that hundreds of feet of boards could be ripped out at specialized lumber mills in a matter of hours. Standardized boards ranging from two-by-fours to two-by-twelves became common, and the wood was machine planed into smooth siding and finished boards for all the necessary framing, doors, window openings, and flooring (Hammett 1976). After 1870, steel nails were likewise mass produced and could be purchased for as little as three cents per pound. Steel nails forever banished the laborious process of creating mortise and tenon joints, and lingering skepticism surrounding their strength diminished by the 1870s (Jackson 1985).

In conjunction with the balloon frame and steel nails, other tools such as the scroll saw and turning lathe affected the use of wood on houses. By the 1870s, exterior and interior ornament and components could be created cheaply and mass produced for practically any household that wanted them. For instance, an improved scroll saw was announced in a monthly edition of *Manufacturer and Builder* in 1869. Announced as an "invention" by J. W. Moyer in New York, this particular saw was claimed to offer numerous improvements over the gate saw. The new saw could handle larger and more complicated pieces of wood, fed to the saw more conveniently. The distinction between news articles and advertisements was often blurred, as was the case here, with the article judging that the new saw "must prove indispensable to every well-furnished wood-working establishment" ("Improved Scroll Saw" 1869, 304). The saw's working parts were noteworthy, consisting of malleable iron and steel, with either an iron or wood frame. The recent advent of steel was already making a noticeable impact on the construction industry.

The balloon frame's relative ease of construction led to numerous published articles focused on how to build such houses. This represented an early wave of "do-it-yourself" literature aimed at prospective home owners of the growing middle class. The news was out that practically anyone with the financial means and the drive could build their own dwellings. Plans and designs ranged from simple, two-room cabins to elaborate, multistory Victorian homes. Instructions for building a small house might only require an article of one or two pages in length. Descriptions of the balloon frame were central to such articles, such as those regularly appearing in *Manufacturer and Builder* by the early 1870s. The ease of construction enabled a freedom not allowed in antebellum, boxy, timber-frame homes. Interior and exterior walls, rooflines, gables, and openings could now be placed virtually anywhere and used to showcase a variety of architectural styles for increasingly status-oriented Americans.

The required construction materials for wood frames were fairly standard, regardless of the house's planned size and shape. Lists of necessary materials were commonly placed in articles such as "How to Plan a Convenient Dwelling," published in an 1870 issue of *Manufacturer and Builder.* The new framing method was already commonplace, given this publication's nonchalant description of the technique. A diagram of a sample balloon-framed room was provided for guidance. The caption simply stated that the illustration "represents one corner of the balloon frame, resting on the cellar wall about two feet above the surface of the ground. Sills, 2 x 8 inches, are first laid on the surface of the wall, with the corners halved together" ("How to Plan a Convenient Dwelling" 1870, 9).

Still, hints of lingering skepticism toward the balloon frame remained, as acknowledged by a pair of architects in their own 1870 article "How to Build a Frame House." They felt it necessary to defend their preference for nails over mortise and tenon joints: "The old method used to be mortise and tenon, even now often done, but we always insist on their being simply well spiked." They further explained how cutting notches and holes for mortise and tenon joints would only weaken the boards while requiring "useless amounts of labor" ("How to Build a Frame House" 1870, 228).

The typical list of materials for a planned home became standard. A balloon-framed house required some combination of standardized lumber boards—often referred to in the 1870s as "sticks"—including four-by-four studs for corners and windows, two-by-four studs for framing, and a variety of joist rafters, roof boards, flooring wood, clapboards, and box-boards—the latter used in one case for the frieze and ceiling beneath the ends of the rafters. A hierarchy of lumber dimensions was recommended for the framing, depending on the need for each component's strength in supporting the structure. The main posts for an average-sized house could be four-by-eight inches in thickness, while four-by-six pieces could be used for girts and braces. Common two-by-four boards were then used for the "filling-in" studs, usually placed 16 inches apart from their centers—a practice relatively unchanged to the present day.

Challenges with Wood-frame Construction

A variety of problems with wood-framed houses had already been either solved or at least acknowledged by the 1870s. Typical issues included the warping and shrinkage of the timber, penetration of moisture from the exterior, and numerous cracks and settlements common to all newly constructed wood houses. This latter issue could be more or less avoided with some preventive care in assembling the balloon frame. It was important to do everything possible to brace and bind the frame together, such as the bracing of studs used for door and window heads and the thorough bridging of studs used on the outside walls and inside wall partitions. The bridges consist of short pieces that connect adjacent vertical studs to one another, for enhanced strength. The use of larger boards was not necessarily better or stronger. Duggin and Crossman advocated for the use of lumber in the smallest dimension possible to meet the desired purpose. Over time, the lumber would season and dry more thoroughly in any new wood building, and smaller-dimension lumber would at least minimize the natural warping.

The filling in of the completed frame presented other challenges. A common procedure into the 1870s was to fill the entire frame with bricks and mortar. Structurally, this was sound practice, if not overkill, given that the balloon frame itself was designed to support the weight of the structure. The bricks filled in between the studs were therefore not load-bearing. The width of the wood frame was typically only four inches, however, as was the width of a common brick laid flat. Laying bricks inside the frame thus created a veritable solid wall from the front to back face of the frame. Solid masonry walls were already known to conduct moisture and dampness to the interior of the dwelling, providing for unwanted cooling during the winter, warming during the summer, and potential cracking of the interior plaster covering. A new alternative to filling in with brick, therefore, was advocated by the early 1870s. In place of bricks, the frame could be simply filled with laths and plaster, the same material used to cover the insides of framed houses in the days before drywall. The thin internal layer of lathing and plaster provided for two separate open spaces within the wall, thereby preventing the usual moisture and dampness from penetrating to the interior. Nailing thin strips to the insides of the studs, and then securing the lathing to the strips, was a relatively easy task. One published article stated matter-of-factly that, "a faithful and quick lather can nail on two to three thousand laths in a day" ("How to Plan a Convenient Dwelling" 1870, 9). Bricks were still recommended for filling in the lowest foot of the framing above the sill, however, to prevent access to mice and rats behind the internal lathing.

Experimentation with insulating materials was also underway, then apparently known as *deafening*. Three early and common materials were sawdust, pulverized charcoal, or cork shavings, in that order of preference. A house in Astoria, Long Island had its roof deafened with charcoal around 1870. Its owner was pleasantly surprised that the top rooms stayed just as cool as those on the first floor during the summer. Likewise, the internal lathing and plastering advocated for filling in the frame was also viewed as a deafening material.

Roofing Materials and Construction

Roof construction on a balloon-frame house also involved placing dimension lumber at regular intervals. One recommendation for roof construction, was a "simple and inexpensive" method for building a gable roof with a practice that has already been used for "many years past" ("How to Build a Frame House" 1870, 228). The sawed rafter end is firmly secured to the plate and to the roof rafters. One-and-a-quarter-inch plank was laid on top of the rafters to form the roof surface. The molded cornice and gutter was then placed at the edge of the roof. The cornice was lined with painted tin and served as the gutter.

Three basic materials were considered standards for roof covering: tin, slate, and shingles. Slate was often viewed as the preferred material, as it was the most durable and, according to the tastes of the day, the most ornamental. Depending on its source, the stone could fade or change color, though certain quarries in Pennsylvania and Maine were apparently favored for slate that remained more visually stable. Slate was more expensive than shingles, but only marginally, and could be cheaper than tin. It was necessary to paint tin roofing every couple of years to prevent it from rusting and leaking. The challenges of condensation on the inside of walls or roofing were well established, if not

entirely understood. Tin was especially subject to condensation on the under-
side, causing it to rust quickly if not thoroughly painted and maintained. Shin-
gles were also widely used, though architects tended to recommend against
them unless the structure was either considered temporary or exceedingly
cheap. Shingles were inexpensive, however, adding to their appeal, and decent
shingles could repel water for many years.

Several kinds of inexpensive paper felting could substitute for shingles. The
felting would be saturated with coal tar or other chemicals and could be cov-
ered with plastic slate once the house was finished. Such roofing paper was
apparently used commonly throughout the country by the late 1860s, given the
material's relative strength and its ability to repel water ("How to Build a Cheap
House" 1869, 298). After applying a heavy coat of paint, the material was de-
scribed as "tight as tin" and less expensive than tin or shingle roofing.

Exterior Cladding

For cladding, or the external wall covering of a wood-framed house, two
methods were well accepted by the 1860s: horizontal clapboard siding, or ver-
tical board and batten siding. Both methods could be aesthetically pleasing
for various architectural styles and—most important—water tight. Clapboards
were horizontal boards that overlapped one another by at least three-quarters
of an inch. Narrower boards were preferred so as to minimize their warping.
In contrast was board and batten siding, employing vertical planks adjacent
to one another and joined through the tongue and groove method. With the
joints internal to the edges of the planks, the finished facade was smooth, un-
like that of clapboard siding. To protect the joints, however, it was common
to cover them with narrow, vertical battens that were typically only an inch
or so wide. This board and batten vertical siding became especially popular to
enhance the tall, slender appearance of so-called Carpenter Gothic style dwell-
ings, a style that advocated a vertical emphasis.

Varieties and Preservation of Wood

Nineteenth-century builders learned to prefer certain wood types over oth-
ers for various purposes. Timber could be divided into the categories of hard
wood and soft wood. Oak served as the standard hardwood during the 1860s
and 1870s and was used for durable building components such as sills, posts,
and beams. Red elm and red beach were recognized as equally reliable alter-
natives to oak, however, and were considered just as durable. Red beach was
likewise useful for sills, posts, and beams, where the timber is likely to be ex-
posed to dampness and alternating influences of wet and heat. Butternut could
also be used as an oak substitute and was often more durable. This was a
soft wood, however—softer than white pine—and therefore was most useful
for roof boards, flooring, casing, window sills, and doors. However, butternut
was liable to warp and spring severely, leading to the recommendation that it
be "stuck up" while the wood was still green. The writers of one article wit-
nessed common mistakes regarding the proper use of wood, stating that, "We
frequently see white-oak or red-elm sills and sleepers of sugar-maple, which
will decay as soon as basswood or buttonwood" ("Selecting Durable Building
Timber" 1870, 15). A hard wood, therefore, was not necessarily synonymous

Galbraith House, Montgomery Street, Idaho City, Idaho. Constructed in 1867, this small-frame house has clapboard siding on the front facade and rough sawn board and batten siding on the other walls. Courtesy of the Library of Congress.

with durability. In contrast, wood used for protected interiors could be of any variety, whether it be basswood, white beech, maple, or pine.

The most common wood used for framing lumber, exterior covering, sheathing, and roof boards was white pine, often coming from Michigan during this time (Hammett 1976). Interior flooring was often fashioned with southern pine into three-inch tongue and groove boards, which were oiled, shellacked, and waxed. Interior trim for doors and windows could be oak, cherry, or walnut, all of which were typically sanded, stained, and varnished.

Given the increasing importance of wood as a domestic construction material, it is no surprise that much scientific attention was devoted to its preservation and durability. Economic motives were at the forefront when it came to extending the life of wood used in building materials and railroad ties. The huge monetary cost of replacing rotted wood was well recognized. One estimate proclaimed that wood structures on American farms alone cost more than $100 million annually to maintain, and railroad ties cost some $25 million each year. A doubling of the useable life span of wood could save the nation around $12 million annually in railroad ties and some $50 million in fences and farm buildings. It may be more surprising that calls for conservation were surfacing by the 1860s, with one writer in *Manufacturer and Builder* cautioning that "our woodlands are being cut down with fearful rapidity . . . In lengthening the duration of wooden structures, we, at the same time, prevent the destruction of

our forests, thus leaving to the coming generation the same resources which we have inherited from our forefathers" ("Preserving Wood" 1869, 198).

Whether the argument was one of economics or conservation, it is clear that the preservation of wood became a leading scientific inquiry after the Civil War. Articles were published on seemingly every small improvement, finding, or experiment—much of it learned from European experiences. For instance, one process patented in 1865 by Louis Robbins was called the "oleaginous vapor process" for preserving wood. This was described in the daily and weekly press as the "Discovery of one of the Lost Arts of the Egyptians" ("Preserving Wood" 1869, 198). The process basically involved placing wood in an iron chamber connected to a still containing coal tar. Heat was applied to the still, up to 600 degrees Fahrenheit. The inventor claimed that the impregnated wood was completely protected against moisture and was therefore "nearly indestructible as granite" ("Preserving Wood" 1869, 198). Whether this process gained wide acceptance is hard to know, but it is typical of the types of experiments and reports associated with wood preservation by the 1860s.

Much attention was likewise paid to ancient methods of preserving wood, including external coatings of resin or oil. The dominant thinking of the time attributed the root cause of wood decay to the albumen of the sap, which was distributed throughout the cellular tissue of the plant and thereby fermented and caused decay of the entire body. Also perplexing was that wood fiber could last thousands of years as long as it was kept under water or exposed only to very dry air. Much was still to be discovered about the characteristics and preservation of wood.

Foundations and Basements

Whether of brick, stone, stucco, or wood, the success of any dwelling depended on a reliable and long-lasting foundation. The reasons for building a proper foundation were the same in the 1860s as in the present day. The weight of the house needed to be well supported, minimizing the risk of sinking or settling over time. The foundation's other primary job was to repel water and moisture to the greatest extent possible. A third issue often involved the freezing and expansion of the earth outside the foundation, an ongoing action that could eventually push the foundation wall inward, especially for foundations with basements. Regardless of whether the advice was always followed (it was not), sufficient knowledge and technology existed by the 1860s to prevent all of these problems in well-built structures.

Whether brick or stone was used for the foundation made little difference for its durability. Stone foundations at least 18 inches thick at the base were recommended by architects, though an optional footing course two or three feet thick could add further strength. The footing course and lower two feet of the main foundation benefited from being laid up solid in cement, which was used regularly by 1870. The remainder of the foundation walls could be laid up with common hydraulic mortar, consisting of a mixture of lime and sand. Brick foundations were typically no less than one-foot thick and bonded with mortar up to the ground surface. Stone foundations were considered the best choice when adding a basement or cellar, and the base of the foundation needed to be dug well below the reach of winter frost. Not satisfying this requirement

would result in alternating cycles of freezing and thawing, thereby rendering the structure unstable and susceptible to uneven settling.

The actions of frost could still cause damage to foundations of improper design, even with a suitably deep base. For dwellings with cellars, and especially those built into sides of hills, it was necessary to include a battering face into the wall to effectively resist the inward pressure of earth. The term *battering* refers to a backward tilt or setback, effectively making the wall tilt outward toward the earth behind the foundation. A 6 1/2-foot basement wall with a 2-foot thickness at its base might thus only be 10–12 inches at the top. Such a foundation wall was known to effectively resist the expansion of earth due to frost action, thereby preventing the buckling inward of the wall. Such walls with battering faces were considered "far stronger and better in every respect," and required the same amount of stone for a standard wall one-and-a-half feet thick ("How to Plan a Convenient Dwelling" 1870, 9). Authors of various articles within *Manufacturer and Builder* strongly promoted the use of battering faces, as they reported numerous nonbattered foundation walls 18 inches thick that had buckled severely and required rebuilding after only a few years of frost action. The recommendation for battering faces continues to the present day, depending on the situation. Despite the good advice of the 1870s, however, masons reportedly disliked making walls with battering and often discouraged property owners against it. For this and other reasons it was likely more common to see foundations with standard, perpendicular walls than those built correctly ("How to Plan a Convenient Dwelling" 1870, 9).

Foundation walls were also required to prevent water from entering the basement from the exterior. Prior to building the foundation wall, it was necessary to dig a channel around the base of the foundation about a foot below the bottom of the planned cellar ("How to Avoid Wet Cellars" 1869, 207). Drain tiles were then laid into the channel and sloped gently to carry off excess water before making contact with the foundation wall. With drain tiles laid, loose stone was filled in with a foot or more thickness around the foundation to facilitate the conveyance of water to the tiles. The whole structure could then be buried with fill ("How to Build Abutment Walls" 1869, 291).

Of course, many foundations not only neglected the drain-tiled channels, but were often built on top of wooden planks. The laying of planks beneath a foundation wall was common, but was considered "a practice decidedly objectionable, as wood in such places will decay unevenly in a few years" ("How to Plan a Convenient Dwelling" 1870, 9). Still, it was recognized that certain types of wood foundations could be successful, especially for lighter wooden structures with no cellars. For instance, charred oak or cedar posts could be driven below the reach of frost and sawed off at the required height above the ground.

BUILDING A BRICK HOUSE AROUND 1870

Aside from wood, common brick increased in demand for dwellings and other structures after 1860. Much attention was devoted in the literature to the improvement and use of mortar, necessary for any successful construction with brick or stone. While stone was quarried from natural sources and shaped according to need, brick was a manufactured material that also gained much attention in the decades following the Civil War. In particular, the hollow brick

Producing a Strong Mortar

A good deal of attention was given to the manufacture and application of mortar. Architects and builders were fascinated with ancient Roman constructive works, recognized to have survived much longer than more recent Norman or medieval structures. The skillful preparation of mortar was viewed as a significant reason for the durability of Roman brick or stone buildings or monuments. The ingredients of common mortar during the nineteenth century were not complicated, generally consisting of varying ratios of lime, sand, and water. The primary object of mortar, it was recognized, was to create a temporarily "plastic" (i.e., malleable) substance used to bind brick or stone, itself hardening with exposure to the atmosphere into a material as strong as natural stone. Though still apparently perplexed about Roman methods, masons still maintained several rules of thumb to produce the strongest mortar. The sand needed to be "clean and sharp," and the lime "strong and fresh." The amount of water depended on the capacity of the lime to absorb it, and it was known that hotter water caused the mortar to set more rapidly. Loam or other materials embedded within the sand would only weaken the mortar. Thus, only the purest sand was preferred. In mixing the lime and sand, the ingredients should be "most intimately mixed," and the maximum amount of lime should be used without adding to the bulk of the sand ("Suggestions About Mortar" 1870, 16).

wall was all the rage, heavily promoted in favor of solid brick or stone walls by the 1870s. Some proponents still favored stone construction, relying on arguments of strength and durability, but the drive for more economical building materials, such as standardized wood or brick, tended to overshadow the remaining calls for stone construction. Either stone or brick was suitable for foundations, presuming they were built properly. Regardless of building material, however, the fundamental principles of building a home remained the same, with respect to the topics of foundations, roofs, floor beams, and advances with plumbing and ventilation.

The Manufacture of Brick

The manufacturing process for bricks varied somewhat depending on their intended use, whether for furnaces, load-bearing walls, foundations, or ornamental facing. As with the standardization of lumber dimensions by the 1860s, so, too, were bricks created with uniform dimensions. The common brick was about eight inches long, four inches wide, and three inches deep. Bricks used for walls of dwellings and other structures were required to be durable and solid enough so they could be neatly cut to necessary dimensions. Bricks needed to be baked at a high enough temperature to ensure their strength and resistance to atmospheric processes.

Brick was manufactured through either manual or mechanical processes, though the latter became heavily favored by the 1870s, for reasons of efficiency and speed (Mosier 2003). Still, *Manufacturer and Builder* was still mentioning both manual and mechanical processes in 1869, with one article explaining that "bricks are formed either with the hand or by manufacturing appliances. Two men, with the hand, can make from six to seven thousand bricks per day." Formed bricks of clay were heated in a kiln with fires fueled by turf, coal, or wood, though wood was most prevalent in the United States during this time. The Flemish process of burning bricks was considered the most economical, using coal for the fuel. Philadelphia and Milwaukee were two of the respected sources for high-quality bricks, given the characteristics of the clay available for their manufacture.

The experiences of brick-making in California reflected the advanced industrial approaches occurring nationally. The earliest bricks in the Southwest

Willson House, 1980 Pacheco Road, Gilroy, California. The first brick house in Santa Clara Valley, it was constructed in 1859 of brick made on the property. Courtesy of the Library of Congress.

and California were made of adobe, generally consisting of mud and straw. They were shaped into large blocks in wooden molds and sun dried. The first common bricks manufactured in California were made in 1847, shaped with wooden molds holding six bricks at a time. Up to 1854, bricks were made and fired at the site of construction, presuming a sufficient source of clay existed there. By 1854, Sacramento had 500 brick buildings. Within city limits there were 30 brickyards with 40 brick machines that could produce a quarter-million bricks a day. Through the 1850s and 1860s, nearly every California town boasted at some point of building their first brick structures. Demand increased as communities learned to prevent devastating fires with brick rather than wood construction. By the 1870s, most California brick manufacturers were using the Hoffman continuous kilns and could make bricks within two days by baking in furnaces (Mosier 2003).

The standard dimensions for common brick were virtually the same after the Civil War as they remain today: about 2 1/4 by 4 by 8 inches. A brick's length is typically twice its width, allowing bricks to be laid, or *bonded,* in the strongest manner possible. Their standardized size and mechanical mass production allowed brick construction to be economical and speedy during the building

boom in eastern and midwestern cities. Prior to reinforcing brick buildings with structural steel in the twentieth century, brick houses and other structures were *load-bearing,* in that the bricks carried the weight of the structure. Walls were consequently built much thicker than the width of one brick, necessitating some creative approaches to laying bricks so as to create a stronger wall.

Laying Brick Walls

Three typical approaches to bonding were in use by the middle of the nineteenth century, namely the *Flemish* bond and the *English* bond. A third variation typical to American buildings was known appropriately as the *American Common* bond. The type of bond was dependent on the way bricks were laid with respect to one another within a given wall. Each row of laid brick is known as a *course* of bricks. The bricks in each course are laid either parallel or perpendicular to the surface of the wall. A brick laid with its long (8-inch) side parallel to the wall is known as a *stretcher,* while a brick laid with its short end parallel to the wall is a *header.* An alternating pattern of headers and stretchers was vital to creating a wall of maximum strength, as the headers were used to bond the brick courses toward the back side of the wall. In this way, a sturdy wall could be constructed to support the weight of the entire structure without steel or wood reinforcements. A variation on the English bond was the American Common bond, apparently the most popular pattern of the nineteenth century. Instead of alternating rows of headers and stretchers, the American Common bond employed six rows (courses) of stretchers to every one course of headers.

As with balloon-frame construction, a foundation to a brick house could be constructed of brick or stone, though stone was occasionally promoted in various literature as being more pleasing to the eye, with its contrast to the brick structure above it. Otherwise, the structural considerations for foundations of brick and wood houses were virtually the same ("How to Build a Brick House" 1870, 266). There existed two basic methods for building brick walls by 1870. For one, a wall could be built of solid brick and "furred off" on the inside of the wall with strips to attach the lath and plaster (the predecessor to dry wall). The second technique involved the construction of a hollow wall with an air space between the courses of bricks. In this case, furring and lathing was not necessary as the plaster (typically two coats) could be applied directly to the interior side of the brick wall.

The issue with solid walls, either of brick or stone, was that of penetrating dampness and lack of insulation from hot or cold exterior temperatures. The architects Duggin and Crossman, for instance, stated their preference for hollow walls in *Manufacturer and Builder.* A hollow brick wall, they claimed, "is warmer in winter and cooler in summer, and does not harbor rats and vermin" ("How to Build a Brick House" 1870, 266). The primary motive was to prevent dampness from appearing on the interior of the wall, which would normally penetrate through solid brick. Given that bricks did not shrink with changing moisture conditions, it was adequate to plaster right on top of the brick without the need for lathing under the plaster. Plaster was also more liable to crack on top of lathing than on brick, as lathing could expand and contract with differing moisture conditions.

A typical hollow wall of adequate strength would consist of brick eight inches thick on the outer wall, followed by two-and-a-half inches of air space,

and finished with four inches of brickwork on the inside wall. The inside and outside walls were tied together with thin iron ties, perhaps 1/4 by 1/4 by 10.5 inches long. Protected with generous coatings of tar, the iron ties would be placed at periodic intervals within the wall, perhaps 2.5 feet apart from one another and within every eighth course of brick. One potential problem with this method involved the excess mortar that would invariably drop down into the hollow space as the walls were being erected. The mortar could build up enough to create a partly solid wall. To solve this dilemma, it was recommended that openings be left at the bottom of the walls on a line with each tier of beams, allowing the dropped mortar to be removed before hardening.

The architects Duggin and Crossman further advised, "Do not permit the mason to persuade you to allow him to put in a binder of brick occasionally so as to 'steady the wall'" ("How to Build a Brick House" 1870, 266). Using header bricks in place of iron ties would surely transmit dampness to the interior of the wall, but only at the spots joined by the headers. They had already discovered that damp spots would appear on the plaster of the interior wall if bricks were used instead of iron ties. Only a year earlier in 1869, one article advised against hollow walls entirely, its writer apparently not yet aware of the iron tie method: "The great difficulty to be encountered in the formation of hollow walls is found in the fact that there must be binders, or bricks laid crosswise, at every fourth or fifth course. Such bricks serve as ducts to convey moisture from outside to inside. And as there must necessarily be a great number of these, it is very evident that the transit of damp is not wholly prevented by the system of hollow-walling" ("Hollow Walls" 1869, 39). The author did recognize an alternative then promoted in California, that of using lathing strips in place of the cross bricks. An additional sanitary concern still remained, however, that the interior hollow spaces would provide "dark chambers for the generation of poisonous gases." Though easy to dismiss such a concern in the present day, this statement reflected the Victorian distrust of presumably foul air and their related obsession with improving ventilation and sanitation after the Civil War.

With the outer brick walls in place—either hollow or solid—it was necessary to apply the roof and interior partitions, or walls. The interior walls were likely brick as well, though hollow walls were not necessary due to their protected,

Stone Construction

What happened to stone construction? Apparently the increasing prevalence to build with mass-produced lumber or brick after the Civil War left proponents of stone construction out in the cold. Though its writers are unknown, an article appeared in an 1869 issue of *Manufacturer and Builder* clarifying the authors' opinion that stone still remained as the best material for building walls for cottages, villas, or mansions. Practically any type of stone could be used, even whatever was available in the fields and could be laid up well. Stone walls would be far superior to the now-popular and ordinary clapboard wood structures, the article claimed. One of the authors' goals was to correct the apparent misperception that stone construction had become the most expensive compared to brick or wood framing. The article attempted to convince readers that "of all the material on earth, none is superior to stone." The reason builders perceived stone as more expensive, they presumed, was the American penchant for specific architectural styles that could be more suitably revealed through brick or wood. Thus, brick and stone were not only becoming popular for economic reasons associated with the efficiencies of mass production, but also for cultural rationales, in that brick or wood might better enable an enhanced freedom of expression. This makes sense during the height of the Victorian Era when American tastes, culture, and fashion became ever more extravagant and trendy for those who could afford it ("Building Material" 1869, 303).

interior location. With the use of hollow outer walls, it was necessary to extend the floor beams out over the hollow space, resting their ends at the center of the outer solid, eight-inch wall. This was to distribute the weight of upper floors or roofing structure evenly down the entire hollow wall, rather than merely on the interior or exterior parts of the wall. The beams were then fastened to the brickwork with iron anchors. It was recommended to place the anchors at eight-foot intervals around the walls, well spiked to the beams.

Though it has become common in America to apply paint to exterior brick walls, there has never been a necessary reason to do so. Even in 1870, it was advised not to paint brick structures because the natural brick material did not require preservation as did iron or tin. If paint was desired for aesthetic reasons, however, it was best to use a special type of face brick as the outside layer. Facing brick was actually recommended for the exterior covering of all brick buildings unless cost restrictions prevented it. Common brick was not suitable for painting, however, but could be used if well rubbed down with another brick and a "free use of cement water" ("How to Build a Brick House" 1870, 266). This was done to fill up the interstices on the outside face of the brick to produce an even surface on which to paint. After rubbing down, the brick should receive two coats of linseed oil, half raw and half boiled, followed with two or three additional coats of oil before applying white lead paint as the base. Americans were apparently more apt to paint brick buildings a variety of colors during the Victorian period, as it was reported that in Europe it was a "very rare occurrence to see a brick house painted" ("How to Build a Brick House" 1870, 266).

Reference List

"A Few Words About Bricks." 1869. *Manufacturer and Builder* 1(2, February): 35.

"Building Material." 1869. *Manufacturer and Builder* 1(10, October): 303.

Hammett, Ralph. 1976. *Architecture in the United States: A Survey of Architectural Styles Since 1776.* New York: John Wiley & Sons, Inc.

"Hollow Walls." 1869. *Manufacturer and Builder* 1(2, February): 39.

"How to Avoid Wet Cellars." 1869. *Manufacturer and Builder* 1(7, July): 207.

"How to Build Abutment Walls." 1869. *Manufacturer and Builder* 1(10, October): 291.

"How to Build a Brick House." 1870. *Manufacturer and Builder* 2(9, September): 266.

"How to Build a Cheap House." 1869. *Manufacturer and Builder* 1(10, October): 298.

"How to Build a Frame House." 1870. *Manufacturer and Builder* 2(8, August): 228.

"How to Plan a Convenient Dwelling." 1870. *Manufacturer and Builder* 2(1, January): 9.

"Improved Reversible Seats." 1869. *Manufacturer and Builder* 1(10, October): 301.

"Improved Scroll Saw." 1869. *Manufacturer and Builder* 1(10, October): 304.

Jackson, Kenneth. 1985. *Crabgrass Frontier: The Suburbanization of the United States.* New York: Oxford University Press.

McAlester, Virginia, and Lee McAlester. 1997. *A Field Guide to American Houses.* New York: Alfred A. Knopf.

Mosier, Dan. 2003. *History of Brickmaking in California.* Available at: http://calbricks. netfirms.com/brickhistory.html.

"Preserving Wood—Robbins's Process." 1869. *Manufacturer and Builder* 1(7, July): 198.

"Selecting Durable Building Timber." 1870. *Manufacturer and Builder* 2(1, January): 15.

"Suggestions About Mortar." 1870. *Manufacturer and Builder* 2(1, January): 16.

Home Layout and Design

THE WELL-TEMPERED HOME

Catharine Beecher's simple 1842 house plan in *Domestic Economy* provided few surprises related to interior layout at that time. Her proposed house "could equally well find itself in Boston, Park Village in London, or even Berlin, at that time, without evoking surprise or even interest," according to Reyner Banham (1984, 99), in his book *The Architecture of the Well-Tempered Environment*. Significant changes in the technologies, manufacturing, and materials were occurring in the decades surrounding the Civil War, however, as the incessant innovations of the Industrial Revolution coincided with a heightened Victorian interest in science and household convenience. By the time Beecher published *American Woman's Home* in 1869, she had already clearly embraced the latest advances in household science and technology. In her newest proposed house plan, Beecher highlighted its modern conveniences including a hot air stove, Franklin stove, cooking range, fresh-air intake, hot-air outlet, foul-air extracts, central flue, foul-air chimney, and a moveable wardrobe. These features were all integrated into the proposed balloon frame used for the entire home, the most contemporary construction method at that time.

It does not require a great leap of imagination to jump from Beecher's innovative home layout to those constructed a full century later. The 1860s and 1870s were decades of immense societal and technological change, with which came unforeseen advances and challenges. Middle-class domestic housing was likewise riding the wave of these transitory decades, producing innovative home designs and layouts that, when tweaked, would closely resemble later homes common to the twentieth century. More specifically, the middle-

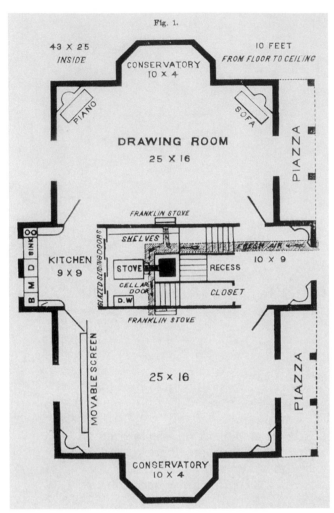

Fig. 1.

43 X 25
INSIDE

10 FEET
FROM FLOOR TO CEILING

CONSERVATORY
10 X 4

PIANO

SOFA

PIAZZA

DRAWING ROOM
25 X 16

FRANKLIN STOVE

SHELVES

FRESH AIR

KITCHEN
9 X 9

STOVE

RECESS

10 X 9

CELLAR
DOOR

CLOSET

D.W.

FRANKLIN STOVE

GLAZED SLIDING DOORS

PIAZZA

MOVABLE SCREEN

25 X 16

CONSERVATORY
10 X 4

The New Housekeeper's Manual by Catherine E. Beecher and Harriet Beecher Stowe, floor plan of first floor of home. Courtesy of the Library of Congress.

class home was transitioning from an independent dwelling of simple, nonstandardized components into its own environmental system designed to connect into larger urban infrastructures of water, sewer, and gas lines. In this way, America was witnessing before its eyes the emergence of the integrated, well-tempered home in the decades that followed the Civil War.

Though not yet common in the majority of American households, the conveniences available during the 1860s included many of those now taken for granted. With the development and increasing adoption of interior technologies and systems for heating, ventilation, lighting, plumbing, and refrigeration, architects and builders were forced to alter their structural plans to accommodate them. The inclusion of modern conveniences into the Civil War–era home, therefore, held significant implications for house design and interior layout, many of which are discussed within the remainder of this chapter.

It is important to ask not only what new technologies and gadgets were becoming available at this time, but also how their widespread adoption affected the entire realm of house planning and design. Architectural publications focused increasingly on incorporating the newer conveniences into house plans. Topics discussed more often included interior plumbing and fixtures, planning for a new "bath-room," and installation of ventilation and heating systems and lighting fixtures. Many articles provided diagrams to explain the actions of water closets and the process of installation and use. Fixed bathtubs were still a novelty but also began to appear in publications (Brumbaugh 1942). Planning for a new house in the 1870s was no longer simply a matter of the exterior frame construction, but now involved solutions to an increasing array of new problems associated with interior technological features.

The new innovations were fascinating in themselves. In 1860, it was already possible to install kitchen sinks with hot and cold water taps, and householders could simply strike a match to light a modern stove, furnace, or kerosene lamp.

Ice was readily available for cooling drinks and refrigerating meat and dairy products. Water closets—notwithstanding their numerous challenges—were being installed as the nineteenth-century version of the modern-day toilet, and families enjoyed more choices for interior artificial lighting than at any time in history. Numerous additional inventions were also entering various phases of mass production leading up to the centennial, including Melville Reuben Bissell's carpet sweeper. One ad for the sweeper offered, "Even the most delicate woman can succeed in pushing it," perhaps emphasizing the gender division of labor associated with Victorian family values emerging at the time (Hilton 1975). For the kitchen, housewives and servants were learning to use new knife-cleaning machines to help beautify the dining-room place settings, along with apple corers, potato peelers, and corn shellers. Given that electric power was not yet an option, all of these devices were hand-powered but still saved time. Foot-powered sewing machines allowed seamstresses to be more productive, and the Triumph Rotary Washing Machine was promised to be fit for a 12-year-old who could accomplish more washing than two women using traditional methods.

Many of these innovations required an adoption phase whereby only wealthier households could initially afford them. With new industrial jobs came an emerging middle class with enhanced purchasing power, allowing more families to spend money on the comforts and conveniences promoted incessantly in the promotional literature. The 1860s represented the largest single-decade increase in the number of industrial firms appearing in America, a growth rate of 80 percent (Ierley 1999a). Cities were confronted like never before with challenges of rapid population growth, unhealthy living conditions, congested and dirty streets, and suffocating air pollution. At the same time, economies of scale associated with mass production of consumer goods led to lower production costs and lower prices for household goods. More jobs were available, and overall discretionary income continued to increase, in turn providing the economic base for the emerging middle class. Even as newer household innovations filtered down the socioeconomic ladder, however, poorer Americans often went without such conveniences. Most houses in the early 1860s still had no sinks or running water, and families without carpet sweepers continued to beat carpets with a wire beater. Those without the new washing machines of the 1870s likewise used the more laborious method of washing clothes, with a large tub and scrubbing board. If newer fuels of kerosene or manufactured gas were not affordable or available, families persisted with the dim artificial lighting provided by candle power or whale oil. The rapidly widening income gap that accompanied the Industrial Revolution was also applying to the adoption of emerging household conveniences.

As Americans migrated westward during the nineteenth century, they brought new knowledge of house construction and household conveniences with them. Victorian Era contributions to new homes in the southwestern and northwestern United States, for instance, included not only the latest fashions of exterior styles and interior designs, but also the newest built-in conveniences of ample lighting, heating, and indoor plumbing. Hot and cold running water, cooking ranges, and water closets were all in use by the 1870s and were often included in the homes of new western towns settled after the Civil War. Early heat sources such as coal stoves and fireplaces were eventually replaced in

larger homes with coal furnaces, and home heating sources shifted from the household rooms to the basement. As with eastern homes, dwellings in far-off places such as Leadville, Colorado, often included holes or registers in the first-floor ceilings to allow warm air to heat the second floors (Stoehr 1975). The 1870s saw finer western homes already feature gas-illuminated chandeliers and wall lamps. More prosperous towns were developing their own waterworks similar to their eastern counterparts, though many small-town westerners still relied on traditional cisterns and wells. The same fortunate western communities also became the first to see specialized bathrooms and water closets to replace time-honored privies or outhouses.

ROOMS AND INTERIOR LAYOUT

Both modest and larger Victorian homes after the Civil War were designed to be picturesque, or asymmetrical, with special rooms devoted to specific purposes. Of course, the grander homes included more rooms with specialized functions, while smaller dwellings relied on fewer rooms to fulfill the minimal household social, private, and functional needs. Whether a newer picturesque floor plan or a more symmetrical, classical one of earlier decades, virtually all homes included an entry hall. This was a place to greet guests and usher them into the more public rooms of the home, usually a parlor or sitting room. In multifloor dwellings, a stairway typically led upwards from the entrance hall. Separating the downstairs rooms from one another was one or more pairs of sliding doors in the grander homes, such as between double parlors, or between parlor and dining room.

Prior to the 1850s, multifloor homes featured central stair halls oriented more for function than design. With the proliferation of more picturesque, Victorian-style dwellings after mid-century, a freedom of interior planning was introduced that allowed the placement and design of staircases to become more decorative. Typical Victorian staircases were located asymmetrically near the front door and often near the parlor. Stairs in earlier Gothic or Italianate homes were typically designed as a straight, single flight to the second floor. Later stylistic trends had the stairs taking more creative L-shaped or circular routes with one or more landings on the way up. Balusters became more complex and ornamental as the nineteenth century progressed, and stairways themselves became the focus of various interior design experiments (Calloway 2005).

Beyond the hall and stairs was the standard roster of rooms for middle-class houses, typically including a dining room and library, along with a parlor, living room, or drawing room. Though the distinction between some of these rooms can be confusing, it is useful to think of the parlor and drawing room as formal places primarily intended to entertain and impress visitors, while second parlors or sitting rooms were designed as more informal spaces for everyday uses of the family. More luxurious homes likely still included combinations of formal and informal rooms. A finer distinction could be made between the formal parlor and drawing room; the parlor was typically intended for family or guests on extended visits, while the drawing room was a reception room for other guests (Winkler and Moss 1986). The household's finest furniture was typically reserved for the parlor, used only for company. If the family owned a piano,

a Victorian clue that the family was "cultured," it would invariably be located in the parlor, along with various other extravagant furniture and decoration such as marble-top tables, bronze statues, plaster casts of famous people, potted plants, fringe cushions, and most certainly the family Bible (Hilton 1975).

More modest, middle-class homes contained only one room devoted to both formal and informal uses, sometimes a double parlor in which half the room was designed to entertain guests while the other half consisted of a family sitting space. A movement was underway by the 1870s that discouraged the inclusion of parlors in middle-class homes, as writers increasingly argued it was unnecessary to maintain expensive rooms to impress visitors. Formal parlors were despised by Clarence Cook, for instance, as "ceremonial deserts," and proceeded to speak of "living-rooms" instead (Winkler and Moss 1986, 133). Though parlors retained their primary purpose in larger homes throughout the Victorian Era, they became less common within newer, middle-class housing. The distinction previously made between the formal parlor and the family living room was abandoned

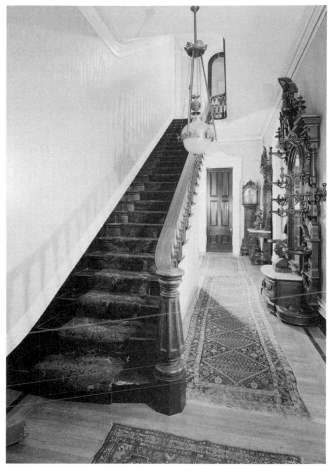

Staircase/entry hall in Ronald-Brennan House (Italianate), 631 South Fifth Ave., Louisville, Kentucky, which was constructed in 1868. Courtesy of the Library of Congress.

by most writers, as the preference shifted to the concept of a drawing room to describe this multipurpose family space. The more informal living room would slowly replace the more formal parlor that preceded it. At least one writer suggested that this new, more practical room be designed as the largest and most pleasant room of the house, intended primarily for multifunctional family purposes. Of course, the living room, or family room, remains one of the most important household spaces to this day.

Other Victorian Era rooms remained more or less standard. Though often thought of in association with the wealthiest households, libraries were actually promoted as one of the more common middle-class rooms, viewed as a more private family retreat than the public living room or parlor. The central hall likewise remained important, as it provided visitors with their first interior view and impression of the home. One publication invoked the Victorian cultural need to impress others, recommending that the hall should provide an immediate sense of cordiality, hospitality, shelter, shadow, and rest (Mayhew and Meyers 1980).

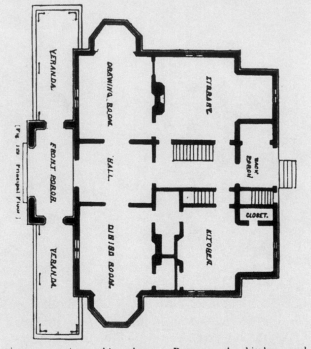

DESIGNS FOR VILLAS OR COUNTRY HOUSES. 297

In the rear hall is the principal staircase, and in a smaller entry, between this hall and the kitchen, is the back stair.

The library is a pleasant and retired apartment, 20 by 21 feet, exclusive of the deep alcove, about 10 feet square. The kitchen is 14 by 20 feet, with a corresponding recess, 10 feet square (which might be partitioned off for a scullery). In the dining-room is a china-closet. Between the kitchen and dining-room is a pantry. In the kitchen itself are two closets. In a space partitioned off from the back porch is the cellar stair

CONSTRUCTION. This cottage should be built with hollow

Cottage-villa in the rural Gothic style, residence of William J. Rotch of New Bedford, Massachusetts, built from the plans of A. J. Davis. Courtesy of the Library of Congress.

Usually located in the rear of the house or in the basement, the kitchen might be adjacent to a pantry, scullery, or porch. Boudoirs, or ladies' morning rooms, were uncommon, especially upstairs. This time period saw both closets and distinct bath-rooms become more common additions to original floor plans, allowing homes of the 1870s and 1880s to more closely resemble standard middle-class homes of today. Larger "villa" homes similar to those offered by Andrew Jackson Downing might also include a sizeable basement, which might include a laundry, serving room, larder, servants' hall, and kitchen, if not located upstairs. At the smaller end of the continuum, Downing's "small cottage for a working man" featured a living room and bedroom on the first floor and two bedrooms and two closets on the second (Mayhew and Meyers 1980).

The *Manufacturer and Builder* provided what was likely a common, middle-class urban house plan in 1869, indicating the rooms likely to be found in more modest homes. The object of this particular two-story plan with attic and basement was "to provide the essential rooms required by small families" ("Cheap City Houses" 1869, 310). This particular plan still included a parlor, as well as a pantry and dumbwaiter, given that the kitchen was still designed for the basement. On the second floor were two bedrooms, a linen closet, and a small room of undesignated purpose off of the hall in the front. The presumed servant's room was in the attic. Being an urban house, the plan also included indoor plumbing with a bath, water closet, pump, and water tanks.

As this plan suggests, closets were also increasingly provided as standard features in new homes following the Civil War. This was indirectly a material consequence of the booming Industrial Revolution, in that industrial employment was providing more leisure income for a greater proportion of the

population who, in turn, used their newfound wealth to accumulate more commercial products such as clothing. The previously free-standing wardrobes, chests, or armoirs were becoming less able to store all the additional clothing, necessitating the need for built-in closet space (Calloway 2005). Likewise, libraries with more permanent, built-in shelves became more common during this period, as large book collections were no longer reserved for just the very rich. Though the amount of disposable wealth remained unevenly distributed throughout American social classes and ethnic groups, the shift from subsistence farm production to industrial manufacturing and steady incomes during the nineteenth century did provide for a vast expansion of middle-class households and the disposable income that enabled greater levels of spending on commercial products that were previously out of reach for many families. In turn, the standard arrangements of the home were modified to accommodate for these new habits of American consumption. Of course, these consumer-oriented behaviors and expectations of American families continued to grow throughout the twentieth century, leading to ever-larger walk-in closets and more spacious two- or three-car garages. By and large this consumer-based manufacturing economy took off quickly following the Civil War and has yet to slacken.

The Kitchen

Kitchens of the 1860s were still likely relegated to the basements of larger homes, though some writers were already advocating their relocation to the first floor allowing for more light and ventilation. As advocates for servants' human rights and more servants themselves demanded better working conditions, kitchens more typically became first-floor features in the back of homes by the 1870s and 1880s. Downing himself supported improved working conditions for servants, writing that "good servants are comparatively rare . . . [and] do not stay long, we should employ the smallest number possible, should arrange all the apartments conveniently, and introduce all manner of labor saving devices, such as the rising cupboard or dumb waiter, the speaking tube, and the rotary pump" (Downing 1868).

Though kitchens eventually made their collective move to first floors, they were still typically relegated to the back of the house where smells could dissipate onto alley ways rather than throughout the home. Americans during the Victorian Era were taught to mistrust smells, as they were commonly thought of as unpleasant and, at worst, possibly the unwitting carriers of illness and disease. Plates of hot-roasted coffee beans were carried through rooms where unwarranted smells were detected (Hilton 1975). The kitchen was invariably the busiest and overworked household room, as most food was still made from scratch, including staples such as bread and butter. The process of canning also took place in the kitchen and was likely a sweltering job. Most foods prepared for canning would reach their proper ripeness only on the hottest days of the year, often in July or August. All fruits and vegetables not immediately used would be jarred in the kitchen and placed on shelves. Extras such as horseradish, relish, catsup, mayonnaise, and pickles were also made in the kitchen, as were nonfood spring tonics and women's cosmetics for preventing sicknesses and removing wrinkles, so they believed (Hilton 1975).

Kitchen with original drainboard, Gen. Grenville M. Dodge House, 605 South Third Street, Council Bluffs, Iowa. 1870 initial construction. Courtesy of the Library of Congress.

The use of ranges, or cook stoves, was becoming more common throughout the postwar decades, though many modest and poorer families continued to cook in their fireplaces. As the years progressed, the practice of cooking in an open hearth was already becoming a lost art (Calloway 2005). Acceptance of early ranges was slow, however, as temperatures were difficult to gauge. As with other innovations of the time, iron ranges were constantly being tweaked and improved upon, eventually to become the most precious piece of equipment in the home. Ranges were designed to burn coal or wood, and a regular supply of one or both fuels was necessary to keep the stove burning most of the day, a common practice. Gas slowly replaced coal and wood as the dominant fuel, to the point where gas ranges were widely available by the 1880s. Certain improvements in range design were documented in Beecher and Stowe's 1869 edition of *American Woman's Home*. They described one range that kept 17 gallons of water hot at all times, provided a warm closet for baked pies and puddings, heated flat irons under the back cover, boiled a tea kettle and pot under the front cover, baked bread in the oven, cooked a main course in a tin roaster, and provided a flat surface on top for cooking in pans (Calloway 2005).

Beyond Beecher and Stowe's work, numerous other publications, advertising, and catalogs showcased the latest technologies and products related to home cooking. One 1869 article in *Manufacturer and Builder* expounded on the importance of well-cooked food and how American cooking ranges were

improving. While simple ranges of less than $100 were satisfactory for even the grandest homes and hotels not many years earlier, claimed the writer, the products available had improved markedly in quality and function. Manufacturers themselves were partly responsible for the expanded variety of ranges, as some had "undertaken to create a demand by furnishing a supply of really elegant and efficient articles." In turn, smaller and lower-priced ranges were influenced and were predicted to "radically affect the domestic economy of a very large proportion of our citizens." Several sample ranges of varying cost and scale were promoted as examples in the article, with one measuring seven-feet long with capacity for two fires feeding one large and one small oven. It was advertised as exhibiting a "great economy of fuel," its simplicity of use, and a "great external coolness," which apparently had only become recently possible. Its construction allowed for the position and size of its fires and ovens to be changed as desired.

The Bathroom

The modern-day features that we associate with a standard bathroom were literally coming together during the 1860s. The concept of a bathroom as a separate room of the house remained rare in 1860, but it was typically included in plans for new homes by 1880. As specialized bathrooms became more common, they were typically placed on the second floor, closer to the source of water from attic tanks or cisterns. They were also located conveniently near the bedroom where most personal washing typically occurred. A. J. Downing's *Architecture of Country Houses* (1859) was one of the earlier writings that featured house plans with a distinct bathroom in the 1850s, and the idea of combining the functions of bathing and elimination into one room was still rather new in 1860. Meanwhile, the bathroom sink was appearing more often in new homes, though bathroom sinks were likewise rare in 1860.

As the War commenced, it was more likely to find typical bathroom functions scattered around—or outside—the home. Before bathroom sinks appeared, the upstairs washbasins were usually found in the bedrooms where personalized washing was done. Without a bathtub or sink in a separate bathroom, the "well-arranged dressing room for a lady" had a washstand with large bowl and pitcher, a small pitcher and a tumbler to use for rinsing the mouth, a sponge basin, bottle of ammonia, a hairpin cushion, and a footbath under the washstand (Hilton 1975, 15). The washing of one's personal body during this time still did not require the privacy of a bathtub or shower, and so it was still commonly accomplished in the bedroom (Ierley 1999a).

The practice of bathing in bathtubs also came into vogue during these decades, especially for higher-income households and those tied into a new, public water supply in the city. In 1860, the city of Boston had 3,910 tubs. With a total population at that time of 177,902, this meant that only 1 in 45 individuals had a bathtub (Ierley 1999a). The first bathtubs, fixed to the floor, were just starting to appear at this time. The earliest models typically included some kind of sheet metal—either tin, lead, copper, or zinc—molded to fit inside a wooden frame or cabinet (Calloway 2005). Painted, iron baths appeared as well, eventually sporting some stylistic details associated somewhat with fashionable interior styles of the day. These free-standing tubs without the wooden cabinetry became

more common following the Civil War and were appearing in catalogues in the 1870s. They eventually included their own built-in faucets and were typically designed to stand several inches off the floor on four supporting legs, often shaped in stylistic ball or animal claw shapes. As the years progressed, the bath and bathtub underwent a revival, as new models of hip baths, sitting baths, and sponge baths became more or less normal (Rybczynski 1986).

The earlier years of bathing were not necessarily comfortable. Health issues remained a concern for some time, leading to recommendations that the bath-tub water remain cold or tepid at best. One writer warned owners of innovative shower baths that "nearly freezing water from a shower bath produces a feeling somewhat akin to what might be imagined to result from a shower of red-hot lead; the shock is tremendous, and the shower, if continued for any length of time, would assuredly cause asphyxia" (Rybczynski 1986, 135). But cold water persisted as the standard temperature for years, as doctors continued to main-tain that cold water was best for healthier living. Rules were strict for proper bathing, and kids were not allowed to play. Baths had to be concluded before the bather caught "his death of cold" (Hilton 1975, 16). Bathtubs were also a concern in themselves, as they might carry disease. In reality, people heeded the cold-water advice not so much due to doctors' advice, but because of the lack of hot-water heaters. With the advent of both hot and cold water into a separate bathroom, people soon ignored the health rule (Hilton 1975). And, even if health was the general reason for bathing, decent soft soap appropriate for the skin was hard to come by. Toilet soap for gentler washing was rare and not commonly manufactured up to the Civil War. Only during the 1860s did washing with soap become more common, and the now-famous Procter and Gamble would not introduce their Ivory soap until 1882 (Ierley 1999a).

Making the bathroom complete during these formative years was the water closet—basically the predecessor to the modern-day toilet. This innovative though controversial device was the first to allow elimination of human waste indoors. Previously, householders were required to make the journey to an outdoor shack, or outhouse, known as a privy. The only way to avoid a rain-soaked trip to the privy at night might be the use of a simple glass jar stored under the bed and emptied in the morning (Hilton 1975). Privies remained in use for a majority of the American population, however, throughout the nineteenth century (Ierley 1999a). Households were somewhat slow to adopt the water closet, though with the advent of indoor bathrooms and plumbing, water closets grew progressively more common. Americans were thus limited to one of two situations—both with unpleasant aspects—during these decades: the privy or the water closet.

Privies were basically pits in the ground that required maintenance and emptying. In some places their occasional emptying was required by law. Their contents were typically hauled away at night, leading to the term "night soil," and their contents were considered a health risk in urban areas (Ierley 1999a). For many years laborers were hired with shovels and carts to take care of the unpleasant task. More efficient wagons with hoses and pumps were increas-ingly deployed by the late 1870s in urban areas, essentially giving America the predecessor to the modern-day septic system cleaning truck.

The use of simple, mechanical water closets slowly replaced the use of out-door privies in urban areas. In 1857, there were only approximately 10,500 water

closets in New York City, which worked out to about 1 for every 62 people. At this time they were also still quite expensive. Two primary factors contributed to their continued adoption, namely health codes that required them and industrialization that mass produced them and drove prices down (Ierley 1999a). As the name implies, water closets required water, though only a couple of gallons per use. Many homes still did not include indoor plumbing, and cities were only beginning to install urban infrastructure for public water supplies. As one might imagine, many Americans also remained suspicious of the indoor water closet, having been used to the privy for centuries and not convinced of their healthfulness. In fact, sanitation experts largely disfavored the use of water closets for some time, especially the pan-type variety, which was quite common. The pan closet was simpler and cheaper than the valve closet, and so the pan type naturally attracted more initial buyers. The pan-type closet featured a simple hinged pan, usually copper, that formed a water seal when horizontal, in order to prevent the backup of sewer gases into the house. A small volume of water would remain in the bowl until flushed, when the pan was tipped and its contents passed below into a receiver, or cast-iron receptacle. From there the contents (mostly) moved into a waste pipe, ending its journey in a cesspool in places where no urban sewer system existed. The biggest problem with this variety of water closet was the accumulation of filth in the receptacle. Sanitation experts despised their use for this reason, though they were still relatively popular right into the twentieth century when a device more similar to the modern-day toilet finally became available.

The advent of the bathroom as a specialized, interior room of the house was consequently enabled due to a combination of factors, including the proliferation of water closets to replace outdoor privies. Households increasingly enjoyed the conveniences and technologies afforded by indoor plumbing, which was necessary to carry water to the washbasin, bathtub, and water closet. It made the most practical sense to include all of these features and their required piping into the same room.

HOUSEHOLD CONVENIENCES

Artificial Lighting

Although electricity would not begin to influence peoples' lives until later in the century, homeowners still enjoyed a wide array of lighting choices in the postwar decades. As with most other features of the Victorian homes, artificial lights gradually became an ornamental symbol of status and fashionable design in the decades following the war. Louis G. Tiffany (1848–1923), for instance, founded his now-famous interior decorating firm in 1878 and catered specifically to wealthier clients looking for advice on interior design. Tiffany is probably still best known today for his iridescent Favrile glass and its use in lamps, vases, and windows, though he also specialized in designing furniture and hand-blocked wallpaper (Boardman 1972).

The technical and functional improvement of interior and street illumination remained an equally vital concern. By the late 1860s, decent artificial lighting was perceived as a significant component of society well being for private homes, public halls, and on the street to help deter crime. "Hence the importance of every improvement in the production of artificial light, whether

affecting its quality or its cost" ("Improvements in the Process of Manufacturing Illuminating Gas" 1869, 207). Gravity-fed oil and fluid-burning lamps had remained the most advanced lighting choices up through 1850, and rooms were only sparingly or modestly lit for basic needs. Argand whale-oil lamps remained popular in their astral lamp form, though alternatives in these earlier years included other lamps for burning fluid or camphene (Mayhew and Meyers 1980). As lighting options and innovations became available, the overall brightness of rooms was enhanced and in turn made possible more leisure activities during nighttime hours. Earlier types of fluid-burning lamps were improved with new burners and chimney designs until they were superseded by gas light. Shades and scrubbers were utilized for gentler and less smelly lighting conditions.

Kerosene was discovered in the 1850s, ushering in the world's ultimate dependence on fossil fuels. Abraham Gesner was a Canadian doctor and amateur geologist who discovered a method for extracting kerosene from asphalt rock, producing a fuel that was relatively clean and less expensive than whale oil. The ensuing discovery of petroleum in Pennsylvania by 1859 only accelerated the use of kerosene for lighting, as petroleum could be distilled and cracked to produce kerosene, enabling a rapid rise in demand for the fuel. The demand for kerosene therefore became the initial mainstay for the budding petroleum industry around the Civil War. The quality control for kerosene lamps was highly varying, however, and they could easily cause fires. "One never knew if a lamp would produce a blaze of light or simply a blaze," explained Witold Rybczynski (1986, 140). More than 100 house fires were apparently attributed to kerosene lamps during the 1880s.

Numerous varieties of kerosene lamps appeared by the late 1860s, with Ives' Patent Lamps advertising their own as the safest, simplest, and best. By this time, lamps were being promoted as design features for the home. Ives' offered bronze chandeliers with 2–12 lights each, pulpit standards with hooded reflectors, vestibule lanterns with double reflectors, hall or entry lamps with ground or cut crystal glass globes, reflector hanging lamps, spring bracket lamps, and elegant lamps combined with vases. All of these variations were promised to light as quickly as gas lights and to fill and trim safely and neatly without the need to remove the shade, globe, or chimney ("Ad for Ives's Patent Lamps" 1869, 59).

Nearly every American family owned at least one kerosene safety lamp at the time of the centennial in 1876 (Hilton 1975). Such improved lamp designs allowed for instant extinguishing if they were kicked or dropped. The pungent odor of kerosene was a tradeoff, however, as it smelled like burning coal oil. Regular maintenance on kerosene lamps was also required,

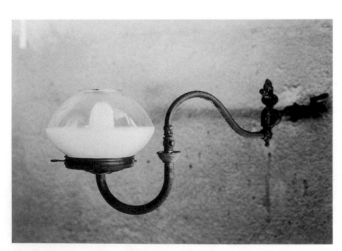

Gaslight. Courtesy of the Library of Congress.

through the necessary trimming of wicks, refilling of fuel, and cleaning the lamp chimneys. Still, kerosene was considered an improvement over earlier lighting choices. Once perfected, kerosene lamps could be easily moved around for specific tasks and required no installation of complex piping required for gas lamps.

Manufactured and natural gas had also become available to urban dwellers as an alternative to kerosene. Improvements to lighting with gas were also continuously occurring, along with new and improved methods for manufacturing gas from coal, one of its two primary sources at the time. Its other source was plentiful but still a mystery by the early 1870s when writers mused about what causes natural gas to form beneath the surface and why the supply was apparently increasing near Erie, Pennsylvania. The community of Fredonia, New York had already taken advantage of natural gas for artificial illumination. The natural gas used in Fredonia would rise from a small brook (i.e., stream), was collected into a gasometer, and distributed throughout the town like manufactured gas ("Natural Gas Fuel" 1871).

Gaslit homes were already appearing in Europe by the 1840s, though the most common use for gas was for illuminating streetlights in America up until the Civil War. Several factors contributed to their post–Civil War appearance in American homes. First, gaslights were prohibitively expensive until the required public infrastructure and manufacturing processes were established in a given city. The *gasolier,* or gaslight, was considered a mass commodity, as it was the product of scientific and technological developments and was financed by investors planning to create a demand for the device. To place gasoliers in homes first required large investments to manufacture the gas in specialized gasworks and networks of gas lines placed beneath city streets. With the necessary infrastructure in place, however, gaslight became much more inexpensive and accessible for all but the poorest households.

A single gasolier was equivalent to the illumination produced by about 12 candles. Unlike kerosene lamps, gaslights were attached to walls or ceilings, rendering them immobile. Another downside was their byproduct fumes, especially on colder nights when the interior air was not replaced through sufficient ventilation (Hilton 1975). Headaches were a common complaint, and doctors remained cautious about other potential health hazards. The "noxious vapors" emitted by gasoliers were believed to tarnish metal, kill plants, and destroy coloring (Rybczynski 1986, 140). These vapors were often referred to as carbonic acid, what we refer to in modern times as carbon dioxide, or CO_2. Research from Germany around 1870 revealed that artificial lighting through gas-burning lamps polluted interior air to a greater extent than initially assumed. Gas requires a considerable consumption of oxygen, explained one writer in *Manufacturer and Builder* ("Artificial Lighting" 1869), leading to the emission of carbonic acid. Aside from common headaches, it was noted that other symptoms of exposure to high levels of carbonic acid might include dry throat, tickling in the larynx, and dry fatiguing cough.

Despite the threats of carbonic acid, gas nonetheless became popular and a common alternative and competitor to kerosene, due to certain advantages. Fixtures using gas did not require refills, and they burned cleaner than kerosene (Calloway 2005). Still, combinations of candles, rush candles, and lard oil lamps remained in use especially in more modest households.

Much of the pre-electric innovation in lighting, therefore, occurred during the 1850s and 1860s and was increasingly adopted through the 1880s. One indicator of this trend is found in a study showing that between 1855 and 1895, the actual amount of illumination in an average Philadelphia household was approximately increased by twentyfold (Rybczynski 1986). Most American households had at least one oil or kerosene lamp by the 1880s, and the use of gas and kerosene lamps transcended socioeconomic classes. Similar types of lighting fixtures could be found in the wealthiest and most modest of homes. Americans apparently agreed with an 1869 ad for kerosene lamps in *Manufacturer and Builder* claiming optimistically that "No one need be in the dark" ("Ad for Ives's Patent Lamps" 1869).

Interior Heating

Until the advent of stoves and later central heating in the nineteenth century, fireplaces remained the standard source for heat. Even with the national proliferation of stoves by the 1870s, many households still used their fireplaces for heating, cooking, or perhaps as a sign of social status. An open fire had become a sign of wealth, as it was more expensive—and therefore more inefficient—to fuel than a stove, and typically implied that household servants were tending it. Describing the social meaning of the Victorian Era fireplace, Mary Gay Humphreys wrote, "The fireplace is really the domestic altar, the true rallying point of the household" (quoted in Calloway 2005, 289). Despite their eventual obsolescence in the face of more innovative heating strategies, therefore, fireplaces themselves were not necessarily abandoned but instead became important social elements of interior design. In fact, every Victorian revival style featured some combination and design of fireplace and mirror, except for Shingle style (Calloway 2005).

Merritt Ierley identified the 1800s as "the century of the stove" (1999a, 130). He further cites that stoves were being produced at the rate of approximately one million annually by 1860, as compared to 375,000 10 years earlier. After the Civil War, the stove shared heating duties with the increasingly common kitchen range. While the range heated the kitchen vicinity, stoves often heated the parlor and occasional bedrooms. A stove could be fueled with wood or coal, though coal was preferred and was considered the dominant energy supply of the nineteenth century. Upstairs rooms including unheated bedrooms might include simple registers on the floor to allow some heat to rise from downstairs. The stove remained the most popular source for indoor heat into the early twentieth century, only to be replaced by the advent and widespread acceptance of central heating (Ierley 1999a).

Coal, in both its bituminous and anthracite varieties, became a common form of fuel by the early 1800s and consequently caused much air pollution in cities such as Pittsburgh well into the twentieth century. The modest 100,000 tons of coal produced by 1800 rose significantly to 20 million tons produced by the 1860s (Ierley 1999a). To burn coal was more efficient than wood, and coal burned longer and hotter than wood. One source in 1869 claimed that a household could consume a full ton of anthracite coal every three weeks (Ierley 1999a). Despite its advantages, coal required a large amount of cellar space for storage, and many people still continued to use wood well into the twentieth

century. Coal and wood consequently remained the primary choices for heating fuels until after the Victorian Era when infrastructure and technology for oil and natural gas would eventually prevail. Until then, however, oil could be used for conversion to kerosene in artificial lamps but would not be feasible as a heating fuel for some time. Likewise, the use of natural gas was still well into the future when the development of the seamless pipe in the 1920s would enable its use.

Though still dependent on coal, the development of central heating and forced ventilation allowed for a special furnace to be located in the basement to provide heat to the entire home. The emerging technology of furnaces and forced air had a fundamental impact on the way architects designed houses and other buildings, and developments of central heating and forced ventilation are considered as determining factors in the planning and design layout of homes after the Civil War (Bruegmann 1978). Other factors eventually influenced the integration of these two household components over time, especially in the fields of chemistry and health. Architects increasingly found it necessary to alter their building designs to incorporate innovative systems of heating and ventilation. Providing spaces for furnaces and central air towers, for instance, were some of the more obvious necessities, though also important was the planning for floor or ceiling registers, radiators, pipes, and other elements. Many of the innovative functions were hidden behind walls or above ceilings, and such equipment continued to require an ever-larger percentage of cubic footage in specific buildings.

The otherwise simple dwelling was becoming an integrated system, increasingly tied into larger urban infrastructures designed for water, gas, and sewers. Though the "building as system" approach was not fully developed until the early twentieth century, much of the elements required for such a system were in place around the time of the Civil War (Bruegmann 1978).

A curious social implication of the widespread use of furnaces was their apparent tendency to break up families. At least, furnaces were accused as such by various writers, including those promoting other forms of heating such as indoor fireplaces or stoves. "It is well enough to have your dwelling warmed top to bottom and have no coals to carry beyond a furnace," claimed a rather biased and presumably futile fireplace advertisement, "But the furnace has done immense mischief to the family powers! It scatters members all over the house and furnishes not one attractive spot in which inmates will gather as they do by instinct to enjoy the cheery comfort of a fireside" (Hilton 1975, 20). There is some truth to this accusation, as furnaces did in fact enable the family to scatter around more than previously, and fathers thought seriously about whether or not to install them. Given the ever-strengthening sentiment toward family during the Victorian Era, it was not uncommon for households to maintain both a furnace for comfort and a fireplace hearth to encourage family interaction. Perhaps not until the 1970s with the proliferation of televisions would concerns for scattering family members become so potent.

Ventilation

Victorians became obsessed with the topic of fresh air, and nearly every book on house planning during this time devoted one or more chapters on ventilation and the "evils of bad air" (Rybczynski 1986, 132). A writer for *Manufacturer*

and Builder in 1870 followed suit, advising that the first thing to consider in ventilating a room is the introduction of fresh air: "All the air in a room must be removed every few hours, and an equal quantity of fresh air introduced. So long as there is no draught to draw out the foul air, and to introduce fresh air, a room may remain filled with an atmosphere that is poisonous to animal life" ("An Economical Way of Ventilating Living-Rooms" 1870, 7). Americans took a more serious interest in public health after the Civil War, leading to a sort of ventilation mania. Several factors conspired to awaken people to health concerns, including fashion, science, medicine, and war. The medical horrors and aftermath of the Civil War focused people's attention on the science of medicine, and increasingly overcrowded cities were associated with worsening disease and epidemics. Scientists and writers were additionally sharing more information about two toxins that people learned to fear—carbon dioxide, then referred to as carbonic acid, and organic effluvia, or the presumably harmful microbes created by the human body and suspended in one's breath. Lewis Leeds, an engineer and self-proclaimed health official, warned in 1866 that "Man's own breath is his greatest enemy" (Townsend 1989, 29).

Scientists in Europe and America had established that humans exhaled carbon dioxide, and they correlated increasing levels of the feared gas with human discomfort. An 1871 article in *Manufacturer and Builder,* titled "Keep your Mouth Shut," added a socially motivated rationale for doing just that, beyond the concern for carbon dioxide. Individuals who breathe through their mouths and let their mouths hang open were never healthy or long lived, and they appeared less intelligent when doing so. Air should only pass in and out of the lungs through the nose, "except in the act of speaking or singing." Readers were urged to obey a "definite law for breathing and sleeping, obedience to which must exercise the most beneficial influence on the well-being of the human race" ("Keep Your Mouth Shut" 1871, 56).

Though Victorian awareness of ventilation needs was heightened due to fears surrounding carbon dioxide, public anxiety was likewise heightened with respect to indoor smells and other pollutants. There was in reality a variety of sources for smells and pollutants, especially ill-washed humans, smoky fireplaces, and open cooking fires. Smells from cooking were particularly despised, leading to the practice of keeping the kitchen in the basement or far to the back of the house. Tobacco was likewise considered an unpleasant smell, and cigars were generally forbidden indoors. People had actually stopped smoking almost entirely during the eighteenth century, and England's Queen Victoria banned smoking from her homes, leading the way for others. Cigars had become popular again during the nineteenth century, but they clashed strongly with Victorian obsessions against smells and foul air.

In addition, new but erroneous scientific theories contributed to the Victorian concerns for foul air. Scientists promoted that numerous horrific diseases, such as malaria, cholera, dysentery, diarrhea, and typhoid fever, were caused by impurities in the air. This notion led in part to the association of urbanization and overcrowding with these diseases. Though a strong link between over-crowding and disease was clearly established, the explanation was still wrong. Germ theory still had yet to be discovered or promoted, which would change the face of medicine and scientific understanding of disease for the twentieth century. For the Victorians, however, fresh air seemed to be the best preventive

measure, and it became an issue of life and death as proponents continued to insist on better ventilation. "When people are well clothed and well fed, the more fresh air, however cold, the better," according to one writer of house plans (Rybczynski 1986, 135). Their newfound focus on fresh air likewise assisted the proliferation of various outdoor activities including bicycling, gymnastics, and even seaside holidays.

Even the realm of refrigeration could not escape the interest in fresh air. The use of wet ice alone was not enough, according to guiding literature, to prevent the rotting of meats and fruits. Smells would accumulate, writers warned, including "damp, musty, ill-flavored" odors that would likely be "fishy, sickly, or sour" ("Refrigeration with Ventilation" 1871, 56). New and improved ice boxes—the precursor to the modern-day refrigerator—were becoming available during these decades to help improve cooling efficiency and ventilation. One such advertised model consisted of a ventilated refrigerator that was designed to consume less ice and maintain a continuous current of cold, fresh air moving through it. The interior box of the unit was covered in felt lining more than an inch thick. The ice chest had a water-tight bottom, and one pipe led outdoors to fresh air. A second pipe led to the chimney. A lamp or gas-light would burn constantly within a lantern housed in the second pipe. The ascending hot air from the lantern would cause a vacuum in the ice chest and force the outside air into the unit. It was estimated that during the seven warmest months of the year, a family of six would only require 2,500 pounds of ice for the purpose of drinking and preserving food.

After the Civil War, only two practical systems existed for ventilating homes: the so-called *natural* ventilation system and the *vacuum* system. As its name implies, the natural system involved little more than "opening some windows and hoping for the best" (Townsend 1989, 31). The downside to open windows, of course, could be unwelcome cold air and drafts. Somewhat ironically, the drafts themselves were believed to cause similar health problems as foul, indoor air. This was the era of invention, however, and the search for improved ventilation techniques did not bypass numerous inventors. Special air inlets were devised, for instance, such as Tobin's Tube and the Sheringham Valve, in an attempt to deflect incoming drafts up toward the ceiling. Of course, periods of stagnant outdoor air made these devices ineffective for exchanging air inside the home. These devices did appear in American publications but were apparently rarely used. The vacuum, or heat-extraction system, was the alternative. This method relied on a source of heat at the base of an exhaust flue to create a simple vacuum. This system created a constant air flow as warm air escaped up the flue, forcing fresh air to replace it. The wealthiest households might employ a furnace or stove at the base of the flue, with ducts leading from each room of the house to the central flue (Townsend 1989).

For many households, however, a permanent heat-extraction system was expensive and out of the question. The easiest though most inefficient vacuum method consisted of the time-honored fireplace. The concern for ventilation actually had the affect of prolonging the use of fireplaces in America when more efficient stoves and furnaces were already available. At least one architect of the time dismissed the fireplace as being unscientific, dirty, wasteful, and inexpensive, while still admitting that it remained the best system for ventilation with a tolerable efficiency (Rybczynski 1986). Though stoves and furnaces were more

widespread than in England, suspicions remained about their being unhealthy forms of heating, similarly prolonging the life of the fireplace in American homes. Downing's own book *The Architecture of Country Homes* (1859) protested against stoves "boldly and unceasingly" (Rybczynski 1986, 137). Others believed that, while stoves admittedly saved fuel and household costs, they would more than make up for any cost savings with increased hospital bills.

Two principal methods of central, forced-air ventilation were available after the Civil War. The first was the Ruttan system, which allowed cold, outside air to flow through an underground pipe to a basement furnace. Typically positioned under a central stair hall, the furnace would send warm air up the stairwell, essentially turning the hall itself into a giant flue. A more intricate variation of this method entailed the use of tin-lined ducts and brick flues that guided warm air more specifically to registers in the floors of all the rooms. The air would therefore rise from the registers to the ceiling in each room, causing cool air to descend in turn. Catharine Beecher provided a second, alternative system in her *American Woman's Home* of 1869. Also employing a hot-air furnace, Beecher's system involved a pipe rising from a furnace and connected to a kitchen stove and two Franklin stoves. Registers were placed in the ceilings of each second-story room to transport foul air to the chimney. Beecher's design reflected her controversial belief—citing a chemistry professor—that carbon dioxide gas did not sink to the floor as commonly thought, but instead rose to the ceiling. Hence the location of registers in the ceiling rather than the floor (Townsend 1989).

Wealthier households in the suburbs or country tended to overemphasize the need for forced ventilation and installed complex systems for artificial air supply that were largely unnecessary (see Sidebar "Lewis Leeds on Ventilation in 1869"). Neither overcrowding nor excessive air pollution existed outside the central cities, though it was generally in the larger country homes where such elaborate systems were found. As air ducts also became fashionable, however, they were viewed as yet another overt

Lewis Leeds on Ventilation in 1869

An 1869 issue of *Manufacturer and Builder* included a special report by Lewis W. Leeds, Consulting Engineer of Ventilation and Heating for the U.S. Treasury Department. Known as one of the foremost experts on the subject, Leeds provided a status report on ventilation technology and recommended that people use what they have available rather than wait for future and better technologies to develop. In part, Leed wrote:

A kind of chronic confusion and bewilderment seems to have taken possession of the public mind in regard to ventilation . . . There seems to be a prevailing belief that what is needed is some new invention that is going to supply, all the time, summer and winter, pure fresh air, without any further thought in regard to time matter. This is a very erroneous supposition. It is also a very unfortunate one, because, while it is impossible that it should ever be realized, its constant anticipation prevents that care and attention to the proper use of the appliances for ventilation which are accessible to all. If, therefore, the public were to cease altogether from looking for new inventions, and wasting money on them, and each one were to devote his whole attention to making the best use of whatever he had for ventilation and warming, real progress would soon be made on a good and substantial foundation . . . Windows and doors are our great natural ventilators; and many persons, in speaking of ventilation, overlook the important part they really play in the ventilation of buildings. Occupants exercise considerable thought and care in opening and closing these according to the ever-shifting conditions of the atmosphere, and ought to exercise the same intelligence in regulating other contrivances for ventilation. ("Ventilation and Warming" 1869, 34)

symbol of social status, which likely contributed to their needless proliferation. Only large, public buildings might have required such extensive forced-air ventilation systems.

Indoor Plumbing

The development of domestic interior plumbing made great strides in the decades following the War. Almost no patents related to domestic sanitation were recorded with the Federal government until the 1840s, whereas hundreds were made annually by the 1860s (Ogle 1996). Following the War, in-house water supply systems were already found in many urban residences, especially in cities with developed public water systems. Still, one writer for *The Builder* in 1865 discussed a typical, state-of-the-art system for indoor plumbing and claimed that nowhere near a majority of homes at the time enjoyed such a system (Ierley 1999a). At this time, the common setup included a cistern that supplied water from the upper part of the dwelling, providing consistent water pressure to the pipes beneath. A cold water pipe led to the kitchen to the range, which included a water heating device consisting of an upright, copper cylinder boiler, perhaps with a 30–40 gallon capacity. A hot-water pipe then led to the bathroom, and to other places where such a convenient water supply was desired. Numerous plan books and other literature already provided detailed discussions of plumbing and descriptions of related products throughout the 1860s and 1870s. Customers in Boston had already owned some 27,000 plumbing fixtures in 1853, which included about 2,500 water closets. This number rose to 124,000 total fixtures by 1870, providing just one indicator of how indoor plumbing was increasingly adopted during this developmental time period. In 1860, the number of public, urban waterworks stood at 132 nationally and increased to a total of 240 in 1870. American cities of all sizes could boast of their own sophisticated water and sewer systems by the 1890s (Ogle 1996).

It was not only the urban or wealthiest households that adopted plumbing fixtures and indoor piping during this time. Residents of dense urban centers and small farming villages variously accepted the conveniences of plumbing simultaneously, as did those of suburbs, farms, villages, and country estates (Ogle 1996). Although fixtures could be expensive when totaled together, Americans representing a wide range of socioeconomic and geographic characteristics were incorporating plumbing and water fixtures to make their homes more convenient. People were already purchasing a wide array of conveniences during the 1850s, including tubs, water closets, washbasins, sinks, and other fixtures that replaced previously portable objects. The technology itself, therefore, was not all that new, as fixed, indoor fixtures were not unlike their portable predecessors. Interest in the conveniences afforded by fixed indoor plumbing corresponded with other household innovations that Americans were adopting simultaneously, such as the pump, dumbwaiter, speaking tube, furnace, and stove.

Domestic reformers and sanitation experts greatly applauded the increasing household shift to fixed, indoor plumbing. Its adoption by the Civil War period, however, was attributed mostly to desires for household convenience and a heightened social status awarded to notions of cleanliness. Conversely,

advances of plumbing technology and public water systems were less influential on America's collective acceptance of domestic plumbing systems. The first half of the nineteenth century saw the construction of America's first, great urban waterworks, for instance, but they did little to promote cleanliness and indoor plumbing on their own. Advocates of expansive reservoirs and urban water systems were more concerned with contaminated drinking water and filthy streets than they were with promoting bathing (Bushman and Bushman 1988). Only the very elite were beginning to accept the use of water to wash their own bodies by the 1840s. Even the attempt to install a bathroom in the White House as late as 1851 caused a public outcry over the expense. In 1860, there existed only 3,910 baths in Boston for a population of some 178,000, most of which were likely still portable tubs. In 1906, bathtubs were still relatively rare, as only one in five Pittsburgh households owned one in that year (Bushman and Bushman 1988). It was consequently a slowly evolving desire for cleanliness and convenience associated with new ideas about domestic life throughout the nineteenth century that best explained the adoption of indoor plumbing (Ogle 1996).

Maureen Ogle (1996) identified two distinct phases in the history of household plumbing, with the first phase coming to an abrupt end in the early 1870s. Prior to then, earlier promotional writers in plan books and other domestic advice had struck a rather benign tone with respect to designing the interiors of homes with conveniences such as plumbing. This style of promotional writing was replaced rather suddenly with an adamant, collective chorus of passionate advisors that blasted the horrors of household sanitary practices and denounced both homeowners and plumbers as incompetent. Various manuals offering advice shifted to the more determined voices of the new reformers, who referred to themselves as the sanitarians. A crusade for more scientific plumbing was thereby launched. Their collective lobbying saw some important successes, including the passage

The Epitome of Convenience in 1860

An excellent example of a home designed to take maximum advantage of 1860 conveniences is found in the James Gallier House, built in the French Quarter of New Orleans. Described in detail by James Ierley (1999b), this dwelling provides a good sense of what was possible just one year prior to the Civil War, but still exceedingly rare throughout America. Gallier desired to install the most advanced technology of the time, as well as the typical roster of Victorian Era rooms. The first floor included the standard double parlor, dining room, pantry, storeroom, and kitchen, while on the second floor there were four bedrooms, a library/general purpose room, bathroom, and servant's quarters. It was the technology that was most exceptional. Rainwater was collected in a cistern in the backyard that supplied all indoor needs and was fed from the roof. A tank in the attic was connected to the cistern, requiring a pump to transfer water from the cistern to the tank. Water could then be sent directly to the kitchen, pantry, and bathroom. Though still exceedingly rare, Gallier used the term *bathroom* in his own plan for the house in 1857. In the bathroom was found a water closet and a copper tub in a walnut cabinet enclosure, representing the first phase of fixed bathtubs. The attic tank supplied cold water to both the tub and water closet, both of which then emptied down into what Gallier called a "water closet sink," or more simply a cesspool. A coal-burning fireplace also existed in the bathroom, as did a wall-mounted gaslight fixture.

The kitchen included its own sink with both cold and hot running water, the latter of which was supplied through a copper boiler adjacent to the cooking range. Water pressure created from the hot-water system was sufficient to provide hot water to the second floor as well. A simple icebox constructed of Cyprus was used for refrigeration, located in a vestibule off the side entrance to protect it from the heat of the kitchen and to allow for convenient delivery of ice. It was likely only used

of various plumbing codes and new interior designs for the arrangement of plumbing fixtures. The previous use of private, self-contained, diverse plumbing systems was consequently giving way to the integration of indoor plumbing into larger urban systems of sewers and water mains.

CLEANLINESS AND PUBLIC SANITATION

(continued)

for special occasions rather than for day-to-day storage. Gallier also installed practically every type of ventilation device then available, involving the house's own design with high ceilings and large windows with shades. An adjustable skylight allowed heat to escape to the attic. For lighting, Gallier employed gaslights throughout the house, taking advantage of the early gasworks installed by the City of New Orleans in 1824—not long after the American takeover.

Corresponding with their increasing belief in science and technology was a heightening Victorian desire for human cleanliness. Although only the nation's elite took baths during the early 1800s, personal cleanliness and hygiene came to rank highly as a mark of moral superiority among the burgeoning middle class after the Civil War. The emerging culture of cleanliness was not so much the result of intense capitalist campaigns by plumbing or soap manufacturers. In fact, soap manufacturers did not produce large quantities of the substance until well after a suitable demand developed (Bushman and Bushman 1988). Only by the 1860s did soap become rather common for washing skin. Likewise, only between 1870 and 1890 could Samuel Colgate boast of doubling his company's soap production over two decades. Instead, the value placed upon cleanliness came to be associated with a civilized society. Dirtiness became a sign of degradation, and reformers proselytized that cleanliness was a basic, rudimentary step toward achieving personal respect. The rise of cleanliness on the American cultural ladder, however, did not occur overnight but instead

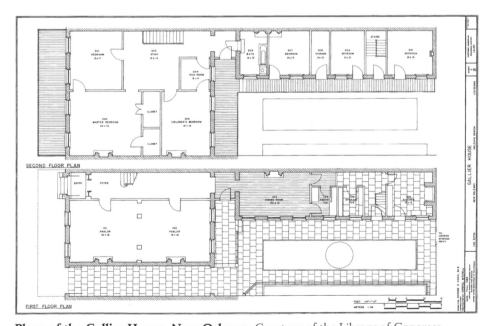

Plans of the Gallier House, New Orleans. Courtesy of the Library of Congress.

required more than a half century to realize its full impact on society. The writings within an early nineteenth-century medical book represented an earlier promotion of cleanliness as a measure of civilization, declaring that, "the different nations of the world are as much distinguished by their cleanliness, as by their arts and sciences. The more any country is civilized, the more they consult this part of politeness" (Bushman and Bushman 1988, 1225). Not until the 1850s, however, did personal bathing become routine for many American families.

The rising interest in cleanliness dovetailed well with the overarching Victorian cultural characteristic that urged personal restraint and self-control. While often oriented to notions of sexual behavior, Victorian self-restraint was likewise applied to personal health, whereby individuals were urged to practice discipline of the body for improved hygiene. Along with the growth in scientific inquiry, Victorians came to think of health as something they could personally acquire by applying various scientific rules. Perhaps the most important manifestation of this notion of health came with the new insistence of regular bathing. After all, the still-popular idea that "cleanliness is next to Godliness" originated with the Victorians (Stearns 1999, 73). More household time was devoted to bodily care, and parents now had even more welcome constraints to teach their children in the oft-futile hope that they would learn how to avoid getting dirty. Eventually, the act of bathing and personal hygiene came to be viewed as pleasurable, whereas earlier use of soap and water was conducted more in the name of health and discipline. Likewise, toilet training emerged during the 1860s as parents no longer treated soiled pants with nonchalance. Children should be trained at an early age to master toilet habits, in part to help keep clean new types of children's clothing beginning to appear on the market.

As the self-proclaimed sanitarians launched their campaign against urban health concerns, housing design became more integrated with larger urban infrastructures associated with waterworks and sewer systems. One immediate and dangerous issue continued to be sewer gas and its potential escape into the home. Water traps on various plumbing fixtures had already been widely implemented to prevent the backup of gases, until new research revealed that water traps were not effective enough for that task. A public scare ensued, as did an onslaught of new inventions that failed as well. During the 1870s, sanitarians promoted for a limited time the use of a ventilation pipe—essentially a branch of the water closet soil pipe that ran through or near a chimney or stove flue pipe. The heated air inside the ventilation pipe, the theory went, would "draw away the poisonous exhalations of the closet" (Ogle 1996, 129). Of course, this method only worked if the stove or chimney was hot. At other times, downdrafts from outside would simply push the sewer gas back into the house. As interest in the ventilation pipe waned, a newer approach soon became the standard, similar to what builders include in modern-day housing. The ventilation pipe was connected up to the roof, with all other pipes joining it. The entire network of pipes was thereby ventilated effectively and provided an outlet for all gases generated in or near the house. Eventually this method, too, was improved upon, as fresh-air inlets were placed near the house and covered with grating. The ventilation pipe itself was opened at the roof and provided the outlet. This also solved the previous problem known as siphonage, caused when

a sudden change in air or water pressure forced the water out of the trap and allowed the entry of sewer gas (Ogle 1996).

Sanitarians found little to celebrate after the Civil War with respect to water closets. Improved, flushable water closets would not appear until the 1880s, long after their predecessors had been declared unsuitable for proper household sanitation. Both dominant varieties of closets available during the 1860s and 1870s—namely the pan and hopper types—received highly negative reviews from sanitation experts, though the hopper type was slightly favored due to less moving parts that could malfunction. The 1870s saw an all-out campaign against the pan closet, though many Americans preferred the pan type as the cheaper alternative. Despised as an "antiquated and decayed relic of barbarism," the pan closet would only partially clean itself of filth when flushed with a small amount of water (Ogle 1996, 132). What was not drained into the soil pipe remained stuck to the receiver's sides and remained obscured by the pan itself. This filth that remained produced unhealthy gases. As water closets became more common in urban households, the waste that did actually make it to the cesspool or sewer caused its own problems with respect to urban drainage.

Sanitarians focused on drainage around the house as well, and throughout the larger urban setting. It was well noted that children would tend to contract illnesses in places with poor drainage around houses. Scientists still believed, however, that smells carried sicknesses (Hilton 1975). Water closets contributed to the larger and expanding crisis of urban environmental pollution. Until well after the Civil War, most urban areas still relied on surface water—that is, ponds and streams, or on rainwater cisterns or ground water pumped to the surface. Household water use was therefore rather low, probably averaging 3–5 gallons per day, per person (Tarr et al. 1984). Household wastewater from cooking, cleaning, and washing was simply thrown onto the ground outside the house, or deposited in a street gutter. Dry wells or leaching cesspools—holes lined with broken stones—were also utilized when available. Human waste was deposited either into a cesspool or, more commonly, into a privy vault, often consisting of a shallow hole in the ground or even receptacle lined with brick or stone located close to the house or in the basement. Privy vaults could be designed to allow their contents to seep into the ground, or to remain inside for occasional removal and cleaning. The cleaning process was both labor intensive and messy. Eventually laborers were hired at night to remove the waste by disposing of it in nearby watercourses, dumps, or on farms. This so-called cesspool-privy vault system, as labeled by Tarr et al. (1984), eventually became so unsanitary that expensive underground sewer systems gradually replaced them in larger cities.

Urban cesspools and privy vaults were becoming overwhelmed between 1820 and 1880. Urban populations were growing and were increasingly concentrated in the city centers during this period of industrial expansion. Existing waste removal systems therefore became increasingly inadequate to handle the population growth. The adoption of piped-in water only contributed to the stress through the proliferation of urban waterworks. The number of cities with waterworks had increased dramatically from only 16 in 1860 to an impressive 598 by 1880 (Tarr et al. 1984). Municipal water systems provided a more constant and cleaner supply for local industries, households, and civic needs,

such as firefighting and street cleaning. Although considered a monumental improvement for any urban area, new water supplies only exacerbated urban pollution. Vast quantities of wastewater now required removal from antiquated systems, and abundant supplies predictably led to increased household water usage. In Chicago, for instance, water use rose from an average of 33 gallons per person per day in 1856 to 144 in 1882 (Tarr et al. 1984). However, few cities had installed elaborate sewer systems to remove this extra water. The situation was only worsened with the proliferation of water closets during the 1860s and 1870s. These popular conveniences—though unsanitary in themselves—were usually connected to existing cesspools, which ultimately overflowed with wastewater. They consequently soaked the existing urban water tables and "converted large portions of city land and streets into a stinking morass" (Schultz and McShane 1978, 393).

Slow but certain to respond, cities everywhere undertook massive and expensive sewer construction projects and street-paving programs starting on a large scale during the 1870s and 1880s. Engineers promoted both paved streets and underground sewer systems both for improved traffic flow and sanitary conditions. A general, collective consensus had emerged among many sanitarians, doctors, and engineers that the installation of decent sewer systems would greatly alleviate many of the environmental issues then facing cities. In Chicago, the chief engineer of the first sewerage commission during the mid-1850s was apparently so persuasive that the city approved the spending of over $10 million for the construction of 54 miles of sewers and for raising the street grades (Schultz and McShane 1978). With many more cities following Chicago's example, the later decades of the nineteenth century were devoted to producing copious underground sewer systems that would finally catch up with the earlier development of municipal waterworks.

Reference List

"Ad for Ives's Patent Lamps." 1869. *Manufacturer and Builder* 1(2): 59.

"An Economical Way of Ventilating Living-Rooms." 1870. *Manufacturer and Builder,* 2(1): 7.

"Artificial Lighting and the subject of Ventilation." 1869. *Manufacturer and Builder* 1(2): 34.

Banham, Reyner. 1984. *The Architecture of the Well-Tempered Environment.* Chicago: University of Chicago Press.

Beecher, Catherine E., and Harriet Beecher Stowe. 1869. *The American Woman's Home.* New Brunswick, NJ: Rutgers University Press.

Boardman, Fon W. Jr. 1972. *America and the Gilded Age 1876–1900.* New York: Henry Z. Walck, Inc.

Bruegmann, Robert. 1978. "Central Heating and Forced Ventilation: Origins and Effects on Architectural Design." *The Journal of the Society of Architectural Historians* 37(3, October): 143–160.

Brumbaugh, Richard. 1942. "The American House in the Victorian Period." *Journal of the Society of Architectural Historians* 2(1): 27–30.

Bushman, Richard, and Claudia Bushman. 1988. "The Early History of Cleanliness in America." *The Journal of American History* 74(4): 1213–1238.

Calloway, Stephen. 2005. *The Elements of Style: An Encyclopedia of Domestic Architectural Detail.* Buffalo, NY: Firefly Books, Inc.

"Cheap City Houses." 1869. *Manufacturer and Builder* 1(10): 310.

Downing, Andrew J. 1859. *The Archietecture of Country Houses.* New Yark: Do Appleton & co.

Downing, Andrew J. 1868. *Cottage Architecture.* New York: John Wiley & Son.

Hilton, Suzanne. 1975. *The Way it Was: 1876.* Philadelphia: Westminster Press.

Ierley, Merritt. 1999a. *The Comforts of Home—The American House and the Evolution of Modern Convenience.* New York: Three Rivers Press.

Ierley, Merritt. 1999b. *Open House: A Guided Tour of the American Home, 1637–Present.* New York: Henry Holt and Co.

"Improvements in the Process of Manufacturing Illuminating Gas." 1869. *Manufacturer and Builder* 1(7, July): 207.

"Keep Your Mouth Shut." 1871. *Manufacturer and Builder* 3(3, March): 56.

Mayhew, Edgar de N., and Minor Myers, Jr. 1980. *A Documentary History of American Interiors: From the Colonial Era to 1915.* New York: Charles Scribner's Sons.

"Natural Gas Fuel." 1871. *Manufacturer and Builder* 3(2): 37.

Ogle, Maureen. 1996. *All the Modern Conveniences—American Household Plumbing, 1840–1890.* Baltimore: Johns Hopkins Press

"Refrigeration with Ventilation." 1871. *Manufacturer and Builder* 3(3, March): 56.

Rybczynski, Witold. 1986. *Home: A Short History of an Idea.* New York: Penguin Books.

Schultz, Stanley K., and Clay McShane. 1978. "To Engineer the Metropolis: Sewers, Sanitation, and City Planning in Late- Nineteenth-Century America." *The Journal of American History* 65(2, September): 389–411.

Stearns, Peter. 1999. *Battleground of desire: The struggle for self-control in modern America.* New York: New York University Press.

Stoehr, C. Eric. 1975. *Bonanza Victorian: Architecture and Society in Colorado Mining Towns.* Albuquerque: University of New Mexico Press.

Tarr, Joel, James McCurley, Francis C. McMichael, and Terry Yosie. 1984. "A Retrospective Assessment of Wastewater Technology in the United States, 1800–1932." *Technology and Culture* 25(2, April): 226–263.

Townsend, Gavin. 1989. "Airborne Toxins and the American House, 1865–1895." *Winterthur Portfolio* 24(1, Spring): 29–42.

"Ventilation and Warming." 1869. *Manufacturer and Builder* 1(2, February): 34.

Winkler, Gail, and Roger Moss. 1986. *Victorian Interior Decoration: American Interiors 1830–1900.* New York: Henry Holt and Company.

Furniture and Decoration

FURNITURE DESIGN TRENDS OF THE ERA

Like exterior facades, interior designs and fashions moved through successive periods of popularity. Victorian interiors did not necessarily match their exterior facades, however, either in name or stylistic treatments. A Second Empire–styled exterior, for instance, might be decorated with Rococo Revival or Elizabethan interior furnishings. Generally, exterior styles had progressed through an overlapping succession of styles, from Gothic and Italianate during the 1840s and 1850s through Second Empire in the 1870s, giving way to more complex and overlapping styles including Romanesque, Queen Anne, Colonial, Stick, and Shingle by the late 1870s into the 1890s (see "Styles of Domestic Architecture around the Country"). Meanwhile, interior styles transitioned vaguely during the nineteenth century in a similar manner, though not always with the same names or geographical source regions. Gothic Revival, for one, was actually designed to complement its exterior styling. Interior styles that followed, however, increasingly overlapped with one another and could be stylish in nearly any Victorian home. Elizabethan, Egyptian, Rococo, and Renaissance Revivals appeared as interior design choices largely after the 1850s. Meanwhile, various French Revivals, such as Louis XVI, appeared by the 1860s, followed shortly by Eastlake, Japanese Revival, and Colonial Revival by the 1870s. As older styles remained popular, newer styles appeared.

Much of the nineteenth century belonged to the optimistic and class-conscious Victorians, for whom their ever-complicated exterior and interior designs became important status symbols and social expressions of newfound wealth. Those who could not afford the complete line of fashionable interior

designs or exterior facades either settled for second-hand décor when opportunities presented themselves, or acquired expensive furnishings and decorations whenever they could. The common result was accumulations of rather diverse mismatches of isolated high-style furniture intermingling with more plain, vernacular and less-styled décor. Even considering the wealthier homes, it was rare to find entire rooms or homes decorated with the same interior style. Most other Americans, including recently freed slave families, were fortunate to acquire one or two pieces of elegant furniture or interior ornaments for their own modest homes. Still, no part of a home's interior was immune from stylistic treatment: from hallways and staircases to walls, ceilings, floors, and windows, not to mention an ever-larger variety of standardized, factory-produced furniture designed for each specialized room of the home.

As with numerous other fundamental aspects of American life and livelihood, it was the growth of factories that allowed for the production and consumption of numerous interior styles and designs. American mills produced more varieties and quantities of wallpapers, textiles, carpets, and stylish furniture with every passing decade. Furniture, wallpapers, floor coverings, sinks, fireplace mantels, and staircase newel posts were increasingly mass produced in expansive factories rather than smaller family-owned workshops. Answering this enhanced variety of products was the budding profession of interior design, emerging in part to assist confused homeowners with challenging decisions for home decoration and furnishings. The earliest interior decorators appeared by the 1840s and 1850s, predictably in the larger cities where owners of large urban villas would be most likely to seek out their advice. George Platt (1812–1873) of New York City, was a pioneer decorator, and by 1850 A. J. Downing was recommending that such decorators provide furnishing advice for "villas of considerable importance" (Mayhew and Meyers 1980, 183).

By the 1860s, one could find published advice on interior decoration, though the literature was not yet prolific or widely read. Samuel Sloan's *Homestead Architecture* (1861) focused primarily on architecture but also offered general suggestions for furniture and interior decoration. One of the more influential works of the time was *American Woman's Home* (1869) by the Beecher sisters, Catharine and Harriet. They provided advice on decoration, as did the equally influential *Hints on Household Taste* by English designer Charles Eastlake, published in England in 1868 and reprinted in New York in 1872. Eastlake included his own philosophy for interior treatments, which influenced a whole generation of homeowners and designers on both sides of the Atlantic. Eastlake particularly cherished and promoted honesty and strength of materials, in that one manufactured material or color should not pretend to represent another. Beyond Eastlake, the 1870s produced numerous influential publications on interior design, including *The House Beautiful: Essays on Beds and Tables, Stools and Candlesticks,* a reworking of articles in *Scribner's Monthly* published by Clarence Cook. Other books provided a wide range of philosophies and decoration advice, including Harriet Prescott Spofford's *Art Decoration Applied to Furniture,* which included text extracted from *Harper's Bazaar* articles.

Perhaps more indicative of Victorian cultural priorities was the relative lack of advancement with interior comfort and practicality. In comparison, it was the cultural realm of visual style that received the bulk of attention. Stylistic trends—whether interior or exterior—answer more to demands of fashions,

tastes, and social status then practical and functional concerns. With the rather constant appearance and promotion of numerous stylistic revivals, most ended up doing little to advance domestic comfort. Gothic furniture, for instance, has been described by historians as adequate for public buildings but ultimately contributed to interiors with funereal, churchlike atmospheres. Likewise, Moorish- and Chinese-styled interiors were "exotic but wearying," as they "all sank in the confusion of the Victorian style wars" (Rybczynski 1986, 101). As the income and social gap widened throughout the nineteenth century, housing ultimately ranged from cramped apartments and tenements to immense, stylish mansions exhibiting the latest trendy interior designs. Like never before, interior décor likewise reflected extreme economic disparities (Mayhew and Meyers 1980).

Victorian Interiors in the West

Western tastes and values were in large part due to the process of cultural diffusion, whereby people's cultural preferences and knowledge move with them as they migrate elsewhere. As Anglo-American settlement moved into new western states and territories, so, too, did their eastern ways of life. Both exterior architectural styles and interior designs arrived in new western towns and mining settlements from the East, due in large part to rapidly developing rail connectivity. A more unified national culture consequently emerged after the Civil War, as domestic fashions and styles in the West came to mirror those from eastern source regions. Though stylistic transitions were collapsed in time as westerners caught up with eastern fashions, small-town and urban landscapes of housing and commercial districts began to look the same regardless of location on the continent (Francaviglia 1996).

Therefore, standard high-end interiors in late Victorian Colorado were not dissimilar from their eastern counterparts by the 1870s (Stoehr 1975). The decades following the Civil War brought the typical irregular, picturesque floor plans, elevations, and architectural styles into the Mountain West. Likewise, one could find similar hardwood floors covered with throw rugs, and in some cases wall-to-wall carpeting. Decorative patterned wallpaper was also used extensively, except in the kitchen where oilcloth was more common. Other Victorian interior design elements included prefabricated plaster ornaments, such as cornices and medallions, and decorative moldings and millwork of fine woods. A standard western parlor might include combinations of secretaries for holding books, desks, library tables, fainting couches, parlor sets, pianos, paintings, and grandfather clocks. A high-end dining room could include a dining room table, sideboard, a crystal chandelier, and a diamond dust mirror. Typical bedrooms might reveal iron, brass, or fine wood bedroom suites, high bedsteads, hand-carved wardrobes, marble-topped dressers, washstands, small tables, rocking chairs, velvet furnishings, hand-made quilts, and birdcages. Kitchen furnishings included coal ranges, pot-and-pan racks, soapstone sinks, cupboards or pantries, bread boxes, and handicrafts (Stoehr 1975). Of course, many pioneer families and rural settlers lived in much less luxury—perhaps for a generation or more—as towns and cities continued to develop. More likely in rural western folk houses, interiors were much more plain or basic, with few extravagances. One pioneer cabin in Elk Creek, Montana Territory, for instance,

revealed some initial attempts to establish minimal comforts (Peterson 1971). Based on an illustration from 1866, the cabin included a wooden gable roof, small glazed window, two roughly framed pictures, a central fireplace with a simple mantle, and food sacs—perhaps to keep flower dry—hanging from the ceiling and wall. Locally made wood and leather containers also appear in the image, along with a few metal cooking utensils. The West was already demonstrating a wide disparity between initial pioneer-style living compared to high-end, fashionable Victorian culture.

A PROLIFERATION OF INTERIOR STYLES

Prior to the Civil War it was common for one interior style to be replaced in popularity by successive newer ones. This relatively linear process broke down as American factories produced ever-greater quantities of furniture and interior decorations. At the same time, printed information and products spread ever-more quickly on a growing network of rail lines. These economic and geographical factors conspired to allow a wide variety of stylistic ideas and trends to flood the American market after the War. As earlier styles remained popular, new styles were added into the mix of options for fashion-craving middle- and upper-class households.

The so-called style wars were on, as there would no longer be one *correct* style. The Gothic Revival, Elizabethan Revival, and Rococo Revival styles had generally succeeded one another in rather rapid succession since the 1840s. The 1860s and 1870s saw a variety of additional styles become popular while very few fell out of favor. One of the postwar styles was Renaissance Revival, which actually appeared prior to the War and remained a popular and fashionable choice right up until the end of the century—especially for the exquisite mansions of the wealthiest families. On top of the Renaissance Revival came numerous French stylistic designs, which filled many pages of literature focused increasingly on interior design. It must have been a challenge to keep track of them all. Which style would be most appropriate for a new, middle-class household—the French style of Francis I, Henri II, Henri IV, Louis XIII, XIV, XV, or XVI? All of these were recommended by various writers (Mayhew and Meyers 1980).

At the same time, various English-derived styles appeared, many of them revivals that featured names such as Elizabethan, Jacobean, Queen Anne, Chippendale, Sheraton, Adam, and Hepplewhite. On top of these, by the late 1870s, came variations on American Colonial Revival, associated largely with the hype surrounding the centennial. As the interior design profession grew and raw memories of the Civil War faded, professional decorators also turned to more exotic sources in the Middle and Far East for their inspiration, not the least being those of Japanese, Chinese, Turkish, Moorish, and Persian influences. Designs focused on Japanese and Moorish motifs became two of the more popular exotic styles following the centennial, as Americans became immediately more familiar with these far-away places by attending or reading about the centennial exhibits sponsored by these places. Whether based on American colonial influences, Gothic, French, English, or far eastern designs, Americans with ever-more disposable income could purchase entire suites of furniture, wallpapers, ceiling treatments, floors, curtains, upholstery, and other

decorative accessories that were appropriate for any or all of these styles. Still, many households paid little attention to such stylistic concerns, as only a small percentage of the population could afford such extravagance.

To make sense of the most popular styles adopted for decorating the interiors of American homes, Smith (1985) provided a useful list of the styles that appeared and remained dominant for one or many decades. The list is perhaps oversimplified, and the dates listed for each style should be viewed as generalizations only, Smith cautioned. Still, his list provides a useful overview of the time at which particular interior styles became popular and how they overlapped one another throughout much of the nineteenth century. The remainder of this section provides more specific details on some of the most widely adopted styles that predominantly influenced the 1860s and 1870s.

Gothic Revival	1840s
Elizabethan Revival	1850s on
Egyptian Revival	1850s–1860s
Rococo Revival	1850s–1900
Renaissance Revival	1850–1875
Louis XVI Revival	1860s–1870s
Eastlake	1870s–1880s
Japanese Revival	1876–1880s
Colonial Revival	1876–1920s

Gothic Revival

Complimenting its exterior counterpart, the initial revival of Gothic-styled interior designs began in England, especially promoted by A.W.N. Pugin during the 1830s, and appeared in the United States by the 1840s. Interior and exterior elements of the Gothic style were largely similar, featuring variations of the pointed arch and pierced tracery, features that represented the ecclesiastical styles of medieval Gothic Europe. By the 1840s and 1850s, Gothic designs had become available for nearly every household feature, including wallpaper, furniture, lighting, fabrics and floor coverings, pottery, and glass. Entire rooms could be decorated in the Gothic style, as promoted heavily by the period's prescriptive literature.

Still, historical evidence indicates that few households in America actually decorated their homes entirely in the Gothic mode, a practice undertaken primarily by the wealthiest few who enjoyed large urban townhouses or grand country homes. Only in such places could architects design entire suites of Gothic furniture to match a room's architecture (Schwin 1994). Most who employed the style at all settled for either a few pieces of Gothic furniture or perhaps, at most, one room devoted to the style. It was more common for Gothic-styled homes to include a variety of interior designs, especially as the nineteenth century progressed. A few pieces of custom-designed Gothic furniture might be distributed here and there throughout the household.

The style still remained pervasive enough that practically any homeowners interested in current fashions ended up acquiring one or more Gothic pieces. Even with numerous additional stylistic choices, Gothic remained more or less acceptable through the end of the Victorian Era. The Jenks family home in Baltimore,

for instance, was updated in 1843 from earlier Classical designs to those of the Gothic. An interior photo from 1885 demonstrated the persistence of the style, still revealing Gothic-styled chairs and a sideboard displaying silver with Gothic tracery. The wall itself was designed to match the décor with pointed arches (Mayhew and Meyers 1980).

As with their promotions of Gothic style cottages and floor plans, Alexander J. Davis and Andrew Jackson Downing likewise recommended various Gothic interior designs and furniture. Davis is credited as being one of the first Americans to design his own Gothic furniture, having found no suitable alternative source of Gothic cabinetwork (Mayhew and Meyers 1980). However, it was Downing who promoted Gothic furniture designs in his publications, including a section at the end of his *Architecture of Country Houses* (1859) devoted to country cottage furniture.

Schwin (1994) described a Lady's boudoir, or sitting room, which was clearly influenced by both Pugin and Downing. The hallway from which one entered the boudoir was somber and heavy with typically uncomfortable Gothic furniture. Within the boudoir was wallpaper inspired by Pugin, designed with gold fleurs-de-lis on a cream-colored background. The room's green wool Gothic style window curtains, however, were adapted from a plate in Downing's Country Houses. The room's décor continued with a small Gothic style center table, two-tiered worktable stands to hold a lady's knitting and sewing projects, and oak-strip flooring stained in alternating light and dark wood.

A further important promoter of Gothic furniture was John C. Loudon and his *Encyclopedia of Cottage, Farm, and Villa Architecture and Furniture* (1839), of which Davis owned a copy. Loudon promoted consistency in one's choice of interior

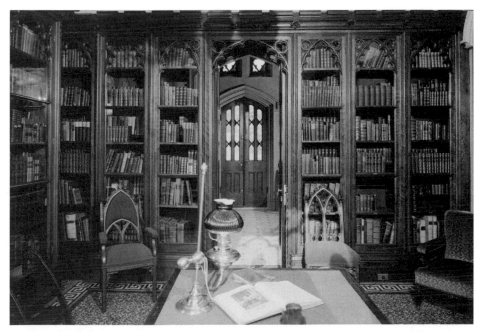

Library at Lyndhurst. Courtesy of the Library of Congress.

style, believing that, for instance, Gothic furniture was only appropriate for dwellings exhibiting exterior Gothic styling. While both Loudon and Downing offered suggestions for every room of the house, Loudon's own English standards emerged with his emphasis on expensive, high-end furniture. Conversely, Downing always promoted smaller "cottage" plans that included less elaborate furniture. Downing was also more willing than Loudon to accept mixtures of various furniture styles in one house. Downing admitted that, "Elaborate bed-room furniture in the Gothic style is seldom seen in country houses in the United States" (Mayhew and Meyers 1980, 164). For urban villas, however, Downing offered more expensive Gothic furnishings including elaborate Gothic beds, tables, and chairs.

Elizabethan Revival

Unlike the Gothic Revival, which was promoted as a consistent interior design, Elizabethan was more of a specialty style that might be used for occasional furniture or decorations. Its impact was more limited than Gothic, though Downing believed the style would appeal to European immigrants who might be reminded more of familiar European interiors. Only occasional American examples of Elizabethan-designed rooms have been found, and the style made its most significant impact with furniture. The nineteenth-century version of Elizabethan was essentially a revival of baroque furniture of the English Restoration of 1660–1688 (Mayhew and Meyers 1980). This revival's furniture was certainly one of the more distinctive, as its characteristic spiral or spool turning can be identified quickly. Posts and legs of chairs, small tables, towel racks, and spool beds were some common applications of the style. The one Elizabethan bedroom set that A. J. Downing suggested for smaller cottages was identified particularly by the furniture's distinctive spiral turnings. Downing claimed that Elizabethan furniture was generally found in libraries, drawing rooms, and bedrooms, and was particularly appropriate for Gothic interiors.

Rococo Revival

Furniture of the widely popular Rococo Revival style was characterized by its fragile and slender appearance but deceivingly sturdy construction. Also distinctive was its typical use of heavily carved natural forms and prolific reliance on the S-curve, or the serpentine line. However, this was not a style reserved for scattered furniture pieces as with its Elizabethan predecessor. The characteristic S-curves and heavy carvings of Rococo became pervasive in nearly every form of interior design, from carpets and furniture to wallpaper, curtain valences, fireplace mantels, ceiling plasterwork, and picture frames.

The style was already being produced by American furniture manufacturers by 1850, though its popularity soared following its display at the Crystal Palace Exposition in London in 1851 and the smaller Crystal Palace Exposition that followed it in New York two years later (Mayhew & Meyers 1980). Rococo furniture was typically expensive and crafted from imported mahogany, until the forests of Santo Domingo were harvested too heavily, which depleted the supply. Rosewood was considered a decent alternative and occasionally was considered superior to mahogany. Its popularity diminished after the Civil War due to reduced American purchasing power and the appearance of newer styles.

Still, Rococo remained influential well into the 1870s, albeit with changing patterns and colors (Schwin 1994). At this time, the style was being over-shadowed by its eventual successor, Renaissance Revival. Because the earlier Rococo had risen in prominence concurrent to the popularity of Italianate and Italian Villa–styled exteriors, the French-inspired Rococo commonly decorated the interiors of Italian-inspired dwellings.

Renaissance Revival

Often incorporating elements of Rococo, the newer Renaissance Revival style had eclipsed its French-inspired predecessor by the 1870s (Schwin 1994). Renaissance Revival was inspired, of course, by actual European styles fashionable at the height of the Renaissance period of the fifteenth and sixteenth centuries. The style is identified with its more rectilinear, rectangular forms with much less emphasis on curved designs. Characterized by an illusion of Classical forms, its furniture made use of incised, paneled or burled veneers, heavy classical moldings, and straight-profiled turned legs rather than the delicate S-shaped cabriole legs found on Rococo pieces. Use of deeply carved ornament, cabochon decoration, portrait medallions, and caryatids were also commonly associated with Renaissance-styled furniture (Mayhew and Meyers 1980). Walnut and mahogany were the standard woods, though Rosewood became especially popular for fine Renaissance furniture, which was generally more massive than that of the Rococo.

Matching furniture suites were common for those who could afford to furnish individual rooms in a single style. The style permeated nearly all aspects of interior design, from curtains, wallpapers, and carpets to upholstery, ceiling decorations, and moldings. Use of gold leaf and gilding was used extensively on Renaissance Revival interior designs and heralded the decades that were to become known as the Gilded Age (Schwin 1994). The style remained generally fashionable in the United States throughout the 1870s and 1880s. It also continued to be popular in rural areas right through the end of the century.

A wide array of Renaissance-inspired variations existed, as noted in Spofford's *Art Decoration Applied to Furniture* (1878). Harriet Spofford, a writer on interior design, viewed the basic Renaissance style as having begun with the Italian Cinquecento, and she distinguished French Renaissance variations of Francis I, Henry II, and Louis XIII styles. Other writers emphasized variations based on Italian, Dutch, and German Renaissance inspirations (Mayhew & Meyers 1980). The style could apparently thus

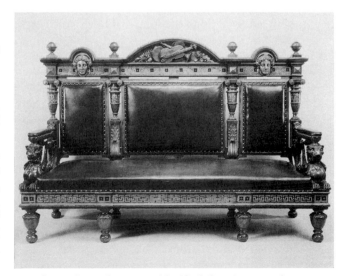

A sofa made in the second half of the nineteenth century by furniture makers Gustave and Christian Herter. Massimo Listri/Corbis.

become as complex and refined as one could imagine. A further variation of the style was the neo-Grec, featuring the application of Greek decorations to otherwise Renaissance designs. Neo-Grec gilt decoration tended to contrast sharply with the dark-wood surfaces that surrounded it. Embellishments included palmettes, eg and dart designs, fans, and urns with a solid gilt line surrounding the area decorated.

Regardless of its refined variations, however, the Renaissance Revival style generally appeared massive and solid. As with the preceding Gothic and Rococo, manufacturers provided entire suites of furniture in the style, along with a variety of wallpapers, textiles, porcelain, silver, iron, and brass exhibiting characteristic Renaissance designs. The style most often appeared with furniture, curtains, walls, and ceiling features.

Elizabethan style remained moderately popular during this period, as it was treated as the English version of Renaissance Revival. The English Renaissance variation incorporated an emphasis on Gothic designs, helping to keep aspects of that style in the mix as well. Later, English revivals of William and Mary, Queen Anne, and Chippendale styles were essentially swallowed up in the Colonial Revival movement.

Eastlake

The son of a prominent Gothicist architect, Charles Eastlake (1836–1906) was an English designer who led the so-called aesthetic reform movement. His earlier works employed the Gothic style, and he emphasized picturesque designs. He eventually began to design his own line of furniture, for which he ultimately became famous on both sides of the Atlantic. Of great interest to Eastlake was the production of innovative furniture designs for urban dwellers often living in rather crowded conditions. Featured heavily at the Centennial Exhibition in Philadelphia, Eastlake displayed varieties of beds that folded up into wall cabinets, chairs that folded into lounges, and various swivel, rocking, and reclining chairs. Eastlake furniture revealed his appreciation of machine-made ornament, though some designs were considered to be fresh and practical (Hammett 1976). By the 1880s, Eastlake had become the chief designer for a major furniture company in Grand Rapids, Michigan.

In 1868, Eastlake published his influential *Hints on Household Taste in Furniture, Upholstery & Other Details* in England, which was then printed in the United

States in 1872. This book's influence on American household architecture and interior design was so significant that only Andrew Jackson Downing had gained a similar level of influence during the mid-nineteenth century (Winkler and Moss 1986). Harriet Spofford praised Eastlake's book to her readers, stating that it met "a great want" in America. She further asserted, "Not a young marrying couple who read English were to be found without *Hints on Household Taste* in their hands, and all its dicta were accepted as gospel truths" (Winkler and Moss 1986, 114–115).

The book's popularity contributed greatly to the spread of reform movement philosophies across the United States. Eastlake, along with other contemporary English critics, railed against ornate, polished, and highly decorated furniture considered fashionable at the time, such as that of the Rococo Revival. Americans should adopt simpler furniture, taught Eastlake and the reformers—furniture that lacked special veneers, lustrous finishes, and excessive ornamentation (Winkler and Moss 1986). These reform ideas appealed to the early British designers of the Arts and Crafts movement, which would play a significant role in both interior and exterior architecture in America by the turn of the century. Eastlake preceded the likewise influential Arts and Crafts movement by promoting honesty in styles and materials, rather than hiding them underneath various facades, ornamentation, or unnatural veneers.

WALLS, DOORS, AND WINDOWS

Wall Treatments

Popular fashions for decorating interior walls shifted between the 1860s and 1880s. While the majority of homeowners and writers still preferred plain white plaster walls in the early 1860s, this sentiment began to change. A decade later, multiple color choices, wallpaper designs, and supplemental treatments, such as wainscoting, were exerting greater influences. New York City initially experienced these trends, as various colored tints replaced previously white walls, following the lead of the French. Around 1870, however, residents of Boston and Philadelphia were still clinging largely to their white walls (Mayhew and Meyers 1980). Increasingly complex and colorful wall treatments became more common, however, as the decade progressed.

A system of wall decoration that enjoyed a revival during the 1870s was the *tripartite,* or three-part, division. Although specific colors and designs were dictated by the individual styles applied—such as Gothic or Renaissance Revival—this preferred division of interior walls remained consistent across the spectrum of styles available. In a tripartite wall system, the wall is divided vertically from floor to ceiling with three distinct treatments: the *dado,* wall or *filling,* and *frieze.* The dado typically included a distinct application of wainscoting, paint, or wallpaper at the bottom of the wall and capped with a molding or chair rail. The frieze, or cornice at the top transitioned to the ceiling. In between the dado and frieze was the remainder of the wall—essentially an open field, or filling space. The top of the wainscoting that comprised the dado was generally 36–42 inches above the floor, though a height of 60 inches was occasionally seen (Winkler and Moss 1986). Numerous guide books were recommending this division by the 1870s, and it was popularized further by Charles

Wainscoting. Courtesy of the Library of Congress.

Eastlake's aesthetic reform movement, which produced numerous wallpapers and decorative borders for the tripartite divisions (Mayhew and Meyers 1980).

Charles Eastlake himself helped to popularize the tripartite system during the 1870s, as he discouraged the use of two other popular wall treatments. One of these was the arrangement of wallpaper in vertical panels around a room, which Eastlake dismissed as "attractive from its novelty" but "false in principle." He concluded that "no one need regret that it has fallen into disuse" (Winkler and Moss 1986, 116). The second treatment discouraged by Eastlake was the application of a monotonous pattern that completely covered the walls. In place of these two unfavorable treatments, Eastlake recommended the components of the tripartite system, including 36-inch wainscoting on the walls of a house's principal rooms, which, he claimed, was visually more interesting and doubled as a protection from human fingers and chairs. American writers followed in Eastlake's footsteps with similar recommendations, and the tripartite division remained popular for about two decades. The architect Henry Hudson Holly praised the dado in 1878 because it solved the decorating conflict that arises: "furniture and costume show to a better advantage when the walls of an apartment are dark, while pictures look well upon a light background" (Winkler and Moss 1986, 117). Others admired wainscoting because it broke up a perceived monotony of an unrelieved pattern and reduced the need for wallpaper throughout the entire room.

The dado could be paneled, papered, or painted. Specifically, the use or appearance of wainscoting for the dado could be achieved through multiple methods and expenses during the 1870s. Companies increasingly offered greater variations of ready-made wainscoting materials into the 1880s, typically one-quarter to seven-eighths inches thick and glued to heavy cloth for simple application. The most expensive type of wainscoting consisted of wood paneling designed specifically for a particular room, while less expensive options involved plain vertical boards finished with a wood cap. Perhaps the easiest method was to attach molding strips to the wall approximately three feet above the floor and apply paint or wallpaper both below and above the

molding, thereby eliminating the need for any wood paneling on the dado. Some writers even advocated the use of wallpaper sets designed to imitate the tripartite division without the use of moldings or wood paneling, claiming that the wallpaper treatments often appeared neater than uneven paint jobs (Winkler and Moss 1986).

Wallpaper

Mass production of wallpaper became possible during the 1840s with new English machines for printing patterns on continuous rolls of paper with cylinders. The Fourdrinier and Gilpin machines allowed the printing of papers on raised cylinders and allowed for the rapid growth of wallpaper supplies and choices. Americans adopted the English manufacturing methods by the 1850s so that by 1857 only five percent of wallpapers were still being imported to the United States (Winkler and Moss 1986). Papers printed with raised cylinders could produce greater varieties of colors, finer line work, and smaller repeat patterns than could the block-printed papers that preceded them. Earlier high-quality wallpapers were created with cotton-fiber paper, although the use of wood-pulp papers increased slowly during the 1850s until it became the standard in the 1880s.

As with wall treatments overall, wallpaper colors and patterns moved through transitions in fashion and popularity from the 1850s into the 1880s. Prior to the Civil War period, Downing provided recommendations for wallpapers suitable for the interiors of Gothic-styled homes. Already economical and easy to apply, the wallpaper designs promoted by Downing were not those that imitated church windows or carved work, but simpler flocked paper that imitated woven silk or worsted instead (Mayhew and Meyers 1980). One alternative approved by Downing was the application of fresco paper, which provided the effect of a wall broken into compartments of panels.

Beyond Downing's preferences, the public fell in love with a variety of Baroque- and Rococo-styled papers throughout the three decades of the 1850s–1870s. These styles typically included realistic designs that resembled pseudo-architectural features, characteristic S and C curves, patterns of various flowers, undulating stripes, or asymmetrical cartouches. Large leaf designs or architectural panels of scroll ornament were popular Rococo Revival designs for wallpaper at mid-century, applied from the baseboard to the ceiling (Calloway 2005). As critics grew weary of such realistic and colorful wallpaper designs, public demand remained high. By the 1860s, writers strove to promote more subdued and subtle colors including yellows, light blues, and light greens, to the point where the popular press essentially declared the end of realism by the late 1860s. Favored instead were smaller, abstract designs that gradually became more popular during the next two decades (Winkler and Moss 1986).

The Centennial Exhibition provided a further opportunity to promote innovative wallpaper designs. Nearly 10 million visitors enjoyed the Exhibition, giving many of them a chance to view the reform-styled products favored by Eastlake. Those that Eastlake and his enthusiastic followers promoted tended to include flat patterns that lacked dimensionality or shading, patterns that were generally smaller than those in preceding decades, and colors dependent more on secondary or tertiary hues rather than primary colors. These newer

English designs consequently became more popular immediately after the centennial, and demand for earlier, more realistic French designs waned. Other, more exotic designs from countries such as Turkey and Japan likewise earned the fascination of centennial-going visitors to the point where a Japanese style became popular for a time after 1876.

Pictures and Mirrors

The addition of various pictures (i.e., paintings) and mirrors to interior room designs remained common in middle- and upper-class households throughout the 1860s and 1870s. This was the primary means of adding a touch of artistry to the home. Portraits were virtually absent, and the number of pictures per household generally increased over these and ensuing decades. Pictures in the Gothic period were still hung rather high, due in part to the high Gothic ceilings of larger homes. Pictures that contributed to Renaissance Revival style played a vital role in the style's interior décor, though few pictures themselves actually showcased Renaissance-related themes. Mirrors were used primarily as overmantels and capped with massive architectural frames (Mayhew and Meyers 1980). Pictures employed for Rococo-styled rooms could either be oils or prints, often depicting landscapes or religious scenes. Rococo frames were available in numerous varieties and sizes, including those with the characteristic S-shaped curves as well as those with straighter, simpler sides. Pictures and mirrors of the Rococo period were typically blind hung at eye level.

The hanging of pictures during this period could be accomplished through at least three common methods: blind hanging, placed unseen behind the picture; hanging with tassels and cords from a nail above; or hanging with a long cord from a picture molding or rail placed closer to the ceiling. The use of nails often caused cracks in plaster walls, which promoted the alternative adoption of brass or iron picture rails, or even more attractive, the use of picture moldings placed along the bottom of the frieze. The *Decorator and Furnisher* recommended copper wire for hanging pictures, as it was considered stronger than normal cord (Mayhew and Meyers 1980). Writers and critics did not agree on the tilting of pictures downward. Some advocated tilting oil paintings to enhance the viewing of brush marks from lower levels, while others preferred hanging pictures flat against the wall.

A variety of illustrated historical evidence has shown some of the common applications of pictures in mirrors throughout the period and in homes of varying socioeconomic status. One modest dwelling during the 1850s revealed a bare wood floor with no drapes or curtains in the windows. Still, multiple pictures existed, hung with long cords draped over ornamental nails in the wall (Peterson 1971). In another example, the Arlington House—known best as the home of Robert E. Lee just outside of Washington, D.C.—was illustrated as it apparently appeared in 1862 while used by Union troops. Numerous pictures were hung on exposed cords or wires over ornamental nails. In this case, the pictures are hanging at an angle from the wall, facing downward.

Window Shades, Curtains, and Draperies

Every decorative style of the Victorian Era made extensive use of window draperies, shades, and curtains. Such dressing might include a wooden cornice

at the top, ebonized and gilded, from which would hang an embroidered lambrequin edged with fringe and tassels. A set of damask curtains may exist beneath the lambrequin, along with a set of point lace curtains, or undercurtains. A muslin roller shade might be added behind both sets of curtains. Whether expensive or more reasonably priced, the complete design would include cornice, lambrequin, two sets of curtains, and a window shade. Venetian blinds were somewhat popular, though some decorators despised them. By the 1860s, roller shades had become popular and were often used behind window drapes (Mayhew and Meyers 1980).

As with other interior elements, the degree of elegance corresponded roughly with family income and the grandness of the home. Painted roller shades appeared for public consumption as early as the Gothic period, and one New York manufacturer sold window shades with "vignettes, arabesque scrolls and roseate centres, sculptural views, fancy sketches, Gothic landscape centres, Tintern Abbeys, moonlight views, the Euro and Episco Gothic and Corinthian designs—besides an almost innumerable number of cheaper patterns from one dollar and upwards" (quoted in Mayhew and Meyers 1980, 168). Earlier shades were simply raised with strings until the 1850s and 1860s with the introduction and promotion of shades with spring mechanisms.

Gothic curtains and cornices might have included, as Loudon suggested, a cloth valence framed in a vague Gothic arch. Even modest homes could enjoy Gothic curtains, and for those in Villas or townhouses, Downing recommended the use of brocades, satin, or velvet in colors designed to harmonize with surrounding upholstery. Undercurtains could be made of lace or thin organdy.

Window curtains were also a hallmark of the ensuing Renaissance style, though the window treatments themselves rarely showed any specific Renaissance design elements. More so, it was the arrangement of the curtains that mattered to complete the design. The use of heavy fabrics was a key trait, typically hanging from elaborately painted and gilted valences. Fringed lambrequins were employed to further impress the viewers.

COLORS AND PAINT

From mid-century to the 1880s, interior paint colors generally became more colorful and vivid as plain white walls became less popular. Dark and heavy colors remained common during and after the Civil War, transitioning to ever-brighter colors by the 1880s. Regardless of theories that promoted various color choices, most writers recommended only two colors per room. Gervase Wheeler, an English Architect who practiced briefly in America, approved of the trend toward more colorful walls, denouncing "the cold, hard, white walls, whose severe surfaces are illy reconciled with . . . gaudy carpets and brilliant scarlet or purple upholstery" (cited in Winkler and Moss 1986, 66). Likewise, Ella Rodman Church declared white paint "objectionable" (Winkler and Moss 1986, 126). These and other tastemakers of the time devised decades-worth of rather standardized rules they hoped would be used for color choices and placements in the home. For instance, ceilings should employ the lightest colors of a room, while the walls and dado should be darker. Any woodwork in the room should be the darkest. Hardwood trim should be stained in some natural color, and softwood should be painted to correspond with a room's overall color scheme.

The proliferation of prescriptive literature during the Victorian Era included a wealth of guiding information on color choices. As with other exterior and interior elements, a variety of critics and writers suggested numerous combinations of colors that would be most appropriate for each room of a fashionable home. Aspects of color harmony and contrast were taken very seriously by those who promoted their favored choices of hues. Earlier theories of choosing colors were provided, for instance, by John Masury in *House Painting* (Winkler and Moss 1986). Masury provided two general approaches for interior colors. The first was referred to as "harmony by analogy," whereby one would combine colors placed next to one another on the color wheel, such as crimson and purple, yellow and gold, or crimson and brown. The second approach was "harmony by contrast," by using pairs of colors opposite one another on the color wheel, such as scarlet and blue, orange and blue, yellow and black, or white and black. The creation of white and black interior designs was most often employed between 1850 and 1870 (Winkler and Moss 1986). These theories of harmony and contrast were not new to the era, however, as David Ramsay Hay of Scotland was credited with both approaches. In turn, Hay's work was based on earlier precedents from the 1820s. Hay's work was highly influential and was referred to often by other writers speaking of colors in the 1850s and 1860s. Architect John Bullockwas one who referenced Hay in 1854 when promoting the contrasting harmonies approach. Bullock recommended color schemes that included pairs of crimson and green, red and bluish-green, reddish-orange and greenish-blue, orange and blue, and a variety of other combinations aimed to create maximum contrast while still remaining fashionable (Winkler and Moss 1986).

Not surprisingly, Andrew Jackson Downing promoted his own color choices during the Gothic period leading up to the Civil War. Downing made it clear to his readers that improper choices of interior colors could ruin an otherwise tasteful décor. His first rule was to employ only one dominant color for each room. Second, the two principal areas of color included the walls and carpets. Painted woodwork should always harmonize with the prevailing room color, though should never be the same color as the predominant tone. Downing recommended white as the dominant tone only for a city or villa drawing room (Mayhew and Meyers 1980). By this time, white was still highly popular for painted plaster walls, though increasingly complex color designs were appearing both in writing and in actual homes.

Gervase Wheeler offered further advice for specific rooms, with his ideal library color scheme being a rich, deep blue with a painted diaper pattern in brilliant red or orange. For dining rooms, however, he recommended sage green or a shade of brown known as "fallen leaf." White ceilings were still recommended by both Downing and Wheeler during the Gothic period, presuming the walls were papered. Various delicate, neutral colors could also be used for ceilings, however, in place of pure white (Mayhew and Meyers 1980). Creating a distinctive sentiment for each room was important for designers during the Victorian Era. Entrance halls, for instance, should be reserved for more sober colors, perhaps to resemble stone, according to Downing. In contrast, he recommended cheerful and bright colors for the parlor (Calloway 2005). In the 1870s, many critics agreed with Downing on the use of subdued hues for entry halls, though by the 1880s, more were recommending brighter colors.

Either distemper or oil paints could be used for painting walls, though each had strengths and limitations. Oils created a pungent odor, and their application was challenging. Unlike oils, distemper was a water-based preparation that applied easily and with no odor. Distempered walls could not be washed, however, and they were easily stained.

FLOORS AND COVERINGS

The most common floors throughout the nineteenth century consisted of plain, unfinished boards of softwood, typically pine (Calloway, 2005). Pine floors could be laid as planks or in tongue-and-groove fashion. Few architects utilized hardwood floors until the 1870s. In wealthier households, wall-to-wall carpets remained popular during the 1850s and 1860s. A slow transition to more hardwood floors, such as parquet, occurred during the 1870s and 1880s, though the trend toward hardwood was rather slow because so many dwellings still employed soft pine. As the century progressed past the Civil War, softwood floors were more often utilized as subfloors for decorative coverings, and interest in wall-to-wall pile carpets waned as Oriental rugs gained favor. At mid-century, Loudon was already recommending that wall-to-wall carpets be tacked down only temporarily. Instead he advocated smaller rectangular carpets allowing for exposure of the wood floor around its edges (Mayhew and Meyers 1980).

Charles Eastlake and his followers played a considerable role in shifting American preferences away from softwood and pile carpets to hardwood, parquet floors and Oriental rugs. Promoters of smaller rugs cited two advantages over wall-to-wall carpets, in that rugs could be turned often to even out the wear pattern, and they could easily be removed for dusting and cleaning (Mayhew and Meyers 1980). Such rugs were favored aesthetically for application on top of parquet flooring by the 1870s. Parquet was a floor covering composed of thick, hardwood blocks, often laid in multicolored, geometric patterns (Winkler and Moss 1986). This newer combination of parquet floors topped with Oriental carpets was Eastlake's preferred flooring choice, citing the superior aesthetics of the combination, as well as for presumed health, sanitary, and labor-saving factors. He also assured his readers that parquet was the latest fashion trend in England.

Exposed hardwood floors complied with Eastlake's philosophy that the nature of construction should always be revealed rather than entirely hidden. Parquet was an expensive floor covering, however, so its use was generally limited to households that could afford such luxuries. Most American homes continued to utilize pine planks and various forms of more inexpensive coverings. One alternative to parquet consisted of a product referred to as "wood carpeting," which could be used to create the effect of parquet. This alternative made use of thin strips of hardwood one-quarter-inch thick, glued to a heavy

The Brewsterian Color Circle

The increasing fascination with science during the Victorian Era also applied to the evolution of color theories. Interior designers of the post–Civil War decades made use of color theories not unlike those familiar to us today. Specifically, the Brewster-Chevreul theory was probably most often used to guide interior color designs, based on a standard color chart known as the Brewsterian color circle. Writers generally advised that colors located directly opposite one another on the circle were naturally harmonious, such as blue and orange, red and green, or yellow and purple. Red, yellow, and blue were identified as the three primary colors.

muslin backing, after which it could be applied over the original flooring. Its popularity by the 1880s was indicated by the more than 50 patterns of wood carpeting already available for sale by the Decorative Wood Carpet Company of Warren, Illinois (Winkler and Moss 1986).

More choices for floors and coverings existed by the 1870s than at any earlier time in history. Earlier pine flooring and pile carpeting remained popular as new alternatives appeared after the 1860s. Many working-class households continued to simply employ exposed, unpainted pine planks, even as the wealthier class shifted to parquet and Oriental carpets. Painted floors remained popular, which was one alternative for covering soft pine that made cleaning easier. Painted floors resisted stains and grease and could therefore be cleaned by wiping them off. One study of painted floors in Texas documented their continued use into the earlier twentieth century.

Further alternatives to paint or carpeting included floorcloths, encaustic tiles, matting, and—after its invention by Frederick Walton in 1863—linoleum. All of these remained in use throughout Eastlake's reform movement, though specific types of floor covering were often favored for particular rooms or seasons. Floorcloths were generally referred to as oilcloths after the 1850s, of which a variety of products were available. Oilcloths imported from England were typically double the price but apparently also lasted twice as long. Oilcloths were most often used in halls and kitchens, as they eliminated the need for scrubbing floors and could be wiped clean with water. Eastlake recommended oilcloths for halls and passages, though he predictably despised those designed to imitate marble or parquet.

Grass or hemp matting was another widely used material, often favored for more modest households as an inexpensive alternative to wall-to-wall carpeting. Domestic straw matting was a more expensive variety. Middle-class parlors and bedrooms might therefore employ matting, typically the rooms experiencing the least wear. Matting could also be used seasonally, during summer months. An additional advantage was its ability to provide a neat appearance to floors of more modest households, covering gaps between uneven plank floorboards. Matting also appeared in bedrooms where wall-to-wall carpeting was generally opposed due to presumed hygiene risks (Winkler and Moss 1986).

Linoleum appeared as an additional, inexpensive alternative during the 1860s. This innovative covering was crafted from a mixture of ground cork, ground wood, and linseed oil laid on a burlap or canvas backing. It became popular in modest households as imitations of carpets or hardwoods, and more wealthy homeowners installed it especially in service areas (Calloway 2005). Linoleum also became appropriate for stair halls and other rooms, according to writers during the 1870s, and it was commended for its durability on par with English oilcloths. Installation of linoleum in kitchens was less favorable, however, as it could be "quickly injured by grease," according to one source during that period (Winkler and Moss 1986, 149). That fact did not necessarily prevent its actual use, however, as linoleum remained popular for kitchens and other rooms throughout the twentieth century.

Also gaining momentum during the post–Civil War years was the use of encaustic tiles. A durable, ceramic tile first manufactured in England in the 1830s, the term *encaustic* referred to patterned tiles with impressed designs. By the 1870s, both plain and patterned varieties were marketed as encaustic tiles in

the United States. Some tile designs were copied from mosaic patterns found in ancient Roman towns, including Herculaneum and Pompeii. Eastlake offered examples of tiles produced by Maw & Company designed with colors of gold, terra cotta, brown, and black. Vestibules of entryways were the most suitable place for installation of tile floors, according to Eastlake, as parquet floors were still more desirable for stair halls. A rising demand for encaustic tile floors during these decades led to increased production by numerous American companies, such as American Encaustic Tile, United States Encaustic Tile, and Low Art Tile. The application of tiles was also promoted for fireplace hearths, around chimney openings, and as floors or wainscoting in conservatories, porches, kitchens, laundries, bathrooms, and especially first-floor hallways (Winkler and Moss 1986).

Cornice. Courtesy of the Library of Congress.

CEILINGS

Victorian homes increasingly included ceiling decorations as part of the overall interior décor, especially after the 1860s. White ceilings were described by critics as cruel and harsh in their contrasts with darker interior walls, and they were promoted only for white-painted rooms by the 1880s (Winkler and Moss 1986). Instead, multitudes of color combinations were suggested for fashion-minded homeowners, not the least being violet, lavender, blue, peach blossom, straw, and gray. Even the simpler rooms required at least the use of cornices around the edges, according to various writers. Colored and patterned ceilings were advocated, though in reality most modest households remained the typical plain white of earlier decades (Calloway 2005). The easiest method of all to decorate ceilings was with wallpaper.

Three-dimensional features could be crafted from wood, plaster of Paris, or papier-mache. Plaster roses or medallions remained popular throughout the

A Modest North Carolina Home

Though the bulk of historical writings emphasize the most elaborate of Victorian interiors, only a small minority of the American population could afford such luxury. A more common middle- or working-class interior is likely represented by the diverse mismatch of furniture and simple decorations of the Bennett Place, which reveals the interior of the North Carolina home where the last major Confederate army surrendered. The walls and floors are bare wood, and the ceiling is unfinished with visible beams. A lone drape is nailed to the window molding and pulled to one side. A mirror and spring scale are hanging above the stairs. The furnishing is a mixture of inexpensive quality and styles, and the chair and clock can be considered average. Some high-end pieces might be a candlestick, drop-leaf table, and corner crib. Such contrasts were likely more common than not for Victorian families of lesser wealth, as one soldier observed: "in half the houses you will find pianos, and half the women play by note. In this house the ceiling is not plastered; the unpainted mantel is covered with broken bottles and old candlesticks; the rough log walls are adorned with two-penny engravings cut from almanacs and country papers; all the furniture in the house is not worth $5. But there is a piano, a handsome one, with a showy cover" (Peterson 1971, Plate 111).

Victorian Era, often placed on the ceiling at the room's center or around the cords of hanging light fixtures. This might be the only decorative feature on a ceiling of more modest houses. Their inscribed designs progressed from one trendy style to the next, transitioning through the decades from early Neoclassical designs to Rococo Revival and Renaissance Revival decorations. Plasterwork was also recommended for panel moldings and medievalized coffers and panels. Post–Civil War ceilings might also feature rich papered or painted decorations that ranged from illustrations of clouds and cherubs to elaborate, geometric patterns. More elaborate ceilings by the 1870s could include extensive stenciling combined with painted and gilded plaster. Wood-ribbed ceilings also appeared throughout the Victorian period, though perhaps made an especially natural addition to a Gothic décor.

Reference List

Beecher, Catharine, and Harriet Stowe. 1869. *The American Woman's Home.* New York, J. B. Ford; Boston, H. A. Brown.

Calloway, Stephen. 2005. *The Elements of Style: An Encyclopedia of Domestic Architectural Detail.* Buffalo, NY: Firefly Books, Inc.

Downing, Andrew J. 1859. *The Architecture of Country Houses.* D. Appleton & Co.

Eastlake, Charles. 1872. *Hints on Household Taste in Furniture, Upholstery, and Other Details.* Boston: J. R. Osgood.

Francaviglia, Richard. 1996. *Main Street Revisited.* Iowa City: University of Iowa Press.

Hammett, Ralph. 1976. *Architecture in the United States: A Survey of Architectural Styles Since 1776.* New York: John Wiley & Sons, Inc.

Loudon, John. 1839. *Encyclopedia of Cottage, Farm, and Villa Architecture and Furniture.* London: Longman, Orme, Brown, Green, and Longmans.

Mayhew, Edgar de N., and Minor Meyers, Jr. 1980. *A Documentary History of American Interiors: From the Colonial Era to 1915.* New York: Charles Scribner's Sons.

Peterson, Harold. 1971. *Americans at Home: From the Colonists to the Late Victorians.* New York: Charles Scribner's Sons.

Rybczynski, Witold. 1986. *Home: A Short History of an Idea.* New York: Penguin Books.

Schwin, Lawrence, III. 1994. *Decorating Old House Interiors: American Classics 1650–1960.* New York: Sterling Publishing Co., Inc.

Smith, Carter. 1985. *Decorating with Americana.* Birmingham, AL: Oxmoor House, Inc.

Spofford, Harriet. 1878. *Art Decoration Applied to Furniture.* New York: Harper & Brothers.

Stoehr, C. Eric. 1975. *Bonanza Victorian: Architecture and Society in Colorado Mining Towns.* Albuquerque: University of New Mexico Press.

Winkler, Gail, and Roger Moss. 1986. *Victorian Interior Decoration: American Interiors 1830–1900.* New York: Henry Holt and Company.

Landscaping and Outbuildings

LANDSCAPING PHILOSOPHIES

Along with *Main Street of Middle America* and the *New England Village,* geographer Donald Meinig (1979) identified *California Suburbia* as one of America's three distinctively symbolic human landscapes. Nowhere else on the planet have these three landscape scenes materialized as they have in the United States. The terms *landscape* and *landscaping* should be defined here, as they can easily be confused. Scholars refer to the *human landscape* as generally including everything in the built environment that humans have created for themselves through time. More specific is the concept of *landscaping,* or the art of arranging domesticated plants and grass for functional or ornamental purposes. The discipline of *landscape architecture,* pioneered by Frederick Law Olmsted in the 1860s, involves this latter concept of landscaping as art.

With respect to Meinig's symbolic human landscapes, his *Suburbia* included freeways, two-car garages, and single-family ranch houses. A persistent theme of this book, however, is that its fundamental origins can be traced to the mid-nineteenth century. A variety of emerging cultural, economic, and technological factors converged after the Civil War, culminating with the 1869 Chicago suburb of Riverside. This Olmsted-designed community is considered the prototype for the contemporary planned suburbs that more or less continue to comprise the dominant American Dream.

This residential ideal remains a powerful component of American culture, long after A. J. Downing and his contemporaries heavily promoted the new life-style. Aside from the obligatory lawn, one can imagine that several varieties of shrubs, trees, and flowers are placed around the stylish home and occasionally

scattered in well-controlled but asymmetrical groupings throughout a yard. Weekends are used for maintenance and upkeep of the suburban dream, including the mowing of fertilized and watered lawns, the fussing with shrubbery, the pruning of trees, the weeding of flower gardens, and the blowing of leaves with oversized, gas-powered hair dryers (rakes are no longer in vogue). These tasks are accomplished less by double-income householders and more by landscape companies hired by neighborhood associations. Various paths, usually curved, lead to the home's entryways, winding through the regulated yard. Streets are gently winding, and access to such neighborhoods invariably requires an automobile.

Take away the automobile, and this dreamy scene was already available in a limited capacity by the 1860s not far from America's largest cities. What were the origins of this quintessentially American residential pattern? Various architectural styles of suburban homes were documented in the chapter "Styles of Domestic Architecture around the Country." This chapter assembles the pieces of the suburban puzzle by examining the cultural evolution of the American lawn, landscaping, and gardening and the land survey systems in which these residential elements are placed. At its conclusion, readers should be able to more intelligently answer the question, "Why do our residential landscapes appear as they do, and what were their cultural and innovative precedents?"

Our suburban communities and their ornamental landscaping generally resulted from two overarching forces—that is, the cultural diffusion of European precedents into North America, and old-fashioned American ingenuity, the latter often associated with the drive for economic gain. Together, these forces underlie the predominant theme of this chapter.

European Precedents for Suburban Homesteads

The detached suburb ultimately grew out of utopian objectives dating back to the early English colonies. The most influential of these was reactionary, as colonists sought to abolish the medieval system of feudalism, with its hierarchical control structure involving serfs and landlords. A suburban home on a small plot of land, they believed, could hypothetically be owned by anyone, regardless of inherited social status. An additional utopian value was the search for healthier living conditions, as it was observed that rural areas fared better during epidemics. The countryside also offered greater privacy, safety, and sanctuary, not unlike a family farm, which could be more or less replicated on the suburban fringe (Vance 1990). It was the elimination of the feudal land tenure system, however, that enabled the creation of suburban homesteads and communities much more quickly than in Europe. Potentially, anyone could own land and perhaps subdivide it in the interest of economic speculation. With the new American freehold system, land was much easier to trade, subdivide, and improve as the owner saw fit, without the burdens of a feudal system. Then as now, private property rights were viewed as a lynch pin of democracy and were manifested most potently on both the family farm and the suburban homestead as the nineteenth century progressed.

Other European cultural patterns were more readily accepted and adopted for use in early America. Perhaps ironically, nearly all of the domestic architectural styles, fashionable interior designs, and outdoor landscaping philosophies were

by and large a product of European precedents throughout the Victorian Era. Even Downing and his contemporaries regularly reminded his readers of the superiority of European culture, tastes, and values. America seemingly had its own inferiority complex, and there existed little in the way of European culture and practice that did not gain the attention of the Americans. As seen earlier in this book, architectural styles had moved through a progression of European-inspired traditions, first with a series of successive styles embodied in the Jeffersonian Greek Revival, Gothic, and Italianate modes; later by an ever-more eclectic array of stylistic choices. Successive transitions of interior designs occurred as well, providing expanded choices of furniture, textiles, wall, and floor materials. After the Civil War, this exterior and interior eclecticism only accelerated as more styles appeared while older ones remained fashionable. This became an era that celebrated democratic choice—for those who could afford it—and the booming industrial market was happy to provide it.

The progression of landscaping philosophies followed architectural trends only to a limited extent. A generally romantic, Picturesque mode of landscaping prevailed throughout much of the nineteenth century, enduring decades of continuous architectural changes. Certainly, the discipline of landscape architecture emerged after the Civil War, and the art of landscaping moved through generational changes with advances in gardening technologies and newly available plant varieties. Still, the "soft, naturalesque, relative amorphousness" of the European Picturesque endured for much of the century, regardless of other changing stylistic fashions (Newton 1971). This endurance of romantic landscaping practices applied most notably to the country villas of the elite, and to emerging middle-class suburbs. By the 1880s, the winding, curved walkway, Picturesque ornamental gardens, and velvet-smooth lawn had all become the standards for future suburban developments.

Natural Versus Geometric Styles of Landscaping

Only two fundamental choices for the general layout of grounds were available during the Civil War period, though specific arrangements and variations of each option were seemingly endless. One choice was the *Picturesque,* or romantic, mode of landscape design, which involved the layout of ornamental shrubs, gardens, and other landscaping elements in purposely asymmetric, naturalistic patterns with little apparent sense of order or planned geometry. The basic idea was to imitate natural conditions in a semicontrolled way. The other choice was a more *Classical,* orderly approach to landscaping, which involved the neat, symmetrical arrangement of trees and plants in a purposely structured, geometric fashion. The Picturesque mode is often simply referred to as the *Natural style,* while the *Geometric style* refers to the Classical, symmetrical mode (Stilgoe 1988). Essentially, both modes of landscape planning still comprise the dominant choices available to municipalities and homeowners in the twenty-first century.

It was the Natural style that earned the favor of suburban homesteads during the mid-nineteenth century, though the Geometric style remained popular for farmsteads and southern plantations. With the feverish industrial development surrounding the Civil War, however, suburban households favored the naturalesque mode, in part as both a symbolic and practical attempt to

return to nature and the countryside. As more families became wealthy from industrialization, they tended to push Picturesque romanticism to extremes in the attempt to emulate existing country homes (Newton 1971). Such results can be seen in Martha Lamb's *The Homes of America,* published in 1879. Her opening paragraph indicates the prevailing mood: "Within the present half century domestic architecture has been running a race with the general development and prosperity of America. Countless styles from all climes, with modifications and abbreviations, have been made subservient to the convenience and tastes of a mixed population. Cottages and villas . . . dot the length and breadth of our land. Many of these are in themselves the expression of sentiment, self-respect, and artistic culture" (Newton 1971, 338). For such cottages and villas, the Picturesque "landscape garden" became the mode of choice.

By the 1850s, wealthier Americans accepted that a proper country house should include a variety of Picturesque landscaping features, especially blossoming plants, acreage devoted to a kitchen garden, a variety of ornamental trees and shrubs, a manicured "greensward," or lawn, and flower beds (Stilgoe 1988). This form of landscaping came to symbolize the Victorian values of the educated middle and upper classes—not the least including a desire to distance themselves from slovenly farmers and villagers, a love for agrarian ideals rooted in the country, and even sentiments of patriotism for improving their nation in a small but significant way.

In the decades leading to the Civil War, wealthier country households increasingly shifted their attention from traditional farming and agricultural production to practice *horticulture,* or landscape gardening. This transition from farming to leisure gardening did not go unnoticed by the traditional farming community, as arguments between horticulturalists and farmers ensued for decades. The growing practice of horticulture among suburban residents, however, was promoted—and practiced—as a sort of tonic, or respite, from the chaos and dirtiness associated with the growing industrial cities. Horticulture rescued the merchant from the obligations of hard work and materialism in the city, according to John Stilgoe (1988), in that the planting and tending of fruit trees, plants, and vegetables provided urban

From Agricultural Village to Picturesque Suburb

As the Civil War weighed heavily on the minds of most Americans, numerous early farming villages found themselves on the outlying peripheries of rapidly growing cities, such as New York, Boston, and Chicago. Previously isolated from their larger urban neighbors, these rural places increasingly became the homes of new suburban residents migrating from their cities along new railroad lines. One such case was documented by James Duncan in 1973 who provided a historical account of Bedford Village, at that time an unincorporated village in the town of Bedford, New York, about 35 miles north of New York City. In the 1970s, residents still apparently described the place as a New England village, with its ubiquitous village green laid out as a New England–style "common" around 1680. The common had failed quickly to serve the numerous farmers, and additional pastureland was made available. Then, as Duncan described it,

Bedford, with its new accessibility to New York City, became a fashionable place for wealthy urban families to establish country estates. The rural atmosphere was cherished by the new residents, and houses and gardens reflected their feelings. Although farmhouses were remodeled and barns were converted into stables, the tendency was to retain a modest appearance. This was the romantic period in American architecture and landscape gardening; the English "natural garden," an asymmetrical arrangement of shrubbery and trees, was in vogue. As rail transportation improved during the late 1800s, Bedford became home to well-to-do businessmen who commuted to work in New York City. (Duncan 1973)

businessmen with a very different sort of work. Numerous letters, diaries, and other testimonials uncovered by historians have demonstrated this "garden as tonic" motivation for landscaping in the Natural style.

More farms by the 1860s had opted for a combination of geometric, orderly farming with plots of land devoted to romantic gardening. An 1858 illustration of a landscape plan published in the *Annual Register of Rural Affairs* for a "Complete Country Residence" indicates an acceptable way at the time to combine the two traditions of efficient farming with leisure-oriented horticulture (Stilgoe 1988, 117). Embedded within the geometric, rectilinear patterns of efficient farm fields is an area devoted to more ornamental grounds resembling Picturesque landscaping, strategically placed for high visibility from passersby.

SETTING THE STAGE: AMERICAN LAND SURVEY SYSTEMS

One is hard pressed to understand the entire Victorian domestic scene without acknowledging the landholding system that evolved out of our eastern colonial hearths. With few exceptions, the primary motive of the colonists and early Americans was to permanently eradicate the medieval system of land tenure known as feudalism. The right to own private property without the oversight of a feudal landlord became a powerful cultural imperative for the early Americans and has yet to diminish. Out of this dominant, antifeudal movement came a variety of related land survey systems in the United States, all of which are uniquely American and found almost nowhere else. In order to sell private land, it first must be surveyed accurately, then recorded legally. Americans soon found the simple, rectilinear grid plan to be the most efficient method of surveying and recording land ownership in both city and country.

The core settlements of the northeastern United States provided much of the inspiration for dominant land patterns imitated throughout the contemporary Midwest and West. Although the American South produced its own distinctive landscape pattern based on the self-sufficient plantation system, it remained a distinctive characteristic of the South without migrating much beyond that region. In contrast, the northeastern cultural hearths of New England and Pennsylvania—focused on Boston and Philadelphia, respectively—provided the types of ordinary human landscapes that Americans would adopt across the continent. Indeed, it was from the Northeast where the bulk of midwestern and western settlers migrated, bringing their cultural habits with them.

"Northeastern ideas would determine where cities would be situated and how their streets would be laid out," explains Peirce Lewis. "They would determine what ordinary houses would look like and how they would be placed in relation to streets and gardens. They would determine where roads would be built, and who would build them; where farmers would live and how they would design barns to house their crops and livestock" (1990, 80). One must therefore look to New England and Pennsylvania to better understand the dominant American landscape patterns that stick with us to this day. In short, New Englanders provided the early prototypes for the modern-day suburban layout, and Pennsylvanians are credited with the origins of the rectilinear, gridded street system for cities, leading to what Americans have come to refer to as Main Street. Other, more regionally limited land patterns are also worth

noting, however, such as that of the distinctive, Caribbean-oriented southern plantation and the Mormon communal system of the intermountain West. All of these patterns and land-use systems were either maturing or already in place by the 1870s.

New England and Pennsylvania Source Regions

As colonial New Englanders sought to stamp out any vestiges of feudal social structure and landholding practices, much of the traditional landscape pattern of northwestern Europe was abolished (Vance 1990). In its place was a land system that better suited the needs and values of the colonial settlers. The two clearest examples of "utopias in America," according to James Vance, Jr. (1990), are the family farm and American suburb. New England farmsteads were immediately provided with the right of freehold ownership without any suggestion of servile, feudal tenure. In the New England village system that materialized, a shared piece of pasture land known as a "common" was theoretically provided for all farm families to share. Around the common existed individual plots of private farmland and the obligatory Puritan meeting house or, later, a Congregational church. With this innovative community land pattern came the nearly instant abandonment and spatial loosening of the previously compact European village.

As the New England agricultural village system matured, each household practiced subsistence farming, virtually self-sufficient for satisfying its own needs for food and simple manufactured products. The necessity of producing nearly everything for its own consumption—the basic definition of peasant agriculture—led to farmsteads with a wide variety of outbuildings, crops, animals, and workshop spaces. New England farms of the 1860s and 1870s typically employed a variety of specialized structures, including the family farmhouse, granary, shelters for animals, workshops, housing for wage laborers, and almshouses for extended family members. Such farmsteads matured by the 1880s into what is known as the New England connecting barn, or elongated farmstead. Harsh winter conditions in northern New England led families to physically connect the important outbuildings with the house, preventing the need to walk outside during the winter, but also producing a fire hazard. Though still self-sufficient on its own plot of land, the New England farm was rarely more than a half-mile from the village center, allowing easy access to the village common, meeting house, or church. Thus was the balance that New Englanders provided the emerging American landscape—a balance between community cohesiveness with private ownership of self-sufficient family farms. The village map of Sudbury, Massachusetts, exemplifies the typical New England village pattern that matured during the nineteenth century. Out of this village pattern, with its free-standing homes, would come no less than the dominant suburban landscape model for the nineteenth and twentieth centuries (Lewis 1990).

The values of efficiency and practicality were relentlessly stamped into the minds of colonial New Englanders. This partially explains the American tendency to control and dominate nature by improving the land in various managed capacities. In his guide to the wilderness, Judge William Cooper (the father of James Fennimore Cooper) scorned English and Irish settlers in New York who wasted

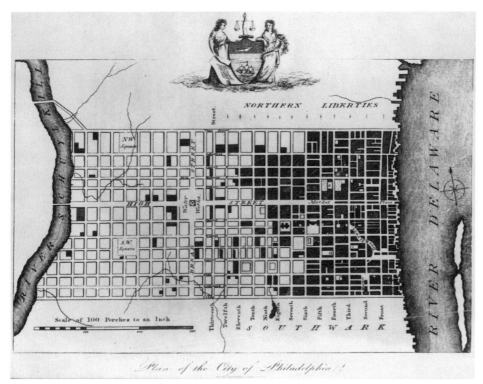

A plan of the city of Philadelphia, circa 1750. Philadelphia was one of the first planned square grid pattern cities of the modern era and became a model to city planners and developers throughout North America. Getty Images.

their time and effort on creating manicured English-style lawns from recently cleared forests. He counseled instead for them to burn the forest and immediately begin planting crops among the charred remains. Planning for next year's harvest was more important than attempting to make their fields aesthetically pleasing to the eye, he taught (Cooper cited in Lewis 1990, 83). Through such council, Americans learned to subdue nature and improve the land for human purposes.

Still, New Englanders were more likely to experiment with land-use patterns than were Pennsylvanians up through the Civil War. As early as the 1820s, the English brick row house had been all but abandoned in New England. The first settlers to move inland from Boston were already experimenting with wood-frame dwellings on separate lots with front and back yards. Pennsylvanians associated wood construction with low social status or poverty, whereas the New Englanders viewed it as practical. Consequently, inland Pennsylvania towns still appeared very English well after the Civil War, with their brick, Georgian row houses lining the streets. By the 1870s, they were still building row houses but were setting them back somewhat from the street, providing for small front lawns. In contrast, the New England village had already assumed an open and countrified appearance (Lewis 1990). It was this latter pattern that was ultimately adopted for residential landscapes west of the Appalachians.

Pennsylvanians may have been conservative when it came to housing, but they provided an innovative urban street pattern. All American colonies had

deviated from the English model of urban street systems. It was William Penn, founder of Philadelphia, who provided the most radical departure. In advance of settlement in 1682, Penn laid out a rectilinear street grid for the new city that became the prototype for future cities across the country.

The rectilinear grid of city streets had been employed for thousands of years. The first urban grids can be traced back to before the fifth century B.C. in the designs of Hippodamus for the Ionian city of Miletus and in the layout of other Greek cities, including Olynthus. Egyptians also used the grid, and the Roman Empire relied on it for cities throughout its realm (Whitaker 1996). In North America, both French and Spanish settlers laid out grids for cities such as New Orleans (the original "French Quarter") and for new communities throughout the Spanish Southwest, according to the dictates of the Laws of the Indies. Nor was Philadelphia the first city in America to implement a grid—one of the earliest is credited to New Haven, Connecticut, which laid out nine rectilinear blocks with a central green in 1638 (Vance 1990).

Penn's was the most ambitious to date, however, and it gained the most attention in British America. The Philadelphia Plan included one central square—often referred to as a Pennsylvania "diamond," with four additional public squares located out from the center. Streets were laid out at right angles to one another. North–south streets were given numbers while east–west streets were named after trees. As Pennsylvanians moved west and south to settle new towns, they essentially created hundreds of "miniature Philadelphias," employing small-scale versions of the Philadelphia Plan.

Penn's Philadelphia was ultimately too successful for his own taste, as he failed to anticipate the power for private land ownership and capitalist speculation in transforming the urban scene. Penn initially expected his large city blocks to fill in with mini-farms with spacious houses surrounded by large gardens, allowing farm families to live within a park-like "greene towne." Land quickly became too valuable, however, and land speculators purchased the large blocks and promptly subdivided them to profit on their investments. Soon, much of Philadelphia was filled in with standard, urban brick row houses (Lewis 1990). Penn had envisioned a semifeudal model of urban growth and land control, as had other elitists of early Middle America and the Tidewater South. Attempts had actually been made to replicate English Renaissance towns with their built-in hierarchy of privilege and power. Penn had envisioned his own elitist version of social engineering in his Philadelphia Plan, attempting to recreate a class-ordered society. Antifeudal sentiments had already become strong in America, however, leading to Philadelphia's brisk subdivision and sales (Vance 1990).

Regardless of Penn's intentions, it was the Philadelphia model that was adopted for American cities and towns thereafter, providing the impetus for Main Street commercial districts throughout the country. Midwestern and western towns therefore emerged as mixtures of New England and Pennsylvania precedents. Downtown cores, laid out on efficient grid plans, became the focus of business and retail. Residential areas outside the urban core were reserved instead for widely spaced houses on separate lots with trees and Picturesque gardens and lawns—quintessentially New England. By the 1860s and 1870s, this residential model had been taken one step further as developers and architects conspired for the first time in American history to lay out separate suburban communities in advance of settlement.

Gentle, winding roads and the natural style of landscaping became essential components of new suburban communities and country homes. The grid may have been ideal for row houses, but gentle, curving streets became the rural ideal for suburban cottages promoted by the likes of Beecher, Downing, Olmsted, and Vaux (Jackson 1985). An ongoing argument ensued between advocates of the grid and those who preferred the Picturesque, countrified landscape scene. Curved roads became emblematic of the pastoral and bucolic pace of home life, in contrast to the bustling and congested realm of the industrial city. All successful developers learned to employ the bending road into their plans, as it had become a powerful component of the suburban ideal. In 1873, one writer found it hardly conceivable "that any sane man will attempt seriously to defend the rectangular system when applied to a tract comprising much inequality of surface," referring to uneven or hilly terrain. He continued to assert that only the "selfish greed of real estate proprietors" prevented the eradication of the rectilinear grid plan entirely from the American scene (Jackson 1985, 76). At this time, rectangular blocks were viewed as a strong contributor to overcrowded conditions and urban poverty endemic within larger cities. Though the Picturesque suburban mode was heavily promoted and occasionally implemented, the truth is that most suburbs were laid out on a simple grid plan well into the early twentieth century, given the system's favorable efficiency for surveying and selling plots of land.

The Midwest and the National Grid

The lessons learned from early urban street grids were not lost on our national leaders. Aside from a few early examples of gridded cities, such as New Haven and Philadelphia, much of British colonial America continued to survey landholdings through the European method of "metes and bounds." For nearly two centuries, this land surveying and distribution system had been employed throughout the colonies from Maine to Georgia, a system that might be described as "part geometry, part topography, and part consensus" (Hilliard 1990b, 155). Metes and bounds relied on natural features and topographical aspects to determine private boundaries and road paths. With the compass and chain came the standard practice to use a combination of natural features, such as streams and ridge crests, to serve as partial boundaries. The remaining boundaries consisted of straight lines that connected at points marked by trees, rocks, stakes, or pins stuck in the ground. As one might imagine, this system proved rather unreliable for efficiently distributing property to private landholders, as boundary disputes were common when natural features could disappear or change locations through time. Still, this was the dominant British system, and much of the property and roadways surveyed during colonial times still remain a fundamental component of the eastern human landscape today. The streets of modern-day Boston, for instance, continue to reflect seventeenth-century street patterns around which the city has grown, providing a useful connection to the city's urban past while contributing to nightmarish driving conditions.

When Thomas Jefferson chaired a committee in 1784 to prepare a plan to distribute the western land holdings of the new nation, it was clear that the metes and bounds system would not suffice for such a grand task. Instead, Jefferson and his committee looked to the rectilinear grid plan for a solution that would

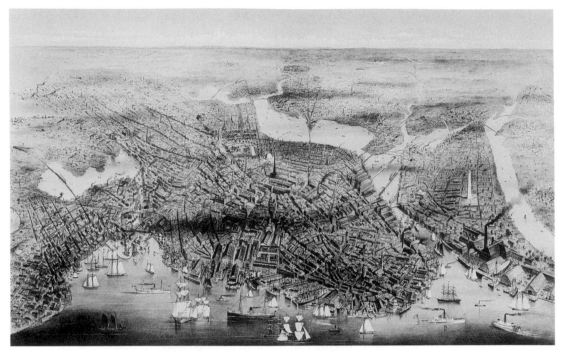

Boston map, circa 1873. Courtesy of the Library of Congress.

enable the surveying and selling of land in advance of settlement. Jefferson's initial proposal was a system known as "hundreds," which would divide the land into *geographical* square miles, slightly larger than *statute* miles. The survey lines for each square mile would follow the cardinal directions—north–south and east–west, and cross each other at right angles. Though modified from this initial proposal, what was legislated into law through the Northwest Land Ordinance of 1787 was a similar system that was more compact in scale, reduced from Jefferson's hundred square miles down to a series of 36-square mile sections, each comprising one *township*. Along the straight north–south township line and the east–west range line, the square miles could be counted off from a starting point or baseline, such as T2N R3E (Johnson 1990). A product of colonial New England, each township was now standardized at 36 square miles, with each square-mile section consisting of 640 acres. This acreage could be subdivided easily into quarters or eighths and sold as private land holdings of 160-, 80-, or 40-acre plots. After piloting this massive project in eastern Ohio, the now-famous seven ranges set the stage for surveying the rest of America's Public Domain.

Though modified somewhat from this initial attempt, the seven ranges served as the standard for distributing the nation's Public Domain as private land to new settlers (Hilliard 1990b). The impact of the so-called National Grid has been profound, as practically all residential, urban, and agricultural land uses have necessarily been planned to fit within the confines of the square-mile system.

Not until the mid-nineteenth century was the surveying largely completed, given the immense scale and inherent challenges of implementation. Though

variations are found in certain states, the Township and Range land survey system covered some two-thirds of the nation and provided the context for the settlement of farms, homesteads, and towns everywhere west of the Appalachians. To Americans and foreigners alike, human landscapes appear as a giant checkerboard from the air.

Aside from elitist calls to employ the naturalistic style of landscaping during the nineteenth century, it was instead the rectilinear grid that held sway over much of American land practices. Though the Picturesque mode of private landscaping gained popularity and prestige—especially for new suburban homes—the vast majority of Americans still adored their straight lot lines, straight furrow lines in the fields, and white-painted houses—especially west of the Appalachians, where "the Federal land surveyors had spread an immense grid across the wilderness and pioneers lived in square houses on square farms beautified by few trees and many straight furrows" (Stilgoe 1988, 114). Square fields and landholdings were praised by agricultural experts, and builders of cities and towns enjoyed the efficiency allowed by the rectilinear grid.

Others continued to argue that the truly educated and genuinely sensitive component of the population should adopt the Natural style. Promotional literature increasingly scorned the Geometric style, whether for private landscape gardening or for the laying out of cities and towns. After three decades of debate, however, it was still only the elite who favored the romantic garden in the 1850s. Its standard incorporation into suburban communities everywhere would have to wait two more decades. In an 1852 *Horticulturalist* essay, George Jaques failed to understand the fascination with symmetry and begrudgingly admitted, "The great mass of the people prefer symmetry, stiff formality, straight lines, and the geometrical forms of the ancient or artificial style of laying out grounds" (Stilgoe 1988, 115).

This latter admission was perhaps nowhere more accurate than on midwestern farmsteads around the Civil War. As vast stretches of cheap and arable land opened for settlement, the midwestern prairie received a continuous flood of immigrant families from the eastern United States and Europe. The rate of midwestern settlement was hastened by the continuous construction of new railroad lines that crisscrossed the region and the aforementioned National Grid, which provided for the efficient sale of land. Certain railroad companies became vast landowners themselves with the blessing of the federal government. The Illinois Central was the first land-grant railroad in the United States, whereby the federal government essentially donated land to support the company's expansion of trackage. With 2.5 million acres of land surveyed as square-mile sections, the Illinois Central worked hard to quickly sell off its government land grants, all of which existed in a giant swath along the railroad right-of-way.

To sell its land to settlers, the company embarked on a massive recruitment strategy to entice Germans and Swedes to buy American farmland. The states of Illinois, Wisconsin, and Minnesota were likewise eager to grow their populations and also recruited European peasant immigrants. Letters from the first wave of immigrant farm families were sent back to Europe, encouraging yet another significant wave of migration into the Midwest (Salamon 1992). Another less significant attraction for immigrant farmers was the federal Homestead Act of 1862, which encouraged the landless to side with the Union during the Civil

War in return for free land in the Midwest (Vance 1990). Whatever the attraction, German immigrants comprised one of the larger groups, beginning in the 1840s and continuing more or less constantly through the 1880s. Among all of the midwestern newcomers, the Illinois Central Railroad sold most of its land to Germans, particularly during the late 1860s.

The systematic and orderly settlement of the midwestern prairie region was underway and was largely in place as a functioning, well-populated, and integrated region by 1880. Family farms were relatively small compared to the large-scale, mechanized agribusiness farms of today. They were also largely self-sufficient as peasant, or yeoman-type farmsteads, producing much of what they needed for their own consumption. Any surpluses generated on the farms might be sold at marketplaces in town. Farms typically consisted of several crops, including cash crops such as corn, beans, or wheat, and food crops for more local consumption. Farms hosted numerous animals as well, raising any combination of poultry, hogs, beef, and dairy cattle, all of which necessitated a variety of functional outbuildings, such as ice, pump, and cob houses; barns; sheds, corn cribs (to hang and dry the corn); and windmills (to pump groundwater).

Farmsteads invariably fit into the geometric order of the national, square-mile grid system. With the farmstead oriented to the cardinal directions, the straight row crops likewise followed the grid, as did the square or rectangular farmhouses and outbuildings. Farm structures situated into the grid since the 1850s had but two organizing rules: square to the road, and hogs to the east. Since interior rooms of the house were also rectilinear, this meant that furniture, beds, and many other household items were aligned north–south and east–west. Midwesterners consequently lived in a social system where they ate, slept, shopped, plowed, and recreated in alignment to the National Grid. Smaller country cemeteries in the Midwest never succumbed to the eastern practice of curvilinear cemetery planning, which meant that "even the dead are settled on the grid system" in regimented lines of gravestones and plots (Riley 1985, 25).

Robert Riley (1985) considers the Township and Range system as the most extensive geometric abstraction to ever appear on the planet. Viewing the grid not only as an efficient mode for land distribution but more as a symbol of American democracy, Riley offers that to look at the National Grid from the air—that is, at the variety of human settlement patterns embedded within it—is to see "the ultimate expression of Cartesian rationality and Jeffersonian democracy, noncentrist, nonhierarchical organization" (Riley 1985, 26). During these formative decades, advocates of the Natural style enjoyed little success with encouraging a Picturesque orientation of farmhouses and landscaping. It would not be until the 1970s when invading modern ranch houses were courageously oriented off of the grid—much to the dismay of grid-loving locals.

The South: Plantations of the Caribbean Realm

Americans typically associate the image of a plantation manor house with the South. The plantation image has become engrained in popular culture, though it represented a more complex system of agricultural production and applied to only a small fraction of the actual plantations. The antebellum (pre–Civil War)

plantation incorporated two of the most potent forces in the American South—a dominant agricultural cash-crop system, which was the region's economic mainstay, and the institution of slavery, which invited global condemnation and alienation (Hilliard 1990a). The southern population expanded gradually leading up to the Civil War, as Anglo-American migrants filtered southward and westward from their Atlantic Tidewater source regions. The plantation system was established in nearly every part of the Southeast, from Virginia to Florida to eastern Texas, though it typically coexisted with smaller family farms. And, with the plantation came a distinctive land settlement pattern and production system like nothing found in the rest of the United States.

Sam Hilliard (1990a) identified six basic elements that comprised the nineteenth-century southern plantation: (1) a landholding of sufficient size, typically over 250 acres, that distinguished it from the common family farm; (2) a distinct division of labor and management, with the latter primarily handled by the owner or through an overseer; (3) specialized production of cash crops grown primarily for export rather than local consumption; (4) location in the South with a pre-established plantation tradition; (5) distinctive settlement forms and spatial organization reflecting centralized control; and (6) a considerable input of cultivating labor or power per unit of area farmed. Because large plantations were often self-sufficient and might even supply their own ships to reach European markets, only marginal industrial activity and urban growth took place in the South. The South consequently remained a predominantly rural region with relatively little port activity on the Atlantic Ocean. The Northeast had its Boston, New York, Philadelphia, and Baltimore, while the South had its less populous cities of Richmond, Charleston, and Savannah. The largest cities representing the South were actually those located on the region's periphery, serving as veritable gateways into the agrarian interior. On a map they collectively form a roughly circular pattern: Louisville, Memphis, New Orleans, Mobile, Savannah, Charleston, and Richmond.

The American plantation economy and resulting land pattern originated from the South American and Caribbean realms. In fact, geographers consider the American Southland more as a northern extension of Caribbean culture and less as a distinct region of the United States alone. As such, the expansive region geographers refer to as Plantation America was defined by its common agricultural system, which encouraged specific economic, social, and ecological relationships with the land (Rowntree et al. 2000). The plantation system was actually an invention of northern Europeans and was introduced to Barbados in 1640. From there the so-called plantation revolution diffused into North and South America where favorable tropical or subtropical climates favored the production of cash crops, such as rice, tobacco, bananas, sugar, and—the staple crop of the American South—cotton.

The sugar plantation became the mainstay of the tropical Caribbean realm, attempting to meet the growing and insatiable demand for the product in Europe. With the introduction of African slaves to provide labor for the system, Plantation America essentially became a neo-Africa. African slaves were first introduced to the Americas in the sixteenth century, in part a response to the increasing need for labor in the face of the sweeping demise of Native American populations. The flow of slaves continued into the nineteenth century until finally outlawed by the American Congress during the Civil War.

The incorporation of Africans into the American South was therefore only a part of a more complex African diaspora—the forced migration of a particular people from their native region. In all, at least 10 million Africans landed in the Americas.

All of this background is necessary to understand the appearance, layout, and situation of the southern plantation with the conclusion of the Civil War. Not surprisingly, the War's physical destruction combined with the forced end to the region's primary labor system severely disrupted planter markets, regional communications, and transportation. Still, the dominant agricultural system remained largely in tact and continued to operate and transition into variations of the wage labor system already familiar to northern farmers. Clearly, without a large labor supply, the traditional plantation system could not survive. This led quickly to a range of experiments with alternatives to slavery. What emerged from the chaos was a system of shared production known as sharecropping (Hilliard 1990a). In theory, sharecropping is a basic system. The landowner (planter) supplies the land, mules, implements, and housing while the cropper supplies the labor. After expenses such as seed and fertilizer were accounted for, the profit from selling the crop was divided 50–50. It was rarely this simple in practice, and numerous variations emerged on this otherwise simple process. Sharecropping did hold a profound influence on the layout and functioning of the postbellum plantation. At first, wage laborers and croppers lived in former slave quarters, typically small cabins lined up not far from the main plantation manor house. With increasing complaints from laborers came the trend to subdivide the entire plantation into smaller sharecropping units, with each worker and his family remaining responsible for cultivating a particular section. Crop proceeds were normally split at the end of the growing season, hence the term *sharecropping* (Hilliard 1990a).

As the postwar years progressed, plantations revealed an altered appearance in their built landscapes. Larger fields had been divided into smaller units, and old slaves' cabins were dispersed to the croppers' individually assigned plots. Boundaries separating the subdivisions grew into hedgerows, and trees grew around the dispersed croppers' cabins. More roads were required, all of which created the visual impression of a collection of smaller farmsteads scattered around the occasional large mansion. The hierarchically structured plantation had become less noticeable, though its underlying function of large-scale, cash-crop production remained paramount. Life on the plantation for many former slaves often changed little, as they earned barely enough wages to make ends meet, still working long hours in the field. Those who could move away from the plantation often migrated into northern cities to find work, with a sizeable number of African Americans finding their way onto passenger trains to work as porters. Out of those beginnings would emerge the African American middle class, though the postwar plantation system itself had little to do with it (Tye 2004).

The Mormon Cultural Realm: Deseret

As eastern-Americans themselves, the Mormon pioneers had moved from the Midwest into the Great Salt Lake Valley during the 1840s. Brigham Young served as president from 1844–1877, presiding over colonization of

the intermountain West from 1847 on-
ward. Individual Church members were
encouraged to view their colonizing
efforts with the goal in mind of estab-
lishing a distinctly Mormon place. The
primary motivation should therefore not
be personal gain but instead the collective
creation of a permanent home for Mor-
mons. By 1903, the determined members
of the Church of Jesus Christ of Latter-
day Saints had established no less than
500 villages in and around current-day
Utah (Norton 1998).

Many standard cultural practices came
with them from the eastern United
States. They took their cues from earlier
New England roots, readily applying the
notion of the freehold, privatized distri-
bution of land, along with the expected
free-standing house with kitchen, gar-
den, barn, and additions for the extended
family (Vance 1990). Their farms and
communities aligned well to the square-
mile sections of the Township and Range
system, which spanned the entire West.
On the surface, the material landscape
of the Mormon culture region appeared
very midwestern and quintessentially
American. This pattern prevailed with
their expansion into adjacent parts of
Idaho, Arizona, California, Wyoming,
Alberta, and northern Mexico.

The Virginia Plantation

At the northern extreme of Plantation America, to-
bacco became the dominant cash crop for Virginia
planters. A more or less typical plantation might
include the following spatial layout and particular
functions to provide for its own self-sufficiency. The
grand manor house would, of course, take center
stage, perhaps on a gentle hill to offer a command-
ing view of the land. Beyond the manor house were
numerous outbuildings, usually including a cellar,
a dairy, dovecote, stable barn, henhouse, kitchen,
slave cabins, and occasionally a schoolhouse for the
planters' children with a room for the hired tutor,
and smaller homes for white workers, such as the
overseer. Both economically and socially, the plan-
tation served essentially as its own integral com-
munity. The grounds would also include a garden
of some scale, to provide fruits and vegetables for
the plantation population itself. Nearby springs or
wells provided the plantation's water needs. Numer-
ous animals also populated the plantation, espe-
cially the standard pigs or hogs, sheep, cattle, and
horses. Prior to the War, slave quarters consisted of
modest wooden cabins and were generally aligned
on two sides of a single street some distance from
the manor house. Other outbuildings, especially the
kitchen, were clustered closer to the house. More
distant, however, was the small cemetery of the
planter's family, which was relegated to a secluded
part of the plantation (Hilliard 1990a).

With these similarities came distinctly Mormon cultural patterns. The
Church-mandated town plan did involve the predictable and expedient grid of
streets. Its prototype was devised for Zion, Missouri in 1833. This plan served
as the template for hundreds of Mormon towns and villages throughout their
envisioned nation–state of Deseret, before they settled for their own state in
the Union. Zion's one-square-mile plan deviates from non-Mormon city grids
in a few fundamental ways. The main streets are typically wider, and each city
block alternates the orientation of its lots and buildings, providing for a more
open character when built up with houses. The three central blocks are not
reserved for the commerce of Main Street or a courthouse square as they might
be in the East, but instead for religious buildings, perhaps a temple. Streets are
numbered sequentially out from the central square, making no mistake as to
what was designed to be the most important cultural feature of the community.
Though smaller towns and villages followed this centrally-prescribed urban
model, the most well known is, of course, Salt Lake City.

In many ways the Mormons were similar to their western counterparts, though
distinctive Mormon landscape patterns appeared. Mormons were particularly

united by a shared commitment to a distinctive religious belief system, and they generally accepted church authority and centralized control. They were consequently more apt to accept communal living as opposed to more typical individualistic and independent western settlers. New Mormon colonies were provided with guidelines by the Church on how to arrange their new towns, their homes, farms, and businesses. Exemplifying such guidance was the following statement issued from the president's office in 1882 for a new settlement in Idaho:

> In all cases in making new settlements the Saints should be advised to gather together in villages, as has been our custom from the time of our earliest settlement in these mountain valleys. The advantages of this plan, instead of carelessly scattering out over a wide extent of country are many and obvious to all those who have a desire to serve the Lord. (Norton 1998, 37)

Mormon communities were concerned above all with agricultural production and self-sufficiency in rather isolated locales. Although their built landscapes differed from one place to another, there is general consensus among scholars regarding typical village features. Particularly, Mormon communities were designed to incorporate farmsteads inside their villages. Close to the center of town, therefore, could be found the gamut of farm structures and functions, including unpainted barns, pig pens, orchards, vegetable gardens, and the distinctive Mormon fences—an "eccentric, vernacular hodge-podge of sticks, boards, and posts" (Norton 1998, 38). Roadside irrigation ditches were necessary to connect the farms with adequate water supplies in typically dry, semi-arid climate conditions. Streets were typically wider than in other western towns, and Lombardy poplars and cottonwood trees were commonly used as windbreaks or field boundaries. This typical village landscape pattern was well established by the end of the Civil War and was guided in large part by the aforementioned City of Zion plan. Homesteads and fields outside the village conformed instead to the cardinal directions of the National Grid.

A. J. DOWNING AND THE PICTURESQUE MOVEMENT

The Picturesque Style in Europe and America

As American settlement pushed westward, the industrialized cities looked eastward to England for guidance on landscape design. The Philadelphia street grid may have proven vastly superior for methodically conveying real estate, as had the Township and Range grid system for the larger national scene. However, a dramatic alternative to rectilinear planning made continuous inroads due especially to Andrew Jackson Downing and his contemporaries. Downing promoted the Picturesque style of English gardens, eventually becoming the Victorian style of choice. Picturesque gardening was relentlessly promoted through popular literature, especially by Downing himself who instructed the emerging middle class on horticultural practices. As the essential leading promoter of the Picturesque movement, therefore, Downing provided an alternative to rectilinear, formal landscaping practices by giving the term *rural* new meaning. He both envisioned and promoted a veritable "middle landscape" of suburban villa and cottage architecture—a residential landscape neither completely urban nor agrarian (Rogers 2001).

The origins of Picturesque design can be traced to the developments by and for the English aristocratic estate owners of the eighteenth century. This was a painting-influenced style articulated by British landscape theorists such as William Gilpin, Richard Payne Knight, and Uvedale Price during the late 1700s. Picturesque style paintings were distinguished by their portrayals of rugged wilderness, and they often incorporated Rococo effects, especially in France where the Rococo style originated (Rogers 2001). Enthusiasm for the Picturesque became a fervor by the early 1800s. Many aristocrats in Europe actually destroyed the formal, geometric gardens of their ancestors as the English garden gained greater popularity throughout Europe. By doing so they hoped to display their own social progressiveness, and individual tastes for landscape design were becoming more acceptable. Even geometric garden design was eventually allowed back into the repertoire, providing yet more alternatives for Picturesque landscaping and individual expression.

With the invention of the lawn mower in 1830, it became possible to maintain large swards of closely mowed turf without the use of traditional scythes or sheep to munch it down. The green lawn became highly desirable for British Victorian estates by the mid-nineteenth century, and small armies of English gardeners could be put to work on the maintenance of great Victorian gardens. Designers typically avoided straight lines in their Picturesque landscaping and were particularly influenced by the curves of the French Rococo style. The circle became a popular form, and planting beds were often raised up into mounds with the intention of enhancing visibility from the otherwise flat lawn. John Claudius Loudon (1783–1843) became one of the premier advocates for the Victorian Picturesque garden throughout England. At that time, the English term *garden* referred to the grassy lawn itself. Also a prolific writer and metropolitan planner, Loudon envisioned a day when urban planning would be undertaken by general public consensus rather than by the wealthy and powerful elite. His first proposal was to apply Picturesque principles to the planting of trees and shrubs within London's city's squares, and he urged women to practice horticulture as well. Loudon's wife, Jane Webb, gained her own lasting renown for promoting the Picturesque tradition. It turned out that the Loudons and their philosophies would be heavily influential to the young A. J. Downing, setting the stage for the Picturesque landscaping movement in America.

The Picturesque mode reflected a sweeping change in attitudes toward nature and wilderness. An idealized notion that "all nature is a garden" began to influence British and American populations, reversing the trend of formal gardens and landscaping practiced since the sixteenth century (Tobey 1973). As interest swung toward a romanticizing of nature, new scientific findings provided more information about the diversity of plants, flowers, and trees that could be employed for ornamental landscaping. However, it was a series of literary works during the early 1800s that perhaps most heavily reinforced the romantic view of nature in both Europe and America. In 1823, James Fenimore Cooper (1789–1851) had written the first of his famous *Leather Stocking Tales* titled *The Pioneers*. His *Last of the Mohicans* in 1826 provided an additional romanticized version of the American wilderness, this time oriented to the Native American population. At the same time, Washington Irving came to be recognized in Europe as one of the first American novelists, having first published a series of humorous periodical essays reflecting on New York Society

in 1802 and 1803. He further focused his readers' attention on the natural landscapes and Dutch influence of the Catskills and Hudson River valley in his still-popular *Rip Van Winkle* and *The Legend of Sleepy Hollow* (1820). By 1835, Irving had also published his *Tales of the Alhambra* and *A Tour of the Prairies,* the latter of which romanticized the Great Plains.

Aside from literary influence, John Stilgoe (1988) attributes the popularization of the Natural style in America to two fundamental forces. The first was a European-inspired fascination with Picturesque scenery and art. The second involved the unrelenting patriotism of the early Americans. Not unlike the twentieth-century mantra of "buying American" to reduce foreign imports, the nineteenth-century elite emphasized native American plants, flowers, and trees for their Natural style landscaping. To be sure, Asian and European varieties of ornamental plants were continuously given their place in American gardens, though a flurry of written advice reinforced the association between native plantings and American patriotism. Wilson Flagg, for one, argued repeatedly throughout the 1850s that American trees, especially the birch, elm, cherry, poplar, and maple, should be employed not only for their genuine beauty but for their patriotic associations. Flagg wrote, "The American elm, indeed, is a fair symbol of a well-bred New England country-gentleman, who has strength without rudeness, politeness without effeminacy, and courage united with a mild and gentle deportment" (Stilgoe 1988, 118).

Other "experts" added their own attacks on exotic species, directed for instance toward the ailanthus tree imported in the early 1800s for its use in tanning leather. Downing particularly taught his readers to incorporate mature, native trees into planned suburban lots. In turn, he despised the practice of American pioneers to chop down every bit of vegetation to clear the land. Instead, country cottages might be placed underneath the larger trees. Henry Hudson Holly agreed, advising in his popular *Country Seats* of 1863, "Do not allow picturesque rocks, or wild forest trees to influence your decision against any site," he explained. "Your landscape gardener can always reconcile them, domesticate them, as it were; in short make them beautiful and appropriate; and your architect, if a man of taste and education, can arrange your house to combine gracefulness with any peculiarities of country, and give it such character as will be congruous with surrounding scenery" (Stilgoe 1988, 118).

Andrew Jackson Downing: Tastemaker to the Nation

If any single individual should be credited with promoting the Picturesque landscaping mode with the suburban ideal, it was Downing. Ever since his *Treatise* was published in 1841, Downing's name had become synonymous with the raised expectations of suburban country life in America (Major 1997). He was recognized as the chief authority of rural art, and his personal role was substantial in democratizing culture by revealing how middle- and working-class households could afford and acquire their own small trappings of gentility and high-style taste (Rogers 2001). Downing was, like all people who influence society, a product of his time, which is important to recognize. He readily absorbed the contemporary thought that prevailed at the time, and to which he enjoyed constant exposure. Contemporary thought was basically English thought, as Downing became an adherent of the English Landscape movement

and sought to adapt its ideals to North America through the improvement of American home life (Tobey 1973).

Born in 1815 in Newburgh, New York, Downing's early stomping ground included nothing less than the countryside of the Catskills and Hudson River valley. He was introduced to the ideas of aesthetic taste and, more particularly, to the evolving discipline of horticulture through his family's nursery, run by his father and older brother. Left more or less alone as a child, Downing developed an early sensitivity to nature and was influenced by the social and cultural influences of upstate New York. As a young man, Downing befriended the Austrian Consul Baron de Liderer, who also practiced mineralogy and botany and helped develop Downing's scientific curiosity. He was also acquainted with an English landscape painter who taught him about "landscape composition." Adding to this early experience was Downing's rare access to numerous country estates through his family's nursery business. All of this background contributed to his budding interest in landscape design, and Downing became one of the first to intently study the natural beauty of a particular site, for which he coined the term, *genius loci* (Tobey 1973).

Downing did not personally introduce the Picturesque landscaping mode to America. Even George Washington and Thomas Jefferson were familiar with the principles of English landscape gardening. Credit goes principally to Andre Parmentier (1780–1830) who gained wide recognition through his article that described naturalistic gardening in the *New England Farmer* magazine. Having influenced Downing's thoughts on the subject, Downing considered "Parmentier's labors and examples as having effected, directly, far more for landscape gardening in America, than those of any other individual whatever," he wrote (Rogers 2001, 326). The Loudons provided further inspiration for Downing, who imitated early on the styles they and their contemporaries developed. Having learned much from his European predecessors, Downing was poised to play a pivotal role in the evolution of American landscape history. Essentially, Downing learned to translate existing European Picturesque methods and ideology into a distinctively American style. Borrow from European practice he certainly did, but Downing developed his own interpretation of the Picturesque. He recognized that his own designs must take into account each site's existing context as well as American climate and culture.

Downing made the significant distinction between what he termed the "beautiful" and the "picturesque." Each site was unique, he realized, containing its own visual qualities. Any landscape design should therefore purposely integrate these various qualities without eliminating them entirely. These might consist of existing landforms and topography, vegetative cover, and sources of flowing water. Downing defined the beautiful as a site's natural, flowing curves of the landform, gentle or rounded trees, and any slow-flowing or still waters. In contrast, the picturesque referred to any rugged, rough, or angular land forms, startling contrasts between trees and tree shapes, and any fast-flowing, wild waters (Tobey 1973). Downing reveals these two basic principles in his *Treatise.* Any place, he believed, might express either the beautiful or the picturesque. What is not shown is the principle he is likely best known for today—his recognition of the genius loci, through appreciating a site's basic visual qualities.

Downing believed that each suburban property owner could enjoy a private piece of paradise. One of Downing's plans for a romantic suburban cottage in

1853 shows an inclusive lawn, derived principally from English precedents. He utilized the term *piazza,* derived from Italy, to describe the cottage's front porch, and described his cottage plan as follows:

> Quite an area, in the rear of the house, is devoted to a lawn, which must be kept close and green by frequent mowings, so that it will be as soft to the tread as a carpet, and that its deep verdure will set off the gay colors of the flowering plants in the surrounding beds and parterre. This little lawn is terminated by an irregular or "arabesque" border, varying in width from four to fourteen feet. The irregular form of this border is preferable to a regular one on account of its more agreeable outline, and more especially for the reason that, to a person looking across the lawn from any part of the walk near the house, this variety of form in the boundary increases the apparent size of the area of turf which it encloses. (Downing, 1853, 38, cited in Tobey 1973, 158)

The similarity of Downing's description to that of a current-day suburban home is perhaps startling. Indeed, Downing's influence on suburban landscaping was long-standing and has yet to diminish significantly more than 160 years after publishing his *Cottage Residences* (1853). Many American families still enjoy their gently curving walks, arabesque flower beds, and diverse evergreens planted in the front yards across much of American suburbia.

Downing's country homes and their romantic environs had planted the idea of a middle-ground lifestyle for Americans ready to escape the city. His mouthpiece was his own popular magazine, the *Horticulturalist,* perhaps the nineteenth-century version of today's talk radio. Readers wrote to comment on his essays, or to forward various questions. Downing would respond in turn through follow-up articles in his magazine. In cautioning his readers, for instance, he advised that before beginning their "voyage of pleasure," with a country home, it must be understood that caring for the home and its landscaping would not be "all smooth water" (Major 1997). Downing likewise addressed the economic constraints experienced by many American families and the monetary costs entailed with maintaining a green lawn with romantic-styled landscaping. He always encouraged suburban newcomers to not destroy all the natural trees and vegetation, teaching readers instead to make use of those features by integrating them into the manicured landscape scene.

Clearly cognizant of limited family budgets, Downing offered designs not only for grand, park-like spaces and pleasure grounds, but also for more modest gardens and lawns that did not require thousands of dollars to install and maintain. For instance, he offered "a cottage embosomed in shrubbery, a little park filled with a few fine trees," and, to avoid the cost of a lawn mower, "a lawn kept short by a flock of favorite sheep" (Major 1997, 147). He also recommended other labor-saving methods, many of them simple: a horse hoe to clean weeds from gravel walks, and a half-dozen or more sheep that were promised to do the work of two lawn mowers. His American readers were also informed that "no nation under the sun may have such lawns as the British," though households in northern states could still enjoy green and pleasant lawns if they were well maintained during the summer months (Major 1997, 147).

By the 1870s, the natural landscaping principles promoted by Downing and his contemporaries had become standard fare. Linked to an extensive consumer

market, households no longer needed to grow their own herbs and vegetables, though many continued to do so. More advanced lawn mowers replaced sheep and rough meadows. Now well established, the suburban dream demanded ever-more open space. The ideal house was one that rested in the middle of a manicured lawn or a picturesque garden—or both (Jackson 1985).

One design for a modest villa, published in an 1869 issue of *Manufacturer and Builder,* described what had apparently become the American dream home. Located on Long Island, the house was already built by 1867, and its owner commuted regularly into New York City. Using this particular house plan and grounds as an example, the writer cautions, "Better not make the attempt to lay out the grounds tastefully, if it be not the intention of the owner to keep them neat and in good order . . . no one having a lot of this size need fear that it is too large to be kept in order without outside help, if the leisure hours of afternoons and evenings after returning home be devoted to the work" ("Design for a Villa" 1869, 217). This house and lot were of a suitably modest size, therefore, to allow its commuting homeowner to take care of the grounds in the evenings after work, reflecting Downing's promotion of landscape gardening as a refuge from the city.

The house was based on a Swiss architectural style and set back from the street, exhibiting a Picturesque floor plan surrounded by Picturesque landscaping. Favoring the romantic, the writer advises that, "Nothing indicates a greater want of taste than a plot of ground of this size laid out in straight lines and paths, or having neglected walks and overgrown lawns" ("Design for a Villa" 1869, 217). The lawn served as a primary feature of the landscaped lot. Throughout America, the lawn essentially symbolized a barrier, akin to a grassy moat that separated the household from the perceived "threats and temptations of the city" (Jackson 1985, 58). Grass further provided a veritable outdoor carpet for leisure activities such as croquet, a lawn game imported from England during the 1860s. The well-kept lawn coincided with Victorian family values, providing an opportune place to nurture children. Grass lawns emerged even on the small, 25-foot wide lots of New York and other large cities, while new suburban yards with more space allowed for landscapes designed in the natural mode.

Downing thus played an instrumental role in forging a national culture. Referred to as a "tastemaker to the nation" by Elizabeth Rogers (2001, 329), Downing greatly influenced the future development of free-standing, suburban country homes and their surroundings. He encouraged middle-class families to take the same pride and attention to their modest, private landholdings as might the owners of the grandest country estates. He further advocated village beautification through the planting of trees and strongly believed that residents of the middle ground contributed to national patriotism by improving the country's beauty. Beyond these influences, Downing established a state agricultural school and contributed significantly to the founding of the National Agriculture Bureau in Washington, D.C. His national exposure also earned him invitations to design the landscape plans for the new Smithsonian Institution, the White House, and the nation's Capitol grounds, now comprising part of the national Mall.

As his theories on landscape gardening matured, Downing expressed a strong desire to apply them to "public pleasure grounds every where," according to his partner, Calvert Vaux (Major 1997). He greatly advocated the creation of public parks—then unheard of in America—similar to those he had witnessed in

The Stylish House

In 1975, May Watts published a book chapter "The stylish house, or fashion as an ecological factor." Invoking a variety of earlier literature on landscape gardening including that of Downing, Watts created a hypothetical homestead that represented how a small farm and its landscaped yard may have appeared during the 1860s and 1870s. Families still enjoyed a relatively intimate connection with nature that led to an expansive knowledge of plant varieties and the soil conditions and sunlight required for their success. Plants were chosen for combinations of ornamental, functional, and strategic purposes, as Watt implies in the following, paraphrased scenario:

The first planting around the Stylish House was in 1856, and newer additions appeared during ensuing decades. Jonathon planted a white pine on the southwest corner of the lot, purchased from a traveling nurseryman. Tea leaves were used as a stimulant for the new plants. Jonathon's wife, Patience, first planted Harison's yellow rose in the front yard and cabbage rose against the board fence, which helped to keep out stray wandering cows. She had brought them from Ohio, and they did well in full sun. She also planted lilies of the valley against the east side of their stone basement. The ostrich fern and lady fern were brought from a Sunday School picnic and planted against the basement's north side. Additional plantings included a russet apple tree, a sweet bough, a maiden blush, a damson plum, a Richmond cherry, raspberries, and grapes. All of these were purchased by Jonathon, along with the white pine and the elms beside the hitching post. The box-elder appeared on its own, out by the barn, as did the ailanthus tree behind the outhouse, the wild plum inside the chicken yard, and the big elderberry in the back fence corner. Patience planted the gourds on the trellis in front of the outhouse door, along with the two rows of tawny day-lilies along the path to the outhouse. "Privy lilies" her friend had called them. She had dug up the roots for Patience from along her own outhouse path. The flower bed consisted of a straight stretch along the board fence, which featured a plethora of plants, included hollyhocks, a red fern-leaved peony, sweet Williams, pinks, feverfew, Johnny-jump-ups, and yellow irises. Johnathon kept up the bed of mint, the rhubarb,

England. Beginning to realize his dreams, he began to design the Mall grounds in Washington, D.C. at the request of President Millard Fillmore in 1851. The L-shaped area under his jurisdiction included the land from the White House, along the Mall, reaching to the foot of the Capitol building.

Downing's accomplishments were all the more impressive given a tragic accident in 1852 that cut his life short at the young age of 37. While aboard a Hudson River steamboat, it caught fire and sank, drowning numerous passengers, including Downing. The accident aborted his progress on the national Mall. Afterwards, the Washington project received a new superintendent, and most of Downing's overall design was lost. His 1851 plan still served as a guide for the Mall project until about 1900, though no trace of it remains in the physical landscape (Major 1997). Instead, his theories and teachings eventually contributed to an equally impressive green space, though not located in the nation's capital. Downing had previously expressed another vision, eloquently described in one issue of his *Horticulturalist* magazine—that of a "New-York Park."

FREDERICK LAW OLMSTED AND CENTRAL PARK

The incredible story of Central Park in New York City—related here in brief—is significant for its numerous cultural and historical implications on a national scale. In particular, Downing's teachings were revived and expanded upon with the design and implementation of this monumental undertaking—credited as the first public park in the United States and imitated thereafter for parks and landscape designs across the country. Further, this vast public space played a significant role in the budding National Park System. Out of Central Park further emerged the professional

discipline of landscape architecture. Downing's previous English partner, Calvert Vaux, combined his talents with those of Frederick Law Olmsted, and neither ever forgot their debt to Downing as they forged their own distinctive interpretations of Picturesque landscaping techniques and philosophies. While molding Downing's English-oriented romantic designs into their award-winning plan, Olmsted and Vaux cre-

(continued)

asparagus, raspberries, and a big vegetable garden behind the barn. The spreading of horse and chicken manure, and wood ashes allowed the plants to prosper. The grass lawn was scythed, though the horse was tethered out on it occasionally. No massed shrubs existed for privacy, so they could see who was passing on the dirt road.

ated in Central Park a characteristically American version that took yet another great leap from Downing's transitional Picturesque style, with his Loudon-derived emphasis on horticulture and architecture (Rogers 2001).

Downing had dreamt of creating public spaces as a contribution to American democracy, essentially providing countrified open spaces for anyone who desired access. Upon Downing's death, his dream was carried forth by Olmsted and Vaux, as it was now their time in history to promote their own vision for improving the nineteenth-century urban scene. The nationwide appeal of Central Park played its own significant role in perpetuating the Picturesque landscape style throughout America, even though the park's purpose was not residential (Newton 1971). Among its other impacts, Central Park stood during the 1860s and 1870s as a powerful model for household landscaping everywhere, with its romantic notions of rolling lawns, curvilinear gardens and walks, diverse arrangements of ornamental plants and trees, and its creative incorporation of natural topographic features.

Preceding the concept of public parks in America was the creation of picturesque, rural cemeteries. Municipalities were challenged not only with growing urban populations during the nineteenth century, but also with a corresponding increase in deaths—all of whom required some form of burial according to acceptable cultural standards. Churchyard cemeteries had been replacing old graves with new ones since colonial times to make more room, which sanitary experts viewed as a pressing health hazard. Churchyards were a source of water contamination and threatened to spread cholera and other diseases. Once again, Europe provided a model solution, as early as 1804 with the establishment of Pere-Lachaise Cemetery in Paris. Out of this initial prototype came America's first public, rural cemeteries in Boston's Mount Auburn and Brooklyn's Greenwood. Designed essentially as Picturesque landscape gardens,

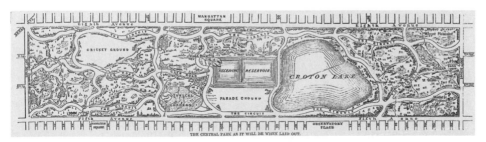

"Central Park as it Will be When Laid Out." Corbis.

they ultimately served doubly as public pleasure grounds—an observation not lost on municipal planners. Rural cemeteries thus foreshadowed America's public parks.

The reform-conscious decades of the 1830s and 1840s saw the first serious discussions about public parks. New Yorkers were not accustomed to the idea of acquiring land for the good of the general public, as the Industrial Revolution was based on the principle of laissez-faire capitalism. Among the many voices seeking to recognize society's responsibility to the burgeoning working class, two individuals stood out. One was none other than Downing himself, who used his monthly issues of the *Horticulturalist* to promote his cause. The other was William Cullen Bryant, poet and editor of the *New York Evening Post* (Newton 1971). Both had experienced the new Royal Parks in England and urged New York to set aside land before it was too late. Bryant advocated in an 1844 *Post* issue for a large, public park, as did Downing's letter four years later citing London's parks as his inspiration.

With mounting public support, in 1851, Mayor Kingsland officially recommended to the Council that the State Legislature in Albany be petitioned for authority to acquire land for a public park. The result from Albany was the passage of the First Park Act of 1851, which simply provided the city government of New York the authority to purchase a tract of land identified then as Jones's Wood—proposed by Bryant since 1844. A campaign ensued to acquire a larger space, however, which led to the Amended Park Act of 1853. This amended state-enabling legislation allowed the city to acquire the land of today's Central Park. The land acquisition process alone took four years, up through 1856, and 65 additional acres were added as a northward extension in 1863.

The Board of Park Commissioners elected Frederick Law Olmsted as the new superintendent in 1857. At the same meeting at which Olmsted was appointed, the board announced a competition that would invite a diverse array of potential design plans for the new park. Olmsted would become involved with numerous careers and professions throughout his productive life and was variously described as a romantic, a trained engineer, an experienced farmer, and a prolific writer. His involvement with Central Park would launch his career in a new profession that he and Calvert Vaux referred to as *landscape architecture*. His practice as a landscape architect would span some 50 years, leading up to his death in 1903 (Tobey 1973). Olmsted was one of the first to recognize the need for urban planning at a metropolitan scale—including city and suburb—and was often misunderstood because he was probably ahead of his time in his approach to handling urban issues. He was most concerned with the future, preferring a long-term perspective. He had the rare patience to project his plans years ahead and recognized that current projects might have long-lasting impacts (Rybczynski 1999).

As the board superintendent, Olmsted had no initial intention of entering the competition for the Central Park design. However, Downing's former partner, Calvert Vaux, did intend to submit an entry, and he eventually encouraged Olmsted to partner with him. The Board reviewed 33 entries (34 according to at least one source) and awarded first prize to Plan 33 on April 28, 1858. Not knowing the competitors' names in advance, the Board opened the sealed envelopes containing their names and discovered that the winning entry—titled "Greensward"—belonged to Olmsted and Vaux (Newton 1971).

All entries for the competition were required to meet a set of criteria. Each plan needed to include three large playing fields, a parade ground, a winter skating pond, a major fountain, a flower garden, a lookout tower, and a music hall or exhibition building (Rybczynski 1999). As did many other competitors, Olmsted and Vaux looked to Downing's work for inspiration. Downing's own initial vision for the park was not particularly helpful, but they predicted that many of the entries would likewise reference Downing. They were correct, as two-thirds of them did just that. Olmsted and Vaux found one useful insight from Downing's naturalist teachings that could be applied for an organizing principle in their plan. "Pedestrians would find quiet and secluded walks when they wished to be solitary," Downing wrote, "and broad alleys filled with thousands of happy faces when they would be gay" (quoted in Rybczynski 1999, 165). This notion was materialized in "Greensward" as a grand Promenade, as they referred to their envisioned quarter-mile long pedestrian boulevard, flanked with double rows of American elms. Quickly renamed the "Mall," writers have since viewed this feature as a brilliant solution, having successfully integrated the axial design of the Mall with terrace, lake, bluff, and tower. This ensemble—combining the Classical with the Picturesque—became the central organizing feature for the southern half of Central Park.

As Tobey (1973, 163) summarized, "Greensward" provided for the features described in the following list. The plan moved creatively beyond the teachings of Downing while still incorporating his Picturesque spirit and organizational strategies.

1. Transverse roadways, at regular intervals, "sunk so far below the general surface that the park drives may, at every necessary point of intersection, be carried entirely over it, without any obvious elevation or divergence from their most attractive routes" (Olmsted 1928, 218, quoted in Tobey 1973, 163).—These predate, by a century, today's limited access highway.
2. Boundary plantings as visual and sound buffer.
3. Vistas and views of "natural" scenery, relief from rigid grid pattern of built-up city.
4. A grand avenue or mall, where people could stroll, meet, and greet one another.
5. Long, winding carriage drives.
6. Bridle trails of sufficient length to provide healthful exercise and pleasurable experience.
7. Pedestrian walkways winding up, down, around various terrain settings.
8. A parade ground, major purpose of which for marching maneuvers for foot troops, but a plane of well-kept grass that would be pleasurable at any time.
9. Playgrounds for active play.
10. Lakes for boating, attractive vistas, and in winter, ice skating.
11. Flower gardens and an arboretum to acquaint people with various trees, shrubs, and flowers.

With these features, Olmsted and Vaux ingeniously incorporated the existing natural beauty of the site, its *genius loci*. The city had been able to acquire this large tract of land only because its complicated, rocky terrain and troublesome drainage prevented its use for development. They turned this liability into

The Father of Landscape Architecture

Frederick Law Olmsted is acknowledged as the "Father of Landscape Architecture" in part because he and Calvert Vaux were the first individuals known to use the term. The story of how the discipline came to be known as landscape architecture is a rather amusing one. As the workforce for Central Park grew to over 3,600 employees by the summer of 1859, the relationship between Olmsted and Vaux with the Board of Commissioners steadily deteriorated. On May 12, 1863, the two finally resigned, claiming that "it will be impracticable for either of us to give a continual personal attention to the Park operations during the ensuing summer" (quoted in Newton 1971, 273). Their letter of resignation was signed, "Olmsted and Vaux, Landscape Architects." The board accepted their resignation and also used the designation of "Landscape Architects" for Olmsted and Vaux. This exchange has since been recognized as the first official use of this term, establishing what is perhaps the best official birthday for the discipline of landscape architecture. Olmsted and Vaux had used the term unofficially before, but this was its first appearance on official government documents. Incidentally, this was only the first of a long series of resignations and reappointments. In January, 1871, Olmsted and Vaux reported to the commissioners that "The primary construction of the park is now essentially complete in all of the territory which was at first placed under your control" (Newton 1971, 277).

an advantage by exploiting the natural outcrops and by converting the swampy lowlands into the park's now-famous lakes. The geometric, axial design of their elm-lined Promenade (Mall) was likely included in "Greensward" because they knew that most commissioners still favored the formal, Classical tradition of landscape gardening (Rybczynski 1999). The rest of the park was intended to appear natural.

What is often recognized as their most important and creative contribution was the series of east–west cross-streets designed to allow the passage of city traffic. They placed curvilinear streets in open trenches at various intervals, eight feet below ground. From the surface, therefore, the visual continuity of the park remained undisturbed. The park's pedestrian and bridle paths and carriage roads simply bridged the trenches. "Greensward" was the only plan to satisfy the cross-traffic requirement in this creative manner.

Their immediate success with "Greensward" assured the reputation of the firm of Olmsted and Vaux, and in later years Central Park served as the model for numerous projects in the United States and Canada. These included parks in Brooklyn, Montreal, Albany, Detroit, and Chicago. As another story entirely, it also contributed to the National Parks movement, and Olmsted became personally involved with the drive to establish Yosemite National Park in 1890.

PICTURESQUE ENCLAVES: TOWARD A NATIONAL LANDSCAPE

Until the 1850s, much of the suburban development occurring on the urban fringe—or *borderlands*—consisted of individual houses on scattered parcels of countryside. Little attempt had yet been made to construct entirely preplanned communities for new suburban families. Escape from the congested, polluted city occurred one family at a time, determined to reach their new suburban homes through any variety of means that existed during the early half of the century—boat, horse, carriage, or simply walking, augmented later by the proliferation of omnibuses and horse cars. Though frequently considered the domain of the super-rich, members of all socio-economic classes could, and did, live in the early borderlands. The difference

is that the wealthiest of them tended to own two houses—one in the city and one on the fringe. "Only middle-class men and women tried to have it all, to sustain a country ambiance near the city with just one residence" (Hayden 2003, 22). It was this lifestyle that Downing so heavily promoted, convincing countless Americans that this suburban dream was indeed within reach of nearly everyone who desired it. Of course, Catharine Beecher added her voice, providing a substantial influence on middle-class, suburban house design and her promotion of modern household technologies for heating, ventilating, cooking, and bathing. Together they both constructed a powerful image in the collective American mindset that offered what would become the dominant suburban ideal.

One of the downsides to borderland living, many women soon discovered, was social isolation. Families enjoyed two of the three components of what Dolores Hayden (2003) has termed the "triple dream"—the quest for house, land, and community. It was the third component of this dream that proved elusive in such scattered, piecemeal developments. Out of this concern for improving community life came the first planned residential suburban developments known as picturesque enclaves (Hayden 2003). These would serve as the precursors to the modern-day suburban neighborhood. The enclave model emerged with a few prototypes in the 1850s and became the established mode for designing suburban communities in the decades following the Civil War. Picturesque enclaves were essentially preplanned communities with curving roads and houses on adjacent, private lots. Homes were placed amid romantic landscape elements, including heavy plantings, grass lawns, pocket parks, and other common spaces. With the community orientation of the picturesque enclave, it was presumed that social isolation would become a thing of the past. The so-called triple dream of house, land, and community had finally come to fruition, integrated with the Picturesque mode of landscape design and all the modern conveniences of the industrial nineteenth century.

Contributing to the emergence of picturesque enclaves was the wider communitarian movement, which had sought to create the ideal American community throughout the early nineteenth century. The designers of the two principle examples discussed herein—Llewellyn Park and Riverside—had strong connections to the Fourierist branch of the communitarian movement. Adherents believed that shared, public open space was necessary to promote the ideal community lifestyle. Prior to New York's Central Park, no such type of public space existed within American cities. The movement itself began in the late 1700s and peaked by the 1840s, including such groups as the Shakers, Oneida Perfectionists, and the followers of Charles Fourier at the North American Phalanx in New Jersey (Hayden 2003). These were not merely isolated, random settlements. The Shakers, for instance, claimed 21 villages of their own in New York, New England, and the Midwest. The French social theorist Charles Fourier believed that 1,600 people would provide the ideal population for a typical community, combining agricultural and industrial production in a collective effort toward harmony. Numerous leaders of the communitarians later assisted with the development of the early picturesque enclaves, including Frederick Law Olmsted who wrote testimonials for the Associationist movement. It is no stretch, then, to see the similarity in layout and design that

accompanied earlier communitarian designs and the picturesque suburbs that followed them. Of course, the emerging economic force that allowed these new suburbs to appear was the drive for profits from suburban real estate development.

Llewellyn Park, New Jersey

Llewellyn Haskell is credited with developing America's first picturesque enclave. Haskell had admired the Shaker settlement while growing up in New Gloucester, Maine, and he came to believe that one could attain a "spiritually perfected existence" on earth (Hayden 2003, 54). His aim for Llewellyn Park at West Orange, New Jersey was nothing less than to produce a secular, sellable version of a Shaker community, advertising "Country Homes for City People." Alexander Jackson Davis was hired to design the subdivision, begun in 1853. Davis partnered with Eugene Baumann to design the Picturesque suburb, heavily employing Downing's principles of romantic, naturalesque landscaping. At the time he was hired, Davis was already working on a nearby project for the Raritan Bay Union phalanx.

Llewellyn Park was only 12 miles from New York City, and construction on the site gathered momentum by the late 1850s. At its height around 1870, Haskell owned 750 acres and planned to offer lots of 1–20 acres to perhaps a hundred families. About 30 families had already moved in by this time. The Park's topography consisted of challenging, mountainous terrain with breathtaking views and steep cliffs. The idea was to surround the homes with nature in the Picturesque mode, providing for a suburban lifestyle with the full Victorian comforts available at the time. Full-time, live-in servants were anticipated for every home. The shared community experience was emphasized above all else, in part by locating the private homes next to semipublic open spaces. Llewellyn Park became home to various wealthy capitalists over time, not the least being Thomas Edison, George Pullman, and Elisha Otis (Hayden 2003). Though a rezoning allowed for half-acre lots after 1941, the Park still remains today in recognizable form as an exclusive, gated community.

Riverside, Illinois

Considering their national reputation earned from Central Park, it was perhaps only fitting that Olmsted and Vaux would be asked to design the layout of Riverside, Illinois. Advancing the ideals of Llewellyn Park one step further, Riverside is now recognized as the prototype suburban development that represented the best approximation to date of what would become the standard, twentieth-century suburban community. As the president of his Riverside Improvement Company, Emery Childs intended to divide 1,600 acres of a former farmstead into residential tracts, located nine miles west of Chicago's center. This was also the first station stop outside of Chicago along the Chicago, Burlington, and Quincy Railroad, providing transportation access for the envisioned suburban residents. Apparently already familiar with Llewellyn Park, Childs met with Olmsted and John Bogart, an assistant engineer at Prospect Park, during the summer of 1868 to formalize plans for a contract with Olmsted, Vaux, and Company. Agreeing with the railroad connection, Olmsted further argued for a separate parkway to connect Child's "villa park" with Chicago. The railroad,

according to Olmsted, "at best affords a very inadequate and unsatisfactory means of communication between a rural habitation and a town either for a family or for a man of business" (Rybczysnki 1999, 291). To supplement the railway link would be a suburban parkway, or pleasure drive, that apparently would pay for itself over time. By this time, Olmsted was familiar with the risk of social isolation on borderland developments and was intent on rectifying it. Although initially planned for, the parkway was never built.

Olmsted also argued against using the Llewellyn Park site as a model for Riverside. He explained to Childs that the topography was entirely different, in this case consisting of a flat reach of prairie most unsuitable for a "park." Suburbs and parks were inherently different, claimed Olmsted, writing in his report that, "The essential qualification of a park is *range,* and to the emphasizing of the idea of range in a park, buildings and all artificial constructions should be subordinated." In contrast to a park, he added, "The essential qualification of a suburb is domesticity, and to the emphasizing of the idea of habitation, all that favors movement should be subordinated" (Rybczynski 1999, 292). Domesticity, he believed, required a plan in which each house was somewhat unique from adjacent ones though still created a harmonious relationship between them. In fact, Olmsted was critical of numerous existing suburbs at this time, calling them "a series of neighborhoods of a peculiar character," or "rude, over-dressed villages," or "fragmentary half-made towns" (Hayden 2003, 62). With Riverside, he attempted to correct these apparent fallacies.

Reminiscent of the plan for Central Park, Olmsted made use of the site's unbuildable wetlands for a park and created a lake out of the dammed Des Plaines River. Nearly a third of Riverside's total area was devoted to public spaces, including the roads and streets themselves, a 160-acre park on both sides of the river, and numerous commons, groves, fields, croquet grounds, and greens scattered throughout the development. Unlike Llewellyn Park, the Riverside plan accommodated commercial space, with a small business district set conveniently adjacent to the railroad depot. Houses were set back at least 30 feet from the roads, all of which were lined with trees to break up the monotony of the seemingly endless, open prairie. Olmsted's roads were gently and gracefully curved for the same reason, aside from those immediately adjacent to the depot. Olmsted also defined streets differently from roads. Streets were urban and straight, he claimed, whereas the roads employed at Riverside were winding and gently curved. As for the project's vegetative cover, Olmsted was responsible for planting no less than 7,000 evergreens, 32,000 deciduous trees, and 47,000 shrubs (Rybczynski 1999). All of the now-standard infrastructure was included as well, with drains and sewers and gas and water lines. Thus, Riverside is considered to be the first fully applied rendering of the American suburban ideal.

With Riverside, Olmsted and Vaux successfully combined the real estate development process with social and recreational considerations learned from their experience in designing public parks (Rogers 2001). The romantic idealism begun in eighteenth-century England was adopted for American purposes and integrated with nineteenth-century industrial technologies (Tobey 1973). In this evolutionary, experimental way, America's modern-day suburb was born, some nine miles west of downtown Chicago. Riverside became the first clearly recorded example of applying landscape architectural designs to a real estate

subdivision (Newton 1971). With that combination of elements, the ensuing two decades found Olmsted and his firm engaged in numerous similar projects, paving the way—so to speak—for the first auto-oriented suburbs in the early twentieth century. It was with Riverside that the Picturesque suburban pattern was permanently established in American practice and mindset.

Reference List

Cooper, W. 1810. *A guide in the wilderness, or the history of the first settlements in the western counties of New York, with useful instructions to future settlers in a series of letters addressed by Judge Cooper of Cooperstown to William Sampson, Barrister, of New York.* Dublin: Gilbert & Hodges.

"Design for a Villa." 1869. *Manufacturer and Builder* 1(7): 217.

Downing, A. J. 1853. *Cottage Residences: A Series of Designs for Rural Cottages and Cottage Villas, and Their Gardens and Grounds Adapted to North America.* New York: John Wiley.

Duncan, James, Jr. 1973. "Landscape Taste as a Symbol of Group Identity: A Westchester County Village." *The Geographical Review* 63: 334–355.

Hayden, Dolores. 2003. *Building Suburbia: Green Fields and Urban Growth, 1820–2000.* New York: Vintage Books.

Hilliard, Sam. 1990a. "Plantations and the Molding of the Southern Landscape. In *The Making of the American Landscape,* ed. Michael Conzen, 104–126. London: HarperCollins Academic.

Hilliard, Sam. 1990b. "A Robust New Nation, 1783–1820." In *North America: The Historical Geography of a Changing Continent,* ed. Robert Mitchell and Paul Groves, 149–171. Savage, MD: Rowman & Littlefield Publishers, Inc.

Jackson, Kenneth. 1985. *Crabgrass Frontier: The Suburbanization of the United States.* New York: Oxford University Press.

Johnson, Hildegard. 1990. "Towards a National Landscape." In *The Making of the American Landscape,* ed. Michael Conzen, 124–145. London: HarperCollins Academic.

Lamb, Martha. 1879. *The Homes of America.* New York: D. Appleton & Co.

Lewis, Peirce. 1990. "The Northeast and the Making of American Geographical Habits." In *The Making of the American Landscape,* ed. Michael Conzen, 80–103. London: HarperCollins Academic.

Major, Judith. 1997. *To Live in the New World: A. J. Downing and American Landscape Gardening.* Cambridge: The MIT Press.

Meinig, Donald. 1979. "Symbolic Landscapes: Some Idealizations of American Communities." In *The Interpretation of Ordinary Landscapes,* ed. Donald Meinig, 164–192. New York: Oxford University Press.

Newton, Norman. 1971. *Design on the Land: The Development of Landscape Architecture.* Cambridge, MA: Harvard University Press.

Norton, William. 1998. "Mormon Identity and Landscape in the Rural Intermountain West." *Journal of the West* 37(3, July): 33–43.

Olmsted, F. L., Sr. 1928. *Forty Years of Landscape Architecture,* vol. 2, ed. F. L. Olmsted, Jr. and Theodora Kimball. New York: Putnam.

Riley, Robert. 1985. "Square to the Road, Hogs to the East." *Illinois Issues* 11(7): 22–26.

Rogers, Elizabeth. 2001. *Landscape Design: A Cultural and Architectural History.* New York: Harry N. Abrams.

Rowntree, Les, Martin Lewis, Marie Price, and William Wyckoff. 2000. *Diversity Amid Globalization: World Regions, Environment, Development.* Upper Saddle River, NJ: Prentice Hall.

Rybczynski, Witold. 1999. *A Clearing in the Distance.* New York: Scribner.

Salamon, Sonya. 1992. *Prairie Patrimony: Family, Farming, and Community in the Midwest.* Chapel Hill: University of North Carolina Press.

Stilgoe, John. 1988. *Borderland: Origins of the American Suburb, 1820–1939.* New Haven: Yale University Press.

Tobey, G. B. 1973. *A History of Landscape Architecture: The Relationship of People to Environment.* New York: American Elsevier Publishing Company, Inc.

Tye, Larry. 2004. *Rising from the rails: Pullman porters and the making of the black middle class.* New York: Henry Holt & Co.

Vance, James, Jr. 1990. "Democratic Utopia and the American Landscape." In *The Making of the American Landscape,* ed. Michael Conzen, 204–220. London: HarperCollins Academic.

Watts, May. 1975. *Reading the Landscape of America.* New York: Macmillan Publishing Co., Inc.

Whitaker, Craig. 1996. *Architecture and the American Dream.* New York: Three Rivers Press.

Glossary

Balloon frame: A lighter, faster, and cheaper construction method that replaced the medieval timber frame by the mid-nineteenth century. Its main ingredient is mass-produced dimension lumber such as the standard "2-by-4," planed into smooth siding and finished boards for all the necessary framing, doors, window openings, and flooring.

Board and Batten siding: A vertical exterior cladding that employed vertical planks (boards) adjacent to one another and joined through the tongue and groove method. To protect the joints, it was common to cover them with narrow, vertical battens, which were typically only an inch or so wide.

Bonding pattern: Refers to the orientation of bricks with respect to one another within a brick wall. Three typical approaches to bonding were in use by the mid-nineteenth century, namely the *Flemish* bond, *English* bond, and the *American Common* bond. Each row of laid brick is known as a *course*. The bricks in each course are laid either parallel or perpendicular to the wall. A brick laid with its long (8-inch) side parallel to the wall is known as a *stretcher*, while a brick laid with its short end parallel to the wall is a *header*.

Borderlands: The rural countryside immediately adjacent to large cities where the first wave of suburban residential development occurred after the 1830s.

Clapboard siding: A horizontal exterior cladding that employed horizontal boards that overlapped one another by at least three-quarters of an inch. Narrower boards were preferred so as to minimize their warping.

Colonial Revival styles: A series of architectural styles reflecting colonial and early-American precedents that gained popularity quickly following the

patriotic fervor of the 1876 centennial. Domestic (i.e., residential) architecture adopted revived forms of Georgian, Federal, Dutch, and Classical styles, with the Colonial Revival gaining full force by the 1880s.

Core-periphery relationship: An urban, industrialized region (the core) supplies manufactured goods and services to a largely rural hinterland region (the periphery), from which the core receives raw materials to use for manufacturing. An interdependent geographical and economic relationship is consequently forged between them.

Cultural Diffusion: The geographical process through which cultural ideas and practices spread from one location to another, either through imitation or human migration. American architectural styles often diffused outward from a cultural "hearth," or urban core region, typically the northeastern United States, during the nineteenth century.

Eastlake style: Named for English interior designer Charles Eastlake, who preceded the likewise influential Arts and Crafts movement by promoting honesty in styles and materials, rather than hiding them underneath various facades, ornamentation, or unnatural veneers. His earlier works employed the Gothic style, and he emphasized picturesque designs. He began to design his own line of furniture, for which he ultimately became famous on both sides of the Atlantic. Of great interest to Eastlake was the production of innovative furniture designs for urban dwellers often living in rather crowded conditions. Featured heavily at the Centennial Exhibition in Philadelphia, Eastlake displayed varieties of beds that folded up into wall cabinets, chairs that folded into lounges, and various swivel, rocking, and reclining chairs.

Elizabethan Revival style: A relatively popular interior decorating style most influential with furniture. The nineteenth-century version was a revival of baroque furniture of the English Restoration of 1660–1688. Characterized by its distinctive spiral or spool turning on posts and legs of chairs, small tables, towel racks, and spool beds.

Friction of distance: A measure of the relative difficulty of moving people and ideas across a region or continent. Successive advances in transportation technology—from interior canals to railroads to automobiles and highways—along with communication technologies, have collectively served to reduce America's overall friction of distance.

Gilded Age: Usually refers to the period of American history between 1875 and 1900, associated with the late Victorian Era. The term originated through a novel of the same name, authored by Mark Twain (Samuel Clemens) and Charles Dudley Warner in 1873.

Gingerbread: A general term describing any form of exterior, Victorian Era ornamentation on the facade of a home, such as wooden spindles and balls, stylish porch columns, finials, and bargeboard.

Gothic Revival style: Considered the first Victorian Era style in America, inspired by the Gothic cathedrals of England and France. Popular between roughly 1840 and 1880 for both interior design and exterior facades. Featured combinations of lancet (pointed) arch windows, vaulted-arch ceilings, steeply pitched roofs, picturesque floor plans, and occasional castellated parapets (battlements). Popular for American churches through the 1940s.

Growth Machine: An alliance or coalition of progrowth interests, usually involving land owners, companies or corporations, urban municipal governments, and other interest groups that mutually benefit from economic growth and development.

Horse Car: A horse-drawn railway passenger car that blended the virtues of the steam train and omnibus, allowing greater mobility for urban residents and contributing greatly to America's first wave of suburbanization and commuting habits.

Human landscape: Also referred to as the *cultural landscape.* Includes everything that humans have created for themselves through time, comprising the entire built environment. Not to be confused with *landscaping,* the art of arranging plants and gardens in either picturesque or geometric patterns on a given property.

Italianate style: Inspired initially by Renaissance-era villas and manors found in northern Italy, in conjunction with the Italian Villa style. Became the most popular exterior style for American houses and townhouses between 1850 and 1880. Features included tall, arched windows, overhanging eaves with brackets. Tends to be more boxy and symmetrical than Italian Villa style, thus suitable for urban lots.

Italian Villa style: Like Italianate style, initially inspired by Renaissance-era villas and manors found in northern Italy. Popular as an American romantic style during the mid-1800s. Typically more picturesque and asymmetrical than the urban Italianate style, often including a tower, or *campanile.*

Omnibus: A horse-drawn, taxi-like carriage invented in France in 1826 and introduced to America in 1829, preceding the age of railway horse cars and electric streetcars.

Picturesque: A romantic perspective during the late eighteenth and nineteenth centuries that celebrated the variety, texture, and unpredictability found in nature. Involved the layout of ornamental shrubs, gardens, and other landscaping elements in purposely asymmetric, naturalistic patterns with little apparent sense of order or planned geometry. The basic idea was to imitate natural conditions in a semicontrolled way. Likewise, Picturesque floor plans for houses were more asymmetrical and open than their formal, Classical predecessors.

***Placita* house:** A term used by New Mexican Spanish for a house with a courtyard surrounded on all sides by rooms. Only the wealthiest families could afford a full *placita.* Most variants were smaller U-shaped, L-shaped, and single-file buildings owned by common families in the Spanish-colonial realm of the American Southwest.

Rococo Revival: A French-inspired interior design style popular in America during the mid-nineteenth century. Its furniture was characterized by its fragile and slender appearance, the typical use of heavily carved natural forms, and a reliance on the S-curve, or the serpentine line. Aside from furniture, the style became pervasive in nearly every form of interior design, from carpets and furniture to wallpaper, curtain valences, fireplace mantels, ceiling plasterwork, and picture frames.

Romanesque Revival style: Commonly referred to as Richardsonian Romanesque, in honor of its founding Boston architect and promoter, Henry Hobson

Richardson. Popular during the later decades of the nineteenth century as one of the last Victorian Era styles. His style relied on heavy, massive construction with brick or stone and was most suitable for grand public buildings and churches. Typically too expensive for average homes; therefore, it was most often applied to wealthier homes of the gentry class.

Row House: First introduced in England during the seventeenth century, a house with shared walls on each side and usually displaying the Georgian style of architecture. Became the standard urban home of choice during the eighteenth and early nineteenth centuries.

Second Empire style: A formal, Renaissance-inspired style popular during the 1870s, imitating contemporary architecture and planning of mid-nineteenth century Paris. Identifying feature is the mansard roof, often placed on top of Italianate-style buildings. Style is named for France's Second Empire during the reign of Napoleon III.

Stick style: A Victorian style of lesser popularity during the 1860s and 1870s, sometimes considered a transition style between Gothic Revival and Queen Anne styles. Features picturesque asymmetry and identified primarily by "sticks" consisting of undecorated, milled boards applied to a building's facade, designed to resemble medieval half-timbering. Art Historian Vincent Scully gave Stick style its name.

Tenement: A large apartment-type building, the most common accommodation for lower-income and immigrant residents after the Civil War, especially in New York City.

Territorial style: The simplified, western version of the Greek Revival, dominated architectural additions in Santa Fe and other southwestern pioneer towns during the mid-nineteenth century. Identified by brick cornices on the roof to resemble Greek style dentil courses, with raw lumber fashioned into door and window frames simulating Greek columns, entablatures, and pediments.

Tripartite wall division: A popular Victorian Era, interior wall decoration system for which the wall is divided vertically from floor to ceiling with three distinct treatments: the *dado,* wall or *filling,* and *frieze.* The dado typically included a distinct application of wainscoting, paint, or wallpaper at the bottom of the wall and was capped with a molding or chair rail. The frieze, or cornice at the top transitioned to the ceiling. In between the dado and frieze was the remainder of the wall—essentially an open field, or filling space.

Victorian Era: England's Queen Victoria reigned between 1837 and 1901, providing a convenient definition for the Victorian historical era in both England and America. Numerous Victorian styles of architecture and interior design appeared and gained popularity in America during these decades.

Water closet: The predecessor to the modern-day toilet. It was the first device to allow elimination of human waste indoors. The cheaper and more popular *pan closet* type featured a simple hinged pan, usually copper, that formed a water seal when horizontal, in order to prevent the backup of sewer gases into the house. A small volume of water would remain in the bowl until flushed, when the pan was tipped and its contents passed below into a receiver, or cast-iron receptacle. From there the contents (mostly) moved into a waste pipe, ending its journey in a cesspool in places where no urban sewer system existed.

Resource Guide

PRINTED MATERIALS

Ames, Kenneth L. 1992. *Death in the Dining Room—& Other Tales of Victorian Culture:* Philadelphia: Temple University Press.

Anderson, Stanford. 1999. "Architectural History in Schools of Architecture." *The Journal of the Society of Architectural Historians* 58(3, September): 282–290.

Banham, Reyner. 1969. *The Architecture of the Well-Tempered Environment.* Chicago: University of Chicago Press.

Bauman, John F., Roger Biles, and Kristin M. Szylvian. 2000. *From Tenements to the Taylor Homes.* University Park: Pennsylvania State University Press.

Beecher, Catherine E., and Harriet Beecher Stowe. 2002. *The American Woman's Home (original 1869).* New Brunswick, NJ: Rutgers University Press.

Boardman, Fon W., Jr. 1972. *America and the Gilded Age 1876–1900.* New York: Henry Z. Walck, Inc.

Bowen, Ezra, ed. 1970. *This Fabulous Century: 1870–1900.* New York: Time-Life Books.

Brierton, Joan. 1999. *American Restoration Style—Victorian.* Salt Lake City: Gibbs-Smith Publishers.

Bruegmann, Robert. 1978. "Central Heating and Forced Ventilation: Origins and Effects on Architectural Design." *The Journal of the Society of Architectural Historians* 37(3, October): 143–160.

This is the resource guide for Part II of the volume (1861–1880). For the resource guide to Part I (1821–1860), please see page 145. For the resource guide to Part III (1881–1900), please see page 489.

Brumbaugh, Richard. 1942. "The American House in the Victorian Period." *Journal of the Society of Architectural Historians* 2(1): 27–30.

Bunting, Bainbridge. 1967. *Houses of Boston's Back Bay: An Architectural History, 1840–1917.* Cambridge, MA: The Belknap Press of Harvard University Press.

Bushman, Richard, and Claudia Bushman. 1988. "The Early History of Cleanliness in America." *The Journal of American History* 74(4): 1213–1238.

Calloway, Stephen. 2005. *The Elements of Style: An Encyclopedia of Domestic Architectural Detail.* Buffalo, NY: Firefly Books, Inc.

Carley, Rachel. 1994. *The Visual Dictionary of American Domestic Architecture.* New York: Henry Holt & Co., LLC.

Carter, Thomas. 1997. "Folk Design in Utah Architecture, 1849–1890." In *Images of an American Land: Vernacular Architecture in the Western United States,* ed. Thomas Carter, 41–60. Albuquerque: University of New Mexico Press.

Carter, Thomas, and Peter Goss. 1988. *Utah's Historic Architecture, 1847–1940.* Salt Lake City: University of Utah Press.

Cashman, Sean. 1993. *America in the Gilded Age: From the Death of Lincoln to the Rise of Theodore Roosevelt.* New York: New York University Press.

Clark, Clifford E., Jr. 1976. "Domestic Architecture as an Index to Social History: The Romantic Revival and the Cult of Domesticity in America, 1840–1870." *Journal of Interdisciplinary History* 7(1, June): 33–56.

Clark, Clifford Edward, Jr. 1986. *The American Family Home—1800–1960.* Chapel Hill: University of North Carolina Press.

Conzen, Michael, ed. 1990. *The Making of the American Landscape.* London: HarperCollins Academic.

Davidson, Marshall B. 1980. *The Bantam Illustrated Guide to Early American Furniture.* New York: Bantam Books.

Dole, Philip. 1997. "The Calef's Farm in Oregon: A Vermont Vernacular Comes West." In *Images of an American Land: Vernacular Architecture in the Western United States,* ed. Thomas Carter, 63–89. Albuquerque: University of New Mexico Press.

Downing, A. J. 1853. *Cottage Residences: A Series of Designs for Rural Cottages and Cottage Villas, and Their Gardens and Grounds Adapted to North America.* New York: John Wiley.

Downing, Andrew J. 1868. *Cottage Architecture.* New York: John Wiley & Son.

Downing, Andrew J. 1969 (reprint). *The Architecture of Country Houses:* New York: Dover Publications [original 1859, New York: D. Appleton].

Duncan, James, Jr. 1973. "Landscape Taste as a Symbol of Group Identity: A Westchester County Village." *The Geographical Review* 63: 334–355.

Eastlake, Charles L. 1878. *Hints on Household Taste.* Repr. New York: Dover Publications, 1969.

Ely, Richard. 1885. "Pullman: A Social Study." *Harper's Monthly* 70(February): 452–466.

Fitch, James Marsden. 1973. *American Building 1: The Historical Forces That Shaped It.* 2nd ed. New York: Schocken Books.

Ford, Larry. 1994. *Cities and Buildings: Skyscrapers, Skid Rows, and Suburbs.* Baltimore: The Johns Hopkins University Press.

Foster, Gerald. 2004. *American Houses: A Field Guide to the Architecture of the Home.* Boston: Houghton Mifflin Co.

Francaviglia, Richard. 1996. *Main Street Revisited.* Iowa City: University of Iowa Press.

Garrett, Wendell. 1993. *Victorian America—Classical Romanticism to Gilded Opulence.* New York: Universe Publishing.

Garvin, James. 1981. "Mail-Order House Plans and American Victorian Architecture." *Winterthur Portfolio* 16(4, January): 309–334.

Gay, Cheri Y. 2002. *Victorian Style—Classic Homes of North America*. Philadelphia: Courage Books.

Gelernter, Mark. 1999. *A History of American Architecture: Buildings in Their Cultural and Technological Context*. Hanover: University Press of New England.

Gillon, Edmund, Jr., and Clay Lancaster. 1973. *Victorian Houses—A Treasury of Lesser-Known Examples*. New York: Dover Publications Inc.

Ginger, Ray. 1975. *The Age of Excess: The United States from 1877 to 1914*. New York: Macmillan.

Hamilton, C. Mark. 1995. *Nineteenth-Century Mormon Architecture and City Planning*. New York and Oxford: Oxford University Press.

Hammett, Ralph. 1976. *Architecture in the United States: A Survey of Architectural Styles Since 1776*. New York: John Wiley & Sons, Inc.

Handlin, David. 1979. *The American Home: Architecture and society, 1815–1915*. Boston: Little, Brown.

Handlin, David P. 1985. *American Architecture*. London: Thames and Hudson.

Hayden, Dolores. 1981. *The Grand Domestic Revolution: A History of Feminist Designs for American Homes, Neighborhoods, and Cities*. Cambridge, MA: The MIT Press.

Hayden, Dolores. 2002. *Redesigning the American Dream: Gender, Housing and Family Life*. New York: W.W. Norton & Co.

Hayden, Dolores. 2003. *Building Suburbia: Green Fields and Urban Growth, 1820–2000*. New York: Vintage Books.

Hilton, Suzanne. 1975. *The Way It Was: 1876*. Philadelphia: Westminster Press.

Hornbeck, David. 1990. "The Far West, 1840–1920." In *North America: The Historical Geography of a Changing Continent*, ed. Robert Mitchell and Paul Groves, 279–298. Savage, MD: Rowman and Littlefield Publishers, Inc.

Howe, Daniel. 1976. "Victorian Culture in America." In *Victorian America*, ed. Daniel Howe. University of Pennsylvania Press, Inc.

Ierley, Merritt. 1999. *Open House: A Guided Tour of the American Home, 1637–Present*. New York: Henry Holt and Company.

Ierley, Merritt. 1999. *The Comforts of Home—The American House and the Evolution of Modern Convenience*. New York: Three Rivers Press.

Jackson, Kenneth. 1985. *Crabgrass Frontier: The Suburbanization of the United States*. New York: Oxford University Press.

Jandl, H. Ward. 1991. *Yesterday's Houses of Tomorrow. Innovative American Homes, 1850–1950*. Washington, D.C.: The Preservation Press.

Jenkins, Virginia Scott. 1994. *The Lawn—A History of an American Obsession*. Washington, D.C.: Smithsonian Institution Press.

Karabell, Zachary. 2001. *A Visionary Nation: Four Centuries of American Dreams and What Lies Ahead*. New York: HarperCollins Publishers, Inc.

Kasson, John. 1990. *Rudeness and Civility: Manners in Nineteenth-Century Urban America*. New York: Hill and Wang.

Lewis, Peirce. 1990. "The Northeast and the Making of American Geographical Habits." In *The Making of the American Landscape*, ed. Michael Conzen, 80–103. London: HarperCollins.

Loth, Calder, and Julius Sadler, Jr. 1975. *The Only Proper Style: Gothic Architecture in America*. Boston: New York Graphic Society.

Major, Judith. 1997. *To Live in the New World: A.J. Downing and American Landscape Gardening.* Cambridge, MA: The MIT Press.

Mayhew, Edgar de N., and Minor Meyers, Jr. 1980. *A Documentary History of American Interiors: From the Colonial Era to 1915.* New York: Charles Scribner's Sons.

McAlester, Virginia, and Lee McAlester. 1997. *A Field Guide to American Houses.* New York: Alfred A. Knopf.

McAlester, Virginia, and Lee McAlester. 1998. *A Field Guide to America's Historic Neighborhoods and Museum Houses: The Western States.* New York: Alfred A. Knopf.

Meinig, Donald. 1993. *The Shaping of America: A Geographical Perspective on 500 Years of History.* Volume 2, *Continental America: 1800–1867.* New Haven, CT: Yale University Press.

Mitchell, Robert, and Paul Groves, eds. 1990. *North America: The Historical Geography of a Changing Continent.* Savage, MD: Rowman & Littlefield Publishers, Inc.

Newton, Norman. 1971. *Design on the Land: The Development of Landscape Architecture.* Cambridge, MA: Harvard University Press.

Norton, William. 1998. "Mormon Identity and Landscape in the Rural Intermountain West." *Journal of the West* 37(3, July): 33–43.

Ogle, Maureen. 1996. *All the Modern Conveniences—American Household Plumbing, 1840–1890.* Baltimore: Johns Hopkins Press.

O'Gorman, James. 1998. *Three American Architects—Richardson, Sullivan and Wright, 1865–1915.* Chicago: University of Chicago Press.

Olmsted, F. L., Sr. 1928. *Forty Years of Landscape Architecture,* vol. 2, ed. F. L. Olmsted, Jr. and Theodora Kimball. New York: Putnam.

Peterson, Harold. 1971. *Americans at Home: From the Colonists to the Late Victorians.* New York: Charles Scribner's Sons.

Poppeliers, John C., S. Allen Chambers, Jr., and Nancy B. Schwartz. 1983. *What Style Is It?* Washington, D.C.: The Preservation Press.

Randel, William. 1969. *Centennial: American life in 1876.* Philadelphia: Chilton Book Co.

Rifkind, Carole. 1980. *A Field Guide to American Architecture.* New York: New American Library.

Riley, Robert. 1985. "Square to the Road, Hogs to the East." *Illinois Issues* 11(7): 22–26.

Rogers, Elizabeth. 2001. *Landscape Design: A Cultural and Architectural History.* New York: Harry N. Abrams, Incorporated.

Roth, Leland. 1979. *A Concise History of American Architecture.* New York: Harper & Row.

Roth, Leland. 1983. *America Builds: Source Documents in American Architecture and Planning.* New York: Harper & Row.

Roth, Leland. 2001. *American Architecture.* Cambridge, MA: Westview Press.

Rowntree, Les, Martin Lewis, Marie Price, and William Wyckoff. 2000. *Diversity Amid Globalization: World Regions, Environment, Development.* Upper Saddle River, NJ: Prentice Hall.

Rybczynski, Witold. 1986. *Home: A Short History of an Idea.* New York: Penguin Books.

Rybczynski, Witold. 1999. *A Clearing in the Distance.* New York: Scribner.

Salamon, Sonya. 1992. *Prairie Patrimony: Family, Farming, and Community in the Midwest.* Chapel Hill: University of North Carolina Press.

Schlereth, Thomas J. 1991. *Victorian America: Transformations in Everyday Life.* New York: Harper.

Schultz, Stanley K., and Clay McShane. 1978. "To Engineer the Metropolis: Sewers, Sanitation, and City Planning in Late-Nineteenth-Century America." *The Journal of American History* 65(2, September): 389–411.

Schwin, Lawrence, III. 1994. *Decorating Old House Interiors: American Classics 1650–1960*. New York: Sterling Publishing Co., Inc.

Smith, Carter. 1985. *Decorating with Americana*. Birmingham, AL: Oxmoor House, Inc.

Stearns, Peter. 1999. *Battleground of Desire: The Struggle for Self-Control in Modern America*. New York: New York University Press.

Stilgoe, John. 1988. *Borderland: Origins of the American Suburb, 1820–1939*. New Haven, CT: Yale University Press.

Stoehr, C. Eric. 1975. *Bonanza Victorian: Architecture and Society in Colorado Mining Towns*. Albuquerque: University of New Mexico Press.

Strasser, Susan. 1982. *Never Done—A History of American Housework*. New York: Henry Holt and Company.

Tarr, Joel, James McCurley, Francis C. McMichael, and Terry Yosie. 1984. "A Retrospective Assessment of Wastewater Technology in the United States, 1800–1932." *Technology and Culture* 25(2, April): 226–263.

Teyssot, Georges. 1999. *The American Lawn:* Princeton: Architectural Press.

Tobey, G. B. 1973. *A History of Landscape Architecture: The Relationship of People to Environment*. New York: American Elsevier Publishing Company, Inc.

Townsend, Gavin. 1989. "Airborne Toxins and the American House, 1865–1895." *Winterthur Portfolio* 24(1, Spring): 29–42.

Tye, Larry. 2004. *Rising From the Rails: Pullman Porters and the Making of the Black Middle Class*. New York: Henry Holt and Company.

Upton, Dell. 1998. *Architecture in the United States*. Oxford: Oxford University Press.

Walker, Lester. 1981. *American Shelter: An Illustrated Encyclopedia of the American Home*. Woodstock, NY: The Overlook Press.

Watts, May. 1975. "The Stylish House, or Fashion as an Ecological Factor." In *Reading the Landscape of America,* 320–345. New York: Collier.

Whitaker, Craig. 1996. *Architecture and the American Dream*. New York: Three Rivers Press.

Williams, Henry, and Ottalie Williams. 1962. *A Guide to Old American Houses, 1700–1900*. New York: A. S. Barnes and Company, Inc.

Wilson, Chris. 1997a. *The Myth of Santa Fe: Creating a Modern Regional Tradition*. Albuquerque: University of New Mexico Press.

Wilson, Chris. 1997b. "When a Room is the Hall: The Houses of West Las Vegas, New Mexico. In *Images of an American Land: Vernacular Architecture in the Western United States,* ed. Thomas Carter, 113–128. Albuquerque: University of New Mexico Press.

Winkler, Gail, and Roger Moss. 1986. *Victorian Interior Decoration: American Interiors 1830–1900*. New York: Henry Holt and Company.

MUSEUMS, ORGANIZATIONS, SPECIAL COLLECTIONS AND USEFUL WEB SITES

Lower East Side Tenement Museum, New York, NY
108 Orchard St.
New York, NY 10002
http://www.tenement.org/

This museum and its Web site offer a rare look into a rather typical tenement building in New York City and the lives of its immigrant tenants during the nineteenth and early twentieth centuries.

The Victorian Society in America
205 S. Camac Street
Philadelphia, PA. 19107
http://www.victoriansociety.org/

Claims to be the only national nonprofit organization committed to historic preservation, protection, understanding, education, and enjoyment of our nineteenth-century heritage. Includes numerous resources on Victorian Era architecture and culture.

Victorian Preservation Association
PO Box 586
San Jose, CA 95106–0586
http://www.vpa.org/

Includes local and national Web resources for historic house museums, national and local historic preservation organizations, and illustrated examples of Victorian homes of all the major styles.

PreservationDirectory.com
http://www.preservationdirectory.com/

Includes an incredible directory of architectural and preservation-related Web resources throughout the United States, including State Historic Preservation Offices, house museums, historical societies, and many other resources.

American Landscape and Architectural Design, 1850–1920
Provided by the Library of Congress
http://memory.loc.gov/ammem/award97/mhsdhtml/aladhome.html

Includes approximately 2,800 lantern slides illustrating historical views of American buildings and landscapes built during 1850–1920. It represents the work of Frederick Law Olmsted, Jr., Bremer W. Pond, and James Sturgis Pray, and includes hundreds of private houses and gardens across the United States.

Society of Architectural Historians
http://www.sah.org/

The SAH is an international not-for-profit organization that promotes the study and preservation of the built environment worldwide. Includes numerous academic-related and student resources, including a comprehensive list of American colleges and universities offering graduate studies in architectural history.

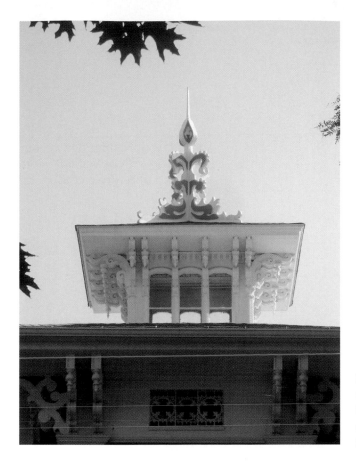

Finials were common on the roofs of Gothic Revival and Italianate buildings. This one from an Italiante-styled home in Medina, New York, is especially ornate. Nancy Mingus.

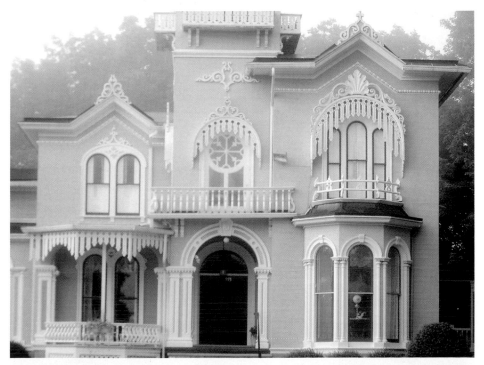

The bright white, intricately detailed trim on the E. B. Hall House in Wellsville, New York, contrasts well with the pink house color. This house represents well the Italian Villa Style. Nancy Mingus.

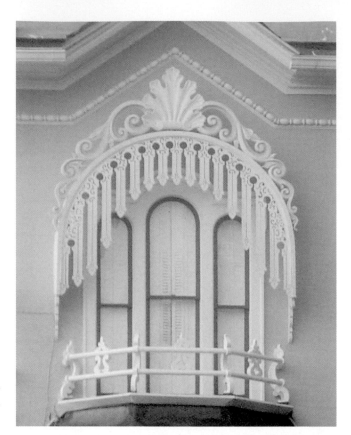

Close-up of window trim to show how trim can be highlighted. Nancy Mingus.

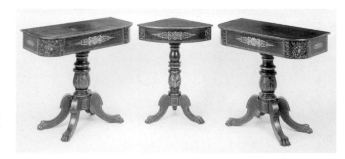

American Classical Revival consoles and corner table. Peter Harholdt/ Corbis.

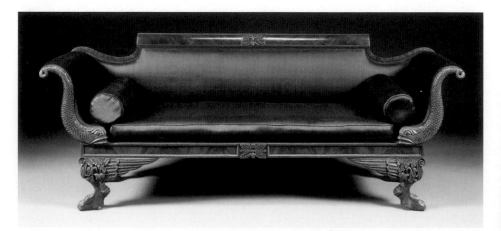

Classical carved mahogany settee attributed to Duncan Phyfe. Christie's Images/ Corbis.

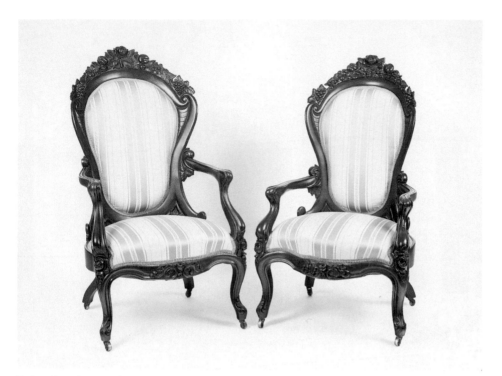

Pair of antique John Henry Belter rosewood armchairs. Peter Harholdt/Corbis.

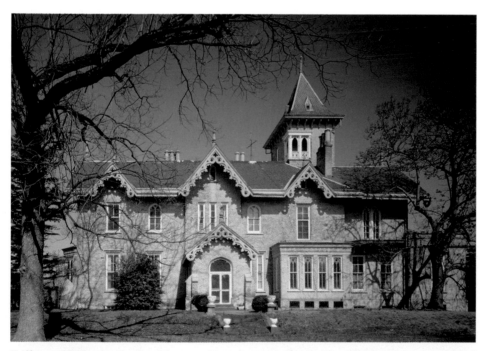

Built ca. 1850, the Lesley-Travers Mansion stands out as a distinctive example of the Gothic Revival in a town noted for its Georgian and Federal architecture, New Castle, Delaware. Courtesy of the Library of Congress.

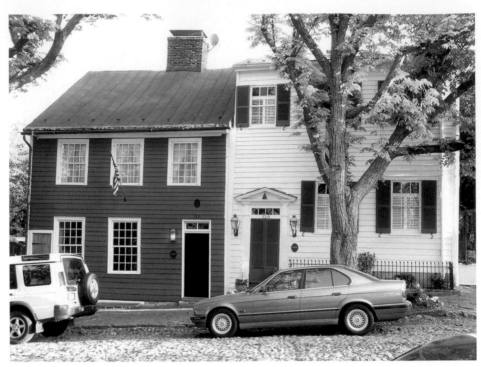

Simple Georgian-style row house (left), updated Greek revival-style row house (right), Alexandria, Virginia. Thomas Paradis.

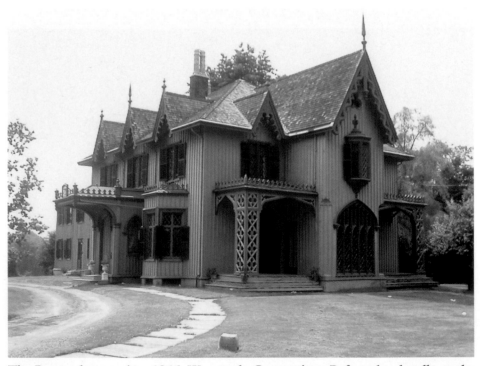

The Bowen house, circa 1846, Woostock, Connecticut. Referred to locally as the "Pink House." High-style example of Carpenter Gothic, with vertical board and batten siding. Thomas Paradis.

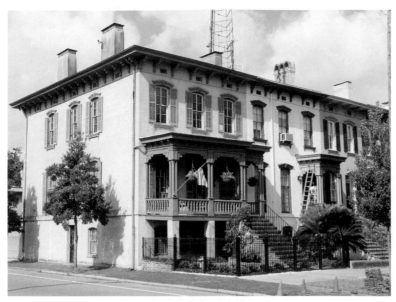

Italianate-style row houses with tall, narrow windows, brackets under the eaves, and Italianate porches. Savannah, Georgia. Thomas Paradis.

Renaissance revival furniture. The legs of this table made by the Herter Brothers are decorated with small pieces of inlaid mother of pearl. Massimo Listri/Corbis.

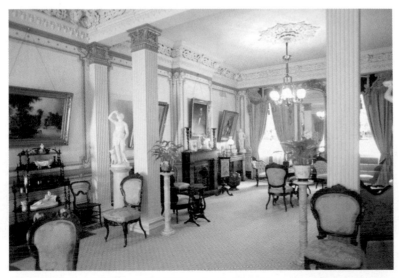

The parlor ca. 1857 at this historic Gallier house in New Orleans. Robert Holmes/Corbis.

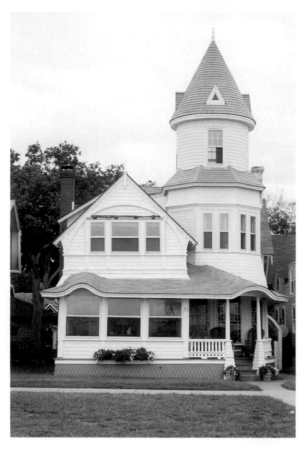

A flamboyant example of the Queen Anne style found in the summer resort of Oak Bluffs in Martha's Vineyard, Massachusetts. Elizabeth Greene.

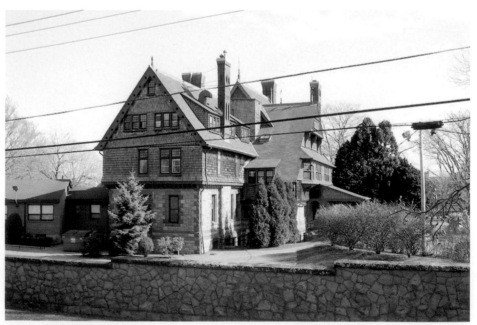

One of the first examples of the Queen Anne style in the United States was the Watts Sherman house in Newport, Rhode Island, designed by H. H. Richardson in 1874. It displayed heavy medieval influence, which was not reflected in the later vernacular examples of the Queen Anne built all over the country. Elizabeth Greene.

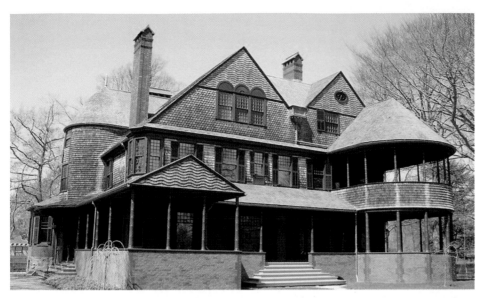

The Issac Bell House in Newport, designed by the pominent architectural firm McKim, Mead, and White, was on of the first Shingle Style houses. Isaac Bell House, Newport, Rhode Island. McKim, Mead, and White, 1883. Elizabeth Greene.

Left: A detail of the seaside ornament on the Isaac Bell house. Elizabeth Greene. *Right:* Advertisement for children's toys for Christmas shows the extent to which manufactured items were available as consumer culture and the cult of Christmas had already arrived in the late 1890s. Courtesy of the Library of Congress.

This building exudes the elements common to the High Victorian Gothic: pointed Gothic arched windows and polychromy (many colored designs in the facade). Courtesy of the Library of Congress.

The picturesque quality of this Currier and Ives lithograph depicts the landscape in a romanticized style. Courtesy of the Library of Congress.

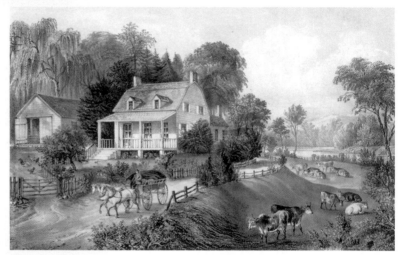

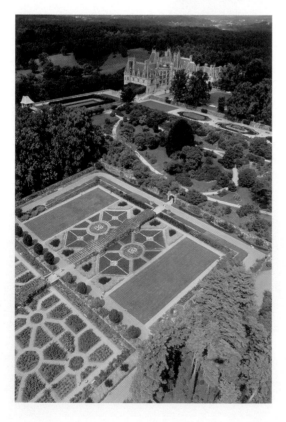

Aerial of gardens at Biltmore estate, exemplifying the geometric style of gardening. Richard A. Cooke/Corbis.

PART THREE

Homes in the Gilded Era, 1881–1900

Elizabeth B. Greene

Introductory Note

As the first writer contracted to participate in *The Greenwood Encyclopedia of Homes through American History* set, I was faced with the felicitous dilemma of which era to select. The period around the turn of the twentieth century intrigued me, because it was characterized by revolutionary changes in technology and in society itself. The arts also saw transformational change, as the flamboyance of the Victorian age precipitated a backlash to it that gave birth to the restrained style of the modern era after 1900. Faced with the option of writing about the decades either before the turn of the century or after, I chose the years 1881–1900, for they acted as the genesis for the twentieth-century transformational changes. Life was in flux for these late nineteenth-century Americans, who were delighted by these developments and disquieted by them as well.

CONTENT AND ARRANGEMENT

There are six chapters, each dwelling on a different aspect of domestic design within the social context. "Historical and Cultural Issues in the Gilded Age" examines the state of American society during these years. Several devastating panics and economic depressions occurred during this era, sandwiched by enormous periods of growth occurring in between. The influx of unschooled immigrants from Europe swelled the new factories, which were producing goods that could be shipped throughout the country on the expanding railroad systems. Corporations emerged as the new business model, allowing investors to make money simply by investing in shares. The wealth created in this corporate culture bred a new moneyed class who were fascinated by European, especially Renaissance, art. That, coupled with a newfound historical interest

in the American Colonial period, engendered an artistic movement called the American Renaissance. The wide-ranging drive toward professionalism affected the architectural profession, as the first architectural schools opened in the United States. A competing development was the popularity of constructing houses according to plans published in magazines and journals.

"Styles of Domestic Architecture around the Country" examines the differing styles of houses encountered in the various regions of the country. Regional differences were beginning to fade at this time, because of the nationalization of corporations and factories, and the newfound ability to ship goods by rail throughout the states. Styles of ornament were standardizing, though areas of the country still depended somewhat on local available resources for building materials. There were many styles of houses during this period, though most displayed a variety of dominant characteristics, for instance the so-called gingerbread ornament ubiquitous on Victorian houses.

Building materials and manufacturing are discussed in the third chapter. The house of the Gilded Era was a conglomeration of new technologies and old traditions. Although indoor plumbing was available at this time, reliable city water and sewer systems often were not. Families installed water and waste systems in their houses using jury-rigged methods that were not hygienic and that hatched a sanitation movement. New methods of construction, specifically the balloon frame, helped the industry build lighter frames more rapidly, which aided the craze for grandiosity and opulence in the middle-class house. Other technologies, such as electricity and central heat, were making their way into the upper-class house, though the universality of these advancements would not be achieved until after the turn of the twentieth century.

Home layout and design is the topic of the fourth chapter of this section, in which the changing layout of the typical house during the Gilded Era is discussed. With the availability of goods and materials, houses grew bigger and rooms more specialized. The glorification of the home spawned the so-called cult of domesticity. The end of the century saw a growing preoccupation with the colonial past, and, with the declining use of domestic servants, a much more simplified layout and a smaller house was born. The nondetached house was manifest at both ends of society as the wretched poor survived in tiny, dark tenement apartments and the super rich luxuriated in lavish "French Flats."

The fifth chapter analyzes the furniture and decoration of the Gilded Era. "Conspicuous consumption" was the battle cry of the period, as burgeoning manufacturing industries convinced families that they just had to purchase the very best knickknacks that boasted of their newfound consuming capacity. Multiple new decorative techniques were available now, and everyone wanted to use them. Furniture was ornate but uncomfortable. Not until the turn of the century did the influence of the Arts and Crafts movement lead to a simplification of furniture design.

What was outside of the house and the development of suburbs are reviewed in the final chapter, "Landscaping and Outbuildings." The persistence of an American disregard for urban culture began with Thomas Jefferson and continues today. Streetcar suburbs developed during the Gilded Era, as middle-class families with city jobs relocated to new suburbs where they were able to purchase detached houses and commute to work by streetcar, either horse-

drawn or electric. Gardens were very popular at this time, and lawns made their appearance after the invention of the mechanical lawn mower.

This part ends with a glossary of terms related to home building, design, architecture, social issues, and events of the Gilded Age. An extensive guide to resources follows, featuring a selected list of sources on the period, including books, articles, videos, and Web sites. The volume concludes with a comprehensive index to the three eras covered: *Homes in the Revival Era, 1821–1860; Homes in the Civil War and Reconstruction Era, 1861–1880; and Homes in the Gilded Era 1881–1900.*

HOME LIFE IN THE GILDED AGE

This section of the volume includes discussion about the way families lived in the houses of this time period. As the name suggests, the Gilded Age was a period of robber barons, but it also included significant numbers of destitute poor, many of whom were immigrants. Not so well-known is the fact that it was also the period of the largest growth of the middle class. A modern cohort of bureaucrats, clerks, and a new group of professionals sought out single-family houses for their families on the outskirts of the cities. These close-in suburbs are often the locales of the typical Victorian house, the ubiquitous rambling Queen Anne's, which have either disappeared, or perhaps have been restored and turned into the town's funeral home.

Though reviled for many years in the twentieth century, the Victorian houses of the late nineteenth century have now become some of the beloved restorations that have breathed new life into historic restored towns such as Cape May, New Jersey. They tell a story of a life that was changing by the year but is now gone. Look at the houses of 1881 to 1900: Though they have some of the features now seen in a contemporary house, many of the room types and virtually all of the furniture is extinct. Large front halls, parlors, conservatories, libraries, and nurseries all went away after the turn of the century. The huge furniture pieces with their very specific uses also disappeared. With the loss of the household servant staff, houses became much simpler, with doors opening directly into the living room, and furniture placement altered to utilize the installation of electric outlets on the wall. Houses built after the turn of the century had living rooms, bathrooms, modern kitchens, and many fewer rooms. The reaction to the ornament of the Victorian age and the embrace of the historic colonial past of the United States made the design of the subsequent time period paler, simpler, and less pretentious.

The years 1881–1900 were the end of an era as well as the beginning of one. The nation changed permanently after the turn of the century led to the First World War. In many ways, the era can be considered quaint in today's eyes, though it was considered modern to contemporary eyes. It was the last throes of servant society.

ACKNOWLEDGMENTS

In helping me write this book, I'd like to thank my wonderful and patient husband, George Concepcion, who always was encouraging me in my venture; my son, Chris, who had never-ending pride in his mother and the family's "first

book"; and my parents, Brad and Mary Greene, who had memories of growing up in the old houses built in the Gilded Age. My friend and colleague Ralph Giordano was my contact with Greenwood Press and my mentor in the historical writing process. He gave endless encouragement and advice, and I owe my utter thanks to him for his help.

Timeline

1877–1881 President: Rutherford B. Hayes (Republican).

1881–1885 President: Chester Arthur (Republican).

1881 Using a $15,000 grant from Congress, Clara Barton founds the American Association of the Red Cross in order to research data regarding 22,000 Union soldiers.

1881 George Pullman begins building factory town outside of Chicago where employees of the Pullman Palace Car Company live.

1883 Pendleton Civil Service Reform Act is passed, setting up federal service guidelines for hiring and promotion based on merit instead of political appointment.

1884 New York's Dakota Apartment House opens on Central Park West, designed by Henry Hardenbergh, and contains nine elevators and luxury apartments.

1885–1889 President: Grover Cleveland (Democrat).

1885 Home Insurance Building, designed by William Jenney in Chicago, considered first skyscraper though it is only 10 stories high, because it has a partially steel frame.

1886 Protest for establishment of an eight-hour work day results in the Haymarket Square riot that kills 11 people and delays the movement for an eight-hour work day for years.

1886 Geronimo surrenders after 15 years.

1887	H. H. Richardson designs the Glessner House in Chicago; this unusual house has no front lawn and is totally turned inward toward the interior garden.
1889–1893	President: Benjamin Harrison (Republican).
1889	Jane Addams opens Hull House in Chicago to provide social services to poor immigrants.
	Singer introduces first electric sewing machine.
1890	Wainwright Building designed by Louis Sullivan is completed in St. Louis; the 17-story Auditorium Building in Chicago, also by Sullivan, is also completed.
	Jacob Riis publishes *How the Other Half Lives* depicting the sorry living conditions of immigrants in New York City in text and photos.
	AFL founded by Samuel Gompers.
	Sherman Antitrust Act passed, first American antitrust law, limited monopolies.
	Massacre at Wounded Knee, South Dakota.
1891	Jim Crow laws enacted in Alabama, Arkansas, Georgia, and Tennessee. Florida already has Jim Crow law, enacted in 1887.
1892	Strikers at Carnegie Steel Mill kill 10 Pinkerton guards.
	In reaction to lynchings in Memphis, Ida B. Wells starts boycott of white businesses and encourages over 6,000 African American Memphis residents to relocate to the Oklahoma territory, also published pamphlet "Southern Horrors: Lynch Law in all its Phases."
1893	World's Columbian Exposition, Chicago, where 700,000 visited, seeing extensive use of electric light, also called "The White City."
1893–1897	President: Grover Cleveland (Democrat).
1893	Economic depression due to a run on the gold supply leads to bank failures, bankruptcies, and high unemployment.
1894	Strike at the Pullman Palace Car Co., Pullman Illinois, in reaction to a huge wage reduction; ended badly with the sending in of U.S. Army troops by President Grover Cleveland.
1895	Boston Public Library opens on Copley Square, designed by McKim, Mead, and White.
1895	William Vanderbilt has a ball to celebrate the 18th birthday of his daughter in his $11 million cottage Marble House in Newport, Rhode Island.
1897–1901	President: William McKinley (Republican).
1898–1902	Cuba occupied (Spanish American War).
1898	Hawaii annexed.

1899 Guam, Philippines, and Puerto Rico annexed.

John Dewey publishes *The School and Society,* pioneering the idea of progressive education.

Thorstein Veblen publishes *The Theory of the Leisure Class,* introducing the modern concept of conspicuous consumption.

1900 American Samoa annexed.

Frank Baum writes *The Wonderful Wizard of Oz.*

Historical and Cultural Issues
in the Gilded Age

HISTORICAL BACKGROUND

The era between the country's centennial until the First World War was a period of transformation. In fact, society itself was transformed. The United States went from being a series of "island communities" to being a broad nation governed by a strong federal government (Wiebe 1967, xiii). These changes occurred because of the technological advances that shattered the isolation of the island communities as a rapidly increasing number of residents relocated to the cities and communication and travel was facilitated. In the 1870s the nation was still primarily rural, and life revolved around a community surrounded by farms, where townspeople knew each other and businesses were run by and for the people in the community. Government was not a strong influence, and the general populace didn't expect it to be. Small towns had their precepts and values; the citizens had their ideas of right and wrong. Generally the residents of the town or village knew their place in the primarily homogeneous Protestant Anglo-Saxon American society. However, by the late century, increased access to education led to a development of a large new middle class. A new cohort of middle management bureaucrats and clerks working for the new corporations pushed out the mom and pop small businesses that had populated the former island communities. Also, the understanding that the frontier was at long last closed, proclaimed by Frederick Jackson Turner in 1893 in a speech at the World's Columbian Exposition, engendered a fear of losing the release valve that the constant reality of the frontier presented.

Economic growth in the last two decades of the nineteenth century led to an upwardly mobile population for all classes. Even the poorest slum-dwellers

were better off than they were in their hometowns in Europe. These immigrants were able to eventually work their way up as newer and more desperate immigrants replaced them. As more and more immigrants came into the United States as the century came to a close, the newest immigrants took the poorest-paying jobs, while the groups that were already working were able to move up. As the immigrants worked their way up the economic ladder, they were able to purchase houses in the newly constructed streetcar suburbs in the areas surrounding the teeming urban core. The other classes of society also moved up economically. A mere 300 to 400 individual Americans were considered millionaires before the Civil War. Most of these fortunes were made through slaveholding, and most of it was lost after the war. By 1892, the *New York Tribune Monthly* cited 4,047 millionaires in the United States. Most of these fortunes were made in real estate, demonstrating the growing amount of wealth and its new provenance (Ginger 1975, 97). Unsurprisingly, the richest members of society made the most money during the Gilded Era. For example, Cornelius Vanderbilt had a net worth of $100 million at his death in 1877. In 1884, even after one of the economic downturns of the period, his son, William, who inherited the money, increased his fortune to $200 million.

Economic Panics and the Railroad Industry

The influx of immigrants in the last two decades of the nineteenth century was influenced by the growth of industry and work available and also by the inexorable advance of the railroads into the heart of the nation. In 1877, the Union Pacific–Central Pacific was the only railroad to span from East to West Coast. In 1882, the Southern Pacific had run its railroad from San Francisco to New Orleans. By 1893, both the Northern Pacific and the Great Northern had trains running to the West Coast. The decade of the 1880s saw the fastest growth of the railroad industry, with the miles of track in the United States doubling between 1877 and 1892 (Ginger 1975, 38).

The first decades of the railroads in the United States were plagued by the predicament that all of the lines were built by private investment for individual interests, and there was no federal regulation. Therefore, what were built most often in the early years were short lines connecting suburban developments with large cities. Each rail line built the tracks with differing distances between the rails, which meant that the lines could not be connected. The freight had to be carried off the train and loaded onto another train, which made it extremely expensive and inefficient. The first transcontinental railroad was built at a standard gauge, due to the insistence of eastern investors. By 1880, most of the lines had the standard gauge, except for the southeastern region, which was not standardized until 1886.

In the late nineteenth century, economic growth did not occur in a straight upward procession. There was a distinct cycle of expansion and recession. For example, the huge depression of 1873 stopped the growth of the railroads in its tracks. In fact, the railroad industry was the trigger for the ups and downs of the market. The industry was controlled by a number of tycoons who had made their money in industries before the arrival of the railroads but invested it in the railroads when the opportunity arose. These men, Vanderbilt, Jay Gould, and Henry Villard, among others, fought among themselves for control of the

railroads sprouting west because they knew it would lead to infinite riches as the lands became developed. The depression of 1873 was caused by one of the railroad companies that tried to float bonds to build additional track but could not do so because of defaults of other railroad companies. When the company could not pay their depositors, other banks panicked, and a series of banks failed. This led to businesses not being able to pay their workers, and the workers were laid off. The 1873 depression was the longest economic contraction in U.S. history and lasted until 1879. The turning point for the country to rebound occurred in 1879 as it returned to the gold standard. As prices fell in the United States, more goods were sold domestically and exported. Weather was good, and farm production was ample. Railroad construction rebounded, and many lines were completed.

The depression of the 1870s brought an abrupt halt to the *establishment* culture of rural society. Government, which was seen as responsible for the failure of Reconstruction, was now seen as the group of rogues who produced the depression of 1873 and, as a result, the lack of public morality (Wiebe 1967, 6). The railroads, which were becoming the lifeblood of the economic and business societies, were hit by a strike in 1877. This became the first national strike, spreading from Philadelphia to San Francisco where strikers went downtown to riot and loot. They were in fact, a group of workers, joined by a crowd of slum dwellers who took advantage of the chaos to create havoc. But it was the first instance of the nation waking up to a community knitted together by railroads and no longer an accumulation of rural communities.

Another downturn took place in 1887 and slowed down construction and expansion for a year. The economy continued to swing back and forth, with

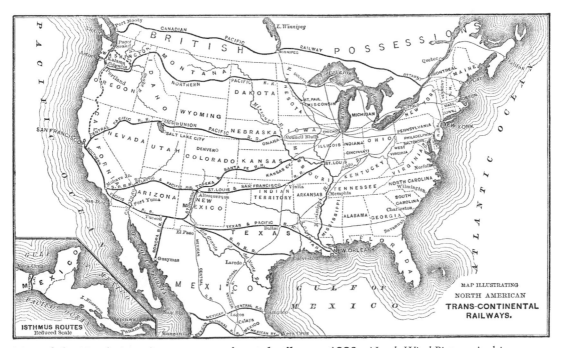

Map of the North American transcontinental railways, 1880s. North Wind Picture Archives.

cycles of expansion and recession, until another huge economic panic took place in 1893. This panic was the worst yet in American history. The subsequent depression lasted until 1897. During this period, many smaller companies were forced to close or were bought out by the largest corporations, leading to consolidation of the market. The beneficiaries of this depression were the richest corporations, as the Rockefellers, Carnegies, and J. P. Morgans of the world increased their wealth and influence. Workers struck all over the country, but the corporations clamped down, and the government and the courts did not favor the workers. The labor movement and the push for the eight-hour work day lost influence until the Progressives gained power at the turn of the twentieth century.

Immigration and the Movement of the Population

The worker in the last two decades of the century was no longer the English, Welsh, or German artisan of the previous decades. Whereas these earlier workers were usually trained in their home countries in their trade and were familiar with trade union practices, the new immigrant workers were most often rural workers who were not familiar with industrial work. In addition, the older immigrants often relocated to this country for political reasons and were not destitute. They were also more educated. The new worker in the 1880s and 1890s came from impoverished circumstances, had never worked in a factory, and had no knowledge of unions or workers' rights. Between 1870 until the 1920s, one out of three industrial workers was an immigrant. Immigrants migrated to urban ethnic districts and survived in terrible living conditions. As the cities grew, the urban slums were crowded with foreign-born immigrants. American middle-class society, alarmed by the transformation of the world they were familiar with, saw the immigrant worker as a threat. The manual laborer was portrayed in newspapers and magazines as a foreigner, with a very foreign culture: frightening, foreign, dirty, not sharing our values, dark, Roman Catholic Papists, and not like us. These were the middle-class views of the immigrant population at this time.

The middle class had a strong influence on society in the period of 1880–1900. There were assorted members of the middle class, including a number of new members. In addition to the typical member of the middle class of the early industrial age, who was a doctor, lawyer, or other professional and educated worker, there were new constituents of this class. These workers were office staff, people who were employed by the gargantuan corporations as well as

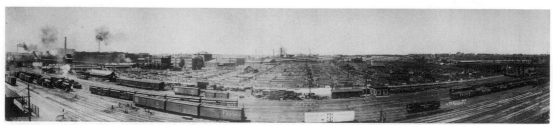

The stockyards of the Midwest provided food for the nation by utilizing the new transcontinental railroads. Courtesy of the Library of Congress.

the smaller manufacturing businesses. They were salesmen, accountants, and managers. The growth of government gave jobs to many new civil servants as well, who also constituted a new segment of the middle class.

The country was industrializing. As immigrants were coming from northern Europe and traveling by train to the northern Midwest, large farms were settled that produced grain at record levels. The farm was becoming mechanized with the new farm machinery available. Whereas it took approximately 61 hours to produce one acre of grain before the Civil War, in the 1890s it took only 3 hours and 19 minutes (Ginger 1975, 39). The flat land of the prairie made it much easier to farm with the new farm machinery available. On the other hand, the East Coast, with the hilly, rocky terrain, lost out to the Midwest as determined farmers relocated there and others changed careers. The only farms remaining on the East Coast were dairy and fruit farms. Because of the new railroad system, grain could be transported to the growing industrial cities on the East Coast. More and more industrial and farm products were being transported throughout the country as regions began to specialize in a certain product. In New England, the number of farmers stayed constant in the years 1880–1890, while the number of workers in manufacturing, trade, and transportation expanded. The same held true for the state of Illinois, which was also becoming a manufacturing state. The states of Kansas, Nebraska, South Dakota, and North Dakota became the country's breadbasket.

As the construction of the railroads wound down in the last decade of the century, the building construction industry exploded. As cities grew in density and buildings grew higher, steel was required in greater quantities. Especially in cities such as New York and Chicago, buildings were being built with elevators and fireproof construction, which required steel. Andrew Carnegie realized that the growth industry would be in structural steel. He retooled his largest (and the nation's largest) steel mill, in Homestead, Pennsylvania, to manufacture structural steel instead of iron rails. As a result, the production of steel burgeoned in the years between 1880 and 1900.

Corporations

The transformation of American society that occurred during the Gilded Age was primarily caused by the growth of the corporation, and with it the

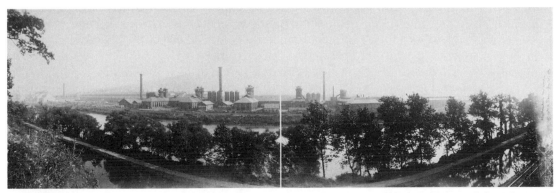

The steel companies were the largest and most powerful corporations. Courtesy of the Library of Congress.

huge factory. The word *corporation* is created from the Latin word *corpus,* which means body. The term refers to a body of individuals sharing the same purpose with a shared name. Through legislative mandate, governments created the first corporations for the purpose of serving the public good. The government would produce a corporate charter solely for companies that were recognized as crucial to the successful growth of urban areas or of trade. The first corporate charters were for the creation of corporations that did business in insurance, banks, and transportation-related companies (Trachtenberg 1982, 6). These corporations were in fact, quasi-government institutions, not unlike the Port Authority of New York and New Jersey, which was created in the mid-twentieth century to manage transportation in urban areas today. The earliest corporations were partly funded by government bonds and partly by private investment. In the United States after the Civil War, courts began to relax laws on the formation of corporations. As the economy became nationalized and large amounts of capital were required in order to fund rising companies, states relaxed rules for the formation of corporate entities.

Corporations were advantageous to the economy in the late nineteenth century for several reasons. Because the nation's economy was expanding rapidly and the supply of money was unstable, funds had to somehow be combined from various sources in order to create an entity that could operate under one name. Unlike the older versions of businesses, the sole propriety or partnership, corporations allowed individuals to invest resources into an entity that would operate as an individual, limiting liability for corporate debt of the investors. Having centralized control, with investors having little influence in the decisions of the corporation, corporate boards were free to create efficiencies such as vertical integration. Also, technology was allowing manufacturing to produce goods faster and more efficiently. The burgeoning influx of immigrants from Europe made certain industries especially important, for instance the Singer Sewing Machine Co., which sold 1,700 sewing machines per day in 1881 (Ginger 1975, 47). Singer later built the tallest building in the world, in 1908, in New York City.

In order to produce the high volume of products demanded by society at the time, companies expanded their plants to become more efficient. As a rule, large companies are more efficient than small ones because of economies of scale. The large company can purchase more raw materials at lower prices by negotiating with the suppliers. (A present-day example of the phenomenon is the behemoth Wal-Mart, the largest corporation in the world. Their managers bargain with their suppliers unmercifully until they get the lowest price, which they then are able to pass on to the customer.)

Companies in the Gilded Age era suffered from the loss in profits due to several terrible and lengthy recessions as well as growing competition from new companies. Because their fixed costs or overhead (the investments in the infrastructure of the factories, equipment, and machinery) did not change no matter how much demand there was, the company was forced to cut prices and take losses. Control of supplies became a necessity for the companies who were suffering from the high costs of overhead. A strategy that the companies came up with was vertical integration. Thus, in order to control the costs of supplies as well as of distribution, the company purchased other companies that provided those services. Steel and oil companies at this time used this strategy.

A series of railroad strikes and economic depressions led to the consolidation of the corporate giants. Courtesy of the Library of Congress.

Other companies tried the strategy of horizontal integration by buying up direct competitors, but these were far less successful and suffered even more severely during the recessions because the merged companies were competing with each other for the same smaller resources.

Government was also expanding in power as regulation became more necessary in order to control the power of the corporate interests. Small towns, with the associated feeling of connection to the producer of the goods one bought, gave way to suburbs. In the suburb, the family bought items produced elsewhere, by faceless corporations. The housewife no longer recognized the owner of the shop or the maker of the product. Department stores sold items produced all over the country, or even imported from foreign lands. Though the corporate culture became even more pervasive in the twentieth century, the end of the nineteenth century saw the first huge change in culture and economics. Products were now manufactured in large factories and distributed throughout the country. Families shopped in department stores or selected from a huge choice of products in a catalog. Men worked in offices of big companies instead of for small town privately owned businesses.

Conditions of the Workers

The growth of corporations and huge factories gave many industrial workers employment. Because of the ups and downs of the economy, workers found themselves losing wages and hours and were getting weary of it. The year 1886 was called the year of the "great upheaval," because 700,000 workers went out on strike during that year. The major issue of the time was the eight-hour work day. A nationwide strike was planned for May 1 to demand an eight-hour work day law. Though the strike did not bring out as many nationwide protesters as

were expected, the aftermath of the protest in Chicago became the most famous labor event of the time. After the police killed four strikers on May 1 in Chicago, a rally was planned on May 4. During the protest, a bomb was thrown, killing a policeman. A riot ensued, where seven more policemen and four civilians were killed. Eight anarchists were arrested, and four were executed, although the actual bomb-thrower was never identified. This infamous "Haymarket Riot" led to a nationwide Red scare, as fear of anarchists and communists pervaded the country. The movement for the eight-hour work day was severely damaged. When the panic of 1893 occurred, many more strikes took place.

The conditions of the workers in these years were abysmal. The continuing strikes put on by the workers were caused by the growing frustration felt by the workers for the years of exploitation by increasingly powerful industrialists. As the economy rocketed between expansion and severe depression, factory owners felt no hesitation in cutting wages, increasing hours, and demanding faster output. Workers were paid extremely low wages. Only 45 percent received more than the poverty level of $500 per year. Forty percent lived below the poverty line and depended on other members of the family to augment their income. Only 15 percent of workers, the highly skilled ones, earned the more livable wage of $800–$1,500 per year. In addition, bosses laid off workers whenever the economy took a downturn, leading to unemployment rates of up to 16 percent (Trachtenberg 1982, 91).

Violence erupted in 1886, the year dubbed "the great upheaval." Courtesy of the Library of Congress.

AN AMERICAN RENAISSANCE

The growth of the nation saw an associated heightening of a hunger for an American culture. Because the United States was growing in size, wealth, and power, the ambitious nation desired an artistic culture to match. Typical for a culture that was suffering from an inferiority complex, the United States began looking elsewhere for its artistic influences. The English Victorian belief in the importance of moral values also had a friend in the United States, where art was expected to portray a moral superiority. Another factor was that the profits made by the industrialists had to be spent on something, and they naturally turned toward Europe for inspiration. Similarly, three hundred years prior, the famous d'Este and Medici families of Italy in the sixteenth century had invested their merchant-created cash in huge estates, painting, and sculpture as they became some of the most remarkable patrons of the arts.

Europeans, who criticized the United States for not having a tradition of art and high culture, exacerbated the inferiority complex suffered by Americans. As the United States became richer and more populated, the idea of art as a crucial aspect of the growth of a genteel culture grew in value, especially for the wealthy and educated. Mathew Arnold, British poet and cultural critic, wrote of the American society in 1888: "Do not tell me only of the magnitude of your industry and commerce; of the beneficence of your institutions, your freedom, your equality; of the great and growing number of your churches and schools, libraries and newspapers; tell me also if your civilization—which is the great name you give to all this development—tell me if your civilization is *interesting*" (Wilson, Pilgrim, and Murray 1979, 29). In this period, the creation of a body

Louis Comfort Tiffany was a member of the group of artists who are now known for the American Renaissance. Courtesy of the Library of Congress.

of art was seen as a way to make the civilization interesting as well as to bring moral uplift to society. The concept of the ideal in art was also an objective. In order to obtain the ideal in art and architecture, the past must be thoroughly studied, according to these cultural critics. Therefore, the study of the past in architecture became essential to the furtherance of American culture and society. Trained architects typically traveled to Paris to study at the École des Beaux-Arts, immersing themselves in the traditions of Renaissance and Gothic design.

Other fields of artistic endeavor also looked to the historical traditions, with artists and sculptors portraying historical or contemporary figures as abstract allegories portrayed as a symbol of a virtue, such as "truth" or "the state" (Wilson, Pilgrim, and Murray 1979). There were multitudes of wings, draped garments, shields, or other allegorical symbols on portraits of contemporary figures. Life as portrayed by these artists was totally idealized, even if presented in contemporary dress and surroundings. (As a reaction to the late nineteenth-century American Renaissance portrayal of life, the Ashcan School of the early twentieth century portrayed the seedier side of urban life in dark colors and mood, rejecting the idealism of the earlier period.) With wealth in the last decades of the nineteenth century came a cosmopolitanism that sought out European culture, as well as other more exotic cultures. The British Victorian culture, as well as the American, embraced the discovery of Japanese and Middle Eastern art and culture.

The Renaissance was rediscovered by American artists in the late nineteenth century, but the centennial of the American nation led to a rediscovery of America's colonial past as well. The popularity of the old style came about because the cultured citizens of America worried that the nation had no cultural history. Nationalism was growing in the United States, and society searched for an artistic tradition to address. The Centennial Exhibition in Philadelphia displayed many examples of seventeenth- and eighteenth-century American culture that were readily embraced by a ravenous American society. The appeal of the Colonial and Federal styles of architecture was also influenced by the interest in Renaissance art, because Georgian, Federal, and Greek Revival styles were all classical in concept and also heavily influenced by classical Renaissance design.

European-trained architects, landscape architects, artists, and artisans of the Gilded Age were typically cross-trained and practiced several disciplines, not unlike their sixteenth-century European predecessors. They, therefore, could consider themselves "Renaissance people." In addition to being based on European models, the American Renaissance was a nationalistic movement. The concept was to utilize European-inspired styles and techniques to portray the progress of American society. Society was proud of its Renaissance men: Henry Adams, famous contemporary historian and intellectual, stated at the World's Columbian Exposition in Chicago in 1893 that people would "talk about Hunt and Richardson, La Farge and St. Gaudens, Burnham and McKim and Stanford White when their politicians and millionaires were otherwise forgotten" (Wilson, Pilgrim, and Murray 1979, 7). Surprisingly, however, while the Astors, Rockefellers, Carnegie, and Teddy Roosevelt were never forgotten, many of the most renowned architects and artists of the late nineteenth century were cast aside with the beginnings of the modernist movements after the turn of the twentieth century. This has now changed since their rediscovery at the end of the twentieth century.

The American Renaissance developed as the United States was becoming an imperial power, and this power was portrayed in the art and architecture of the period. American industrialists and their designers considered it no blunder to purchase European artwork and install it in American buildings. America was the new superpower, and the display of art from the declining powers only proved its economic provenance.

DEVELOPMENT OF STANDARDS IN THE ARCHITECTURAL PROFESSION

A significant development of the late nineteenth century in the United States was the introduction of architecture as a profession. Up until that time there were two types of designers for homes and commercial buildings. First, there was a cadre of builders and carpenters, not professionally trained, who were responsible for the construction of the multitude of new houses necessitated by the population surge in the nineteenth century throughout the United States. In addition, so-called architects who had been trained as apprentices for master architects designed houses for wealthy clients. Most of the architects who practiced up until the end of the nineteenth century were not trained in architectural schools but were trained by other architects in their offices and through experience (Hull 1993, 281). The student would enter the firm and begin by observing the master and copying the

> **In History: The World's Columbian Exposition of 1893 and the City Beautiful Movement**
>
> The City Beautiful movement at the turn of the century was based on the Beaux-Arts principles that were taught at the École des Beaux-Arts in Paris. Reform-minded cities, encouraged by the Progressive movement, set up planning commissions to develop grand civic areas in downtowns that brought beauty and order to the city. The reforms included formal planning of streets and regulating spatial relationships between buildings. The World's Columbian Exposition in Chicago in 1893 was the first major example of the technique. Cities such as Cleveland, Philadelphia, and Washington, D.C. used Beaux-Arts planning for their urban centers. Many planned suburbs followed aspects of the Beaux-Arts teachings, such as grand boulevards with large houses and city parks (McAlester and McAlester 2000).
>
> The World's Columbian Exposition, with its so-called White City in Chicago, was extraordinarily successful in presenting a new and modern look at the United States. The buildings were designed by the premier architects of the period, mostly in the Beaux-Arts style. The exposition was lit with electric lights and showed the average American what electricity could do. New products, such as Pabst Blue Ribbon beer and Cream of Wheat, were introduced there, as was the Pledge of Allegiance. The Exposition, though only open for six months, had over 26 million visitors, and many more were aware of it. Hundreds of photographs were taken of the fair, which are available today. The Exposition was torn down after the six months was up, and all that remains now are the historical photographs and two original buildings. The World's Columbian Exposition, however, led to a number of later world's fairs, for instance the St. Louis World's Fair in 1901 and the Pan-Pacific Exposition in San Francisco in 1915.

drawings. He, (it was almost exclusively a male profession) would subsequently be trained to supervise construction of the firm's commissions and generally proceed from being the apprentice to the master himself. These arrangements were called *ateliers,* the French word for workshop or studio. The first modern architectural office was that of Richard Upjohn, a well-known Gothic Revival architect, who opened a firm that employed seven draftsmen, a business manager, and two junior partners as early as the 1850s (Hull 1993, 281). The partners also were under contract for certain duties and for their share of the profits. Upjohn encouraged the professionalization of the architect as well as the requirements of professional ethics standards.

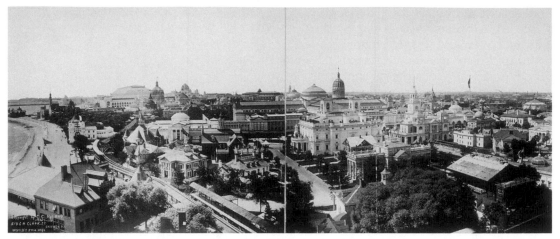

A general view of the World's Columbian Exposition of 1893. Courtesy of the Library of Congress.

Upjohn assembled 12 other architects in 1857 in order to launch an organization that would "promote the scientific and practical perfection of its members" and "elevate the standing of the profession." By 1858, the group was enlarged, the name cemented as the American Institute of Architects (AIA), and the mission of the organization modified to say: "The objects of this Institute are to unite in fellowship the Architects of this continent, and to combine their efforts so as to promote the artistic, scientific, and practical efficiency of the profession." By 1887, the AIA had chapters in Philadelphia, Chicago, Cincinnati, Boston, Baltimore, Albany, Providence, San Francisco, St. Louis, Indianapolis, and Washington, D.C. A rival organization, the Western Association of Architects (WAA), was created in Chicago in 1884. Architects of Chicago considered New York and northeastern architects, in general, elitist and arrogant. But in 1889, the two organizations were able to reconcile their differences and merged. Louise Blanchard Bethune became a member of both the WAA and the AIA and thus became the first woman member of the professional organization in the United States, in 1886. The AIA relocated to Washington, D.C. in 1898 in order to have a greater influence on the federal government and, therefore, on the large public building projects constructed at the time (AIA, 2007).

Development of American Architectural Schools

The AIA originally favored the creation of a national school of architecture, similar to the École des Beaux-Arts in Paris. However, the funding did not materialize. As sometimes happens, lack of funding can have historical implications, because what followed was a very different type of professional school system for architects. In 1868, the Massachusetts Institute of Technology (MIT) was the first private university to offer an architectural degree program, set up by William Robert Ware. It was one of the Institute's five original departments, along with civil engineering, mechanical engineering, mining and geology, and chemistry. Ware was the first head of the program and an architect who was known for his design (with Henry Van Brunt) of the Gothic style Memorial

Hall at Harvard. Other private colleges followed suit: Cornell in 1871, The University of Illinois in 1873, Columbia University in 1881, and the primarily African American college Tuskegee Institute in 1881 (AIA). In addition, the Morrill Act of 1862 gave federal land to the states in order to provide sites and funding for new state colleges, which would be dubbed "land grant colleges." Some of these colleges set up architecture and engineering programs, which increased the availability of the profession to the middle class.

The professors at these programs had been either schooled at or had taught at the École des Beaux-Arts in Paris. The École emphasized rational planning and historically accurate details. Architectural theory was taught, and the newly minted professional architects considered theory more important than practical knowledge (Gelernter 1999, 175). Courses were taught in architectural history, construction, physics, and physical geometry. Students also had studio classes, which required them to draw and design under the purview of the demanding professors. Classicism was the order of the day, especially Roman, French, and Italian varieties. As described by Sean Dennis Cashman, the architectural students in these early schools were taught by a very specific method: "The method of design taught in schools entailed three separate activities. In the first stage the student studied a problem and devised a preliminary solution, or parti, in the form of a sketch, or esquisse. If the parti was considered successful, it would be developed in a further sequence of drawings—the second activity. The third activity was the elaboration of the original ideas in drawings revealing elevation, plan, and section. Architectural drawings were the means by which ideas were investigated and made available to patrons and builders. By the time a building was under construction, transfers, also know as blueprints, had been made from the working drawings and given to the construction team" (Cashman 1993, 188). After finishing the college degree program, the student would be required to work under a trained architect. This requirement is still in force, for all graduate architects must work for a licensed architect for a prescribed period in order to get a license themselves.

As professionalization increased, it became progressively more difficult for people to hang out shingles and call themselves architects. The term *architect* was used legally, but indiscriminately, before 1897, when it was no longer allowed, at least in Illinois, which became the first state to pass a licensing law. Because the laws were state requirements, it took 50 years to initiate licensing examinations for all 50 states. Presently, there is a national licensing board, the National Council of Architectural Registration Boards (NCARB), which recommends standards for state testing.

Architectural Journals

By 1890, there were many architectural journals being published in the United States, including three national journals and seven regional publications in Chicago, Minneapolis, San Francisco, Denver, Atlanta, Kansas City, and Syracuse (Woods 1989, 117). The continuing quest for professionalization of architecture was influenced by these publications, which were not aimed at the carpenter or builder, but at the trained architect. The discussions in these periodicals were about architectural theory as opposed to practical ideas on construction techniques. The thinking behind these journals was that the

profession should further organize itself and create a better-trained group of professionals. Architects were attempting to develop formal educational practices, normalize ethical practice (that is, abandon the practice of taking bribes, which was endemic in the field at the time), and set standard fees for the profession. The publications editorialized about these issues. Strangely enough, in the early architectural journals, the emphasis was not on criticism of differing architectural styles, but on pragmatism, on furthering the profession, and helping prominent architects' careers.

The first successful journal appealing to professional architects was the *American Architect and Building News* first published weekly in Boston in 1876 and continuing publication until 1938. Its most important contributor was William Robert Ware, the founder of the architecture program at MIT. The journal was full of illustrations, which were the favored parts of the magazine. The editorials mandated the following: professional and public education, study abroad, sharp distinctions between architects and builders, competition reform, state licensing and registration, and the use of private architects for government commissions. The editors also claimed that only training and group action as a profession would improve architectural design in the United States (Woods 1989, 135). The group of professionals who dominated the *American Architect and Building News* was primarily from New York and Boston. They encouraged formal training, study abroad, and AIA membership. The journal, published weekly and lavishly illustrated, had a huge impact on architecture of the period. The architectural style of H. H. Richardson, dubbed the Richardsonian Romanesque, was frequently published by the *News* and consequently became extremely popular around the country even after the architect's untimely death in 1886. This led to a backlash from the midwestern and western states, where there was a thriving construction business and a growing architectural

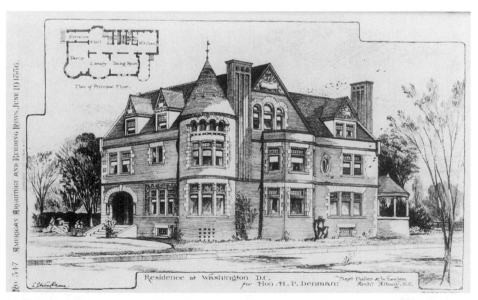

A drawing of a house in Washington was featured in the June 19, 1886 issue of the *American Architect and Building News*. Courtesy of the Library of Congress.

profession. Chicago architects published a rival publication *The Inland Architect* from 1883–1908. Other regional publications were created in the 1880s and 1890s, for instance, *California Architect and Building News* and *Architectural Record,* a monthly journal of architectural criticism that was launched in 1891 and continues publication today (Woods 1989, 138).

Architect vs. Plan Books for Home Design

Although much less publicized in the written record, the enduring influence on home design in the late nineteenth century was not the professional architect and the professional architect's publications, but a cheap and ubiquitous type of publication called the mail-order plan book. It was true that individual professional architects were organizing and were successfully attempting to create a professional organization and licensing and ethics requirements, but they were losing the battle for the hearts of the middle-class homeowner. Most families in the burgeoning middle class of the 1880s and 1890s were not wealthy clients who had the wherewithal to engage a professional architect. The middle class was looking for a way to gain status, build an attractive house on a small lot, and pay as little as possible for it. The mail-order plan book publications provided a means to that end.

The United States was growing substantially in the last two decades of the century, and homes were being built everywhere. In the pre–Civil War years, publications by Andrew Jackson Downing, Calvert Vaux, Gervase Wheeler, and others had enormous influence on the design of single-family houses, which were most often built by carpenters. Individuals hired a carpenter to build the

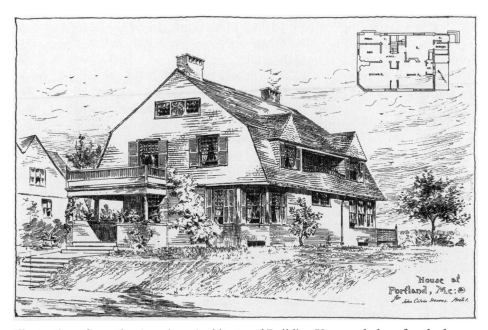

Illustrations from the *American Architect and Building News* and plans for the house done by the HABS survey for an 1884 house in Maine. Courtesy of the Library of Congress.

house, often requesting to follow a certain theme either from another house in town or from a pattern book. Most often, however, the house was not an exact copy of the pattern book but a loose interpretation, depending on the wealth and needs of the client. The books produced by Downing and others were primarily intended to influence design. They had a didactic purpose; they were attempting to influence the taste of the homeowner (Garvin 1981, 309). Other post–Civil War publications detailed ornaments, for instance mantels, for the individual carpenter, who could therefore become familiar with the prevailing styles.

In the growing suburbs expanding on the edges of the urban areas in the United States, there are examples of every type of architectural design and ornament available at the time. Even today, every small town and older suburb shows evidence of the variety of Victorian houses. As stated by James L. Garvin, "Late nineteenth-century American suburbs often display an amazing inventiveness in their house design rather than the monotony and repetition that one finds in most areas developed within a limited span of time. Moreover, Victorian suburban houses frequently incorporated the aesthetic innovations of leading architects only a few years after these new ideas were introduced" (Garvin 1981, 309). Even high styles like the early Queen Anne and the Shingle style, which were developed by the most famous architects of the day, were seen in small towns where an architect had never met with a client. What led to this explosion of diverse and appealing home design developments? The answer was the proliferation of the plan book, which actually provided complete architectural plans, details, and cost estimates to the prospective homeowner or housing speculator and their carpenter.

After the Civil War, as the country grew ever faster, the pattern book business took a different turn. In 1876, an English carpenter George Palliser and his brother Charles published their first book titled, *Model Homes for the People, A Complete Guide to the Proper and Economical Erection of Buildings*. What made this book extremely popular among the middle and lower middle class was its price. Whereas there were other books on the market, lavishly illustrated, on expensive paper, and selling for up to $10 a copy, this book cost only 25 cents. It was printed on inexpensive paper and contained 22 pages of advertising (Clark 1986, 76). The book was enormously successful, selling thousands of copies. There was a clever gimmick to the book, whereby a potential purchaser could fill out a questionnaire at the back of book and send it in to the Palliser brothers, indicating individual requirements concerning cost, size of property, and requested details. Of course there was a fee, which ranged from 50 cents to $40 for a set of plans, sections, and elevations, depending on the cost of the house. This ability to attain complete working drawings, cost estimates, and specifications became the "architectural innovation of the final quarter of the nineteenth century" (Garvin 1981, 312). The price of the house could range from $3,000 to $7,500. There was another option for the homebuyer, which was the custom-designed house by the Pallisers at a fee of 2 percent of the house's cost, 1.5 percent less than a registered architect would charge. Later books published by the Palliser brothers sold over 50,000 copies. Clark comments, "By combining a wide range of house styles with practical advice on building construction, Palliser proved to be far more influential than professional architects. As 'Every Man a Complete Builder,' the subtitle of one of his popular books suggested, Palliser

democratized the house construction process by arguing that any person with a minimum of professional help could supervise the design and construction of his own house" (Clark 1986, 77).

Palliser wrote advice in his books encouraging his clients to build their own dream house, with remarks such as: "You may be very inexperienced yourself in building, but if so your architect should know enough for both himself and you, and while your busy neighbor may ply you with his wholesale advice, you need not sacrifice yourself to any whims or suggestions he may make. Never mind how much he don't (sic) like your large roof, your gables, or your internal arrangement, if they are what you want; go straight ahead in the path you have marked out" (Clark 1986, 78). By instigating clients to choose their own details and ornamental designs, Palliser did not promote one particular architectural style over another. What was created with the Palliser designs was dubbed by him a "national style," but was in fact an eclectic style, one that included elements of many popular styles of the time.

The success of the Palliser plan books led to other even more successful building plan entrepreneurs. For instance, in 1881, Robert W. Shoppell published *Artistic Modern Houses at Low Cost*. Shoppell set up an architectural office in New York where he employed up to 50 anonymous architects who produced complete sets of drawings, plans, sections and elevations, framing plans, specifications, quantities of materials required, and even a chromolithographed colored sheet suggesting paint colors. The office called itself the Cooperative Building Plan Association. The set of documents, according to Shoppell, cost about one-fifth of the cost of hiring an architect (Garvin 1981, 314). Shoppell expanded his empire by providing additional plan books, a periodical with new plan ideas, advice on financing, and a publication expressly for contractors including data about how costs were calculated and how to include a profit margin. Shoppell included detailed advice for the contractor on presenting the plans and cost estimates to the client. Collections of Shoppell's designs were published in the 1890s classified by cost. The most popular were the homes in the $3,000–$4,000 range (Garvin 1981, 325).

Shoppell standardized the mail-order plan book business, but he was not alone in it. In the 1880s and 1890s, a number of other architects joined the fray, including Frank L. Smith of Boston, who also published a periodical called *Homes of To-Day* that included drawings of " the most desirable designs from . . . [Smith's] practice for the preceding three months" (Garvin 1981, 326). Smith had a very successful practice and was therefore able to provide a large number of diverse designs. The periodical also covered topics such as drainage, heating, plumbing, paint color, wood stains, mantel design, and modern kitchens. Other architects in the plan book field included the National Architects' Union of New York and Philadelphia, who produced eight volumes of designs between 1885 and 1894; David Hopkins, *Houses and Cottages* (1889); Frank P. Allen, *Artistic Dwellings* (1892); and W. K. Johnston, *Modern Homes* (1894). Even Frank Lloyd Wright as a young man worked in a studio that produced standard house plans. The mail-order house plan phenomenon was further refined after the turn of the twentieth century by architects who provided plans and prefabricated houses to the public. At prices ranging from $1,200 to $2,500, merchants such as Sears, Roebuck and Montgomery Ward later sold these houses and house plans (Garvin 1981, 334).

Did you Know? The Study of Material Culture

The study of popular material culture is a fairly recent development, combining various fields including art history, history, sociology, anthropology, psychology, and philosophy. In the past, the study of art history included items considered art by the scholars in the field. Of course, this study focused on the high-end of society and sometimes even excluded many items within that category. For instance, because Gilded Age design went out of fashion after the turn of the twentieth century, the work of even the great architects and designers of the period was scorned as historicist, that is, based on historical precedents, and unoriginal. This teaching continued well past the second half of the twentieth century until the advent of the study of material culture, a multidisciplinary approach that examines the history of how people lived and the material items they used in daily life. While not necessarily considered art by the art historians, the items tell a story that was unavailable to students of the art history field in the past years. The study of material culture is related to the study of archeology, in that the items used by the members of society are studied in order to illustrate their relationship to the way society functioned.

At this time, a student can find a number of books that examine the daily life of a particular culture. But these books primarily date from the last quarter of the twentieth century up until today.

The many houses that can be seen in the United States today dating from this time period show evidence of the eclectic mix of styles. The plan book promoters popularized open plan front halls that were the innovation of the leading architects of the day. Although the Queen Anne was the most popular mode of the period, decorative elements were mixed and combined to produce "little more than assemblages of intricately machined, factory mass-produced ornament" (Clark 1986, 78). Not all critics agree that the homes were a muddle of ornament. In fact, trained architects provided most of the plans, and the styles of the day were promoted. Also, the latest technology was incorporated in these mail-order houses. It became a democratization of architectural design for the ordinary middle-class American. Until recently, students of architectural history were not often taught about these plan book designs, yet they had an enormous influence on the appearance of every American town.

Although stylistic purity was not an objective of the Palliser designs and was not embraced by the middle-class clients, it was, however, a goal of the country's trained architects. The publications mentioned previously, which were produced by the architects of the time, the *American Architect and Building News* and the Chicago version, *Inland Architect,* both lambasted George Palliser and Robert Shoppell, as well as the other pliers of the trade. They were criticized for not being formally trained architects (though they employed them) and for not following any particular style. They also condemned the designs for not being well thought out as to weather and repair issues. As trained architects, they lobbied for the promotion of the aesthetic knowledge and technical expertise that they retained. The plan book writers countered with their own advice on dealing with contractors, builders, and tradesmen. And the middle-class public invariably chose the cheaper and less elitist local carpenter, who, with the help of the plan book, could build a house safely and to the client's specifications at a lower price.

Reference List

American Institute of Architects (AIA). 2007. "History of the American Institute of Architects." Available at: http://www.aia.org/about_history

Cashman, Sean D. 1993. *America in the Gilded Age: From the Death of Lincoln to the Rise of Theodore Roosevelt.* New York: New York University Press.

Clark, Clifford Edward, Jr. 1986. *The American Family Home, 1800–1960.* Chapel Hill: University of North Carolina Press.

Garvin, James L. 1981. "Mail-Order House Plans and American Victorian Architecture." *Winterthur Portfolio* 16(4): 309–334.

Gelernter, Mark. 1999. *A History of American Architecture—Buildings in their Cultural and Technological Context.* Lebanon, NH: University Press of New England.

Ginger, Ray. 1975. *The Age of Excess: The United States from 1877 to 1914.* New York: Macmillan.

Hull, Judith S. 1993. "The 'School of Upjohn': Richard Upjohn's Office." *The Journal of the Society of Architectural Historians* 52(3): 281–306.

McAlester, Virginia, and Lee McAlester. 2000. *A Field Guide to American Houses.* New York: Alfred A. Knopf.

Trachtenberg, Alan. 1982. *The Incorporation of America: Society in the Gilded Age.* New York: Hill & Wang.

Wiebe, Robert H. 1967. *The Search for Order.* New York: Hill and Wang.

Wilson, Guy, Dianne Pilgrim, and Richard Murray. 1979. *The American Renaissance 1876–1917:* New York: The Brooklyn Museum.

Woods, Mary. 1989. "The First American Architectural Journals: The Profession's Voice." *The Journal of the Society of Architectural Historians* 48(2): 117–138.

Styles of Domestic Architecture around the Country

In the final two decades of the nineteenth century, there were two concurrent themes in design: interest in European historical design and the influence of American innovation. By the turn of the twentieth century, American historical themes dominated, and a true American style was born. These last two decades were preceded by a surge in construction in the 1870s. An economic depression in 1857 and the Civil War combined to halt major construction of housing in the United States until about 1866. By that time, the taste of the nation had evolved, and a greater interest in European design was evident. Technology, especially in the manufacture of factory-made wood decorative elements, had also developed in that period and influenced architectural design. Distribution of manufactured goods through new railroad links facilitated factory-produced building products available through mail-order catalogs. Experimentation in construction was apparent as new products were marketed. A period of growing affluence and economic expansion after the Civil War gave rise to immense fortunes. Alternatively, increased immigration and industrialization bred extreme poverty and exploitation. The government was at its most laissez-faire and would not interfere in the business of capitalism. The developing theory of Social Darwinism allowed maltreatment of the newly arrived workers to proceed apace, because it was presumed that evolution as expressed in society favored the survival of the fittest. However, until the proclamation of the closing of the frontier by Frederick Jackson Turner hit home at the end of the century, belief in the ever-expanding frontier and Horatio Alger's view "there's always room at the top" encouraged Americans to remain enthusiastic and energetic about the nation and its future (Roth 2001, 211). This attitude also had an influence

on home design in this period. The styles of houses constructed in these years were exuberant, high-spirited, and prone to excess, as was the mood of the country. What we now think of as Victorians, styles that include the Second Empire, Queen Anne, Eastlake, Stick style, and High Victorian Gothic, display such a riot of superfluous ornament that they have been called "tubercular" by a contemporary architect, referring to the multiple outcroppings of various colors and various materials on these animated buildings (Handlin 1985, 124).

By the last years of the nineteenth century, serial economic depressions, accompanied by increasingly dreadful conditions for the poor in the cities and a general cultural malaise, influenced architectural design toward a more restrained, simpler, and less extravagant architectural taste. The 1876 Philadelphia Centennial Exhibition, which was a huge celebration of the country's first hundred years, helped to spawn a new American nationalism. This led to a nostalgic examination of the Georgian and Federal colonial designs of the past century, which were less fussy in ornament. Historian Robert Weibe defined this era as a "search for order" (Wiebe 1967). Order was defined in various ways: for instance, setting up standards for professions, such as architecture, as well as medicine and law. Professional architects were newly trained at the country's first architectural schools. They searched for a new, American style, unfettered by the copies and interpretations of previous European styles that had dominated architectural styles in the previous decades. They studied and interpreted previous American styles, which grew into the Colonial Revival and Mission styles. They also developed new styles, such as the Prairie and Craftsman styles. By the turn of the twentieth century, the emerging home styles were much simpler, as modernists like Sullivan and creative geniuses like Frank Lloyd Wright took center stage and began the journey toward the stripped-down ornament of the International and Bauhaus styles of the early twentieth century.

The Industrial Revolution and the millions of new Americans had a profound influence on the social context of housing, its design, and where it was built. For the first time, the United States found itself dealing with a number of divergent social classes, from the extremely rich to the desperately poor, and a large middle class coping with the changes. Linda Smeins (1999) describes the mindset of the middle class this way:

> Through the last quarter of the nineteenth century, fears that dominant values were being eroded contributed to forging 'American' attitudes and beliefs. Already living with economic fluctuations, the middle classes saw massive numbers of immigrants crowd into city tenements, labor riots spread across the states, trade unions grow in size and number, and socialism and communism proposed as alternatives to the current form of government. To many, the foundations of American life—Christian values, a work ethic based on a self-help conviction, a belief in social mobility, capitalism, and nuclear family structure—seemed to be at risk, and norms of cultural practice were sought to uphold the notion that there was a singular American character. Constructing an 'American dream' narrative of financial, moral, and domestic security became a common enterprise, and the home surrounded by lawn and like-minded neighbors became its cultural symbol. (Smeins 1999, 20)

Cities also factored into the mix, with the size and influence of cities rising as the century came to a close. For the first time, architects in the United States developed a unique architectural style, wholly American and not based on European precedents.

Following is an overview of the various architectural styles of the period, listing the common styles found throughout the country. This chapter concludes with a review of regional architectural styles.

THE SECOND EMPIRE STYLE

One of the most popular house design styles of the late nineteenth century was the Second Empire style. Though the style was originally seen in the United States pre–Civil War, it had sustained popularity, especially in the rural areas, until well into the 1880s. The style developed from previous popular styles in the United States, the Italianate and the Gothic Revival, though its actual provenance was France. The Second Empire style originated in France in the 1850s in the design for the New Louvre in Paris designed by architects Visconti and Lefuel. The name Second Empire was taken from the French Second Empire, reign of Napoleon III, from 1852–1870.

The Second Empire style spread swiftly to England and then the United States after the Paris exhibitions in 1855 and 1867. The most significant identifying element in the style is the mansard roof, named after a seventeenth-century French architect, François Mansart. The mansard roof was a two-pitched, hipped roof with dormer windows on the lower slope. It could be built in numerous variations: straight, concave, convex, or S-curve. The mansard had the advantage of giving the owner of the house additional usable space in the attic.

Buildings of this style were symmetrical, with the plan on a straight axis. There were often prominent pavilions at the center or at the end of the building. The decorative elements were heavily carved, similar to the previous Italianate style. There were often projecting columns on the outer walls (Gelernter 1999, 169). The style came in several incarnations: with a simple mansard, a centered wing or gable, an asymmetrical plan, a version with a tower, and an urban version for a townhouse. The Second Empire style was opulent and ostentatious and was popular both for houses and public buildings. The New Louvre in Paris contained government uses, residences, and cultural spaces. Therefore, the style was adopted in the United States for a variety of uses. The supervising architect in Washington, D.C. after the Civil War, Alfred B. Mullett, promoted the style for use in new government buildings. Americans found the style to be grandiose and imposing and many wealthy homeowners demanded it for their homes. The Second Empire style was found throughout the United States, but more often in the Northeast and Midwest than the South and the Pacific states.

The Second Empire style was an exuberant style and considered modern and fashionable by the architects of the day. In the continuing conflict in the nineteenth century between the classical or rational versus the medieval or picturesque, the Second Empire was classical and rational in spirit. Although exuberant in ornament and seemingly unrestrained, the style was usually symmetrical and axial, as opposed to the Gothic Revival and Queen Anne, which both tended toward the picturesque and asymmetrical. Gelernter, in his

book *A History of American Architecture—Buildings in Their Cultural and Technological Context,* describes the Second Empire by stating that "emphatically horizontal lines break the façade into piled up layers like a wedding cake" and dubs the style "more brazen than refined, more muscular than delicate" (Gelerntner 1999, 169).

THE STICK STYLE

The Stick style was a transitional style popular in the mid to late nineteenth century. Evolving out of the Gothic Revival and related to the High Victorian Gothic, the Stick style linked the earlier Gothic Revival to the later Queen Anne. Medieval English building styles were evoked. The style was picturesque as opposed to classical and was disseminated through pattern books of Andrew Jackson Downing. Downing was influenced by English sources, especially landscape architect John Claudius Loudon (Scully 1971, 6). Vincent Scully was the first architectural historian to identify the style, in his book *The Shingle Style and the Stick Style.* What differentiated the Stick style from its Gothic cousins was its use of exposed framing, a so-called "basketry of sticks" (Scully 1971, 6). The structure of the house was expressed on the exterior, presaging later developments of the Shingle style and the modernists. This house "literally jumped out of its skin, expressed its structural skeleton and projected itself outward in bays and porches" (Scully 1961, 18). Although Scully defines the style as expressing its structural skeleton, the structure was not truly shown on the exterior. In fact, the exterior beams were just decorative. The Stick style had a number of characteristics, including angularity, verticality, and asymmetry. The roofs often had intersecting steep gables, and porches were a common element. Overhanging eaves were popular, with exposed rafter ends or brackets in townhouses. The

Did you Know? Picturesque vs. Classical in Architectural Design

During the nineteenth century, there was a continuing design debate underway in architectural circles. This debate questioned whether the superior style of design was picturesque or classical. The picturesque was a notion expounded in the mid-nineteenth century by influential Romantic designers such as Andrew Jackson Downing, who recommended the charm and moral superiority of a natural, park-like landscape. In addition, these Romantics extolled the virtues of the proper location of a house within the context of its site. In the building itself, picturesque refers to an asymmetrical massing, usually with the front door to one side, and elements of the design on one side of the building would not be repeated on the other side. Picture a Queen Anne house, with a door on the side and perhaps a gable on one side and a dormer on the other. All the Gothic Revival styles were considered picturesque, and therefore picturesque houses were also considered to be medieval in provenance. Many architectural styles of the nineteenth century were picturesque, including several types found in the Gilded Age, for instance the Queen Anne and High Victorian Gothic.

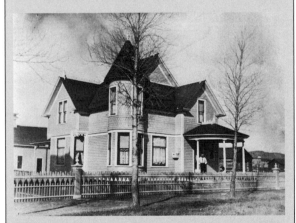

Queen Anne house, Gunnison, Colorado, 1899. This charming Queen Anne house is asymmetrical, the front door off-center and it is romantic in spirit. Denver Public Library, Western History Collection.

On the other hand, the classical style was the opposite of the picturesque. Growing out of the Greek, Roman, and later Renaissance styles, the classical emphasized symmetry, rationalism, balance, and restraint. Picture the Greek temple, white, with beautifully elegant columns surmounted by a symmetrical

(continued)

pediment—simple to the extreme and considered a standard of beauty to this day. (We now know that the original Greek temples were painted with strong, even garish colors, which may conflict with the Victorian ideal of classicism.) Many nineteenth-century styles were based on classicism, including, of course the ubiquitous mid-century Greek Revival. Later styles of the century were a reaction to the picturesque, or medieval influences, as the Colonial Revival and the Beaux-Arts styles rose in popularity. Students who were trained at the École des Beaux-Arts in Paris or the new architectural schools in the United States were trained in classical vocabulary. As technology improved, some architects considered the classical, the more rational style, to be more appropriate for the modern age, against the more religiously based, medieval style of the picturesque. The battle between the two theories of beauty, classical vs. picturesque, permeated architectural criticism throughout the century. It was a conflict fought on moral grounds, both sides staking out the high ground.

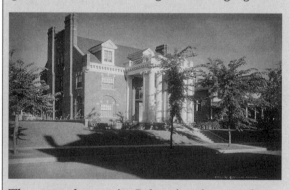

These two houses in Colorado (above and previous page) are examples of the conflicting approaches of the Classical and the Picturesque in architecture. This house, a stately example of the colonial Revival is symmetrical, has classical elements like the colonnaded portico in the front and recalls Greek and Roman design as well as early American architectural styles. Denver Public Library, Western History Collection.

houses were wood, and different patterns were used on the exterior. Wood siding, shingles, or boards interrupted by patterns of vertical, horizontal, or diagonal boards (or "stickwork") were raised from the surface for emphasis (McAlester and McAlester 2000, 255). There were three common subtypes of Stick style houses: the gabled roof, which was most typical; the towered, with a square or rectangular tower; and the townhouse, which was flat roofed but had vertical stickwork under the cornice and squared bay windows (McAlester and McAlester 2000, 256). The style petered out in the 1880s when the Queen Anne took over throughout the United States. Though not as common throughout the country as the Second Empire or the Queen Anne, the Stick style had an influence on later architectural developments because of its so-called truthful expression of its structure.

THE EASTLAKE STYLE

The Eastlake style, common in the 1870s and 1880s, was named after an English interior designer Charles Locke Eastlake. This style was based on the book *Hints on Household Taste* published by Eastlake in England and the United States where he criticized the common interior design of the day, which was heavy, ornate, and overstuffed. The furniture he designed displayed light, scroll-sewn wood decorative elements, with incised linear ornament. In the United States, architects and especially house plan book writers published varieties of houses designed with decorative elements reminiscent of the furniture from the Eastlake book. The style became especially popular in California, where the famous wood townhouses in San Francisco from the 1880s were (and those existing still are) excellent examples of the style. A book was written describing the style by John Pelton, called *Cheap Dwellings,* in 1882. The Eastlake style is related to both the Queen Anne and the Stick style but utilizes elements from the Eastlake book. The designer, for

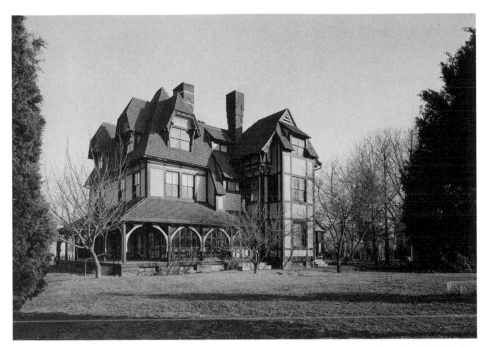

The Emlen Physick house in Cape May, New Jersey, designed by Philadelphia architect Frank Furness, is a fine example of the Stick style. Courtesy of the Library of Congress.

his part, was not impressed with the architectural style. He was, after all, not an architect but a furniture designer. He wrote, in response to inquiries made to him from California about the origin of the style, "I now find, to my amazement, that there exists on the other side of the Atlantic an Eastlake style of architecture, which, judging from the specimens I have seen illustrated, may be said to burlesque such doctrines of art as I have ventured to maintain," and he dubbed the houses, "extravagant and bizarre" (Roth 2001, 239).

THE QUEEN ANNE STYLE

Probably the most popular house style in the United States during the 1880s and 1890s was the Queen Anne. When the general public refers to older neighborhoods full of Victorians, they are very probably describing Queen Anne houses. The mode originated in England and was popularized by the English architect Richard Norman Shaw (1831–1912). Although the style was based on historical precedent, the label was not historically accurate. The name of the style was supposedly derived from the vernacular architecture style in England at the time of Queen Anne, who ruled England from 1702–1714. However, the buildings in that period were of a formal Renaissance style. What was copied, or freely interpreted, by Shaw and his compatriots was a style based on English late medieval architecture of the Elizabethan and Jacobean periods, which were earlier (McAlester and McAlester 2000, 268). Architects in nineteenth-century England admired building techniques and skilled carpentry of past centuries in a nostalgic look back at

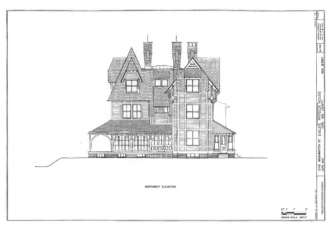

Drawing of the Emlen Physick house in Cape May, New Jersey. Courtesy of the Library of Congress.

the past, although what was actually copied were the architectural details and not the building techniques (Wright 1980, 64).

The Queen Anne style had a number of common features and several basic exterior forms. The earliest examples of the style were very similar to the English Shaw-inspired versions. The English version of the Queen Anne style was introduced to the American culture in 1876 during the Centennial Exhibition in Philadelphia. The first important American example of the Queen Anne style house was the William Watts Sherman house in Newport, Rhode Island, by architect H. H. Richardson, built in 1874. The house appeared to be very medieval. The houses of this type featured half-timbering and patterned masonry. After 1880, the style spread throughout the United States and two other, wholly American interpretations became popular: the spindlework type (related to the Eastlake style) and the free-classic type (McAlester and McAlester 2000, 268). Spindlework is the wooden decorative "gingerbread" seen on so many Queen Anne houses. The development of the railroad transport helped spread the style because precut decorative ornament was inexpensively shipped throughout the country. The free-classic version displayed American colonial elements, influenced (as were other architectural styles of the period like the Colonial Revival) by the American historicism popularized after the centennial. These elements included Palladian windows and classical columns. The development of this version of the Queen Anne led right into the later Colonial Revival style, which utilized similar elements but was more symmetrical in massing. American architectural journals began showcasing this style in 1876, and architects and builders quickly became familiar with its elements.

Though not a strict reinterpretation of a previous style, the Queen Anne displays historical elements that are all thrown in to create an exuberant, lively, and excessive style so typical of the Victorians' love of overindulgence (Wright 1980, 64). There are a number of features evident in this style, although its hallmark is its variety and eclecticism. In the fracas concerning the classical vs. the picturesque, Queen Anne is the queen of the picturesque, evolving from the earlier traditions of Italianate and Gothic Revival. The famous Chicago style architect John Wellborn Root dubbed the popular Queen Anne the Tubercular Style because of its many unsightly eruptions, both external and internal (Handlin 1985, 124). Many of the elements of this style recalled English medieval traditions. The style is high-spirited and decorative and less vertical than the Second Empire or High Victorian Gothic. The facade of the Queen Anne house typically has a dominant front-facing gable and irregular rooflines with steep pitches. It is asymmetrical, with the front door almost always off-center. There is often a porch, one-story high, either partial or full-width of the facade. The balusters

on the porch display ornate turned lathe work. The second floor frequently includes turrets or other projections. Chimneys are massive and grouped together. The roofs often have decorative iron cresting (Cudworth 1997, 19).

The materials used in the Queen Anne house are varied and include brick, stone, clapboard, ornamental shingles, terra cotta, and wood. The materials are combined in various patterns and shapes often with each story displaying contrasting materials of differing colors. The windows are frequently banks of casements with small panes, Palladian windows, or cutaway bay windows. Doors display fans and sidelights. Stained glass windows were also popular. Half-timbering in the medieval style was also common.

In plan, the Queen Anne style was informal and open. The opening up of the interior plan was predictive of later innovations by the Prairie style architects such as Frank Lloyd Wright. The plan is inventive, with cross-axes and projecting wings (Rifkind 1980). The first floor of the Queen Anne house is asymmetrical, with no formal front hall, but a grand living room with a stairway. The space was more free-flowing than previous styles. Dark wood paneling was used in the interior instead of the wallpaper and plaster ornament found in Second Empire and Italianate styles (Poppeliers, Chambers, and Schwartz 1983).

The style grew in popularity throughout the country until about 1900. As explained by Linda Smeins in *Building an American Identity,* the "Queen Anne connoted a genre of design that was quintessentially middle class: suburban, modern yet with old-fashioned comfort, a secure haven for the nuclear family and an excellent choice for a display of status and participation in the ideology of social mobility" (Smeins 1999, 210). Cities also created a version of the Queen Anne row house. This house had a projecting bay front with a gable or pinnacle roof. It was found throughout the country in the urban areas. By necessity, this Queen Anne row house was a simpler version of the style, and instead of the variety of projections found in the free-standing version, it displayed decoration in brickwork designs and stained glass transoms (Poppeliers, Chambers, and Schwartz 1983, 57).

Most of the houses built by the builders and carpenters utilizing the pattern books were in the Queen Anne style or some interpretation of it. Though criticized by many as the ultimate in Victorian fussiness and excess, the Queen Anne style remains attractive even today. Many of the preservation efforts seen around the United States in the late twentieth century involved saving what is left of the homes built in the Queen Anne style. As a reaction to the minimalist and sterile modern style of the twentieth century, many admire the individuality and charm of these old ladies.

HIGH VICTORIAN GOTHIC

An influential style of the mid to late nineteenth century is the High Victorian Gothic style, which has various other names including Ruskinian Gothic (Rifkind 1980, 146). The Gothic style had many incarnations in the nineteenth century. The Gothic Revival was very popular in England and in the United States in the early decades of the century. The style, promoted by the medieval historian Pugin and the ecclesiologists in England, endeavored to recreate the Gothic of medieval times and connected it to the moral and religious elements that they wanted to bring back to society. The High Victorian Gothic developed

in England from the Gothic Revival but freely interpreted the constraints of the original style, which had been a strict recreation. These High Victorian Gothic buildings were not archeologically correct by any means, but they were creative combinations of Gothic elements (Gelernter 1999, 170).

High Victorian Gothic was an amalgam of various Gothic forms, including early French Gothic and the Italian Gothic of Venice and Tuscany. The French Gothic was an aggressive, powerful style. The Italian had frequent use of polychromy, that is, the use of various colors on the facade through differing material and colors of brick, stone, and so on. John Ruskin, an influential English critic and admirer of the original medieval Gothic style, sought structural honesty and integrity in design. He recommended the French Gothic and found the English version too weak. Gelernter, in his book *A History of American Architecture—Buildings in their Cultural and Technological Context,* states that the popularity of the Gothic in the United States displayed "bold massing and the strident coloring of polychromy [that] would help a building stand up against its often grimy industrial backdrop, while providing a more assertive picturesque effect" (Gelernter 1999, 171).

Another influential critic in the nineteenth century was the French Gothicist Eugene Viollet-le-Duc, who wrote *Dictionnaire raisonne de l'architecture francaise du Xe au XVIe siecle* (1854–1868) and *Entretiens sur l'architecture* (1863, 1972; Gelernter 1999, 171). Viollet-le-Duc studied the French Romanesque and Gothic styles in preparation for the renovation of buildings in France. He saw structural rationalism in the medieval designs. He believed that the buildings expressed their structure through their design. His theory of architectural design influenced the protomodernists such as Wright, Sullivan, and the California architect Bernard Maybeck in subsequent years. Pugin and Ruskin were Gothicists, but they did not interpret the Gothic style in a way that would create a new type of architecture. They merely wanted to copy the previous style. Viollet-le-Duc saw that Gothic buildings expressed their structure through their design, exposing the piers, vaults, and flying buttresses instead of covering up the structural members like other contemporary styles did. This led directly to the designs of the twentieth-century architects who pushed the limits of the exposed structural elements.

This Victorian Gothic style was utilized for many types of buildings, not only religious architecture. The influence of Viollet-le-Duc and Ruskin was also seen in the Stick style houses designed by Richard Morris Hunt among others, where the structure was expressed in the exterior, for instance the Griswold House in Newport, Rhode Island, built 1862–1863. The Carson House in Eureka, California, designed by Samuel and Joseph Newsom and built in 1884–1885, is the most eccentric example of High Victorian Gothic, though showing elements of other styles. Carson was a lumber producer who wanted to keep his employees busy during the slow season. The house "exemplifies the picturesque ideal of bold and asymmetrical massing, a dominant tower, steep medieval roofs and extensive wooden detailing" (Gelernter 1999, 174).

SHINGLE STYLE

Considered one of the first truly American styles, the Shingle style evolved from the Queen Anne, although it had elements of several contemporaneous styles, including the Colonial Revival and the Richardsonian Romanesque. The

Shingle style originated in New England where wood shingles were commonly used. Colonial houses found in the coastal towns in New England often were shingle-clad. Interest in Colonial architecture stemmed from the Philadelphia Centennial Exhibition of 1876. Architects saw the houses in towns such as Newport, Rhode Island and copied the look. The Shingle style was fully developed in the 1880s. From the Queen Anne style, the Shingle style utilized wide porches, shingles, and an asymmetrical massing. From the Colonial Revival, it often had a gambrel roof, lean-to additions, and Palladian windows. From the Richardsonian Romanesque, there were sculpted shapes and Romanesque arches (McAlester and McAlester 2000, 290). It was more sophisticated than the Queen Anne, most often designed by trained architects and found in wealthy resort towns, though vernacular versions of the style can be seen in towns primarily in the North-

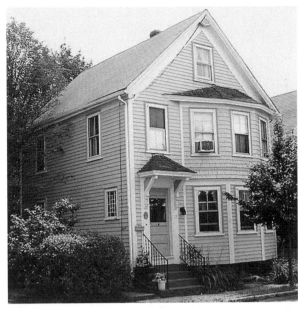

The Isaac Bell house in Newport, designed by the prominent architectural firm McKim, Mead, and White, was one of the first Shingle style houses. Elizabeth Greene.

east. Architects known for the style were: H. H. Richardson, Bruce Price, William Ralph Emerson, John Calvin Stevens, and McKim, Mead, and White. On the West Coast, Willis Polk designed in the Shingle style (Poppeliers, Chambers, and Schwartz 1983, 60).

The Shingle style had a more horizontal appearance than the Queen Anne, but, like the Queen Anne, had a prominent and complex roofline and dormers. Unlike the Queen Anne, the Shingle style had eyebrow dormers instead of gable ones. There was an overall reduction in ornament in the Shingle style, and although there were verandas and turrets, the style was simpler in massing. The style displayed shingled exteriors, but additional materials included rough-hewn materials such as fieldstone. Overall, however, the exterior of the Shingle style was unified with its one major element: shingles. The interior was open and informal in plan, even more than the Queen Anne (Poppeliers, Chambers, and Schwartz 1983, 60).

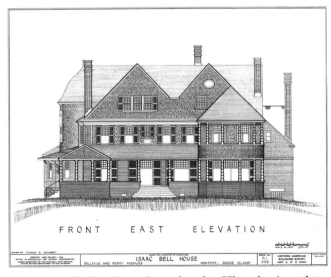

A measured drawing, done by the Historic American Buildings Survey (HABS) program, of the Isaac Bell house. Courtesy of the Library of Congress.

Vincent Scully, an American architectural historian, was the first to identify the Shingle style in the mid-twentieth century. Scully eloquently discusses the "horizontal continuity" of the Shingle style. He also avers that the style was "the freest and, on the whole, among the most generous forms that the United States has yet produced," and "the gentlest forms: the most relaxed and spiritually open and . . . most wholly wedded to the landscape" (Scully 1971, xx). In addition, Scully states that H. H. Richardson, inventor of the Richardsonian Romanesque style, and other architects who designed in the Shingle style "transformed influences from early American colonial architecture itself into thin, shingled skins of wall, tightly stretched by the pressure of the continuously open spaces inside them and engulfing the exterior spaces of porches into their volumes. Continuity and permanent shelter were thus united as a single theme" (Scully 1961, 18). Scully claims that the Shingle style influenced Frank Lloyd Wright in his early work. Wright utilized the horizontally extended plans of the Shingle style, as well as the central fireplace and the cross-axial space that continued out to porches and terraces. "The whole fabric was integrated around this spatial idea, so that the building broke out of the old containing skin to enhance the continuity of its space and to embody it plastically both inside and out" (Scully 1961, 20).

RICHARDSONIAN ROMANESQUE

There were several incarnations of a Romanesque Revival in the early to mid-nineteenth century, which related to the medieval influence seen in the Gothic Revival and other historical resurgences. However, one of the most influential architectural styles of the late nineteenth century was an original and truly American invention, named after its originator and adapted to all types of buildings including houses, churches, and commercial buildings. The style is dubbed Richardsonian Romanesque, and it is named after Henry Hobson Richardson. Born in Louisiana in 1838, Richardson graduated from Harvard College in 1859. He traveled to Paris in the early 1860s to avoid the American Civil War and to study architectural design at the École des Beaux-Arts. Armed with a diploma from the École, Richardson returned to the United States in 1865 and set up an architectural practice in New York City. Richardson won several commissions for church designs in Massachusetts, the most famous of which is the Trinity Church in Boston (1873–1877). Though he died in 1886 at the young age of 48, Richardson's work had an enduring influence on architectural design throughout the United States.

The style Richardson looked to for inspiration was the Romanesque. A precursor to the Gothic in European architecture, the Romanesque style used rounded arches in huge church structures constructed in twelfth-century France. As a student of French architectural history, Richardson considered the Romanesque to be the greatest synthesis of the earlier Roman and the later Gothic styles. Handlin states:

> When Richardson began to practice, Romanesque was usually seen as a transitional style between Roman and Gothic architecture. Richardson reversed this interpretation. For him, Romanesque synthesized the best qualities of both. Like the Roman vault and the Gothic arch, the rounded Romanesque arch was the basis

of a consistent structure. But unlike Roman architecture, Romanesque buildings were not based on an armature of cheap materials covered buy a coat of applied and often highly refined decoration. Nor did they depend for their quality on a high degree of elaboration, as was true of Gothic architecture. Instead, Romanesque was direct and simple, characteristics which Richardson thought reflected the American approach to building construction as it had developed by the end of the nineteenth century. (Handlin 1985, 116)

Though the Richardsonian Romanesque house is not as common throughout the United States as, for instance, the Second Empire or the Queen Anne, Richardson is considered one of America's greatest and most influential architects. The architectural historian Vincent Scully waxes poetic on his discussion of Richardson's work: "The power of Richardson's forms gave a demonstration of unmatched confidence to those architects who most closely followed and understood him, and that confidence was in three things: in continuity, in permanence, and in the power of a building to embody an heroic attitude" (Scully 1961, 18).

The Richardsonian Romanesque style did give an impression of permanence and power not seen before in American architectural design. The houses that embodied this style had characteristics that appealed to the wealthy and powerful, and therefore most of the domestic architecture in this style were homes of the robber barons and other well-off types. The style was most popular from 1870 to 1900 and was costly to construct because the most common material for this style was rough-hewn masonry. Heaviness was accentuated along with a horizontality that presaged the Prairie style of Frank Lloyd Wright. Broad, round arches are the style's hallmarks, hence the term Romanesque. Short, squat columns often sported intertwining, carved, floral engraved designs. Eyebrow dormers, which Richardson is also credited with inventing, were a common feature. (Rifkind, in her 1980 book, *A Field Guide to American Architecture*, contends that the Richardsonian Romanesque is simply a manifestation of the Shingle style, constructed in masonry instead of wood shingle.) Many urban row houses, many of the so-called brownstones in New York City, were constructed using the Richardsonian Romanesque.

COLONIAL REVIVAL

One of the most enduring house styles in the United States is the Colonial Revival. It is seen, in varying incarnations, in houses built throughout the twentieth century and even in the twenty-first. The mode first appeared in the late nineteenth century as both a reaction to the excess of the Queen Anne and the High Victorian Gothic and as an expression of the interest in the American colonial design after the Centennial Exhibition in 1876. The Colonial Revival eventually took over from the Queen Anne in popularity for house design. Instead of interpreting the old traditions of Britain, architects and builders in the United States began to search for more local traditions to unearth. The houses of the seventeenth and eighteenth centuries were rediscovered. The houses of the Colonial period were woefully unfashionable in the earlier part of the nineteenth century and were often torn down. However, with the popularity of the Queen Anne and the Centennial Exhibition of 1876, architects began to appreciate the comfortable, homey styles of the American past. When the centennial

was celebrated, the country was suffering a severe economic depression, and "Americans saw the colonial period as an ideal world when values were clearer, life was simpler, and the world was less crassly materialistic" (Gelernter 1999, 180). The Colonial Revival's appeal was based on patriotic sentiment.

The Colonial Revival of the 1880s and 1890s combined elements of many different colonial traditions, including New England colonials, Federal and Georgian styles, and Dutch Colonial. Classical and medieval detailing was often added. There are a variety of subtypes of the Colonial Revival, and they were modified as the times changed into the twentieth century. The primary influences on the earliest Colonial Revival houses were the Georgian and Adam periods, which covered the eighteenth and early nineteenth centuries. Other influences include the Dutch Colonial and English post-medieval styles. Pure examples of earlier styles were not as common as freely combined ones (McAlester and McAlester 2000, 324). The major elements of the Colonial Revival style are: an accentuated front door, with a decorative pediment supported by pilaster or columns with a small entry porch; front doors with sidelights or fanlights (windows at either the side or the top of the door); symmetrical facade, with the door generally in the center, not to the side; and windows are double-hung with multiple panes and often grouped in pairs. Many of the early examples of Colonial Revival houses had asymmetrical facades as a continuation of the Queen Anne style, but this was not typical of the original, Colonial examples. Later incarnations of the style, built after 1900, as well as houses designed by the fashionable, high style architects of the day, such as McKim, Mead, and White, sought a more accurate interpretation of the earlier styles (McAlester and McAlester 2000, 322). Often the style is identified as a puffed-up version of the original Colonial house. The scale of the Colonial Revival house is larger than the original.

The Colonial Revival style in the United States has produced a torrent of criticisms in architectural circles throughout the years, but it has maintained a tremendous popularity with the average homebuyer. The style was seized upon by the important architects of the day. The John Hancock house was demolished in 1863, though it was rebuilt at the World's Columbian Exhibition in Chicago in 1893. It influenced building in Pittsburgh, among other cities. Montgomery Schuyler, architectural critic of the day, remarked that it was difficult to walk around the east end of Pittsburgh without seeing a copy of the Hancock house. Virginia also joined the bandwagon and recreated Washington's home Mount Vernon at the Columbian Exhibition. McKim, Mead, and White also recreated Mount Vernon in 1898 in Farmington, Connecticut (Rhoads 1976, 241).

Mariana Griswold van Renssalaer, an architectural critic of the period, stated in 1886 that contrary to the common belief that Colonial Revival was a truly American style, the only truly American style was the "wigwam of the north and the pueblo of the south." Van Renssalaer did consider the style now identified as the Shingle style an American style. Edith Wharton, distinguished American novelist, also wrote (with Ogden Codman, Jr.) a celebrated book on interior design titled *The Decoration of Houses*. She stated, "the application of the word 'Colonial' to pre-Revolutionary architecture and decoration has created a vague impression that there existed at that time an American architectural style. As a matter of fact, 'Colonial' architecture is simply a modest copy of Georgian models" (Wharton and Codman 1997, 86). Ernest Flagg, a Beaux-Arts architect

of the period, averred, "At no time since the Europeans first began to build in America has there been anything which might be called properly an American style of architecture" (Rhoads 1976, 253).

Modernist architects of the early twentieth century despised the Colonial Revival, and the style has been reviled since the modern style was first introduced. Louis Sullivan, famous Chicago architect of public buildings of the time, derided the use of eclecticism and imported styles, of which he considered the Colonial Revival to be one. Louis Mumford, architectural critic of the mid-twentieth century, also criticized the Colonial Revival in his book *The Brown Decades*. He derided the Colonial Revival as "the archaic note of colonialism . . . being emphasized by the fashionable architect" (Mumford, 1971, 76).

THE BEAUX-ARTS STYLE

The term *Beaux-Arts* means "fine arts" in French, and this popular and influential style of the late nineteenth and early twentieth century was a style based on French provenance. The name refers to the École des Beaux-Arts in France established in Napoleon's time as successor to French Academie, which was founded in the seventeenth century to monitor painting, sculpture, and architecture. The Academie monitored what it considered proper and appropriate in all the fine arts, including architecture. The teaching and beliefs of the Academie dominated French architecture until the twentieth century. The proper

The Breakers, summer "cottage" for Cornelius Vanderbilt in Newport, Rhode Island, is an example of the Beaux-Arts style, designed by society architect Richard Morris Hunt. This photo was taken in 1893. Courtesy of the Library of Congress.

style to the Academie was that based on classical precedents, therefore in the classical vs. medieval or picturesque debate, the Beaux-Arts style was definitely in the classical vein. The term *academic,* when referring to art or architecture, is a reference to the Academie; any academic type work of art is one that is based on principles taught at the Academie. The Beaux-Arts style as seen in the United States was therefore an academic style.

Many American architects trained in France at the École, including Richard Morris Hunt, Louis Sullivan, Henry Hobson Richardson, and Carrere and Hastings. Examples of the Beaux-Arts style were typically designed by trained architects, usually were large and grand, and were found in urban centers such as in New York, Boston, Washington D.C., St. Louis, San Francisco, and Newport, Rhode Island. An early example is the Breakers in Newport, designed by Richard Morris Hunt for the Vanderbilt family in 1893. Virginia and Lee McAlester, in *A Field Guide to American Houses,* comment, "More than any other style . . . the Beaux Arts expressed the taste and values of America's industrial barons at the turn of the century. In those pre-income tax days, great fortunes were proudly displayed in increasingly ornate and expensive houses" (Mcalester and McAlester 2000, 380). The houses were so big that they were difficult to maintain and most have been demolished. A few still exist in Newport, Rhode Island and can be visited.

The features of the Beaux-Arts style emphasized design principles, study of Greek and Roman structures, pleasing composition, and symmetry. Though the style was most often used for grand public buildings (for example the Grand Central Terminal in New York City), it was also used for townhouses and resort villas for the extremely wealthy. The Beaux-Arts style displayed decorated surfaces, a symmetrical facade, columns and pilasters, masonry walls, and often had a rusticated first story. The style was classical, not picturesque. Of the classical influences, the Renaissance style was most important. There was plenty of surface decoration, with classical entry porches and columns. Cornices and other classical detail were seen on the Beaux-Arts building. Quoins and windows with balustrades were also common. There were two typical types: one, a flat or low pitched roof (more common) based on Italian or northern European Renaissance buildings; or two, a mansard roof type, based on seventeenth- and eighteenth-century French examples, similar to Second Empire but stone instead of wood and larger and more elaborate (McAlester and McAlester 2000, 379).

The Beaux-Arts style appealed to high society and trained architects of the period for various reasons, including the cultural attitude in society at the time. As expressed by David P. Handlin in *The American Home, Architecture and Society*:

> [L]abor difficulties of the late 1880s and the influx into the United States of an increasingly diverse population were only two manifestations of what many perceived to be a general state of divisiveness and disintegration. In 1890 the Census Bureau announced that the frontier was closed; stark confirmation that a critical turning point had been reached. These diverse facts seemed all to have one message: if the United States was to avoid dissolving into anarchy and self-destruction, a new phase of development would have to begin. Shared values, based on the highest cultural standards, were necessary. Because of its high visibility, Americans once again looked to architecture to express and inspire the renewal they hoped would take place. The new direction, a return to classical principles, was as alluring as it was obvious. (1979, 132)

Many feared that society was spinning out of control in the last years of the century. Beaux Arts design was beautiful, predictable, and pleasing. Because wealth was expanding among the wealthy, price was no object, and ostentation was desired. Joseph Wells, the chief designer from the firm of McKim, Mead, and White, one of the most famous proponents of the Beaux-Arts style in the 1880s, added fuel to the classical vs. medieval debate when he stated: "The classical ideal suggests clearness, simplicity, grandeur, order and philosophical calm—consequently it delights my soul. The Medieval ideal suggests superstition, ignorance, vulgarity, restlessness, cruelty and religion—all of which fill my soul with horror and loathing" (Handlin 1979, 132).

REGIONAL ARCHITECTURAL STYLES

Chicago Midwest Architectural Styles

Architectural design in the late nineteenth century was developing on a parallel track in Chicago from in the eastern part of the country. What would develop out of Chicago at the turn of the century is considered America's finest innovations in architectural design. Much of the innovation came in the form of public buildings, though there were some architects who designed houses as well. It came from a background very different from where architects were on the East Coast. The tradition in Chicago was not toward an architect-designed house. Since the Great Fire of 1871 in Chicago and the depression of 1873, many houses were built in Chicago, but not remarkable ones. People did not generally settle down in the area, and many quickly built houses using slipshod construction techniques that could be found throughout the area.

The trained architects in the city were bitter about the condition of residential architecture. Peter Bonnet Wight, stated that Chicago had "no Homes. Her population has always been so transient, and the spirit of speculation has been such, that no one ever thought of living long in one house, or of making it a comfortable home. Every one was aspiring to a higher state; and no one felt warranted in building for permanence" (Wright 1980, 70). John Wellborn Root, another particularly well-respected Chicago architect of the time, also criticized the local residential design, stating that it had, "too much color, too much gaudiness, too much waste and pretense" (Wright 1980, 70).

Although some of the architects felt that the newly rich and successful Chicagoans still portrayed the innate bad taste of the poor and middle-class, others, namely Dankmar Adler, insisted that in this country class differences were nonexistent. Because middle-class people were able to climb to the upper classes through monetary success, he believed that even the wealthy were originally middle class and were therefore the typical American. These architects attempted to eschew the belief in the architect as elitist. This view developed into the democratic architecture of later Midwest architects, such as Frank Lloyd Wright (Wright 1980, 73).

The architects in Chicago were pulled between the elitism of the typical architect of the time and the local appreciation of the "up-from-the-bootstraps" wealth. Hostility to the East Coast architect, who was called the "gentlemanly decorator," was evident in the group formed in the area, called the Western Association of Architects, or WAA. (The architects in the Midwest did not embrace the national architects' professional group, the American Institute

Did you Know? The Town of Pullman, Illinois

On another scale altogether is the complete model town built by George M. Pullman for the workers of his factory, which produced the world famous Pullman railroad cars. George M. Pullman was the founder of the Pullman Palace Car Company in 1867. In 1880 he purchased nearly 4,000 acres of land outside of Chicago near Lake Calumet. The town was built between 1880 and 1884. Pullman, in typical nineteenth-century moralist fashion, believed in the humanizing effect of beauty on the working-class soul. He hired a well-known architect, Solon S. Beman (1853–1914), who had trained with one of the most famous architects of the Beaux-Arts style, Richard Upjohn in New York. Pullman also commissioned landscape architect Nathan F. Barrett (1845–1919) to contribute to the design. Beman had designed a house for George Pullman in 1879, as well as an office building for the Pullman Company. The town abutted the factories, which were on the other side of 11th Street. The center of town had a clock tower; the houses had many modern conveniences including indoor plumbing, sewage, and a gas works. The houses were constructed of brick and were separated from each other in order to prevent spreading of fires and contagious diseases. There were landscaped parks and streets, also a market where meat and produce was sold, most of it grown on farms just south of town. There was also a bank, library, theatre, post office, church, parks, and recreational facilities. The shops were owned by the corporation, as were the houses. Even the Methodist Church built in the town was owned by Pullman. The rents were high; therefore, the church remained empty most Sundays because the residents couldn't afford to contribute to the collection plate. Taverns were not permitted in the town. Pullman was given an award for the "World's Most Perfect Town."

The town of Pullman was profitable for the company; the rents charged were high, 30 percent of wages. Residents in Pullman had no power in the town; the corporation paternalistically controlled everything. The town prospered until the depression of 1893–1894 when Pullman, like many other companies at the time, reduced wages and hours. Unlike other companies, Pullman refused to reduce the rents. This resulted in the infamous Pullman Strike of 1894, when workers at the Pullman Palace Car Company went on strike and were joined by all other railroad workers and brought all transportation, including movement of the mail, in the United States

of Architects [AIA], and virtually none joined the group.) According to Gwendolyn Wright, the Midwest architects were interested in building houses for middle-class, more modest families. In contrast, the architects on the East Coast felt compelled to begin a public relations campaign to improve the image of the profession in the public's eyes by sponsoring competitions for a "cheap dwelling" or an even less expensive "Mechanic's dwelling" (Wright 1980, 68).

One journal published in the Chicago area, the *Inland Architect,* was popular among architects of the time and presented an alternative vision from that presented by *American Architect* published on the East Coast. The publisher Robert Craig McLean wanted to show that the local architectural culture was more libertarian, both politically and architecturally, than its counterpart on the East Coast (Wright 1980, 72). Architects in Chicago began to accept commissions for houses for the newly wealthy in the area. They complained, however, of the frustrations of working with clients who wanted more than they could afford and insisted on commenting on the design themselves. Though this is a typical complaint of architects throughout history, the profession in Chicago never really developed a local style in residential architecture and had much more success, in fact historic success, in designing public buildings. Most architects in Chicago were more interested in the design of public buildings than in domestic architecture. However, some architects did concentrate on houses, including Joseph Silsbee, Frank Lloyd Wright, W. Carbys Zimmerman, and Solon S. Beman.

Architectural Styles for Houses in Chicago

The Shingle style did not find followers in the Midwest. Though Richardson was not a midwesterner himself,

the Richardsonian Romanesque had its greatest influence in the Midwest, in both public buildings and houses. New towns and cities turned to the Richardsonian Romanesque to present, strong, sturdy, massive structures as bulwarks against the cold unforgiving prairie. The style is seen in the wealthy to the middle class, from the suburban villa to the urban townhouse. It is also seen in the typical heavy stone as well as interpretations in wood frame. Fred Hodgson, editor of *Builder and Woodworker* and also Chicago's *National Builder,* stated that Richardson "exemplified the native American genius" and that the work showed economy but not cheapness (Wright 1980, 68). The Queen Anne style was also very popular in the Midwest. They were, however, generally smaller and more compact than their East Coast counterparts. The houses had juxtapositions of varied materials within a smaller facade.

(continued)

to a halt. President Grover Cleveland sent in federal troops and a riot occurred, resulting in several deaths. In 1898, the Supreme Court required the company to sell all its nonindustrial property. The negative publicity surrounding the riot at Pullman put company towns in a bad light and discouraged other companies from joining the effort. A stigma against workers' housing ensued. It was an unfortunate development, because the town of Pullman was a model town in many ways. It provided safe and pleasant housing and a complete town with all its amenities to its residents. Unfortunately, the paternalistic viewpoint of society at the time allowed Pullman to run his town as a dictator. With self-government, the town could have prospered through the strike and beyond. The town of Pullman was all sold by 1907 and has been privately owned since. The town was threatened with demolition in 1960, but residents and the Pullman Civic Organization helped defeat the plan. The town became a state landmark in 1969 and a National landmark in 1971. The houses are presently undergoing restoration.

Other Midwest Housing Types: The Nebraska Sod House

The settlers on the prairie in the Middle West, were forced to make do with what materials they could find. There were no forests on the prairie and therefore no wood to construct traditional houses. The first settlers followed the Native Americans of the area and built sod houses by digging shallow holes in the ground and piling up layers of sod. They were known in the area as "soddies." The houses were constructed of bricks that were made from soil plowed into strips 12 to 14 inches thick. The strips were cut into two-foot lengths. They were laid grass side down to create two-foot deep walls. At the top of the structure the settler placed a cedar ridgepole and rafters. Willow brush matting and a sod roof were placed on the rafters. The sod houses were extremely well insulated and protected the settlers from the cold winters and hot summers. The major problem with the construction technique was leaky roofs. Some settlers were able to plaster the exterior of the house to ward against erosion. Sod houses were built until about 1910 (Walker 1998, 169). The settlers, however, imported wood as soon as they were able to afford it and built houses that followed the styles found in the Northeast.

West Coast: Mission Style

A style that was popular in California from 1890 to 1920 was the so-called Mission style. The style was based on the Spanish missions seen around California and in the other southwestern states. That is where the style was most influential. The Mission style can be found in other parts of the country, but it wasn't until after the first decade of the twentieth century. The mode had been

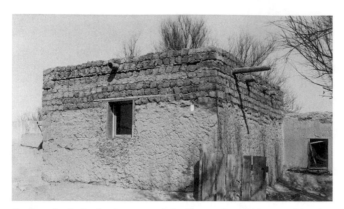

Sod and adobe houses were built on the plains and in the Southwest. This house is from Isleta Pueblo, Bernalillo County, New Mexico. Courtesy of the Library of Congress.

compared to its counterpart in the East, the Colonial Revival style, as it is based on the colonial heritage of the region. Architects of the time were turning to their regional roots, as nationalism and patriotism took hold throughout the country. Several California architects advocated for the use of the Mission style in the 1880s and 1890s.

The Mission style displayed certain invariable features. The houses were made of smooth stucco with a red tile roof. There was often a dormer or roof parapet. The house displayed deep overhanging eaves, with an open porch supported by large columns. There were two common types: a symmetrical house, with a simple plan and a hipped roof; or an asymmetrical one, which had varied forms. Dormers of various shapes, with roof parapets resembling Spanish colonial missions, were seen on Mission style houses. Most of the homes have one-story porches either at the entry way or across the width of the facade. Common details include quatrefoil windows and little other decorative detailing. Contemporaneous styles were the Craftsman and Prairie styles, and architects in the Mission style often borrowed from them (McAlester and McAlester 2000, 409).

West Coast: American Bungalow

A regional style that originated in the West and became extremely popular there was the American bungalow. The word bungalow is used by many to describe a small house, usually built in the years between the 1880s to the 1930s. The derivation of the word is from Bengali, India, *bangla,* which means a low house with porches all around. The first use of the word in its present spelling was by Mary Martha Sherwood in 1825, in *The Lady of the Manor,* as modest structures "built of unbaked bricks and covered with thatch, having in the center a hall . . . the whole being encompassed by an open verandah" (Lancaster 1958, 240). The house was common in South Asia and many western visitors commented on it, though it was not considered a dwelling of any importance or beauty. The first American building dubbed a bungalow was designed by William Gibbons Preston, a Boston architect, in Monument Beach, Massachusetts in 1880. The house resembled more a Stick style house than the later bungalows, but it did have a large verandah, horizontal massing, and connection to the site (Lancaster 1958, 240).

The first interpretation of the bungalow to attain the mature style was published in 1896 in the *American Architect and Building News,* designed by Julius Adolph Schweinfurth, with Peabody and Stearns Architects, for William H. Lincoln of Newton Center, Massachusetts. The house was low and nestled into the sloping site with bands of windows. Bungalows were thought of as being unpretentious, simple houses with one and a half stories and few rooms but

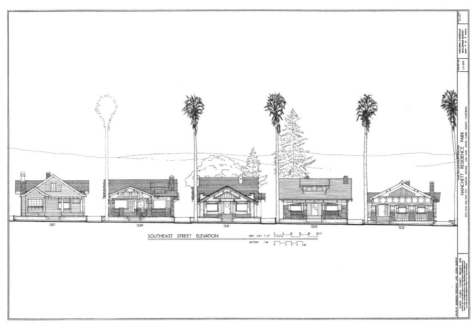

A Street showing various examples of the bungalow style. Courtesy of the Library of Congress.

an open plan. The original bungalows were built on the East Coast as summer residences, but the full flowering of the style took place on the West Coast, where it was built as a yearround residence.

There were several prototypes for the bungalow style as practiced at the turn of the twentieth century. First, the World's Columbian Exhibition, the "White City" in Chicago in 1893, contained the Louisiana pavilion. This structure, modeled after the oldest house in New Orleans, "Madame John's Legacy" (ca. 1727), displayed Spanish colonial influence though it was raised above the ground to accommodate the wet soil of the area. The raised cottage was found throughout the Louisiana region and created much interest at the Fair because of the renewed nationwide interest in the country's colonial past. As a building, it was vastly different from the large, pretentious white Beaux-Arts structures that dominated the Exhibition. The architect Louis Sullivan also built a bungalow for himself, located at Ocean Springs, Mississippi. The other influence for the bungalow style was Spanish colonial houses found in the Southwest, in New Mexico, and later, in California. These houses were constructed of adobe. (Adobe is loam, sand, clay, straw, and tile chips or other binder, hardened in the sun and covered with a mud coating that was whitewashed annually, creating a protective lime plaster.) The floors and the roofs were tile or wood (Lancaster 1958, 242). Spanish Colonial architecture in California was also more strictly interpreted to become the Mission style, a contemporaneous style also popular in the region.

As a state, California took to developing the bungalow style with abandon. There were two major reasons: first, the warm, dry climate in California provided the resident yearround use of an open, breezy structure. In *Bungalow Architecture from a Layman's Viewpoint,* George A. Clark asserted, "California, on account of its favorable climatic conditions, affords unending opportunity for

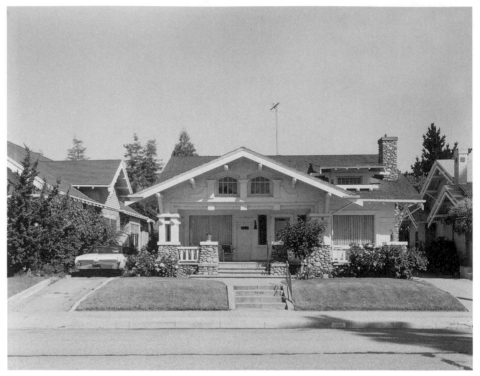

The bungalow style was popular in California. Courtesy of the Library of Congress.

variety in the construction as well as in the architecture of the house, large or small" (Lancaster 1958, 243). The second reason for the style's popularity in California was the area's well-known openness to new ideas. Even in the first years of the state's burgeoning growth, Californians saw themselves as more on the cutting edge in design. The East Coast was considered stodgy, wallowing in the classical revivals and Beaux-Arts affectation, while California was searching for something new, something that would set the area apart architecturally.

The West: Utah, Mormon Polygamous Houses

A peculiar twist on the development of regional housing styles can be seen in the houses built in Utah in the late nineteenth century. Not influenced by geography or economic conditions but by religious dogma, the carpenters and builders of the new towns in Utah had to design houses to accommodate multiple families. Instead of the multiple families found in the tenements in the eastern cities, these were multiple wives and a single husband. This practice, known to the believers of the Church of Jesus Christ of Latter-Day Saints, or Mormons, as "living the principle," is what we know as polygamy. A humorist in the Mormon faith, John Taylor, would tell this tale: "Salt Lake City is a curious place. It's the only town I know where a man can get off the streetcar, head in any direction he chooses, and end up at home." Taylor had six wives. In the years between 1850 and 1900, one out of five Mormon families were polygamous, according to estimates (Carter 2000, 223).

"Living the principle" was considered a commandment from God to the Mormons. The Latter-Day Saints believed that current practice of Christianity had abandoned the true teachings of Christ and harkened back to the early biblical times or "latter days." It was believed that Old Testament figures such as Isaac and Jacob had several wives, and the Mormons wanted to emulate them. In the afterlife, Mormons believed, elders of the Church would be given status through having numerous wives and many children and would lead to "celestial exaltation" (Carter 2000, 225).

The founder of the Church of Jesus Christ of Latter-Day Saints, Joseph Smith, had mixed feelings about polygamy and spent his life alternating between promoting it and condemning it depending on the revelations he was experiencing. Some in the Church decided to follow the practice, though it was condemned by American society. The Mormons were forced to relocate several times from Ohio, to Missouri, to Illinois. Smith was murdered by an angry mob after being arrested in 1844 in Carthage, Illinois, because the secret practice of polygamy within the Church had leaked out. The subsequent leader of the LDS Church, Brigham Young, was a promoter of polygamy. The continuing practice of polygamy among the Mormons in Illinois led to the ouster of the group, finally, in 1846 to the isolated Utah area. In 1852, the policy of polygamy was openly announced.

The growth of the religion and the practice of polygamy created difficulties for the builders of the new communities in Utah. Although there were no official Church suggestions for the layouts of the multiple family houses, several types emerged. The preferred living arrangements were to have the husband

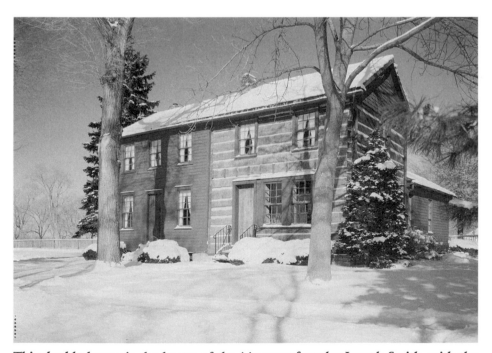

This double house is the house of the Mormon founder Joseph Smith, with the typical two entrances found on the polygamists' houses. Courtesy of the Library of Congress.

run several households in separate houses, sometimes in different towns miles apart. Many of the leaders of the LDS Church had six or more wives scattered around the territory. Other church members didn't have the standing to support multiple wives in multiple towns, and many had two or three wives living in the same community but in separate houses. The ones we shall look at are the families who "went cohab" as it was dubbed at the time, that is, having more than one family living in the same house.

One of the most popular cohabitation arrangements was house design known as the double cell house. This type was common in the eastern states and also found in the West. The house had two front doors with two rooms symmetrically placed on either side of the front doors. Typically this was a single-family house, though it had two front doors. The house was easily converted into a two-family house for the Mormon family with two wives. A wall was built down the middle of the house, and each of the two wives had separate quarters. Another type of house was a Scandinavian design called a "three-part house," where living and dining rooms were used commonly and each side of the house had separate quarters and separate stairs to upstairs bedrooms. Other houses grew with the growth of the family, and as men took on more wives, quarters were added to the existing house, sometimes in different building materials, which differentiated the space.

Although Mormons and later historians prefer to bring attention to the concept of "equal comforts" when discussing the situations of the multiple wives and families of the Mormon polygamists, study of the actual arrangements themselves show otherwise. As men married over and over, the wives were given a variety of accommodations, which may change as time passed. For example, a young man might marry a woman and later in life marry many younger ones. The oldest wife may become the matriarch of the group and may be given a separate house with more autonomy and a more prominent location. Or he may relegate the older wife to a small, less prestigious location, either with other wives or alone. The woman who was the current "first wife" got the greatest benefit, with the man spending the most time with her, building her the most prominent house, and entertaining there. Brigham Young, the most famous of the Mormon polygamists, had 27 wives and 56 children. He was wealthy as the head of the LDS Church and built residential compounds in Salt Lake City and towns throughout Utah. The hierarchy of marriages was evident in the accommodation: the oldest wife, May Ann Angell, lived alone in the White House away from the multifamily Lion House down the street in Salt Lake City. Several other wives had separate houses, though some were more prestigious than others. A young wife Young married in his later years, Amelia Folsom, had a huge Victorian Second Empire mansion in Salt Lake City called Gardo House, which became the official house of the head of the LDS Church. Other wives were relegated to the Lion House, where the hierarchy was very explicit. A huge house built for Young's many other wives, the Lion House resembled a dormitory and functioned like one. The rooms for the women and children were assigned according to how many children the wife produced; more was better, and those wives got the more desirable spaces.

In the nineteenth-century Mormon Church, men owned all the property; women were not allowed to own property. The husband chose when

and where to spend his time. He had the freedom to travel (and often did, to proselytize), while the women were relegated to the house permanently. Women stayed home with the children and took care of the house. They had little control over their husbands. The men were responsible for the financial support of the families. Carter, in his study of the architecture of the Mormon polygamists, compares the design of the cohabitation houses to slave quarters in the antebellum South, or company-provided housing in coal and other one-industry towns, where the "built environment is used to decrease the mobility of workers, thereby increasing capitalists' access to them by making the workers dependent on the company for shelter" (Carter 2000, 250).

Carter makes the comparison of the Mormon architectural interpretation and the typical American household in the late nineteenth century. In his view, though we criticize the Mormons for their polygamy, there isn't that much difference between the multiple-wife Mormon household and the Victorian woman's "cult of domesticity." The idea of separate spheres of activity between the male and female roles, which developed during that time period, also left the wife home, accessible to her husband, while not free to move outside of the household sphere. "Men inhabited the world of work, which was located away from home in the city, while women stayed at home in the newly developing suburb, where they assumed responsibility for managing the household and raising the children but at the same time being increasingly bound to that household and to those children," asserts Carter (2000, 251). The familiar styles used by the Mormons for their architecture reveal a similarity to the homes built in the other parts of the United States at the time. Architectural design reflected styles used elsewhere; location, size, and décor indicated wealth and prominence even within one single polygamous family. "When viewed against the backdrop of the emerging ideal in American domestic architecture—the single-family suburban house—the Mormon polygamous house is exposed not as something pulled out of a hat but as an exaggeration of a fundamental trend toward female isolation and availability that characterized and in many ways continues to characterize the American single-family home itself." The only difference seems to be the second front door (Carter 2000, 251).

Regional Industrial Housing Efforts

Along with the rampant exploitation of workers, the Gilded Age was known for its unrelenting pursuit of moral values in society. The government advanced a laissez-faire policy toward capitalism, and therefore it was left up to private philanthropies to look after the welfare of the working class. In a few cases, however, corporations themselves took responsibility to care for their workers. They reasoned that a happy employee was a productive employee. Of course, from the corporation's viewpoint, the happy employee would also be less likely to join a union, go on strike, or otherwise bring down profits. There were numerous examples of corporate workers' housing built during this period, several in New England. In Cumberland Mills, Maine, the S.D. Warren Company built duplexes and single-family houses for its workers. In Willimantic, Connecticut, a development named Oakgrove was constructed for the Willimantic

Linen Company, from 1865–1884, which included modest but not tiny single-family homes designed in the popular styles of the day. Similar industrial villages sprang up in Hopedale, Massachusetts for the Draper Company, and in Ludlow, Massachusetts for the Ludlow Manufacturing Company. These developments demonstrated the predilection toward the suburban single-family house in order to facilitate the accretion of moral values to the working class. Instead of the earlier workers' housing built in the first half of the nineteenth century, which were tenements of various sorts, these industrialists maintained the modern belief that workers would be more productive if they were afforded the opportunity to live in a private house. The rent for the best of these developments was only 15 percent of the workers' wages. The design of these workers' houses was of the typical vernacular style, that is, the style most common in the area as built by local carpenters, not trained architects. Later, some of the most famous architectural firms would participate in designing workers' housing (Roth 2001).

Reference List

American Institute of Architects (AIA). 2007. "History of the American Institute of Architects." Available at: http://www.aia.org/about_history

Carter, Thomas. 2000. "Living the Principle: Mormon Polygamous Housing in Nineteenth Century Utah." *Winterthur Portfolio* 35(4): 223–251.

Cudworth, Marsha. 1997. *Architectural Self-Guided Tours—Cape May, N.J.* New York: Lady Raspberry Press.

Gelernter, Mark. 1999. *A History of American Architecture—Buildings in their Cultural and Technological Context.* Lebanon, NH: University Press of New England.

Handlin, David P. 1979. *The American Home, Architecture and Society 1815–1915.* Boston: Little Brown and Co.

Handlin, David P. 1985. *American Architecture.* London: Thames and Hudson.

Lancaster, Clay. 1958. "The American Bungalow." *The Art Bulletin* 40(3): 239–253.

McAlester, Virginia, and Lee McAlester. 2000. *A Field Guide to American Houses.* New York: Alfred A. Knopf.

Mumford, Lewis. 1971. *The Brown Decades: A Study of The Arts of America 1865–1895.* New York: Dover Publications.

Poppeliers, John C., S. Allen Chambers, Jr., and Nancy B. Schwartz. 1983. *What Style Is It?* Washington, D.C.: The Preservation Press.

Rhoads, William B. 1976. "The Colonial Revival and American Nationalism." *The Journal of the Society of Architectural Historians* 35(4): 239–254.

Rifkind, Carole. 1980. *A Field Guide to American Architecture.* New York: New American Library.

Roth, Leland M. 2001. *American Architecture—A History.* Boulder, CO: Westview Press.

Scully, Vincent, Jr. 1961. *Modern Architecture—The Architecture of Democracy.* Repr. New York: George Braziller, 1974.

Scully, Vincent J., Jr. 1971. *The Shingle Style and the Stick Style,* rev. ed. New Haven, CT: Yale University Press.

Smeins, Linda E. 1999. *Building An American Identity—Pattern Book Homes and Communities.* Walnut Creek: Altamira Press.

Walker, Lester. 1998. *American Shelter.* Woodstock, NY: The Overlook Press.

Wharton, Edith, and Ogden Codman, Jr. 1897. *The Decoration of Houses.* Repr., New York: W.W. Norton and Company, 1997.

Wiebe, Robert H. 1967. *The Search for Order.* New York: Hill and Wang.

Wright, Gwendolyn. 1980. *Moralism and the Model Home: Domestic Architecture and Cultural Conflict in Chicago, 1873–1913.* Chicago: University of Chicago Press.

Building Materials and Manufacturing

Americans who lived in the last 20 years of the nineteenth century witnessed an explosion of technological advancements that affected the building trades and brought additional comfort and convenience to the homeowner. The Industrial Revolution was revolutionizing methods of manufacturing, and new products were continually being brought to the market. Sawmills, which were now powered by steam instead of water, were able to produce wood products no matter what the season, and the railway network carried the new products on freight trains throughout the nation. Architectural design plan books, trade magazines, and catalogs grew in popularity, making new technologies and products available to the general consumer or tradesman. The inexpensive production of wood and other building products by machine affected the style of contemporary houses as the Victorian fondness for ornament was enabled by the availability of ornate wood gingerbread. The accessibility of cheap lumber from sawmills also influenced construction through a major change in wood framing, with the introduction of the balloon frame. This innovation made the construction of new houses cheaper and easier and furthered the expansion of the suburbs. The electric light bulb was invented in this period, permanently affecting the look and comfort of the home. Indoor plumbing, though technically available before the last two decades of the nineteenth century, became ubiquitous in city and suburban homes by the turn of the twentieth century. Sewers also became a standard amenity in the cities during this era. In this chapter, the effect of technological achievements on how people lived in the last two decades of the nineteenth century will be explored.

An English visitor to Boston described the availability of certain new technologies in the second half of the nineteenth century, when, in 1861, Anthony Trollope wrote;

> In Boston the houses are very spacious and excellent, and they are always furnished with those luxuries which it is so difficult to introduce into an old house. They have hot and cold water pipes into every room, and baths attached to the bed-chambers. It is not only that comfort is increased by such arrangements, but that much labour is saved. In an old English house it will occupy a servant the best part of the day to carry water up and down for a large family. Everything also is spacious, commodious, and well lighted. I certainly think that in house building the Americans have gone beyond us, for even our new houses are not commodious as are theirs. (Ierley 1999, 95)

Described by Trollope, this house was actually ahead of its time. The characteristic house of a middle-class family was not necessarily as up-to-date as described in this quote.

The typical house in 1880 had an ad-hoc assemblage of laborsaving and comfort-producing amenities. Inventors were producing many new products as the nation was growing and the population grew and needed new homes. James Marsden Fitch, architectural historian, stated in his book *American Building—The Historical Forces That Shaped It*:

> [T]he impact of American building during this period was actually more in the hands of a constellation of remarkable outsiders than of the architects themselves: Morse with his telegraph, Bell with his telephone, Otis with his elevator, Goodyear with his gutta-persha [a natural latex developed from East Asian evergreen trees,] Westinghouse with his transformer and airbrake. These men were not necessarily the discoverers of the principles or inventors of the mechanisms they patented . . . [what they] did accomplish, brilliantly, was the conversion of a laboratory curiosity into a socially productive reality . . . It was the cumulative impact of the work of these men, in the years between 1865 and 1900, which completely transformed the character of both our buildings and the landscape in which they stood . . . it was they who were to release building from its centuries-old limitations of size, density, and relationship. Thanks to them, the flow of men, ideas, things, both inside and between buildings, was speeded up to an extraordinary degree. (Fitch 1973, 174)

New technology expanded the possible scale of office buildings and apartment buildings through the invention of the elevator, pneumatic tube, telephone, dictaphone, and loudspeaker. Electric trolleys made possible the growth of suburban developments, as workers could easily live miles away from their urban jobs. The building trades also had to become more specialized due to the increased technology. Heating, ventilation, and sanitation systems were being devised for use in houses and had to be considered by builders and architects in the design phase of a project for the first time in history.

Much of the technology discussed here was available by the 1880s, though it was not necessarily utilized in the middle- or lower-class home. Although houses were being built with all the new gadgets in mind, older houses were still being used that contained none of the new technology. Houses by their

Edward Bellamy (1850–1898)

For a look at Americans' contemporaneous attitudes toward innovation and their own stake in the future of the country at this time, a look at a utopian futurist Edward Bellamy is warranted. Edward Bellamy was a novelist and social reformer from the late nineteenth century. Born in Chicopee Falls, Massachusetts, he became a lawyer, newspaper editor, and later a novelist. He felt a supreme anger at social and economic injustices, of which there were countless during the Gilded Age. In 1888 he wrote the famous utopian novel *Looking Backward*. It became a sensation, and "Bellamy Clubs" sprouted up all over the country. The Populist Party developed a nationwide following based on the ideas put forth by Bellamy.

The novel *Looking Backward* portrayed a future, in the year 2000, where technology was a benevolent force behind a perfected American life. He foresaw numerous advances in technology that have actually come to pass, for instance, abundant electric power, artificial lighting, and air conditioning. In his description of the city of Boston in 2000, Bellamy writes:

At my feet lay a great city. Miles of broad streets, shaded by trees and lined with fine buildings, for the most part not in continuous blocks but set in larger or smaller enclosures, stretched in every direction. Every quarter contained large open squares filled with trees, along which statues glistened and fountains flashed in the late-afternoon sun. Public buildings of a colossal size and architectural grandeur unparalleled in my day raised their stately piles on every side. Surely I had never seen this city nor one comparable to it before. Raising my eyes at last toward the horizon, I looked westward. That blue ribbon winding away to the sunset—was it not the sinuous Charles? I looked east—Boston harbor stretched before me within its headlands, not one of its green islets missing. (Bellamy 1888, 43)

The contemporary city of the day was gritty, dirty, with air pollution from factories spewing out smoke from coal fires, rivers contaminated with raw sewage that poured into them from city sewers, diseases rampant, and stenches ghastly. The city of Boston described by Bellamy was truly a utopian vision. In addition, Bellamy included designs of houses where Victorian clutter was eliminated, and women were able to work outside the home. He wrote about a society, which was utopian and socialist, but also contained all the technological improvements he could think of, based on what was happening in science at the time.

nature can last for hundreds of years and may not be updated with the newest technology for years after becoming available. Also, poorer families occupied old houses and were forced by economic reasons to live in old buildings rented out by greedy landlords. Technology came to the older houses slowly, and by the end of the nineteenth century most dwellings were still without the contemporary modern conveniences. However, in Victorian society, houses were considered substandard if they did not contain the basics of plumbing, heating, and electricity by 1900. Families able to afford a new house aimed to install the newest technology, if possible.

Builders, who wanted to construct their speculation-built homes as rapidly and cheaply as possible, found friends in the new technology and its available products. Professionally trained architects, however, did not. Architects at the time were trained in historical styles and historical design. Changing their perspective in order to accommodate the newer gadgets did not impress them. Many architects were not admirers of new inventions that were created by the Industrial Revolution. They were frequently romantically influenced by the historical styles and not impressed with the modern technology. On the other hand, engineers and other scientifically trained professionals were fascinated by the new technology (Fitch 1973, 180).

Reformer Edward Bellamy presented a popular utopian vision of a socialist, Marxist society, where the centralized government owned all businesses and regulated everything. There were an enormous number of rules governing operation of the society. Why did this appeal so much to the public at the time? As in the Roaring Twenties several decades later, capitalism in the Gilded Age had profoundly run amok. The rich were growing richer, and the poor were destitute. The middle class began to fear that the disease and anger generated in

the poor neighborhoods would infect the whole city. Middle-class families were fleeing to the newly created suburbs in order to live in a safer, cleaner environment. In addition, people were waking up to the belief that society had to be an integrated whole. It was the beginning of the Progressive Era, when reformists started to question a totally unregulated society and its consequences. Bellamy's book appealed to the notion that we are all in this together. Though Marxism never was successful as a major political movement at the time, the influence of the Progressive movement was tremendous, affecting all aspects of society after the turn of the twentieth century.

INNOVATION IN BUILDING MATERIALS

Modern building techniques and innovative building materials revolutionized the construction industry and carpenter's trade in the last two decades of the nineteenth century. The two major factors in the change were both facilitated by the Industrial Revolution: the availability of standard sized, machine-cut lumber created by steam-powered sawmills; and the development of the lighter, more adaptable balloon frame. Other factors were also results of the continuing industrialization of the nation: machine-made bricks and wooden ornamental bric-a-brac, which adorned many late nineteenth-century Queen Anne houses. As Gwendolyn Wright states in her book *Building the Dream,* the Victorian dwelling embodied both an ideal and its antithesis. Though supposedly individualized and expressive, these houses depended on the factory system for their decorative effects and their wide availability (Wright 1983, 100).

Though most houses in the country were made of wood, there were also brick houses found regionally throughout the United States. Bricks were machine-made by the 1870s, and there were several types available: common bricks, which were cheap and durable; dry-pressed bricks, which were more expensive, with a uniform, smooth exterior; thin Roman bricks; and shiny glazed and enamel bricks (Wright 1983, 100). Brick was a material that was only popular in certain areas where timber was inconvenient to obtain and clay was readily available. These cities included Denver, which was 50 miles from forests; and Chicago, which suffered a devastating fire, and thereafter looked for more fire-resistant materials and built many of its late nineteenth-century structures in masonry. However, the typical American building was constructed of wood, or later, steel framing, even when brick was used. The brick was generally used as a facing material. The East Coast and the West Coast preferred houses constructed in wood. Plan book writers most commonly recommended wood in their designs, as wood was becoming even more readily available through the railway network.

Factories were producing many other building materials at the time that helped builders easily add ornament to the houses they constructed. Money saved on heavy timbers could be invested in ornamental gingerbread and other decorative features. Catalogs were circulated throughout the country that listed a variety of presawn wooden detail work. A company named M. A. Disbrow in Lyons, Iowa, produced "elaborate spindle work to span wide doorways, bulls-eye corner blocks for door-frames, turned veranda posts, bay windows, gable decorations that were adjustable to the pitch of the gabled porches and other familiar feature of late nineteenth-century houses were designed to appear hand-produced" (Smeins 1999, 77). In 1887, *American Builder* added that "Modern

houses are put up pretty much as Solomon's temple was, the parts are brought together all prepared and fitted, and it is short and easy work to put them together" (Smeins 1999, 77).

BALLOON FRAMING

One of the factors that continued to influence construction methods at the end of the nineteenth century was the invention of a new type of framing system, dubbed balloon framing in Chicago in 1833. The traditional building technique for wood structures in the United States, imported from Europe, had been the post and beam or timber framing. The heavy timber framing used in the United States for house construction was identical to medieval techniques used in Europe for centuries. (Another form of construction found in the United States was log cabin construction, which was imported from Northern Europe, not England. This technique was traditional in Scandinavia and Germany and was imported to the middle Atlantic colonies. It was transported out to the Middle and Far West and became the typical wilderness house as the country expanded out West.) The post-and-beam framing method consisted of heavy, hand-hewn beams placed far apart. The beams all had to be extremely thick, because the beams were connected by hand-hewn joints, like mortise and tenons, and dovetails. Structural engineering class teaches that a beam is only as strong as its weakest part. The weakest part is the joint, because the beam has to be cut down in order to fit into the other, adjoining beam. In order to create a strong enough structure, the beams had to be oversized, usually 4 by 4 inches or 4 by 6 inches for the upright posts. At the time, beams that were called 4 by 4 were actually that size. In the twenty-first century, dimensional lumber that is still called 4 by 4 is actually significantly smaller. The large size of the beams was not a concern here in the early colonial period, because the United States was replete with forests with large trees.

The construction of a house with timber, or post and beam construction required a large crew of construction workers and was bulky and work-intensive. In addition, the design of the house was constrained by the structural members themselves. The house was generally rectangular; and any deviation from the rectangle required much work and planning. The designs of the late nineteenth century, for instance Queen Anne and other styles, which had more interesting obtrusions, were certainly influenced by the invention of balloon framing. Such changes would not have been possible without the new technique.

New Techniques and Tools for Balloon Framing

The introduction of the balloon frame led to a change in both the manner of building and the tools used. The writer George Woodward, who wrote many architectural plan books, stated in 1869 when balloon framing was a relatively new technique, "A man and a boy can now attain the same results, with ease, that twenty men could on an old-fashioned frame" (Schweitzer and Davis 1990, 53). Other tools also changed with the new technology. Whereas the heavy timber construction required the use of many traditional tools, such as the ax, adze, hatchet, chisel, pit saw, jack, drawknives, plane, gouge, auger, peg, and piercer, the balloon frame requires totally different tools: nails, hammers, handsaws, sawhorses, and so forth (Schweitzer and Davis 1990, 53).

Manufactured nails were available in the United States as early as the Revolutionary War and were common by 1830. However, they were not round nails but flat nails, made from sheet metal, and they were not easy to use for construction. Round nails were first available in Europe in the 1850s but were not the most common nail here in the United States until the 1890s. Round nails are made from steel wire and are manufactured that way to this day. Additionally, steam-powered sawmills could mass-produce two-inch by four-inch lumber much more effectively than the previously used water-powered ones. The steam-powered sawmill could be run yearround, whereas the water-powered one had to shut down due to freezing.

Another factor in the development of balloon framing was the invention of the steel carpenter's square around 1860. The tool is necessary in order to square up a frame, in other words, build a frame exactly level and at right angles. The carpenter's square also allowed for easy measuring of the 16-inch spaces between studs required for balloon framing. A book written in 1879, *The Steel Square and its Uses,* sold many copies as the popularity of the technique grew.

Equally important, the modern balloon-framing tradesmen had to have the academic skill of geometry, instead of the skill of woodcutting necessary for timber framing. The new houses, with light framing as well as all the gingerbread popular on the house, required the carpenter to figure out the angles and cuts. Many of the popular plan books of the day educated carpenters on the skill of geometry. One could say that the introduction of balloon framing brought down the manual skill level required for construction in the same way that the Industrial Revolution brought down the skill level of other trades. As manufacturing became more mechanized and more standardized, the skilled worker became less necessary and the factory worker required less skill. A late nineteenth-century carpenter, likewise, required less manual dexterity to build the new balloon frame houses. Manual dexterity, however, was replaced by a requirement of mathematics skill previously not essential.

Houses were constructed with earlier timber framing techniques until well into the nineteenth century. Many historians believed that the new balloon framing technique was utilized commonly after the introduction of the technique in 1833. However, this is not true. Carpentry books do not demonstrate the use of balloon framing until the 1880s. Surprisingly, the old technique of timber framing was still in use in the United States as late as the 1930s, especially in New England. Statistics show that in 1940, only 60–80 percent of American houses were built with balloon framing (or its later version, platform framing; Schweitzer and Davis 1990, 50). Architects, who were becoming a profession at the time, tried to differentiate themselves from builders, who were following plan book designs and successfully building houses all over the country. Trained architects did not recommend the use of balloon framing, contending that it was too light to build a solid house. The balloon-framed houses were considered flimsy by many architects of the day. Builders, however, looked to the latest and most efficient building techniques in order to save time and money.

The Importance of Balloon Framing

The balloon frame revolutionized American house construction, though it took many years to be universally accepted. Kenneth Jackson, in his book

Crabgrass Frontier, contends that the new framing system was as important as mass transportation in making the private house available for middle-income families and even those of lower-income status (Jackson 1985). Architectural writers in East Coast journals like the *American Architect* maligned balloon frame construction and insisted the houses would not last 10 years. The framing recommended by the *American Architect* was traditional mortise and tenon timber framing, which they considered more durable. The architects on the West Coast, however, in their writing for *California Architect,* insisted that most of their houses had been built with balloon frame for several decades and were still standing. Houses built with balloon framing were more durable than they seemed, and by spreading the stress over a large number of light boards of a few sizes, the balloon frame had a much greater strength than it seemed (Jackson 1985). The balloon frame had an influence over the development of the United States, for many working-class families and recent immigrants were able to build their own houses or afford to have one built for them. Whereas in Europe, homeownership was not at all common at this time, in the United States it was growing at a fast pace. Europe never adopted the balloon framing system.

The history of balloon framing was not over by the end of the nineteenth century. Although the method transformed construction techniques and allowed for a more flexible plan at a cheaper price, it also created other concerns. Architects who were typically conservative in their contention that the balloon frame would not stand up for years were wrong. At least structurally, the houses were not flimsy. However, another problem arose. Health and safety professions, which were developing at the time, discovered that the balloon frame was not safe in a fire. Whereas the older post-and-beam type of frame would withstand a fire for a longer period, as the heavy beams took a long time to burn, the newer system caught on fire immediately, and the light members carried the fire throughout the house up to the roof, and houses burned down rapidly. Though the old timber construction was never resurrected, a hybrid type of framing system was devised in the early twentieth century dubbed platform framing. This method is still used today. Here, the small vertical members called studs are still used, but a larger horizontal member, or platform, is placed at each story so that each floor is basically a unit of framing unto itself. The risk of fire was reduced as the platform could contain the fire on one floor for a longer time.

INDOOR PLUMBING

The technological achievements of the nineteenth century completely altered the comfort, convenience, and cleanliness of contemporary homes and of their inhabitants. The inclusion of indoor plumbing changed the interior layout of the typical American house by the end of the century, as well as the habits of the homeowners. From the perspective of the twenty-first century, it seems surprising that indoor plumbing was one of the first technological achievements of the era. It was a feat that was incorporated into the home in fits and starts, yet the technology was actually available long before most people realize. It is also a topic that was not discussed in history books for many years because of its personal nature. Now, happily, along with the study of material culture and the interest in design as it relates to society, a number of scholarly

books have been written that study the history of indoor plumbing and the development of the modern bathroom.

The invention of indoor water supply goes back to ancient times in Europe. Personal cleanliness was held in high esteem in many ancient civilizations. The Greeks had water supply systems with pipes that were both below ground and elevated. Rome built extensive waterworks systems, including reservoirs, aqueducts, and catch basins. There were also water drainage systems in Rome that drained both wastewater and sewage through *cloacae*. However, bathing has had a checkered history in western culture. By the Middle Ages, personal bathing was discouraged, especially public bathing. The Roman aqueducts were abandoned. The population obtained their water from cisterns and wells. Although pumps were invented in the fifteenth and sixteenth centuries to serve the growing European urban centers, the water pumped was filthy river water. Hollowed-out logs were the pipes used all the way through the medieval era up until the nineteenth century. Cast iron was invented and began to be used for water pipes in the early nineteenth century. Most piping carried water from upland sources through gravity. However, sewage disposal continued to be done through cesspools, even in the cities, until the mid-nineteenth century.

Surprisingly, the toilet also has a long and storied history. The first water closet (the original moniker for the modern toilet) used a valve, amazingly, and was invented by the godson of Queen Elizabeth I as early as 1596. However, the patent for the device was not executed until the late 1700s when several inventors came up with similar valve closets. This design, by way of Joseph Bramah, was used for 100 years. Water closets were the first of our modern bathroom fixtures to become common in English households. Bathtubs and sinks were much later installations. This is also true in American households. In fact, the daily bath was not typical in the early years of the United States. Families that did install bathtubs, in the first half of the nineteenth century, took several baths in a row without changing the water. Soap was not typically used until late in the century.

With the arrival of the Victorian age in the United States in the middle of the nineteenth century, cleanliness had become a sign of class stature. People in the middle and upper classes developed concern with keeping themselves clean. Bushman and Bushman, in *The Early History of Cleanliness of America* state:

> Cleanliness had social power because it was a moral ideal and thus a standard of judgment. Cleanliness values bore on all who wished to better their lives or felt the sting of invidious class comparisons. Dirty hands, greasy clothes, offensive odors, grime on the skin—all entered into complex judgments about the social position of the dirty person and actually about his or her moral worth. By the middle of the nineteenth century, among the middle class, anyway, personal cleanliness ranked as a mark of moral superiority and dirtiness as a sign of degradation. Cleanliness indicated control, spiritual refinement, breeding; the unclean were vulgar, coarse, animalistic. A dirty person evoked one of the most powerful of social forces—scorn. (Bushman and Bushman 1988, 1228)

Indoor Plumbing in the Mid-Nineteenth Century

In American households, by the 1840s, only the wealthier families had indoor plumbing, which consisted of a single faucet usually in the back of the

house in the kitchen. Water closets were also found in these more prominent houses, served by the same supply pipe. The wastewater was sent through brick or log pipes into outside cesspools (Stone 1979, 286). Also in the 1840s, magazines began to feature plumbing fixtures and discussions about indoor running water. In popular architectural plan books of the mid-nineteenth century, designers displayed house plans and elevations and added domestic and architectural advice. In addition, the house plans included descriptions of plumbing installations and detailed discussions on what to buy and how to install it (Ogle 2000, 8).

By the 1840s, a well-to-do household may have had wood washtubs, a lead-lined sink, one or two water closets, a bathtub lined with lead, and several washstands. The washstands did not have running water and were usually in the bedrooms. The prevailing custom in the United States until the late century was to have a washbasin in the bedroom. Having a bathroom for washing and eliminating was a new concept. However, by 1860, a water closet was not rare. For instance, there were 10,000 water closets in New York City. Bathtubs were also making an appearance into the wealthier homes. For supply, a tank in the attic provided indoor running water. How did the water get to the house, and where did water come from for the indoor plumbing? Many towns had no central water supply. If no water supply was available, then water was collected for the house in other ways. One method was the collection of water in a cistern at the back of the house from rainwater. A large tank, fed by water from the roof served as water for the house. Another tank in the attic provided water for the bathroom. Water was pumped into the house with a force pump.

By the 1880s, the state of indoor plumbing in American homes had improved slightly. In fact, the manufacture of plumbing parts was a booming industry by the 1880s. By this time, middle-class houses were being built with flush toilets, porcelain sinks, and zinc-lined bathtubs. However, these were still the newest of modern conveniences. Most houses still boasted a simple kitchen pump, and hot water heated on the stove. The most common form of sanitation in the 1880s was an earth closet, not a water closet. The earth closet used soil instead of water to cover up, not dispose of the waste, similar to today's cat litter box. They had to be cleaned out regularly. Many houses also had bathtubs that folded out from the wall and water was poured into it from the kitchen tap heated on the stove. Families with enough resources had the servants carry water upstairs and down for the bath and change the soil in the earth closet. Otherwise, it was left to the housewife to do the dirty work (Wright 1983, 102).

Municipal Waterworks in the Mid-Nineteenth Century

It is not common today for a homeowner's water supply to come from their own water collection device, such as by cistern or by a tank installed on the owner's property, but it was often the case in the nineteenth century. Water works, including huge reservoirs, aqueducts, and outdoor water supply pipes, were being constructed in the large cities in the United States by the middle of the nineteenth century. However, the first waterworks were built in cities in the early nineteenth century in order to provide protection from fire and also to provide water to industry. The first uses of the municipal water supply were

industrial. Society did not even contemplate municipal water for domestic use. Nevertheless, the number of indoor running water installations and the typical family's interest in its installation was evident in rural, suburban, and village communities where municipal water supply was long in coming. Whereas plumbing installations were found in individual houses on an ad-hoc basis, the construction of waterworks in cities was motivated by the need for fire fighting, street cleaning, and manufacturing (Ogle 2000, 9).

We think of modern household plumbing as an integrated system of water supply, sewer system, and indoor plumbing. However, in the nineteenth century, it was not generally linked in collective mind. The first development of indoor plumbing systems took place in the 1840s, and their major purpose was to provide comfort for the inhabitants. Convenience was the watchword of the designers of indoor plumbing, not disease prevention or sanitation. Decades later, after the 1870s, science discovered the cause of much disease was bacteria, and the "sanitary revolution" began.

Why was plumbing important to the eventual construction and design of houses in the late nineteenth century? There were a number of factors that led to the ubiquity of the indoor bathtub and indoor toilet and sink. There was a concurrent interest in the installation of indoor bathtubs, as well as indoor toilets or water closets, during the last half of the nineteenth century. The Victorian culture influenced Americans to want to bathe more regularly, and the installation of indoor running water made that more possible. The availability of indoor running water also made possible the installation of water closets. However, the installation of indoor plumbing in the houses of the poor was slow to come. By 1906, in Pittsburgh there were still only one in five dwellings that contained an indoor bathtub. Most people were still carrying water into their homes (Bushman and Bushman 1988, 1231).

Growth of the Plumbing Profession

Because of the burgeoning interest in indoor plumbing, by the mid-nineteenth century plumbers became important tradesmen. The root of the word *plumber* is the Latin *plumbum,* which means the metal "lead." Plumber in the fourteenth century meant an artisan who worked in lead. Household pipes were manufactured from lead, though it was later discovered that lead was not a healthy product for carrying drinking water. The name plumber continued to be used even after the use of lead of was discontinued (see http://www.word-detective.com/052699.html).

The first tasks of the nineteenth-century plumber were the installation of mechanical water closets (toilets) and cast iron bathtubs. Other fixtures, such as the earthenware washbasins, were purchased from exporters. Plumbers, who were usually trained as apprentices in shops owned by master plumbers, did the installation of the piping pumps and cisterns (Ogle 2000, 6).

Change in Attitude Toward Proper Sanitation after the Civil War

In England and other parts of Europe, in the middle years of the nineteenth century public health became an important issue for society to address. Industrialization had brought many ills to society that encouraged contemporary scientists to try to find the cause and the solution to the terrible disease and death

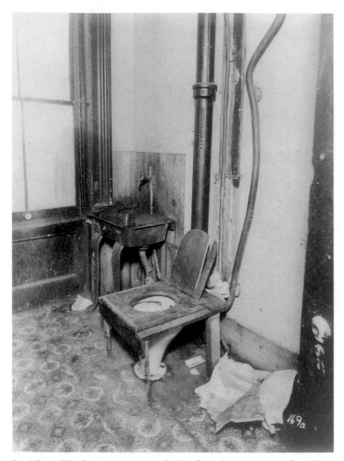

In New York, tenements built for the poorest families were among the first homes to have indoor plumbing in order to replace the unsanitary backyard privies. Generally, two apartments had to share one toilet and sink, whereas the bathing took place in the kitchen. Courtesy of the Library of Congress.

that stalked the large urban centers. However, in the United States it was not a popular cause, at least until after the Civil War. Many houses had indoor plumbing; in fact, there was more plumbing in the United States than in any other country. Americans considered the luxury of having indoor running water to be a wonderful convenience and wanted to have it installed any way possible.

After the Civil War, the United States began to turn away from the romanticism of the first half of the nineteenth century and began to face reality about their society. The War had left Americans battle-scarred, and they had to look at what technology was doing to society as a whole. Epidemics plagued the urban areas in the mid-nineteenth century. Though Boards of Health were set up during this time as a response to a recent epidemic, they were subsequently abandoned. Only in 1866, when New York City formed the Metropolitan Board of Health, did other cities follow New York's lead. In 1850, New York, Boston, Chicago, and Philadelphia were the only municipalities that had any sort of public water supply. The cause of the lax oversight by municipal governments can be seen in the basic ineffectiveness of local governments of the time. Because of the traditional mistrust of government in the United States, cities and towns had weak centralized governments. Mayors were merely figureheads; police and other city workers were appointed as payoffs. Corruption was rampant in government, and private industry ruled the roost in real estate speculation. Regulation was uncommon. Most services, if provided at all, were provided by private firms. Of course, private firms had no authority to condemn land and had no incentive to provide services to the poor who could not pay the high prices. When progressives and reformers influenced ideas about government in the last years of the century, the situation changed, and by 1900, only 9 of the 50 largest cities in the United States had privately owned water supplies (Schultz and McShane 1978, 393).

In their inimitable way, Americans had thought of themselves as exempt from the evils of industrialization seen in Europe. The late nineteenth century brought a realization that the same issues were becoming endemic in

American society. What could alleviate these ills was science and technology. The nation's cities were the crucible of this progress, a place where technology and science were necessary components for the management of the hordes of new residents and the growth of industry and building. Regulations, codes, and infrastructure were products of urban environments and were necessary there. In New York City, after the draft riots in 1863, society began to focus on the misery in the slums of the city. In 1864, an association was formed to conduct a survey based on English methods to study sanitary conditions in New York City. The report was published in 1865 and showed very unsanitary conditions throughout the city. Fear of a cholera epidemic led reformers to pass a law in 1866 called the Metropolitan Health Law, which became a model for later legislation throughout the country. In 1879, the Tenement House Law, passed by New York State, gave power to the Board of Health for construction and design issues. Mortality was high in New York City in the 1870s. Although Pasteur believed that bacteria caused diseases, most American scientists did not believe in the germ theory. The so-called miasmatic theory contended that diseases were spontaneously created through decomposing filth, which generated zymotic diseases. People believed that sewer gases were the cause of disease, though it is now understood that they are not the direct causes of disease; actually, bacteria are.

However, the poor design and installation of plumbing systems in American houses did lead to unsanitary conditions and a profession called "sanitary engineer" was born. Most sanitary engineering experts were British, and most of the early literature was published in England. The first American to take up this cause was George E. Waring, Jr., who was trained as an agricultural chemist. His first book on the sanitation subject was published in 1878 and called *The Sanitary Drainage of Houses and Towns.* He wrote many other books and articles on the topic and had a great influence on the field during the last 20 years of the century. He was an expert on drainage and sewerage, and was the New York City Commissioner of street cleaning from 1895–1897. Waring's assistant, Paul Gerhard, became the leading expert on sanitary engineering from the 1880s to the 1920s. Waring claimed that the modern conveniences of indoor plumbing were dangerous and unhealthy. He wrote about the wealthy homeowner, who, in the middle of the century, installed various plumbing fixtures attached to jury-rigged waste disposal methods. The plumbing fixtures made for convenience for the family, but lack of knowledge of sanitation and germs precluded the installers from properly fitting the plumbing fixtures with appropriate wastewater disposal.

After years of using these types of fixtures, many unsanitary conditions were created. With the use of cesspools, cisterns, and pumps to bring water to and from the house, the conditions created were ominous. The cesspool could contaminate the well; the soil pipe could crack and leak into the foundation wall. Plumbers attached water pipes to joists within the house, and as the house settled, the pipes cracked, allowing gases to come out. The sewer gases ate away at the lead pipes, which created small holes through which sewer gases could be emitted. The solid wastes of the pipes were never completely flushed out and clung to the sides of the pipes, which created more gases. Plumbers did not traditionally install traps except at the water closet, but that one was often without water due to lack of ventilation in the system (Ogle 2000, 121).

Sanitarians' Belief in Science

A group of northeastern intellectuals started an organization in 1865 called the American Social Science Association. They believed in the use of the scientific method for the eradication of society's problems. Science gained relevance as the population turned to it in order to solve society's problems. Life was becoming more complicated, and use of the scientific method discouraged reliance on opinion or supernaturalism. Science was also becoming specialized. The scientists, however, wanted to impart their knowledge to the general public, and came up with ideas such as the magazine *Popular Science*. Scientism and the growing professionalization of trades combined to produce a new group of scientists, called sanitarians, who described their work as sanitary science. In 1872, a group of physicians, engineers, professors, architects, and others started an organization called the American Public Health Association. This group tackled topics such as municipal waste removal, diseases, and factory requirements for sanitary food production (Ogle 2000, 103).

The members of this group believed in research and the scientific method. Sanitarians rejected the perception that disease was caused by moral turpitude, or a punishment by God. Many sanitarians were trained in medicine, and some were practicing physicians. They understood that disease was caused by something specific, whether germs, or other causes. They aimed to investigate and identify the causes of diseases, and fully believed that the troublesome diseases of the day were preventable using the proper scientific techniques. Because sanitarians believed, in the late nineteenth century, that sewer gases were responsible for many of the diseases rampant in the cities, they did not approve of the traditional construction of the sewers, which were originally built to carry off storm water, not wastewater, and did not efficiently dispose of the solid waste.

The understanding of the source of disease-creating bacteria led sanitarians to complain that individual solutions to wastewater in houses were a health danger. They encouraged the use of sanitary appliances, which avoided the dirty pipes and waste disposal methods commonly practiced (Ogle 2000, 120). Not only the poor, but also the well-to-do, who were the most likely to have these cobbled-together plumbing systems in their houses, were criticized by the sanitarians as contributing to health dangers.

The journal *Sanitary Engineer*, later called *Engineering Record*, was launched in 1877 after a plumbing supplies manufacturer decided that the typical plumbing installation in the United States was faulty and dangerous. The journal became a big hit not only with plumbers who learned how to properly install indoor plumbing with drains and traps, but also with the general public who were also developing a growing interest in the topic. Plumbing regulations were passed in the cities of New York and Brooklyn in 1881. Other publications also popularized the cause of sanitation in the 1880s.

Cities built municipal waterworks, most being constructed during the years between 1870 and 1890. They replaced the catch-as-catch-can systems of water delivery found in cities and towns in the first half of the century. These new systems carried water from far away in huge pipes that had high-pressure pumps and provided an integrated system. Sewer systems were also constructed during this time. A study produced in 1879 in Chicago contended that the existence of sewer systems were linked to lower mortality rates in urban areas. And therefore, interest in the sanitation movement led to the urge to bring clean sewer disposal to cities and towns. Although the severe national depression in the 1870s delayed much of the municipal sewer construction, it picked up in the 1880s, and by 1900, most cities provided underground sewer systems to their residents. Cities were forced to reorganize their budgets after the 1870s economic disaster and began increasing taxes and fees, which allowed them to construct a variety of municipal projects, including water and sewer mains and electrical lines, as well as other urban amenities (Ogle 2000, 96).

Whereas the suburban house had its own problems with sanitation, the city dweller was worse off. The homeowners who connected their existing plumbing

fixtures to the new sewer lines were in even more trouble. The temperature differences between sewers and houses produced a strong air current, which pushed sewer gases past the trap and into the household air. In heavy rain, the gases were worse, as the water displaced the sewer air and pushed it up and into the house. In the 1880s, James Bayles issued five editions of the book *House Drainage and Water Service,* the first American book tackling the subject of house sanitation. It was used for architects and engineers to help them understand the sanitary construction of indoor plumbing. It also was the first time an American had applied the principles mostly invented in England for indoor sanitation.

By the 1880s, the actual fixtures were changed, with tubs and water closets being designed with open bottoms instead of enclosed with wood. And by 1890, the sanitarians developed a method of designing indoor plumbing safely and efficiently. They considered plumbing to be a system of water transfer and disposal, as opposed to the previous use in the mid-century of plumbing as a water storage system.

Regulation of Plumbing in the Late Nineteenth Century

The trade of plumbing changed in the 1870s as the scientific study of sanitation led to criticism of the traditional plumber. First, the construction of water systems meant that homeowners no longer required individual cisterns and pumps for their indoor plumbing needs. The field also developed a new system of threaded wrought-iron pipe. The trade now required less skill. Sanitarians blamed plumbers for being the major perpetrators of household's unsanitary conditions. In response, the master plumbers organized themselves into trade organizations. In the 1880s, plumbers formed trade unions and sided with the scientific view of plumbing.

Though suffering a poor reputation in the 1870s, plumbers in the 1880s were becoming more professionalized. The City of New York required all plumbers to be certified in 1881, as well as all work to be approved by the city. These were the most advanced practices on the nation, and were soon copied by other cities. Though all work had to be approved after 1882, all installations done before that date were still of the inferior variety, and therefore there were many improperly installed drains and traps in the houses of the city. This condition remained for many years until older buildings were renovated.

By the 1880s, plumbers were aware of the issue of sanitation in installing indoor plumbing and understood traps, sewer gases, and ventilation pipes. By the 1890s, the conversation had changed, and by then the necessity of regulating plumbers and their installations was well known. The question became: Who was going to regulate it? Local governments were gaining power due to the influence of the Progressive movement. In general, the power fell to the municipal governments to regulate installations, monitor construction, and manage the water and sewer systems. So-called domestic science, later to be dubbed home economics, emphasized science and efficiency in American homes. As plumbing fixtures became more sanitary, produced out of porcelain and easily cleaned, American manufacturers began advertising the new fixtures in women's magazines as evidence of the new technology for a clean, efficient home. Public health as a profession grew in specialization, as trained

physicians, instead of architects and engineers, were the major influence. Germ theory was advancing in popularity, and doctors investigated the use of vaccines to prevent disease. The development of plumbing codes had a beneficial effect on urban problems.

Improvements in Household Plumbing

Sewage systems were regulated in the cities before indoor plumbing was. However, the knowledge that the piping installed in houses actually created a dangerous condition led the sanitarians to push for standardization of those installations. In the journal *Plumber and Sanitary Engineer,* the editor Charles Wingate wrote: "The regulation of street drainage has a long time been considered a proper function of city government among civilized communities, while the details of house drains have . . . been left for each builder and owner to follow his own devices . . . in the modern city . . . no man has a right to do, even in the privacy of his own house, what would imperil the welfare of his neighbors" (Ogle 2000, 145).

In the 1860s, a Board of Health was created in New York City, but it had only the power to regulate indoor plumbing installations in tenements. Houses considered private were not required to follow standardizes practices. The city discovered, however, that the death rate due to unsanitary plumbing installations decreased in tenement buildings but increased in private houses. This fact led to a push to give the Board of Health the power to regulate indoor house pipes and drains even in private homes. And although the Croton Dam and huge aqueducts connected New York City to fresh water from Westchester County by 1843, the system for wastewater was far less organized. There were some sewer pipes, but they were not constructed properly and many were not connected to any sewer.

Use of water in New York increased immensely in the years between 1859 and 1880, from 40 gallons to 78 gallons daily per capita usage. The Department of Public Works was created in New York City in 1870. They standardized the construction of plumbing connections and did other modernizations. They also tried to improve the sewer conditions throughout the city. By 1891, Emmons Clark, secretary of the Board of Health in New York, declared cesspools and privies eliminated from the city (Stone 1979, 294).

By the 1880s, plumbing codes were created in cities around the country. In Denver, laws were passed requiring all new construction to have plumbing plans approved by the city engineer. Only registered plumbers could perform the work. Pipes were required to be made from iron and had to be laid at a certain downward flow. Each fixture in the house had to have a separate trap, and each water closet had to have a separate water cistern (Ogle 2000, 147). Other cities passed similar laws in the 1880s.

The standardization of indoor plumbing occurred in the 1890s. The influence of the sanitarians was crucial to the development of municipal waterworks and laws regarding safe water delivery and disposal systems. By 1900, building and plumbing codes had been developed so that houses that were built at that time had bathroom fixtures and disposal methods similar to those used today. The influence of the sanitarians was part of the American belief in standardization being seen in various facets of American society. The country was turning

away from unregulated, romantic individualism seen before the Civil War and toward the more integrated, disciplined approach of the Progressive Era.

Society was beginning to be seen as interdependent, and science was gaining in importance. Regulations were becoming a crucial part of government policy. With the announcement of the end of the frontier, Americans were realizing that the country was no longer expanding forever, and the influx of immigrants into existing cities bringing poverty and disease to their midst brought home the realization that society was totally interreliant. As evidence of the reliance on science to take care of society's expanding needs, Americans who had the money were extremely proud of their new indoor plumbing. Bathrooms were built in gleaming white tile with the various fixtures proudly on display. Whereas, in the previous decades, families may have had haphazard plumbing in their houses, they were not talked about much or on display (and were probably not at all sanitary either).

The fact that water closets and running water were available in the mid-nineteenth century in the United States is just the beginning to the story of household indoor plumbing. Americans, in their individualistic way, devised idiosyncratic methods of providing the convenience of the toilet, sink, and bathtub. But the problem of sanitation was not addressed until the last part of the century, when urban problems led scientists to investigate the cause of the horrible health conditions and diseases. This brought about the science of sanitation, which profoundly shaped the methods of construction and the trade of plumbing, and which has not been changed much since.

ELECTRIC LIGHTING

Artificial Lighting before the Age of Electricity

The innovation of electrical lighting was available in 1880, as evidenced by the construction of the estate Cragside, by the English industrialist and arms manufacturer Lord Armstrong. The architect who designed it was Norman Shaw, one of the most famous English architects of the period, and the house included electric lighting, room-to-room telephones, central heat, and two hydraulic elevators. (Strangely enough, Shaw, however, did not include any of these technologies in any of his subsequent house designs. Architects of the period were not proponents of using the newest technology. The only reason that the "latest and the greatest" were included in Armstrong's house was that Armstrong demanded it and contacted contractors who were able to provide the technology [Rybczynski 1986, 147].) Earlier, in the 1860s and 1870s, the only artificial energy available for domestic use was gas. Whereas steam was available to run factories, trains, and steamships, none was available for domestic application. What the public yearned for were two things: better sources of light and heat for their homes.

Artificial light has been a perennial need as human beings built houses and winter brought early darkness. The history of artificial lighting began with the invention of wax candles. The Phoenicians used wax candles before A.D. 400. In medieval times, crude oil lamps and torches were also utilized to provide artificial light. Although candles were the best artificial source of light, they actually gave off very poor light. The light flickered and was too dim to read by. In addition, the candles had to be lighted and snuffed, and care had to be taken to

prevent fires. In the eighteenth century, candles were made from tallow, an animal fat. Beeswax candles were available but could only be afforded by the well to do. The smoke from the tallow candles irritated the eyes and smelled acrid.

In 1783, Ami Argand, a Swiss physicist, invented a new type of oil lamp called the Argand Lamp. This lamp revolutionized home lighting, for it could be put on a table and gave off enough light to allow for reading or playing a game. The lamps became very popular in Europe and the United States. The French Astral lamp gave off a circular light from a ring-like reservoir in the base of the lamp. Bernard Carcel invented another version of the lamp in 1800 with a pump that fed oil from a reservoir at the base to the wick, which produced a light whose flickering was less pronounced.

By the mid-nineteenth century, inventors began searching for better fuels for lamps. The United States used whale oil, and Europe used colza oil, from a turnip-like vegetable, and camphine, a product of turpentine. In 1858, a Canadian, Abraham Gesner, patented kerosene, a fuel made from extraction of asphalt rock. It was cleaner and cheaper than whale oil. It was also much cleaner and brighter than any other oil. (Surprisingly, though gasoline was a by-product of kerosene, it wasn't commonly used until the early twentieth century. Gasoline was considered a useless product during the nineteenth century.) The popularity of the kerosene lamp led to the drive for even better artificial illumination. Although the light produced by the kerosene lamps was much improved, the lamps still required plenty of maintenance: cleaning, refilling, and trimming. They also produced heat and soot. In addition, they were highly flammable and were responsible for many fires.

The next improvement in the artificial light game was gas light, which was very popular after the Civil War in the United States. In the early years of gas light, Americans were afraid to use gas for light in the home because it was considered dangerous. The gas did not completely burn, produced a noxious odor, and induced drowsiness. Gas lit rooms had to be ventilated. Factories and public buildings used gas light because the larger spaces could ventilate the fumes more easily. Candlelight was still used for many years after the introduction of coal gas, because it was inexpensive and did not produce unpleasant smells. It was not until the invention of the atmospheric burner, which burned the gas completely, in addition to the technology of purification of coal gas, that Americans were convinced to turn to gas light in the home. The noxious odors were nearly eliminated, and the gas was able to provide a brighter light.

Even with the improvements, soot was still a side effect of using gaslight. The soot dirtied the ceilings, draperies, and furniture. This effect led to the annual ritual of spring cleaning. The fabrics were taken out and aired, while the ceilings and walls were washed or even repainted. But the middle-class consumer desired the improved lighting provided by the gas light, and dealt with the dirty side effects (Rybczynski 1986, 141).

The invention of gas light revolutionized middle-class living in the United States. From 1855–1895, the amount of light (candlepower) available in a typical Philadelphia household increased 20 times (Rybczynski 1986, 142). One gas light produced the light of 12 candles. The increase in light led to improved reading skills, as citizens were able to read at night. This produced increased literacy in the United States. People were also more concerned with cleanliness; because of increased light levels, families were better able to see dirt. (This

coincided with the scientific advances in sanitation and interest in cleanliness due to the popularity of the two theories of disease: the germ theory and the miasmatic theory. Although the germ theory was eventually proven correct, the ideas behind the miasmatic theory, which advanced the importance of ventilation, also were a factor in the cleanliness mania that was rampant in the last years of the nineteenth century.)

Gas light was primarily a middle-class and urban technology. Although it was invented early in the century, gas light did not become very common in middle-class houses until the 1870s and 1880s. The use of gas was dependent on the construction of gas lines and the investment in gasworks by large utility companies. The first city to build a gasworks was Baltimore in 1816. Although there were problems in the beginning, by the 1830s the town had 100 street lamps and 3,000 private customers. New Orleans was also one of the first cities to have a gasworks, and the middle-class population used gas light frequently in their houses. New York had its first gasworks in 1823, called the New York Gas Light Company. It obtained a franchise to lay pipe in lower Manhattan from Canal Street to the Battery. By 1827, the New York Gas Light Company started lighting the streets with gas lights on light poles that it had provided.

New housing developments in the far-flung areas surrounding the cities were soon provided with gasworks and gas lines. The popularity of the product increased with its availability. Surprisingly, however, the use of gas for stoves was not popular until the turn of the century. Families continued to use coal or wood stoves, which sat apart from the other areas of the kitchen, and so integrated work areas in kitchens were not seen in the United States until later.

Although the middle class was using gas light in the 1880s, the poor still had no interior lighting, with the exception of one oil or kerosene lamp, which they moved around as needed in the house. Gas light was popular for both the middle class and wealthy in the United States. In England, however, the wealthy, in a fit of reverse snobbery, shunned the use of the bourgeois technology and even up to the last part of the century built large estates without bathrooms or artificial light (Rybczynski 1986, 143).

Invention of Electricity

Thomas Edison and Joseph Swan, working independently in the United States and England, invented the carbon-filament light bulb. Humphry Davy invented the very first electric light bulb in 1800 in England. The light was produced with a fragment of carbon and an electric battery. Both Sir Joseph Wilson Swan and Thomas Alva Edison experimented with thousands of different filaments to find just the right materials to glow well and be long lasting. In 1879, both inventors discovered that a carbon filament in an oxygen-free bulb glowed but did not burn up for 40 hours. Edison eventually produced a bulb that could glow for over 1,500 hours. Lewis Howard Latimer was a member of Edison's research team, working in Menlo Park, New Jersey, dubbed "Edison's Pioneers." In 1882, Latimer developed and patented a method of manufacturing his carbon filaments.

Whereas gas light was available for 50 years before it became commonplace and publicly accepted, electricity gained in popularity at a much faster rate. Edison built a generating station in lower Manhattan in 1882 that powered

This engraving from *Harper's Weekly* depicts workers laying electrical cables in 1882. In most towns, the first structures to receive electricity were the stores on the main thoroughfares and the houses on the surrounding streets. Courtesy of the Library of Congress.

a square mile, including J. Pierpont Morgan's house, as well as 200 other wealthy property owners. In 1884, 500 more subscribers had signed on to Edison's power supply. Edison built a number of other stations in other cities, including those in Europe. He got together with Joseph Swan and built electrical plants all over England.

The first electrical power stations were built for the provision of electric light. Although the public was finally accepting gas light for the home, electric light was so much better. It was safer, brighter, cleaner, and had no noxious fumes or soot. By 1900, most city houses had electric light. (This, however, was not true in the rural areas where electrification took place in the Depression years of the 1930s in the Roosevelt era "Rural Electrification Program.")

An example of regional electric light development can be illustrated by the story of John Doane, who, in November 1882, installed a complete electrical system in his backyard. This effort made him the first user of domestic electric lighting in Chicago. It cost him $7,000 to $8,000. The installation was a celebration of his silver anniversary, when Doane had a party to mark the occasion. He set up his backyard with 250 incandescent lights around an awning installed for the purpose. He of course also had to install a complete, self-contained electrical plant and steam engine in his yard. Not surprisingly, Doane was a director of the local Edison company.

In addition, the famous architects of the Chicago School were some of the first to use the new technology in their buildings. Louis Sullivan designed a number of theaters and multiuse buildings containing theaters, and he included electric light in them. The *Real Estate and Building Journal* stated that the motto of Sullivan and his partner, Dankmar Adler, was "let there be light" (Platt 1991, 38). The renowned Auditorium Building, a multiuse structure and a precursor of the modern skyscraper, was the first building to use electric construction lighting in 1886 in order to allow night work. The main hall of the auditorium contained over 5,000 houselights.

The young architect Frank Lloyd Wright was hired by Sullivan on the Auditorium Building project and learned about the fledgling electric light industry. In 1889, another architectural firm in Chicago, Burnham and Root, designed the first skyscraper office building, the 16-story Monadnock Building, and it was completely electrified. Stores, factories, and other commercial establishments all clamored for electric lights, even though the cost was still double that of gas lights. As one storekeeper installed the new lighting, the neighboring

ones wanted to get it in order to compete.

By the late 1880s in Chicago, middle and upper middle class homeowners were demanding that their new houses be built with electrical service. At first real estate developers offered electricity as a special incentive, but customers soon demanded it as a standard amenity. In 1881, a new development called Edgewater on the north side of Chicago was designed with a complete Edison self-contained system that provided both street and interior lighting. It also had such amenities as sidewalks, landscaping, curbs, and paved streets (Platt 1991, 70). The architect, Joseph L. Silsbee, who hired a very young draftsman, Frank Lloyd Wright, designed the project. By 1894, the neighborhood had become exclusive and extremely popular.

The city of Chicago passed a law requiring wiring to be buried underground. Therefore, some new suburbs, which were able to avoid the underground requirement, installed electrical service before many areas of the city. There were a number of small companies building and selling electrical service at the time. They were able to invest a small amount of money for a large return. The new developments were clamoring for the service, and these companies were happy to provide it. In the new neighborhoods, with

From Frank Leslie's *Illustrated Newspaper,* this 1880 engraving depicts six views of the groundbreaking work done by Edison in his Menlo Park, New Jersey, laboratory. Courtesy of the Library of Congress.

aboveground wiring, the main street would get the service first, and then the electrical poles would be strung along the side streets to provide the service to the neighborhood homes.

Though available, in the 1880s electricity was still relegated to the upper and upper middle class, due to its cost. A single light bulb cost one dollar, which was the equivalent of half a day's wages. One-kilowatt hour of electricity cost up to 20 cents. Most of the earliest generating stations were located in wealthy areas. And even though the wealthy wanted the convenience of electric light, they maintained the gas service for a number of years, because electricity was

not necessarily reliable at all times. Before 1900, the existence of electricity in houses was common but was often considered a novelty, not a necessity.

The first use of electricity in homes was for lights. The use of electricity for heat and other types of power came later. Users of electric lights did appreciate the safety of the product; though an electrical fire was always a possibility, gas was infinitely more dangerous inside the house by asphyxiation or explosion. The development of the annual ritual of spring cleaning became less necessary, as electric lights were clean and did not create soot and demand extra ventilation.

As an expensive yet convenient novelty, the electric lights of the nineteenth century were placed in the most public of rooms. They were shown off to the visiting public. The fixtures were variations on the gas light fixtures, as cut-crystal chandeliers called "electroliers," and in beautiful desk lamps with elaborate stained glass shades, as created by Louis Comfort Tiffany (Nye 1990, 243). One of the first popular uses of electricity apart from lighting came in electrically lighted Christmas trees. In 1882, the vice-president of New York Edison put electric lights on his tree. A reporter from the Detroit Post and Tribune described the tree in magnificent detail. By the following year, lighting Christmas trees became a sensation (Nye 1990, 245). General Electric soon was selling electric Christmas tree light kits. Lighting in the home was used for decorative, as well as utilitarian purposes, even at its outset.

Other early uses for electricity in addition to lights were for children's toys. Many electric toys, for instance cranes, electric trains, and others were very popular by the end of the century. Many of the toys encouraged boys to construct the electrical device, thereby teaching boys about electromagnetism. Later, in the 1920s, many more electric toys became available, including many miniature appliances for girls' playtime use. Appliances such as electric fans were also early popular electrical devices by the 1890s. Also lawn mowers, carpet sweepers, and of course irons, became motorized for homeowners' convenience.

As electric lights became more available, the effects on the layout of new houses could be seen. With electric lights, rooms could be opened up and this led to the revolutionary interior planning of Frank Lloyd Wright after the turn of the twentieth century. Gas light demanded the construction of small rooms, which could be easily aired out. Electricity did not. Gas light also required doors on all rooms to prevent drafts and loss of heat when airing out rooms, also to prevent the danger of the wind blowing out the gas jets when airing out the room; electricity did not (Nye 1990, 253).

Paint colors and heavy draperies could be lightened up. Victorian dark paint colors were popular because of the soot created by gas fixtures. With electricity, there was no soot. Rooms could be opened up, and colors lightened; draperies could also be less voluminous. So, in addition to the interest in the lighter colors and simpler design of the Colonial Revival, which took place at the end of the nineteenth century, electricity also influenced the changes in interior design. Though new technologies added cost to the construction of new houses, many builders reduced the price where possible by simplifying the floor plan, designing fewer rooms and having less square footage. This was another factor in the interest in simplifying design, which was taking place all throughout the domestic design business by the end of the century.

Two methods of providing electricity to customers emerged in the 1880s. Edison was the inventor of direct current, known as DC. The innovation of AC current was the brainchild of George Westinghouse, a rival of Thomas Edison. Alternating current, or AC, was able to conduct electricity at high voltage, or "pressure," over thin copper wire without as much energy loss. The electrical transmission was more efficient as the voltage was raised. A transformer was added that boosted the electricity for long-distance transmission and then reduced it when it was locally distributed (Platt 1991, 73).

Companies began using this technology, as it was cheaper to carry electrical current over longer distances. It was also easy to include in the expanding suburban developments. A bitter rivalry ensued between Edison and Westinghouse, with the latter eventually winning out. Many incredible stories have been told of Edison's attempting to prove the superiority and safety of direct current by conducting horrible public experiments. His experiments included shocking and killing dogs and cats at his Menlo Park laboratory to prove that AC was too dangerous with its high voltage current. One of the experiments was the electrocution of an elephant by sending a current of AC through his body. Edison recorded the execution with a motion picture camera, another of his inventions. He showed his film to audiences around the country, as part of his unsuccessful attempt to discredit alternating current. Edison also dubbed the electric chair, a brand new form of capital punishment, "Westinghousing." In a strange twist, although AC and DC are just as safe in domestic and industrial uses, the use of AC for electrocution caught on. New York became the first state to install the electric chair for use in capital punishment. Though it was not initially successful, the later versions were used for many years after throughout the United States.

Although house buyers were tremendously excited by the availability of electricity for their homes, architects were resistant to the use of the evolving technology available in the late nineteenth century. They were, in fact, conservative in their views when it came to utilizing the techniques that were mechanizing the home. For instance, a book written in 1874 by the famous architect and plan book writer Calvert Vaux, *Villas and Cottages,* made no mention at all of artificial light in its discussion of house design. This was at a time when the use of gas light was common (Rybczynski 1986, 145). Other books published at the time evidenced the same lack of interest in technology by architects. Engineers were fascinated with science and technology, and the pace of scientific advancement was rapid in the late nineteenth century. But architects, taught in the styles and the techniques of the past, had no desire to incorporate modern technologies into their views. Most contemporary architects displayed a design approach that was *retardetaire,* a French word for "behind the times." Some contemporary engineers devoted themselves to the modernization of the home.

In a critique of the architect of the time, Henry Rutton, a Canadian engineer, wrote a book in 1860 about how to incorporate modern advancements in technology to house design. He wrote about architects of the period: "Amid the blaze of light which in this nineteenth century has so illumined the world, architecture alone lies motionless, covered with the dust of ages. Not a single new idea, so far as I know, has been suggested by the profession within the memory of man" (Rybczynski 1986, 146).

Interior decoration, a new and developing field in the late nineteenth century, was equally resistant to technology in the design of homes. A book on interior decoration published in 1898 asserted that the only proper form of heating in a house is a wood fireplace and contended that good taste showed in the house that had no central heat. At that time, central heat was very available and popular. It again demonstrates the reverse snobbery and conservatism of the profession. Engineers displayed an interest in technology, and designers, both architects and interior designers, had an aesthetic bent. Consequently, they have had a continuing battle of pragmatism versus beauty. Though they should not be mutually exclusive, the primary focus of each of the two professions is so different that a rift was created that has dogged them for more than a century. The new technologies, which were emerging in the last part of the nineteenth century, were embraced by builders, engineers, and the public, but not by the architectural profession.

The technologies discussed in this chapter were new and available by 1900. Most middle-class houses in the cities or the close-in suburbs boasted varying degrees of these innovations at the turn of the century. Of course, the poor city-dweller and the rural dweller had to wait up to several more decades to receive all the amenities of electricity and indoor plumbing. Many rural and exurban houses don't have city sewer systems or public water delivery systems even as of today.

Reference List

Bellamy, Edward. 1888. *Looking Backward.* Repr. New York: New American Library, 1960.

Bushman, Richard L., and Bushman, Claudia. 1988. "The Early History of Cleanliness in America." *The Journal of American History* 74(4): 1213–1238.

Fitch, James Marsden. 1973. *American Building 1: The Historical Forces That Shaped It,* 2nd ed. New York: Schocken Books. (Orig. pub. 1947.)

Ierley, Merritt. 1999. *The Comforts of Home—The American House and the Evolution of Modern Convenience.* New York: Three Rivers Press.

Jackson, Kenneth T. 1985. *Crabgrass Frontier: The Suburbanization of the United States.* New York: Oxford University Press.

Nye, David E. 1990. *Electrifying America—Social Meanings of a New Technology, 1880–1940.* Cambridge, MA: The MIT Press.

Ogle, Maureen. 2000. *All the Modern Conveniences: American Household Plumbing, 1840–1890.* Baltimore: Johns Hopkins University Press.

Platt, Harold L. 1991. *The Electric City—Energy and the Growth of the Chicago Area, 1880–1930.* Chicago: The University of Chicago Press.

Rybczynski, Witold. 1986. *Home—A Short History of an Idea.* New York: Penguin Books.

Schultz, Stanley K., and Clay McShane. 1978. "To Engineer the Metropolis: Sewers, Sanitation, and City Planning in Late-Nineteenth-Century America." *The Journal of American History* 65(2): 389–411.

Schweitzer, Robert, and Michael W. R. Davis. 1990. *America's Favorite Homes—Mail-Order Catalogues as a Guide to Popular Early 20th-Century Houses.* Detroit: Wayne State University Press.

Smeins, Linda E. 1999. *Building an American Identity—Pattern Book Homes and Communities, 1870–1900*. Walnut Creek: AltaMira Press.

Stone, May N. 1979. "The Plumbing Paradox: American Attitudes toward Late Nineteenth-Century Domestic Sanitary Arrangements." *Winterthur Portfolio* (Autumn): 283–309.

Wright, Gwendolyn. 1981. *Building the Dream—A Social History of Housing in America*. Repr. Cambridge, MA: The MIT Press, 1995.

Home Layout and Design

Two transformations in American interior design took place in the second half of the nineteenth century. Both transformations occurred during the lengthy reign of Queen Victoria in England, which extended over a span of 63 years, from 1837–1901. The first development was the ornate, Victorian style. The second development was actually a reaction to the ostentation of the Victorian style, brought on by the Progressive movement, the Arts and Crafts movement, and the Colonial Revival. The Victorians, influenced by many factors, including the Industrial Revolution, engineered a specific notion of what the home should symbolize and how it should look. One influence was that, for the first time ever, the availability of cheaply produced how-to books and magazines, which popularized architectural as well as interior design, made the middle-class family aware of how to design and decorate the home; and the notion of style in Victorian interior design reached its highpoint in the 1880s to 1890s. In the following years, from the 1890s to the early twentieth century, there was a sea change in design aesthetic influenced by the simplicity of the Colonial Revival and other cultural factors, including the Progressive movement. In this chapter, the interior of the home will be investigated, from the changes in the developing room uses and functions, the influence of the concept of ventilation and its relation to the technology of home heating, and the differing types of dwellings, single family or multifamily. In addition, the sociological phenomenon of the cult of domesticity, its identification of the separateness of the lives of the male and female, and its resulting impact on the interior of the home will be examined.

The style of the American home interior was influenced significantly by the effect of the growth and industrialization of the country as a whole. The nation

was expanding. Seven states joined the union from 1880 through 1900: North Dakota, South Dakota, Montana, Washington, Idaho, West Virginia, and Utah. Frederick Jackson Turner famously declared the end of the frontier in 1893, and the urban population was growing faster than the rural. One-third of the population lived in towns larger than 2,500, and 28 cities had populations of more than 100,000. The construction of the railroads meant that undeveloped land could be settled, also providing the ability to carry goods and farm products across the vast land. By 1884, refrigerated cars created a boom for the beef industry, as companies like Swift and Armour in Chicago delivered beef safely throughout the country. A new creation, called the department store, was originally begun by Alexander T. Stewart in New York and copied throughout the country by John Wanamaker, Marshall Field, and others. Trolley lines also gave urban dwellers additional means to move to the outlying suburbs to live while still maintaining city employment.

The single-family house evolved through the period with rooms of differing sizes and purposes. The bathroom, kitchen, and dining room gained in prominence as the parlor rose and then fell in importance. The decoration of the house became extremely important for the family in order to portray its wealth and concern for beauty. However, in the last years of the century, the notion of beauty in interior design made a complete turnabout when ideas of family, beauty, domesticity, and decoration were transformed. The end of the nineteenth century was a critical period in the history of the home interior.

THE CULT OF DOMESTICITY

One of the major factors in the interior design of the American home during this time period was a cultural phenomenon dubbed by historians as the "cult of domesticity." This trend evolved in the late nineteenth century as a reaction to the American Industrial Revolution and its related cultural effects. This cult comprised a glorification of the home, the family, and especially the woman as wife and mother. The adulation of the female was placed in juxtaposition to the reality of the man's world, that is, the world of work and society. The cult was a metaphorical as well as a literal view of the interior (i.e., the home and family) versus exterior (i.e., the world of outside employment). Therefore, in discussion of the interior of the Victorian house, the sociology of the cult of domesticity must be understood. This trend was developing in the second half of the century and was most evident in the postbellum period, from Reconstruction to the beginning of the twentieth century.

In contradistinction to commonly held beliefs, the concept of the nuclear family is not as ancient and venerable as one might think. As stated by the French social historian Phillippe Aries, the modern interpretation of the family as a close, interdependent group of parents and children is only about 200 years old. Before the 1700s in Europe, the family was subordinate to the community. At this time, a small percent of population served in the manor houses of the wealthy aristocrats. These situations, not unlike that of the slaves in following centuries in the United States, prevented families from living together in any kind of nuclear way. On the other hand, prior to the early nineteenth century in Europe, the rural population lived in hovels,

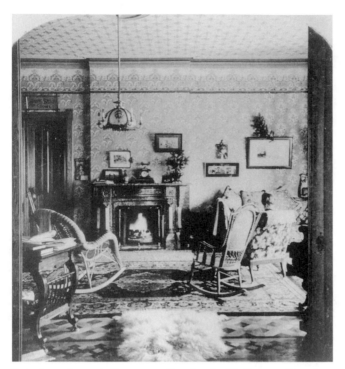

Interior view of Governor Benjamin H. Eaton, Greeley, Colorado, 1902. A typical upper middle class parlor displaying the Victorian love of pattern. Denver Public Library, Western History Collection.

which were home to various unrelated people and farm animals. The population living in the cities contained households organized around business groups. For instance, where a blacksmith lived, he had his business, his apprentices, servants, journeymen, and their own wives and children, who were all sharing the house with the family itself. In other words, before the 1700s in Europe, there was no concept of the individual nuclear family, and the modern concept of privacy did not exist, nor did our idea of a family home. In the eighteenth century, the idea of privacy began to emerge. Families established themselves in private houses, and rooms within the houses became more differentiated as to use. In the United States, the concept of domestic privacy became fully realized, especially in the second half of the nineteenth century. Because of the expanding wealth and geographical size of the country, the idea of the private, isolated house favored by the American people became possible (Jackson 1985, 47).

What caused the so-called cult of domesticity? In the 1820s, the emergence of the idea of separate spheres of work for women and men coincided with the construction of the first American factories where men began to work outside the home. With the growing industrialization of the United States came an increased fear of loss of control. Americans were afraid that traditional family values were being undermined by industrialization and the characteristic American ambition and appetite for monetary success. American culture has perennially faced the dichotomy of the American compulsion for financial success conflicting with the Puritan moral tenets of humbleness and simplicity. The tradition of conservatism in American culture led Americans to fear that the drive to thrive would undercut family values believed to have been a bulwark of a moral society. In order to stave off the commercialism insinuating itself into American culture, something had to be contrived that counteracted this development. This creation became a popularized notion of the idealization of the home, of family, of the woman, or what's come to be known as the cult of domesticity. The cult of domesticity effected a feminization of the home. The new housewife was no longer a partner to her husband in their farm-based self-sufficient economy; she now became the nonworking partner of the relationship. The woman had a separate realm, and it garnered diminished respect,

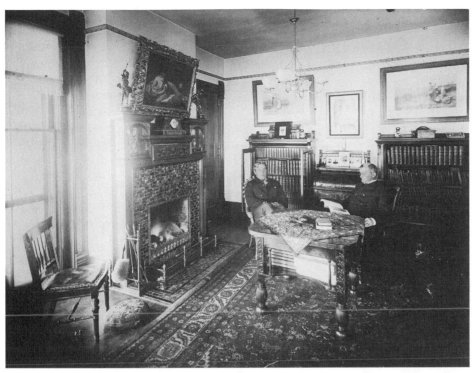

Library of the Patterson Residence, Littleton, Colorado. This photo demonstrates the men's sphere in the notion of the cult of domesticity. Denver Public Library, Western History Collection.

as it was not connected at all to political life and did not produce any monetary remuneration. Though home represented virtue, good morals, and retreat from the competitiveness of the outside world, it also did not receive the respect given to men who operated in the outside sphere. Catherine Beecher, a proponent of the emerging field of home economics and scientific management of the home, presented advice and even house plans for the contemporary housewife in order to boost the value of the woman's realm. A century later, Betty Friedan dissented against the still approved concept of the comfort of the home and its homemaker

"For the benefit of the girl about the graduate," cartoon in *Life* magazine, May 22, 1890. Artist, Charles Howard Johnson. Shows a young woman who may have been educated, but is still threatened by the cult of domesticity. Courtesy of the Library of Congress.

in her seminal feminist manifesto *The Feminine Mystique* in 1963, when she dubbed the home "a comfortable concentration camp" (Friedan 1963, 307).

Catherine Beecher: Proponent of Household Scientific Management

Catherine Beecher was an influential leader in the cause of conveying more respect to domesticity and of examining all aspects of home life in a scientific way. A member of one of the most prominent families of the nineteenth century, Catherine Beecher began writing in mid-century in an attempt to bring respect to the housewife's work. Beecher wrote many articles and books that were extremely popular around the country, providing a guide to housework and maintaining the family home. The work of the housewife was important, according to Beecher, and represented Christian values within the household. Beecher, along with her sister, Harriet Beecher Stowe, wrote *The American Woman's Home* in 1869. They emphasized the notion that housework should be scientifically studied. Women should be knowledgeable about all the sciences, Beecher contended. A strong proponent of education for women, Beecher promoted education for women in all the sciences in distinction from men, who specialized in their own area of expertise. Her books and articles argued that the home should be run as an organized, scientific enterprise. Beecher gave many nuggets of advice and very specific suggestions to her readers. She recommended that the home be run systematically, with a daily schedule of household tasks. Each day had a weekly assignment: for instance, Tuesday was washing day, Wednesday was ironing day, and Sunday, of course, was for religious observance. To be totally systematic and scientific, Beecher had detailed recommendations for decoration within the house. She was very influential in interior design, in highlighting efficient layout and design for the kitchen and other rooms. James Marsden Fitch calls her ideal house, presented in *The American Woman's Home*, as a "machine for living" (Fitch 1973, 118).

Beecher included designs for houses and interiors in her 1869 book. They were a style similar to the Gothic Revival, a popular style of the mid-nineteenth century. She was keenly interested in using the available technology to aid in the efficient management of a household. She showed exhaustive drawings of kitchen designs, including elevations of kitchen work centers and storage walls. She developed one of the first examples of rational kitchen design, based on the efficient arrangement for the task at hand. Entire house plans were included in her books, which were designed for the

The effect of the cult of domesticity was to influence architecture, decoration, interior layout, and technological innovation, as well as other aspects of society. Women were seen as the antidote to the ambition of men, as naturally selfless and giving, as opposed to the greedy, grasping society occupied by the opposite sex. Children were seen as born innocent and perfect and like women were protected in the home from the corrupting influence of worldly society. The Gilded Age saw the growth of enormous wealth to the detriment of many of its poorer citizens, and the middle class noted this gap and reacted with an attempt to diminish the effects of an acquisitive culture through its "fairer sex."

Women, the official decorators of the interiors of houses, now had new choices for obtaining *objets d'art* for their homes. Department stores were a new invention that had a strong influence on contemporary housewives. The department stores had advertisements in newspapers and magazines and even set up model rooms in the store that popularized the style of the moment. These rooms displayed knickknacks, wallpapers, furniture, carpets, and other items that were for sale in the store. The items were mass-produced, they were not the handmade objects displayed in parlors in the earlier years of the century. The objects for sale appealed to the pretensions of the rising middle class. They were not expensive items, but they were ornate and exemplified an artistic beauty aspired to by the housewives who did the shopping. The middle-class housewife was looking to emulate the elite and their architects through machine-made objects and designs now available. This group was aspiring to the gentility epitomized by the rich of the so-called Gilded Age (Wright 1980, 97).

One of the popular magazines of the day, the Philadelphia-based magazine *Godey's Lady's Book,* edited by Sarah

Josepha Hale, was aimed at the middle-class housewife of the late nineteenth century. The magazine led an effort to "institutionalize the female as homemaker and queen of the house" (Jackson, 1985, 49). Women were supposed to be dependent on men, and in fact were, legally in the United States and England under the law. Another popular culture manifestation of the cult of domesticity recognized today is the famous Currier and Ives prints. These ubiquitous images were produced using the newly invented technique of lithography and popularized the images of "home" and "mother" as the family's source of happiness and success. The single-family house was depicted as the symbol of middle-class success. Walt Whitman wrote: "A man is not a whole and complete man unless he owns a house and the ground it stands on" (Jackson 1985, 50).

In reality, industrialization led to many new innovations and a social revolution that affected family life immensely, but a strong reaction to it surfaced in American culture. Gwendolyn Wright contends that the very same items that were manufactured by industry were the items that exemplified the ideal of home and hearth. These were no longer homemade handicrafts. Women traveled on streetcars to department stores to purchase machine-made knickknacks to decorate the family home.

This led to two developments in home life. First, the individualism of the home, through its myriad of bric-a-brac and individualized exterior gingerbread, made the family feel unique in an increasingly automated society. The worker was now working in a factory or an office where many

(continued) middle-class American household where there were few, if any, servants. Beecher specified rooms for certain functions. She advocated the use of many of the emerging technologies. She included bathrooms on each floor, use of gas light instead of oil lamps, a dumbwaiter for carrying coal up and down from the basement for use in the stove, a kitchen sink, and a complete laundry in the basement. Fitch calls this "the direct progenitor of the modern American house" (Fitch 1973, 121).

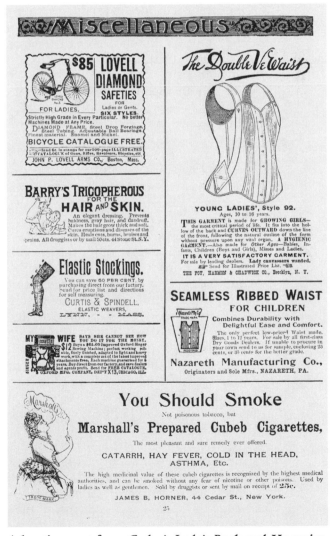

Advertisement from *Godey's Lady's Book and Magazine*, February 1893. Courtesy of the Library of Congress.

others did exactly the same job. Individuality was given up in the workplace in exchange for additional pay and many new material objects. In response, homes were decorated in a very individualized way. Ironically, all these items obtained for the unique home were made possible by the industrialized society itself. Advertising, large factories, and commercialization made popular the ornate decoration inside and outside of the Victorian home (Wright 1980, 99).

The purchase of decorative items led to a second effect on the home: ostentatious display of items for the middle and upper classes. Until the final 20 years of the nineteenth century, women had contributed to the beauty and uplift of the home by creating their own handmade decorative items. In the 1880s, the availability of factory produced items and advertising led housewives to purchase store-bought decorative pieces. The more expensive items were placed in the most prominent locations in order to demonstrate the wealth of the family. The idea of producing your own handmade decorative items was a holdover from the Puritan ethic that endorsed self-denial and frugality. With the Industrial Revolution came a new abundance of factory-produced goods that had to be sold, and therefore, a demand had to be created. The culture of consumerism was born. In order to get the decorative items to the homes of the Victorian families, the self-concept of the moral American as the prudent producer of the family's own personal property had to be rethought. Instead of the production of goods by the family for the family, the acquisition of goods became the axiom. Instead of self-denial, magazines and how-to books stressed the amassing of consumer goods. The culture of the home interior mutated in the last two decades of the nineteenth century from a source of moral edification to a demonstration of one's own personal self-realization through the display of store-bought goods.

The enduring contradiction between the idealization of the home and the commercialism of the marketplace was illustrated by the fact that the woman, who was supposed to improve society through her altruism, was in fact often segregated from society. Americans, however, did truly believe in this ideal, and the concept of domesticity was embraced by most Americans of the Victorian Era. People were genuinely worried about the effects of industrialization on the morals of a society, and the cult of domesticity, for a short period of time in the nineteenth century brought comfort to the middle-class family (Wright 1980, 102). In another strange irony, though American houses were built to recall the past and represent durable, permanent havens, most Americans moved more often than their European counterparts. In the long-term "Middletown" studies of Muncie, Indiana, 35 percent of residents relocated between 1893 and 1898. So, in fact the cult of domesticity could be considered a belief based not on reality, but only on the wishful thinking of the citizens. Also happening in the latter half of the nineteenth century was the development of streetcar suburbs, which were within a few miles of the downtown core. As urbanization began to take hold in the United States at mid-century, many social critics feared that citified buildings and urban corruption would erode the rural homestead ideal of the colonial era. The growth of cities and the construction of railroads and streetcars encouraged these nearby suburbs, which were accessible by public transportation, and in fact developed because of public transportation.

LAYOUT OF ROOMS

Rooms for specialized use came into fashion in the second half of the nineteenth century. The availability of foreign-born servants made it possible for many families, including the middle-class ones, to hire multiple servants. The lifestyle of the Victorian was formal and required multiple sets of china, flatware, and so on. The availability of factory-produced goods made the use of these various items possible. The rooms, therefore, were designed for specialized uses. As complex as the Victorian house and its functions was, the complexity of the plan permitted specific uses for specific rooms. Spaces were segregated for separate uses by differing genders, ages (adults/children), and classes (homeowners/servants).

The cult of domesticity identified the separate realms of the male and female in a family; similarly large Victorian houses had a differentiation between public and private spaces. The house typically had a front staircase for adults and guests, and a back staircase for children and servants. The back staircase might also be used for taking down laundry, chamber pots, or other household work. The front hall divided the front, public part of the house from the back, or private part of the house. The private part of the house contained the kitchen, bathroom, and pantry. The public part of the house contained the parlor, front hall, and dining room.

The Front Hall

The first American houses in the Federal and Greek Revival periods had a front entrance hall that included the staircase and bisected the house. The house had a symmetrical floor plan with the central hall running from the front to the back of the house. There was only one staircase in the house, and it had a prominent position near the front door. Victorian houses, on the other hand, were generally of asymmetrical floor plan. The front hall grew in size but did not run to the back of the house. Larger houses had a front hall that was the size of a room and was actually called the living hall. Based on the English Arts and Crafts movement designers, the living hall was influenced by the medieval great hall. The room was very ornate, often with decorative wood paneling, and even contained a large fireplace and seating group. This room had a main staircase, and another staircase for the servants was located at the back of the house. The front hall usually was large, 6 or 8 feet wide and up to 20 feet long. The walls were covered in wallpaper with a chair rail and a dado. The front hall separated the back part of the house, either with an actual door, or a lowered ceiling or change in wall decoration, in order to plainly differentiate the formal from the functional areas of the house. The front hall served as a public space and one that could effectively separate the family and its guests from the servants and the children.

The Dining Room

Another example of the specialization of rooms was the newly popular inclusion of the dining room in middle-class houses. The dining room had existed in the houses of only the upper class up until the mid-nineteenth century. With the growth of the middle class and the new group of white collar workers

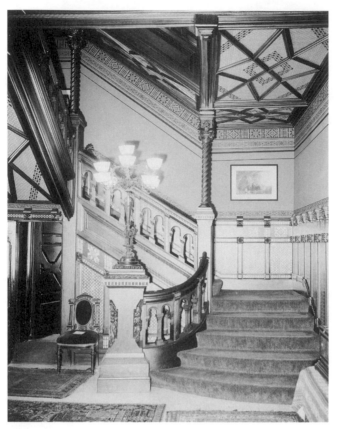

The front hall of the Mark Twain house in Hartford, Connecticut, is an example of the ornate interiors of the 1880s. Courtesy of the Library of Congress.

in the cities and suburbs, the desire to aspire to upper-class amenities led to another room added onto the expanding Victorian house: the dining room. This was a new concept to the average American home. In the previous centuries, Americans had eaten in the kitchen in most homes.

The Parlor

Why did houses have parlors in the nineteenth century? The parlor, also called the front parlor, the front room, or the sitting room, in the late-nineteenth century was the archetypal Victorian room. The idea of the parlor grew out of the colonial parlor, which was used for a variety of purposes, and from the drawing room of the wealthier houses in the 1700s. The parlor that was first seen in the 1850s became the ubiquitous room of Victorian times. It was based on the drawing room of the grander houses of earlier eras and had the pretensions of the previous drawing room. The typical middle-class house, however, did not have the other rooms associated with a larger house. The Victorians adopted the parlor because they wanted to have a room used for ceremonial purposes, a room for social interaction and showing off their worldly goods.

The idea of the parlor was ubiquitous during this era, it was found in public buildings, offices, hotels, railroad cars, and so forth. Etiquette manuals encouraged the use of parlors and their accompanying appropriate furniture. All houses were expected to have a separation between the public and the private rooms. Even smaller houses had these separations, and therefore would have tiny, cramped rooms, but separated ones. All types of homes, including poorer, smaller apartments, had a space designated as a parlor. The front room of the tiny tenement apartment was set aside for family heirlooms on display or family pictures, whatever the family had to show off to company. The parlor, though used for many other purposes in the tenements, was the ceremonial space of the house. This was where the family entertained visitors, had holiday celebrations, and put out its best items. The purpose of the Victorian parlor was to show off the family's finest possessions for display, to have a formal space set aside for ceremonial occasions, and to officially designate a separate sphere for visitors to be entertained.

The furniture in the middle-class parlor was different and didn't have to be durable enough to withstand daily family use. Families purchased special parlor sets in order to impress visitors as the family attempted to portray a certain image to the guests. As a room, the parlor had limited utility. While wealthy people had entertaining rooms that were often utilized due to their busy social lives, middle-class families included a parlor in the house but rarely used it. These families saved the use for weddings, funerals, visits from clergy, and other important occasions. They also sometimes had formal calling, that is, the use of calling cards for visits from friends and relatives, which was a ritual borrowed from the rich. The existence of the parlor

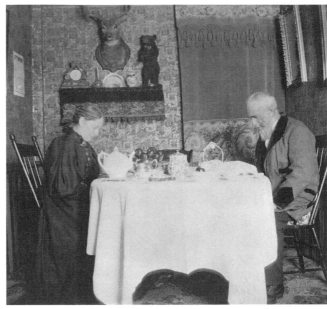

This tiny dining room shows how even the less well-off family wanted a separate dining room. Denver Public Library, Western History Collection.

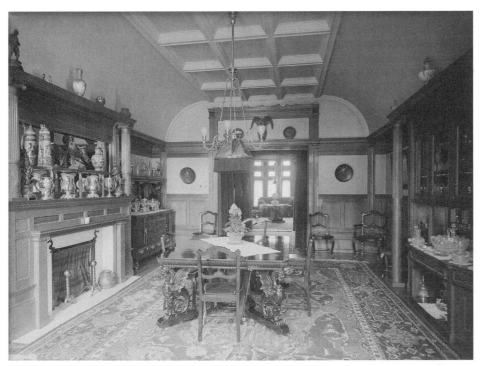

A wealthy person's home shows how the dining room was a significant public room. Denver Public Library, Western History Collection.

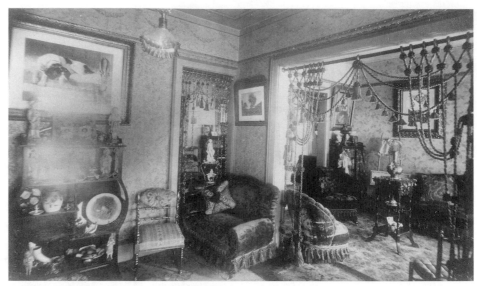

A parlor in the 1880s style displaying multiple large pieces of furniture and bric-a-brac. Denver Public Library, Western History Collection.

in middle-class life led to the addition of social ceremony in a more formalized fashion than previously seen in these social strata. Though extremely popular throughout the country from the 1870s into the 1890s, certain critics, including Harriet Beecher Stowe, disdained the overly decorated, underused space.

The parlor became one of the symbols of the cult of domesticity, displaying the perceived dichotomy of public and private life. The home was the domain of the wife, whereas the outside world was the domain of the husband. The wife was responsible for the upkeep of the symbolic ideals of the home, which included the items displayed in the parlor. These items included needlework, houseplants, framed family photos, and other bric-a-brac, which was placed on every surface and wall in the room.

In many large Victorian houses, there was a second parlor. It was the middle room of the first floor and was also called the music room, drawing room, or sitting room. The second parlor was more child-centered. It usually contained a round table for games and other family activities and had simpler wallpaper, ceiling, and carpet. In comparison to today, the second parlor can be compared to the family room and the front parlor to the living room in many of today's large suburban houses. The difference, however, might be that the front parlor was probably used more often than today's totally underutilized suburban living room. Families always entertained guests in the front parlor. Formal spaces were used for formal gatherings. Today, most families entertain in the family room, if at all. It is usually the more comfortable and appealing space. In Victorian times, the second parlor was the subordinate space.

Living Room

In the 1890s, the parlor began to go out of fashion. Designers thought it was an unnecessary vanity to have a rarely used and overly formal room assigned for

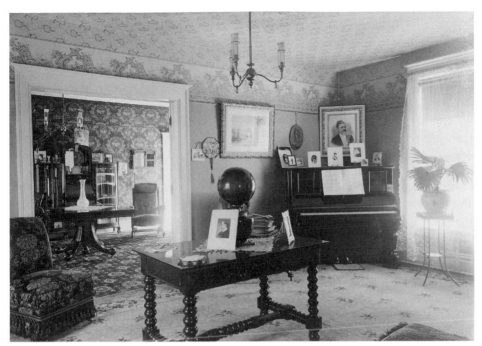

A parlor of some ten years later, showing the simplifying influence of the Colonial Revival. Denver Public Library, Western History Collection.

only selected uses. Immigrants found factory work more remunerative, and the use of servants began to decrease. In addition, the lifestyle of the middle-class American became less formal, and therefore the interior layout of the house also simplified. The rooms used for specific uses, especially the various entertaining rooms and rooms specifically designed for servants' use, were dropped from the plans of newly designed houses. These rooms included music rooms, conservatories, reception rooms, butler's pantries, the service stair, and the parlor. Parlors that were still in use during that time were redecorated to reflect a simpler design aesthetic, with simpler furniture, lighter colors, and more user-friendly decor. Architect Edward Hapgood wrote: "The ultra-queer colors have disappeared, and the carpets and wallpapers no longer suggest perpetual biliousness or chronic nightmare" (Clark 1986, 144). At this time the "living room" made its appearance. This room combined the uses of the parlor, sitting room and the library.

As the parlor went out of fashion, another factor that influenced the layout and allowed for the creation of the living room was the advent of artificial lighting. A central gas or oil fixture in a room required a central table with chairs gathered around. This led to the "dark corners" found in Victorian houses. Even when electricity was installed in the house, the wiring was most often fed to a central hanging fixture, with the same required center table. It was only much later that electrical wiring was installed in the walls of new houses and wall outlets were provided. Then, lamps could be placed along the periphery of the room, ridding the rooms of their dark corners. Living rooms were typically designed with furniture along the periphery, which was only possible when electricity was installed in the house.

The Bathroom

Only wealthy people had actual bathrooms, that is, places for bathing, in the 1870s. The development of the bathroom as we know it was still evolving in the last 20 years of the nineteenth century. In general, in these years, plumbing fixtures were being installed in lower- to middle-class houses, but they were not in any specific part of the house, and they normally contained only a toilet. Most families put the toilet room in a closet somewhere close to the plumbing entering the house, usually in the back of the house near the kitchen.

Sinks were only seen in the kitchen, and a washbasin was found in the bedroom. Tubs were portable units used in the kitchen, where the water could be found and easily heated up. So, the invention of the bathroom, per se, took place as an evolution at the end of the nineteenth century as newer houses were being designed and had indoor hot and cold running water. As the new century dawned, houses were designed with entire bathrooms included. The color was white, and the fixtures were gleaming porcelain. This was another huge change in the use and appearance of the middle-class house. For the first time, homeowners began to see their home as part of an integrated system of amenities, including water service, sewer service, and the new services of electricity and telephones.

Before the bathroom appeared, in the mid-nineteenth century, Catherine Beecher was a proponent of a version of the toilet, the earth closet, designed by George Waring, which could be placed anywhere in the house because it required no water or plumbing system. Waste was dumped on a layer of earth, which then released a fresh layer from a hopper in the back of the unit. Sanitarians who were wary of sewer gases thought this model would be safer and more convenient than the units requiring water and sewer systems. However, the number of earth closets required in urban settings and the requirement to cart off the waste made the units unfeasible. The convenience of having toilets attached to sewers and no additional work won out eventually.

The Bedroom

The location of the bedroom changed in the Victorian decades. In prior years, many bedrooms were located on the first floor, next to the parlor and across from the dining room. These bedrooms had more than one doorway, often opening into the parlor, the entrance hall, or the dining room. Most likely, the master bedroom would be located on the first floor, in order to make it more convenient for the owners to be closer to the work going on in the house. Later, with the idea of privacy taking hold in the late nineteenth century, the bedrooms began migrating to the upper floors. The second floor became the sleeping floor, for the parents, children, and even the servants. When this migration took place depended on class and wealth. The larger, more affluent households had their bedrooms upstairs earlier chronologically. Designs for workers housing, as late as the 1880s still had bedrooms located on the first floor of the house. As middle-class homeowners desired the appearance of wealth as well as privacy, most middle-class, smaller houses were designed with all the bedrooms upstairs. This change took place in the last quarter of the nineteenth century.

Who got what bedroom? Most often the married heads of household slept in the same room, though there were times when it was not advised (for instance

when the wife was pregnant). As children were considered asexual during Victorian times, they were often assigned rooms together until early adolescence. How-to books suggested that servants have their own room, or at least their own bed. Maid's rooms became guest rooms in the later years when servants were less common. Babies most often slept in the bedroom of the parents; when the babies got bigger, they were given a room with the siblings, male or female. Sleeping porches were favored at the turn of the century in order to get the proper fresh air required for the prevention of tuberculosis.

The bedroom was one of the less ornate rooms in the house. This one shows a brass bed, which was becoming more popular in the 1890s because of the interest in ventilation. Denver Public Library, Western History Collection.

The Nursery

Another room that was a new arrival to the Victorian house was the nursery. The concept of the role of children in the family evolved in the late nineteenth century. In Victorian times, children were thought of as innocent creatures, descending directly from heaven and even androgynous, sexless. The growing sophistication of American society due to the Industrial Revolution led to the culture of domesticity, which consigned the woman to be the representative of home and moral values. Children, too, were assigned to the house. In order to protect the innocent child from the worldliness of the man's world of work and wealth acquisition, the home became the realm of the innocent and the teaching of moral values.

However, the Victorian house was full of knickknacks, items that were very delicate and not child-friendly. Therefore, rooms were set aside for the children's use. In addition to the night nursery, or child's bedroom, there often was a day nursery, or playroom in the house. If not, then the nursery performed double duty as the playroom and the bedroom for the children. It was often in a high part of the house, away from the busy areas of the adults. As public versus private space was a concern for the Victorian family, this was the most private of rooms. Many middle-class families employed a nurse to care for the children. The room was not decorated as were the other rooms in the house. It remained a simple room, with furniture that was discarded from the other rooms.

As with other aspects of society of the time, a transformation took place at the turn of the century in relation to the role of children in the family. Sigmund Freud, and others in the field of psychiatry, advocated that children were not complete innocents sent from heaven. Children were not perfect, and therefore did not have to be completely protected from the ills of the outside world. The later developments of the home layout incorporated children more into the life of the family, as rooms became less numerous and more multifunctional.

The Library

The room called the library in the Victorian house was a new creation. As was the Victorian family's wont, rooms within the Victorian house were separated for differing uses. In the Georgian, Federal, and Greek Revival periods, libraries did not exist in typical American houses. As many people were not literate and books were expensive, often the only book in a house was the Bible. In the late nineteenth century however, the availability of factory produced books and the growing wealth of the populace, as well as the novel idea of consumer culture, led many architects and builders to include a room set aside as a library in their houses.

Libraries often had a collection of books, some of which were purchased as sets, with collections of famous writings. Schooling often took place at home in these years, and the accretion of a library of books aided in the education of the children. At the turn of the century, children commonly began to attend public schools, and the library was not necessary for that function alone. However, it was a popular room for families to demonstrate their breeding and literacy. Later incarnations of the home library were simply inglenooks or bookcases built into the simpler forms of the Colonial Revival or bungalow evident at the turn of the twentieth century. The library was most often a man's room, with dark, manly colors and comfortable furniture, where a man could retreat from the worldly demands of his work.

Changes to Interior Layout in the 1890s

A number of changes took place in the layout of the house in the 1890s. The most evident change was the trend toward more simplicity: There was a marked transformation in the exterior design of houses in the 1890s, and the result was a related change in the layout of the interior of these new homes. For the first time since the 1750s, interior layouts were altered to reflect a simpler, more streamlined lifestyle. The front hall virtually disappeared with the disappearance of the formal parlor and the advent of the living room, which took place in the last years of the nineteenth century. The bungalow style and other modern styles had plans where the visitor went directly into the living room from the outside without the benefit of a front hall. Most often the staircase became part of the living room. For the homeowner who still had a servant, a combination staircase was developed, where there were two entrances to the staircase, one from the front and one from the back of the house, and the staircase turned at a landing and continued up as one individual staircase.

In addition to the elimination of the parlor and front hall, other rooms were transformed. The dining room now was designed with built-in buffets and storage nooks, for efficiency was the maxim of the day. The kitchen was becoming ever more important, and the room was designed for sanitary food preparation and storage, with hot and cold running water and built-in counters, a new innovation. The concept was to stress efficiency and rational design. Also, sleeping porches were added onto houses for additional fresh air in the house.

Clifford Clark states: "In place of the romantic Victorian justification of art and beauty as complex and inspirational was a new theory of aesthetics that stressed practicality and simplicity, efficiency and craftsmanship" (Clark 1986, 132). The developing spaces in the transformed house were the living room,

larger kitchen, breakfast nook, sleeping porch, and sunroom. These spaces were designed for the housewife to do her own housework. Sunrooms were popular and took the place of the conservatory and even the ubiquitous front porch found on most Victorian houses. The front porch became less popular as the automobile became more popular and led to additional street noise. Front porches eventually lost out to back porches, patios, and decks. The home as a sanctuary, and the idealized idea of home and family, had become a tired formula by the 1890s. A number of critics from varying fields began to find fault with the Victorian view of the domestic life.

Architects Join the Rush to Simplify Design

After the advent of the professional architecture program at MIT in 1868, with the many others that joined it soon after, American architects were being trained in a new and increasingly professional field. Standardization in all fields was becoming accepted. But the architects who were jilted by homeowners and homebuilders in the 1870s and 1880s decided it was their moment to shine. Whereas in the earlier years, architects were clinging to the notion of the "artistic" being based on classical training and ancient ideas of beauty, publishers of plan books were making fortunes based on what the public was demanding. That is, ornament to the extreme, eclectic designs not adhering to any historical precedent, and use of the newest innovations of building materials and techniques. Architects were not very accepting of the newest advances in technology at the beginning. They were still being trained in classical forms, even being schooled in Europe as a rule. They did not favor the great "Victorian pile" form of building so beloved by the middle-class homeowner and the willing builder or speculator.

Architects criticized the popularity of the Victorian house but had little to say about its growth. What architectural historians have studied are the high-style homes of the super-wealthy, who were able to hire the great architects of the day and who interpreted the Victorian style based on their classical educations. But at the turn of the twentieth century, the reaction against Victorian clutter and excess played right into the abilities of the new profession. Many architects were being trained at the architectural schools and were being licensed around the country. In the 1890s, architects rejected the artistic ideal of the home that had been prominent in the 1880s. (Another influence was the sanitarian, whose scientific beliefs had a profound effect on design in the 1890s.) Lack of consistency of design was a major complaint by professional architects in the 1880s. They felt that the houses had no aesthetic rationale and were guided by nothing more than cleverness unimpeded. The elaborate houses of the Victorians had too many rooms and were too large, said the architectural reformers of the 1890s. Licensed architects now had the opportunity to design houses for a willing public.

MULTIPLE HOUSING DWELLINGS

In addition to the ubiquitous middle-class Victorian house, there were a number of alternative housing types in the last years of the nineteenth century. Two types of housing styles were concentrated in the cities, and they were both built for multiple families. Cities had the unique problem of a dearth of space. Therefore, architects were continually faced with the dilemma of fitting

the largest number of people into the smallest footprint. Later, technological advances like the elevator would allow the innovation of the skyscraper, which would be created for this very reason. In housing, there were two major types of multiple dwellings being constructed during the last two decades of the nineteenth century. They both were found in the urban areas but they housed two very different groups: the extremely poor and the extremely well off.

Tenements

Although tenement housing was decried in earlier times, for instance by Walt Whitman in his article "Wicked Architecture" in July 1856 (Roth 2001, 229), no remedy was offered. However, in the 1880s and 1890s, an influx of immigrants to cities led to even more overcrowding than in previous decades. Immigrant groups were segregated in the poor areas of the cities, creating ghettos. Housing had to accommodate different demographic groups: single men and women and whole families as cheaply as possible. The central city had some existing building stock that was converted into housing for the poor: warehouses, factories, and breweries. However, most of the housing was created for multiple families on lots that were re-used from demolished frame houses or demolished commercial structures. The new housing were called tenements and were the city's first multiple dwellings built as housing for more than one family. Multiple dwellings were not accepted in the middle- and upper-class societies until the end of the century when so-called French flats were imported from Paris to New York.

The lots where masonry structures were built often contained existing frame structures in the rear of the lot where more families were housed. Landlords built the tenements in order to house as many people as possible and charged rent that, though small for each tenant, added up to an enormous sum for the landlord. Wright states: "Books and magazine or newspaper articles describing city life seldom mentioned the landlord's avarice. Instead, they revealed a frightened fascination with what life was like in Manhattan's Lower East Side or Chicago's Near West Side" (Wright 1981, 115). Some of the titles Wright's referring to included *The Spider and the Fly; or, Tricks, Traps and Pitfalls of City Life By One Who Knows* (1873) by Henry William Herbert; or *The Lower Depths of the Great American Metropolis* by Peter Stryler (1866). Even so-called model tenements were not designed as help for the needy, but as models for private developers to

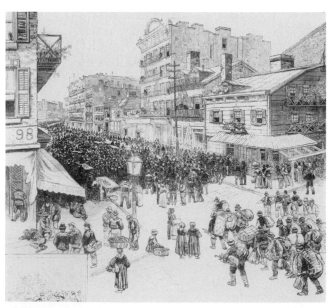

Mulberry Bend was the center of the Lower East Side immigrant community. It contained a variety of structures used as dwellings for the poor. Courtesy of the Library of Congress.

be more efficient. Charles Loring Grace's book *The Dangerous Classes of New York* (1872) suggested solutions to the horrid conditions, such as sending young boys to the Midwest to work on farms. The Children's Aid Society in New York, one of New York's earliest and most enduring charities, was sending boys out to farms by the thousands in the mid-1890s. Children were also sent from Baltimore, Boston, Philadelphia, Saint Louis, Cleveland, San Francisco, and Washington, D.C. (Wright 1981).

The first accommodations of the poor in the cities were in converted warehouses where sometimes several hundred people would be housed. In the 1830s, landlords in New York, Philadelphia, and Boston began building tenant houses to house the influx of African American and Irish workers. These were the first dwellings constructed to house a number of different families or unrelated groups. They were three or four stories high, with two families on each floor. The basement, wet and underground, also housed two families. The lot usually contained another building in the backyard. The houses had very little light, air, or space for each tenant. In 1850, the average tenement housed 65 people in New York or Boston (Wright 1981, 117). The so-called housekeeper, a middleman who worked for the landlord, was the gatekeeper who chose the tenants and gauged how much rent they paid. The more people he crowded into the apartments, the more money he made.

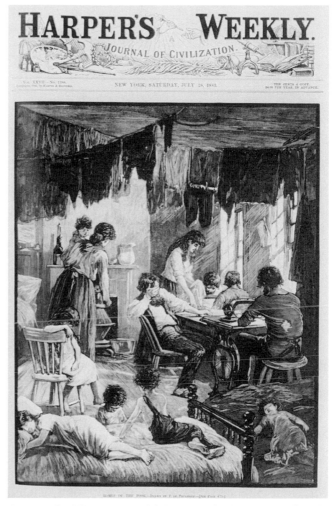

A cover for *Harper's Weekly* in 1888 depicts a poor family crowded into a tiny tenement. Courtesy of the Library of Congress.

The word *tenement* is a word from the nineteenth-century United States but is derived first from Latin, and then the medieval English tenement, an abode for a person or soul, where someone else holds the property (Wright 1981, 118). These early tenements were common after the 1850s as industrialization brought factories and factory workers to the large northeastern cities. A word used to describe the ghettos for the poor was "rookery," an English term, derived from the original meaning of a breeding ground for a large number of noisy birds, such as rooks. Manhattan had one of the most notorious rookeries, called "Five Points," in downtown Manhattan. The residents were primarily Irish and Italian, as witnessed in the 2003 Martin Scorsese film, *The Gangs of New York*.

The next incarnation of the tenement in the 1850s in New York City, the most densely populated city in the country, was the railroad tenement. The 90-foot long structure filled up 90 percent of the entire lot, which was typically 25 feet by 100 feet. The building was 25 feet by 90 feet. This multifamily dwelling was built to house up to 20 families in 6 stories, with 4 apartments per floor. There were 12 to 16 rooms on each floor. Only the ones facing the street or the tiny backyard had any light or air. The apartments were called railroad, because, like the southern shotgun house, there were no hallways connecting the rooms. The rooms were connected by interior doors, which led directly from one room to the next, in order to maximize the usable space in the apartment. The rooms of the apartment were tiny; the entire apartment contained only 325 square feet. In that apartment, families of up to 12 were housed. Some poorer families had to sublet their apartments to unrelated tenants in order to pay the rent. The sewers were outside and were open, clogged, and overflowing, and garbage was everywhere. The areas were extremely unsanitary, dark, and foul.

New Yorkers formed a group called the Citizens' Association in 1864 in response to fears of typhus and cholera epidemics, the draft riots in New York, and the high death rate. In investigating housing in the poor neighborhoods, the Citizens' Association discovered the sorry state of housing conditions and published maps, drawings, and photographs of the conditions. The report suggested four solutions to the problem, which would remain the principle type of proposals for the poor for many years afterward. The four proposals were: (1) collection of vital statistics, (2) moral uplift through church missions, (3) public health control and information dispersal throughout the community, and (4) encouragement of resettlement to working-class houses outside the city (Wright 1981, 118).

Most reformers regarded urban life itself as the cause of many of the ills of the poor. Relocation to the suburbs was considered the solution to the urban blight problem. The fact was that there were many people of considerable means also living in the city, who also required city services, and they influenced the creation of the Metropolitan Board of Health in New York and the local tenement house law. Unfortunately, there was no power in the law to enforce it. The common fear of disease in the filthy tenement districts was proven valid when, in the 1880s, Louis Pasteur and Robert Koch discovered bacteria. Reformers cited scientific evidence that damp, dirty environments created havens for disease-growing bacteria (Wright 1981, 120). There was, in fact, a preponderance of disease in the poor neighborhoods where tuberculosis, typhus, and pneumonia were three to five times more common than in middle-class areas. In addition, many of the newly arrived immigrants performed work in their apartments, for instance, sewing clothes, rolling cigars, and making a variety of small items that were considered home work. Some families set up whole dressmaking shops in their tiny apartments.

Tenements and Reformers

Many middle-class citizens living in the outlying suburbs did not concern themselves with the health conditions of the immigrants in the slums. However, the middle and upper class were concerned that diseases rampant in the tenement could contaminate the clothing or other items being pieced together

in the tiny apartments. The reformers, attempting to get the attention of the general public, took advantage of these fears, often citing sick, dying people sharing rooms with expensive items for sale. Reform was promulgated by the leading magazines of the day: *Harpers, the Atlantic, Scribners,* and others. Architectural publications, becoming very popular at the time, also took up the cause.

Before the Progressive movement gained influence, society routinely considered poverty the fault of the poor themselves. The miserable state of life in the ghettos was cited over and over in newspapers and magazines. They often blamed the immigrant culture more than the conditions in which they lived for their predicament. The *Chicago Herald* asserted that "it is not abject poverty which causes such nasty and cheap living; it is simply an imported habit from Southern Italy" (Wright 1981, 121). The poor were thought of as undeserving and responsible for their plight, which was a belief of the Social Darwinist. Social Darwinism, related to the theory of evolution then recently proposed by Charles Darwin, claimed that the survival of the fittest applied to the population as a whole. The poor were poor because they were the segment of society that had not evolved as a superior group, either in intelligence or in vigor. The Social Darwinists contended "cream rises to the top." The poor should be given a hand only because the Christian religion advised that charity was the Christian thing to do. In accordance with Social Darwinism, reformers searched for the so-called deserving poor in order to lift up the masses. The deserving poor were those who were willing to

In History: The Progressive Movement and Social Darwinism

The Victorian culture was coming under assault by the 1890s. The so-called Progressive movement in the United States began in the last decade of the nineteenth century, continued until about 1920, and influenced all aspects of society. Because of the growing misery suffered by the poor and the expanding gulf between the rich and the poor, the middle class saw the opportunity to improve society through expanding the power of the state. Activists who saw the danger of huge monopolies attempted to persuade the government to regulate corporations for the good of the public. The women's suffrage movement finally began gaining steam. The temperance movement, another cause of many women, also was influential. The horror stories of the poor that were being described in magazine articles and books, such as Jacob Riis' *How the Other Half Lives* (1890), led to an outcry over child labor practices as well as housing reform. Women also contributed to the social worker movement, for example, Jane Addams in Chicago, who built settlement houses that helped the poor. John Dewey at the University of Chicago espoused new ideas regarding progressive education. The Progressives, who believed in the ideal of social justice, rejected the nineteenth-century notion of Social Darwinism, espoused by the leaders of the corporations. Social Darwinism taught that, in society as well as in evolution, the strongest would survive. No thought was given to the ones who did not survive; that was "God's will." The Progressives had an opposite view: The state should be strong enough to represent all the people, the weak as well as the strong. And through regulation as well as private charity, the weak could be assisted against the enormous power of the rich and corporations. Government grew immensely during the Progressive movement, and for the first time, the constitution was amended so that the federal government could institute an income tax in 1913 after several false starts in the 1890s.

forgo alcohol, go to church regularly (preferably not Catholic), and perform good, honest work. In fact the reality was that most of the people in these slums, consisting of many southern and eastern European immigrants in the 1880s and 1890s, were hard working, God-fearing people, who kept their tiny apartments neat and had strong social and family support networks.

The deserving poor were targeted for social programs to encourage them to move to the suburbs into cottages where sanitation was improved and light

and air vastly improved. New York, Philadelphia, and Boston had reduced rates on their elevated trains for workers to travel into the city from the new cottages. Building and loan societies helped the more affluent of the immigrants to purchase houses. However, with the continuing surge of new immigrants coming to the cities until well after the turn of the century, the cities retained the aura of extreme crowding and unhealthy conditions no matter how many had the chance to move out.

Many architects of the time were interested in the tenement problem, including Ernest Flagg, Frederick Law Olmsted, and Calvert Vaux. They attempted to design alternatives to the existing "old law" tenement. The New York magazine *Plumber and Sanitary Engineer* had a competition in 1879 to design a new tenement that would provide improved sanitation, ventilation, and fireproofing as well as providing a profit for the landlord. Won by James L. Ware, the so-called dumbbell tenement contained an airshaft in the center of the otherwise solid structure. Though criticized by many architectural critics of the day, speculators and builders jumped on the solution because of its high profit margin. The state of New York passed a tenement house law in 1879, which used the dumbbell model as the minimum standard. The new dumbbell tenement was only supposed to cover 65 percent of the lot, instead of the common 90 percent. Unfortunately, the new tenements did not follow the law, and most of them still covered 75–90 percent of the property (Roth 2001, 230). After 1879, the dumbbell became ubiquitous in New York City. It was not, however, the model tenement. The dumbbell tenement was on lot that was 25 feet wide and up to 90 feet deep. Indentations were 28 inches wide and 50–60 feet long, enclosed on all sides because another building was built immediately adjacent to it. Light and air did not really penetrate because the higher floor tenants would throw their garbage into the well, which was not collected and was left to decay. It was difficult to carry trash out of the building because the stairways had no source of light. The only light on the stairway came from one small window in the door on the first floor. In 1893, the Board of Health in New York found that over one million people in New York City (70% of residents) lived in multiple dwellings, of which 80 percent were tenements and most of those dumbbell tenements. Thousands of modified dumbbell tenements are still in use today. Speculators who built hundreds of them in Manhattan between the years of "old law" tenements in 1879 and "new law" tenements in 1901 preferred the design. In 1901, the state of New York passed the Tenement House Law, which contributed, greatly to the comfort of the tenement dwellers by demanding several new amenities. One, each room had to have a window, which was interpreted as an interior window within the walls of the apartment, but in fact did provide much more daylight. Also, all apartments had to be provided with indoor toilet facilities on each floor. These were communal, however, not private.

Tenement Improvements

In the 1870s, some reform-minded people began to link the deplorable conditions in the urban slums to the houses themselves, arguing that the environment itself could demoralize and even physically destroy its residents. The abysmal poverty, disease, and discontent of the inner city were starting to be

attributed to the overcrowded tenement dwellings. Those who wanted to uplift the victims of poverty now viewed tenement-house reform as a key to changing the residents' lives. Housing conditions were evidence of every failing of character, the cause of every social problem, and the surest path to improvement. Home improvement for the urban poor, like home improvement for the middle class itself, was considered the direct route to virtue; bad home environments were the inevitable roads to despair. The architect Ernest Flagg tossed himself into the fray by suggesting that "reform can only be brought about through the pockets of the landlords. Show them how they can build good houses for less than it now costs to build bad ones" (Wright 1981, 117). Other developments in the 1880s included giving model housekeeping classes and anti-tuberculosis exhibitions. Unfortunately, though familiar to all preservation students, these experiments were extremely rare and not the experience of most of the immigrants and other poor people who lived in New York City in the last years of the century.

As typical of the time, government was not expected nor did it seek any involvement in providing for the proper housing for the poor. Model tenements of the late nineteenth century were designed and built by philanthropists who were concerned about the conditions of the poor, as well as the possibility of contamination into middle-class and upper-class society. Speculators were looking for a profit in their investments. Proponents of the model tenements proposed "philanthropy and five percent." Five percent was much less the than the 20 to 25 percent earned on the typical tenement, so it was not a popular proposal among the speculators. Model tenements were much discussed; however, they were not a significant influence in the lives of the poor. Between 1855 and 1900 in New York City, about 200 buildings were erected as models, though some 50,000 of the typical tenements were built.

One of the major characteristics of successful model tenements of the late nineteenth century was that the developments were large in scale. For instance, the Home and Tower Buildings (1877–1878) in Brooklyn, and the Riverside (1890) also in Brooklyn, built by Alfred T. White, were influenced by British developments. They were much larger than the typical tenement, which had a 25-foot frontage. These were entire city blocks—the size was 200 by 400 feet, where there would have been 32 buildings in a typical tenement. In the center was a large open quadrangle; therefore, every room got light and air. Secondly, they had sanitary facilities: toilets, sinks, and washtubs were on every floor, served by water tanks erected on the roofs, although they were communally used.

Some model housing advocates backed suburban cottages instead of model tenements. Frank Lloyd Wright designed a model-housing complex in 1895 for the philanthropist Edward Waller in Chicago. It had only two stories and separate entrances for each family, with a hood over the entrance to look like private residences. There were some housing reformers who advocated suburban cottages as panaceas for the urban poor. Boston had a development of 116 substantial workingman houses in the 1890s. New York City had a large development called Homewood in Brooklyn that was 53 acres, with tiny 2- story brick and wood houses with a porch and a gable roof to "add quaintness," according to the description. The dictatorial policy was that there could be no multiple families in the dwellings, no bars, no factories, and each family had to have life insurance to cover the cost of the house (Wright 1981, 127).

The tenement in New York City was ubiquitous and studied by contemporary reformers and historians ever since, but in fact it was an anomaly within the design of housing for the poor in the country as a whole. Thomas J. Schlereth states: "tenements never constituted more than a fraction of the housing that was built. New York's Lower East Side, the case study most frequently cited because of its extensive slum housing, did indeed contain densely crowded tenement districts and vile living conditions. A similar density of tenements, however, appeared in few other cities. Instead, all sorts of multiunit dwellings, made of masonry, brick, or wood and rarely more than three stories high, characterized multifamily housing for the urban working class" (Schlereth 1991, 109).

Although many books have been devoted to the tenement in New York, and a living history museum has opened up on Orchard Street in Manhattan solely devoted to the immigrant's tenement experience, the experience was nearly unique to New York City, and primarily Manhattan. Other cities housed their poor in other types of conditions, for instance the shotgun house in New Orleans, and not in the six-story multifamily apartments found in New York. The tenements were influential, however, because they were in New York, and because so many of the nation's families had ancestors who lived in one at some time in the family's history.

Other Types of Multiple Dwellings

Although dumbbell tenements were a New York City invention, other cities provided other types of housing for the poor. Mostly, older housing stock, row houses, single-family dwellings, and even shacks were converted and subdivided to house several families. All cities, however, had the problem of overcrowding, poor sanitation, poor construction, and poor health. The legal definition of a tenement in New York City is a building housing three or more separate apartments. After the 1890s, when sanitary facilities were typically being installed into apartment buildings, the difference between tenements and apartments was that the apartment had separate bathroom facilities for each dwelling unit, and the tenement had shared toilet facilities, usually one per two dwelling unit. A type of tenement found in Chicago on the south side was actually derived from older large houses vacated by the original owner (who most likely moved out to the suburbs) and purchased by speculators hoping for redevelopment of the area for manufacturing purposes. In the meantime, the rooms were rented out to workers who did their own cooking on a hotplate. Other eastern cities, and later, midwestern cities, had some housing stock known as tenant houses, which were three stories high and had a family occupying each floor. These houses were specifically constructed as multifamily dwellings. These types of tenement were known as bandboxes, or father-son-holy-ghost houses in Philadelphia. In Washington, D.C., the alley tenement was created, which was 12 feet wide and 30 feet deep with two stories. The living room and kitchen were on the first floor and the bedrooms on the second floor. Before the Civil War, white workers' families lived in these, but after, the alley tenements housed mostly African Americans.

Other regions had other solutions to housing the working poor. An ubiquitous sight throughout New England, from Connecticut to Maine, is the

so-called triple decker, New England's solution to the housing problem for poor immigrants and other working-class families. Though not found in downtown Boston, triple deckers were built in Boston's suburbs and all other small towns and cities. These were versions of the workers' cottages found elsewhere, but for multiple families. On a narrow but deep lot, the wood-framed triple decker contained three apartments, all the same size. They most often had porches at the front and the back on every floor. These large houses are still seen all over the region today and provide roomy and adequate apartments for families, usually with a parlor, dining room, kitchen, and three bedrooms. The major risk with these dwellings is fire because, as large wood framed structures, they were in no way fireproof.

Boarding and Rooming Houses

One of the ways poor and single people found accommodation during this period was in boarding or lodging houses. Boarding houses, popular until the early to mid-twentieth century, provided housing for people who were not able, for various reasons, to buy a house for themselves. (Boarding with other, not related persons, was a time-honored practice in the United States. It was also practiced by immigrants in the tiny tenement apartments in New York, as the practice of subletting rooms within one's own apartment in New York is still going on today.) Boarding houses, however, were often seen in middle-class neighborhoods where a family, often headed by a widow, rented out rooms and provided meals for unrelated boarders for a reasonable rent. Most boarding houses had many rules and aspired to an air of refinement. They required references from the prospective boarders, and many prohibited alcohol and guests in the rooms. Boarders were allowed to stay in their own rooms, the parlor, and the dining room only. Dinner was served usually at an appointed time, though if boarders were on a night shift, the proprietor had to prepare several meals for different dining times. Boarding houses became extremely popular around the turn of the century, and by 1910, one-third to one-half of Americans had either been a boarder or lived in a house that rented to boarders sometime in their life.

The work of the boarding house was the woman's. Here was an opportunity for the woman to be a landlord, a restaurant proprietor, and a hotel manager. With the discrimination practiced toward women's work at the time, and the cult of domesticity chaining the woman to the house, a career running a boarding house gave the woman a chance to make money in a genteel manner while staying at home and tending the home and the flock. It was one of the few opportunities for a woman to be independent without the scorn of society's watchful eye.

On the other end of the economic and social scale was the lodging or rooming house. The rooming house was a building where tenants paid for a room, but not board. This crucial difference made the lodging house a social evil, condemned by reformers as a source of urban decay. In the book *The Lodging House Problem* (1906), Albert B. Wolfe described the lodging house as a house in the downtown area, usually originally an upper-class home in a neighborhood that has deteriorated. The rooms are rented out for $1 to $7 per week. The owner was usually a woman who lived the basement. The house did not offer

the amenities of the boarding house and often had only one toilet with up to 12 residents and only infrequent hot water (Schlereth 1991, 105).

The lowest level of the multiple family dwellings was the so-called flop-house. Cribs or cages were rented for 5 cents to 25 cents per night depending on the accommodation, for a tiny cubicle or a space wherever you could find it. These buildings were not originally residences; they were most often converted warehouses. Also, people did not rent the room; as soon as one person departed, the bed would be rented out to the next person to come along.

In addition to the flophouses and rooming houses in the urban areas, reform groups and philanthropies built alternate accommodations for poor and single residents. The most famous of these is the YMCA, which built residences as part of their mission all over the country. There were other reformers, such as Jane Addams in Chicago who started Jane's Clubs, houses where residents boarded and paid three dollars per week.

French Flats for the Wealthy

For the city dweller, a new mode of living was introduced into the United States in the late nineteenth century. Apartment living, called French flats, was imported from the Continent and had a faintly racy and glamorous reputation. The idea of sharing a building with other nonrelated families was appealing to some of the wealthiest in society. American real estate developers retained best-known architects to design apartment buildings, which were completely different from previous designs by these architects. The first apartment building built in Boston in 1855, the Hotel Pelham, was called an apartment hotel. The Stuyvesant Flats was built in 1869 in New York City and designed by Richard Morris Hunt, who was a society Beaux-Arts architect trained in France (Roth 2001, 224). Both the Hotel Pelham and the Stuyvesant Flats were very luxurious buildings for very wealthy tenants. Early apartment buildings were often designed in the Second Empire style to look French. The effect of the mansard roof made the building look closer to the ground and more residential to the new residents. Stuyvesant Flats became known as French Flats—only the city's rich lived here. The apartments had 6 to 10 rooms each and rented for $1,200 to $1,800 a year. The building was very popular with a waiting list. It cost $150,000 to build and brought a $23,000 profit the first year. The French Flats had the amenities of a hotel, and at first were run as apartment hotels, with dining rooms, room service, laundries, and maid service. The appeal of the apartment hotel was the technological innovations built right into the structure. They had hot water, bathrooms, kitchens, telephone service, electric lighting, and elevators. In New York, there were nearly 200 French Flat–type buildings built between 1860 and 1876. Boston, in 1878, had 108 apartment hotels; Chicago built 1,142 apartment buildings in one year after the fire of 1871 (Wright 1981, 138). Design of this type of building was encouraged by the high profit (10–30%) and by the space limitations of the new urban development.

Smaller apartment houses were soon built for the middle class. These were not apartment hotels, but were exactly what we think of today as apartment houses. Many still exist in New York City and are the most desirable apartments because of their size. These apartment houses were also built in all the major cities, along the streetcar lines. The apartments ranged in size from

four rooms to a one-room studio. Later, after 1900, a small apartment called an efficiency became popular in California. These had tiny kitchens, which came to be known as kitchenettes, and were the first manifestations of the modern, small kitchen for preparing convenience foods and ubiquitous in today's apartment buildings.

INTERIOR VENTILATION

Another influence in the interiors of the late nineteenth century was the concern for ventilation and its related need for central heat. This concern developed due to the air pollution coming from industrialization as well as the indoor air pollution created by gas light, fireplaces, and cooking smells. As a consequence, the Victorians were obsessed with fresh air. They abhorred cooking smells and located the kitchen as far away from the living areas as possible. They also disliked smoking smells, and confined smoking to smoking rooms inside the house or outside the house altogether.

The foundation of the Victorian fixation on ventilation was scientific theory. Scientists had discovered that air consisted of three

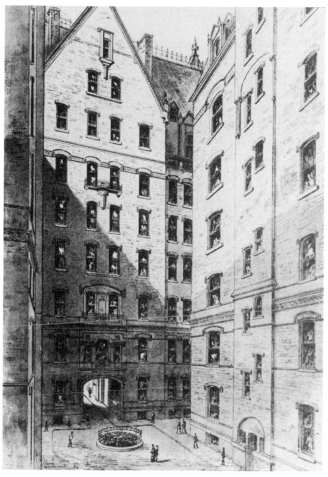

This 1884 drawing of the Dakota Flats, now the famous Dakota apartment building where John Lennon lived and was killed, is an example of French Flats in New York City. Courtesy of the Library of Congress.

elements: oxygen, nitrogen, and carbon dioxide, known as carbonic acid. Scientists saw that when a human breathed out, the expired breath was carbon dioxide, and they believed that too much carbon dioxide was detrimental to one's health. The evil of carbon dioxide was supposedly proven by the comparison of a candle being extinguished when placed under a glass with a person living in an unventilated apartment. However, the actual culprit was lack of oxygen, not a surfeit of carbon dioxide. Sanitary engineers and other scientists told stories like the infamous "Black Hole of Calcutta" where, in 1756, 146 men were forced into a hole only 18 feet long and 14 feet wide with only two small ventilation holes. The next day, 123 men were found dead, and the others were barely alive. Similar stories were related about deaths due to lack of ventilation. The blame for these deaths was placed on carbon dioxide. In addition, experience demonstrated that a crowded room soon became stuffy, and scientists believed that the effect was created by too much carbon dioxide. To correct these

critical problems, ventilation was required, that is, fresh air must be introduced. Though the theory of excess carbon dioxide was later proven wrong, the idea of increased ventilation was on the right track. Homes do need ventilation due to heat, dust, humidity, and ionization.

Scientific thinking of the era alleged that the carbon dioxide level in a house should not exceed one and a half times the level outside. The figure now is two and a half times. Contemporary science also did not fully comprehend the amount of air that leaked through windows, doors, and cracks. A book written in 1880 on "healthy dwellings" stated that 50 cubic feet of fresh air per minute per occupant was needed to properly ventilate a room. Others contended that 60 cubic feet was necessary. Today's engineering standards call for between 5 and 15 cubic feet of fresh air (Rybczynski 1986, 134).

The other consideration in ventilation was the belief in airborne diseases. The miasmic theory purported that germs in the air caused many serious diseases. These diseases included malaria, cholera, typhoid, dysentery, and diarrhea. The popular term for this condition was foul air, or vitiated air. Scientists assumed that, because epidemics occurred in crowded, urban environments, the source of the disease must be airborne. The belief that exhaled air contained poisons was accepted in the nineteenth century, especially after the Civil War. The supposed guilty toxins were carbon dioxide, known as carbonic acid, and organic effluvia, which were microbes suspended in the exhaled breath (Townsend 1989, 29).

Houses that were built with these ideas in mind contained extensive air ducts and ventilating flues. These houses did provide the owner with fresh air, but of course the air was cold, and the owners sometimes blocked the vents so that they could more effectively heat the houses. These were primarily houses of the upper middle class who were interested in being fashion-forward. Most houses were not constructed with ventilating ducts. Unfortunately, the buildings that needed the increased ventilation, in the crowded tenements of the cities, didn't get them. Therefore, the epidemics continued until architects began to design model tenements, which attempted to address the foul air problem.

Though not as involved in the technology as engineers were, some architects designed houses at this time with ventilation concerns in mind. Architectural periodicals published at the time were filled with discussions of designing for well-ventilated spaces. Basements had to be big enough to contain a central heating system, for storage of coal, a large furnace, and ductwork or pipes and radiators. The walls had to be able to contain ducts and flues. By the end of the century, the type of heating and ventilating system had to be, for the first time, considered when designing the house. The design of the house also took into account the location of the house and the location of the main rooms to maximize sunlight and breezes. Windows were large and recommended to be on at least two sides of the room. Metal screens were available at this time and were used for keeping out bugs during the summer months. Wood was considered more porous than masonry and therefore preferable for ventilating purposes. Strangely enough, contrary to today's designs, insulated houses were considered unhealthy. Of course, heat was wasted. Porches were also very popular on Queen Anne, as well as other popular house styles of the time. Though porches were common throughout the nineteenth century, advocated by Andrew Jackson Downing in the 1840s, the end of the century produced the largest porches.

These porches provided ventilation. A bay window was often located adjacent to the porch, adding to the breezes available for indoor air. These factors may have contributed to the popularity of the Queen Anne style.

In 1895, the Smithsonian Institution published a report of an investigation by several research physicians debunking the foul air theory. They stated: "it is very probable that the minute quantity of organic matter in the air exhaled from human lungs has any deleterious influence upon men who inhale it in ordinary rooms, and, hence it is probably unnecessary to take this factor into account in providing for the ventilation of such rooms" (Townsend 1989, 42). By the end of the century, ventilation no longer was a crucial factor in design and in scientific circles. Electric fans were available as one of the first electric appliances. The Society of Heating and Ventilation Engineers was formed in 1895. The field was rapidly professionalizing, as were other professional fields, therefore, engineers began to calculate the actual requirements for ventilation.

HEATING THE HOUSE

In addition to ventilation, all houses had to contend with the infiltration of the winter's cold air. The first American homes were heated with the large main fireplace, which provided for both heat and cooking apparatus. The fireplace had to be continually fed, and the family generally gathered in the hall, which was the central room of the house. The fireplaces in the other rooms of the house, if any, were small and didn't provide much heat. There was no insulation in these old houses, and much heat was lost to the cold outside air. The immigrants from Britain arrived in the cold New England winters without much knowledge about interior heating. English winters rarely have below freezing temperatures. The English colonists built houses from wood, which became the most common form of construction in the country. On the contrary, the colonists who settled many middle Atlantic states were from Germany and other parts of northern Europe. They had more knowledge of the science of home heating. They most often built their homes with brick or stone, a better insulator, and located the fireplace in the center of the house where it lost less heat to the outside. They also brought over the idea of the log house, which made the transition to the western frontier. Unfortunately, however, the influence of the English colonists was stronger, and the wood house with the fireplace on the exterior wall became the standard for the country.

The Franklin stove, designed by Benjamin Franklin in 1742, was popularized in the first half of the nineteenth century. It was an adaptation to the existing fireplace whereby cast iron plates were fitted into the fireplace with dampers and flues. It was able to provide additional heat to the room without losing as much heat up and out the chimney. Differing versions of the cast iron stove developed during the nineteenth century. Pot-bellied and other types of cylindrical parlor stoves became a ubiquitous feature in the homes and apartments of Victorian families. These stoves had exposed flues and were prominent members of the household. Stoves and hot-air furnaces, with names like Crown Jewel or Art Garland, were decorated with lots of rosettes, ribbons, and other ornament, which contributed to the beautification of the house as well as its environmental comfort. Though the technology was available, only the wealthiest citizens had central heat after the Civil War. These systems were often

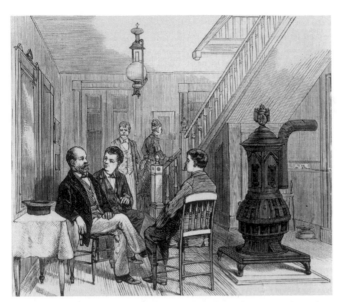

This illustration is of James Garfield's house, showing men meeting in the corridor where the stove is keeping them warm. Courtesy of the Library of Congress.

hot-air furnaces, pumped through the house with ducts. Hot water systems and steam systems were also available.

Catherine Beecher, the domestic science expert, advocated central heat in two of her publications. In her 1841 *Treatise on Domestic Economy,* she included plans for a central chimney system whereby the fireplace could heat more than one room with one fire, and the heat would not escape through the exterior walls. Unfortunately, the concept was not popularized until decades later. Beecher also recommended another system in 1869 in her second book *The American Woman's Home.* This system was an attempt to solve the heating and ventilating concerns of the day and connected the basement furnace to a kitchen range and Franklin stove. It had a central foul air pipe, rising from a hot-air furnace in the basement, and connected to a kitchen stove and two Franklin stoves on the first floor. The Franklin stoves had air-intake pipes to the outside, and the second floor was heated by warm air from the basement furnace. Registers in the ceilings of the second floor rooms carried the used air out to the chimney and out of the house. This also was not a commonly seen apparatus. Most houses still had independent Franklin stoves. Central heating, though available for years, was not extremely common until after the turn of the twentieth century. Even Sears, with its popular house plans, did not provide central heat in its houses until after 1900. By 1908, the company provided options for coal-fired furnaces for both hot air and hot water and also sold radiators, pipes, and fittings (Strasser 1982, 54).

The fuel used for heating the houses of the late nineteenth century was most often coal. Wood had become scarce on the East Coast as early as the 1600s and was regulated in the colonial towns during the eighteenth century. Fuel was always in short supply and had to be imported from Britain until the discovery of soft, or bituminous, coal in Virginia in 1750. By the mid-1800s, most of the coal in the United States was produced here. The coal industry burgeoned by the 1880s because of the construction of the railroads, which were able to provide coal throughout the nation. Coal was an exceedingly popular commodity because all houses used coal for heat by the end of the century. Those who had central heating units had furnaces fueled by coal; those who had stoves also used coal. Frontier families chopped wood, but by 1900, the frontier was officially closed and more and more people lived in cities and towns and were, therefore, coal consumers. Some western settlers, such as prairie dwellers far away from a forest, used whatever they could find to fuel the stove, which often included cow chips. They served as an efficient, if malodorous, fuel.

Late nineteenth-century women often tended coal stoves and furnaces, not unlike their earlier colonial counterparts. Because of the societal ascendancy of the cult of domesticity, the realm of the house was the woman's. Therefore, though the man made the money to buy the coal, the woman handled it. That meant hauling the coal into the house and feeding it to the stove many times a day. The later versions of the stove, which were self-feeding, required fewer trips, but still required tending several times a day. Dangers lurked in the heating stoves, especially the ones that were designed as airtight. They produced carbon monoxide. Though the fear of the day was carbon dioxide produced by exhaling, the real risk of these stoves was the carbon monoxide that they emitted. The concern for ventilation had legitimate causes; one of them was carbon monoxide, but the scientists of the time didn't comprehend that yet. Catherine Beecher also considered ventilation a crucial issue. She recommended using pans of water to increase humidity in the house dried out by the stove. She also recommended houseplants that used some of the carbon dioxide produced by the human breath. No matter what was done, the heat provided by Franklin stoves was inadequate. Houses had no insulation and drafty windows and doors. The upper floors had no heat, although many houses had grates in the ceiling to direct the heat to the second floor bedrooms. Any floor above the second floor had no heat whatsoever.

New Heating Techniques

The engineer David Boswell Reid, in the Houses of Parliament in England, designed the first major use of central heat in 1834. The methods of central heat developed in the nineteenth century were: hot air, hot water, and steam. Another technique that was developed was forced ventilation, either by means of the drawing power of heat or mechanically by means of a fan. Because of the obsession with ventilation in the years after the Civil War, several techniques were proposed for heating and ventilating a house, but there were two fairly typical means. The first technique was via natural ventilation, which required only the opening of windows. This, however, created drafts, which were also not considered healthy at the time. The second technique was a heat-extraction system, which depended on a source of heat at the base of an exhaust flue. Interior air was drawn to the heat and sucked out the exhaust flue, which forced outside fresh air back into the house. The easiest way to keep this system going was to have fireplaces in every room. These old-time sources of heat were considered healthier than newer stoves that people were using because stoves did not ventilate the foul air and even provided additional toxic fumes through gases emitted by the stove itself. The idea that fireplaces provided the best type of heat was common in the 1870s. Though fireplaces wasted fuel, a new invention called the Jackson Ventilating Grate was popular. This device had an open metal grate and rear air chamber. The fire in the grate drew fresh air into the chamber, and then warm air was pushed out of registers located above the fireplace. The warm air would descend in the room and then be drawn into the fireplace and expelled (Townsend 1989, 32).

Central heating was also available at this time to those who could afford it. The most common was the hot air system, which was designed to provide ventilation in the house through a central exhaust flue, ducts from each room to

the central flue, and a furnace or stove at the base of the central flue. The flue channeled foul air vertically out of the house through the chimney. A system designed by the Canadian inventor Henry Ruttan got fresh air from an underground pipe to a furnace located under the stair hall. Registers in the first floor stair hall received the warm air and the stairwell acted as a flue to carry warm air up to the second floor of the house. There were also tin-lined ducts and brick flues that brought warm air to registers on the floors of the individual rooms. The warm air rose to the ceiling, and as it cooled off it fell back down to the floor, where there were outlets located to collect the used (or foul) air. The foul air was drawn under the floors to a chamber in the basement, where the central flue pushed out the foul air (Townsend 1989, 33).

A dilemma had to be faced in regards to the philosophy of central heat. Many scientists, engineers, and sanitarians questioned the healthiness of central heat due to the obsession with ventilation. Also, architects and engineers had conflicting opinions about all types of technology; whereas the engineers were looking for innovative solutions to current issues, architects were generally conservative and did not encourage technological innovation in their designs.

The advent of central heat in the majority of American homes didn't come about until the 1920s. Even then, many of the poorer residents still made do with Franklin stoves. The development of the cult of domesticity contributed to the popularity of the fireplace and its related hearth warmth and home and family connotations. As central heating became more popular, fireplaces took their place as a symbolic, if generally decorative, feature of the house.

By the end of the nineteenth century in both England and the United States, architects and engineers were working together to design and provide buildings that were considered integrated systems, which included central heating and ventilation. It was very important for the development of designs for institutions, especially hospitals, prisons, factories, and so forth, but it also influenced house design in the drive for additional comfort and ventilation in domestic architecture.

Reference List

Beecher, Catherine E., and Harriet Beecher Stowe. 1869. *The American Woman's Home.* Repr. New Brunswick, NJ: Rutgers University Press, 2002.

Clark, Clifford Edward, Jr. 1986. *The American Family Home, 1800–1960.* Chapel Hill: The University of North Carolina Press.

Fitch, James Marsden. 1973. *American Building—The Historical Forces that Shaped It,* 2nd ed. New York: Schocken Books. (Orig. pub. 1947.)

Friedan, Betty. 1963. *The Feminine Mystique.* New York. W. W. Norton & Co.

Jackson, Kenneth T. 1985. *Crabgrass Frontier: The Suburbanization of the United States.* New York: Oxford University Press.

Riis, Jacob A. 1890. *How the Other Half Lives.* Repr., Boston: Bedford Books of St. Martin's Press, 1996.

Roth, Leland M. 2001. *American Architecture—A History.* Boulder, CO: Westview Press.

Rybczynski, Witold. 1986. *Home—A Short History of an Idea,* New York: Penguin Books.

Schlereth, Thomas J. 1991. *Victorian America—Transformations in Everyday Life, 1876–1915,* vol. 4. New York: Harper Perennial.

Strasser, Susan. 1982. *Never Done—A History of American Housework.* New York: Henry Holt and Company.

Townsend, Gavin. 1989. "Airborne Toxins and the American House, 1865–1895." *Winterthur Portfolio* 24(1): 29–42.

Wright, Gwendolyn. 1980. *Moralism and the Model Home: Domestic Architecture and Cultural Conflict in Chicago, 1873–1913.* Chicago: The University of Chicago Press.

Wright, Gwendolyn. 1981. *Building the Dream—A Social History of Housing in America.* Repr. Cambridge, MA: The MIT Press, 1995.

Furniture and Decoration

> The quasi-peaceable gentlemen of leisure, then, not only consumes of the staff of life beyond the minimum required for subsistence and physical efficiency, but his consumption also undergoes a specialization as regards the quality of the goods consumed. He consumes freely and of the best, in food, drink, narcotics, shelter, services, ornaments, apparel, weapons and accoutrements, amusements, amulets, and idols or divinities . . . Since the consumption of these more excellent goods is an evidence of wealth, it becomes honorific; and conversely, the failure to consume in due quantity and quality becomes a mark of inferiority and demerit. (Veblen 1899, 46)

The "man of leisure" described by Veblen is the quintessential Gilded Age American man. This quote is from the seminal work by economist and social theorist Thorstein Veblen (1857–1929) whose book *The Theory of the Leisure Class* was published in 1899. The book satirically characterized the middle-class and upper-class culture of the late Victorian age in America. Veblen coined the now-famous term "conspicuous consumption," by which he meant the consuming of material goods simply for the purpose of having them. The term is an apt description of the culture of the American family (particularly but not uniquely in the middle to upper classes) during this period. The interior of the home of the Gilded Age family was a testament to a consumption that was meant to be conspicuous. These interiors were contrived through conscious design to give an impression that the family had enough money to buy items that were not unambiguously necessary to sustain life. To Veblen, the flaunting of wealth and the goods associated with it betrayed the shallowness of the

society, and it was evident in the furniture, decoration, and ornamental goods found in the typical American household. In this chapter, the interior of the home will be examined, from the walls, floors, ceilings, and furniture to the colors and surface materials chosen and the use of new labor-saving devices available at the time, all of which could be used by those with enough money to flaunt one's success, which was a distinctive characteristic of the Gilded Age.

Though Veblen was concentrating on the upper middle and upper classes in his description of the leisure class, he was also describing a tendency endemic to the society as a whole. Though lower middle and lower class families did not have the wealth and time to become a leisure class, or anything close to it, the society that Veblen was describing was becoming a consumer-based society. Most of the population was unable to become true members of the leisure class, but they were developing the ability, through the proliferation of inexpensive, factory-produced goods, to purchase items just for the sake of having them. This consumer culture, which began in the late nineteenth century, has only grown as the twentieth and twenty-first centuries unfolded. The availability of consumer goods, produced by the burgeoning manufacturing industry, made it necessary to sell these items, and thus, the advertising industry was born. Catalogs like Sears and Montgomery Ward, as well as many others, and the new creation the department store, were the conduits for the sale of these new consumer goods. Thus, the man of leisure, the upper-class gentleman, as well as his lower-class counterpart, became complicit in the formation of Veblen's concept of conspicuous consumption. Victorian society's norms helped the public participate in the culture by encouraging families to flaunt their success, no matter how lowly it may have

The Theory of the Leisure Class by Thorstein Veblen

Thorstein Veblen, American sociologist and economist, wrote the Theory of the Leisure Class in 1899. The book describes his social theory of human civilization. In addition, he explains what he saw as a development of the United States in the second half of the nineteenth century, the idea of conspicuous consumption.

Veblen saw human development as consisting of two stages of civilization: The first stage was dubbed the savage stage, where classless settlements of people were peaceful and sedentary, and subsistence living was the standard. The second development of culture was the barbarian culture, a predatory way of life, where some in the community gained advantage over others, and they, therefore, were able to obtain more than enough to live and gained access to leisure time. The wealthier members of the group became the leisure class. Men and women were also differentiated by type of work: Men did the exploitative work, which was the work that was considered worthy, whereas women did the drudgery work, which was considered unworthy and debasing. As Veblen saw the stages of barbarism develop into late nineteenth-century society, the differentiation between classes and between genders increased.

Thorstein Veblen is known for his dubbing of the term conspicuous consumption, which continues to be used today. This term was used by Veblen to describe the consumption, that is, the purchase of goods and services that were not necessary to subsist but were desired in order to fill up the time of conspicuous leisure that came about through the creation of the leisure class. The new class had to prove that they were rich enough to not be required to work or to save in order to get by. They were able to consume just for the sake of consuming. The goal was not to be abstemious and frugal but to be the opposite, conspicuously consuming whatever could be purchased in order to show off your ability to do so. Purchase of property became very important in this quest to display wealth.

Veblen also believed that women were a commodity. Women could be acquired by men of the leisure class in order to flaunt them as evidence of their wealth. In addition, as the barbaric state developed, men who had such wealth could display their women as mere decorative objects who were not required to work or produce anything for society. These women became the conspicuous consumers,

(continued)

for that was their role in life, to buy unnecessary products. Victorian society spawned the concepts in the *Theory of the Leisure Class,* as Veblen was attempting to explain what he saw going on at the time. He even pointed out how people not truly in the leisure class seized upon the concept of conspicuous consumption, and even middle- and lower middle-class families made sure that the wife did not work. No, according to Veblen, the wife's role was to purchase gratuitous merchandise.

been. Even the poorest families wanted to show off their finest items in their parlors, or the areas designated as ceremonial space in the home.

INTERIOR DESIGN TRENDS

The style of the home's interior design went through a transformation during this period, as did the layout of the house. The proliferation of ornament and excess linked to the styles of the Victorian period was particularly evident in the interiors of homes during the 1880s. The typical 10-room house in 1888 suited a middle-class to upper middle-class family and cost about $3,750, and the furniture in the house might cost about $1,000 (Mace 1991, 3). Growth of the middle class and of the white-collar workforce created a large cohort of Americans with higher salaries and more disposable income. The average income in the United States grew 20 percent between 1870–1900. The relentless growth of industrialization made cheaply produced furniture and interior finishes available to the average consumer, who was growing more and more eager to consume it. A new center for furniture manufacturing in Grand Rapids, Michigan, had sprung up as faster and more dependable rail shipping from the Midwest provided access for families all over the country. Victorian people were collectors of things—usually for the purpose of broadcasting wealth, achievement, and creative talents. And as manufacturing of consumer products gained steam, the manufacturing and advertising industries were eager to provide. The public loved gadgets, and as gadgets became more and more available, they clamored to own the next big thing.

Creative expression was also a factor in the design of interiors. The interiors of the middle-class home in the 1880s and 1890s were often designed to depict a theme that portrayed an expression of the family's values. Clifford Clark states, "The ideal Victorian house was thus expected to be an instrument of display" (1986, 114). When entering the house, the visitor was confronted with a number of examples of the family's values on display. The front hall was the first room viewed by the visitor. Though technically unnecessary, the front hall often contained a large fireplace in order to convey a feeling of warmth and coziness to the visitor. Then, the visitor went into the front parlor, which contained the choice knickknacks of the family. Artistic expression was an important factor in the lives and interior design of the house. The parlor often had a theme, and the family wanted the visitor to figure out what the theme was through the discovery of the various symbolic objects in the room.

Like the stories of Sherlock Holmes and others that catered to the public fascination with disguise, false appearances, different cultures, and exotic lands, the ideal house was to be a mystery to be pondered and figured out. The sophisticated interior was supposed to be, in one sense, a book that would repay several readings, a complex set of ideas about beauty and individual expression that might be explored by friends and visitors. The downstairs with the draped doors, screens,

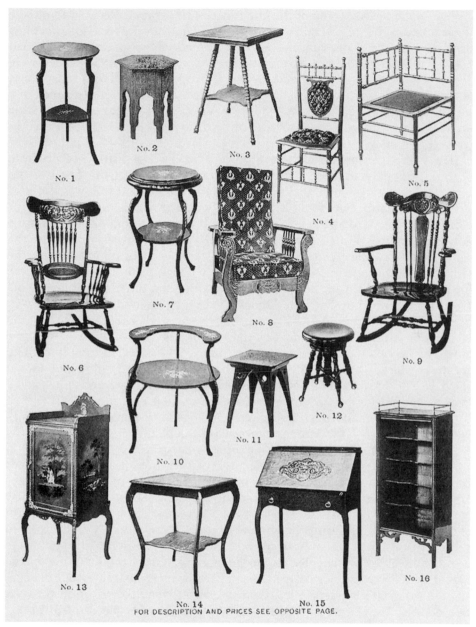

No. 1
No. 2
No. 3
No. 4
No. 5
No. 6
No. 7
No. 8
No. 9
No. 10
No. 11
No. 12
No. 13
No. 14
No. 15
No. 16
FOR DESCRIPTION AND PRICES SEE OPPOSITE PAGE.

By 1900, catalogs including this large, colorful Christmas catalog, were available to buy many furniture items. Courtesy of the Library of Congress.

and partially obstructed views was to be a form of maze to be explored and discovered (Clark 1986, 117).

Artistic expression was crucial to the Victorian family, and was expressed through the interior design, furniture, and knickknacks displayed in the home.

The middle-class family of the late nineteenth century was able to pursue these interests due to several factors. First, the family of the era had fewer children: The United States census showed that the average American family had 5.5 members in 1850; in 1890, the number was reduced to 4.93. Women were also more educated as more and more went to high school, or even college, and married later. The wages of the husband also went up as jobs became more plentiful and higher paid (Clark 1986, 121). Women, as queens of the domestic sphere, were now encouraged to carry out artistic pursuits, which were decorative as opposed to practical.

The style of the interior in the 1880s was influenced by historical styles from several previous centuries. The prevalent furniture style of the first decades of the Victorian age (after Victoria's rise to the throne in 1837) was the Empire style, based on the French style of the period of Napoleon. This style was classically influenced, with a heavy, scrolling ornament found on the furniture. A typical example of the Empire style still seen today is the sleigh bed and the scroll end sofa (Mace 1991, 1). The next style to gain in popularity was the Gothic Revival in the mid-nineteenth century. This style had Gothic elements in the wood, tracery with pointed arches, cutouts, and other types of elements found in Gothic churches. The French Revival, or Rococo Revival style, very popular for furniture by the 1870s and 1880s, was based on a French style of the eighteenth century. It was touted by the ubiquitous *Godey's Lady's Book* magazine. The Rococo was an enormously decorative style, delicate and ornate. The furniture typically had cabriole legs, which were curved legs with a little foot at the base. The decoration had flower designs set in apparently three-dimensional backgrounds, using perspective techniques to make it look more realistic. The furniture actually had three-dimensional carvings on the arms, backs, and legs with seashells, leaves, flowers, and other delicate depictions. The manufacturing techniques invented at this time made these ornate pieces possible.

The most important designer of this style of furniture was John Henry Belter of New York. He invented a process of laminating wood in a number of layers. These layers made the intricate carvings possible. The wood most popular for these pieces was rosewood. The Rococo Revival style was loosely based on styles seen in France during the reign of Louis XIV and Louis XV. Examples of these styles are the balloon back chair and the tete-a-tete sofa. (The tete-a-tete sofa was a seat for two people designed in an S-curve so that the two occupants would face each other. The term *tete-a-tete* literally means *head to head* in French, though the phase is often used to indicate an intimate conversation between two people.) New factories were producing hundreds of pieces of furniture, wallpapers, and carpets with roses, ribbons, and arabesques. American middle class families were impressed with this fashion, and because it was available at reasonable cost, they bought as much of it as they could afford.

The other popular furniture style of the time was the Renaissance Revival style, another historical style. This style was very different in tone, not at all delicate or ornate. It was based on Italian Renaissance precedents and appeared heavy and ponderous. It is exceptionally solid, architectural, and straight with turned legs. It also featured architectural elements such as columns and pediments. American families liked it for its seriousness and its imposing quality. The Renaissance Revival style helped shape the ideas of Charles Eastlake, one of the most influential of the late nineteenth-century designers.

The prodigious number of factory-made goods available on the market affected the flamboyance of the late nineteenth-century furniture and design at the time. The tradition of making your own household goods lost out to the pretension of showing good taste and artistic expression through the purchase of new machine-made goods. These new furniture and other decorative items did not appear to be handmade, but were obviously produced by machine. In previous eras, furniture was accumulated over a number of years as families saved the money to buy the item. Therefore, furniture in a house was a collection of eclectic styles. At the end of the century, the fashion was to purchase furniture in suites, or sets that obviously matched. Families that could afford a whole suite of furniture evidently had money to burn. Rooms were often designed around a certain theme, and the furniture was purchased to portray the desired theme as a group.

REACTION TO ORNAMENT

Highly ornamental, machine-made furniture styles were excoriated by a group of reform designers that originated in England but had influence on American design as well. A preoccupation with a national style was evident in mid-nineteenth-century England. The first proponents of the reform movement in England were the members of the Aesthetic movement. This group asserted that aesthetics were the most important factor in design. They were the moralist designers, those who believed that good design equaled good moral values and that ugliness equaled falsehood. The first proponents of the Aesthetic movement were the Gothicists, starting with John Ruskin (1819–1900) and Augustus Welby Northmore Pugin (1812–1852) in the 1850s. They believed that the medieval style, especially the Gothic style, was the only true and honest style and in fact was an English style, though it was originally French. The styles promoted by the Classicists were the styles originating from the Greek, Roman, and Renaissance periods. Such styles displayed balance, symmetry, and simplicity. They were considered the antithesis of the medieval or Gothic style. The Gothic style represented the Romantic style and displayed attributes of asymmetry and intricate ornament. The battle of the styles, between the Classicists and the Romantics, so prevalent in architectural design, also took place in interior design both in the United States and in Britain.

As furniture design relied heavily on historical styles of both the Rococo and the Renaissance periods, a group of designers reacted to the styles and formed their own movement. William Morris (1834–1896) set up a design firm that produced furniture and other decorative items based on medieval principles. A Scottish architect Bruce Talbert (1838–1891) produced a book of furniture designs published in the United States in 1873 and 1877 called the *Gothic Forms Applied to Furniture, Metal Work, and Decoration for Domestic Purposes* that was very successful. There were two variations of the Aesthetic movement. The first was led by Ruskin, the Gothicist, and the later designer William Morris, who both believed that art should be naturalistic and that the only true art should be inspired by nature. Morris became very popular in England and in the United States, with his plant-like naturalistic wallpapers and carpets. They are still popular today and in fact resemble pieces of artwork.

The other faction of the Aesthetic movement believed that design should not imitate art but be flat, like the flat surface it is on. In order to be true to the medium, a flat surface should have a flat form, or in their term, be *conventionalized*. The major proponent of this camp was Charles Eastlake, another Englishman, who also became very popular in the United States. The Gothic influence of the Aesthetic movement can be seen in Eastlake's furniture and Christopher Dresser's wallpaper designs. The so-called modern Gothic recalled the early Gothic panels, dating from the twelfth century, that were very flat without any perspective. The concept of perspective is the technique in art of representing three-dimensional objects on a two-dimensional surface. It was invented in the early Renaissance in the fourteenth century in Italy. Therefore, as an invention of the post-medieval era, the use of the historical Gothic style of the nineteenth century did not depict perspective in any way.

The Aesthetic movement grew into the Arts and Crafts movement, which also had a great influence on American interior design. Honesty in design was the catch phrase of the movement. Gustav Stickley was the major designer of the Arts and Crafts movement. True Arts and Crafts furniture was made of oak with large, exposed hinges and pulls, which were made by hand. Of course, the furniture industry discovered its appeal and made knockoffs in the factories of Grand Rapids, which could be found in homes all over the country by the turn of the twentieth century. Grand Rapids was so successful in producing American furniture that, by 1900, the town had 62 furniture-manufacturing firms and employed 9,000 workers (Davidson 1980, 54).

CHANGES IN STYLES IN THE 1890S

In addition to the reform styles originating in Britain, the American Colonial style was gaining influence by the 1890s. The Centennial Exhibition in 1876 reintroduced Americans to the Georgian and Federal styles, classical styles that

had been considered out of fashion for many years, and interest in American Colonial history and design also shaped reaction to Victorian excess. Clarence Cook, an American who wrote an influential book named *The House Beautiful* as well as writing a column for *Scribner's Monthly,* rejected the highly ornamental styles ubiquitous in American homes of the day. Cook introduced Americans to Japanese and Chinese design, as well as the new English reform movement and the Colonial Revival style. He advocated the use of simple materials, woods like oak and pine and little use of ornament. Cook's designs were not hand-made or intended to look handmade, unlike some of the other reformers. His designs were simple, though not inexpensive.

As was seen in Cook's publications as well as others, the reform styles of the 1890s and earlier led to a great number of competing styles. Though Colonial Revival was coming into vogue, other styles were also gaining in favor. Middle-class homeowners read the design magazines and wanted to be fashionable and display their sense of taste. In addition, the Aesthetic movement and later Arts and Crafts movement reacted to the revival styles by promoting styles that were more true, in that they were originally handmade and pre-industrial. The Arts and Crafts movement led into the Craftsman style in the United States. These interests included the medieval past, as well as the new fascination with the Japanese and the Turkish. The new items that were coming over from Japan, an exotic culture that was opened to the West by Commodore Perry in 1854, intrigued Americans. The flat surface decoration of Japanese graphic design was something new to the Victorians. Turkish style was also very popular in the United States, and many houses had a Turkish corner with some lounging area with lots of tassels, pillows, and Indian prints. (Turkish meant anything from the Middle East and was not necessarily authentically from Turkey.) The typical American homeowner thought of Turkish as being exotic, and even decadent. Oriental carpets were newly imported and became popular in American homes.

Also, furniture was not fully upholstered in the United States until the Turkish infusion. The words *sofa* and *divan* are Arabic words, and the word *ottoman* refers to the Ottoman Empire. The typical Victorian chair, loveseat, or sofa required the sitter to sit up straight. There was no lounging on a Victorian seat. But these new fully upholstered, inner spring items were extremely comfortable and induced lounging. They were considered Turkish and decadent to the Victorians (Zingman-Leith and Zingman-Leith 1993, 45). Often the house included aspects of the many competing styles. There might be elements of the Japanese, Moorish, English Arts and Crafts, or American Colonial all within the same room. The typical house actually contained many of these elements. This muddle of styles led to the *cri de coeur* of the purists at the end of the decade, such as Edith Wharton who decried the eclecticism of the time. The modernists, designers of the coming twentieth century, abhorred all Victorian style because of its inconsistency and excess.

Another influence on interior design in the 1890s was the revival of the French Louis XV, Louis XVI, and Empire styles. Edith Wharton (1862–1937), an American novelist, and Ogden Codman (1863–1951), an architect from Boston, teamed up to write the book *The Decoration of Houses* in 1897. In this book, the writers recommended the French style, which, though very decorative, was much lighter and more sophisticated than the style found in most American

homes of the day. Codman was retained to design the bedrooms in one of the grandest of all American homes, the cottage at Newport, Rhode Island, called the Breakers, for Cornelius Vanderbilt in 1894. Of course, this French style did not have a great influence on the typical American middle-class house; it was aimed at the most affluent segment of the Gilded Age society. Wharton and Codman were against the moralistic judgment of the design writers of the day. They were not advocating for moral architecture but for traditional, aesthetic, classical ideas of proportion, harmony, and scale. The book went into detail about the decoration of each room in the house, including what is on the walls, floors, ceiling, furniture, and so forth, in traditional French and classical styles.

Wharton and Codman also advocated for interior design to be thought of as part of the architecture, instead of as an afterthought to be brought in after the house is completed. The idea of proportion and scale inside the house was something that they deemed forgotten in the nineteenth century. They wanted architects and designers to look back at Italian and French Renaissance architects, who performed as both architect and interior designer in their work, and considered the interior and exterior all of a piece. They abhorred the "superficial application of ornament" without the consideration of the proportion of the room as a whole (Wharton and Codman 1897, 2).

Elsie de Wolfe, considered one of America's first great female interior designers, had a considerable influence on interior design at the turn of the twentieth century. Her book *The House in Good Taste* (1913), has recommendations and photos of interiors that are diametrically opposed to the typical Victorian interior. They are light, airy, and have pastel colors with simple furnishings. She was ferociously opposed to the typical Victorian excess. De Wolfe was concerned with simplicity, proportion, and suitability. She was very advanced for her day and took inspiration from the Colonial Revival and from the writings of Wharton and Codman. Her writing and design looked to light, air, and comfort and showed a simplicity that was absolutely revolutionary for the time period. She used chintz, a light and flowery English cotton fabric, and also painted furniture with decorative paint with flowers. De Wolfe, though revolutionary in her design, still adhered to the cult of domesticity and contended that the woman was responsible for the house. She wrote: "Men are forever guests in our homes, no matter now much happiness they may find there" (de Wolfe 1913, 5).

Many historians have documented the reform movements of the day as well as the high end of interior design, like Wharton and Codman. Influence of the reformers did exist, but the average American family was more affected by the advertised items found in magazines and newspapers. Kenneth Ames asserts that the commonly read literature of the day, for instance Cook's *House Beautiful* and other reform minded texts, lead to a skewed sense of what people actually had in their houses. Though reformers in England and the United States wrote crusading polemics on furniture and interior design that are still in print today, the interiors of the typical American household were different. Whereas Cook as well as many others decried machine-made furniture and called for a return to artisan-made goods, that was not what was found in the American home. The reaction against machine-made items created the Arts and Crafts movement and other reform movements, but it remained a reaction and did

not affect the everyday lives of millions of American families. In addition, the reform movements did not lead to an actual reduction in the further influence of industrialization on the home. The availability of mass-produced goods at inexpensive prices was the cause for the great expansion of items seen in the Victorian home. Reformers who called for the return to handmade furniture could only appeal to the wealthiest who were able to afford such items. The typical bourgeois household of the American town was not a candidate for the reformers' proposed reforms. Ames adds: "In a rough analogy we could say that their publications reflect conventional Victorian . . . furnishings about as accurately as today's professional architectural journals do suburban tract housing" (Ames 1992, 25).

SURFACE DECORATION

Walls

The overall effect of the interior design of the prereform Victorian house was one of pattern on top of more pattern. The interior was extremely busy; every surface was covered with a pattern, and some surfaces were covered by several patterns. Take walls, for instance. The typical Victorian interior wall of the upper-class house was divided into three sections for three separate and distinct patterns. Families of more modest means would try to emulate these typical design trends whenever possible, though every facet of the styles could not be replicated. (The floors and ceilings, also with a patterned decoration, will be discussed later.) There was a name for this divided wall; it was called the tripartite, or three-part wall. The three parts were: the dado, also known as the wainscot, closest to the floor; the field, above the dado; and the frieze, a narrower band of pattern closest to the ceiling. Of course, there were also moldings on the wall: next to the floor was a wood molding called the plinth, and up next to the ceiling was a molding called the cornice. An architrave was a wood molding surrounding either a door or window.

The dado (referred to as a dado instead of wainscot for this discussion) was a much-debated feature of the surface decoration of the wall. The dado was recommended to be approximately 36 to 42 inches high and composed of wood, though many homeowners could not afford a wood dado installed throughout the house. At the very least, the family would like to have a wood dado put on the walls of the front hall and the dining room where fewer pieces of furniture would be placed along the wall and the beauty of the wood could be seen. The use of the dado was advocated by many designers in the 1880s for aesthetic as well as practical reasons. Henry Hudson Holly wrote in 1878 that dados were a useful installation, because furniture looked attractive set against a wood background, and likewise, pictures looked good against a light background above the dado. The dado also protected the wall in vulnerable areas of the house. Ella Rodman Church in 1882, wrote that the use of the dado would "break the monotony of an unrelieved pattern the whole height of the room" (Moss and Winkler 1986, 117). Clarence Cook also recommended the use of the dado because he disliked the overuse of wallpaper, and with a large wainscoting the use of wallpaper was reduced. Eastlake also favored the use of a dado calling the "unrelieved pattern of monotonous design" the "most dreary method of decorating the wall of a sitting-room" (Moss and Winkler 1986, 116). The emphasis on a horizontal axis

led to a new view of picture hanging on the walls of the house. Instead of hanging pictures all over the wall, including way up at the top of the wall near the ceiling, the new recommendation was to hang pictures at typical eye level. The pictures would be hung by a cord that was attached to the cornice at the top of the wall.

Several new products were invented in the late nineteenth century that made the dado more affordable to the middle-class family. Ready-made wainscoting became available in the 1880s that could be easily installed panels with a wood cap. A new product that became very popular in the 1880s was called Lincrusta-Walton. Frederick Walton, who invented linoleum in 1860, devised a faux wood by embossing semiliquid linseed oil with a backing of heavy canvas paper. The Lincrusta-Walton could look like metal, wood, or leather depending upon how it was finished. It could be painted or left in the original color. Frederick Beck and Company, in Stamford, Connecticut, became the first American company to produce Lincrusta-Walton in 1882, though the product was invented in the previous decade. Another product newly available to the American homeowner was called anaglypta, which was heavy embossed paper that was not as durable as Lincrusta-Walton, but typically used for wall, frieze, or ceiling decoration. Japanese leather paper was paper that resembled leather, which, in addition to other decorative papers, also was available on the market for wall decoration.

Instead of installing expensive wood or other surrogates on the dado, several alternate solutions were available. To create the appearance of a dado, a molding at the height of the wainscot could be installed in order to divide the wall into its three requisite parts. On either side of the molding the homeowner would install a different wallpaper. William Morris, the English Arts and Crafts designer, favored this approach, or recommended simply painting the wall above and below the molding. (This, however, was not a typical approach in the middle-class, pattern-happy house.) Another type of faux wainscot was comprised of the installation of wallpaper with a pattern that mimics a wood wainscot. The famous designers of the day, including Christopher Dresser, E. W. Godwin, and Walter Crane, designed wallpapers that feigned the appearance of a wooden wainscot. Woodwork, or whatever substitute of wood was installed on the wainscot, was most often stained or varnished. It could also be painted to match the color scheme of the room but it was never painted white. The colors used were very vibrant, rich colors favored by the Victorians.

Simplicity began to gain influence by the last decade of the nineteenth century. The unrestrained ornament of the 1870s and 1880s was waning in fashion because of the Craftsman and Colonial Revival influence. The ubiquitous tripartite wall division was gone, and the walls were divided into two sections, or none. Even the wainscoting that was still used was found only in the front hall, dining room, or library. Walls were covered in the same materials that were found in the previous decades, including paint, wallpaper, Lincrusta-Walton, and anaglypta. However, the colors would be totally different in these newer rooms.

In the 1890s, French-inspired rooms, like Codman's, used light colors, such as cream, light green, and gold. The wallpapers had traditional, formal, classical patterns like stripes, floral, and tapestry types. Chintz patterns were also popular and brought a much lighter, brighter, more delicate feeling to the room. These patterns were most common in the bedrooms. Reform designers created new wallpapers designed to have the look of a frieze that matched the wallpaper on the background wall. Colors were matching instead of contrasting as

had been popular in the previous decade. Other reformers provided different changes to the look of the 1890s interiors. Craftsman-inspired rooms used wallpaper patterns with none of the delicate florals, wreaths, stripes, and so on of the French style. The patterns were geometric and abstract. Many of the greatest Arts and Crafts designers still popular today include William Morris, Walter Crane, and C. A. Voysey. These wallpaper and fabric patterns, extremely abstract with bold colors, were very creative and artistic. They were popularized in the United States after the Centennial Exhibition of 1876.

The other major influence was from reformers who promulgated the use of plain solid colored walls. These could be either painted or papered with various types of coverings that had a texture but no pattern. That was the most revolutionary reaction to the tripartite wall, the wall of the contrasting colors and patterns from the earlier decades. Despite these new developments, even in the 1890s, most houses contained a combination of these popular styles. They might have different rooms with an assigned style, or one room might have elements of several styles.

Ceilings

In the 1880s, ceilings were also joining the pattern bandwagon. White ceilings were completely unfashionable. As shocking as it may appear to us in the twenty-first century, colors recommended for ceilings were: violet, lavender, blue, peach blossom, straw color, and gray (Moss and Winkler 1986, 123). The strong colors of a Victorian interior were, however, strongest at the bottom of the wall and were lighter as one looked up at the ceiling. Colors such as lavender and peach blossom were less saturated on the ceiling than the colors on the wall. A paint technique known as pencil striping was done around the edge of the ceiling above the cornice. In addition, stenciling might be done on the ceiling around the perimeter of the room. Where there were light fixtures, gas or electric, commonly in the center of the room, large medallions were installed around the fixture. Another popular ceiling finish, found in many simpler homes, or in the kitchens of the wealthier homes, was embossed tin ceilings. These ceilings are found in many older houses and stores today and are available for purchase or replacement. Wallpaper was another technique recommended by some designers to be placed on the ceiling. By the 1890s, the fashion for a highly patterned ceiling was fading. In the mid-1890s, the high style of Wharton and Codman advocated the use of a plain plaster ceiling with a simple cornice at the top of the wall.

Floors

Floors had patterns as much as did the rest of the house in the Victorian period. Because hardwood floors were becoming available in ready-made lumber and at affordable prices, they became the common floor of the time in the formal rooms of the house. But, of course, the family had to cover the floor with a variety of carpets, or what we would call area rugs. Small carpets were placed around the room, often overlapping each other. In addition to the imported carpets from Europe or Asia, housewives also made rugs by hooking, knotting, or braiding. Carpets manufactured by Axminster and Wilton made in England were popular and inexpensive choices. Oriental carpets made in the

Near East were very popular but only available to the wealthiest of consumers. Linoleum was also available at this time and was used for kitchens and other utilitarian spaces.

Paint Colors

Advances in technology made new colors available for the paint industry. With ready-mixed paints came the introduction of color sample cards, which made it easy for a housewife to plan and actually see the colors that would be going into a room. The French scientist Michel Eugene Chevreul, French Minister of Wools and Dyes, did the first scientific analysis of colors. He wanted to come up with a standard for dying fabrics because many dyes appeared dissimilar when juxtaposed with different colors. He came up with the idea that complementary colors adjacent to one another appeared to be more intense. Chevreul created a color wheel and did a systematic study of colors and their effects on the brain. Because technology had developed many new tints for paint manufacture, Chevreul's analysis of colors had great influence on the colors produced and the recommendations of the design writers like Eastlake. Colors were suggested for the tripartite walls and were recommended for the walls of the main rooms of the house. These colors were rich, dark colors that were complementary, according to the theories of the colorist Chevreul. The colors found in the houses of the 1880s were what we would now consider garish and strong—subtle they were not. Chevreul's theories about color stated that there were primary colors, secondary colors, and tertiary colors. Primary colors are red, blue, and yellow. Secondary colors are orange, green, and violet. Tertiary colors are russet (between red and orange,) claret (between red and violet), plum (between violet and blue), and peacock blue (between blue and green.) The use of colors in the 1880s relied on tertiary hues, those rich, dark, saturated colors one associates with Victorian design.

As the 1890s advanced, the use of colors went back to basics, using more primary and secondary colors instead of the complex tertiary colors. Reformers recommended the use of analogous instead of complementary color schemes, which use colors adjacent to each other on the color wheel, which is less jarring to the eye. The use of monochromatic schemes in rooms was also gaining favor, especially in the work of Wharton and Codman. Walls in Codman's rooms could be gray or ivory and fabrics in the rooms could be one color only. Most other designers also recommended the use of fewer colors in a room than was seen in the previous years. As the rooms began to evolve into fewer, more multipurpose rooms and more open in plan, the idea of painting each room in a distinct color scheme began to fade. Because the eye can see one room or space flow into another, the color scheme of adjacent rooms had to be the same, or at least compatible, and seen as a total composition instead of individual components.

FURNITURE

Parlor

The parlor was considered the ceremonial space of the house. No matter how poor or rich the family might be, there was always a space allocated for

parlor-like functions. Of course, a separate parlor was desired, and many houses had a second, back parlor. But the tenants in tenements also set aside an area of the tiny room to display family mementos. Often the poor family had a bed in the parlor, which was disguised during the day with pillows and a feather comforter. The farm family also dedicated one room as a parlor although farm publications encouraged families to create a multipurpose room, a sitting room, instead of an impractical parlor. The Grange movement, a political and social movement that advocated for small farmers after 1880, also recommended the use of a room as a sitting room instead of a parlor. However, many farm families, with the nationalizing of catalogs and magazines,

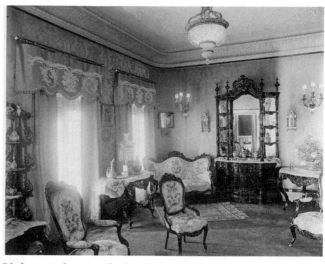

Lighter colors and simpler ornament are shown here in this late Victorian parlor, which display influence of the simplification of design. Notice the large étagère and smaller whatnot in the photo. Denver Public Library, Western History Collection.

wanted to be on an equal footing with city families and therefore felt a parlor was necessary.

The furniture in the parlor was the finest in the house, or at least the newest and showiest. However, the family rarely used the parlor; it was set aside for ceremonial functions and receiving of guests. The family would even most likely close off the room when it was not in use. Rooms had certain gender connotations at this time and were frequently divided into masculine and feminine, and the parlor was considered feminine, in the woman's domain. The wife often entertained guests and would use the parlor for this purpose. The parlor furniture was covered with *passementerie,* a French word describing the ubiquitous tassels, fringes, and cords. The French word *passement* means lace, and lace was also included in the decoration of the parlor. Lace was found on doilies, which were on all pieces of furniture as well as curtains and tablecloths. Housewives were expected to demonstrate their artistic talents through the creation of lace and crocheted doilies. Draperies had heavy cording drawbacks and tassels and long and heavy fringes. Art was similarly hung from picture rails by heavy tasseled braided cords. Furniture in the parlor was made of popular woods from the period: rosewood, mahogany, and maple. Oak became very popular at the end of the century with the influence of the Arts and Crafts movement. The fabrics used in the room included satin damask, velvet, and horsehair. (Not surprisingly, the fabric called horsehair, very popular in the nineteenth century, was woven from the tail of a horse.) Fabrics were used throughout the room, and wood was never left uncovered. Not only was each surface covered with fabric, it was covered with several layers of fabric, most commonly with tassels and fringe at the bottom of each and every piece. The parlor also had tidies, lace or embroidered pieces that covered the backs of

chairs and sofas, and lambrequins, another form of decorative fabric with heavily fringed edges, which were placed over the drapery on the window, or on any other surface, such as a mantel or table. Another French term, *portiere* (meaning "on the door"), was used to describe the heavy drapery at open doorways or even where doors existed to decorate the opening and to keep heat from escaping the room. When the Arts and Crafts movement made inroads into the popular culture, people began leaving wood uncovered for the first time in years. This was a revolutionary change (Gay 2002, 30).

The parlor had furniture that was typically divided up into seating groups. Rooms such as the parlor were not arranged as a whole composition as modern interiors are, and instead contained many small furniture pieces. The parlor had a scattered appearance to today's eye, and seemed almost without design, though it was in fact the most carefully composed room in the house, meant to impress the guests who were the primary users of the room. A parlor suite, which was a very popular set of seating pieces for the parlor and was often purchased as a set from one of the Grand Rapids furniture companies, comprised the largest grouping of furniture in the parlor. These sets were so popular that working-class families were given credit by the department stores to buy the parlor suites on time, requiring them to make regular payments. The peak of their popularity was in the 1870s and 1880s. By the 1890s, the styles had moved on, and the parlor suite's pre-eminence ebbed. The suite most often included seven pieces—a sofa, a gentleman's chair, a lady's chair, and four side chairs—and was unified visually. In fact, the set almost seemed like it was individual component pieces pasted together. The origin of the parlor suite was in the French aristocracy of the seventeenth and eighteenth centuries. The existence of the parlor suite in the parlor of the middle-class house indicated that the family had enough wealth to purchase such a set. (Though the family may have bought the set on credit.) This was a new phenomenon. The Victorian family wanted to show that it could afford a whole new set of matching furniture. Here was another example of conspicuous consumption.

In the parlor suite, the sofa was the largest piece, with seating for three. Although it was upholstered, the sofa was heavily trimmed with wood. Styles included heart back, oval back, medallion back, and round back. These sofas were not comfortable; they had minimal upholstery and an abundance of wood trim. The seating was constructed perpendicular to the floor and forced the person to sit straight up, almost as if perched on a chair. Kenneth Ames describes this posture as a demonstration of control. The person had to sit frontally: no lounging allowed, no slouching, and no sitting sideways. It was a very formal stance. Ames compares it to the sitting of kings and queens on a throne (Ames 1992, 190). The public was not looking for comfort, however; they were looking for style, ornament, and formality, of which these sofas had plenty.

The other major item in the parlor was the parlor table, also known as the center table. In the middle- to upper-class house, the parlor table was typically located in the center of the room under the light fixture (usually a gas fixture) and held lamps, plants, or other decorative items. In poorer homes, the center table was the only table in the house and was used for a variety of functions. Parlor tables were about two to three feet in diameter, had a pedestal base, and often were in the Eastlake, French Revival, or Renaissance Revival style, lending the table a solid, massive quality. The parlor table often had a marble top and

was 30 inches high, the typical height for a dining table. There were no coffee tables at this time. The coffee table, a lower table that is placed next to the modern sofa, was invented in the twentieth century.

The parlor contained a number of other accessory pieces. The sofa table was located at the end of the sofa. The pillar table, also known as a lamp stand or plant stand, was a small column-like table used to hold plants or lamps. These were very popular in the Victorian home, as large plants were considered fashionable and healthy in the house. Only a few plants available at the time were hardy enough to thrive in a dark Victorian interior, including the philodendron, aspidistra, and dumbcane. Because the parlor was a room often used by the wife to entertain her friends for afternoon tea, the teapoy table held a tea service and was specifically designed to display the decorative tea service when not in use. The table was approximately 20 by 30 inches and had four turned legs that met under the table to become two cross feet with casters. A drawer held the silverware and linens, and a shelf held the tea caddy (Mace 1991, 44). A game table may also have been in the parlor and often had a flip-top. The parlor also may have had corner chairs lurking in the corners of the room. As a rule, furniture was not placed along the edges of the rooms but in groups in the center of the room.

One of the most important pieces of furniture in the parlor, for symbolic purposes, was the *étagère*. An elaborate, multitiered shelf, the *étagère* most likely was placed in the corner of the room or against the wall. The *étagère* was a piece that could be in any room, but the one in the parlor would be the most elaborate and would display the most impressive knickknacks the family owned. The *étagère* in the parlor would be a tall piece, with a center mirror, and shelved on either side. The style would most often be French Rococo or Renaissance Revival. Another piece of similar design was called the whatnot, which also displayed family mementos. Whatnots were placed either on the floor against the wall or hung on the wall. They were less elaborate pieces of furniture than the *étagère*. Another more common feature in the parlor was a piano. If the family could not afford a separate music room, the piano was placed in the parlor, and the lady of the house, as well as her daughters, were trained to play it. It was considered good breeding to learn how to play the piano.

A new product available at this time was patent furniture. This furniture, protected by patent, was mechanical in nature. Such pieces included platform rockers and high chairs that converted into baby carriages. Foldaway beds were also available. The style of these pieces was often more informal, either the Country or Cottage style. They were common in country homes or in maid quarters.

Back Parlor

Many houses in the period had back parlors, though this room may have been referred to as the music room, den, or family room. It functioned as a family room, because this was the room that was actually used by the family, unlike the seldom-used parlor. The back parlor was set up with similar furniture to the front parlor, though it was more durable and chosen for function instead of beauty. There was usually a parlor table, where the family played games or cards or read, because the table was placed under the central light fixture, a hanging chandelier. Everyone brought in their favorite amusement:

musical instrument, games, or scrapbooks. Other furniture pieces found in the back parlor were armchairs, which were the most comfortable chairs in the house, though still not very comfortable. These armchairs were upholstered with wood trim, and there were gentleman's and lady's versions. The man's chair had wood arms. The lady's chair had little wood handle-like pieces that connected the back to the seat of the chair. These were for women to sit in to accommodate the voluminous skirts of the time period.

Front Hall

The front hall in the large Victorian house was not a hall but a room. It was the first line of defense for the family to make an impression on the guest.

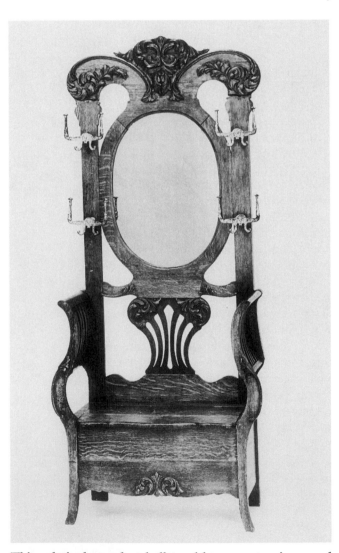

Impressions were important to the Victorian family. The concept of impression management originated in the Victorian period. The theory of cognitive development in the nineteenth century put emphasis on making a good first impression. (Whereas the term is now primarily used in the corporate world, it originated in the domestic sphere.) The first impression created by the front hall of the house was therefore an important factor in showing off to one's guests. The Victorians had a sentimental, self-conscious view of their world, and the front hall of their house was the location where a visitor first entered into that world.

In the previous stylistic periods, the front hall was simply a narrow passage to the back of the house, with rooms on either side of the hall. By 1880, the concept of the front hall was recreated based on medieval antecedents and influenced by Gothic Revival and the Arts and Crafts movement in England. The space as described by contemporary architects was the great hall, which indicates the size and grandiosity of the room's intent. The front hall was the controlling locus of the house, where the visitor had to be met and directed to the appropriate part of the house, or maybe left there to wait,

This relatively modest hallstand has a seat, mirror and hooks for coats for visitors to use. Gjon Mili/Time Life Pictures/Getty Images.

depending on the prominence of the visitor. If you were an important person visiting the family, you would be directed into the parlor. If you were a servant, you would be ushered directly into the kitchen without disturbing the family. Because life was tightly scripted and self-conscious, hall furnishings were "significant parts of a deliberate and pervasive strategy to ceremonialize and ritualize the commonplace activities of everyday life" (Ames 1992, 8). As Victorians preferred the specialization of each room in the house, the front hall was one of the most specific. In addition, the availability of consumer goods made it possible to fill up the front hall with items that would make an impression on the visitor. In order to identify the division from the rest of the house, the front hall was often separated from the back of the house by an actual architectural barrier: a lowered ceiling, a soffit, or a change in paint color or wall treatment.

There were specific pieces of furniture in the front hall, many of which are unfamiliar to the twenty-first-century eye. The most prominent of these was the hallstand. The hallstand had no historical antecedent; it was purely a nineteenth-century invention. It also faded completely from popularity by 1920 and has not been a popular antique because of its limited use and huge size for today's houses, which also don't have large front hall spaces for these very tall pieces. The hallstand contained several crucial elements: an umbrella holder, hat and coat hooks, a large mirror, and usually a small table with a marble top. Umbrellas were important accessories, as were canes or walking sticks for men. Umbrellas were also a symbol of being a member of the bourgeoisie, that is, the middle to upper middle class. The hallstand contained an area for the umbrella to be stored with a container at the floor to catch the water and protect the wood floor or carpet. Coats were temporarily stored on the hallstand. A mirror was also a part of the hallstand, as it was part of many other popular furniture pieces. Mirrors, though still relatively expensive at that time, were considered valuable because they reflected the limited amount of light in the room. On the hallstand, a family member or guest could check their appearance before going out. A hallstand might have a table as part of the unit, which would be topped with marble. The use of marble on furniture (it was also seen on tables, *étagères,* side boards, and chests) was another allusion to royal precedents as proof of the stature and wealth of the family. The hallstand was often made of walnut, though smaller versions were manufactured from cast iron. High and wide, though not deep, the hallstand was the focal point of the front hall. Only people of relative wealth could afford a hallstand, so evidence of one indicated social standing. The Victorian hallstand displayed architectural elements and looked like a piece of architecture. It had columns, architraves, and pediments along the side and top of the mirror. This piece was of high symbolic value to the house and was a ceremonial object for a ceremonial age. Reform designers rejected the elaborate hallstand but advocated for a more minimalist version. With the modern idea of closets, and the distaste for messy hanging coats and hats, hallstands have little use today. However, Victorians did not have hall closets (or many closets at all), so the hallstand had a definite practical use as well as a symbolic function.

The front hall had several other important pieces of furniture. There was typically a chair or small settee for the visitor to sit in while waiting to be directed somewhere in the house. One type of chair commonly found in the front hall was a small flip-seat wood chair with storage under the seat. These chairs were architectural in design and supremely uncomfortable. However, they were meant

to be used by people who were of lower social standing, such as servants, messengers, and others who were delivering something to the family but would never be directed into the main part of the house. Owners or visitors of higher social standing would use the chair only to put on their boots (Ames 1992, 32).

Another ubiquitous item in the front hall was the card receiver. Many of these articles were actual pieces of furniture, free-standing on a pedestal, while others were table-top models on smaller pedestals set on a small table or stand. The card receiver, now obsolete, was very common during the years 1870–1910. The card receiver was an item that was specific to the tradition of using calling cards, another obsolete practice. Where cards are still used today for business, everyone in the domestic sphere used them during the Gilded Age. Calling cards were printed in the husband's name, but often used by the wife as she made her visits to her social circle. Cards were used for a number of other purposes: as invitations, responses to invitations, condolences, changes of address, or any other communication desired. The lady of the house would go calling on a person in her social realm. Upon arrival, the butler would greet her and would take the card for the lady of the house. The butler would escort her to the parlor where she would be seated and wait for the lady of the house to arrive. A lady of certain social standing did not have to sit and wait in the hard chair located in the front hall. Another card would be left for the gentleman of the house. If the lady were not at home, three cards would be left in the card receiver so that the lady of the house may return the visit. The lady of the house may actually visit or may just drop off another card. It was a complicated custom.

Mark Twain, in his book *The Gilded Age*, commented on the calling card practice: "The annual visits are made and returned with peaceful regularity and bland satisfaction, although it is not necessary that the two ladies shall actually see each other oftener than once every few years. Their cards preserve the intimacy and keep the acquaintance intact" (Schlereth 1991, 188).

There were a number of other items located in the front hall. A boot scraper would be there for the use of gentlemen who often had to slog through muddy streets without the benefit of paved streets or sidewalks. A doorstop could be made of wood, cast iron, brass, bronze, lead, ceramic, or glass. They were often made into interesting characters or shapes like animals or famous celebrities. A chandelier was also located in the front hall. Sometimes the front hall had a pier table, which was designed to fit against the wall, often with a center drawer, and with decorative front legs, which were meant to recall piers, or columns, supporting the ends of an arch. There was sometimes a mirror above the table and even a mirror below the table (called a petticoat mirror) that would allow a lady to view her dress in its entirety (Mace 1991, 4). The pier mirror was sometimes found in the front hall. It was a huge mirror, ornate and tall, and it sometimes included a small table or shelf and resembled a hallstand. A tall case clock, also known as a grandfather's clock, was sometimes located in the front hall. This item would be old at the time of this discussion, but was often saved as an heirloom, hence the name grandfather's clock.

Dining Room

The dining room was an important feature of the house, almost as important as the parlor and the front hall, for it was a room used for guests as well

as family. The room was typically connected to the parlor by sliding doors. The dining room was used daily by the family, unlike the parlor. On those days, the door to the parlor was closed. When the family had guests and was entertaining, the doors could be slid open, and the dining room became an extension of the parlor. The dining table was typically covered with a linen tablecloth on a daily basis and often several layers of tablecloth. This was for looks only, or for a formal dinner. When the family ate, the table would be covered with a simple cotton tablecloth. When the influence of the Arts and Crafts was felt in the 1890s, the table would be uncovered on a daily basis to show the beauty of the wood. The most popular type of table in the middle-class home was a pedestal table in the Renaissance Revival or Eastlake style. The table was heavy and massive and often had one or more extensions. Extension tables were invented in the late nineteenth century. The shape of the table could be round, oval, or rectangular.

The typical Victorian dinner was a complex affair. There were many specific utensils and dishes. Dinners had numerous courses, and tablecloths would be removed to reveal a clean one underneath several times as the dinner proceeded. The dinner had these courses: soup, fish, game, or meat (served with a vegetable); salad; dessert; fruit; and coffee. After dinner, the men would retire to the library for smoking and brandy, and the women would retire to the parlor.

The side chair, also known as the dining chair, was the identical chair found throughout the house as occasional chairs. In the dining room, the dining chairs might be a matching set, but they often were not. Chairs were added when the family needed more and were often of various styles, but always a straight back with no arms. Most popular styles were the Renaissance Revival or Eastlake. Simpler styles of the mid-nineteenth century were followed by more elaborate, large, and massive styles of the late Victorian Era. These chairs were often upholstered on the seat and back with wood trim. A highchair was also part of the dining room where there were small children.

The most imposing piece in the dining room was the sideboard. This large piece of furniture had architectural ornament and was massive. The upper section would display glassware, china, or other pieces. The large serving shelf would usually be made of marble and would hold serving pieces when the family was dining. Under the serving shelf were the center drawers, which would hold the family's silverware and linens. Under the drawer was a cabinet that contained storage of other serving items.

Kitchen

The kitchen in the Victorian house was nothing like the contemporary twenty-first-century kitchen. Large, swanky, comfortable cook's kitchens of today were not known at this time. Because most families had servants, and servants had the worst accommodations, no special care was given to the design or comfort of the kitchen. Even for those households without servants, because the kitchen was part of the private domain, it was not intended to impress any outside visitors, for those visitors would never see it. By the 1880s and 1890s, homes did have a large kitchen inside the house and typically had running water, sometimes heated. The kitchen was typically located at the back of the house, away from the public spaces, usually behind the dining room.

There was typically a door outside from the kitchen so servants could enter and leave as necessary without interfering with the public rooms of the house. In houses that could afford servants, they used the kitchen almost exclusively. Poorer families relegated the wife and daughters to the kitchen. After the Civil War, kitchens were included in the construction of the house, often with a small toilet room attached, because this is where the plumbing was connected.

The kitchen was actually not one room, but several, in many houses. The scullery was a room where washing was done, both the dishes and the clothes, unless the house had a separate laundry room. The scullery contained a sink and a drain board. The pantry was another small room attached to the kitchen that had open shelving that provided storage for the nonperishable food, silver, glassware, and linens. The kitchen itself was a larger room with several typical pieces of movable furniture. There were virtually no built-in cabinets or shelves in the kitchen. The floor of the kitchen rooms was most commonly hardwood or brick tile. When linoleum became available, it became a popular choice for kitchen floors (as it still is). The walls were painted with oil paint, in neutral, unassuming colors, unlike the other rooms in the house.

The major feature in the kitchen was the stove. A sink may have also been in this room. In the center of the room was the kitchen table. This table had multiple purposes: It was the surface on which food was prepared, as there were no counters at this time; it was also used for the servants to eat meals, and possibly for the family to eat breakfast and lunch. There was also a free-standing kitchen cupboard that contained pots and pans, dishes, and possibly some food. However, the cupboard was not large. It had shelving on the upper section, with glass doors, center drawers, and a lower cabinet. Another smaller version, called the jelly cupboard, held canned goods. It was half as tall as the kitchen cupboard. Other pieces of furniture in the kitchen would include: a pie safe, which was a storage cabinet for pies; a pastry table with a marble top to roll out pastry dough; and an icebox. The icebox, a new invention, kept perishable items cool. Though not electric until after the turn of the twentieth century, the icebox did provide a cool place for food through the actual use of ice. In the 1890s, technology provided the ability to create ice throughout the summer. An iceman delivered a large block of ice to the house, which he then dropped into the icebox, an oak box with a tin interior and brass hardware. The icebox generally contained two sections, one for ice and one for the food. The invention of the icebox was a boon to the housewife and the servants who could now keep perishable food for a while longer. Though the electric refrigerator was invented early in the twentieth century, iceboxes and icemen still were seen in many communities well into the 1930s.

Library

Many houses had a library, if the family could afford it. It was a room designed to impress visitors with the culture and breeding of the family. Households bought books in sets in order to place them in the library and dazzle their social network with the fact that they were so well read. Not that they actually read the books—it was often just for show! In the Victorian house, the library was the man's domain. It was decorated with dark colors, lots of wood paneling, dark carpets, and dark wood furniture. Built-in bookshelves were common, as

were fireplaces with heavy wood mantels. If the Victorian house was the epitome of heavy and ornate, the library was the ultimate in this style. The children were not allowed into this room unless invited by the father. There was often a desk, but there were also a variety of chairs, parlor tables, settees, and other occasional pieces found in other parts of the house. Of course, there were many books, as many as the family could afford to display. Secretary desks were common in the library, although they could be found in other rooms of the house as well. The husband often used the library to read or to write letters. It was also a place to entertain male friends and to smoke and drink brandy after dinner. The man of the house did the family business in here, the bills, and other correspondence. This room was the man's lair and could be compared to the cave, such as some men today might call a TV or game room. Though Victorians did feminize the home with the cult of domesticity, the library remained exclusively the man's domain.

Sewing Room

In juxtaposition to the library, in large houses the sewing room was the woman's exclusive domain. The wife and daughters used the sewing room for sewing as well as for other activities, or "lady's work." Not only would sewing be done here, but also babies could be fed and letters written. The woman of the house knew she would not be disturbed by the men and boys when ensconced in the sewing room. The room often contained a lady's desk, where she would write her own letters. There would be a comfortable chair, often a rocking chair in order to rock babies to sleep. A sewing stand contained accessories for sewing work. A worktable was also there for laying out the material to be sewed. Elias Howe of Cambridge, Massachusetts, invented sewing machines in 1846. The foot-pedal version of the sewing machine was available to families who could afford to buy one during the 1880s and 1890s. Women often sewed their own garments and at least did mending, crocheting, and other handiwork. The sewing room would also contain a magazine rack, which would display the ubiquitous *Godey's Lady's Book,* a very popular magazine of the time, and maybe a department store catalog.

Bedrooms

The bedrooms, located upstairs in the Victorian house, were part of the private domain of the house. For that reason, they may not have had the new furniture that was required in the public rooms of the house downstairs. Apart from the bed, the other furniture in the bedroom could be older, discarded items from the downstairs rooms. Because of the popularity of matching sets, however, chamber suites were available for purchase for the wealthier families. These sets included a bed, two nightstands, a dresser, and an armoire. The bed itself was a huge affair, usually of the Eastlake, Renaissance Revival, or Spool style. Beds in the sleigh style or four-poster style could also be found, though those styles dated from the earlier years of the nineteenth century. As the nineteenth century progressed, the style of beds changed as scientific research and technology altered the perceived and real requirements for the bed. Heavily curtained and draped beds were used in the early years of the century to keep sleepers warm. The advent of central heating, which was not common

until the end of the century, or the use of individual coal or wood stoves, made bedrooms significantly warmer at night. Heavy draperies at the bed, windows, and floors were not as necessary. Also, the concept of the value of ventilation and air circulation and the danger of bacteria led to ideas of better health in an open bed. Though beds lost their heavy drapery, they still had huge headboards without the fabric. Later metal beds, made of brass or iron, came into fashion as even more healthful. They were common in children's rooms, hotel rooms, and poorer homes because they were less costly than the huge wooden beds.

Though bathrooms were common in houses at this time, the tradition of the washstand in the bedroom was still in place. The washstand of course had no running water, but a stand with a bowl, pitcher, and slop jar for the dirty water, so one could wash up in the privacy of one's own bedroom. A larger piece used for the same purpose was called a commode. It had a marble top and backsplash with a mirror above and drawers below. There was probably also a chamber pot for overnight bathroom duties, which was left for the servants, if there were servants, to clean up the next day. The bedside stand during this period was called the *somno* after the Roman god of sleep, Somnus. These tables performed double duty if needed in other parts of the house. The dresser was a large piece containing a set of drawers on the bottom and a large pivoting mirror on the top, often with smaller drawers on either side of the mirror. The bureau was a large piece with only drawers, while the chiffonier was a similar, but taller and narrower piece with drawers. The largest piece in the room, apart from the bed, was the armoire, which held hanging clothes. Because there were typically no closets in houses at this time, armoires, also known as wardrobes, performed a critical function. Women had many clothes and outfits for every

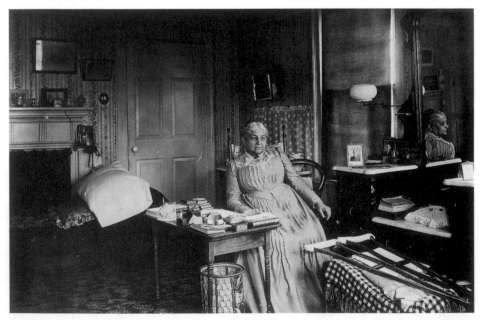

The bedroom was a private domain and did not necessarily display the prominent furniture of the public rooms. Notice the large dresser with the center mirror. Courtesy of the Library of Congress.

conceivable occasion. Though the typical practice during this period was to fold clothes and store them in a drawer (servants, if present, did the ironing), whatever could not be folded was stored in the armoire. The word *armoire* is French and refers to the cabinet designed to store armor. Common styles for this period were Eastlake, Renaissance Revival, or Country or Cottage style. The armoire was large, about 75–80 inches high, 45–50 inches wide, and 20–30 inches deep (Mace 1991, 123).

In the lady's bedroom, there might be a fainting couch, also known as the chaise lounge (or *chaise longue* in correct French, meaning long chair). The fainting couch was purported to be for the weak, fainting women, though it was mostly used as a comfortable place to relax in the privacy of one's own room. The lady's bedroom also contained a dressing screen, for even in the bedroom the lady had to be hidden in order to change her clothes or use the chamber pot. The screen typically comprised three panels made of leather, wood, or fabric. The man's bedroom may have had an easy chair with a footstool. There might also have been a clothes tree, which aired out a man's suit.

In houses where space was not at a premium, spouses did not share a bedroom. Husband and wife each had their own bedroom, which was their own private space. Though they might actually sleep together, they maintained their own private space for their own private things. They may have connecting rooms, where the man might pay a visit to his wife at night. References to sex were absolutely taboo, even within marriage. (And birth control was illegal.)

In the middle-class house, the children's room could be shared by up to three children. Most families separated the children by gender. The boy's room would have typical boy's décor, such as ships and animals. The girl's room would be over-the-top feminine, with lace, frills, dolls, and dollhouses. The gender roles were absolutely prescribed. Child-sized furniture became available for purchase, and there were many chairs, cribs, cradles, and entire bedroom sets on the market for the discerning consumer. Of course, the poorer families put children in whatever rooms that they could. Tenements generally had one tiny bedroom, with a double bed taking up most of the room. Children most often slept in the parlor (the other room besides the kitchen) in a bed that was converted to a daybed. Depending on how many children there were, they also might share the bed with the parents in the bedroom.

LABOR-SAVING DEVICES

The interiors of the Victorian houses sported many new devices for the use of the housewife. Though the avalanche of new inventions wouldn't hit American culture until after the turn of the twentieth century, the end of the nineteenth had a variety of new devices for the home. Foot pedal sewing machines were invented in 1846 and were a common device in the middle-class home by the 1890s. Cook stoves improved in technology, and there were several types available though they were still heated by coal or wood. Stoves were still made of cast iron at this time; the steel stove was a later invention. Cast iron cooking pots were typical, but in the 1890s enameled steel pots became available and were popular. Aluminum had a new refining process, which made it less expensive to produce, and it was growing in popularity, but it was still more expensive than the other products. Its advantage was its purity: it would not rust, did

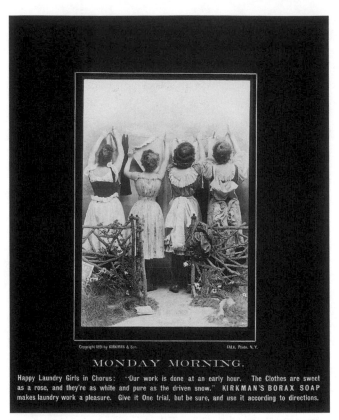

MONDAY MORNING.

Happy Laundry Girls in Chorus: "Our work is done at an early hour. The Clothes are sweet as a rose, and they're as white and pure as the driven snow." KIRKMAN'S BORAX SOAP makes laundry work a pleasure. Give it One trial, but be sure, and use it according to directions.

"Blue Monday" was washday for the housewife. This 1891 advertisement for Kirkman's Borax Soap humorously depicts a happy washday when using this product. Courtesy of the Library of Congress.

not contain toxins found in some other materials, and did not take on the flavors of the foods cooked. Electric irons were some of the first electric appliances available on the market, making their debut in 1893. The first of the electric irons had no thermostat, and therefore they were hot or cold, with no variety of temperatures. Thermostats were an invention of the 1920s. These irons were still a huge improvement over the irons that had to be continually heated on the stove. However, electricity was not common in the middle-class home until the turn of the twentieth century, so electric irons had no use unless the home had electrical service. Though the vacuum cleaner was invented after the twentieth century, the mechanical carpet sweeper was a product of the 1880s and was very popular.

The washing machine was invented in the mid-nineteenth century, though it was only a wringer type that imitated the rubbing of clothes on a washboard. The electric washing machine with the agitator and rinse cycle only became available to the American housewife in the early twentieth century. The wringer machine took some of the hard work out of washing but none of the time. The Monday washday still required an overnight soaking, a boiling of the clothes, use of the hand-cranked wringer that circulated the soapy water through the clothes, then a rinse and another bluing rinse. The soap used was very harsh: lye, sal soda, lime, and borax. The clothes had to be carefully rinsed because the harsh soap burned holes in the clothes. These machines were not connected to the plumbing, and water had to be carried in and out. Many housewives, if possible, had additional servants come in on "Blue Monday" to help with the laundering. Other laundresses took in laundry and did it in their own homes. These businesses eventually developed into commercial laundries, which were the first to buy the newest in washing machine equipment when it became available (Strasser 1982, 78).

Because of the cult of domesticity, the devices becoming available to the late Victorian housewife were not necessarily accepted for use by the culture. Handlin contends, in his book *The American Home, Architecture and Society-1815–1915,* that "these devices were antithetical to the human element and . . . the housewife who used them betrayed her true role in the home" (Handlin 1979, 416). Women had to justify the money spent on new appliances such as

sewing machines. Sometimes women used these machines to produce goods for sale. This, however, meant that the woman was going into business, another disallowed venture. Though the labor-saving devices allowed mothers to spend more time with their children, many of the domestic science writers, such as Catherine Beecher, emphasized systematic organization of the home, but not the use of new appliances. However, the consumer economy depended on the sale of these new devices so a cultural defense had to be constructed. After Frederick Taylor published his seminal paper on scientific management in 1911 for businesses and factories, Mary Pattison devised a similar system for home management, published in 1915 (Taylor 1911; Pattison 1915). She advocated the use of labor-savings devices for use by the manager of the house, also known as the housewife. Until the work of home economics pioneers in the beginning of the twentieth century, labor-saving devices were still distrusted because they "challenged traditional ideas about the housewife's work" (Handlin 1979, 420). After the turn of the century, Taylor and Pattison, among others, justified the purchase of such devices by defining scientific management of the home.

THE INTERIOR SPEAKS OF THE PEOPLE

The interior of the Gilded Age house meant more to its occupants than its superficial appearance. The interior was a statement about the personal tastes of the family and its cultural values. Although someone else designed the exterior of the house, the family itself personally designed the interior. It was a reflection of the owner's sensibilities, which were very blatantly on display for all to see. The romantic self-consciousness of the Victorian culture was an aspect of the culture that was part of the conspicuous consumption identified by Veblen. But popular preacher and abolitionist Henry Ward Beecher, described by historian Debby Applegate as "the most famous man in America," was an advocate of interior design as expression of self-fulfillment, and wrote: "a house is the shape which a man's thought takes when he imagines how he should like to live. Its interior is the measure of his social and domestic nature. It interprets in material form, his ideas of home, of friendship, and of comfort" (Clark 1986, 104). In describing the urge to express oneself in one's home, Kenneth L. Ames states: "The interiors of people's houses provided more accurate, more authentic information about them. Moving inside a house brought someone into a more intimate association with its inhabitants. Knowing the inner house was like knowing the inner person. Exteriors of houses and houses unfurnished spoke of architects and builders. But insides of houses and houses furnished spoke of the life that went on within and the character of those who lived it" (Ames 1992, 7).

Reference List

Ames, Kenneth L. 1992. *Death in the Dining Room & Other Tales of Victorian Culture*. Philadelphia: Temple University Press.

Clark, Clifford Edward, Jr. 1986. *The American Family Home 1800–1960*. Chapel Hill: The University of North Carolina Press.

Davidson, Marshall B. 1980. *The Bantam Illustrated Guide to Early American Furniture*. New York: Bantam Books.

De Wolfe, Elsie. 1913. *The House in Good Taste*. New York: The Century Co. (Orig. pub. 1911.)

Eastlake, Charles L. 1878. *Hints on Household Taste*. Repr., New York: Dover Publications, 1969.

Gay, Cheri Y. 2002. *Victorian Style—Classic Homes of North America*. Philadelphian: Courage Books.

Handlin, David P. 1979. *The American Home, Architecture and Society—1815–1915*. Boston: Little, Brown and Company.

Mace, O. Henry. 1991. *Collector's Guide to Victoriana*. Radnor, PA: Wallace-Homestead Book Company.

Madigan, Mary Jean Smith. 1975. "The Influence of Charles Eastlake on American Furniture Manufacture, 1879–1890." *Winterthur Portfolio* 10: 1–22.

Moss, Roger W., and Gail Caskey Winkler. 1986. *Victorian Interior Decoration—American Interiors 1830–1900*. New York: Henry Holt and Company.

Pattison, Mary. 1915. *Principles of Domestic Engineering*. New York: Trow Press.

Schlereth, Thomas J. 1991. *Victorian America—Transformations in Everyday Life, 1876–1915*. New York: Harper Perennial.

Strasser, Susan. 1982. *Never Done—A History of American Housework*. New York: Henry Holt and Company.

Taylor, Frederick Winslow. 1911. *The Principles of Scientific Management*. New York: Harper, 1947.

Veblen, Thorstein. 1899. *The Theory of the Leisure Class*. Repr. New York: Dover Publications, Inc., 1994.

Wharton, Edith, and Ogden Codman, Jr. 1897. *The Decoration of Houses*. Repr. New York: W. W. Norton and Company, 1978.

Zingman-Leith, Elan, and Susan Zingman-Leith. 1993. *The Secret Lives of Victorian Houses*. New York: Viking Studio.

Landscaping and Outbuildings

The history of the United States has had many champions of the rural ideal, commencing with Thomas Jefferson, who stated, "A city life offers you indeed more means of dissipating time, but more frequent, also, and more painful objects of vice and wretchedness" (Jefferson 1823). The allure of the city, while defended by writers like Walt Whitman, held no thrill for other popular writers of the period, most notably Henry David Thoreau, writer of *Walden,* and the other transcendentalists of New England. Thoreau wrote, in his essay "Walking," "Nowadays almost all man's improvements, so called, as the building of houses and the cutting down of the forest and of all large trees, simply deform the landscape, and make it more and more tame and cheap" (Thoreau 1862). The American cultural denigration of urban living was capped off in a speech by the famous Democratic Party populist William Jennings Bryan in 1896. Bryan, famous for his defense of the Biblical teaching as opposed to Darwinism in the Scopes "Monkey Trial," was also a frequent presidential candidate. At the Democratic Convention in his legendary "Cross of Gold" speech, he exhorted: "I tell you that the great cities rest upon these broad and fertile prairies. Burn down your cities and leave our farms, and your cities will spring up again as if by magic. But destroy our farms and the grass will grow in the streets of every city in the country" (Bryan 1896).

Of course, during the years of 1880–1900, cities were suffering from the expansion of manufacturing, in and near the cities themselves, and the flood of new European immigrants, who were settling in the cities in extremely crowded and unhealthy conditions. Americans of higher social and economic standard felt the need to escape the city, if possible. The development of the

near-city suburbs, often called streetcar suburbs because they were easy to reach by public transportation, backed by critics and designers such as Andrew Jackson Downing, Calvert Vaux, and innumerable books and magazines of the time, encouraged them. The rapidly expanding suburbs were the elixir of the recently created middle class who wanted a more healthful and moral environment in which to raise their families.

The nineteenth-century American suburb was created through a number of influential factors. One of the influences on the American suburban yard was the Arcadian myth, which was endorsed by romantic late nineteenth-century landscape designers. The original Arcadia was a district in Ancient Greece where the residents were lauded as wholesome, happy country people. In the colonial and federal periods in the United States, because nature was something to be protected from, houses had small gardens and hedges that surrounded the house in order to protect it from the wilds of an untamed world. The home yard and garden was portrayed as a respite from the wilds of the American frontier landscape. As the Industrial Revolution transformed American cities and towns into urban built environments, the concept of the house as a shelter from the landscape slowly changed. The new profession of landscape architecture, as well as cultural critics and architects of the time, revered the model of the Arcadian myth. Nature became romanticized in their view, and the precept of visually framing a house with a manufactured, but natural-looking landscape was paramount. The garden and yard around a house was a respite, not from the frontier, but from the urban life of the city, "a relief from the too insistently man-made surroundings of civilized life," said Frederick Law Olmsted, landscape architect and designer of Central Park in New York City, in 1923 (Tobey 1973, 171).

The change in the appearance of the residential landscape that occurred in the late nineteenth century had several fathers. It was influenced by the aesthetic criteria of the upper class, which originated in Britain and filtered down to the rest of society. Landscape architects, suburban real estate developers, urban reformers, moral improvement societies, and further access to transportation and public parks also affected the suburban landscape. In addition, popular architectural books and periodicals, trade journals, pattern books of house designs, domestic guides and home magazines, and newspaper advertisements to an insatiable and literate public gradually led to a new residential landscape that became the suburban yard. Virginia Scott Jenkins states: "Middle-class homeowners, influenced by Jacksonian democracy, romanticism and transcendentalism, magazine articles and architectural design books, made the single-family detached house with a front yard the most characteristic feature of European settlement in North America" (Jenkins 1994, 31). The American Dream became a house with a yard.

The public park movement was also influential in the creation of the late nineteenth-century individual yard, for both the wealthy and the middle class. Parks designed by Frederick Law Olmsted in Boston, New York, and other cities were based upon the large landscaped estates of the English well-to-do. These parks were picturesque designs, with grassy meadows, lakes, and trees. Olmsted designed a new town using his principles of romantic landscape design in 1868, which was to influence later suburban development. This project was called Riverside in Illinois. Each house was required to be set back 30 feet from

the sidewalk, a proposal that still is typical, in some form, of suburban zoning today. This project was an interpretation of English romantic landscape design. The fire in Chicago in 1871, which destroyed most of the city, made it possible to design residential neighborhoods based on the newest ideas of suburban development. The Olmsted-designed town of Riverside influenced the new towns around Chicago with their setback houses, grass, and landscaped yards.

Another factor in the growth of the new suburbs was the idea of the building and loan association that became an avenue for middle- and lower middle-class families to buy a house in the 1880s and 1890s. Having a mortgage on a house was a somewhat new concept, as banks did not provide mortgages until the second half of the nineteenth century, and even then, required a down payment of half the value of the house with a short payoff period of several years. Building and loan associations were cooperative associations that took the place of banks (which often failed) for providing mortgages. The members of the association were all stockholders, and each one paid dues and elected members to the board of directors. Many members of the board also had loans themselves. The association helped the family with a budget for the mortgage and calculated how much they would need to carry the house, including costs for commuting. The board of directors handled the problem when the homeowners fell behind in their payments. Building and loan associations continued to be popular well into the twentieth century. One of the most popular movies of all time, Frank Capra's *It's a Wonderful Life,* made in 1939, described the value of the small town building and loan association for the health of the community.

The revolution in design that created the nineteenth-century suburb was part and parcel of the Victorian culture of the period. Industrial growth and the growth of the nation gave the United States the opportunity to expand horizontally away from the urban centers, as families chose to relocate away

People: Frederick Law Olmsted (1822–1903)

The so-called father of landscape architecture, Frederick Law Olmsted was not a trained architect, though his designs for parks and developments throughout the country had enormous influence. He was born in Hartford, Connecticut, son of a well-to-do dry-goods merchant. He attended Phillips Academy and Yale, where he studied engineering but did not complete his studies. His first passion was farming, and desiring to attempt "scientific farming," he bought a farm on Staten Island, in New York. Too impatient to remain on the farm, Olmsted took a job as a journalist, which took him on many trips throughout Europe and the United States, including covering the South and the horrendous conditions of slaves for the predecessor of the *New York Times*. He later cofounded the liberal political journal *The Nation* in 1865.

Olmsted was a fan of nature and admired Andrew Jackson Downing and his picturesque designs for houses and parks. Through Downing, Olmsted met Calvert Vaux, an English architect who relocated to the United States at the behest of Downing. When Downing died in a tragic boating accident, Vaux teamed up with Olmsted in the preliminary plans for Central Park in New York City. The concept of the park for all the public's use was a new one, and one that was heavily promoted by Olmsted, a believer in egalitarian ideals. Olmsted had a zeal for creating a picturesque and tranquil space within the hustle and bustle of the late nineteenth-century city. He believed that all citizens should be allowed to enjoy a tranquil and beautiful area in which to relax.

Olmsted moved to Boston and opened the first landscape architectural firm in 1883. The firm was to be responsible for public parks, urban greenways, college campuses, the site planning of the World's Columbian Exhibition in Chicago in 1893, and many other projects throughout the country. He also collaborated with Henry Hobson Richardson, a renowned architect. In 1895, Olmsted had to retire because of dementia. He died in 1903, but his sons carried on the work of the firm for half a century more.

from the city and into the new suburb. Kenneth Jackson states: "The solid and spacious houses that lined the tree-arched avenues and fronted the winding lanes of dozens of suburbs exuded success and security. They seemed immune to the dislocations of an industrializing society and cut off from the toil and turbulence of emerging immigrant ghettoes. Pitched roof, tended lawns, shuttered windows and separate rooms all spoke of communities that valued the tradition of the family, to the pride of ownership, and the fondness for the rural life" (Jackson 1985, 71).

But of course, the flocks of immigrants and other lower income workers still had to remain in the urban environments, which also appealed to the wealthiest. The middle, and upper middle class, however, rejected the commercialism of the city, while taking advantage of the modern conveniences provided in the new suburbs, such as electricity, and water and sewer systems. As Gwendolyn Wright contends, the suburbs seemingly rejected industry in favor of a rural ideal, but without the inconveniences of a true rural life. The suburbs were never truly rural or agrarian, and in fact the yards were not large, but they represented the ideal of the rural past that Americans, even the new American immigrants, hungered after (Wright 1981, 100).

THE HISTORICAL PERSPECTIVE OF SUBURBAN GROWTH

Andrew Jackson Downing

The unique development of the American suburb had its greatest early influence in the books written by Andrew Jackson Downing (1815–1852) in the mid-nineteenth century. Downing, son of a nurseryman, was born in Newburgh, New York, a small city on the Hudson River north of New York City. When Andrew and his brother Charles assumed responsibility for the nursery that was established by his father, they encountered wealthy New Yorkers who went to the nursery to purchase plants for their estates built on the Hudson. Andrew was charming and ambitious and yearned for acclaim apart from the nursery business. He wrote a number of books, the first being *A Treatise on the Theory and Practice of Landscape Gardening, Adapted to North America,* which had three revised editions in Downing's lifetime and continued to be popular for many subsequent decades. He founded a periodical called *The Horticulturalist* for which he wrote editorials on various subjects. In 1850, he wrote a book titled *The Architecture of Country Houses,* a classic treatise still available today, which had enormous success. In it, he recounted his thoughts on the ideal way of life in the United States. He designed 13 cottages, 7 farm houses, and 14 villas in the book. He included discussion of architectural theory as well as some scientific theories, such as how to ventilate a house.

Downing became an arbiter of American taste as well as a well-respected spokesperson for the Gothic Revival style. He popularized many design theories of the day, especially romanticism and the picturesque. He collaborated with a number of prominent architects for his 1850 book, chiefly the architect Alexander Jackson Davis. He planned to go into business with Davis, but eventually did not. He met an architect in England named Calvert Vaux (1824–1895) who came to the United States and had similar tastes in design to Downing's. Vaux came to the United States with Downing in 1850 and opened an office with him. They set up a partnership in 1851, but it was not to last

because Downing was killed in an accident in 1852 at the age of 36. He was on the steamboat Henry Clay in a race with *The Armenia* when the heat from the boilers set their canvas covers on fire and everyone had to jump overboard. He was hurling down deck chairs to help passengers hang onto them to stay above water, but he eventually drowned himself. Vaux continued to promote Downing's ideas for many years after, and later went into partnership with Frederick Law Olmsted. Andrew Jackson Downing's death was mourned by the nation, and an urn in his memory can still be viewed on the Mall in Washington.

At the time of his death, Downing was in the process of designing the grounds and surrounding area for the new Smithsonian Museum in Washington, D.C. (The museum that was eventually constructed, designed by James Renwick, Jr., is a Romanesque Revival sandstone Victorian pile now dubbed "the Castle" and used for administrative offices for the Smithsonian.) The plan for the surrounding area designed by Downing was romantic and picturesque, irregular, with wandering paths and wooded areas. This plan was scrapped after Downing's death, and the eventual plan was the Beaux-Arts classical, symmetrical plan of the mall now existing, surrounded by the chilly, marble classical buildings now surrounding the rest of the mall. What a different look Washington would have if Downing had lived to fulfill his plan for the mall area!

Andrew Jackson Downing had an enormous influence on the development of middle-class suburbs. In his book *Crabgrass Frontier* (1985), prominent Columbia University historian Kenneth T. Jackson describes Downing as the most literate and articulate architectural critic of his generation and the single most influential individual in translating the rural ideal into a suburban ideal. Though many thought him a snob and an aesthete, Downing was a proponent of the single-family house as a manifestation of character and republicanism, not ostentation. Downing recommended three types of suburban homes: the cottage, the farmhouse, and the villa. The villa, which was his ideal type of home, would have to maintain a household of several servants. His idea was that the villa would compare to the home of an English country gentleman.

Downing's writings had an enormous influence on the middle-class and even working-class audience. The cottages he designed were in popular print and popularized the idea for the common man. The writings of Downing showed evidence of what Alexis de Tocqueville saw when he traveled through the United States in the 1830s and wrote his book *Democracy in America* (1835). In it, de Tocqueville described "American Exceptionalism," a phenomenon still characterized by modern social theorists as the perception that the United States differs in quality from other developed nations, most particularly France and England. This difference is due to the nation's unique origin, as the first colony to successfully revolt, and also to its singular political institutions and constitution. De Tocqueville remarked on how wealthy the average American family was in comparison with the French or English, with which he was familiar. Similarly, in Downing's writings, he describes a middle- to upper middle-class homeowner and one who is not dependent upon the wealth of his ancestors. Demonstrating his uniquely American belief in the equality of opportunity, in his book *The Architecture of Country Houses,* Downing wrote:

> Fortunes are rapidly accumulated in the United States, and the indulgence of one's taste and pride in the erection of a country-seat of great size and cost, is

Alexis de Tocqueville and American Exceptionalism

When Alexis de Tocqueville (1805–1859) visited the United States and wrote his celebrated book *Democracy in America* in 1835, he described a country unique in the world and coined the term *American Exceptionalism.* Tocqueville expected to see a rural nation with a few urban elites and many rural uneducated peasants. What he beheld was a different story. As he writes:

When you leave the main roads you force your way down barely trodden paths. Finally, you see a field cleared, a cabin made from half-shaped tree trunks admitting the light through one narrow window only. You think that you have at last reached the home of the American peasant. Mistake. You make your way into this cabin that seems the asylum of all wretchedness but the owner of the place is dressed in the same clothes as yours and he speaks the language of towns. On his rough table are books and newspapers; he himself is anxious to know exactly what is happening in old Europe and asks you to tell him what has most struck you in his country . . . One might think one was meeting a rich landowner who had come to spend just a few nights in a hunting lodge. (Rybczynski 1996, 112)

Tocqueville added: "The spirit of equality has stamped a peculiarly uniform pattern on the habits of private life" (Rybczynski 1996, 112). Tocqueville identified a uniformity, a homogeneity, in culture in the United States. He discovered that a farmer in the United States was an occupation. In Europe, it denoted a set of cultural values and a lack of education and sophistication. The mentality of the rural/urban/suburban aesthetic was already evidenced in American culture. The middle-class lifestyle made the United States exceptional in western society. Though small towns and villages in the western expansion in the United States may have been rural, they were not provincial and unsophisticated. Rybczynski writes, "the United States is the first example of a society in which the process of urbanization began, paradoxically, not by building towns, but by spreading urban culture" (Rybczynski 1996, 114). The distinction of the urban centers, so crucial in the Old World, was not evident in the new country. "There never was a sense of cities as precious repositories of

becoming a favorite mode of expending wealth. And yet these attempts at great establishments are always and inevitably, failures in America. And why? Plainly, because they are contrary to the spirit of republican institutions, because the feeling upon which they are based can never take root, except in a government of hereditary right; because they are wholly in contradiction to the spirit of our time and people. (Downing 1969, 266)

And he adds, in condemnation of the feudal tradition of passing down wealth and property from generation to generation:

There is something beautiful and touching in the association that grows up in a home held sacred in the same family for generations. . . . But the true home still remains to us. Not, indeed, the feudal castle, not the baronial hall, but the home of the individual man . . . The just pride of a true American is not in a great hereditary home, but in greater hereditary institutions. It is more to him that all his children will be born under wise, and just, and equal laws, than that one of them should come into the world with a great family estate. It is better, in his eyes, that it should be possible for the humblest laborer to look forward to the possession of a future country house and home like his own, than to feel that a wide and impassable gulf of misery separates him, the lord of the soil, from a large class of his fellow-beings born beneath him. (Downing 1969, 270)

As a proponent of the suburban lot, Downing recommended home lots of 100 feet wide in developing suburbs a train ride away from the city. He recognized the significance of the new suburban railroad lines in getting the workers from the cities to the new towns where the family could live in a single-family home. He recommended commuting as the method to get to a semirural home

with a garden. Downing's designs reflected the romantic English ideal of winding streets and lots that maximized the use of the permutations in the land. He endorsed the inclusion of a central green area in the town where families could gather as a combination of individual and communitarian values. Downing advocated for the middle-

(continued)

civilization," he adds (Rybczynski 1996, 114). That's why, to some extent, cities did not retain hegemony in the American culture as they did in European culture. This led to the continuing march of suburbanization.

class version of the wealthy landowners' landscaped grounds. Even though the lawnmower was not invented at this time, Downing urged people of moderate wealth to clean up and beautify their properties. The smaller properties could cut down grass by scythe whereas the larger properties had to be trimmed with other means, one of them being sheep, or horse drawn mowers.

Concept of the Picturesque

Landscape painters from the Renaissance on were struggling with the concept of man's place in nature. Kenneth Clark states that landscape painting marks the stages of our conception of nature, a perennial attempt to create harmony with the environment (Shepard 2002, 122). At first, painters portrayed human subjects, often portraits, within a romanticized background landscape. Paintings evolved so that, by the seventeenth century, the landscape was the subject itself. The Romantic period in art portrayed a certain formula for a romanticized classical landscape. The stereotyped portrayal of the landscape influenced ideas of beauty in the coming centuries.

The Romantic movement in the fine arts and literature influenced the idea that the landscape was benign, not intimidating. The movement in Europe affected the writings of American authors in the 1840s, such as the transcendentalists of New England and James Fenimore Cooper and Washington Irving in the Catskills in New York. Artists such as Thomas Cole, Asher B. Durand, and Frederick Church created a school dubbed the Hudson River School of painting, which considered nature to be beautiful and benevolent instead of frightening.

The concept of the picturesque was a profound influence on the landscape and garden designers of the nineteenth century, because it introduced the notion of the landscape as a picture. In return, pictures painted by landscape painters influenced the concept of the picturesque, and eventually, the landscape was conceived as a two-dimensional surface similar to a canvas. The picture had to be framed like a painting was, as well. Uvedale Price's *Essays on the Picturesque* (1794) defined the picturesque as, "Those irregular details, rough surfaces, and coarse textures in nature and art that pleased the eye with their shadowy chiaroscuro. The picturesque was characterized by roughness, irregularity, abruptness, variation, and the broken interplay of light and shade" (Shepard 2002, 126). (*Chiaroscuro*, an Italian word for "light-dark" is the effect produced in painting where a subject is brightly lit but surrounded by a pool of shadow. Rembrandt is one of the more familiar painters known for using the technique of *chiaroscuro*.) The picturesque, the sublime, and the beautiful were considered the crucial factors creating scenery that appealed to the eye.

INDIVIDUAL HOUSES AND THEIR LANDSCAPES

Siting the House

As is obvious in the oldest sections of any old American city or town, the siting of houses on the property was not of great importance before 1860. The concept of placing a house on the lot with a setback from the lot line or with a large lawn or a certain distance between houses was not a consideration. Most houses were built right onto the front lot line near the street. City houses were built without a front yard, as can still be seen in urban environments. Builders in small towns and even rural areas believed that cities were something to be copied, because that was where money and culture resided. So, ironically, in order to look more urban, even small towns that had plenty of space placed the houses right on the street.

After 1840, the idea of having houses built right on top of each other lost appeal, except in the big cities where space was constrained. The growing popularity of the architectural pattern book, influenced by the Romantic movement and the picturesque designs of A. J. Downing, showed drawings of houses set back from the street in the first evidence of the suburban house. Because of the availability of land and the new public transportation to new suburban towns, builders were able to construct houses on larger lots with grass and gardens around them. In addition, after 1840, the appeal of the city for cultural, monetary, and safety concerns was beginning to fade. The emergence of the Industrial Revolution and, with it, the recently arrived poor immigrant workers, made cities feel more dangerous and less healthful to the middle-class residents.

The development of the American suburban lot of the late nineteenth century and the siting of the house on the lot was based on English models and utilized the vast expanses of the sprouting nation. The American suburban lot was a very different creature from its European counterpart. The lots in American towns and villages capitalized on the existing topography to create wandering paths and clumps of trees and shrubs in the Romantic style. French, Italian, and Asian homes, by contrast, were more formally sited, close to the street, but with a small yard displaying formal landscaping and ornaments, such as fountains, statues, and so forth. A wall surrounded the property to completely seclude the house from the street. The backyard or interior courtyard was the private outdoor space for the house. This design was appropriated in the United States only in the Southwest and California. There, under the influence of the Spanish style house, residences were sited behind

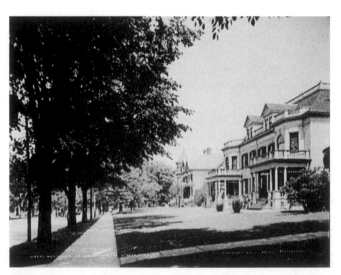

This street in Utica, New York, shows an example of Colonial Revival houses set back from the street, with street trees, a typical example of late nineteenth-century suburban development. Courtesy of the Library of Congress.

hedges, walls, or high fences designed to completely privatize the house from the public domain.

Vernon L. Parrington, who wrote at the end of the nineteenth century, advanced an opposing view to the popular version of the Downing picturesque. For the suburban lot, Parrington disapproved of the setback of the house on the property, surrounded by open lawn and foundation plantings. He considered the arrangement merely a plea for approval from the neighbors, at the expense of their own comfort and privacy. He disdained the blurring of property lines with continuous lawns in front yards. Parrington dubbed this typical landscaping design a "curious love of publicity" (Handlin 1979, 170). Parrington understood that the suburban placement of the house within the property was a throwback to the frontier, where families yearned for companionship in a wild, forbidding, and isolated world. Parrington, however, derided this attitude as merely legacy of the frontier days, which did not apply by the turn of the twentieth century. He wrote that the suburban house should be turned inward, away from the street, with the major focus being in the backyard. He designed a site plan with a large porch at the back of the house instead of the front and a high hedge at the front property line to give privacy to the house's occupants. Parrington's designs did not catch on at the time. His ideas were new and not appealing to the nineteenth-century aesthetic. The typical suburban lot, with the house set back and the front yard sporting an open lawn and the porch at the front, continued to be the suburban ideal for decades to come. However, Parrington was prescient in that by the mid-twentieth century, the focus of the suburban site plan did turn to the backyard. Front porches, if at all present, were merely perfunctory appendages. The major family space was the deck, always at the back of the house, where the family could enjoy the privacy, away from street life, that Parrington extolled.

Nevertheless, the American suburban yard, with its single-family house, surrounding yard on four sides, and the setback house was becoming standard practice in the suburbs by 1870. In describing the suburban lot, Kenneth Jackson states:

> The yard was expected to be large and private and designed for both active and passive recreation, in direct antithesis to the dense lifestyle from which many families had recently moved. The new ideal was no longer to be part of a close community, but to have a self-contained unit, a private wonderland walled off from the rest of the world. Although visually open to the street, the lawn was a barrier—a kind of verdant moat separating the household from the threats and temptations of the city. It served as a means of transition from the public street to the very private house, as a kind of space that, by the very fact of its having no clearly defined function, mediated between the activities of the outside and the activities of the inside. (Jackson 1985, 58)

In contrast to the typical suburban lot, cities like New York still had the lot size of 25 feet, with no setbacks for the townhouses built there. The effect is totally different from the suburban lot: The houses were directly on the street, with no front or side yards, and no lawn. The urban character of the New York street is still its most attractive feature. For, though most Americans are still clamoring for the "house with a yard," most New Yorkers will pay exorbitant

amounts to live in a New York townhouse, or brownstone. However, the urban appearance of New York City was not repeated in other cities. Most American cities built enumerable in-town suburbs with single-family houses.

In contradiction to the middle- and upper middle-class homeowners of the period who followed the advice of Olmsted in the siting of their houses in the 1880s, many of the poorer families were forced to adhere to the traditional siting of the house. This meant that the urban factory workers, southern tenant farmers, miners, and others of the working class had houses without front yards (Jenkins 1994, 27). And the upkeep of the lawn was still a chore, even for the wealthier homeowner, who had to spend many weekly hours cutting the lawn with still-awkward and expensive manual lawn mowers.

Frank J. Scott (1828–1919)

The most influential book for the late nineteenth-century home landscaper and landscape designer was Frank J. Scott's *The Art of Beautifying the Home Grounds,* written in 1870. Thoroughly indebted to Andrew Jackson Downing, Scott's book followed the ideals of the Downing books of the 1850s and applied them to the small suburban lot of the late century. He appealed to the middle-class, commuting homeowner, who lived in the nearby suburban town and likely worked in the city. The houses and the aesthetic described in the book were neither farm, nor country estate, nor city lot. They were for the homeowner who lived in a developed area, of similar small (small for the period) houses on small, continuous lots. *The Art of Beautifying Suburban Home Grounds* was immensely popular among the newly minted, middle-class homeowners.

Frank J. Scott was the son of Jesup W. Scott, who was originally from Connecticut and relocated to Ohio where he bought land in 1830. Jesup Scott believed that the greatest city in the country would be a midwestern city and further predicted that it would be Toledo. Frank Scott was also a promoter of the Midwest, but became famous because of his book, which did not champion any particular section of the country. Scott was an advocate of the suburban town, which was becoming more popular after the Civil War as public transportation became more available. He wrote a "township of land, with streets and roads and streams, dotted with a thousand suburban homes peeping from their groves" had a "broader, more generous and cosmopolitan character than old-fashioned villages" (Scott 1870, 27).

Scott's vision was a middle-class one: He did not favor large estates that required lots of household staff to maintain. He recommended against growing fruits and vegetables on the suburban lot. He preferred the property be designed for beauty and not for farming. Under the influence of Downing and the picturesque ideal, the house and its surrounding yard was supposed to look like a picture, in Scott's view. The landscaping Scott recommended created a series of pictures for the eye as one ambled through the property and the surrounding properties. He believed that houses should not be obscured by walls, fences, or landscaping. They should be framed by a variety of trees and shrubs. He adhered to the picturesque idea of the suburban house where, "Decorative Planting should have for its highest aim the beautifying of HOME. In combination with domestic architecture, it should make every man's home a beautiful picture . . . Let us, then define Decorative Planting to be the art of

picture making and picture framing, by means of the varied forms of vegetable growth" (Scott 1870, 18). The ideal landscape had to be obtained within a limited space, because suburban lots were often less than an acre. Scott, in fact, was a proponent of small lots so that the new suburban housewife could spend time at home, but still retain ties to the neighbors, other suburban housewives. As a custom derived from frontier living, Scott believed that the family should have easy contact with the neighbors in order to prevent isolation. Too much contact, what happened in urban living, was also not desirable to Scott. The typical property in Scott's book was a half-acre.

Scott did not extol the virtues of certain types of plantings, as some other landscape designers did. He did not care whether the homeowner preferred formal, French type plantings or more wild looking English gardens. He was concerned with the overall picture of the scene. He wanted to leave the front and side of the property as open as possible and leave the sitelines of the house open to view. He liked grass, and was one of the early proponents of a large lawn, as it gave an open and welcoming vista to the property. Scott was also a proponent of foundation plantings, a custom still popular today. The foundation plantings, usually bushes and shrubs, not flowers or trees, made the house look like it was growing out of the landscape. The plantings were placed next to the foundation, with the largest ones closest to the house stepping down to the smaller ones away from the house. This type of planting was part of the picturesque, picture-framing ideal of landscape design.

Although Scott did not concern himself with types of plantings or style of landscaping, there were many landscape designers of the time that had definite opinions about what to plant. Some writers recommended using native plant material; others wanted to introduce exotic foreign species. There were writers who thought that growing fruit and vegetables on the small lot was a good idea, unlike Scott. There were ones that preferred the formal garden, using manicured hedges, topiaries, and so forth, while many others recommended a less manicured approach. Many homeowners used ideas from their own ethnic background to design their own personal home landscape. For instance, the typical yard of an Italian in New York was heavily influenced by the Italian garden in Italy, using topiaries, statues, and highly groomed shrubbery. But the general idea of the suburban property, with its lawn and its general openness, was absorbed into American culture through the considerable influence of Frank J. Scott's book in 1870 and its successors.

GARDENS

One of the major components of the late nineteenth-century suburban lot was the garden. Gardens designed expressly for their looks were not part of the yard in the earlier years of the United States. Assuredly there were vegetable gardens, but they were not planted for beauty but for practical use. The idea of a formal garden originated in Italy, though small kitchen gardens were common in northern countries. During the Renaissance, the garden as an art form developed in the estates of the Villa d'Este in Tivoli. The Italian garden was large, with groomed hedges and topiary, straight paths, and hardly any grass or flowers. The idea of these formal gardens was to demonstrate control of nature, for the "natural" growth of nature was not considered beautiful because it was

too wild and undisciplined. This was an example of nature under man's control. The French took this view of nature and expanded on it in the magnificent formal gardens of Versailles and others. Here, the gardens were more extensive; the manicured grounds went on for miles around the palace.

On the other hand, the English created a different type of garden. Formal gardens were losing appeal in the late seventeenth century. The English invented the landscape garden, which was more romantic in focus. The concept of picturesque had new influence on the garden. Many English parks were built in the eighteenth and nineteenth century based on picturesque principles, which became the basis for American landscape design in both parks and yards surrounding middle-class houses.

The concept of gardening in the United States experienced a massive shift in the nineteenth century. Previously, gardening was something only the very rich would have the space, inclination, or household help to accomplish. With the advent of the small suburban lot, the availability of the inexpensive and usable lawn mower, and the growing amount of leisure time, the garden became a pleasurable task pursued by many Victorian middle-class families. The book *The Art of Beautifying Suburban Home Grounds,* by Frank Jesup Scott, popularized middle-class suburban gardening after its publication in 1870. It gave specific advice to the neophyte gardener as to how to create an attractive yard, including a flower garden and a lawn. Downing was also a great influence on the population in creating a picturesque suburban landscape, even for the middle-class homeowner.

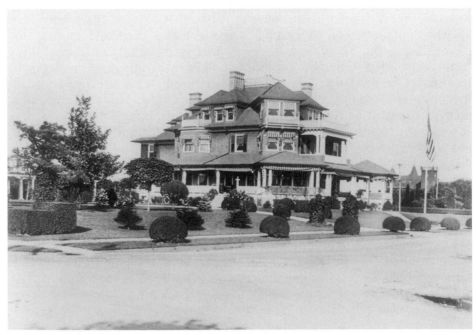

A formal, showy garden complements a large house in Spring Lake, New Jersey. The idea of foundation planting was not yet popular. Plantings were placed symmetrically throughout the lawn and even along the street. Courtesy of the Library of Congress.

Small front gardens and back gardens in the suburbs were not comparable to the gardens in the picturesque neighborhoods and large houses of the wealthy. Those gardens had exotic plants and designed landscapes. But the homes of the working-class suburbs often had small vegetable gardens that were evidence of their ethnic background. These families were anxious to have a house with a yard, but may not have had time or inclination to create a basically superfluous garden just for the beauty of it. However, the idea of the suburban garden created merely for beauty's sake was indisputably increasing in popularity for the families of the middle class.

On the other hand, city dwellers did not have the ability to have much of a garden, if any. But the reformist attitudes of the late nineteenth century promulgated the importance of gardening and nature for community and personal growth. Consequently, schools were designed with playgrounds by this period, because reformers thought that fresh air and exercise were beneficial as well as healthful to children. The scourge of tuber-

The journal *Garden and Forest* had many tips on gardening and advertisements for plants and gardening paraphernalia. Courtesy of the Library of Congress.

culosis also influenced cities in building schools with playgrounds; some were even built on the rooftops of the school when there was no additional space for a playground.

Allotment gardens were given to poor city dwellers in some communities. After the depression of 1893, the mayor of Detroit, Hazen Pingree, recommended that the poor, starving unemployed workers of the city be given a tiny allotment on vacant properties to grow their own food. This program, which came about after the mayor convinced owners of vacant property in the city to allow their lots to be divided up into allotment gardens, made more money in the value of the crops than the startup costs for the program in the first year. This successful program, dubbed "Pingree's Potato Patches," was copied in all the major cities in the following years. Another program for the urban poor was flower missions, which delivered fresh flowers to the poor in the tenements. These programs flourished in many cities, allowing slum dwellers to see the beauty of nature in their squalid apartments. Nature was considered beautiful and healthy, and the aim was to bring all the population as close to

nature as possible, even those that lived in squalid urban tenements where nature was nowhere near.

For the typical middle- and upper middle-class homeowner with the house and the yard, gardening became a huge fad in the years 1880–1900. Similar to the interior of the house, the exterior became a showplace for the Victorian family to flaunt their taste and affluence to the admiring passerby. The passion for gardening that took hold in the Victorian Era was aided by the discovery of new plants brought in from exotic lands. Palms, water lilies, cannas, orchids, and forsythia, as well as many other plants, became imported favorites in the American garden. Verbenas were also popular, originating from Brazil but becoming a favorite bedding plant.

The Victorian taste for large and showy in all aspects of design was certainly evident in the garden. The plants most coveted were the big-leafed plants (many imported from tropical locales) and the most colorful flowering plants. Cannas, for instance, were displayed at the 1893 World Columbian Exposition and soon became all the rage in the American garden and greenhouse. The forcing of blooming plants became possible as the well-to-do built conservatories as part of their huge, rambling Victorian houses. The conservatory could now be heated, and the homeowner was now able to grow lush, colorful tropical plants all year long.

In addition to the interest in an individual family's suburban garden, from 1890 to 1915 garden contests became popular diversions for American families. Started by George Washington Cable, a well-known southern writer who relocated to Northampton, Massachusetts, these contests involved the entire community. Every season, a committee of "garden visitors" would make the rounds at the homes of the local residents and invite them to enter the contest. A monthly visit to the homes would be made, and the homeowner would be advised as to the importance of garden and lawn maintenance. These were the factors in consideration for the contest: lawns had to be regularly mown; weeds had to be pulled; plantings should be placed along the foundation; plantings should also be done avoiding straight lines; and more important than flowers were the shrubbery or leaves of the flowers and how they fit into the planting scheme. Following this formula would "make the whole place one single picture of a home, with the house the chief element and the boundary lines of the lot the frame" (Handlin 1979, 192). Cable, a novelist who became a social reformer after realizing how African Americans in his native South and immigrants in his adopted New England were often discriminated against, encouraged these gardening contests for all people, including the working class. He thought that the ability to understand nature in one's own little property would lead to other healthful and educational effects, as well as being a boon to the beautification of the neighborhood. The popularity of garden contests grew all over the country as large factories and other organizations sponsored them for their employees. National Cash Register, one of the largest American companies, in Dayton, Ohio, pursued a gardening and landscaping program for its employees for years. Begun as a landscape beautification program for the new factory, the company hired the firm of Frederick Law Olmsted to design the grounds and to advise the factory workers in creating their own home gardens. Contests were conducted, plants were sold at the factory for the workers' use, and lectures were given using slides to

demonstrate the way gardens can be created to beautify the house.

In addition to the home garden, the idea of putting trees next to the street in the new suburban developments grew in popularity in the last years of the nineteenth century. At first, the towns allowed the property all the way up to the street to be the responsibility of the homeowner. However, there was no consistency in the way the street looked, and the homeowner may or may not take care of the trees. Village improvement societies encouraged the maintenance of the street trees, but there was no legal responsibility. Eventually, generally after the turn of the century, towns started to take over jurisdiction of the green strip along the street and the sidewalk. Towns and cities often planted trees of the same type to foster uniformity. At times the thought was to vary the type of tree when the road was curving, not straight.

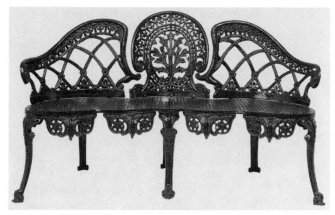

Benches like this one were popular in the Victorian garden. Getty Images.

The garden of the Victorian suburban house displayed certain styles that were very popular at the time. The design that first took over in the second half of the century was to decorate your garden with extremely bright colors and elaborate designs. Similar to the design and color of the house itself, the garden was showy and ornate. The fashion of "bedding out" meant planting large areas of annual flowering plants, such as geraniums, petunias, allyssum, zinnias, and others, planted in specific patterns to form colorful designs. These beds were not placed along the foundation planting only, but were often scattered throughout the lawn to form colorful patches for the family inside the parlor to easily see. The beds were laid out in intricate curvy designs, such as the "tadpole," which had an insert the shape of a tadpole within the larger bed of a contrasting color. The colors were garish to our eyes, like the paint colors used on Victorian houses of the period; bright yellows were placed with purples, reds, and pinks to create a color riot.

Toward the end of the nineteenth century, the craze for bedding out was waning, at least for the wealthier tastemakers of the country. The middle-class homeowner with the small garden still planted the colorful annual bedding garden in single plant designs because it was familiar and it gave a cheerful look to the house. However a new fashion came over from England, and that was the perennial border. These gardens were much more subtle in appearance. The perennial plant, the plant that returned each year, for instance, phlox, delphinium, and dahlias, had a leafier look, less flower and more green, and the flowers bloomed only for a couple weeks during the season. That meant that more planning had to take place in the design of the garden, although once planted, it was easier to maintain over the seasons than the annual bedding garden that had to be replanted each year. The border garden did not get placed in the middle of the lawn; it was along a border, fence, wall, or the side of the

house. The plants for the border garden had to be carefully selected, because, as they were only flowering for part of the year, other plants had to be chosen to flower at other times of the year, and the colors and size of the plants had to be carefully considered. Generally, the design of the border was with the shorter plants first with graduated higher plants toward the wall or fence, so all plants could be easily seen. The border plantings were more informal than the bedding schemes, and the popularity was fed by the nostalgia of the period for an earlier, simpler society before the Industrial Revolution. The interest in the colonial past also was an influence on the change in the color, design, and plants used in the popular flower garden of the American homeowner. Colors, influenced by the Colonial Revival, were subtler and not as garish.

A wilder garden than the formal, colorful beds of the Victorian house was to be found in the concept of the picturesque imported from England. John Ruskin and John Loudon in Britain and of course, Andrew Jackson Downing in the United States, influenced garden design toward the less formal and more romantic. The picturesque, which was the major influence also on Frederick Law Olmsted in his garden and park design, was a contrived version of the naturalistic. Though picturesque gardens were totally planned to attain a certain look, they were designed to appear as if they were growing wild. The idea of the picturesque included veneration for the antique with Gothic undercurrents. The industrialization of the current society led to a nostalgia for the past that included a fallacious interpretation of a romantic nature. Flowers were planted to look like they were wildflowers, though they were actually planted there. Paths were constructed to meander through hills and dales with possible ancient ruins encountered along the way. The ruins, of course, were not ancient but contemporary versions of ones. The concept was to walk through a picturesque garden slowly and see beautiful vistas and surprising natural outcroppings along the way. The informal picturesque garden was the antithesis of the formal garden, where the flowerbeds were obviously designed and predictably symmetrical, the shrubs were shaped, and the paths were straight. The picturesque garden, on the other hand, was just as carefully designed, but with the aim of appearing like a romanticized version of the English countryside as envisaged by the designer.

Though the picturesque garden did not catch on with the middle-class homeowner to a great degree, parks such as Central Park in New York, designed by Frederick Law Olmsted in the 1860s, were verdant examples of the picturesque enjoyed by millions of people. The park realized its full potential as a beautiful example of the picturesque in the 1890s as all the shrubs and trees grew to full size. Olmsted initially planned the park to look as it did 30 years after its construction. Luckily, he lived to see the successful growth of the park into its natural state, with its enduring popularity in the middle of the city of New York.

The picturesque landscape as portrayed by Downing was generally in a large plot of land or a countrified setting, but many homeowners of smaller suburban properties used aspects of the picturesque in designing their gardens. Many small houses had curving paths up to the house, and instead of formal beds of flowers, the garden had a border of flowers next to the house. A garden could have an ornamental tree, such as a weeping birch, beech, or willow, or an asymmetrical shrub, such as althea, also known as rose of sharon. The

typical suburban homeowner utilized aspects of the picturesque for effect. Picturesque gardens generally contained a romantic piece of garden furniture, for instance a twig bench, or a cast iron settee. Urns were also popular pieces of garden furniture. Though handcrafted plant stands became the rage, they often contained very expensive plant material, which demonstrated that the rustic look of the plant stand was purely intentional and not necessary for monetary reasons (Leopold 1995, 79). Another Victorian affectation was the rockery, a contemporary term for a rock garden. All gardens, no matter how small, in the late nineteenth century had to contain a rockery of some sort. The rockery was a "deliberate artifice" that consisted of a collection of rocks within a clump of trees or shrubs, piled up to look natural (Leopold 1995, 79). Vines and plants were planted to grow over the rocks, and ferns were planted to grow at the bottom of the pile where it was dark and moist. The rockery might contain a fishpond or other piles of shells or pottery shards. The intent was to appear casual and as if all the elements had naturally arrived there, which of course they had not. Wisteria with its gnarly vines was a perfect element for a picturesque vine of a rockery.

Considered a separate room to the Victorian house, the suburban garden had to be jammed full of furniture as did the inside rooms of the house. Whole industries were created that manufactured pieces of furniture solely designed for the exterior garden. A new industry of cast iron furniture was developed expressly for use in gardens and porches. It was popular though not inexpensive. Another option for the garden was rustic wood furniture based on the Adirondack seating used in the popular New York State resorts. This furniture, still used as a type of outdoor furniture in suburban yards, was less expensive than cast iron though also less durable. It appealed to the picturesque sensibility because of its gnarled, rustic appearance. Other types of furniture also found their way into the middle-class garden, such as the metal ice cream parlor chair, still used in cafés today, and canvas folding chairs, today called director's chairs (Leopold 1995, 91). Other accessories were used in the Victorian garden to fill up the area, as the indoor spaces were similarly crammed. Urns, gazebos, fountains, and classical columns and busts all found their way into the garden of the middle-class homeowner, if financially feasible.

An example of the picturesque garden for the Gilded Age super-rich is Vanderbilt's estate in Asheville, North Carolina, called Biltmore. Architect Richard Morris Hunt and landscape architect Frederick Law Olmsted designed the home, dubbed America's largest house, and garden in 1896. The amount of money controlled by Vanderbilt made it possible for these designers to create for the client an estate fit for a king. It was similar to kingly estates in Europe, for the house was based on a Beaux-Arts French chateau style and resembled a European castle. Olmsted realized that he was commissioned to design a private park, with the ostentatious display of wealth required for one of the richest men in the world. The opportunity for Olmsted, in addition, was to create a park that utilized conservation techniques not available in public parks in American cities. The estate has been preserved, with both the house and its grounds intact, exhibiting the power of wealth in the Gilded Age. The estate was an interpretation of a "romanticized version of a pioneer farm in the wilderness" (Tobey 1973, 173).

PORCHES

The porch was a ubiquitous feature of the Victorian house. Andrew Jackson Downing stated: "The porch, the veranda, or the piazza, are highly characteristic feature, and no dwelling-house can be considered complete without one or more of them . . . In all countries like ours, where there are hot summers, a veranda, piazza, or colonnade is a necessary and delightful appendage to a dwelling-house, and in fact during a considerable part of the year frequently becomes the lounging apartment of the family" (Shepard 2002, 237).

The front porch was the first room in the house to be occupied by a visitor in the Victorian house. The Victorian house was divided up into separate spheres: public and private. As the first space entered into by a visitor, the porch was considered a public sphere, a transitional space not unlike the front hall inside the house, taking the guest from the exterior to the interior of the house. The porch was used for children to play during bad weather and for young couples to court. Adults also used the porch to greet the neighbors and watch the street life. Most houses built in this period had front porches. Although some earlier house styles had porches, they had a variety of names, such as gallerie, piazza, colonnade, or veranda. After the so-called front porch campaign of President Garfield, in 1880, the descriptive term *porch* caught on throughout the country. The concept of the porch was to orient the house to the street, which changed in the twentieth century as houses became more insular with back decks facing the backyard.

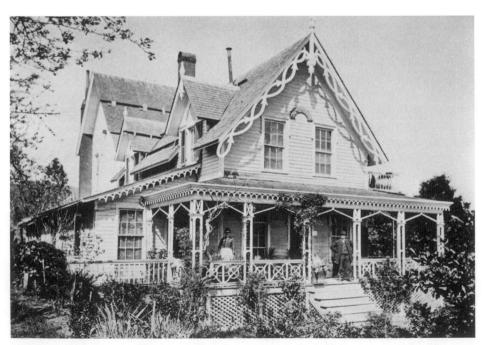

Oregon house with couple standing on front porch. Porches were ubiquitous on middle class houses of this period. Courtesy of the Library of Congress.

Most houses from this period also had back porches, which had a very different function. They were part of the family's private domain. They were also the opposite of the clean, attractive porch in front where the family showed its stature in the community. The back porch was a working porch, used by servants or family members for the dirtier, but necessary aspects of home life. The back porch had coal or woodpiles, garbage mounds, or even outhouses depending on the plumbing available in the house. Back porches were used for storing perishable food in the winter and to air the bedding. African Americans were expected to enter houses by the back porches during this period (Schlereth 1991, 134). It was a different world from the front porch of the house.

Porches in the American home first appeared in the South in the 1700s. Georgian, Federal, and Greek Revival styles of houses did not feature porches except in southern climes where the heat and humidity demanded the relief from the sun afforded by the front porch. The rest of the country adopted the concept of the front porch after the 1850s. By the Victorian Era, the porch had become the symbol of American home values. Politicians were often photographed sitting on their front porch, or even campaigned from the front porch. Many of the architectural styles of the Victorian period featured front and back porches, including Queen Anne, Second Empire, Stick, Shingle, and the foursquare. There were also specific types of porches: sleeping porches, breakfast porches, and sun porches.

The campaign for President of the United States in 1880 made use of the ubiquitous element in the Victorian house: the front porch. The party of Abraham Lincoln, the Republican Party, was in disarray after Reconstruction and the corruption and economic problems of the country. The Republican nominee, James A. Garfield, was a personable fellow who decided to run his campaign from the new front porch he built on his old farmhouse in Mentor, Ohio. The party convinced the local railroad to build a spur to the backyard of the house. All summer and fall, Garfield entertained all types of visitors, and most importantly, journalists, from the front porch of his house. The campaign was dubbed the "front porch campaign," and it worked, as Garfield won the election by over 9,000 votes. The sad end to the story, however, is that an assassin shot Garfield on July 2, 1881. His wound became infected, and he died. Possibly as a result of the front porch campaign of James Garfield, after 1880, the front porch became an element in the growing advertising business. The sentimental ideal of the home and family promoted by the advertising industry utilized the ever-present front porch to portray the all-American family in a cozy attitude on the front porch in many magazine advertisements.

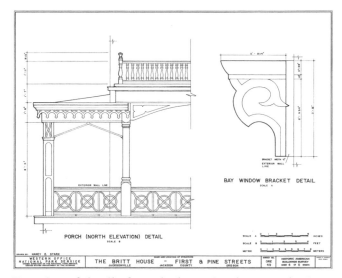

Drawing of detail of porch shown in photograph. Courtesy of the Library of Congress.

LAWNS

The major element of the late nineteenth-century landscape for the sub-urban home was the newly installed front lawn. This ingredient in the yard of the small suburban lot was something totally novel for the middle class. Lawns as perceived by the American culture are unique to the United States. Before the middle of the nineteenth century, American houses did not have yards that contained lawns. As a matter of fact, most houses were built very close to the street where there was no room for a lawn. The house was usually surrounded by a small garden, enclosed by a fence. Farms had fields or gardens surround-ing the house or a packed dirt area. The southern house might have a yard of dirt covered with pine straw. The adobe houses of the Southwest were close to the street with an interior courtyard in the Spanish style.

The origin of the American grass lawn was in English garden design, in large country estates. The English garden had vistas and rolling hills. The American version was popularized by a variety of factors. Once again the most influential book regarding lawns was Frank J. Scott's *The Art of Beautifying Home Grounds* of 1870. Scott advocated for a well-manicured lawn. He wrote in his book:

> A smooth, closely shaven surface of grass is by far the most essential element of beauty on the grounds of a suburban home. Dwellings, all the rooms of which may be filled with elegant furniture, but with rough uncarpeted floors, are no more incongruous, or in ruder taste, than the shrub and tree and flower-sprinkled yard of most home-grounds, where shrubs and flowers mingle in confusion with tall grass, or ill-defined borders of cultivated ground . . . And however choice the variety of shrubs and flowers, if they occupy the ground so that there is no pleas-ant expanse of close-cut grass to relieve them, they cannot make a pretty place. (Scott 1870, 107)

Bernard McMahon, in 1806, wrote *The American Gardeners Calendar.* This was the first book about landscaping in the United States. McMahon wrote his book as a monthly calendar, assigning gardening chores for each month. The landscape he depicted was in the English country manor tradition and included a grand and spacious lawn and shrubs, clumps of trees, serpentine gravel walks, and flower beds. Jacob Weidenmann's *Beautifying Country Homes: A Handbook of Landscape Gardening* was also an influential book for the American homeowner. However, before the 1870s, only the very wealthy, with their mansions and ex-pansive grounds, had beautiful lawns. Grass was cut by grazing animals or by a scythe. Most homeowners merely left the yard in an untended state, cutting down the growth with a scythe twice a year.

Architectural pattern books were another factor in the growth of the popu-larity of the suburban lawn. These books and magazines, read by millions of middle-class Americans in the late nineteenth century, portrayed drawings of houses in landscaped estates. The drawings showed expansive lawns that exag-gerated the size of the actual yard in order to emphasize the independence of each piece of property.

Farmlands were being developed into subdivisions in many parts of the country, especially in the Northeast as farmers relocated to the Midwest, and factory and office workers sought shelter in the streetcar suburbs of the East. In

the Northeast region, development was occurring at a different rate than in the tradition-bound South. Farms were always small and struggling in the Northeast, with the harsh weather and rocky soil, so with the opening of the West for expansion, many farmers relocated and left their farms. The area was growing with development of industry, and housing was needed for the expanding population. Suburban developers bought up abandoned farms and broke the land up into suburban lots. With the invention of the streetcar, more families were able to commute to the cities from the new suburbs. These suburban lots were small and did not contain barns for horses, which were unnecessary because of the new public transportation. The households in the Northeast that were attempting to have a lawn were aided by the installation of city water systems. In maintaining a lawn, the homeowner used city water and often bought a lawn sprinkler, which were available at this time. These new subdivisions were depicted in the advertising literature showing large lawns, which were loose interpretations of English gardens, without the picturesque trees and water features found in the real thing. Converting farmland into grass lawns, without the costly addition of trees and shrubs, is the easiest thing to do for a developer, as is still the case today.

Lawnmowers

The lawnmower was invented in England in the 1830s but made its debut in the United States in the 1870s. This invention helped bring the manicured lawn to the American nineteenth-century suburb. Englishman Edwin Budding in 1830 invented the first reel lawn mower. It was based on the machine called a rotary shear that cut the nap on carpets. Although it was available, it was not popularized because it wasn't needed by the typical homeowner in the United States or in England. A cylindrical lawn mower was invented in 1868, and patents were issued for a number of American versions of the lawn mower in the 1870s. Most of the lawn mowers were sold to homeowners in the Northeast and northern Midwest, such as Illinois and Ohio, which was where many New Englanders had relocated. The rest of the country was not interested in the lawn at this time. In 1880, less than one half of one percent of households in the United States owned a lawn mower. By the 1890s, the lawn mower became a standard item in mail-order catalogs and, therefore, meant that many homes were including a front lawn (Jenkins 1994, 29).

Arbiters of good taste advocated for the lawn mower, but the facts of life were that not many people had lawns at this time. The wealthy family with many servants and lots of land would most likely have a garden and lawn and a lawn mower. Some middle-class families in the Northeast and Midwest had lawns because they were at the forefront of the style. However, in the South, West, and Southwest, the lawn was not considered an important feature of the house until well into the twentieth century. Although many design writers advocated for the use of lawns in the late nineteenth century, the creation of a beautiful lawn was not an easy process. Even after the invention of the lawn mower, the maintenance of a lawn was difficult because of other factors. Grasses that would thrive in the various climates in the United States were not developed until later, and the requirements of lots of water (from city water supply) and pesticides were not available. Advice books were suggesting that

families try to put in a lawn, and if it fails, pull it out and try again. Many lawns before the turn of the century were ratty, full of holes and weeds.

Gardening was becoming popular in the 1880s and 1890s, and books and articles were being published advising homeowners on the care of a lawn and garden. The front lawn was depicted as a part of the public space as designed on the interior of the Victorian house, that is, the parlor and front hall. The lawn could be decorated with plantings and lawn furniture. But, although design writers in books and magazines advocated for manicured lawns beginning in the 1870s, as mentioned previously, many homes did not boast a lawn until after the twentieth century.

For those families who had one, the lawn was considered a transitional space between the house (private) and the street (public). It also was a buffer zone representing the separation between the city and the country. Though a small space, the small suburban lot acted as a symbol of a rural spot within an urban setting. Lawns were closely shorn when lawn mowers became available at the end of the century, and the symbolic meaning of the close-cut lawn was as a version of the indoor carpet. Andrew Jackson Downing suggested that the yard include items found inside the house, such as sculpture, as a "harmonious union between the architecture and the landscape, or, in other words, between the house and the grounds" (Shepard 2002, 236).

Olmsted also recommended the transitional space on the suburban lawn. He considered a fence or wall surrounding the property as an outer wall of the house, and therefore undesirable. He liked a lawn, with some lawn ornaments or cast iron furniture, to mimic the interior.

The lawn became an obsession of some homeowners by 1900, with contests being held for the greenest lawn, as well as for the best garden displays. Crabgrass also became an issue during this time when it was imported from Europe by Eastern European immigrants, and it still remains a problem today. Lawn games, such as croquet, were imported from England and were greatly popular in the 1880s. They were played by all ages and both sexes, and even in farm areas wherever they had a lawn.

Lawns became an example of Veblen's theory of conspicuous consumption—the Victorian concept of having items just for the sake of having them. Lawns were not necessary but were merely a luxury that proved one's ability to afford such an unused piece of land. They were difficult to grow and difficult to maintain. With the invention of the lawnmower, in the 1880s and 1890s lawns were becoming more and more popular. By the turn of the century, the suburban lot with the front lawn had become part of the American dream: owning a house with a yard and, of course, a front lawn.

THE STREETCAR SUBURBS EMERGE

With the advent of the American picturesque ideal of a house with a yard, cities in the late nineteenth century in the United States developed so-called streetcar suburbs, with radial growth in concentric circles with the urban core at its center. The suburbs were connected to the downtown by a streetcar line. The streetcar could be an omnibus, horse car, or electric streetcar. These developments appealed most to first-generation Americans who may have grown up in the squalid tenements of the city and craved a little piece of land with a

house on it, after reading the advertisements in the newspapers and magazines depicting houses with appealing yards in the Downing picturesque tradition. Most of the houses were single family and had small lots, not at all like the parklike grounds advocated by Downing. The communities were often linked by particular ethnic groups and had churches and social clubs providing neighborhood support. Eventually, the government agencies would provide services to the community such as roads, sidewalks, sanitation, plumbing, and, later, electrical and telephone lines. The typical suburb was designed for the emerging middle class. In fact, in the early twentieth century, they were dubbed zones of emergence by sociologists, who were referring to the emergence from the tenements to a home of their own (Hayden 2003, 73).

These streetcar suburbs, a term originally dubbed by Sam Bass Warner in 1962, are not like suburbs we encounter today. They are most likely within the city itself, or very close to it. (Boston, whose streetcar suburbs had resisted the urge of the city to annex them into the city of Boston, now has many nearby individual small cities within very close proximity to the city, for instance Cambridge, Medford, and Somerville. This, however, is an anomaly among most American cities. New York, for instance, took over all the surrounding suburbs in 1898 to make the city as large as it is today. The original city, consisting of only the island of Manhattan, is now five boroughs: Manhattan, Brooklyn, Queens, the Bronx, and Staten Island.)

The development of the typical house with a yard was the major revolution in the appearance of the American town. Contemporary architects Duany, Plater-Zyberk, and Speck, known for their New-Urbanist designs of houses within walkable communities, decry the present state of the American suburb in their book *Suburban Nation:*

> Today's suburban reality finds its origins in the pastoral dream of the autonomous homestead in the countryside. Articulated throughout U.S. history, from Jefferson through Limbaugh, this vision has been equated with a democratic economy in which homeownership equals participation. However, this equation seems to have its limits, as only a small number of people can achieve that dream without compromising it for all involved. As the middle class rushes to build its countryside cottages at the same time on the same land, the resulting environment is inevitably unsatisfying, its objective self-contradictory: isolation en masse. (2002, 40)

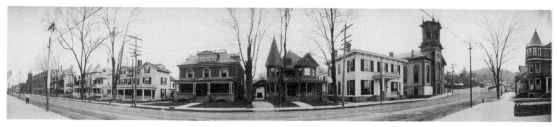

This early panoramic photo shows an example of streetcar suburbs in a town in New Jersey. Courtesy of the Library of Congress.

The development of the original suburb, the house with the yard, has seen more and more outward growth, larger lot sizes, and greater distance from urban centers. Architects, such as the authors of *Suburban Nation,* are harkening back to the concept of the late nineteenth-century suburb, with a town center and amenities within walking distance, which has been lost in the twentieth century's penchant for horizontal growth, also known as suburban sprawl.

Reference List

Bryan, William Jennings. 1896. "Cross of Gold" speech. Available at: http://historymatters.gmu.edu/d/5354/

de Tocqueville, Alexis. 1835. *Democracy in America.* Repr. New York: Signet Classics, 2001.

Downing, Andrew J. 1850. *The Architecture of Country Houses.* Repr. New York: Dover Publications. 1969.

Duany, Andres, Elizabeth Plater-Zyberk, and Jeff Speck. 2000. *Suburban Nation—The Rise of Sprawl and the Decline of the American Dream.* New York: North Point Press.

Handlin, David P. 1979. *The American Home, Architecture and Society—1815–1915.* Boston: Little, Brown and Company.

Hayden, Delores. 2003. *Building Suburbia—Green Fields and Urban Growth—1820–2000.* New York: Vintage Books.

Jackson, Kenneth T. 1985. *Crabgrass Frontier: The Suburbanization of the United States.* New York: Oxford University Press.

Jefferson, Thomas. 1823. "Thomas Jefferson to William Short." In *The Writings of Thomas Jefferson,* 20 vols., ed. Andrew A. Lipscomb and Albert Ellery Bergh, 15:469. Washington, D.C.: Thomas Jefferson Memorial Association, 1903–1904. Available at: http://etext.virginia.edu/jefferson/quotations/jeff1320.htm

Jenkins, Virginia Scott. 1994. *The Lawn—A History of an American Obsession.* Washington, D.C.: Smithsonian Institution Press.

Leopold, Allison Kyle. 1995. *The Victorian Garden.* New York: Clarkson Potter.

Rybczynski, Witold. 1996. *City Life.* New York: Scribner.

Schlereth, Thomas J. 1991. *Victorian America: Transformations in Everyday Life.* New York: Harper.

Scott, Frank J. 1870. *The Art of Beautifying Suburban Home Grounds.* New York: D. Appleton & Co.

Shepard, Paul. 2002. *Man in the Landscape: A Historic View of the Esthetics of Nature.* Athens: University of Georgia Press.

Thoreau, Henry David. 1862. *Walking, A Journal.* Repr. Carlisle, MA: Applewood Books, 1996.

Tobey, G. B. 1973. *A History of Landscape Architecture: The Relationship of People to Environment.* New York: American Elsevier Publishing Company, Inc.

Wright, Gwendolyn. 1981. *Building the Dream—A Social History of Housing in America.* Repr. Cambridge, MA: The MIT Press, 1995.

Wright, Gwendolyn. 1980. *Moralism and the Model Home: Domestic Architecture and Cultural Conflict in Chicago, 1873–1913.* Chicago: University of Chicago Press.

Glossary

American Exceptionalism: A term first used by Alexis de Tocqueville in 1831 to describe the perception that the United States differs qualitatively from other developed countries because of its unique origins, national creed, historical evolution, and distinctive political and religious institutions.

American Renaissance: A movement of the fine arts and architecture in late nineteenth-century United States that identified American interest in Renaissance design and the quest for an American version of the flowering of sixteenth-century art. The style was not specifically based on the Renaissance style. Beaux-Arts architecture and the City Beautiful movement were elements of the American Renaissance movement, as well as many decorative art trends, including the glasswork of Louis Comfort Tiffany.

Arts and Crafts movement: An American and British movement of the late nineteenth and early twentieth centuries that developed out of the British Aesthetic movement, accentuating authentic and simple design and handmade instead of manufactured objects. It was a reform movement that reacted to the Victorian ostentation. Those prominent in the movement were the English designer William Morris and American furniture designer and builder Gustav Stickley.

Balloon frame: The house framing technique invented in the nineteenth century that allowed the use of numerous, light framing members instead of a few, heavy timbers. The technique, utilizing factory-manufactured nails, allowed the construction of larger, more complicated structures and was part of the impetus for the home construction boom of the late nineteenth century.

City Beautiful movement: A branch of the Progressive movement and related to the Beaux-Arts architectural style, promulgated by prominent architects of the late nineteenth and early twentieth centuries. They believed that a beautifully designed city would encourage increased civic virtue and moral rectitude. The City Beautiful movement was influenced by reformers such as Jacob Riis, who helped to expose the horrible conditions of the poor in the nation's largest cities.

Classicism: In architecture, it refers to the emulation of the forms of classical antiquity. Based on Greek and Roman orders, the forms are restrained, rational, and symmetrical. In the nineteenth century, classicism was popular in such styles as Greek Revival, Colonial Revival, and the Beaux-Arts style.

Colonial Revival: The movement in the arts and architecture in the late nineteenth and early twentieth centuries that recalled the colonial past of the United States. The movement began after the first centennial of the United States took place in 1876, and a nationalistic sentiment brought feelings of nostalgia for the design of the Georgian and Federal periods. The simplicity of the Colonial Revival was a reaction to the pretentiousness of the Victorian style.

Conspicuous consumption: The idea conceived by Thorstein Veblen in 1899 that the United States had developed a culture that promoted spending extravagantly on unnecessary products simply for the purpose of displaying wealth and social status.

Cult of domesticity: The sociological concept of the mid- to late nineteenth century that glorified the female's role in the home. The wife and mother was believed to be the avowed moral leader of the household and had the task of bringing up the children in a moral way, as well as providing a refuge for the husband from the competitive life outside the home. The modern feminist movement has rejected the cult of domesticity, aspects of which have continued into the twentieth century, especially in the post World War II era.

École des Beaux-Arts: The school of the fine arts in Paris where most American architects and artists were trained before the advent of American architectural schools. The training was based on classical traditions. The Beaux-Arts architectural style of the late nineteenth century was named after the École des Beaux-Arts.

Fanlight: A type of transom window, the fanlight was a window above a door that was formed into a fan design. Often, fanlights were accompanied by sidelights, which were narrow windows at either side of the door.

French flats: An invention of the late nineteenth century for urban living, they were the first residential buildings that were constructed expressly as luxurious apartments. The concept originated in France and was popular in New York City and Chicago, but it did not catch on in most areas of the country where the detached house was the norm.

Gable: An architectural term describing a type of roof construction whereby two sloped roofs meet to form a triangular shape.

Gothic: The architectural style originating in twelfth-century French churches that was characterized by tall, pointed arches and structural supports extending out of the building called flying buttresses. The style was revived in the nineteenth century by a group called the Gothicists in England.

Gothicism: The concept that architecture should emulate the twelfth-century Gothic style, as opposed to the classical style. In the nineteenth century, Gothicists sought to revive medieval forms in distinction from the Classical styles that were prevalent at the time. Influenced by medievalism, Gothicism was a part of the interest in all things antique in the nineteenth century. Social and architectural critics such as A.W.N. Pugin and John Ruskin and architect Viollet-le-Duc promoted the Gothic style for its aesthetic, religious, and moral significance.

Landscape architecture: A professional field that encompasses the design of all aspects of the environment apart from the building, which is the scope of the architect. This includes: site planning, environmental restoration, urban planning, parks, and garden design. A practitioner in the field of landscape architecture is called a landscape architect. The field was developed in the second half of the nineteenth century.

Lathework: Wood ornamental elements often found on Victorian houses, produced with a lathe, which is a machine tool that turns a block of wood and cuts a symmetrical design around an axis of rotation.

Massing: An architectural term referring to the basic volumes of the three-dimensional shapes of the exterior of the building.

Palladian window: A large window that is divided into three parts. The center section is larger than the two side sections and is usually arched. Many Renaissance buildings had Palladian windows, named after the Renaissance architect Andrea Palladio. Queen Anne and Colonial Revival houses sometimes had Palladian windows.

Pediment: A classical element of triangular shape originally found in Greek temples, resting on the entablature, which in turn was above the columns. It is often found in many later styles that used classical architectural vocabulary.

Picturesque: A concept that influenced art, architecture, and landscape design in the eighteenth and nineteenth centuries based on an aesthetic category somewhere between beautiful and sublime. It was applied mainly to rugged landscapes with rocks, waterfalls, and winding paths. The concept in landscape design referred to a landscape that resembled a picture. It appeared to be natural, though it was usually a designed landscape. In architecture, it referred to irregular forms, the opposite of classical symmetry.

Polychromy: Literally, "many colors," the architectural technique of using a variety of finishes or paint colors on the exterior of buildings as decorative elements. The use of polychromy was popular in certain late nineteenth-century styles, for instance the High Victorian Gothic and Queen Anne style.

Romanesque: A medieval architectural style from the eleventh and twelfth centuries, used primarily in churches, that was characterized by round arches and barrel vaults. The style was found throughout Europe and was thought to be influenced by ancient Roman architecture. The nineteenth-century architect Henry Hobson Richardson created an American style dubbed Richardsonian Romanesque because his heavy, massive, round-arched forms recalled the European models.

Romanticism: A movement that is seen by many as a reaction against the Enlightenment. Whereas the thinkers of the Enlightenment emphasized the

sovereignty of deductive reasoning, Romanticism emphasized intuition, imagination, and sensitivity. Romantic thinkers are the antithesis of rational thinkers. The nineteenth century had Romantic trends in music, art, architecture, and landscape architecture.

Rustication: A technique of cutting masonry blocks to look rough-hewn, with deep-set joints. Often used on Renaissance buildings, it was also found on Richardsonian Romanesque buildings.

Social Darwinism: The sociological concept based on the Darwinian theory of natural selection that purports that society is ruled by the "survival of the fittest." Therefore, Social Darwinists believe that one's place in society is directly related to biological inferiority or superiority. This belief was common in the late nineteenth century.

Streetcar suburbs: The development of suburbs built in concentric rings close to the city in the late nineteenth century where middle-class families could buy a single-family house and travel to work on the newly built streetcars. Historian Sam Bass Warner first identified the development of streetcar suburbs in 1962.

Symmetrical: Having the same corresponding parts in relative positions on opposite sides. In design, symmetry is commonly found in some styles more than others. For instance, Classical styles are generally symmetrical while Picturesque styles are not.

Tenement: A term used to describe a modest apartment building built to house indigent families, historically immigrant families. The tenement usually was five or six stories high and had no elevator.

World's Columbian Exposition: A World's Fair intended to celebrate the 400th anniversary of Christopher Columbus' discovery of the New World. The six-month long fair had influence on the country through its early use of electricity, its architectural design in the style of the Beaux-Arts, and its introduction of new products to the marketplace.

Resource Guide

PRINTED SOURCES

Ames, Kenneth L. 1992. *Death in the Dining Room & Other Tales of Victorian Culture.* Philadelphia: Temple University Press.

Anderson, Stanford. 1999. "Architectural History in Schools of Architecture." *The Journal of the Society of Architectural Historians* 58(3): 282–290.

Andrews, Wayne. 1947. *Architecture, Ambitions and Americans.* New York: The Free Press.

Bauman, John F., Roger Biles, and Kristin M. Szylvian. 2000. *From Tenements to the Taylor Homes.* University Park: Pennsylvania State University Press.

Beecher, Catherine E., and Harriet Beecher Stowe. 1869. *The American Woman's Home.* Repr., New Brunswick, NJ: Rutgers University Press, 2002.

Bellamy, Edward. 1888. *Looking Backward.* Repr. New York: New American Library, 1960.

Benway, Ann. 1984. *A Guidebook to Newport Mansions.* Newport, RI: Ft. Church Publishers.

Brierton, Joan. 1999. *American Restoration Style: Victorian.* Salt Lake City: Gibbs-Smith Publishers.

Bushman, Richard L., and Claudia Bushman. 1988. "The Early History of Cleanliness in America." *The Journal of American History* 74(4): 1213–1238.

Carr, Caleb. 2006. *The Alienist.* New York: Random House.

Carter, Thomas. 2000. "Living the Principle: Mormon Polygamous Housing in Nineteenth Century Utah." *Winterthur Portfolio* 35(4): 223–251.

This is the resource guide for Part III of the volume (1881–1900). For the resource guide to Part I (1821–1860), please see page 145. For the resource guide to Part II (1861–1980), please see page 317.

Cashman, Sean D. 1993. *America in the Gilded Age: From the Death of Lincoln to the Rise of Theodore Roosevelt.* New York: New York University Press.

Clark, Clifford E., Jr. 1976. "Domestic Architecture as an Index to Social History: The Romantic Revival and the Cult of Domesticity in America, 1840–1870." *Journal of Interdisciplinary History* 7(1): 33–56.

Clark, Clifford Edward, Jr. 1986. *The American Family Home, 1800–1960.* Chapel Hill: University of North Carolina Press.

Cudworth, Marsha. 1997. *Architectural Self-Guided Tours—Cape May, N.J.* New York: Lady Raspberry Press.

Davidson, Marshall B. 1980. *The Bantam Illustrated Guide to Early American Furniture.* New York: Bantam Books.

de Tocqueville, Alexis. 1835. *Democracy in America.* Repr. New York: Signet Classics, 2001.

De Wolfe, Elsie. 1913. *The House in Good Taste.* New York: The Century Co. (Orig. pub. 1911.)

Downing, Andrew J. 1850. *The Architecture of Country Houses.* Repr. New York: Dover Publications, 1969.

Duany, Andres, Elizabeth Plater-Zyberk, and Jeff Speck. 2000. *Suburban Nation—The Rise of Sprawl and the Decline of the American Dream.* New York: North Point Press.

Eastlake, Charles L. 1878. *Hints on Household Taste.* Repr., New York: Dover Publications, 1969.

Fitch, James Marsden. 1973. *American Building 1: The Historical Forces That Shaped It,* 2nd ed. New York: Schocken Books. (Orig. pub. 1947.)

Foy, Jessica H., and Thomas J. Schlereth, eds. 1992. *American Home Life 1880–1930.* Knoxville: The University of Tennessee Press.

Friedan, Betty. 1963. *The Feminine Mystique.* New York: W. W. Norton & Co.

Garrett, Wendell. 1993. *Victorian America—Classical Romanticism to Gilded Opulence.* New York: Universe Publishing.

Garvin, James L. 1981. "Mail-Order House Plans and American Victorian Architecture." *Winterthur Portfolio* 16(4): 309–334.

Gay, Cheri Y. 2002. *Victorian Style—Classic Homes of North America.* Philadelphia: Courage Books.

Gelernter, Mark. 1999. *A History of American Architecture—Buildings in their Cultural and Technological Context.* Lebanon, NH: University Press of New England.

Gillon, Edmund, Jr., and Clay Lancaster. 1973. *Victorian Houses—A Treasury of Lesser-Known Examples.* New York: Dover Publications, Inc.

Ginger, Ray. 1975. *The Age of Excess: The United States from 1877 to 1914.* New York: Macmillan.

Handlin, David P. 1979. *The American Home: Architecture and Society, 1815–1915.* Boston: Little, Brown and Co.

Handlin, David P. 1985. *American Architecture.* London: Thames and Hudson.

Hayden, Delores. 2003. *Building Suburbia—Green Fields and Urban Growth—1820–2000.* New York: Vintage Books.

Hitchcock, Henry-Russell. 1966. *The Architecture of H.H. Richardson and His Times.* Cambridge, MA: The MIT Press.

Hitchcock, Henry-Russell, Albert Fein, Winston Weisman, and Vincent Scully. 1970. *The Rise of an American Architecture.* New York: Praeger Publishers.

Hull, Judith S. 1993. "The 'School of Upjohn': Richard Upjohn's Office." *The Journal of the Society of Architectural Historians* 52(3): 281–306.

Ierley, Merritt. 1999. *The Comforts of Home—The American House and the Evolution of Modern Convenience.* New York: Three Rivers Press.

Jackson, Kenneth T. 1985. *Crabgrass Frontier: The Suburbanization of the United States.* New York: Oxford University Press.

Jenkins, Virginia Scott. 1994. *The Lawn—A History of an American Obsession.* Washington, D.C.: Smithsonian Institution Press.

Lancaster, Clay. 1958. "The American Bungalow." *The Art Bulletin* 40(3): 239–253.

Larsen, Eric. 2004. *The Devil in the White City.* New York: Bantam Books.

Leopold, Allison Kyle. 1995. *The Victorian Garden.* New York: Clarkson Potter.

Lewis, Arnold. 1982. *American Country Houses of the Gilded Age.* New York: Dover Publications, Inc.

Mace, O. Henry. 1991. *Collector's Guide to Victoriana.* Radnor, PA: Wallace-Homestead Book Company.

Madigan, Mary Jean Smith. 1975. "The Influence of Charles Eastlake on American Furniture Manufacture, 1879–1890." *Winterthur Portfolio* 10: 1–22.

McAlester, Virginia, and Lee McAlester. 2000. *A Field Guide to American Houses.* New York: Alfred A. Knopf.

Morrison, Hugh. 1935. *Louis Sullivan—Prophet of Modern Architecture.* New York: W. W. Norton and Co.

Moss, Roger W., and Gail Caskey Winkler. 1986. *Victorian Interior Decoration—American Interiors 1830–1900.* New York: Henry Holt and Company.

Mumford, Lewis. 1955. *Sticks and Stones.* New York: Dover Publications.

Mumford, Lewis. 1971. *The Brown Decades: A Study of The Arts of America 1865–1895.* New York: Dover Publications.

Norton, Thomas E., and Jerry E. Patterson. 1984. *Living It Up—A Guide to the Named Apartment Houses of New York.* New York: Atheneum.

Nye, David E. 1990. *Electrifying America—Social Meanings of a New Technology, 1880–1940.* Cambridge, MA: The MIT Press.

Ogle, Maureen. 2000. *All the Modern Conveniences: American Household Plumbing, 1840–1890.* Baltimore: Johns Hopkins University Press.

O'Gorman, James. 1991. *Three American Architects—Richardson, Sullivan and Wright, 1865–1915.* Chicago: University of Chicago Press.

Omoto, Sadahoshi. 1964. "The Queen Anne Style and Architectural Criticism." *The Journal of the Society of Architectural Historians* 23(1): 29–37.

Pattison, Mary. 1915. *Principles of Domestic Engineering.* New York: Trow Press.

Platt, Harold L. 1991. *The Electric City—Energy and the Growth of the Chicago Area, 1880–1930.* Chicago: The University of Chicago Press.

Poppeliers, John C., S. Allen Chambers, Jr., and Nancy B. Schwartz. 1983. *What Style Is It?* Washington, D.C.: The Preservation Press.

Rhoads, William B. 1976. "The Colonial Revival and American Nationalism." *The Journal of the Society of Architectural Historians* 35(4): 239–254.

Rifkind, Carole. 1980. *A Field Guide to American Architecture.* New York: New American Library.

Riis, Jacob A. 1890. *How the Other Half Lives.* Repr. Boston: Bedford Books of St. Martin's Press, 1996.

Roth, Leland M. 2001. *American Architecture—A History.* Boulder, CO: Westview Press.

Rybczynski, Witold. 1987. *Home—A Short History of an Idea.* New York: Penguin Books.

Rybczynski, Witold. 1996. *City Life.* New York: Scribner.

Rybczynski, Witold. 1999. *A Clearing in the Distance: Frederick Law Olmsted and America in the 19th Century.* New York: Simon & Schuster.

Schlereth, Thomas J. 1991. *Victorian America: Transformations in Everyday Life.* New York: Harper.

Schultz, Stanley K., and Clay McShane. 1978. "To Engineer the Metropolis: Sewers, Sanitation, and City Planning in Late- Nineteenth-Century America." *The Journal of American History* 65(2): 389–411.

Schweitzer, Robert, and Michael W. R. Davis. 1990. *America's Favorite Homes—Mail-Order Catalogues as a Guide to Popular Early 20th-Century Houses.* Detroit: Wayne State University Press.

Scott, Frank J. 1870. *The Art of Beautifying Suburban Home Grounds.* New York: D. Appleton & Co.

Scully, Vincent, Jr. 1961. *Modern Architecture—The Architecture of Democracy.* Repr. New York: George Braziller, 1974.

Scully, Vincent J., Jr. 1971. *The Shingle Style and the Stick Style,* rev. ed. New Haven, CT: Yale University Press.

Shepard, Paul. 2002. *Man in the Landscape: A Historic View of the Esthetics of Nature.* Athens: University of Georgia Press.

Shoppell, R. W. 1983. *Turn-of-the-Century Houses, Cottages and Villas.* New York: Dover Publications Inc.

Smeins, Linda E. 1999. *Building An American Identity—Pattern Book Homes and Communities.* Walnut Creek: Altamira Press.

Stickley, Gustav. 1979. *Craftsman Homes.* New York: Dover Publications.

Stone, May N. 1979. "The Plumbing Paradox: American Attitudes toward Late Nineteenth-Century Domestic Sanitary Arrangements." *Winterthur Portfolio* (Autumn): 283–309.

Strasser, Susan. 1982. *Never Done—A History of American Housework.* New York: Henry Holt and Company.

Taylor, Frederick Winslow. 1911. *The Principles of Scientific Management.* New York: Harper. 1947.

Teyssot, Georges. 1999. *The American Lawn.* Princeton Architectural Press.

Thoreau, Henry David. 1862. *Walking, A Journal.* Repr. Carlisle, MA: Applewood Books, 1996.

Tobey, G. B. 1973. *A History of Landscape Architecture: the Relationship of People to Environment.* New York: American Elsevier Publishing Company, Inc.

Townsend, Gavin. 1989. "Airborne Toxins and the American House, 1865–1895." *Winterthur Portfolio* 24(1): 29–42.

Trachtenberg, Alan. 1982. *The Incorporation of America: Society in the Gilded Age.* New York: Hill & Wang.

Upton, Dell, ed. 1986. *Roots—Ethnic Groups the Built America.* Washington, D.C.: The Preservation Press.

Upton, Dell. 1998. *Architecture in the United States.* Oxford: Oxford University Press.

Van Rensselaer, Mariana Griswold. 1996. *Accents as Well as Broad Effects. 1876–1925,* ed. David Gebhard. Berkeley: University of California Press.

Veblen, Thorstein. 1899. *The Theory of the Leisure Class.* Repr. New York: Dover Publications, Inc., 1994.

Walker, Lester. 1998. *American Shelter.* Woodstock, NY: The Overlook Press.

Wharton, Edith, and Ogden Codman, Jr. 1897. *The Decoration of Houses.* Repr. New York: W.W. Norton and Company, 1997.

White, Samuel G. 2004. *The Houses of McKim, Mead and White.* New York: Universe Publishing.

Wiebe, Robert H. 1967. *The Search for Order.* New York: Hill and Wang.

Wilson, Guy, Dianne Pilgrim, and Richard Murray. 1979. *The American Renaissance 1876–1917.* New York: The Brooklyn Museum.

Woods, Mary. 1989. "The First American Architectural Journals: The Profession's Voice." *The Journal of the Society of Architectural Historians* 48(2): 117–138.

Wright, Gwendolyn. 1980. *Moralism and the Model Home: Domestic Architecture and Cultural Conflict in Chicago, 1873–1913.* Chicago: University of Chicago Press. 1985.

Wright, Gwendolyn. 1981. *Building the Dream—A Social History of Housing in America.* Repr. Cambridge, MA: The MIT Press, 1995.

Zingman-Leith, Elan, and Susan Zingman-Leith. 1993. *The Secret Lives of Victorian Houses.* New York: Viking Studio.

MUSEUMS, ORGANIZATIONS, SPECIAL COLLECTIONS, AND USEFUL WEB SITES

Lower East Side Tenement Museum
108 Orchard St.
New York, NY 10002
http://www.tenement.org/

This museum, a real-life peek into the lives of immigrants on the Lower East Side of Manhattan during the nineteenth and early twentieth centuries, aims for teaching of tolerance and historical perspective. The apartments are actual apartments, recreated from research into the actual tenants. The Web site has virtual tours of the spaces and lots of historical information about the time period.

The Preservation Society of Newport County
424 Bellevue Avenue
Newport, RI 02840
http://www.newportmansions.org

The Preservation Society of Newport County conducts tours of the majority of the remaining Newport cottages for the mega-rich of America's Gilded Age.

The Mark Twain House
351 Farmington Avenue
Hartford, CT 06105
http://www.marktwainhouse.org

The Mark Twain House demonstrates a true Victorian upper middle-class aesthetic. This was the house that Mark Twain lived in during his happiest years.

Harriet Beecher Stowe Center
77 Forest St.
Hartford, CT 06105
http://www.harrietbeecherstowecenter.org

Close to the Mark Twain House, the Harriet Beecher Stowe Center is the last house lived in by the noted author of *Uncle Tom's Cabin*. The Center also has historical information about the famous abolitionist's family.

Glessner House Museum
1800 S. Prairie Ave.
Chicago, IL 60616
http://www.glessnerhouse.org

Finished in 1887, H. H. Richardson's Glessner House is open for tours and also contains a collection of decorative objects from the period.

Jane Addams Hull-House Museum
800 S. Halsted St.
Chicago, IL60607
http://www.hullhousemusuem.org

The settlement house started by Jane Addams in 1889 is open as a historical museum.

Cape May, New Jersey

The town of Cape May, New Jersey was a fashionable summer resort in the late nineteenth century. After a fire in 1878, most of the town had to be rebuilt and was done so in the great Victorian style. A visit here today shows a town that was restored to its Victorian splendor by preservationists and a strict building code.

The Museum of the Gilded Age at Ventfort Hall
104 Walker Street
Lenox, MA
http://www.gildedage.org

This museum is the cottage, or summer home built for Sarah Morgan, sister of J. P. Morgan, in 1893. It has guided tours of the mansion, as well as exhibits displaying the accoutrements of the gilded age society. Part of the film *Cider House Rules* was filmed there.

Flagler Museum
One Whitehall Way
Palm Beach, FL
http://flaglermuseum.us

This museum, designed by Carrere and Hastings, was the 1902 mansion of Henry Flagler, the builder of the first Florida railroad. The house is restored and has tours of the mansion as well as temporary exhibits regarding the Gilded Age.

Biltmore Estate
1 Approach Road

Asheville, NC 28803
http://www.biltmore.com

Biltmore, built for George Vanderbilt, opened in 1895. It was designed by Richard Morris Hunt with the grounds designed by Frederick Law Olmsted. It is still owned by the Vanderbilt family, but is operated as a house museum.

VIDEOS/FILMS

1900 House. 2000. Video, PBS. Reality TV of modern family dealing with life in 1900 London.

Age of Innocence. 1993. Daniel Day Lewis, Michelle Pfeiffer, directed by Martin Scorsese. Film of Edith Wharton's novel that portrayed the restrictive society of the well-to-do in late nineteenth-century New York.

America's Castles: The Victorian Era—The Mark Twain House, Glessner House And Glenmont. 1997. 50 minutes. A&E. Tours of several Gilded Age houses, including Mark Twain's in Hartford, Thomas Edison's in New Jersey, and H. H. Richardson's Glessner House in Chicago.

Ethan Frome. 1993. Liam Neeson, Joan Allen, directed by John Madden. The famous Edith Wharton tragic novel, portraying life in working-class New England.

Gangs of New York. 2002. Leonardo DiCaprio, Daniel Day-Lewis. directed by Martin Scorsese. Depiction of the Five Points district of Lower Manhattan in the 1860s when the Irish immigrants battled native born Americans for power.

The House of Mirth. 2000. Gillian Anderson, Dan Aykroyd, directed by Terence Davies. Another Edith Wharton novel, depicting love within the confines of the Gilded Age society.

Life with Father. 1947. William Powell, Myrna Loy, directed by Michael Curtiz. Clarence Day's comic memoir about an upper-class family in the 1880s in New York City, where the father thinks he runs the house, but it's really his wife that does.

Index

518 Index

About the Editor and Authors

NANCY BLUMENSTALK MINGUS is President of Mingus Associates, Inc., a Buffalo-based company founded in 1989, specializing in writing, training and consulting on project management and preservation topics. She has been involved in historic preservation for nearly twenty years, is on the board of the New York State Barn Coalition and the Preservation Coalition of Erie County, and served on the Town of Amherst Historic Preservation Commission for eight years. She has presented sessions at Restoration and Renovation, as well as at the Society of Architectural Historians, the Landmark Society of the Niagara Frontier and the Cleveland Restoration Society conferences.

Mingus has taught in a variety of online education programs and has written four books and more than forty articles. She has an MS in Education and an MA in Historic Preservation.

ELIZABETH B. GREENE is an Interior Designer at the College of Staten Island. She received a B.A. in Art History from McGill University in Montreal, where her specialization was Modern Art and Architecture. She attended the Columbia University Historic Preservation Program at the Columbia Graduate School of Architecture, Planning and Preservation and has served on the board of the Staten Island Preservation League. Her numerous travels through the United States, Canada and Europe have fueled her continuing fascination with 19th century architecture.

THOMAS PARADIS is Associate Professor of Geography at Northern Arizona University at Flagstaff, where he has been a faculty member in the Department

of Geography, Planning & Recreation since 1997 and has served as the university's Director of Academic Assessment since 2005. He has taught numerous courses in world and U.S. geography, urban design and historic preservation, small-town development, and geographic field methods. His research interests and associated publications include topics on cultural and historical geography, downtown and rural development, tourism and theming, historic preservation, and techniques to assess student learning.